Electronic String Art

String art is a well-known and popular activity that uses string, a board, and nails to produce artistic images (although there are variations that use different modalities). This activity is beloved because simple counting rules are used to create beautiful images that can both adorn walls and excite young minds. The downside of this highly tactile activity is that it is quite time-consuming and rigid. By contrast, electronic string art offers much more flexibility to set up or change nail locations and counting rules, and the images created from those changes change instantaneously.

Electronic String Art: Rhythmic Mathematics invites readers to use the author's digital resources available on the ESA website to play with the parameters inherent in string art models while offering concise, accessible explanations of the underlying mathematical principles regarding how the images were created and how they change. Readers will have the opportunity to create visually beautiful works of art while learning concepts from geometry, number theory, and modular arithmetic from approximately 200 short-interdependent sections.

Features

- Readers are able to drill down on images in order to understand why they work using short (one- to two-page) stand-alone sections
 - Sections are lessons that were created so that they could be digested in a single sitting
 - These sections are stand-alone in the sense that they need not be read sequentially but can be referred to based on images that the reader finds interesting
- An open-ended, inherently flexible teaching resource for elementary, middle, and high school-level mathematics
 - The most mathematically challenging sections (or portions of a section) are designated **MA** and may not be accessible to elementary and middle school readers
- Will be appreciated by anyone interested in recreational mathematics or mathematical artworks even if the users are not interested in the underlying mathematics
- Includes exercises, solutions, and many online digital resources
 - These QR codes take you to these digital resources. One takes you directly to the web version of the string art model (used as a starting point for teaching the parameters of the model in Section 25.5). The other takes you to the ESA web page with additional links to a variety of resources.

WEB VERSION

ESA web page contains:
Links within sections
Excel Files
Teaching materials

i

AK Peters/CRC Recreational Mathematics Series

Series Editors

Robert Fathauer
Snezana Lawrence
Jun Mitani
Colm Mulcahy
Peter Winkler
Carolyn Yackel

Luck, Logic, and White Lies
The Mathematics of Games, Second Edition
Jörg Bewersdorff

Mathematics of The Big Four Casino Table Games
Blackjack, Baccarat, Craps, & Roulette
Mark Bollman

Star Origami
The Starrygami™ Galaxy of Modular Origami Stars, Rings and Wreaths
Tung Ken Lam

Mathematical Recreations from the Tournament of the Towns
Andy Liu, Peter Taylor

The Baseball Mysteries
Challenging Puzzles for Logical Detectives
Jerry Butters, Jim Henle

Mathematical Conundrums
Barry R. Clarke

Lateral Solutions to Mathematical Problems
Des MacHale

Basic Gambling Mathematics
The Numbers Behind the Neon, Second Edition
Mark Bollman

Design Techniques for Origami Tessellations
Yohei Yamamoto, Jun Mitani

Mathematicians Playing Games
Jon-Lark Kim

Electronic String Art
Rhythmic Mathematics
Stephen Erfle

For more information about this series please visit: https://www.routledge.com/AK-Peter-sCRC-Recreational-Mathematics-Series/book-series/RECMATH?pd=published,forthcoming&pg=2&pp=12&so=pub&view=list

Electronic String Art
Rhythmic Mathematics

Stephen Erfle

CRC Press
Taylor & Francis Group
Boca Raton London New York

CRC Press is an imprint of the
Taylor & Francis Group, an **informa** business

AN A K PETERS BOOK

Designed cover image: Stephen Erfle

First edition published 2024
by CRC Press
2385 NW Executive Center Drive, Suite 320, Boca Raton FL 33431

and by CRC Press
4 Park Square, Milton Park, Abingdon, Oxon, OX14 4RN

CRC Press is an imprint of Taylor & Francis Group, LLC

Library of Congress Cataloging-in-Publication Data
Names: Erfle, Steve, author.
Title: Electronic string art : rhythmic mathematics / Steve Erfle.
Description: First edition. | Boca Raton : AK Peters/CRC Press, 2024. |
Series: AK Peters/CRC recreational mathematics series | Includes
bibliographical references and index.
Identifiers: LCCN 2023046181 (print) | LCCN 2023046182 (ebook) | ISBN
9781032515175 (hardback) | ISBN 9781032512730 (paperback) | ISBN
9781003402633 (ebook)
Subjects: LCSH: String craft--Technological innovations. | String
craft--Mathematics. | Computer art.
Classification: LCC TT880 .E74 2024 (print) | LCC TT880 (ebook) | DDC
746.1--dc23/eng/20231102
LC record available at https://lccn.loc.gov/2023046181
LC ebook record available at https://lccn.loc.gov/2023046182

ISBN: 9781032515175 (hbk)
ISBN: 9781032512730 (pbk)
ISBN: 9781003402633 (ebk)

DOI: 10.1201/9781003402633

Typeset in Avenir
by Deanta Global Publishing Services, Chennai, India

Access the Support Material: www.routledge.com/9781032512730

Contents

Contents

Contents

Preface

This book evolved from a series of fortunate events spanning many decades. Although I am an academic economist by training (PhD Harvard, 1983), I have spent much of my academic career devoted to pedagogical issues, primarily focusing on how to explain mathematical concepts in intuitive terms, often to students with limited mathematical backgrounds. At some level, this book is simply an extension of that focus.

I was introduced to string art more than 50 years ago by my high school math teacher, Art Fruhling. He worked under George Pólya during summer institutes for mathematics teachers at Stanford from 1969 to 1972. He tells me that string art (also known as aestheometry, curve stitching, parabolic art, and rhythmic geometry) was often mentioned there as well as during math conferences at Asilomar during the late 1960s. String art's deeper roots are traced to the curve stitching described by Mary Boole in her 1904 book, *The Preparation of the Child for Science*. My mentor, U.C. Davis professor emeritus of mathematics, Don Chakerian, has told me that some of the images I have shared with him remind him of images from H. S. M. Coxeter's book, *Regular Convex Polytopes*.

I was fascinated by the idea that one could create curved images using straight lines, and I created many pieces during my teen years. Most were abstract mirror-image pieces contrasting black string on white artboard with white string on black artboard. One of the most intricate pieces I created was a three-dimensional model using threaded steel rods, fishing line, and string that adorned the picture window of my undergraduate dorm room at U.C. Davis until I traded it for a painting that hangs in my office in the International Business and Management Department of Dickinson College. I am lucky to teach at a school that has allowed me wide latitude to pursue interests outside the traditional bounds one would expect of someone with my training.

I did not think about string art very much again until 2008 when my son's fifth-grade teacher, Denise Eschenmann, asked if I would like to share with the class some of the things you can do with *Excel*. (At the time, I was writing an intermediate microeconomics text in which all figures in the text had interactive counterparts in *Excel*, and I had gotten pretty good at doing graphical things in *Excel*.) One of the files I shared with this class, and with my daughters' classes once they too were in Denise Eschenmann's fifth-grade class, was a version of the string art file that spurred the creation of this book. That file encouraged kids to explore (x, y) graphing by mimicking string art on a closed set of student-provided vertices using three parameters.

Once my daughter Kate decided to study math at Dickinson, I decided to work with her on papers using that file as a starting point. The article "Exploring Symmetry Using Aestheometry in Classrooms and Beyond," *Proceedings of Bridges 2020: Mathematics, Art, Music, Architecture, Education, Culture*, pp. 547–554 is based on this file. (Links in the static text can be used via the *Links* document on the ESA website using the QR code on the *Features* page at the front of this book.) This article has a 13-minute introductory video that you can see by clicking here. This article also provides a link to an earlier unpublished piece Kate and I did with Denise Eschenmann and

Adam Jackson using the idea behind the file. Neither piece is readily accessible to younger users because graphing in the coordinate plane is initially discussed in about the fifth grade according to Common Core State Standards, 5.G, but the *Bridges* article forms the basis for ESA Chapter 19, *Busting out of our Polygonal Constraint* as well as Chapter 17, *Four-Color Clock Arithmetic*.

My other daughter, Vera, was interested in early elementary education. As a result, I worked with her, together with two other colleagues, (Wensel and Polinka) on a "pre-aestheometry" piece targeted at grades K-2. The article "Connecting Geometric Patterns to Numeric Patterns using the *Polygons and Stars* Excel File," *Spreadsheets in Education*, 2021, pp. 1–11, forms the basis for ESA Chapter 2, *Polygons and Stars*. As I worked on this piece, I started to think about how I could create string art materials that were accessible to younger viewers.

My epiphany came in recognizing that if I restrict my focus to regular polygons and stars, I could make the files accessible to young children since all they need to do is click and watch what happens. This became the basis for what has become ESA. I did not initially envision a book entirely based on string art. Instead, I envisioned it as simply a chapter in a book called *Playing with Polygons*.

ESA emerged as its own book in large part due to teaming up with Liam Myles, a full-stack programmer from the UK, whom I met online due to this fortuitous choice of words for my original project. During the early months of the pandemic, Liam had created an online app that he called "Playing with Polygons." His original materials can be seen here. Happily, Liam was interested in working with me to create an "*Excel*-free" web version of my materials. In short order, Liam created an online app that can recreate many of the images in ESA. Click here to go to that app.

As I began working on this as a book, rather than a series of academic papers, I have come to appreciate how synergistic are the two methods of delivery. The two delivery mechanisms complement one another, as each has features not available in the other. As a result, you will find that many sections of this book utilize both delivery mechanisms. As I refined the presentation, I also discovered how layered and deep the mathematical topics are that can be expressed in geometric terms. Even now, almost two years into writing this, I continue to come across images, or ways of looking at images, that surprise me. Indeed, these surprises are what caused me to pursue *Electronic String Art* as a stand-alone book.

Acknowledgments

As should be clear from the preface, this book has benefited from interactions with many people over the years. This list includes my teachers, Art Fruhling and Don Chakerian; my coauthors, Katherine Erfle, Vera Frfle, Lauryn Wensel, and Brittney Polinka; Liam Myles, who created the web version; and individuals involved in K-12 education starting with Denise Eschenmann but extending to Jeffrey Schwartz, Christopher Kenny, Dave Kennedy, Lisa Shelton, Naomi Rodriguez, and Marie Habib. Many of these educators opened their classrooms so that I could test-drive this material on students.

I am also indebted to Dickinson College for allowing me to pursue this work and to the Dickinson College students who have worked on this project with me in the past two years. James Marks, my summer 2021 research assistant, worked with me as I came to the notion of treating this as a series of *explainers* (short stories of lessons) rather than a traditional book. I also benefited from discussions with Scarlett Davidovich and Ben Stoopack, my research assistants from fall 2022 and spring 2023, as well as the students from my fall 2021 educational studies course entitled "Combining Math and Art using Polygons and Electronic String." These students test-drove my materials, and their own, in after-school programs at four elementary schools over a series of afternoons. My fall 2023 First Year Seminar provided helpful comments at the proofing stage. Andrew Connell is to be applauded for obtaining the laptops we used during those after-school programs. Friends and colleagues Bruce Katuna, Laura Weber, and Pam Ko, and my brother, Robert Erfle, have acted as sounding boards when I wanted to test an explainer or see whether I was conveying an idea effectively.

Finally, I would like to thank my editor, Callum Fraser, and his editorial assistant, Mansi Kabra, for their encouragement and patience in helping me navigate this process. I recognize that this is not a "typical book," and they have been very willing to work with me to create the most effective book possible given the nature of the material I am trying to convey. I am certain that their suggestions have improved the final product.

About the Author

Stephen Erfle is a professor at Dickinson College. Although he was trained as a microeconomic theorist specializing in industrial organization and regulation, he has spent much of his academic life working at the borders of traditional economics. He has used his economist's toolkit to examine topics in a wide variety of fields including public health, exercise psychology, political geography, mathematics education, and communications theory in addition to economics.

He has consulted for a variety of organizations including the Seagram Classics Wine Company, the Forum on Education Abroad, and the Pennsylvania Department of Health. His Seagram Classics sabbatical reoriented the direction of his teaching and research, as it turned his former analytical focus (theorem and proof) into a more empirical focus (what does the data tell us). It also led him to co-found the International Business and Management major at Dickinson College. One of the core courses in that major, "Managerial Decision-Making," teaches students to analyze the kinds of decisions he was asked to answer during his time working for Seagram Classics.

He has spent much of his time in the past couple of decades devoted to pedagogical issues revolving around providing geometric interpretations and explanations for a variety of topics. The books and papers in these topic areas seek to explain economic and mathematical concepts in intuitive terms, often to students with limited mathematical backgrounds.

He received his BS in Mathematics and BA in Economics from the University of California, Davis, and Ph.D. in Economics from Harvard University.

AN INTRODUCTION TO PART I

Preliminary Issues

Electronic String Art, ESA, is a book made possible by electronic programs that simulate traditional string art. String art requires that individuals set up a series of nails and then connect string from nail to nail using a counting rule. ESA simulates those nail locations and allows the quick completion of a final image based on that counting rule.

Part I is made up of two chapters.

Chapter 1 provides an introduction and overview of the book in four sections. The first section is a comparative introduction that contrasts ESA with traditional string art to show the basis for wanting to pursue the electronic version. The second lays out the basics and discusses why this is not like a traditional book that should be read from front to back. The third describes the layered nature of mathematics required to enjoy ESA, and the final section of Chapter 1 provides a general overview of the book as well as what is available on the ESA website (available by scanning the QR code at inside front cover of the book).

Chapter 2 examines polygons and stars. All but one chapter of this book is based on regular polygons and *continuously-drawn* stars; therefore, at one level, this is a foundational chapter for doing string art. But that foundation need not be read before moving on to Part II, String Art. Indeed, only the first two sections of Chapter 2, Sections 2.1 and 2.2.1, are "must reads" that are on the list of basics noted in Section 1.2. These sections deal with two of the four parameters necessary to create string art images in Part II: n, the number of vertices in the polygon, and J, the number of jumps between vertices used to create an n,J-star. The most common star is the pentagram or 5,2-star. If, instead, the jump is 1, the result is a polygon, not a star.

The other topic mentioned in Section 2.2.1 is what it means to be *continuously-drawn*. When a string is strung from nail to nail in a string art image, the string is not tied off after every nail. Instead, the counting rule is re-applied, and the string is connected to the next nail, and so on. If, instead, the image is being drawn with pencil and paper, the lines are connected one to another. As a result, some stars cannot be continuously-drawn, the most well-known of which is the 6,2-star.

Additional sections within Chapter 2 examine sharpest stars, angles in stars and polygons, stars as rotating polygons, and the notion of stars within a star. The last section provides challenge questions for Chapter 2. Answers to challenge questions are provided in Chapter 27 at the end of the book.

DOI: 10.1201/9781003402633-1

Chapter 1

Introduction and Overview

1.1.1 A Comparative Introduction, Part I

String art is a well-known activity (480 million results in a *Google* search) that uses string, a board, and nails to produce artistic images. There are variations that use different modalities, such as a needle, thread, and art board, which produce images like the ones shown to the left and right. The intricate internal forms are created by stretching the thread from side to side and not by placing holes in the interior of the image. This activity is beloved because simple counting rules are used to create beautiful images that can both adorn walls and excite young minds.

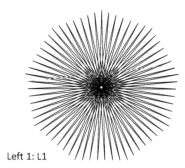

Left 1: L1

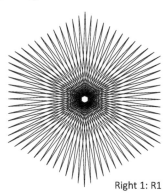

Right 1: R1

Traditional versus electronic. The downside of this traditional, highly tactile activity is that it can be quite time-consuming and inflexible. It takes time to set up the board, pound in the nails, and create an image using string and a specific counting rule (such as "connect every 31st nail"). Traditional string art can also lead to frustration if you want to modify the image. It is challenging to change nail placement once the nails are secured to the board, and changing the counting rule requires removing the prior image from the board. By contrast, electronic string art (ESA) offers much more flexibility to change "nail locations" and counting rules. In an electronic setting, these adjustments are accomplished easily by changing parameters. By altering three parameters—the number of vertices (n), the number of subdivisions (S), and the number of subdivision endpoints between drawn lines (P)—users can turn the image on the left above into the one on the right in a matter of seconds.

Moving from the left to the right image above requires changing n from 9 to 6, S from 7 to 12, and P from 31 to 35. The **red dots** are "subdivision endpoint nail locations" for both images. L1 (Left 1) has nine vertices (and sides) and seven **dots** per side (9·7 = **63 nails**) with a line connecting every 31st nail. R1 has six vertices and 12 **dots** per side (6·12 = **72 nails**) with a line connecting every 35th nail. The counting rule P in both images was to count *almost* halfway around the set of

DOI: 10.1201/9781003402633-2

63 dots on the left and **72 dots** on the right (so **P** = 31 on the left and **P** = 35 on the right). This rule creates prickly *porcupine polygons* instantaneously as the parameters are adjusted. The ability to make such changes quickly and effortlessly allows users to modify the appearance of the image even though they might not understand (or care about) the math behind such changes.

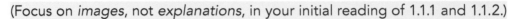

(Focus on *images*, not *explanations*, in your initial reading of 1.1.1 and 1.1.2.)

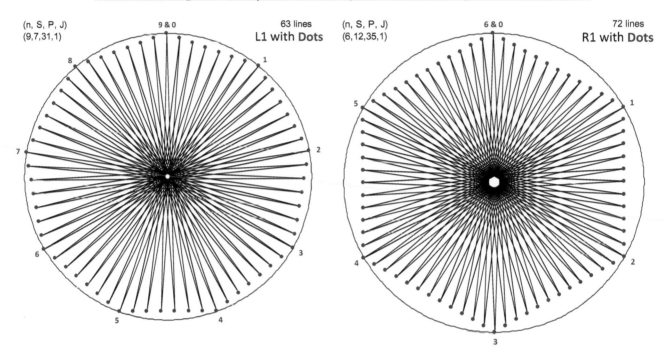

Electronic string art. ESA examines string art on a closed circuit. A closed circuit simply means that the last vertex connects to the first. By tying the vertices to equally spaced coordinates on a circle and thereby having vertices that create regular polygons or stars, ESA completely removes the necessity for users to worry about the location of the vertices. All the user needs to do is decide the number of vertices, **n**, that their polygon should have or how many jumps, **J**, between vertices that their **n,J**-star should have. User choices (of **n** and **J**) set up the frame on which the subdivision nails, **S**, are set. Lastly, a counting rule **P** is chosen. ESA becomes accessible to users well before they learn about graphing in late elementary/early middle school. To change values, users need only click ⬍ arrows and watch what happens. The above examples had **J** = 1, and so all the nails were on the edge of the polygon, a 9-gon for L1 and a hexagon (6-gon) for R1. L2 and R2 change **J** to 2 (left) and **J** to 4 (right) using the **n** = 9, **S** = 7, and **P** = 31 values from L1.

If **J** > 1, 9-point stars may result. The images on the next page are in two rows: The top row shows a **circle (purple)**, **vertex labels (red)**, **star (blue)**, **nail locations (red)**, and the **first line of the image**; the bottom removes these *structural elements* and shows only the image. The L1 63-nail 9-gon image becomes L2, a **63**-nail **9,2-star**, or R2, a **63**-nail **9,4-star** by changing **J** from 1 to 2 to 4.

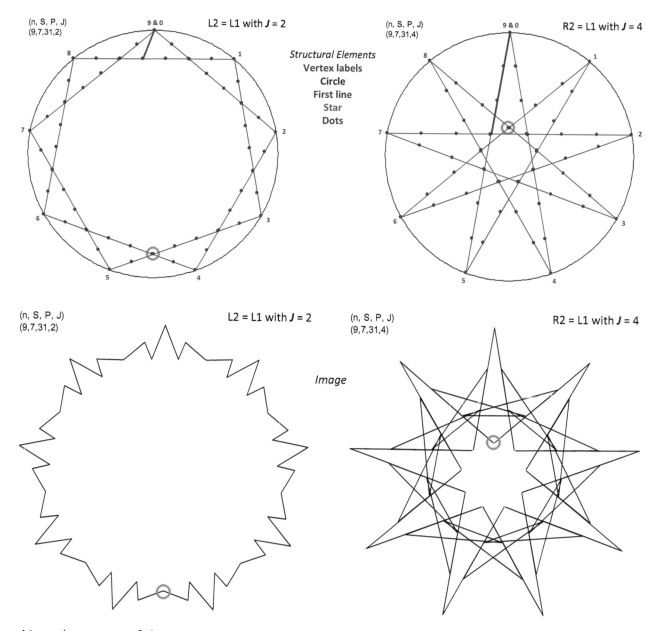

Note that some of the top-row **nails** almost coincide. This near coincidence shows up in the bottom images: In L2, the fourth line drawn from a vertex is very short; in R2, the inner parts of the small 9,3-star in the center are very close to one another but do not touch. Examples of both are **circled in green**. Like L1, the L2 and R2 images use 63 connected lines.

Sections in this book are small and targeted at specific topics. Some sections are connected, like this one and the next, 1.1.2.

1.1.2 A Comparative Introduction, Part II

The second part of the introductory section focuses attention on what we can do once we have some base images to work with. Section 1.1.1 produced four images. The first two were called *porcupine polygons* because they were very prickly and they were easy to create by going almost "halfway" around the polygon before drawing the first line, without being exactly halfway around. (If you draw a line exactly halfway around, the end result is a pretty uninteresting vertical line.) One polygon had nine sides, the other had six.

Next, we created images using the same **n** = 9, **S** = 7, and **P** = 31 values that produced the *porcupine 9-gon* with one adjustment. Instead of jumping to the next vertex, we jumped two or four vertices to produce the **9,2-star** or **9,4-star frames** shown at the top left (L2) and right (R2). In each instance, the **first line** is three subdivisions in on the fifth line of the vertex frame because 31 = 4·7+3. The first five **frame lines** of L2 are **0–2–4–6–8–1** and for R2 are **0–4–8–3–7–2** (– means draw a **line**). The first line of the image is **a red line from the top to the third subdivision dot** on the **8–1 frame line** for L2 and the **7–2 frame line** for R2.

(Once again, you are advised to **focus on *images***, not *explanations*, **in your initial reading** of Sections 1.1.1 and 1.1.2.)

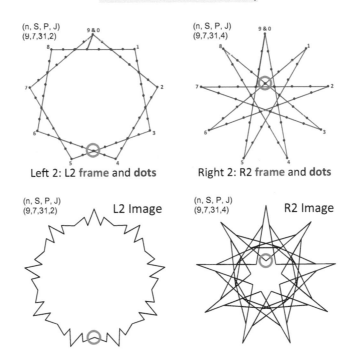

Left 2: L2 **frame** and **dots** Right 2: R2 **frame** and **dots**

The discussion above dives deeper into how the **vertex frame star** was created and how the **first line of the image** uses **subdivision dots** placed on the **frame**, but the final images are the same here as on page 2 of 1.1.1 (which is why we continued the labeling from 1.1.1 and call them L2 and R2). Quite clearly, the prickly porcupine nature of images when **J** = 1 and **P** is close to **n·S**/2 (half of all subdivisions) no longer holds if **J** > 1 as the L2 and R2 final images attest.

ESA allows you to quickly answer questions and test new ideas. Suppose you liked those prickly images. You might ask:

*Is it possible to adjust **P** and create images that are prickly when **J** > 1?* **There are two ways to obtain an answer:**

1. ***Play to learn***. We could simply adjust **P** using the ⬍ arrows. That is, we could proceed by simply *playing* with **P**.

Playing **with this book.** The term *playing* is used advisedly here. Specifically, it means working with the files (in *Excel* or via the web version) to discover what you find interesting. Think of playing as exploring. The user is then encouraged to think about why it is interesting and *play* some more. As you *explore*, you may begin to see patterns in those explorations. That is, you may begin to *extract* patterns from your explorations. Finally, you may be able to *explain* what you have found. Sherman Stein called this *The Triex: Explore, Extract, Explain*. He argued that this is the essence of more deeply understanding mathematics and that it also provides a useful starting point for how to teach mathematics.

2. ***A more analytical approach***. We could use what we learned from the **nail** locations in images L2 and R2. What if we choose a **P** that is associated with one of the **green circled nails**? The first line would then be almost vertical. Finding that **P** is really quite simple. To see how, look at the L2 and R2 **frame** and **dots** images on the previous page.

 P for the L3 image. The 9,2-star in L2 starts at the top and then jumps two vertices each time: **0–2–4–6**. The **circled dot** is the second **dot** after vertex **4** on the way to vertex **6**, so **P** = 7+7+2 = 16.

 P for the R3 image. The 9,4-star in R2 starts at the top and then jumps four vertices each time: **0–4–8–3**. The **circled dot** is the third **dot** after vertex **8** on the way to vertex **3**, so **P** = 7+7+3 = 17.

The resulting images (shown on the next page) are instructive. You can see the **9,2-star** in the pattern of needlepoints in the L3 image and notice that the second needle in from each vertex needle (the longest ones) is in fact two needles, just as we expect given our **circled dots** observation in L2. The R3 image has nine vertex needles, with each needle open to the center and the rest of the image creating a superstructure surrounding those needles. Both images are also created using 63 connected lines.

The eight images beneath L3 and R3 show *some* results from the ***Play to Learn*** approach given **J** = 4 (R2 **frame** with **P** noted).

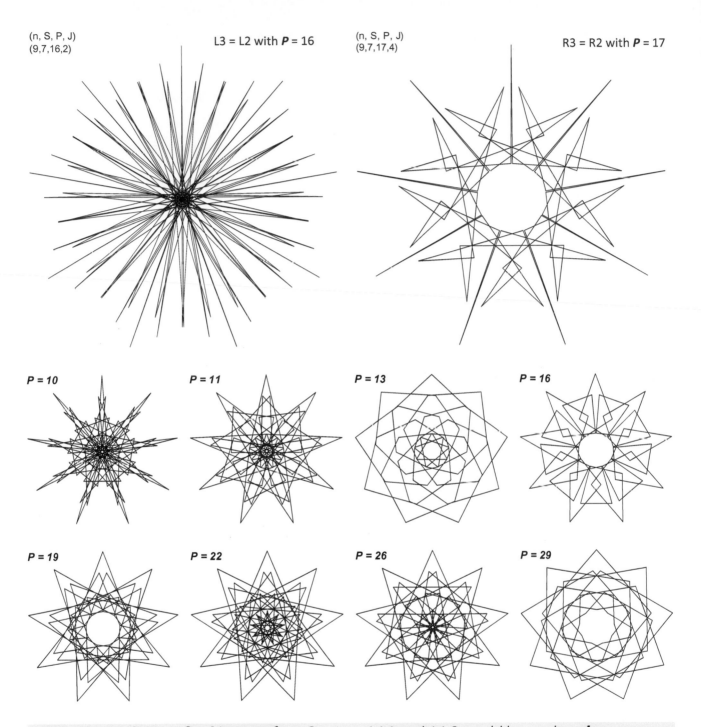

(n, S, P, J)
(9,7,16,2)

L3 = L2 with **P** = 16

(n, S, P, J)
(9,7,17,4)

R3 = R2 with **P** = 17

P = 10

P = 11

P = 13

P = 16

P = 19

P = 22

P = 26

P = 29

NOTE: *The **14 distinct final images** from Sections 1.1.1 and 1.1.2 would have taken **days** to create via traditional methods, not **minutes** using ESA.*

What is in the rest of this chapter? This book is meant to be interactive in nature and was not written to be read from front to back. Section 1.2 provides a rationale for this somewhat unusual statement. Therefore, the book is written as a series of *explainers* (using the third *ex* of Stein's *Triex*)—short, targeted sections that need not be read sequentially, beyond the few **Just the basics** sections noted in 1.2. Think of *explainers* as short, self-contained vignettes that are digestible in a single sitting.

Section 1.3 discusses the layered nature of the mathematics involved in ESA and notes that one can enjoy the images while not completely understanding how they were created. Section 1.4 provides an overview of the book as a whole.

1.2 You Can "Pick and Choose" How You Read This Book

About *explainers*. This book is NOT built to be read in the traditional linear fashion from front to back. This book is built to be picked at, beyond the basics at least, based on what you find particularly interesting. As a result, the book is written in small sections (called *explainers* as noted in Section 1.1.2), each interconnected with others but each focused on a single idea or point. Sections are labeled by chapter and section number. Think of an *explainer* as a very small short story or lesson that can be read in a single sitting. Some of these lessons are interconnected enough that they are noted by section and subsection, like the two-part comparative introduction, 1.1.1 and 1.1.2. This book has about 200 sections. Since you may bounce-around in your reading, if you find yourself confused about a term, just check in the glossary in Chapter 28. There you will find a definition and find out where that term was first introduced.

This book is meant to be interactive in nature and to respond to what you find interesting about the images you create. String art images are created from four numbers labeled **n**, **S**, **P**, and **J**. These parameters are controlled by ⬍ arrows so that you could, of course, proceed to simply play with these parameters and watch what happens. *As you play, you will inevitably begin to see patterns, and you will find that these patterns are interesting and engaging in their own right.*

Excel versus web. There are two modalities for image creation: *Excel* and a non-*Excel* web version developed by Liam Myles. Both can be accessed by QR codes on the *Features* page at the front of this book. Each version has its own strengths and weaknesses, and if you have access to *Excel*, you should initially work from the *Excel* files as they restrict options in order to focus attention on the topic at hand. For example, the *Polygons* sheet in *Excel* file 2.0.1 allows you to only vary **n**, the number of equally spaced vertices around the circle, and the *Stars* sheet adds in the number of vertex jumps, **J**, so that you can learn about this variable before moving on to **S** and **P**. The *Excel* files also provide greater flexibility for those who wish to teach from this book. There are specific features that teachers will find helpful in discussing various attributes of the model, including files built for teachers. The web version allows users to dynamically see how an image is created as a series of *continuously-drawn* lines using various *Drawing Modes*.

Just the basics. Here are six *explainers* that cover the basics. They are noted by ESA location, topic, and short title.

The first four focus attention on the individual parameters of the model.

2.1	The **n**umber of vertices in the **n**-gon.	How Polygons Are Drawn
2.2.1	The number of vertex **j**umps, **J**, used to create stars.	Stars That Work and Stars That Don't
3.1	The number of **s**ubdivisions, **S**.	A Primer on **S**
3.2	Drawing lines between **p**oints in the final image, **P**.	A Primer on **P**

The remaining two deal with commonality between numbers and searching for image patterns.

4.1	Commonality issues.	Lines Used (with VCF and SCF)
9.1	Searching for patterns.	Finding Similar Images

If you want to add a seventh *explainer* to this list, it starts to get harder to justify one reading path versus another. This one was chosen because reducing the size of numbers without changing the image helps you more easily understand how the image was constructed.

6.1	Finding smallest parameter values.	Simplifying Parameter Values

It is worth explicitly pointing out that the above suggestions are not the first seven explainers in the book. They are sprinkled throughout the first third of the book with noticeable gaps present between these basic *explainers*. In particular, you should not feel that you must read all of the Chapter 2 *explainers* before moving on to 3.1 (nor do you need to read everything between 4.1 and 9.1 in order to read 9.1). That is, do not treat this like a traditional book.

An alternative way to get most of the basics. Some material in the *explainers* mentioned above involves multiplication, division, and the notion of greatest common divisor (GCD). Since younger users may not know these concepts, they are introduced to these concepts in a visual fashion via two **directed inquiry** *explainers*: 25.5.1, Changing Numbers; and 25.5.2, Web Jumps. These **directed inquiries** walk users through how to enter and interpret values using the web version.

A final suggestion. Look at 11.1, Image Archetypes, as it provides examples of some of the types of images that you may encounter as you play with the string art model. This can be done even before you read any of the *explainers* noted above as a purely visual way into this material. The 12 images shown there do not form an exhaustive list of types of images but are simply provided as a way of modeling how to categorize some of what you will encounter as you play.

1.3 The Layered Nature of the Mathematics in ESA

A natural question is: **How much math do you need to know to enjoy this book?**
The interesting answer is this: **That depends on how you want to enjoy this book.**

This book would not be possible without the electronic files that create the string art images, and those files can be manipulated by users without any mathematical training at all, simply by changing parameters with ⬍ arrows. These files can be accessed using the QR codes on the *Features* page at the front of the book. Users will inevitably learn things about the images as they play, even if what they learn is informal in nature. Users learn that you see things happening with even numbers that differ from odd numbers, even if those notions have not yet been formally defined in an educational setting. Stein argues that such informal learning cements formal understanding once that takes place.

Users are willing to play with the files because the images they create are engaging. They can create their own beautiful images, and then change those images just by pointing and clicking. Users learn more as they search for other similar images, finding out what works and what does not as they change parameters, deepening their understanding of mathematics, even if that is simply the side-effect of this play.

This book's value-added is that it provides a comprehensive guide that acts as a road map exploring why images change as parameters change or are drawn the way they are drawn for a fixed set of parameters. The question therefore becomes: **How much math do you need to know to understand what is going on with the images?**

What mathematics is required? The basics can be fully understood even without knowledge of multiplication and division since lines are simply placed connecting every P^{th} endpoint, so one need only be able to count to P over and over again (if one were manually counting). Of course, repeated addition is the edge of multiplication, and the location of P on the frame created by the n,J-star is easiest to explain using division. The **Guided Inquiries** in Section 25.5 walks younger users through seeing the effect of commonality between parameters without requiring them to know about the concept of greatest common divisor. (A more formal examination of commonality is provided in Chapter 21, which includes a discussion of a method of finding the GCD of two numbers, which is more than 2000 years old, in Section 21.2.3, *Euclid's Algorithm*.) Despite this low mathematical bar, the book will be of interest to those with a greater degree of mathematical sophistication due to the strong visual appeal of the images created using just four numbers: n, S, P, and J.

The mathematics used is not advanced, but it is used intensively. The only mathematical concepts contained in the book beyond middle-school mathematics are a couple of theorems about angles from geometry, discussed in Chapter 22, and the idea of modular arithmetic, examined in Chapters 23 and 24. However, modular arithmetic is just a fancy term for doing old-fashioned division and ignoring everything except the remainder. If this sounds abstract, realize that you already know some modular arithmetic because you know that five hours later than 10 pm is 3 am and not 15 pm. Without thinking about it, you threw away the 12 and kept the remainder of 3 when you added 5 to 10 and got 15. Clock arithmetic is a form of modular arithmetic, and this analogy will be used throughout the book, but especially in Chapter 17, *Four-Color Clock Arithmetic*.

Layered mathematics. This material can be considered from a layered perspective and examined with different degrees of mathematical sophistication. As a result, parts of some sections (or indeed, entire sections) are noted as **MA** (for **M**athematical **A**pproach). **MA** material can be skimmed or ignored by those who do not want to wade through the mathematics (such as modular multiplicative inverses, the topic of Chapter 24). And note that, even if an image requires an **MA** explanation to fully understand **WHY** it works, the image itself is intrinsically engaging as an artistic object. The *Teaching Companion to the Web Guide* in Section 26.4 provides examples of how you might layer your discussion of this material, even in an introductory setting.

Who should be reading (or using) this book? The book is primarily a book of recreational math. It could also be thought of as a recreational art book because it brings together math and art. The math is overt, the art is undeniable.

There are many ways in which this could be used in a classroom or in after-school settings for students in K-12. This book is surprisingly flexible in covering topics at a wide range of grade levels. Chapter 26 provides suggestions for teachers, and there are ancillary teacher resources including links to *Common Core State Standards* on the ESA website (available by scanning the QR code on the *Features* page at the front of this book).

This flexibility extends to college-level classrooms since this material provides geometric interpretations of topics covered in Number Theory and Abstract Algebra classes (like modular multiplicative inverses or group theory). Finally, there are links between this material and the literature on regular convex polytopes, see Coxeter 1974, but those connections have not been pursued in this book.

1.4 An Overview

Layout. This book is organized into four parts. Additionally, there are important supplementary materials available on the ESA website.

Part I: Preliminary Issues

Part I lays out the basics by describing regular polygons and stars and what the phrase "continuously-drawn" means. If you create a star by drawing lines connecting vertices that are a fixed number of jumps greater than 1 apart from one another until you end up where you started, you can create at least one n-pointed star for every n larger than 4 except for $n = 6$ (if $n = 6$, a jump of 1 or 5 is a hexagon, a jump of 2 or 4 is a triangle, and a jump of 3 is a vertical line). There are many more distinct n-point stars possible if n is prime than if n is composite (so that there are four distinct 11-point stars and five distinct 13-point stars but only one distinct 12-point star and two distinct 14-point stars).

Part II: String Art

The heart of this book is the string art model examined in comprehensive detail in Part II. Chapters in Part II lay out the attributes of this model based on four parameters, **n**, **S**, **P**, and **J**. **n** and **J** determine the vertex frame star or polygon, just as described in Part I. Each line of the vertex frame is subdivided into **S** equal-sized segments. Lines of the string art image are drawn every **P**th subdivision endpoint until the circuit is completed by having the last endpoint coincide with the starting point. There are a variety of ways that these images can be conceptually analyzed. There are also a variety of types of images possible using these parameters. An expressed goal of this analysis is to be able to create altered but similar versions of those images based on different values of **n**, **S**, **P**, and **J**.

Part III: Variations on the String Art Model

Part III lays out variations on the constant jump pattern theme examined in Part II. One variation explicitly includes jumps to the center of the circle after each vertex jump. Additional variations allow jump sets of two or more distinct jumps before repeating the pattern. A final variation provides users the chance to create their own non-polygonal images.

Part IV: Issues, Mathematical and Otherwise

Part IV provides help with various mathematical topics encountered throughout the book as well as a guide to the web version and suggestions for teachers. Two additional chapters provide answers to challenge questions and a Glossary/Index that notes when common terms are first discussed. Part IV can be thought of as an extended set of appendices.

Challenge questions. Challenge questions accompany each of the first three parts of ESA. Challenge questions for Part I are in Section 2.7. Chapter 14 contains challenge questions for Part II, and Chapter 20 contains challenge questions for Part III. A few challenge questions are located in other sections. As noted above, answers to challenge questions are provided in Chapter 27. A file with complete answers including geometric detail is on the ESA website.

Supplementary ESA web materials. The ESA website, available through QR code on the *Features* page at the front of this book offers links to many resources. The *Links* document provides links to the web version set to specific images in various sections as well as other external content. Posted materials on the ESA website that will be of particular interest to teachers include handouts suitable for classroom use as well as information linking ESA material to Common Core Standards and a few introductory videos.

The ESA website also provides access to more than 80 *Excel* files that are discussed in various chapters of the book. Many of these files have been created so that users need only click ⬍ arrows or check-boxes and watch what happens: *Excel* experience is not required. When a file requires a higher level of *Excel* competence, explicit instructions are contained within sections of the book delineating how to manipulate the file. An additional QR code takes you directly to the web version of the string art file.

Chapter 2

Polygons and Stars

2.1 How Polygons Are Drawn in This Book

About polygons. A traditional polygon is a closed object created by connecting a number of line segments, **n**, to one another in sequential order. A closed object means that the starting point and the ending point are the same. It is worthwhile to call the starting point P_0 and the final point P_n and to note that, since the system is closed, $P_0 = P_n$. That way, we can describe the segment number by its endpoint. The points and line segments are subject to the following three properties:

(1) All points (except the noted $P_0 = P_n$) are different from one another.
(2) The line segments cannot intersect (meaning cross over one another), except at their endpoint.
(3) No two line segments with a common endpoint are collinear (meaning on the same line).

The endpoints are called *vertices*, and the line segments are called *sides*.

It is worth considering what happens if one of these properties is not followed. Consider images (a)–(h): Which are polygons, and which are not polygons? If the image is not a polygon, which property is violated?

Challenge questions. Consider images listed above (a)–(h): Which are polygons, and which are not polygons? If the image is not a polygon, which property listed above is violated? (See Chapter 27 for answers.)

| (a) | (b) | (c) | (d) | (e) | (f) | (g) | (h) |

About regular polygons. Regular polygons occur if all of the sides and all of the angles are the same size. A regular **n**-sided polygon, called an **n**-gon, is most easily visualized by drawing a circle and then positioning **n** points equally spaced from one another. Once these **n** equidistant points are positioned, draw lines between points that are next to one another (adjacent points), and a regular **n**-gon results.

Drawing the polygon. Once you have identified the points in a regular polygon, you need only connect adjacent points with line segments until you end up where you started to draw the polygon. This always involves two choices: **a)** Where do you start, and **b)** which direction do you go around the circle?

How this book draws polygons. We always start at the top of the circle containing the vertices and draw (or count) in a clockwise direction. The images on the next page show a square and a 12-gon. The 12-gon should feel comfortable because this is just a clock face (and it is why we use these rules).

DOI: 10.1201/9781003402633-3

13

2.2.1 Stars That Work, and Stars That Don't

A **continuously-drawn** image is created by connecting vertices that are a defined number of jumps, **J**, away from one another until the image is complete. **J** = 1 results in a polygon. If **J** > 1, stars can, but do not have to, result. Such stars are completed in **n**, or fewer, segments. One can visualize a continuously-drawn image as being created from a single piece of string.

The simplest example is the 5-point star (or pentagram), which occurs when every other vertex is connected, **n** = 5 and **J** = 2. We often call this a **n**,**J**-star.

The jumps involved are (→ means jump): **0→2→4→1→3→5&0**, and the image is complete after two <u>clockwise</u> trips around the circle (jumping from larger to smaller number (like **4→1**) means going past the top again).

The same image results if **J** = 3, with jumps of **0→3→1→4→2→5&0**. The only difference in this instance is that it takes three <u>clockwise</u> trips around the circle to complete the circuit.

On J < n/2. The same image occurs for jumps of **J** and **n-J**. The only difference is the number of times around the circle required to complete the circuit. For this reason, we typically restrict our star discussion to 1 < **J** < **n**/2.

When stars don't exist. If **J** and **n** have a factor in common, the circuit is completed in less than **n** jumps. The simplest example of this is **n** = 6 and the only **J** between 1 and 3 = **n**/2 is 2. But 2 has a factor (2) in common with 6, therefore no continuously-drawn 6-point star exists. The only way to obtain a 6-point star is to create a second circuit such as the blue and red circuits to the right.

We Only Deal with Continuously-Drawn Stars in This Book

How many stars are there? Distinct *n*-point stars exist whenever *n* and *J* have no factors in common and 1 < *J* < *n*/2. This means that there are a greater number of different *n*-point stars if *n* is prime than the surrounding values of *n*.

For example, consider values of *n* close to the prime number 13. How many different continuously-drawn *n*-point stars exist for *n* from 12 ≤ *n* ≤ 16? The answers are:

1 for *n* = 12; 5 for *n* = 13; 2 for *n* = 14; 3 for *n* = 15; 3 for *n* = 16.

You should use the file to verify that this is the case. The five stars for *n* = 13 are shown below (with 1 < *J* < *n*/2 = 6.5).

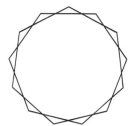 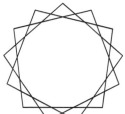 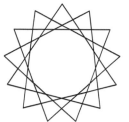 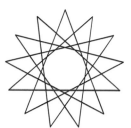 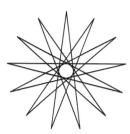

Challenge question: Without using the file, answer the following: How many different 17-point stars exist?

Use the file to verify your answer or check your answer in Chapter 27.

2.2.2 How Many Points Does a *Continuously-Drawn n,J-star* Have?

On commonality. The reason there is no continuously-drawn 6-point star is that 2 is the only number between 1 and 3 = 6/2, and 2 has a factor in common with 6 (namely 2). The 6,2-star is an equilateral triangle connecting even vertices **6&0–2–4–6&0** as seen to the right. The three odd vertices (**1**, **3**, and **5**) are simply not part of the "star" that has been created.

The same argument could be made for a 9,3-star except that now the only used vertices are **9&0–3–6–9&0** or multiples of 3 because 9 and 3 have a common factor of 3. In this instance, the vertices that are not divisible by 3 (namely **1**, **2**, **4**, **5**, **7**, and **8**) are excluded from the second figure, just as odd values were excluded from the first.

Other examples of **n,J**-stars with fewer than **n** points, triangular and otherwise, are easy to construct. All that is required is that **n** and **J** have a factor (larger than 1) in common.

When two numbers have a factor larger than 1 in common, there must be a largest such factor. There are two interchangeable terms for this factor: *greatest common factor* and *greatest common divisor*, GCD. Finding the GCD of two numbers is discussed in Section 21.2. [In *Excel*, type =GCD(**a**,**b**) to find the GCD between two numbers **a** and **b**.]

VCF. The polygons and stars discussed here are an important component of the string art model. Indeed, they form the skeletal framework on which string art images are hung. We will fill in the rest of the model in the next chapter, but here we should acknowledge that *because analyzing string art images depends on more than one GCD, we have a special name for GCD(**n,J**), namely the Vertex Common Factor, VCF.*

VCF = GCD(**n,J**).

How many points does an n,J-star have? An **n,J**-star will have **n**/VCF-points. Put another way, if we examine the image of an **n**/VCF,**J**/VCF-star, it would be the same as the **n,J**-star (except that the unused vertices would no longer be visible). Take a simple example. The 5,2-star, VCF = 1 at the bottom left (pentagram), is the same image as the 10,4-star, VCF = 2 at the bottom middle, or the 15,6-star, VCF = 3 at the bottom right. The only difference is the fraction of vertices used in each case, 1/VCF, so the bottom left uses 100% of its vertices, the bottom middle uses 50%, and the bottom right uses 1/3 of its vertices.

Fact. Every value of **n** > 4 EXCEPT for 6 has at least one **J** that produces an **n**-point **n,J**-star. This is true because one can always find at least one value of **J**, 1 < **J** < **n**/2 with GCD(**n,J**) = 1 if **n** > 6. Fewer **J** satisfy this criterion when **n** is small and composite and only one **J** satisfies this criterion when **n** = 8, 10, and 12 (namely, **J** = 3, 3, and 5, respectively).

2.3.1 Sharpest Stars

When more than one **n**-point star exists, some will have sharper points than others. The one with the sharpest points will have **J** be as close to $n/2$ as possible without equaling **n/2**. The reason is straightforward: If $J = n/2$, a vertical line will result. This is only possible when **n** is even. A separate rule exists for even **n** and odd **n**.

Sharpest star when n is even. The sharpest star occurs when $J = n/2 - 1$.
Sharpest star when n is odd. The sharpest star occurs when $J = (n - 1)/2$.

Examples of both are provided below for **n = 23** and **n = 24**. Both have the angle at the top vertex highlighted with **red lines** over the lines forming the angle.

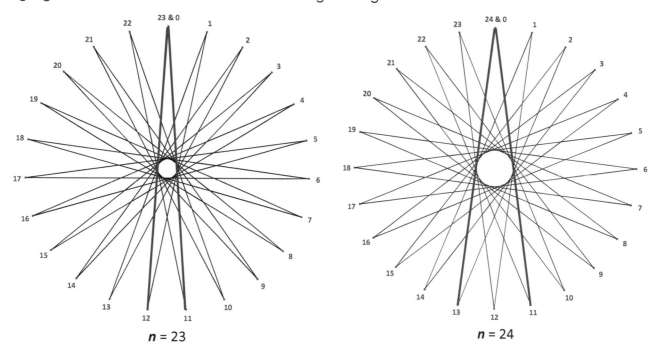

$n = 23$ $n = 24$

There are more vertices on the right, but the points are sharper on the left. Additionally, the hole in the center is larger on the right. This is true in general when comparing an odd **n** and the next larger value of **n** (which is **n+1** and is even). The reason why is seen by looking at the vertices at the top and bottom of each image. These vertices create the angle at the top. The **right** side of the angle at 0 goes from 0 to 11 in both panels. This follows the **Sharpest Star Rules** given above for two values of **n** next to one another with the odd **n** being the smaller **n**. In particular, the value of **J** for **n** = 23 is $J = (23-1)/2 = 11$ and the value of **J** for **n** = 24 is $J = 24/2-1 = 11$. The **left** side is one vertex over when **n** is odd (from 0 to 12), but two vertices over when **n** is even (from 0 to 13). Put another way, the sharpest odd angle spans one vertex (11 to 12) but the sharpest even angle spans two vertices (11 to 13).

Optional information for those interested in angle measurement. When **n** is odd, the sharpest angle is 180°/**n** and when **n** is even, the sharpest angle is 360°/**n**. (This follows from a rule of geometry called the *Inscribed Angle Theorem*, discussed in Section 22.1.) This angle is the same for every vertex point in a regular star. The two images above thus have angles of 180°/23 = 7.83° on the left, and 360°/24 = 15° on the right. You can verify that these equations work by looking at **n** = 3, which produces an equilateral triangle (with 60° angles), and **n** = 4, which produces a square (with 90° angles).

2.3.2 How Sharpest Stars Are Drawn

We use the **n** = 23, **J** = 11, and **n** = 24, **J** = 11 sharpest stars shown below to examine how the final image is constructed as a series of connected lines. The first line goes from 0 to 11 and the second from 11 to 22 in both images. These two jumps are highlighted with **red lines** over the lines in both images.

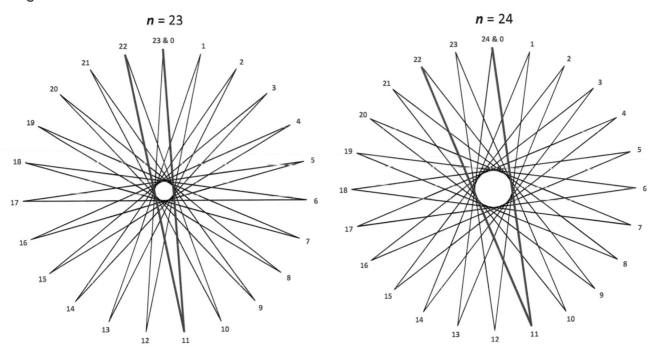

The third jump in each takes us from 22 to 33 vertices, but what does vertex 33 mean in each instance? The answer comes by subtracting **n** from 33 since we are now simply counting the SAME vertices a second time around. The third vertex endpoint is thus 10 = 33 − 23 on the left and 9 = 33 − 24 on the right.

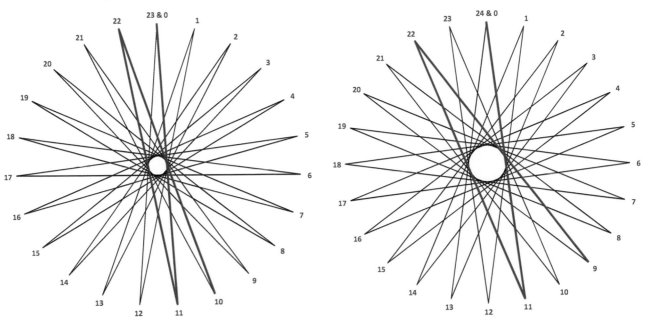

Think of what is going on in each image. In both images, the used vertices are moving in a COUNTERCLOCKWISE direction (11 to 10 and 23 to 22 on the left, and 11 to 9 and 24 to 22 on the right). As additional segments are added, the same pattern will continue. The image is completed in half a rotation on the left but a full rotation on the right. To see this play out, click below, then click *Drawing Mode* and choose *Fixed Count Line Drawing* with *Drawn Lines* = 1 or 2. Instructions such as these apply to the electronic version of this book. To access these hyperlinks using the hard-copy go to the *Links* document using the QR code for the ESA website on the *Features* page at the front of this book. This document contains links the web version of this particular image and links to other documents.

<u>Left image</u> <u>Right image</u>

Want to have the rotation occur in a clockwise direction? Just change J = 12 in the left image and J = 13 in the right. More generally, replacing J with n-J produces the same static image but the image is drawn in the reverse order.

2.3.3 Not All Even Stars Are Created Equal

The sharpest angle that can be created from an n-gon depends on whether n is even or odd. As discussed in Section 2.3.1, the sharpest star using an odd value of n spans a single vertex of the n-gon. By contrast, the sharpest star based on even n spans two vertices because even stars have a point at the bottom (at $n/2$) so the largest number less than $n/2$ is a whole number (1) smaller rather than 1/2 when n is odd.

One can always set J = $n/2$ − 1 to create the sharpest angle based on an even n-gon but this DOES NOT guarantee that the n,J-star thus created will have n points. Indeed, *half the time, it has half as many points* (as this 10,4-star shows us, this star is a pentagram).

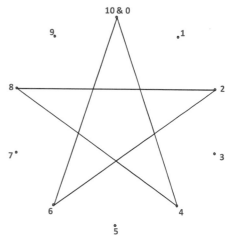

To see why this is the case and to obtain a general rule for the sharpest n-star, we need to consider two different types of even numbers: those that are divisible by 2 but not 4 and those that are divisible by 4.

n divisible by 4. The first star divisible by 4 has eight points so it is convenient to use n = $4k+4$ to represent these values. Given this, halfway around is $n/2$ = $2k+2$ and one less is J = $2k+1$, which is **ALWAYS an ODD** number.

CLAIM: GCD($4k+4$, $2k+1$) = 1 for all $k \geq 1$.

Rationale: All factors of n = $4k+4$ are also factors of $n/2$ = $2k+2$ (except one less power of 2). Therefore, if n is divisible by some other number f (such as f = 3 to take the smallest example) then so will be $2k+2$. This means that $2k+1$ cannot be divisible by f (the next smaller value divisible by f is $2k+2$-f, which for f = 3, would be $2k-1$).

In this instance, since n and J have no common factors, this value of J will be the sharpest n,J-star with n points.

n divisible by 2 but not 4. The first star divisible by 2 but not 4 has ten points (there is no continuously-drawn 6-point star as noted in Section 2.2.1), so it is convenient to use n = $4k+6$ to represent these values. Halfway around is $n/2$ = $2k+3$ and one less is J = $2k+2$, which is **ALWAYS an EVEN** number. This poses a problem because GCD($4k+6$, $2k+2$) = 2, so even though we can create the n,J-star, it will have $n/2$ points (like the 10,4-star shown above).

The sharpest **n**-point star in this instance occurs when **J** is 2 less than **n**/2 or **J** = 2**k**+1. Note that this value of **J** is necessarily odd, and it has no factors in common with **n** using the above *Rationale*. Note that this angle spans four vertices rather than two when **n** is divisible by 4, or 1 when **n** is odd.

Angle measures. To recap and put this in terms of angles (and organized according to the three images below):

The sharpest angle possible in an **n**-point star = (the number of spanned vertices)·180°/**n**, or:

360°/**n** if **n** is divisible by 4. 180°/**n** if **n** is odd. 720°/**n** if **n** is divisible by 2 but not 4.
n = 12, (360/12 = 30°) **n** = 13, (180/13 = 13.85°) **n** = 14, (720/14 = 51.43°)

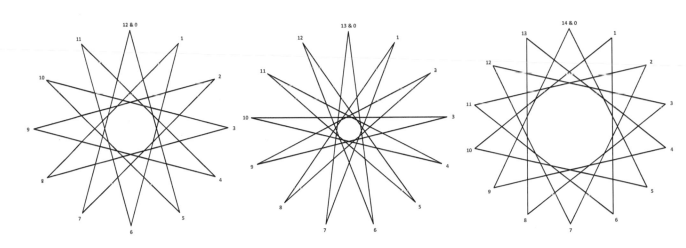

2.4.1 Angles from Regular Polygons and Stars

Continuously-drawn stars are created from regular polygons having **n** vertices by jumping **J** vertices between each line. Such stars have **n** points if there is no common denominator between **J** and **n**.

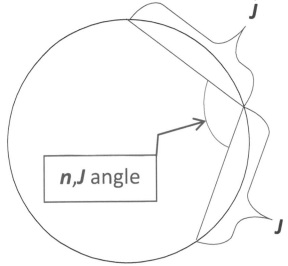

All **n** > 4 except **n** = 6 has at least one **J** that produces an **n**-point star. Call the angle created between successive lines, the **n,J** angle.

Imagine a star is created from a regular **n**-gon with **J** jumps. In order to focus on the general rule, specific values of **n** and **J** are not provided in the image to the left. In this instance, the formula for the **n,J** angle, shown in blue to the left, is:

$$n,J \text{ angle} = \frac{(n-2*J)}{n} * 180° \text{ as long as } J < n/2.$$

If **J** = 1, the image is a polygon, but the same equation for determining the **n**,1 angle holds. This formula is provided without proof, but it is based on the *Inscribed*

Angle Theorem discussed in Section 22.1. The table below applies this formula and provides angle measures for polygons and stars for $n \leq 30$.

Angle in degrees of regular polygons and stars, n = 3 to 30

n	Polygon (J = 1)	Star jump value J (J and n have no common factors greater than 1, and $J < n/2$)												
		2	3	4	5	6	7	8	9	10	11	12	13	14
3	60													
4	90													
5	108	36												
6	120													
7	128.57	77.14	25.71											
8	135		45											
9	140	100		20										
10	144		72											
11	147.27	114.5	81.82	49.09	16.36									
12	150				30									
13	152.31	124.6	96.92	69.23	41.54	13.85								
14	154.29		102.9		51.43									
15	156	132		84			12							
16	157.5		112.5		67.5		22.5							
17	158.82	137.6	116.5	95.29	74.12	52.94	31.76	10.59						
18	160				80		40							
19	161.05	142.1	123.2	104.2	85.26	66.32	47.37	28.42	9.474					
20	162		126				54		18					
21	162.86	145.7		111.4	94.29			42.86		8.571				
22	163.64		130.9		98.18		65.45		32.73					
23	164.35	148.7	133	117.4	101.7	86.09	70.43	54.78	39.13	23.48	7.826			
24	165				105		75				15			
25	165.6	151.2	136.8	122.4		93.6	79.2	64.8	50.4		21.6	7.2		
26	166.15		138.5		110.8		83.08		55.38		27.69			
27	166.67	153.3		126.7	113.3		86.67	73.33		46.67	33.33		6.667	
28	167.14		141.4		115.7				64.29		38.57		12.86	
29	167.59	155.2	142.8	130.3	117.9	105.5	93.1	80.69	68.28	55.86	43.45	31.03	18.62	6.207
30	168						96				48		24	

2.4.2 MA. Two Questions About Angles

The formula for the n,J angle shown in Section 2.4.1 was:

$$n, J \text{ angle} = \frac{(n-2 \cdot J)}{n} 180° \text{ as long as } J < n / 2.$$

Since regular polygons have vertices that are equally spaced from one another, it does not matter which vertex the angle is measured from. The n vertices will all have the same angle, so we can talk about **the** angle of an n,J-star.

As is clear from a quick perusal of the table of angles from n = 3 to 30 shown in the previous *explainer*, many of the angles are whole numbers. The polygonal angle (the J = 1 column) increases as n increases, but we know that this angle must be less than 180°. Additionally, for a given n, the star angle (row n) decreases as J increases. These observations suggest two questions:

1. **Can two distinct images have the same angle?**

Some of the values are close to one another. For example, the pentagon's angle (n = 5 and J = 1) is 108° and the n = 24, J = 5 star has an angle of 105°. Is it possible that if the table were extended,

there would be a star that has exactly the same angle as the pentagon, or could there be another star that has the same angle as the 24,5-star?

We will find our answer to the first question by considering the second question.

2. Are there values of *n* and *J* that create polygons or stars for every whole number angle?

Are all whole numbers less than 180 possible? Let **A** be a whole number angle. If there are values of **n** and **J** that produce this angle, this must be true:

$$A = \frac{(n-2 \cdot J)}{n} 180.$$

Regrouping: $\frac{A}{180} = \frac{(n-2 \cdot J)}{n} = 1 - \frac{2J}{n}.$

Regrouping: $\frac{2J}{n} = 1 - \frac{A}{180} = \frac{180-A}{180}.$

Dividing by 2: $\frac{J}{n} = \frac{180-A}{360}.$

We see that the ratio **J/n** is a ratio of two parts, both of which are whole numbers. If these two parts are relatively prime then **J** is simply the numerator, and **n** is the denominator. More generally,

$$J = \frac{180-A}{GCD(360, 180-A)}, \quad \text{and} \quad n = \frac{360}{GCD(360, 180-A)}.$$

(In the above equations, GCD(**x,y**) is the greatest common divisor between **x** and **y**.) This means that there is an **n** and **J** that produces an angle of **A**.

Take, for example, **A** = 105. Then, 75 = 180 – **A** and GCD(360, 105) = 15 so **n** = 360/15 = 24 and **J** = 75/15 = 5, just as we saw in the table. This also implies that two distinct **n,J**-stars cannot have the same angle.

Consider now the ends of the whole number angle range. What are the **n**, **J** pairs for a 1° and a 179° angle?

1° 179 = 180 - 1 and GCD(360, 179) = 1, so **J** = 179 and **n** = 360. This is a really sharp, *sharpest star.*

179° 1 = 180 - 179 and GCD(360, 1) = 1, so **J** = 1 and **n** = 360. This 360-gon looks a LOT like a circle!

2.4.3 MA. A Totally Optional Addition to Section 2.4

Creating the *Angles Table* in *Excel* by Entering a Few Numbers and Two Equations

This section helps you understand *Excel*. It is provided to show how easy it is to create a table like that shown in Section 2.4.1 using *Excel*. As you will see, the final table was created using a preliminary table showing which cells to include.

Excel is essentially a calculator that does repetitive calculations very easily. *Excel* file 2.4.0 on the ESA website (available by scanning the QR code at inside front cover of the book). was used to create the table. The focus here is on how to create the table, not formatting it. The table was created in three steps.

1. Decide how large to make the table.
2. Determine which jump values should be included in the table.
3. Calculate the angle for those cells slated for inclusion in the table.

Once I decided to stop at $n = 30$, I knew that $J = 14$ was the largest J that was necessary (since $J < n/2$).

Creating runners. There are numbers included in the first row and first column. To create the pattern, simply start the pattern then highlight the pattern, depress the mouse, and drag the pattern as far as needed.

In the Excel file, n is started in cells A4 and A5 where 3 and 4 are entered. From there highlight A4:A5, then hold down the mouse and drag down to A31 where 30 occurs. Start J in B3 with 1 and C3 with 2. Then, highlight B3:C3 and drag B3:C3 to O3 where the number 14 occurs.

Creating cells to include (creating the preliminary table). Only include cells where $J < n/2$ and GCD(n, J) = 1.

In the Excel file, go to cell B4 and type (or notice it is already there): **=IF(B$3>$A4/2,"",IF(GCD(B$3,$A4)=1,1,""))**

This equation has been color-coded for explanatory purposes. Cells are excluded for two reasons:

1. If $J > n/2$ (that is the **red IF** statement).
2. Cells are included if GCD(J, n) = 1 (that is the **blue IF** statement).

Three things should be explained about the equation:

1. "" (2 double quotation marks) means leave the cell empty if this condition holds.
2. A $ in front of a number (like the **3** in B**$**3) means hold the row at 3 even if the equation in B4 is dragged down to row 5 or beyond.
3. A $ in front of a letter (like the **A** in $**A**4) means hold the column to **A** even if the equation in B4 is dragged sideways to column C or beyond.

Once the equation in B4 is written click *Enter*. Then return your mouse to B4 and move to the bottom right corner. Once you see the open white ✛ sign turn into a black **+** sign, click and hold the mouse then drag the equation sideways to O4 and release the mouse. The entire row from B4:O4 will now be highlighted. Once again, find the black **+** sign, click and hold then drag this row of equations down to row 31.

Calculating the angles for included cells. The *Angles Table* is created to the right (from Q1:AE31) of the preliminary table. The labels are typed into cells and the runners are dragged sideways (in row 3) and down (in column R). The rest of the table is based on one equation. That equation is $180 \cdot (n - 2J)/n$.

In the Excel file, go to cell R4 and type (or notice it is already there): **=IF(B4=1,180*($A4-2*B$3)/$A4,"")**

There is a 1 in the first table everywhere that you want an angle. That is why the IF statement references B4=1.

Because B4 is referenced without $ signs, B4 turns into C4 if the equation in R4 is dragged to the right but it turns into B5 if the equation in R4 is dragged down.

The $ signs work the same as above. Drag this equation to AE4 and drag the set of equations down to row 31 and you are done.

This equation puts an angle value in each cell where there was a corresponding 1 in the first table but leaves all other cells blank.

2.4.4 On Why the Angles Table Has a Ragged but Regular, Right Edge Pattern

As noted in Section 2.3.1, the sharpest stars occur if J is the largest number less than $n/2$. Given that, you might expect the progression of sharpest star J values to increase by 1 for every n increase of 2. Stylistically, you would expect the right-most table cell (largest J) for any n to increase as shown by ■ in Table 1.

This table works best if you think of n as being odd so $n = 2k+1$ and $n/2 = k+\frac{1}{2}$, which means the largest J is $J = k$. The next n, $n+1 = 2k+2$ so half that is $k+1$, but this cannot be used for J as this creates a vertical line image. Therefore, the largest value of J possible given $n+1$ if n was odd is $J = k$. This is the first stack of two ■ cells in Table 1. To make this concrete: if $k = 3$ then $n = 7 = 2\cdot3+1$ and $n+1 = 8$, both of these values of n have the sharpest stars with $J = 3$. The next stack simply increases J by 1 as n has increased by 2 and so on.

The right edge of the Angle Table in Section 2.4.1 does NOT step down like Table 1. Instead, it looks like Table 2. The obvious difference is the location of the sharpest $n+3$ star, which, rather than being at $J+1$, is at J.

This issue is discussed in Section 2.3.3, "Not All Even Stars are Created Equal." The point there was that even the sharpest stars alternate between having an angle that spans two and four vertices. That analysis focused attention on whether the even n was divisible by 2 but not 4 or by 4. We will come at the same issue in a slightly different way here.

Even n. An even n means that $n = 2k$. Choosing $J = k$ produces a vertical line, so the sharpest possible alternative is $J = k-1$.

CLAIM: This will produce an n,J-star with n-points only if J is odd. J **odd.** If $J = k-1$ is odd, then k is even or $k = 2h$ in which case $n = 2\cdot2h = 4h$ and hence n is divisible by 4. Such an n,J-star would span two vertices.

J **even.** If $J = k-1$ is even, then the n,J-star will have $n/2$ points because the odd vertices of the even n-gon will be excluded from the final star via this jump pattern. As jumps of J vertices per line added are counted around the polygon, one will maintain only even endpoints even after one passes over the top of the n-gon because n is even. To be explicit, consider the first three jumps (from 0 to J to $2J$ to $3J$).

0 to J ends at a vertex that is even by assumption.

J to $2J$ is the same as $k-1$ to $2k-2 = n-2$. Since n is even, so is $n-2$.

Expected Sharpest Star Pattern						
Table 1	...	**J**	**J+1**	**J+2**	**J+3**	**J+4**
...						
n		■				
n+1		■				
n+2			■			
n+3			■			
n+4				■		
n+5				■		
n+6					■	
n+7					■	
n+8						

Given, $J < n/2$ but $J+1 \geq n/2$.

Actual Sharpest Star Pattern						
Table 2	...	**J**	**J+1**	**J+2**	**J+3**	**J+4**
...						
n			■			
n+1		■				
n+2			■			
n+3		■				
n+4				■		
n+5				■		
n+6					■	
n+7				■		
n+8						

2**J** to 3**J** is the same as 2**k**-2 to 3**k**-3 = **n**+**k**-3 which ends at vertex **k**-3. By assumption, **J** = **k**-1 is even, so **k**-3 is as well.

This process continues until all even vertices have been used and an **n**/2,**J**/2-star results.

Since **J** = **k**-1 does not produce an **n**-point star, **J** = **k**-2 will because **k**-2 is odd, so **k** is odd, **k** = 2**h**+1 in which case **n** = 2·(2**h**+1) = 4**h**+2, or **n** is divisible by 2 but not 4. Such an **n**,**J**-star would span four vertices.

To conclude: The pattern of sharpest angle stars shown above starts from an odd **n**, but more specifically from an **n** of the form **n** = 4**k**+3 with **J** = 2**k**+1. The next three sharpest stars (**n**, **J**) values are (**n**+1, 2**k**+1), (**n**+2, 2**k**+2), and (**n**+3, 2**k**+1). This is easy to check for **k** = 1: The 7,3-star; 8,3-star; 9,4-star, and 10,3-star are all the sharpest stars for each of these values of **n**.

2.5.1 Viewing Stars as Rotating Polygons

When **n** is a multiple of **J**, then the image collapses to that common multiple. For example, if **J** = 10 and **n** = 30, a triangle results, but if **n** = 40, a square results. On the other hand, if **n** is close to 30 or close to 40, then the star that results can be thought of as being constructed by rotating triangles or squares. (These images are **NOT** triangles or squares but are close to those images.) The following are two examples that have been annotated with the first three and four segments.

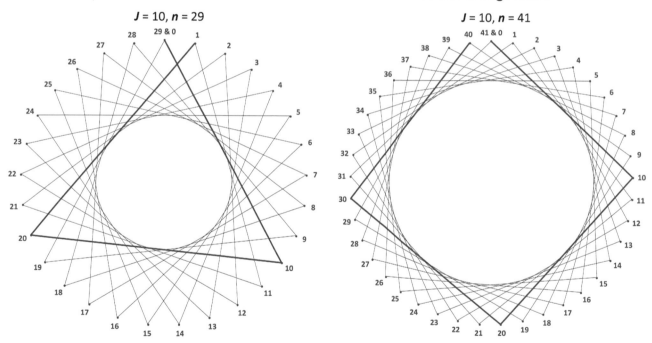

$J = 10, n = 29$ $J = 10, n = 41$

"One-off" images. The left image is a bit more than once around (since 30 > **n**), and the right image is not quite once around (since 40 < **n**). The next iteration will move to 2 on the left and 39 on the right. This will continue until the last iteration concludes with a segment from 19 to 29 on the left and from 31 to 41 on the right. The triangles on the left rotate clockwise, while the squares on the right rotate counterclockwise. If you want to see these rotations reverse, just change to **n** = 31 for triangles and **n** = 39 for squares. And if you want to see a rotating pentagon, set **n** = 49 or 51.

This link (use the QR code for the ESA website on the *Features* page) takes you to the first image. Click *Drawing Mode*, choose *Fixed Count Line Drawing*, and watch the image emerge in 1/3 of a clockwise turn. Then change **n** to 31 to see the reverse. Do the same for the image at the right by

changing **n** to 39 and 41, set *Drawn Lines* = 4, and watch the image emerge in a quarter turn clockwise or counterclockwise depending on **n**.

"Multiple-off" images. If you try 2-off versions of **n** (28 and 32 or 38 and 42), then every other vertex is skipped due to the common factor (of 2) with these values of **n** with **J** = 10. *If we choose **J** to be a prime number, we no longer have this issue.*

If we choose larger values of **J** and **n**, the rotating images are easier to see. As a result, consider the following starting point based on **J** = 67 and **n** = 200 (which produces a rotating triangle). Click *Drawing Mode, Fixed Count Line Drawing* like above. **n** = 200 is just under **n** = 3*J (3*67 = 201), so this rotates clockwise just like the left image on the previous page. Change **n** to 202 and the rotation reverses. Both are "one-off" images. As a result, the image is completed after 1/3 rotation of the triangle.

Try instead the 2-off image, **n** = 199 or **n** = 203 (**n** = 3*J ± 2). What happens now after 1/3 rotation? How much rotation is required to complete the image? What happens if **n** = 198 or **n** = 204? What happens after 1/3 rotation? What happens after 2/3 rotation? How many thirds does it take to complete the image in this instance? What happens as **n** gets further away from 3·**J**? Can you come up with a rule to tell how many rotations it takes to complete the image?

Other pairs to consider are **n** = 267 and 269, or 334 and 336. One final pair to consider are **n** = 167 and 168. A rotating pentagram occurs if **n** is near **n** = 2.5·**J** (2.5 makes sense when you note that a pentagram is 5 jump 2).

2.5.2 MA. What Is Regular About the Angles in Rotating Polygons and Stars?

These three images (on this page and the next) are examples of 2.5.1, *Rotating Polygons and Stars*.

Top Right. The first five lines of an 18,7-star are shown in **red**. These lines show a 5,2-star cracked open between vertex **17** and **0** appear counterclockwise (↺)-drawn.

Bottom Left. The first seven lines of an 18,5-star are shown in **red**. These lines show a 7,2-star also cracked open between vertex **17** and **0** that will appear ↺-drawn.

Bottom Right. The first three lines of a 20,7-star are shown in **red**. These lines show a triangle "over-closed" between vertex **1** and **0** that will appear clockwise (↻)-drawn.

Claim. Each of the angles in these "almost" polygons or stars that rotate to create an **n,J**-gram are equal EXCEPT for the point that is **not** part of the polygon.

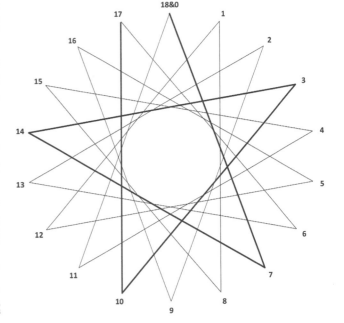

The fact that all but one angle is the same follows from the *Inscribed Angle Theorem* discussed in Section 22.1. In our context, the size of the angle is 180/**n** times the number of open side vertices spanned (**n** − 2**J**), given **J** < **n**/2. These images were chosen because all angles are multiples of 10° for **n** = 18 and multiples of 9° for **n** = 20.

TR. As discussed in 2.4.1, a regular 5,2-star has 36° angles as opposed to 40° at vertices **3**, **7**, **10**, and **14**. There is an *"open-top"* with no angle for the fifth point, but if you extend the **0–7 and 10–17** lines they intersect outside (and above) the polygon because 3, the span between **7** and **10**,

is larger than 1, the span between **17** and **0**. The angle resulting from this intersection, the *Implied Exterior Angle* (see 22.3), is 20° = 180·(3-1)/18. (Note that 5·36 = 180 = 4·40 + 20.)

BL. A regular 7,2-star has 180·3/7 = 77.14° angles as opposed to 80° at vertices **2, 5, 7, 10, 12**, and **15**. The *Implied Exterior Angle* is 180·(7-1)/18 = 10·6 = 60°. (Note that 7·180·3/7 = 540 = 6·80 + 60.)

BR. An equilateral triangle has 60° angles as opposed to 54° = 9°·6 at vertices **7** and **14**. The interior angle between **0** and **1** is 180°·(7+1)/20 = 9°·8 = 72° according to the *Interior Angle Theorem* (see Section 22.2). (Note: 3·60 = 180 = 2·54 + 72.)

A general rule. The vertex angles of a rotating image are larger than its regular counterpart for "*open-top*" images (and its implied exterior angle is smaller) but smaller for "*closed-top*" images like at **BR** (with a larger interior angle).

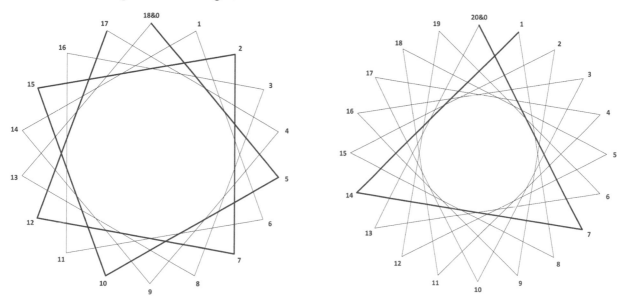

2.6.1 Stars Inside of a Star

The large images are 5-jump stars. Both are *Sharpest Stars* as discussed in Section 2.3.1; first is an 11,5-star and second is a 12,5-star where we denote the star as ***n,J***. To the right are three smaller 11-point stars for reference: 11,4; 11,3; and 11,2. As noted in Section 2.2.1, the only continuously-drawn 12-point star is the 12,5-star.

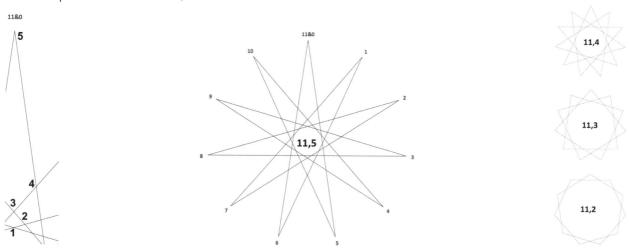

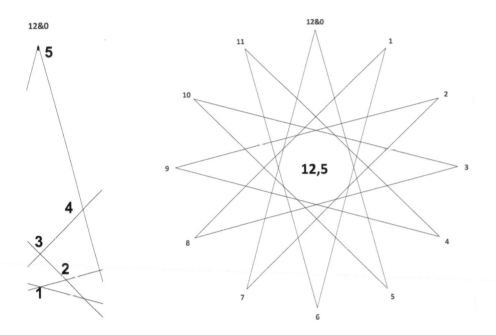

Note the following:

Stars create internal intersection points of lines.

Consider the line from 0-5. There are 2 intersections for each vertex jumped over so that there are 8 intersections on line 0-5.

The intersection points are symmetric about the center of the line.

The intersection points create concentric circles of *n* points per circle.

Each circle of points forms the vertices of smaller jump internal *n*-stars.

The blow-ups label these vertices according to the jump level of each resulting internal star (or polygon if *J* = 1).

2.6.2 MA. Analyzing Stars Inside of a Star

The *Stars Inside of a Star*, Section 2.6.1, had several assertions regarding patterns of line intersections. This *explainer* examines why those assertions are correct. We also consider generalizations available based on these observations using images and table on the next page.

Why are there two intersections per jumped-over vertex? An *n,J*-star (*J* < *n*/2) has *n* lines. This does not mean that there is one line per vertex because each line uses two vertices: One denotes where the line starts, the other where it ends. Each of the *J*-1 vertices from 1 to *J*-1 has "other endpoints" that MUST be vertices from *J*+1 to *n*-1 since otherwise, the difference between vertices is less than *J*. With *J* < *n*/2, those lines with starting points at vertices 1 to *J*-1 are to the right and below the center while those ending at these vertices started on lines that are above the center.

Why do the interior angles created by these intersections match other *n*-stars? As noted in Section 2.4.1, the angle is $\alpha = 180(n-2J)/n$ using the *Inscribed Angle Theorem* (see Section 22.1). For *Sharpest Stars*, this simplifies to 180/*n* if *n* is odd, 360/*n* if *n* is divisible by 4, and 720/*n* if *n* is divisible by 2 but not 4 (see Section 2.3.3). These are the values shown in the top row of the table (given *J* = 5 for *n* = 11 and 12, annotated and in images at left and right).

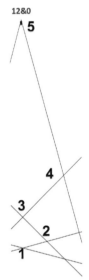

Consider how the *n,J* angle relates to the *n,J*-1 angle using the angle equation just posed. Replacing *J* with *J*-1 in the above equation increases the numerator by two vertices ((*n*-2(*J*-1)) = (*n*-2*J*+2)).

The *Interior Angle Theorem* generalizes the *Inscribed Angle Theorem* to allow for interior intersections (see Section 22.2). In this setting, the angle is the sum of vertices spanned on both sides of the intersection point under consideration times 180/*n*. (When the number of vertices spanned on one side is 0, the intersection is at a vertex just like at *J* = 5 to left and right.)

The table shows what happens as we move zigzag from intersections 5 to 4 to 3 to 2 to 1. Each move changes one line, which increases spanned vertices by 1 at the top and 1 at the bottom.

Line spanning Vertices	Color	Line spanning Vertices	Color	Vertices spanned at Top, T	Bottom, B	Angle° 180(T+B)/n	Point label*	Line spanning Vertices	Color	Line spanning Vertices	Color	Vertices spanned at Top, T	Bottom, B	Angle° 180(T+B)/n
0-6	Brown	0-5	Black	0	1	16.36	5	0-7	Brown	0-5	Black	0	2	30
1-7	Red	0-5	Black	1	2	49.09	4	1-8	Red	0-5	Black	1	3	60
1-7	Red	4-10	Green	2	3	81.82	3	1-8	Red	4-11	Green	2	4	90
2-8	Blue	4-10	Green	3	4	114.55	2	2-9	Blue	4-11	Green	3	5	120
2-8	Blue	3-9	Gold	4	5	147.27	1	2-9	Blue	3-10	Gold	4	6	150

*Point labels noted in *Stars inside a Star* explainer. Angle degree measurements are based on applying the *Interior Angle Theorem*.

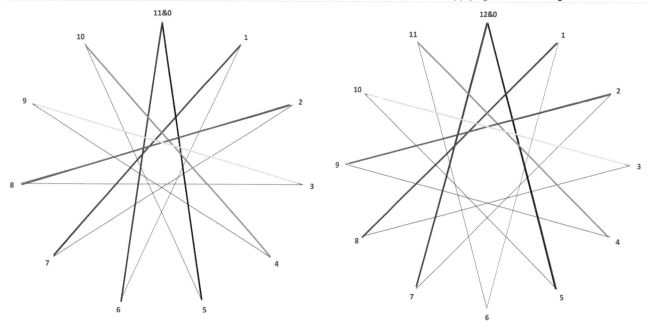

We see that the move from internal intersection point *J* to *J*-1 (5 to 4 or 4 to 3, etc.) increases the numerator by two vertices, just like changing from an *n,J*-star to an *n,J*-1 one using the *Inscribed Angle Theorem*. Both types of stars have the same angles. And, of course, the *Inscribed Angle Theorem* applies even if GCD(*n,J*) > 1 in which case one cannot create a continuously-drawn *n,J*-star.

Why is there symmetry about the midpoint of the line segment from 0 to 5 in both images? If you look at the lines starting at vertex **1** and *J*-1 you will see that the line (above the center) from *n*-*J*+1 to **1** and the line from *J*-1 to 2*J*-1 are the lines closest to the vertices at **0** and *J*. Similarly, the interior lines from each of these vertices form the closest to the center intersections on line **0-5**. A similar argument applies to vertices **2** and *J*-2, etc.

Divisible stars. The lines of a continuously-drawn *n,J*-star create the initial star as well as *J*-1 additional regular images. There are *J*-2 stars and one polygon. The images can be described as *n,k*-stars, 1 < *k* < *J*, nested inside one another with the smallest image being an *n*-gon. The interesting point is that this happens even if one cannot create a continuously-drawn *n,k*-star because GCD(*n,k*) > 1.

To be explicit, if you set **n** = 12 and **J** = 4 you obtain an equilateral triangle connecting vertices **0**, **4**, and **8**. As we see above, setting **J** = 5 produces four equilateral triangles, one of which has a point at the **red-black** line intersection noted as 4 in the blow-up above the right image at the start of this section. This peak is midway between vertex **0** and **1**, tilted 15° from the **0–4–8** one. More generally, all 12 equilateral triangle points (from the four equilateral triangles) are at the "half-hour," midway between vertices of the 12-gon. These form the vertices of the internal 12,4-star.

One final point should be made about the equilateral triangles. If you focus on every other triangle, you end up with a 6,2 internally drawn star. The pairs to consider are two hours apart: 12:30 and 2:30 or 1:30 and 3:30.

Right angles. The intersection marked 3 in the right image is a right angle as noted in the table. It is one of 12 such intersections based on three squares. As compared with the equilateral triangles above, these 12 points are "on the hour" so the internal 12,3-star has a peak on the vertical centerline.

Zigzag peaks. The internal stars and polygons peaks profiled in the table are on two radiuses, the vertical radius, and the radius midway between vertices **0** and **1**. (We could think of this as *on the hour* versus *on the half* (hour) if we think of the **n**-gon as an **n**-hour clock.) One should not conclude that odd internal star peaks must be on the vertical radius simply from the examples provided. Had we examined the internal stars based on a 13,6-star, the even peak points would be on the hour and the odd peak points would be on the half.

Parallel lines. The 11,5 image has no parallel lines and each of the lines in the 12,5 has a parallel counterpart. This dichotomy is, indeed, general. Any **n**-gram will have no parallel lines if **n** is odd and **n**/2 pairs of parallel lines if **n** is even. The reason is instructive. Suppose you have an **n**,**J**-star. If two lines are parallel, then they do not cross and therefore they span 2**J** of the **n** vertices. Notice that 2**J** is even regardless of **J** so that the remaining un-spanned **n**-2**J** vertices are even if **n** is even but odd if **n** is odd. Parallel lines based on vertices of regular polygons require that the segments have the same number of vertices between the lines on both sides of the polygon (this follows from the *Inscribed Angle Theorem*). This can only occur if **n** is even.

How far apart are these lines for even **n**? The answer is (**n**-2**J**)/2. So, the 12,5-star has parallel lines separated by 1 vertex (1 = (12-2·5)/2), but the 14-5-star parallel lines are separated by two vertices on each side of the 14-gon (2 = (14-2·5)/2).

Horizontal lines. If an **n**,**J**-star has a horizontal line, then **n** is odd. A horizontal line requires the same number of vertices spanned on both sides of the vertical center line. If **n** is even, there is a vertex at **n**/2 so that **J** would have to be even. But **n** and **J** both even means GCD(**n**,**J**) ≥ 2 so that this star cannot be continuously-drawn. By contrast, if **n** is odd and **J** is coprime to **n**, then there will be a single horizontal line in the image. If **J** is odd, that line is below the center of the polygon (like 11,5 or 11,3 or 11,1), and if **J** is even, it is above the center (like 11,4 and 11,2).

Internal polygons. An early *Polygons Exercise* notes that if **n** is odd, the **n**-gon has a flat bottom, and if **n** is even, the bottom is pointed because we always start at a pointed top (by construction). The same is not true with internal polygons. All even internal **n**-gons have pointed bottoms but odd internal **n**-gons have a flat top if **J** is even because the flat line is above the center. Again, compare 11,5 or 11,3 with 11,4 or 11,2 to see this internal 11-gon distinction.

2.6.3 Calculating Triangle Angles Using Vertices

Three non-parallel lines will eventually intersect one another. Unless they intersect at a single point, they inevitably create a triangle.

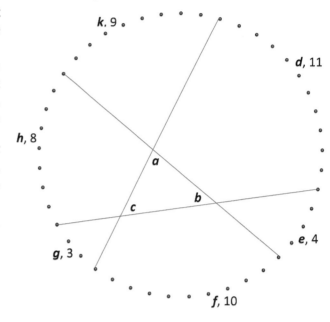

If the lines are from vertex to vertex of an ***n***-gon and if each line intersects the other two lines at two distinct points on the interior of each segment, then an image like the one at the right occurs. The interior triangle has three angles, ***a***, ***b***, and ***c***.

The three lines create six non-overlapping arcs of the circle. Each arc spans one or more vertices. The arcs are labeled from ***d*** to ***h*** and ***k***, and the number of vertices spanned by each arc is also noted.

This image has ***n*** = 45, the sum of the six numbers. This was chosen so that each angle is a multiple of 4 (because 4 = 180/***n*** = 180/45). Angles are obtained using the *Interior Angle Theorem*, which is 180/***n*** times the sum of opposing arcs, or:
a = 4·(***k***+***f***) = 4·(9+10) = 76°; ***b*** = 4·(***e***+***h***) = 4·(4+8) = 48°; ***c*** = 4·(***d***+***g***) = 4·(11+3) = 56°.

NOTE: The lines above were chosen so that different values occurred for each arc. Single-jump stars would not show this variety as the sum of three consecutive values would have to be ***J*** or ***n-J*** (as with the **red** and **blue** sets of lines on the next page).

Finding triangles inside stars. Section 2.6.2, *Analyzing Stars Inside a Star* showed that an ***n,J***-star had ***J***-2 internal ***n***-stars and an internal ***n***-gon at the center of the image. Of course, once ***n*** and ***J*** become somewhat "large," the internal stars are difficult to pick out of the overall image. One might ask: *Where and how many **equilateral triangles**, ▲s, are there in the image at left on the next page?*

Consider the bottom left 60,29-star. Embedded in that central mass are ▲s, based on a 60,20-star. Two of the 20 ▲s that comprise this 60,20-star are shown to the right. These are from three sets of parallel lines drawn at 10-line intervals starting with **blue line 1** from vertex **0** to **29** and noted as **1 0–29; 11 50–19; 21 40–9; 31 30–59; 41 20–49; 51 10–39**. Each internal 6,2-star creates 8 ▲s total, the two large ones and six surrounding smaller ones. In all the left image has 80 ▲s.

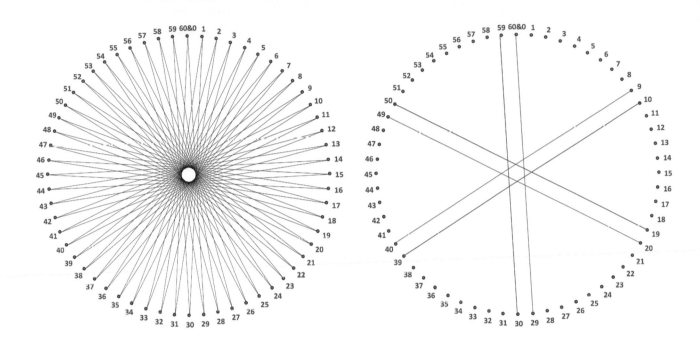

2.7.1 Challenge Questions for Chapter 2: Analyzing Jumps, *J*

The *Excel* file for this chapter, 2.0.1, available by QR code on the ESA website, includes basic polygon questions (with answers) embedded in the sheet, which focus on the parameter *n*. These questions are not repeated here, but they are worth working through.

 Here are some reasonably open-ended questions that focus attention on the parameter *J*.

Fix *J* at some small value larger than 1 (like 2, 3, 4, 5, or 6). Then set *n* = *J*+*J*.

1. What fraction of vertices is used in this instance?
2. What image results?
3. What is the next larger value of *n* where VCF = *J*?
4. What is the image in that instance?
5. If you continue repeating this pattern for larger *n*, what happens?

Set *n* = 7 and *J* = 1. Increase *J* and see when you find that pattern once again.
Do the same for *n* = 7 and *J* = 2. Then do it one more time for *n* = 7 and *J* = 3.

6. Can you explain why the same image exists for two values of *J* for any *n*?

Set *J* > *n*, with *J* not a multiple of *n*, like *J* = 8 and *n* = 7. Can you find a similar image with *J* < *n*?

7. Provide a general rule that allows you to find such images.

NOTE: Questions 8–11 ask you to use *Excel* file 2.0.1 to answer the questions. That is why the size restriction on *n* is placed on *n* in each question setup.

Set *n* < 25 and find a *J* that gives an image you like.

8. Find a value of *n* > 25 that produces the same image.
9. What is *J* in this instance?

Set *n* < 17 and find a *J* that gives an image you like.

10. Find two more values of *n* > 17 and *J* that produce the same image.

Set *n* < 13 and find a *J* that gives an image you like.

11. Find three more values of *n* > 13 that produce the same image.

2.7.2 Stars as Rotating Polygons Challenge Questions

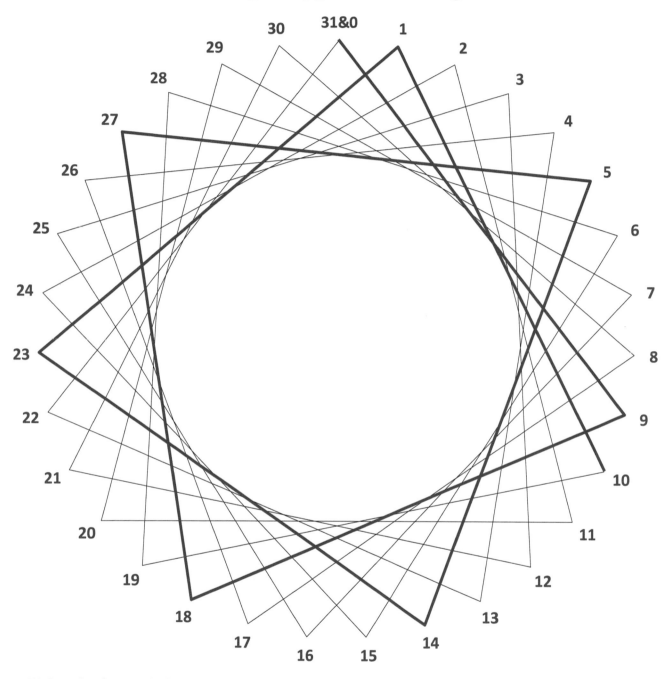

FACT. The first eight lines are shown in **red**. Question 2 assumes familiarity with Section 2.5.

1. Describe this image as an **n,J**-star. What are **n** and **J**?
2. Could this image be considered to be drawn as a rotating polygon or star? If so,
 a. What type of polygon or star is it?
 b. Is it clockwise-drawn or counterclockwise-drawn?

c. What is the common angle, and what is the angle that appears only once? What vertices are the common angle associated with in the initial sub-image? (It may be easier to provide your answers in fractional form rather than as decimal numbers.)

d. Verify that the angles sum to the same number of degrees as its regular polygon or polygram counterpart.

2.7.3 Creating Internal 12,3 and 12,4-Stars Challenge Questions

Assumes You Have Read Section 2.6

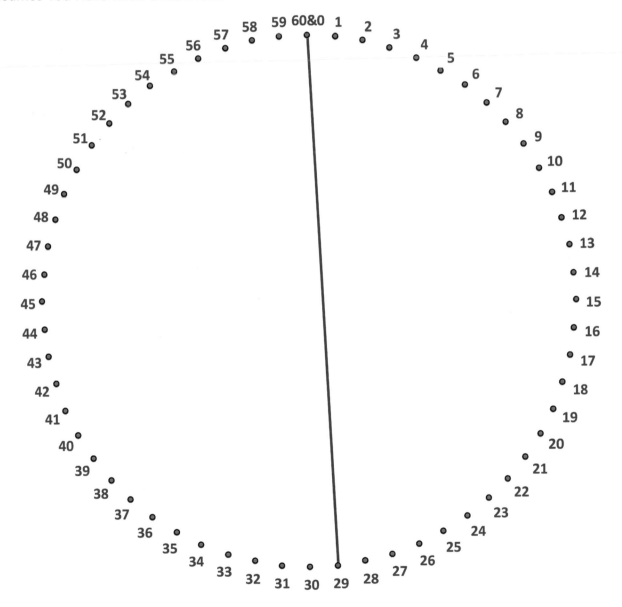

Each of the Questions Is Based on a 60,29-star, the First Line of Which Is Shown On the Prior Page
1. Suppose you wanted to see a different 6,2-star from the one examined in Section 2.6.3. The first line you want to use is line 5 from vertex **56** to **25**.
 a. What line numbers are used in this instance? (You need not provide vertex to vertex line placements but instead, focus your attention on the pattern that must develop to get the appropriate lines drawn.)
 b. Describe your answer in modular terms.
2. The internal 6,2-star discussed in Section 2.6.3 used equilateral triangles.
 a. How could you add to this to create an internal 12,4-star?
 b. How many lines are required?
 c. What line numbers are used in this instance? (You need not provide vertex to vertex line placements but instead, focus your attention on the pattern that must develop to get the appropriate lines drawn.)
 d. Describe your answer in modular terms.
3. Suppose you wanted to create an internal 30,10-star that includes line 1 from vertex **0** to **29** as part of the image.
 a. How many lines are required?
 b. What lines would you need to use in this instance? (You need not provide vertex to vertex line placements but instead, focus your attention on the pattern that must develop to get the appropriate lines drawn.)
 c. Describe your answer in modular terms.
 d. Would this star include both the **blue** and **red** portions of the 6,2-star used in Section 2.6.3?
4. Suppose you wanted to create an internal 15,5-star that includes line 1 from vertex **0** to **29** as part of the image.
 a. How many lines are required?
 b. What lines would you need to use in this instance? (You need not provide vertex to vertex line placements but instead, focus your attention on the pattern that must develop to get the appropriate lines drawn.)
 c. Describe your answer in modular terms.
 d. Would this star include both the **blue** and **red** portions of the 6,2-star in Section 2.6.3?
5. An internal 12,3 star was discussed in Section 2.6.2. Use the image above, together with a pencil and ruler to create an internal 12,3-star that includes the first line of the 60,29-star shown. The rest of the lines are suppressed but can be obtained using the *Excel* file (or the web version).
 a. Is this star also created from equilateral triangles?
 b. How many lines are required?
 c. What line numbers are used in this instance? (You need not provide vertex to vertex line placements but instead, focus your attention on the pattern that must develop to get the appropriate lines drawn.)
 d. Describe your answer in modular terms.
6. This is only if you have done both problems 2c and 5c.
 a. Explain why you got the same answer to both questions.
 b. Are there any other internal 12-stars possible using these lines?

2.7.4 Triangle Angles Challenge Questions

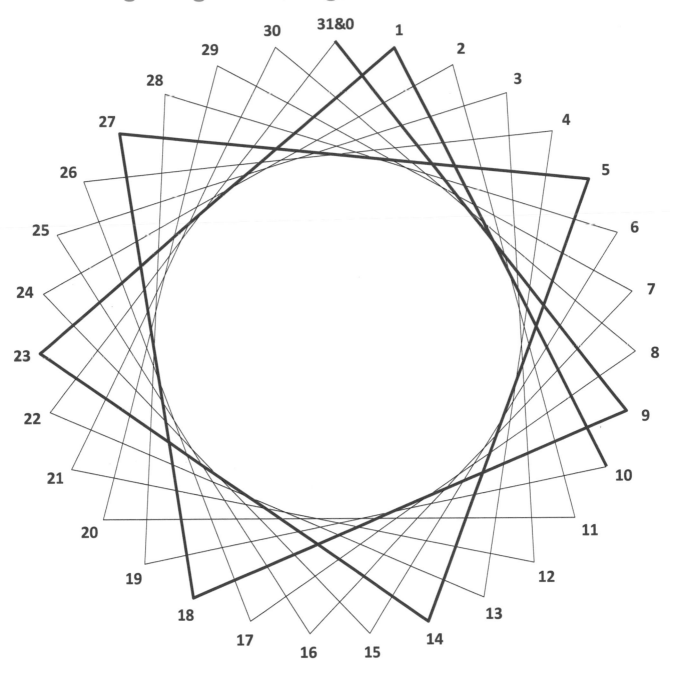

FACTS. The first eight lines are shown in **red**. This is the same image used in Challenge Questions 2.7.2 but is reproduced here for convenience. Question 1 requires an understanding of Section 2.6.3.

1. Consider the triangle bounded by the following three lines: **1–10**, **5–14**, and **9–18**.
 a. One of the triangle's angles appears that it may be a right angle. Is it a right angle? Briefly explain. Is it isosceles?
 b. Provide values for each of the angles in degrees in either decimal or fractional form.

2. Would it be possible to use an alternative third line to **9–18** and create an isosceles triangle with lines **1–10** and **5–14** creating the vertex angle (the vertex angle is opposite the base and is created by having line segments the same size as legs)?
 a. In particular, what angles are created from lines **1–10** and **5–14**?
 b. If it is possible, what is the line that provides the base of the triangle, and what are the vertex and base angles?

AN INTRODUCTION TO PART II
String Art

The heart of ESA is the string art model examined in comprehensive detail in the 12 chapters in Part II. Chapters in Part II lay out the attributes of this model based on four parameters: n, S, P, and J. n and J determine the vertex frame star or polygon, just as described in Chapter 2. Chapter 3 lays out the basics. Each line of the vertex frame is subdivided into S equal-sized segments. Lines of the string art image are drawn every P^{th} subdivision endpoint until the circuit is completed by having the last endpoint coincide with the starting point. At one level, that is all you need to know to start exploring how images change as you change parameters in the model. The remaining 11 chapters in Part II include three chapters, 11, 12, and 13, that delineate specific types of images. Chapter 14 provides challenge questions for Part II. The other seven chapters analyze these images in a variety of ways. An expressed goal of this analysis, delineated in Chapter 9, is being able to create altered but similar versions of those images based on different values of n, S, P, or J.

DOI: 10.1201/9781003402633-4

Chapter 3

String Art Basics

3.1 A Primer on *S*, the Number of *Subdivisions* between Vertices

*The most important concept in truly understanding string art images is to understand subdivisions, **S**. (We need to understand **S** before we draw an image. We discuss drawing images using these dots in the **P** primer, Section 3.2.) This primer has three rows of images. The left column in the first two rows has large* **black dots at vertices** (*n* = 3 top and *n* = 4 middle) *with **S** equal-sized subdivisions with* **S red subdivision dot endpoints** *between each vertex (**S** = 3 top and **S** = 2 middle). Because this is true for all **n** line segments connecting vertices, there are a total of **n·S** subdivision dots in the image. Note that a vertex is also an endpoint of a subdivision (which is why each* **black dots** *has a* **red dot** *in the middle).*

The other columns in rows 1 and 2 show how subdivision dots are counted based on *J* vertex jumps. The middle column shows the typical situation with *J* < *n*/2, here *J* = 1, and the right shows that the same dots are counted in the reverse order when *J* = *n*-1. This is why the **numbered green subdivision endpoints** reverse direction between middle and right columns. Both versions produce the same final static image and only differ in the order in which the image is drawn.

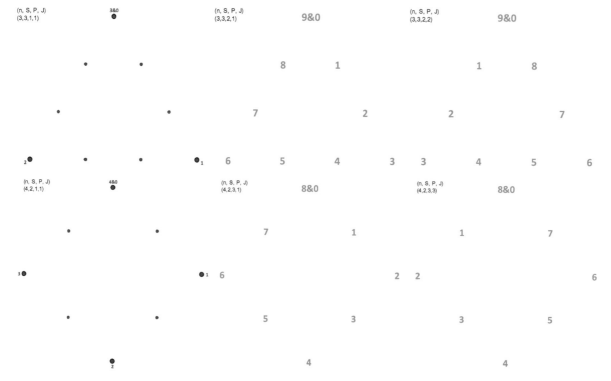

Both images below show only the **numbered subdivision points** and have **n** = 5 and **S** = 2 so there are ten subdivision points in each image. When **n** > 4, **J** > 1 is how stars are created. On the left is a pentagon, and on the right is a pentagram.

Even though the lines between vertices are not shown, you should be able to look at the image and visualize the lines between vertices.

For example, try to visualize a line between vertex **5&0** and **1** to the left and **5&0** and **2** to the right by noticing that the green points **10&0**, **1**, and **2** are on the line from the top (at **5&0**) to vertex **J**.

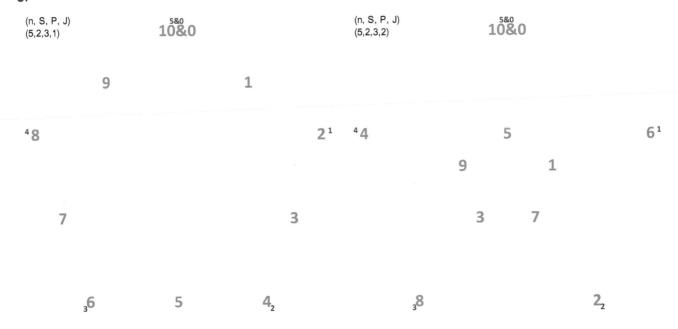

(n, S, P, J)
(5,2,3,1)

5&0
10&0

9 1

⁴8 2¹ ⁴4

7 3

₃6 5 4₂

(n, S, P, J)
(5,2,3,2)

5&0
10&0

5 6¹

9 1

3 7

₃8 2₂

3.2 A Primer on *P*, the Number of Subdivisions Between Points

Lines are drawn every **P** *subdivision points.* The left column provides **subdivision counts** from the **S** primer. The top image shows **P** = 2 so a line is drawn (read → as draw line) every second subdivision endpoint. The first four lines connect even subdivision endpoints 0 → 2 → 4 → 6 → 8. *The next* line (**line 5**) *goes from* 8 → 1 *because* 8+2–9 = 1 *is the second endpoint after* 8 *since* **counting continues past the top** (*here 9, just like 1 o'clock is 2 hours after 11 o'clock*). *This is the key to counting.*

From there, the last four lines connect odd subdivision endpoints 1 → 3 → 5 → 7 → 9&0. The image is completed with nine connected lines.

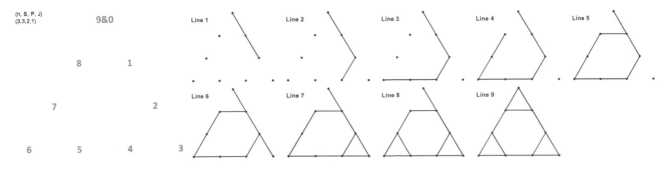

(n, S, P, J)
(3,3,2,1)

9&0

8 1

7 2

6 5 4 3

Line 1 Line 2 Line 3 Line 4 Line 5

Line 6 Line 7 Line 8 Line 9

The next three drawn images have **S** = 2 and **P** = 3 but differ by **n** and **J**. The same rules apply to line creation as before.

n = 4. The first two lines connect subdivision endpoints **0 → 3 → 6,** but 6+3-8 = **1**, so **6 → 1 → 4 → 7** and 7+3-8 = **2**, so **7 → 2 → 5 → 8&0**.

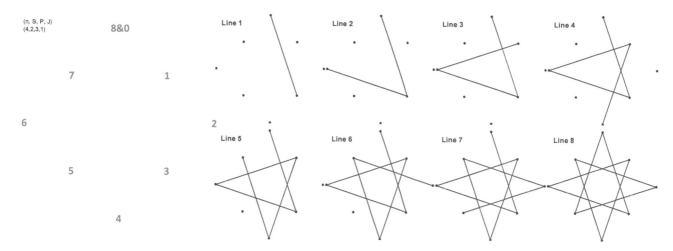

n = 5. The first three lines connect **0 → 3 → 6 → 9**, but 9+3-10 = **2**, so **9 → 2 → 5 → 8** and 8+3-10 = **1**, so **8 → 1 → 4 → 7 → 10&0**.

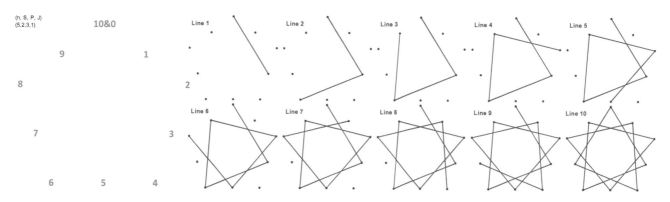

Note. **J** = 1 above, **J** = 2 below.

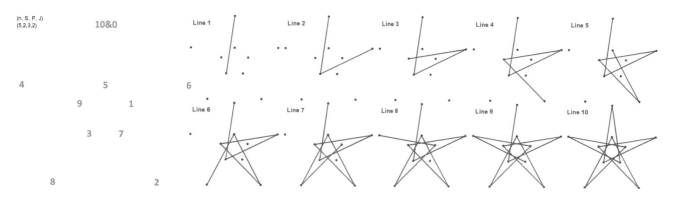

3.3 How Lines Are Created from *S* and *P*

The most important thing to understand in **Part II** is the subdivision counting rule. Subdivisions are equally spaced segments between vertices. If *S* is **2** then there are two subdivisions between the starting point and the first vertex, and two more between first and second, and so on. Each of the intermediate points would be a midpoint between vertices so that there are twice as many points to use if we include the midpoints along with vertices of the polygon as line segment endpoints. So, if *n* = **4** and *S* = **2** we would have eight points that can be used as the endpoint of a line segment.

Suppose we want to connect every third subdivision endpoint with a line segment. Call this *P* = **3** where *P* stands for the number of subdivisions between points. Put differently, *P* is the count-ing rule for line creation. Subdivisions are counted clockwise starting at the top, then draw a line con-necting every third subdivision endpoint. There are multiple ways to count off subdivisions to create line segments, but the simplest is to simply say: **1, 2, 3 draw line**; **1, 2, 3 draw line**; **1, 2, 3 draw line**; etc. Once this is done eight times, you end up back at the top, and you have created an 8-point star using a square frame. A version of what that looks like is provided below with annotations in color denoting counting subdivisions around the circle (on which the square is inscribed) with **PINK** first time around, **RED** second, and **DARK RED** third. Line segments are numbered in **BLUE**. Follow from **0** to **1** to ... to **8** to see the image created as eight connected (or *continuously-drawn*) segments:

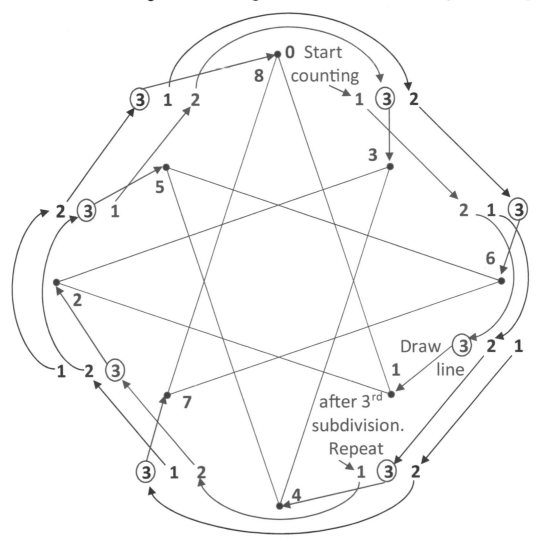

Here is the math. The location of the k^{th} endpoint is easily obtained using the *remainder function* (MOD, see Chapter 23). Given $n \cdot S$ possible endpoints, the k^{th} is located at $r = MOD(k \cdot P, n \cdot S)$, so the end of the seventh line is at $5 = MOD(7 \cdot 3, 4 \cdot 2)$ above. This is the midpoint between the second and third vertex because $r/S = 5/2 = 2.5$ in this instance, and it was attained during the third time around the circle since $2 < (k \cdot P)/(n \cdot S) = 21/8 < 3$.

Use this link (using the *Links* document available by QR code for the ESA website on the *Features* page at the front of this book) and click *Drawing Mode, Fixed Count Line Drawing*, and set *Drawn Lines* = 1 to watch the 8-point star connect from segment to segment.

Here are two more examples. Both use triangles with three subdivisions ($n = 3$, $S = 3$), so there are nine possible endpoints for line segments. The image connects numbers 0 to 1 ... to 9.

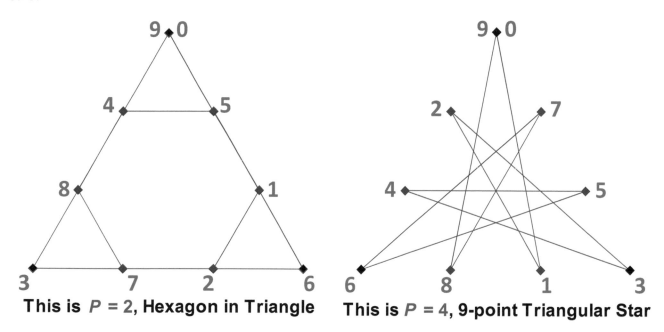

This is $P = 2$, Hexagon in Triangle **This is $P = 4$, 9-point Triangular Star**

The only other image that can occur when $n = 3$ and $S = 3$ is a triangle. You can use the file to see that a triangle occurs when $P = 1, 3, 6,$ and 8, and the above images occur twice. Images typically occur twice for $P < n \cdot S$ because P and $n \cdot S - P$ produce the same image (but require going around the triangle a different number of times). The table below shows the possibilities.

Given $n = 3$, $S = 3$, and $P =$	1	2	3	4	5	6	7	8
Image:	Triangle, △	○-in-△	△	9-pt.△-lar☆	9-pt.△-lar☆	△	○-in-△	△
Segments required:	9	9	3	9	9	3	9	9
Times around triangle:	1	2	1	4	5	2	7	8

Chapter 4

Issues Involving Commonality

4.1 Finding the Total Number of Connected Line Segments in an Image, VCF and SCF

A circuit is completed once the top of the polygon (the starting point of the image) is used as a segment endpoint. With the annotated images used to explain the difference between **S** and **P** shown below, this occurs at the eighth segment in the star on the left, or the ninth segment for the middle and right images. Both occur after **n·S** connected segments (8 = 4·2 and 9 = 3·3) because **P** has no divisor in common with **n·S**.

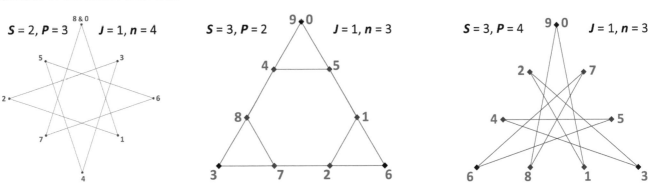

The maximum number of possible segments is **n·S** because that is how many subdivision endpoints exist given **n** vertices and **S** subdivisions between consecutively used vertices. Not all of these endpoints need to be used, however. For example, if **P** = **S**, no subdivision endpoints except the polygon vertices themselves will be used, regardless of the size of **S** (if **P** = 2 in the left example, a square results, or if **P** = 3 in the other two, a triangle results). Similar issues occur when **J** has a common factor with **n** (if **J** = 2 in the left example, the resulting image would be a vertical line since **n** = 4).

The total number of line segments used to complete a circuit and create an image depends on **n**, **S**, **P**, and **J**. Creating an image is a two-step process: 1) Setting the vertices being used, then 2) setting the subdivisions being used. Each step requires finding if there are common factors involved between two or more of the parameters used to create the image.

On the relative size of J and n: If **J** = **n**, the image degenerates to a point. Suppose **k** > **n** where **k** is the number of vertex jumps. This requires that you count around the circle at least once before landing on the **k**[th] vertex. That vertex is one of **n** possible vertices, so the same image occurs using **J** = MOD(**k**, **n**) < **n**, where MOD is the remainder function discussed in Chapter 23.

DOI: 10.1201/9781003402633-6

On the *Vertex Common Factor, VCF*: If there is no commonality between n and J, then all of the polygon's vertices will be used. If there is commonality, then fewer vertices will be used. For example, if $n = 12$, all vertices are used when $J = 1, 5, 7,$ or 11. $J = 1$ and 11 produce a dodecagon, and $J = 5$ and 7 produce 12-point stars. If $J = 2$ or 10, half as many vertices are used, and a hexagonal image results. If $J = 3$ or 9, one-third of the vertices are used, and a square image results. If $J = 4$ and 8, one-fourth of the vertices are used, and a triangular image results. And when $J = 6$, a vertical line results.

Mathematically, the *vertex common factor, VCF*, is: \quad VCF = **GCD**(J, n),
where **GCD** is the greatest common divisor function (discussed in Section 21.2).
The number of vertices used, v_{used}, is then given by: $\quad v_{used} = n/$**VCF**.

On the *Subdivision Common Factor, SCF*: We connect the v_{used} vertices using the jump rule J to form the *vertex frame*. On each of the v_{used} lines of the vertex frame, we create S subdivisions. The total number of possible subdivision endpoints is thus $S \cdot v_{used}$. Not all of these endpoints are used if P has factors in common with $S \cdot v_{used}$.

Mathematically, the *subdivision common factor, SCF*, is: SCF = GCD(P, $S \cdot v_{used}$).
The number of lines in the image, L, is then given by: $\quad L = S \cdot v_{used}/$**SCF**.

An example: Suppose $n = 12$, $S = 8$, $P = 20$, and $J = 9$. One might imagine that there are $n \cdot S = 12 \cdot 8 = 96$ possible line segments in the final image. But VCF = GCD(9, 12) = 3, so $v_{used} = 12/3 = 4$. Similarly, the SCF = GCD(20, 8·4) = 4 so that the number of lines in the image, $L = 32/4 = 8$. Indeed, the image is the same as the 8-point star in a square frame on the left.

4.2.1 Visualizing the *Vertex Frame*: The Visible Number of Line Segments Might Differ from the Calculated Number of Segments

On the vertex frame. *The vertex frame is the set of line segments which include all possible subdivisions.* The vertex frame is solely determined by n and J so that we see that the vertex frame is either a polygon or a continuously-drawn star as defined in Section 2.2.1. The vertex frame of an image is always visible when $S = P$. It is worth explicitly noting that all subdivision endpoints used to create an image are points on the vertex frame.

The line segments that comprise the vertex frame need not be part of the final image. In fact, if $P > S$, then NO parts of the vertex frame are on the image *except* subdivision endpoints. Conversely, if $P < S$, then at least some part of each line segment creating the vertex frame is included in the image. In any event, it is worthwhile considering what the frame looks like because all lines in the image connect subdivision points that are themselves on the frame.

The visible number of line segments might differ from the calculated number of segments. There are a variety of reasons why this may occur. Two reasons emerge in Part II.

1) If **S** is a multiple of **P**, **S** = **m·P**, then each line in the vertex frame is created by connecting **m** colinear line segments (*colinear* means on the same line).

Take the example to the right with values of **n**, **J**, and **S** listed. Four of the six values of **P** ≤ 6 produce the vertex frame (because **S** = 6), which has three apparent line segments in the final image (since **n** = 3). But the calculated number of line segments (shown in the **Lines** column) varies dramatically because many of these segments are colinear parts of the triangular vertex frame.

Each line in the vertex frame contains **m** segments in this instance, so if **P** = 1, **m** = 6, and so on for other values of **P**.

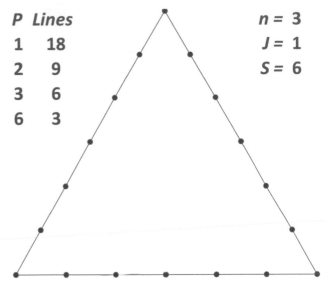

P	Lines
1	18
2	9
3	6
6	3

n = 3
J = 1
S = 6

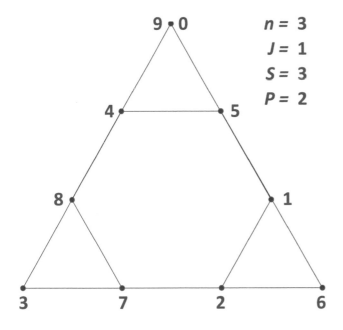

n = 3
J = 1
S = 3
P = 2

2) The triangular image at the left, used to explain **S** versus **P** in Section 3.3, counts nine line segments to create the image.

Visual inspection of this image leads to the impression that there are only six segments: The three lines in the vertex frame and the three lines from 1 to 2, 4 to 5, and 7 to 8.

The difficulty here is that, in order to complete the image while maintaining the counting pattern (i.e., to be *continuously-drawn*), one needs nine line segments to create the six-line final image. Some of those segments partially overlap in achieving this image. For example, the last half of the first segment coincides with the first half of the sixth segment.

3) Additional reasons why the visible number of line segments differs from the calculated number of line segments are found in Part III.

4.2.2 Drawing the Vertex Frame

When 1 < **J** < **n**-1 and VCF = 1 a star results. This star is the VF for string art images and the order in which VF lines are drawn determines subdivision point order and hence line placement in the final image.

These images show all eight possible 19-point stars. Each star can be drawn in two ways depending on whether **J** < **n**/2 or **J** > **n**/2.

The order in which the MIN(**J**,**n-J**)-1 *ending vertices* **E** fill in the vertices between **n**&0 and **J** or **n**&0 and **n-J** is noted below. These values of **E** are based on the equations provided at the bottom of the table.

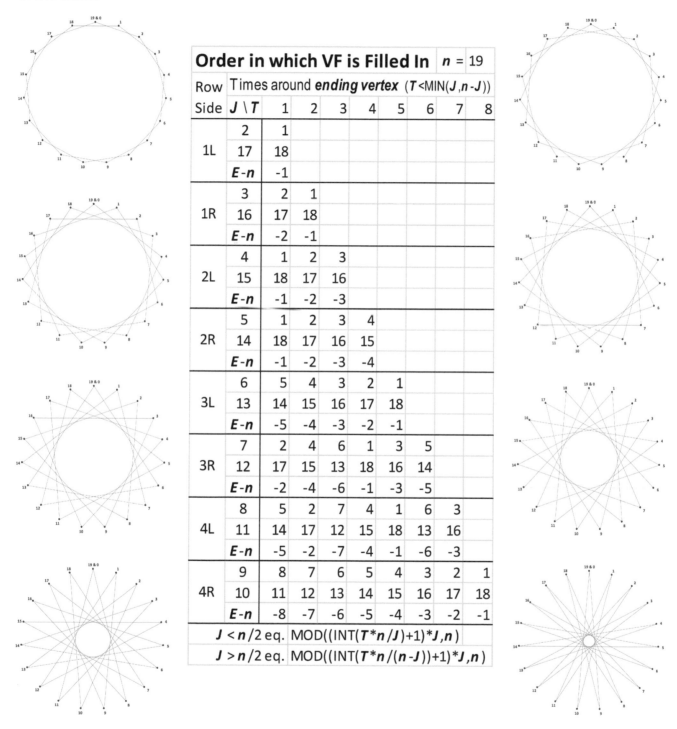

Order in which VF is Filled In									*n* = 19
Row	Times around *ending vertex* (**T**<MIN(**J**,**n-J**))								
Side	**J \ T**	1	2	3	4	5	6	7	8
1L	2	1							
	17	18							
	E-n	-1							
1R	3	2	1						
	16	17	18						
	E-n	-2	-1						
2L	4	1	2	3					
	15	18	17	16					
	E-n	-1	-2	-3					
2R	5	1	2	3	4				
	14	18	17	16	15				
	E-n	-1	-2	-3	-4				
3L	6	5	4	3	2	1			
	13	14	15	16	17	18			
	E-n	-5	-4	-3	-2	-1			
3R	7	2	4	6	1	3	5		
	12	17	15	13	18	16	14		
	E-n	-2	-4	-6	-1	-3	-5		
4L	8	5	2	7	4	1	6	3	
	11	14	17	12	15	18	13	16	
	E-n	-5	-2	-7	-4	-1	-6	-3	
4R	9	8	7	6	5	4	3	2	1
	10	11	12	13	14	15	16	17	18
	E-n	-8	-7	-6	-5	-4	-3	-2	-1
J < **n**/2 eq.	MOD((INT(**T*****n**/**J**)+1)***J**,**n**)								
J > **n**/2 eq.	MOD((INT(**T*****n**/(**n-J**))+1)***J**,**n**)								

Two notes: 1) The order in which vertices are filled in is **not** necessarily sequential (see 3R or 4L). **2)** When **J** > **n**/2, the ending vertex order can be viewed as negative of its **n-J** counterpart (**E-n**). This same strategy works for other **n** and **J** values if VCF = GCD(**n**,**J**) = 1.

4.2.3 MA. Analyzing Patterns in Continuously-Drawn n,J-Stars

One interesting result from Section 4.2.2 is that many continuously-drawn **n,J**-stars (which form the VF) are filled in sequentially (on either the 1 to **J**-1 or **n**-1 to **n-J**+1 side). This *explainer* dives more deeply into the conditions under which this might occur (and when it does not occur).

We noticed there that the order of filling in vertices was symmetric about **n**/2 so we can (and here will) restrict our discussion to **J** < **n**/2. As a result, this explainer reformats the tabular information from the earlier explainer to focus on **J** < **n**/2, which produces **n**-point stars. (When **n** is prime, all **J** from 2 to INTEGER(**n**/2) produce distinct continuously-drawn stars, but when **n** is a composite number, we require **n** and **J** to be coprime (VCF = GCD(**n,J**) = 1) in order to create a continuously-drawn **n,J**-star (as is discussed in Section 2.2.1). The angles created by such star points are discussed in Section 2.4.1.)

n		Times around *ending vertex, T* (T < J)							
19	J \ T	1	2	3	4	5	6	7	8
▲	2	1							
	3	2	1						
▼	4	1	2	3					
	5	1	2	3	4				
	6	5	4	3	2	1			
	7	2	4	6	1	3	5		
	8	5	2	7	4	1	6	3	
	9	8	7	6	5	4	3	2	1

The table to the right provides the same information in a more compact format. The location of vertex 1 is automatically highlighted in each row in *Sequential Polygons and Stars Excel* file 4.0 (available by QR code from the ESA website) which allows analysis up to **n** = 66. If there is a 1 in the **T** = 1 column, then the VF fills in from 1 to **J**-1 ↻ (clockwise), and when 1 is the final entry in the row (such as **J** = 3, 6, and 9) then the VF fills in ↺ (counterclockwise) from **J**-1 to 1. (The 1 in the **J** = 2 row is both since it is a one-entry series.)

Claim: J = 2, 3, and 4 are **always** sequential (assuming VCF = 1). The first two are straightforward. **A)** If **J** = 2 then **n** must be odd. The VF endpoints are 2, 4, ... **n**-1, 1, 3, ..., **n**-2, **n**&0 with the first time around using even vertices and the second time around with odd vertices. (Of course, a sequence involving only one value is tautologically a sequence, albeit an uninteresting one.) **B)** If **J** = 3, then **n** is of the form **n** = 3**k**+1 or **n** = 3**k**+2. The former (like **n** = 19 above) produces an endpoint of 2 for **T** = 1 so the next time around must have a remainder of 1 = 2+2 MOD 3. The latter (like **n** = 20) would have an endpoint of 1 for **T** = 1 and therefore 2 for **T** = 2. Both possibilities are sequential.

C) The **J** = 4 claim is a bit more interesting. To produce a continuously-drawn **n**-star with **J** = 4, **n** must be odd. The first VF crossing, **T** = 1, must go from a multiple of 4 to the next multiple of 4, but any multiple of 4 is a multiple of 2 so the starting point for the crossing line must be at **even** vertex **n**-1 or **n**-3 in which case the ending vertex is at 3 or 1. The second VF crossing vertex is 2 in both instances (2 = 3+3 MOD 4 in the first instance and 2 = 1+1 MOD 4 in the second). The third VF crossing completes the sequence: 1 = 2+3 MOD 4 in the first and 3 = 2+1 MOD 4 in the second.

The T = 1 endpoint of the VF tells the whole story. Call this endpoint **E** (so **E** = 2 with **J** = 7 or **E** = 5 with **J** = 8 in the table above). The order of subsequent fill-in vertices is **k·E** MOD **J** for 2 ≤ **k** ≤ **J**-1.

To understand *n*, look at factors of *n*-1 and *n*+1 less than n/2. If you want to have **E** = 1 (for **T** = 1) it must be the case that **n**+1 is a multiple of **J**. This would produce an increasing sequence that fills in endpoints ↻ from 1 to **J**-1; the **J**-1 lines form the internal lines for the star that intersects the vertical radius starting at point **n**&0. In the above example, **n**+1 = 20 has factors 2, 4, and 5 < **n**/2). This implies that **J** = 2, 4, and 5 have sequences that increase from 1 to **J**-1. By contrast, **n**-1 = 18 has factors 2, 3, 6, and 9 < **n**/2). This means that **J** = 2, 3, 6, and 9 have sequences that decrease ↺ from **J**-1 to 1. (**J** = 2 is on both lists, as noted above.)

n/J provides information on the VF as Rotating Polygons. As noted above, **J** =2, 3, and 4 always produce sequential images (which are therefore viewed as versions of rotating polygons discussed in Section 2.5.1). The table to the right provides **n/J** whole number values for **J** = 2 through 4, and the closest mixed fraction values to a single digit for **J** > 4 (given **n** = 19). The type of the rotating polygon is given by the closest number to **n/J** if the sequence of ending points **starts or ends** with 1, so **J** = 5 is a rotating quadrangle, **J** = 6 is a rotating triangle, and **J** = 19 is a rotating line. Additionally, if the fractional part is just below 1, the rotation is ↻ (like **J** = 4 and 5), and if it is just above 0, the rotation is ↺ (like **J** = 3, 6, and 9).

n/J (1 digit fraction)	n 19	J \ T
10	▲	2
6		3
5	▼	4
3 4/5		5
3 1/6		6
2 5/7		7
2 3/8		8
2 1/9		9

Rotating Stars. When the vertex frame lines are not filled in in a sequential fashion, one can still obtain interesting insights from **n/J**. Note from the table on the previous page,

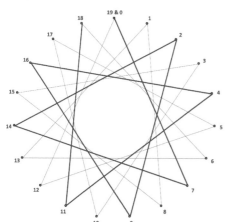

J = 7 and **J** = 8 both have 1 in the third cell from the end of the sequence (at column **T** = **J**-3). Both images are ↺ rotating 3-jump stars. The **J** = 7 version is shown to the left, and the **J** = 8 version is shown to the right. The fraction **n/J** can be used to determine what type of star is appropriate in both situations.

Left image: The whole number portion of 19/7 is 2 and the fractional portion is 5/7. 5/7 is closest to 2/3 and we know we want a 3-jump star. The number of points in the rotating star is the whole portion times 3 plus the numerator of the fraction 2/3 (or 8 = 2·3+2). Since the ending 1 was 3 from the right (at **T** = 4), the star is open at the top and rotates ↺.

Right image: The whole number portion of 19/8 is 2 and the fractional portion is 3/8. 3/8 is closest to 1/3 and we know we want a 3-jump star. The number of points in the rotating star is the whole portion times 3 plus the numerator of the fraction 1/3 (or 7 = 2·3+1). Since the ending 1 was 3 from the right (at **T** = 5), the star is open at the top and rotates ↺.

To finish this discussion of stars as rotating polygons or stars it is worthwhile to remember that the underlying VF is a star such as the 19,7-star to the left or the 19,8-star to the right. But each of these stars also can be thought of as being created in a sequential fashion from rotating smaller-sized stars (a ↺ 8,3-star of the left and a ↺ 7,3-star on the right).

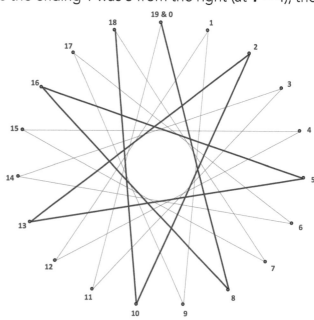

n/J (1 digit fraction)	n 60	J\T	1	2	3	4	5	6	7	8	9	10	11	12	13	14	15	16	17	18	19	20	21	22	23	24	25	26	27	28
30	▲	2																												
20		3																												
15	▼	4																												
12		5																												
10		6																												
8 4/7		7	3	6	2	5	1	4																						
7 1/2		8																												
6 2/3		9																												
6		10																												
5 4/9		11	6	1	7	2	8	3	9	4	10	5																		
5		12																												
4 3/5		13	5	10	2	7	12	4	9	1	6	11	3	8																
4 2/7		14																												
4		15																												
3 3/4		16																												
3 1/2		17	8	16	7	15	6	14	5	13	4	12	3	11	2	10	1	9												
3 1/3		18																												
3 1/6		19	16	13	10	7	4	1	17	14	11	8	5	2	18	15	12	9	6	3										
3		20																												
2 6/7		21																												
2 5/7		22																												
2 3/5		23	9	18	4	13	22	8	17	3	12	21	7	16	2	11	20	6	15	1	10	19	5	14						
2 1/2		24																												
2 2/5		25																												
2 1/3		26																												
2 2/9		27																												
2 1/7		28																												
2		29	27	25	23	21	19	17	15	13	11	9	7	5	3	1	28	26	24	22	20	18	16	14	12	10	8	6	4	2

With this in mind, six of the seven 60-point VF stars noted above can be recast as rotating stars. **J** = 7 is ↻ 17,2; **J** = 11 is ↻ 11,2; **J** = 13 is ↻ 23,5; **J** = 17 is ↻ 7,2; **J** = 19 is ↻ 19,6; and **J** = 23 is ↻ 13,5. Verify each dynamically <u>at this link</u> using the *Single Line Drawing* mode by setting *Drawn Lines* to the number of points in the rotating star (e.g., 13 for **J** = 23).

Two additional patterns emerge in the **n** = 60 table. First, 1 is right in the middle of the **J** = 29 row, and 2 is the last entry (for **T** = 28). Indeed, the numbers decline with all odd values, then all even values. The 2 in the final position means that this is a two-time-around ↻ line (60/29 is close to but a bit larger than 2) so set *Drawn Lines* = 2, **J** = 29 and watch the VF get filled in using the odd first, then the even vertices on the right half of the 60-gon.

Twin primes. The second point to note given **n** = 60 is that there are NO sequential values for **J** in this instance. This occurs for an interesting reason: 60 is sandwiched between two primes, 59 and 61. Such pairs of primes are called *twin primes*. Whenever this occurs, there are no factors (other than 1 and the number) of the adjacent numbers. But above we saw that factoring the numbers just above and just below **n** tells us which **J** values produce sequentially drawn stars. This is not unique to **n** = 60; the same pattern occurs for **n** = 12, 18, 30, and 42 because each is surrounded by primes.

Additional patterns based on primes. The table on the next page, reproduced from the *Sequential Polygons and Stars Excel* file 4.0, summarizes polygon and star information for 5 ≤ **n** ≤ 66. The prime **n** values are highlighted for convenience. In addition to the absence of sequentially drawn polygons when **n** is between a twin prime, you can see that there are additional patterns based on whether **n** is at or near a prime.

If **n** is prime, there are INTEGER(**n**/2) − 1 total possibilities since all 2 ≤ **J** ≤ INTEGER(**n**/2) have GCD(**n**,**J**) = 1. Any composite **n** has fewer possibilities (than nearby primes) because when **n** is

composite, some of the **J** have factors in common with **n**. One cannot create a continuously-drawn **n,J**-star if GCD(**n,J**) > 1.

If **n** is one more than a prime (i.e., **n**-1 is prime), then any sequentially rotating polygon must be based on a factor of **n**+1. As a result, the cross-over endpoint for the first line is at **E** = 1. As noted in the table, each increases (rotates ↻).

If **n** is one less than a prime (i.e., **n**+1 is prime), then any sequentially rotating polygon must be based on a factor of **n**-1. As a result, the start of the first cross-over line is **n**-1 and the endpoint is **E** = **J**-1. Many examples are noted in the table (as *all decreasing, 1 less than prime*), each rotates ↺. Note that **n** in each instance is even (**n**+1 is prime).

There are additional odd **n** (13, 21, 25, 33, 37, 45, 57, and 61) for which all sequential **J** are decreasing (except for **J** = 2 which, as noted above, is both). Clearly, **n** is not one less than a prime in this case (since **n**+1 is even and therefore divisible by 2). The unifying attribute of each of these numbers is that in each instance, there are only two non-trivial factors of the number: 2 and (**n**+1)/2. Put another way, (**n**+1)/2 is prime. Since (**n**+1)/2 > **n**/2, it violates our restriction on **J** that **J** < **n**/2.

Challenge Question. The 57,**J**-star at left can quite clearly be described as a ↺ rotating 5,2-star. **Without counting vertices,** what is the value of **J** here?

	Sequential?	Patterns of Rotating Polygons and Stars		Sequential?			
n	#yes	#no	Notes on sequential polygons	n	#yes	#no	Notes on sequential polygons
5	1			36	2	3	all decreasing, 1 less than prime
6			no continuous 6-point star	37	7	10	all decreasing (except 2)
7	2			38	2	6	all increasing, 1 more than prime
8	1			39	6	5	
9	2			40	2	5	all decreasing, 1 less than prime
10	1			41	10	9	
11	4			42		5	Surrounded by twin primes
12		1	Surrounded by twin primes	43	8	12	
13	4	1	all decreasing (except 2)	44	4	5	all increasing, 1 more than prime
14	2		all increasing, 1 more than prime	45	4	7	all decreasing (except 2)
15	3			46	4	6	all decreasing, 1 less than prime
16	2	1	all decreasing, 1 less than prime	47	8	14	
17	5	2		48	1	6	7 sequential n=7^2-1 & 47 prime
18		2	Surrounded by twin primes	49	10	10	
19	6	2		50	3	6	
20	2	1	all increasing, 1 more than prime	51	6	9	
21	4	1	all decreasing (except 2)	52	2	9	all decreasing, 1 less than prime
22	2	2	all decreasing, 1 less than prime	53	8	17	
23	6	4		54	2	6	all increasing, 1 more than prime
24	1	2	5 sequential, n = 5^2-1 & 23 prime	55	10	9	
25	6	3	all decreasing (except 2)	56	4	7	
26	3	2		57	6	11	all decreasing (except 2)
27	4	4		58	2	11	all decreasing, 1 less than prime
28	2	3	all decreasing, 1 less than prime	59	10	18	
29	8	5		60		7	Surrounded by twin primes
30		3	Surrounded by twin primes	61	10	19	all decreasing (except 2)
31	8	6		62	4	10	all increasing, 1 more than prime
32	2	5	all increasing, 1 more than prime	63	5	12	
33	4	5	all decreasing (except 2)	64	6	9	
34	4	3		65	9	14	
35	7	4		66	2	7	all decreasing, 1 less than prime

4.2.4 An Analytical Approach to Line Placement

The images to the left and right are based on common **n** = 7, **S** = 3, and **P** = 5. Each image has 21 line segments. The only difference is **J** = 2 to the left and **J** = 3 to the right. These examples will be used to explain line placement in the final image. Any line segment can be fully described by noting the starting point and ending point of the segment.

Number and location of endpoints, B. Each line segment endpoint in the final image must be a part of the Vertex Frame, VF. In general, there are $B = nS/VCF$ **possible subdivisions** in the final image (VCF = GCD(n,J)). If VCF > 1 we obtain the same image by dividing both n and J by VCF, therefore *we restrict our discussion to n and J which are relatively prime and $B = nS$.* (For example, the VF for $n = 10$, $J = 4$ (VCF = 2) is the same as $n = 5$, $J = 2$; both VFs are clockwise drawn pentagrams ($n = 5$, $J = 3$ is counterclockwise drawn).)

How many endpoints are used? If SCF = 1 (SCF = GCD($nS/VCF,P$), then all B subdivision points are used in the final image. The order in which these points are used determines the ultimate image.

When SCF > 1, a total of B/SCF subdivision endpoints are used in the final image. (For $n = 7$, $S = 3$, all 21 possible endpoints are used if $P = 5$; seven are used if $P = 6$ (since SCF = 3), and three are used when $P = 7$ (since SCF = 7).) When SCF > 1, each endpoint is a multiple of SCF (once modular considerations are controlled for). To make this explicit, consider $P = 6$. The seven counted subdivisions used to complete the image in this instance are 6, 12, 18, 24, 30, 36, and 42 as shown in the table to the right, but the last four of these values are counted in the second time around the VF at endpoints 3 = 24 MOD 21, 9 = 30 MOD 21, 15 = 36 MOD 21, and 0 = 42 MOD 21. In the end, all subdivision endpoints used to create the final image are multiples of 3 = SCF. By contrast, the three subdivisions that are used when $P = 7$ are easy to see: 7, 14, and 0 = 21 MOD 21.

Which endpoints are used? The first line starts at the top of the n-gon and ends after P subdivisions have been counted along the VF, the second line goes from this point to the endpoint, which is $2P$ subdivisions along the VF, and so on. This continues until the final endpoint connects with the initial starting point at the top of the n-gon. Note that this counting occurs even if $kP > B$ (as we saw in the example above). The B/SCF used endpoints are $E_k = \text{MOD}(kP,B)$ for $1 \le k \le B/SCF$.

Subdivision endpoint		
k,	kP,	$E_k = \text{MOD}(kP,B)$
1	6	6
2	12	12
3	18	18
4	24	3
5	30	9
6	36	15
7	42	0

Where on the VF is a used endpoint located? Each used endpoint is $k \cdot P$ subdivisions along the VF. The location of that point depends on both S, the number of subdivisions per segment of the VF, as well as n and J. The location can be thought of as a two-part process: **I)** Find which part of the VF the point is on; and **II)** find where that segment of the VF is located based on polygonal vertices. An example shows the relevant calculations based on four parameters in yellow.

I) Let $C = k \cdot P$ be the counted number of endpoints that is the location of a used subdivision of the final image. If we divide C by S, we obtain a number that has a whole part, W, and a fractional part, r/S, where $r < S$. W tells us the starting point of the VF segment on which this point is located, and r tells us how far towards the next segment the endpoint is located.

II) The polygon vertex for VF_{start} and VF_{end} is based on n, J, and W. Each VF vertex is J vertices of the n-gon past the previous vertex. Equations for start and end vertices are as noted in the last two lines of the example to the right. The next page shows how the above images are created using the same calculations. Both images are based on a 7-gon with $S = 3$ and $P = 5$. The images show the **seven vertices in red, vertex frame in blue**, and **possible subdivisions in green**. The only difference is $J = 2$ to the left and $J = 3$ to the right. The upper table shows the order of subdivision usage, and the lower shows the location of each point on the VF.

372	$C = kP$, counted endpoint
17	S
21 15/17	C/S written as a mixed number, $W\ r/S$
	The endpoint is on the $W+1^{st}$ segment of the VF from W to $W+1$. Each segment of the VF has S subdivisions. The endpoint is r subdivisions along this segment of the VF from W to $W+1$. (In Excel, $W = \text{INT}(C/S)$ and $r = \text{MOD}(C,S)$.)
	The VF segment location relative to polygon vertices 0 - n-1 is based on n & J. n-gon vertices for this segment are in red.
13	n
6	J
9	Location of W on VF, ($\text{VF}_{start} = \text{MOD}(WJ,n)$)
2	Location of $W+1$ on VF ($\text{VF}_{end} = \text{MOD}(\text{VF}_{start}+J,n)$)

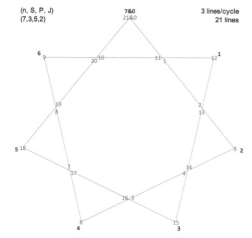

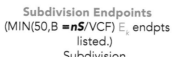

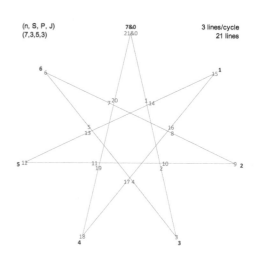

Subdivision Endpoints
(MIN(50,B $=nS$/VCF) E_k endpts listed.)
Subdivision

$k, kP,$	E_k =MOD(kP,B)	
1	5	5
2	10	10
3	15	15
4	20	20
5	25	4
6	30	9
7	35	14
8	40	19
9	45	3
10	50	8
11	55	13
1 2	60	18
13	65	2
1 4	70	7
15	75	12
16	80	17
1 7	85	1
18	90	6
19	95	11
2 0	100	16
21	105	0

Location of start and end point of VF segment given		**7**	**N**	Location of start and end point of VF segment given		
		3	**S**			
	2 j	**5**	**P**	**3 j**		
V_{start}	V_{end}	k	$C=kP$	W r	V_{start}	V_{end}



V_{start}	V_{end}	k	$C=kP$	W	r	V_{start}	V_{end}
2	4	1	5	1	2	3	6
6	1	2	10	3	1	2	5
3	5	3	15	5	0	1	4
5	0	4	20	6	2	4	0
2	4	5	25	8	1	3	6
6	1	6	30	10	0	2	5
1	3	7	35	11	2	5	1
5	0	8	40	13	1	4	0
2	4	9	45	15	0	3	6
4	6	10	50	16	2	6	2
1	3	11	55	18	1	5	1
5	0	12	60	20	0	4	0
0	2	13	65	21	2	0	3
4	6	14	70	23	1	6	2
1	3	15	75	25	0	5	1
3	5	16	80	26	2	1	4
0	2	17	85	28	1	0	3
4	6	18	90	30	0	6	2
6	1	19	95	31	2	2	5
3	5	20	100	33	1	1	4
0	2	21	105	35	0	0	3

55

A Final Note

A cycle is completed once $r = 0$.

Both image's are 3 lines long (Sec. 5.1).

Both image's first cycle is shown in red on the images to the right.

Challenge Q.
Use the numbered images above to sketch out what the images would look like if $P = 2$ rather than 5. Check your work using the file. How do these images compare to the triangular one in Section 3.3?

4.3 Symmetry About $n \cdot S/2$ and the Number of Distinct Images as a Function of P for Given Values of n, S, and J

Porcupine images are created when P is the largest number less than (or smallest number larger than) $n \cdot S/2$. The images are identical above and below $n \cdot S/2$ as long VCF = GCD(J, n) = 1. If VCF > 1, then the same is true for P above and below $(\frac{n}{\text{VCF}}) \cdot S/2$. In general, if this is an integer, $P = (\frac{n}{\text{VCF}}) \cdot S/2$ is a vertical line.

The *vertex frame* occurs if P is a factor of S because each line in the frame is created using one or more segments. (If $S = 12$, six P values produce the vertex frame, $P = 1, 2, 3, 4, 6,$ and 12.) Let $N_{\text{FACTORS}}(S)$ be the number of factors of a number S (including 1 and S). Each of these factors will produce a single image (the vertex frame). As a result, there are $\text{INTEGER}((\frac{n}{\text{VCF}}) \cdot S/2) - N_{\text{FACTORS}}(S) + 1$ distinct images. Below are eight of nine distinct images given $n = 4$, $S = 6$, and $J = 1$.

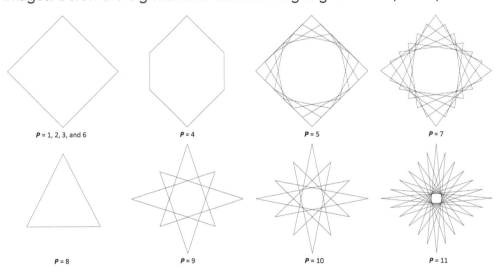

$P = 1, 2, 3,$ and 6	$P = 4$	$P = 5$	$P = 7$
$P = 8$	$P = 9$	$P = 10$	$P = 11$

The final image, $P = 12$, is a vertical line. There are nine distinct images because $\text{INTEGER}((\frac{n}{\text{VCF}}) \cdot S/2) - N_{\text{FACTORS}}(S) + 1 = \text{INTEGER}((4/1) \cdot 6/2) - 4 + 1 = 9$.

Chapter 5

Cycles

5.1 The Number of Segments in a Cycle and the Number of Cycles in a Circuit

A completed image includes at least one vertex from the parent polygon because a circuit is completed once the top of the polygon (the starting point of the image) is used as a segment endpoint. As can be seen in the (**n,S,P,J**) = (4,3,4,1) top image, the top vertex may be the only vertex of the parent square included in the final triangular image. It is important here to not confuse the triangle's vertices with the parent polygon's vertices.

If more than one of the parent polygonal vertices are included in the final image, then the image is made up of multiple cycles. *A cycle, **C**, is the smallest number of connected segments that are required to achieve a vertex of the polygon as an endpoint of a segment.* An image is created from one or more cycles.

The cycle in the (**n,S,P,J**) = (9,5,6,2) image is **C** = 5. The image is made up of three such cycles: The first is shown in **red**, the second is shown in **blue**, and the third is in **black** (starting at vertex 6 and ending at 9&0). (By contrast, the top image has one cycle of **C** = 3 shown in **red**.)

Each cycle is a rotated version of other cycles. The **blue cycle** is simply the **red cycle** rotated clockwise by 120° (or 3/9 = 1/3 of a full rotation). The black cycle is a 2/3 clockwise rotation of **red** (or a 1/3 counter-clockwise rotation). Put another way, ***the lines in a single cycle show us the essential character of the image.***

It is worth looking at the locations on the vertex frame of **red's** cycle endpoints. Remember, here,

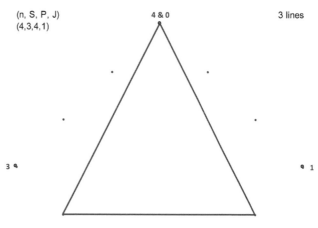

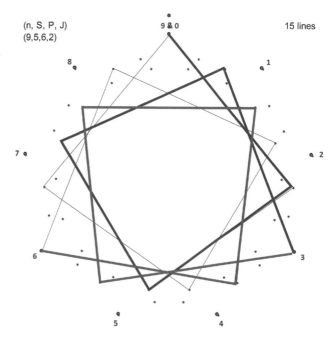

DOI: 10.1201/9781003402633-7

S = 5 and **P** = 6. The first point is **1/5** of the way along the second part of the vertex frame (from **2** to **4**). The second point is **2/5** of the way along the third line of the vertex frame (from **4** to **6**). The third point is **3/5** of the way along the fourth line of the vertex frame (from **6** to **8**). The fourth point is **4/5** of the way along the fifth line of the vertex frame (from **8** to **1**). The fifth point is **5/5** of the way along the sixth line of the vertex frame (from **1** to **3**) or vertex **3** of the 9-gon. Each subdivision fraction, **1/5** to **5/5**, is used.

Note that **C** = **S** in the two above examples. This need not be the case as we can see in the (**n**,**S**,**P**,**J**) = (12,4,6,5) image at right. The first cycle is shown in **red**. The first end point is 2/4 of the way on the second vertex frame line (from **5** to **10**), and the second end point is 4/4 of the way on the third vertex frame line (from **10** to **3**) or at vertex **3** of the 12-gon so that **C** = 2. The *number of segments in a cycle*, **C**, is given by:

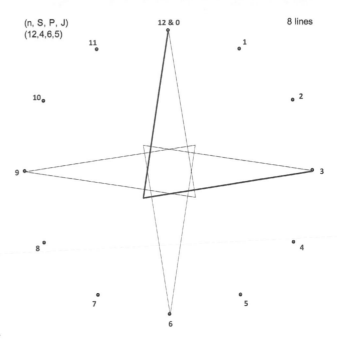

(n, S, P, J)
(12,4,6,5)

12 & 0 8 lines

$$C = \frac{S}{\text{GCD}(S, P)}$$ where GCD is the greatest common divisor function.

The *number of cycles in the image*, **M**, is given by:

$$M = \frac{L}{C}$$ where **L** is the number of lines in the image.

(As discussed in Section 4.1, **L** = (**S**·**n**/VCF)/SCF with VCF = GCD(**n**, **J**) and SCF = GCD(**S**·**n**/VCF, **P**).)

NOTE: *The number of cycles is the same as the number of vertices of the parent polygon that are part of the image.*

5.2 Where the First Cycle Ends Tells Us How the Image Is Filled In

Finding E. If the first cycle ends at the top, the image is complete. In all other circumstances, there will be multiple cycles to complete the circuit (or image). There are **C** lines per cycle, and each line is created by counting out **P** subdivisions on the vertex frame. But note that a polygonal vertex occurs every **S** subdivisions on the vertex frame, and, by construction, this point is **J** polygonal vertices away from the 0, the top of the parent polygon. Putting all of this together, we see that *the endpoint of the first cycle*, **E**, is:

$$E = \text{MOD}(\frac{C \cdot P}{S} J, n)$$ where MOD is the remainder upon division by **n**.

The image will appear to add polygonal vertices to the image in a ↻ (clockwise) direction if **E** < **n**/2 *because the second endpoint will be at* 2**E** < **n**.

If **E** > **n**/2, the polygonal vertices appear to be added to the image in a ↺ (counter-clockwise) direction *because* MOD(2**E**, **n**) < **E**.

An example: Consider two ways of drawing the image to the right. Quite clearly, **S** = 3 and **n** = 4. **J** can be either 1 or 3. Let **J** = 1. The first cycle must start at the top so the end of the first segment in the cycle is the last subdivision before vertex **2** or the first subdivision after vertex **2** on the vertex frame. Simple counting suggests that **P** = 5 or **P** = 7 and **C** = 3.

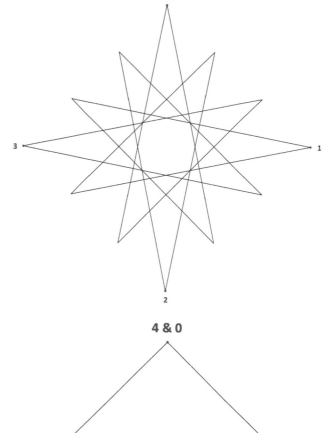

P = 5: Then **E** = MOD(3·5/3, 4) = 1 and polygonal vertices are added in a ↺ direction from **1** to **2** to **3** to **4&0**.

P = 7: Then **E** = MOD(3·7/3, 4) = 3 and polygonal vertices are added in a ↺ direction from **3** to **2** to **1** to **4&0**.

Finally, if **E** = **n**/2 the image will have two and only two cycles, which are mirror images of one another. This occurs because the second cycle ends at the top of the parent polygon: 0 = MOD(2**E**, **n**) if **E** = **n**/2. The hexagonal image to the right has the same **S**, **n**, and **J** as above but now **P** = 2 or **P** = 10.

P = 2: Then **E** = MOD(3·2/3, 4) = 2, and the first cycle is the right half of the image.

P = 10: Then **E** = MOD(3·10/3, 4) = 2, and the first cycle is the left half of the image.

In both instances, the second cycle completes the image.

E tells us how the image is filled in. The size of **E** relative to the number of cycles in the image, **M**, tells us how many times around the parent polygon vertices the drawing must lay down cycles to fill in the image. For example, this image has **E** = 3 with 29 cycles and **n** = 29, so it takes *3x-around* to fill in vertices 1 and 2.

Click (29,12,224,13) then use *Drawing Mode* and click *Fixed Count Line Drawing*.

By contrast, this (30,3,58,13) **E** = 4 image is a *2x-around image* since the number of cycles, **M** = 15, so only half the vertices are points on the im age (click *Toggle Vertices* if unclear about this fact).

More generally, the number of times around the parent polygon vertices one must travel to fill in the image, **T**, is given by an equation that depends on whether those additions are counter-clockwise (**E** > **n**/2) or clockwise (**E** < **n**/2):

Times around to fill in the image, **T** = IF(**E** > **n**/2, (**n**-**E**)/(**n**/**M**), **E**/(**n**/**M**)).

One-time-around* images.** If ***T = 1, then the image is created in a series 1 used-vertex changes around the parent polygon. This may involve a large number of repetitions of counting subdivisions around the vertex frame, but the cycle moves one used-vertex at a time. Additionally, if ***n*** = ***M***, the image is drawn one vertex at a time. The way such images are drawn can be quite dramatic:

This (30,11,127,13) image is ↻ because ***E*** = 1, and this (30,12,233,13) image is ↺ because ***E*** = ***n***–1. To see both images get drawn, use *Fixed Count Line Drawing* mode. Set *Drawn Lines* = 2 with a higher *Drawing Speed* or *Drawn Lines* = ***S*** (11 or 12) with a slower *Drawing Speed*. Both provide interesting drawing dynamics and are spinning stars (see Section 11.8).

5.3 Using Cycles to Understand Images

Excel file 3.0.3 allows you to create materials suitable for classroom presentation, but the file can also be used to help understand the underlying aspects of a given image.

One *toggle* in particular helps to show how the image was created by letting the user scroll through the first ***k*** lines in the image (cell B10). The value of ***k*** can be set by typing a number in cell C11, using the ↕ arrow keys in C10:12, or by linking C11 to a specific cell.

A useful cell to link ***k*** to is ***S*** (type =C1 in cell C11) because this shows the first cycle if ***S*** and ***P*** have no factors in common. (If the *Equations* toggle in cell C6 is clicked on, then you could alternatively type =M9 in C11.)

The image to the right shows the **first cycle**, the **vertex frame**, and **labels**. The first cycle ends at vertex **1** and has 38 lines. The endpoints of these 38 lines are subdivision points on 9 of the 20 lines on the vertex frame. The used vertex frame lines can be seen as the lines from: **12-1**, **13-2**, **14-3**, **15-4**, **16-5**, **17-6**, **18-7**, **19-8**, and **20&0-9**.

The image below shows how 20 such cycles create the full image, one cycle spanning each pair of successive vertices.

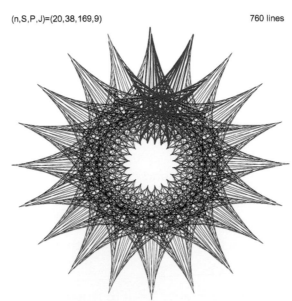

(n,S,P,J)=(20,38,169,9) 760 lines

Using the web version, click (20,38,169,9) then use *Drawing Mode* to see this get drawn. For details on drawing modes, see Section 25.4. If you set *Drawn Lines* = 9, the image is *single-step* (see Section 8.5.1). It is worth noting a few things about nearby images:

1. If you change **S** with fixed **n**, **P**, **J**, and GCD(**S**, **P**) = 1, then the first cycle will continue to end at **1**; the image remains a one-time-around image. **S** = 34 looks like a pulsing square, and **S** = 31 is a 20-point spinning needle star.
2. If you change **P** for fixed **n**, **S**, and **J**, the images produced are no longer necessarily one-time-around. For example, **P** = 167 looks very similar to **P** = 169, but it is a three-time-around image because the first cycle ends at vertex **3**.

5.4.1 Image Density: The Role of *Vertex Common Factor*, VCF = GCD(n, J)

Here $n = 60 = 2^2 \cdot 3 \cdot 5$ and $S = 10$, J Varies by Column

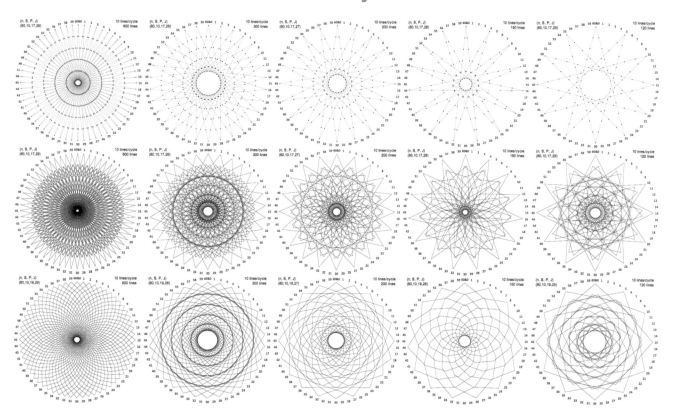

Each column is based on VCF = 1 to 5 from left to right based on **J**, 25 ≤ **J** ≤ 29. The top row shows the *vertex frame* **VF** (see Sections 4.2.1 and 4.2.2) and **subdivision points**, and the next two rows show **P** = 17 and **P** = 19 images. Both **P** produce images with the same number of lines as **subdivision points** since SCF = 1 in each case.

1) *Image Density* here means the number of lines in the image, relative to what is **possible**. Columns 2 to 5 have 1/2 to 1/5 as many lines as 1 since VCF = 2 to 5. But in a more general sense, each is full density because each **subdivision point** on the **VF** is used in the final image (because SCF = 1).

2) Only vertices that are multiples of VCF are used in the **VF**. Indeed, as noted in Section 6.1, the same image occurs if you divide **n** and **J** by VCF in each case.

5.4.2 Image Density: The Role of *Subdivision Common Factor*, SCF = GCD($n \cdot S$/VCF,P)

Here $n = 60$, $S = 10$, and $J = 29$ so VCF = 1

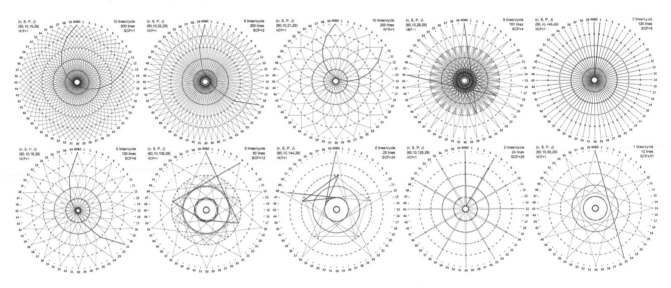

The *Top* left image (*T1*) is the same as the lower left image from Section 5.4.1 with the exception that, for comparison purposes, each image above shows all **600 possible subdivision points as red dots** (also on the upper left **VF** image on 5.4.1) and **60 vertex labels**. Finally, the **first cycle** for each image is shown in **red**.

Recall from 5.4.1 that **Image Density** means the number of lines in the image, relative to what is **possible**. The images shown above vary **P** while holding **n**, **S**, and **J** fixed. **P** values were chosen so that SCF increases from 1 to 5 across the top row. **Image Density** examines what portion of the dots are used in the final image. One can distinguish concentric circles of subdivision points, ◎ (Section 7.1) and vertices of the **n**-gon (columns 4 and 5 in the table). For example, half the dots are used, and hence there are half as many lines in T2 because all vertices are used as are all even subdivision levels (0, 2, and 4), but odd subdivision levels (1, 3, and 5) are excluded. By contrast, T4 uses all even subdivision levels but only half the vertices so that density is ½·½ = 1/4 for T4. Similar comparisons could be made with B1–B3 and between T5 and B4.

Row (T-B) Col. (1-5)	P	SCF	Fraction of subdivision points/Vertices used on: ◎	Vertices of n-gon	Lines per cycle = $S \cdot$) = S/GCD(S,P)	Number of cycles = $n \cdot$ Fraction of Vertices used	Lines = 600/SCF = Lines/cycle· #Cycles
T1	19	1	1	1	10	60	600
T2	22	2	1/2	1	5	60	300
T3	21	3	1	1/3	10	20	200
T4	28	4	1/2	1/2	5	30	150
T5	145	5	1/5	1	2	60	120
B1	18	6	1/2	1/3	5	20	100
B2	108	12	1/2	1/6	5	10	50
B3	144	24	1/2	1/12	5	5	25
B4	125	25	1/5	1/5	2	12	24
B5	50	50	1/10	1/5	1	12	12

It is worth focusing attention on T3 for a moment. This is a *One Level Change* image (as is T1, see Section 7.2). The one-third reduction in density is due entirely to the first cycle ending at vertex 9, which has GCD(9,60) = 3. But this DOES NOT MEAN that you could create this image by adjusting *n* and *J.* For example, the first subdivision endpoint used (the 21st since *P* = 21) is the first subdivision point on the third **VF** line from **58** to **27** (since *S* = 10 and *J* = 29) and uses vertices that are divisible by 2 and 3, but not both.

B5 uses no internal subdivisions (GCD(10,50) = 10), so 1 in 10 points on ◎ is used, 1/50 = 1/10·1/5.

5.4.3 MA. How Image Density Is Distributed Between Concentric Circles of Internal Subdivision Points and Polygonal Vertices

The rows switch *S* and *n* so that *nS* = 210 and *J* produces the sharpest VF star possible: Top row, *n* = 14 = 2·7, *J* = 5, *S* = 15; Bottom row, *n* = 15 = 3·5, *J* = 7, *S* = 14. SCF varies by column from 1 to 2 to 3 to 6 by adjusting 36 ≤ *P* ≤ 39. As noted in Section 5.4.2, Image Density depends on SCF and SCF depends on divisibility of *P* with *n* and *S*, chosen here to have no factors in common with one another to clarify how the interaction occurs. The table summarizes these interactions.

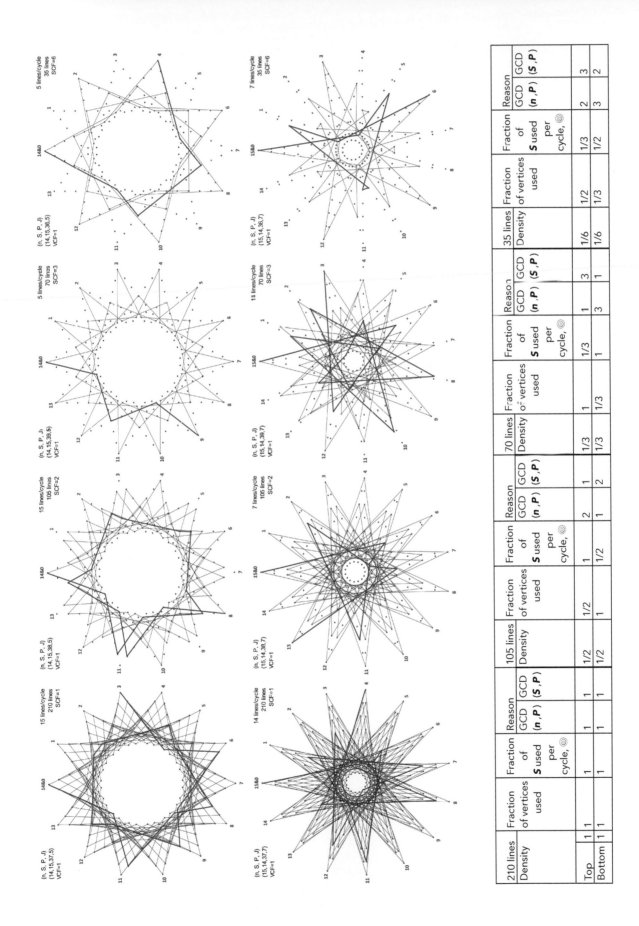

Challenge questions: Without looking at the String Art file, suppose **P** = 77 = 7·11 or **P** = 91 = 7·13. Given (**n**, **S**, **J**) values for the top (14, 15, 5) and bottom (15, 14, 7) rows, consider what the image might look like in each instance. What fraction of vertices and what fraction of **S** is used per cycle in each instance? **FACT:** One of these **n**, **S**, **P**, **J** values is a *Sunburst Polygon* (Section 11.5.1). Can you guess whether **n** = 14 or **n** = 15 in this instance? Check your answers in Chapter 27 or with the file.

5.5 Single-Cycle Images

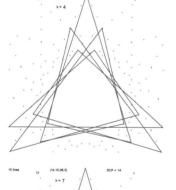

As noted in Section 5.1, each image must have AT LEAST one cycle. This explainer focuses on where there is AT MOST one as well.

At left and right are single-cycle images with **n** and **S** switching between 14 and 15. Single-cycle images are created by setting **P** = **n**. We also require VCF = 1 and GCD(**n**,**S**) = 1.

Additional versions are found when **P** is a multiple of **n**, **P** = **k·n**. Due to the symmetry discussed in Section 4.3, we need only consider multiples **k** ≤ **S**/2. These multiples are noted in the upper **k** = 1 images by the numbers **1** to **7** (the image on the right and the other versions are cropped to save space).

In both images, there are 210 = **nS** possible subdivision points, and both are *One Level Change* images (see Section 7.2) since **S** and **P** differ by only 1. Put another way, both images have full density on concentric circles of subdivision points (denoted ◎ in Section 5.4.1), but vertex usage is 1/**n** since only one vertex is used in the final image.

If you use the small numbers from **1** to **7** in the upper images you can see why the **k** = 2 to 7 versions look like they do (these numbers are the ending point for the first segment of each image).

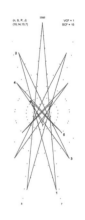
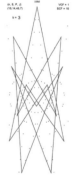

Note in particular that there are five triangles to the left and 14-line "finger traps" to the right because GCD(**k**,**S**) = 1.

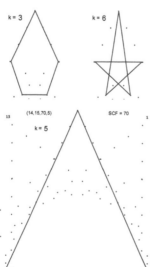

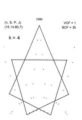

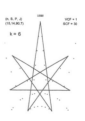

As **k** increases, we maintain full density on concentric circles unless GCD(**k**,**S**) > 1 in which case ◎ density diminishes (by 1/3 for **k** = 3 and 6, and by 1/5 for **k** = 5 to the left (since **S** = 15), and by ½ for **k** = 2, 4, and 6 to the right (since **S** = 14)). The **k** = 7, **P** = 7·15 = 105 version to the right is omitted: it is the vertical line loop from vertex **15&0** to subdivision point 105 to **15&0**.

Chapter 6

Alternative ways to Obtain an Image

6.1 On Finding the Smallest Values of *n*, *S*, *P*, and *J* that Create an Image

To make analysis easier, it is generally worthwhile to adjust parameters so that VCF and SCF are as small as possible and to decrease *J* and *P* so that they are as small as possible. It will not always be possible to have both VCF = 1 and SCF = 1, but it will make understanding how the image was created easier if you follow these suggestions. [Mathematically, VCF = GCD(*n*, *J*) and SCF = GCD(*S*·(*n*/VCF), *P*); see Section 4.1.]

An example: Suppose you want to understand a bit more about the image on the right. This was created by the *Initial* settings of *n* = 15, *S* = 8, *P* = 30, and *J* = 9. You would like to know how this was created.

In this instance, VCF = 3 and SCF = 10, so the first thing to do is to divide *n* and *J* by 3, and *S* and *P* by 2 giving *S* = 4, *P* = 15, *J* = 3, and *n* = 5. The same image emerges, but now VCF = 1 and SCF = 5.

One cannot reduce *n* and *P* by the common factor of 5 without doing damage to the image (*n* = 1 results).

Nonetheless you can obtain the same image by making further adjustments to decrease the size of *J* and *P*.

Let *J* = *n* – 3 = 2 (since then *J* is, clockwise, less than halfway around), and similarly, *P* = *S*·(*n*/VCF) – 15 = 5.

The *Final* version, *n* = 5, *S* = 4, *P* = 5, and *J* = 2 will be easier to count.

To see the difference, compare the two images on the next page. These images include **vertex labels** and **dots**, **subdivision dots**, **vertex frame**, the resulting final image in **black**, and **the first line used to create that image overlaid in red**. Both have the same final image as the one above. Consider how each **first line** was drawn.

Left image. There are **40 subdivision dots**. The **30th subdivision dot** (endpoint of the first segment) is on the **fourth line of the vertex frame** since 30 = 3·8+6. The **first three segments of the vertex frame** go from vertex **0** to **9** to **3** to **12** and the **sixth subdivision point of 8 total** on the **fourth line of the vertex frame** from **12** to vertex **6** is the endpoint of the first segment in the final image.

Right image. There are **20 subdivision dots**. The **fifth subdivision dot** (endpoint of the first segment) is the first subdivision on the second line of the **vertex frame** since 5 = 1*4+1. The first

DOI: 10.1201/9781003402633-8

vertex frame segment goes from vertex **0** to **2**, and the second goes from **2** to **4**. The first **dot** past vertex **2** on the way to vertex **4** is the endpoint of the first segment in the final image.

Both methods produce the same image, but the one on the right is easier to follow and involves much less counting.

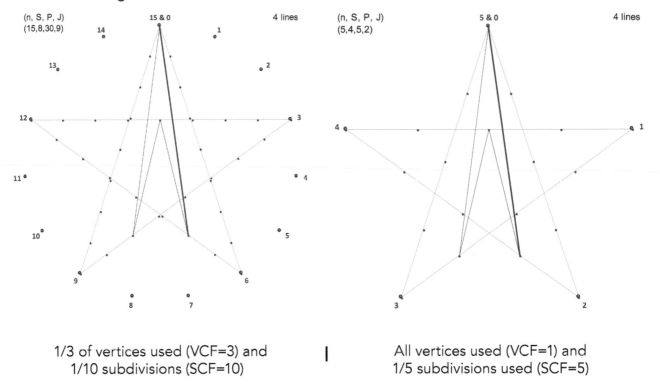

| 1/3 of vertices used (VCF=3) and 1/10 subdivisions (SCF=10) | All vertices used (VCF=1) and 1/5 subdivisions used (SCF=5) |

6.2 There Are Only Two Ways to Draw an Image (but there are four ways to describe it using (*n*, *S*, *P*, *J*))

Suppose you stumble onto an image you like. Section 6.1 argues that a reasonable strategy to understand how the image is made is to look for the smallest numbers for *n*, *S*, *P*, and *J* that produce the image. This can be accomplished by simplifying the vertex frame and by reducing the size of *P* and *S*.

Simplifying the vertex frame. First, we restrict ourselves to *J* < *n* because *J* > *n* simply means counting more than once around the polygon before finding the next vertex to jump to on the vertex frame. Second, we remove common factors from *J* and *n* so that VCF = GCD(*J*, *n*) = 1. And finally, by choosing *J* < *n*/2, the vertex frame is drawn in a clockwise fashion.

Reducing the size of *P* and *S*. First, note that if *P* > *S*·*n* you can get the same image by subtracting as many multiples of *S*·*n* as you need to from *P* in order to have *P* < *S*·*n*. The reason is simple: There are *S*·*n* subdivisions total so why count more times around than necessary before finding the endpoint for the next line in the image? Second, the simplest way to reduce *S* and *P* is to make sure they have no common factor among them. If there is a common factor, then divide both by that factor until GCD(*S*, *P*) = 1. Additionally, note that $P = P_0$ and $P = S·n - P_0$ produce the same image. As a result, we can choose the one that is smaller than *S*·*n*/2.

The strategy outlined above produces the values listed for this *Spinning Needle Star*. Spinning needle stars are discussed in detail in Sections 11.8.1 and 11.8.2. The web version of this image is available using the QR code on the *Features* page at the front of this book.:

$$(28,21,136,13).$$

(n, S, P, J)
(28,21,136,13)

147 lines

The first cycle of this image is shown in **red**. With the cycle information shown it is quite clear, even without using the web version *Drawing Mode*, that this spinning star is created in seven clockwise cycles around the polygon. Every fourth vertex is part of the image, but the other vertices help create the spiky image. This happens because SCF = 4.

Suppose we were contrarians who wanted to have the SAME image spin in a counter-clockwise direction if we use the *Drawing Mode*. We could accomplish this in two ways.

1. Replacing J with $n\text{-}J$ gives (28,21,136,15).
2. Replacing P with $S\text{·}n\text{-}P$ gives (28,21,452,13).

The question naturally arises: *What if you do both?* In that instance, the image is once again drawn clockwise, just like above: (28,21,452,15). More generally, if $J_0 < n_0$, $P_0 < n_0\text{·}S_0$, and VCF = 1, then (n_0, S_0, P_0, J_0),

$(n_0, S_0, P_0, n_0\text{-}J_0)$,

$(n_0, S_0, n_0\text{·}S_0\text{-}P_0, J_0)$, and

$(n_0, S_0, n_0\text{·}S_0\text{-}P_0, n_0\text{-}J_0)$ all produce the same image.

The middle two are drawn one way and the first and last are drawn the other.

Notice that the top vertex is always attached to the image by two lines, one going out (the first line) and the other coming in (the last line). This is the reason WHY there are two ways to describe how this image is drawn even though four (n, S, P, J) values produce the same static image.

The only thing that you need to change if VCF > 1 is that the total possible subdivision dots, $n_0\text{·}S_0$, must be replaced by $n_0\text{·}S_0$/VCF.

6.3.1 A Primer on Vertical Symmetry

String art images in Part II always exhibit vertical symmetry because the vertex frame (VF) is a regular star or polygon and, as such, has vertical symmetry. [This image was chosen with large enough n, S, P, and J that you should not worry about counting the numbers involved. The link below reveals these values.]

As noted in Section 4.1, there are a total of $v_{used} = n/VCF$ lines in the VF. Call these lines $1, 2, \ldots, v_{used}-1, v_{used}$. Each line has S subdivisions so there are $T = S \cdot v_{used}$ subdivisions. Consider the first and last line of the VF.

1. The first line of the VF goes from vertex $n\&0$ to vertex J.

v_{used}. The last line of the VF goes from vertex $n-J$ to vertex $n\&0$.

Reason. Because the VF is a complete continuously-drawn star, the end of the last line in the VF is the vertex $n\&0$. Each line in the VF spans J vertices so the start of that line must have started at vertex $n-J$ as shown in Figure 1.

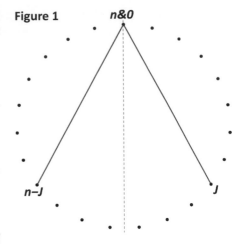

Figure 1

These lines are mirror images of one another through **the dashed blue vertical line** from the top vertex through the center of the polygon. That is, these lines exhibit *vertical symmetry*.

Both lines have S subdivisions, and the start of the first is the end of the last, as both are at the top vertex as shown in Figure 2. Because each VF line spans the same number of vertices, both are the same size, and therefore subdivisions are the same size on each line of the VF.

The end of the first segment (at **1**) and the start of the T^{th} segment (at $T-1$) are at the same location on their respective lines.

This same sameness occurs for other subdivision segments on the first VF line with the end of the S^{th} being at vertex J, just at the start of the $T-S^{th}$ segment at vertex $n-J$ in Figures 1 and 2.

Put another way, these subdivisions exhibit vertical symmetry as well.

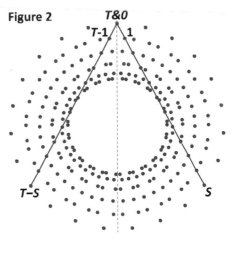

Figure 2

The same positioning is true for other VF segments and for the subdivisions on each segment on these lines on the second through $v_{used}{}^{th}$ line. All VF lines and subdivision segments exhibit vertical symmetry.

Given this symmetry, the P^{th} subdivision endpoint and the start of the $T-P^{th}$ starting point are symmetric across the vertical line as shown in Figure 3. For ease of exposition, this shows $P = S+1$.

The image to the left is the result of continuing this process of drawing lines every P^{th} subdivision. This image would be the same whether the first line is at P or $T-P$.

To see this 253-line image get drawn, use the *Fixed Count Line Drawing* option in *Drawing Mode* and adjust the *Drawing Speed* to suit your preferences.

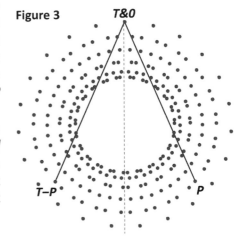

Figure 3

6.3.2 A Slick Way to Verify Symmetry of *J* and *n-J* (using Excel file, 10.0.1)

The same static string art image occurs with *J* and *n-J*, the only difference is the direction in which the image is drawn (see Sections 6.1 and 6.2). As a result, we typically focus on *J* < *n*/2 with VCF = 1. If *P* = 2 and *n* and *S* are odd, the image is created in two "halves," the even subdivisions and the odd subdivisions. Each half has (*nS*-1)/2 segments, and the final segment is the midway connection between subdivision *nS*-1 and **1**. You can show the even half of the image by setting *J* < *n*/2 with First *r* lines clicked on in B10 *r* in C12 set to the value given by (*nS*-1)/2. (These restrictions ensure that SCF = 1 and provide all even vertices are connected in successive order.) To see the odd half, replace *J* by *n-J*.

The first image is **VF** and **numbered subdivisions**. The **second** highlights the **even half**, and the **third** highlights the **odd half**.

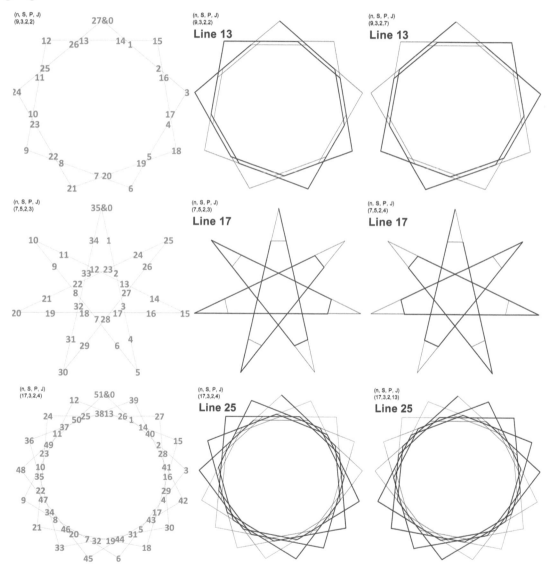

One line is missing from **2ⁿᵈ+3ʳᵈ** column (the horizontal line from *nS*-1 to **1** or 26 to **1**, 34 to **1**, and **50** to **1** for top, middle, and bottom). This trick works for other *n*, *S*, *P*, *J* values: Set *r* ≤ INT(Lines/2) = INT(M3/2).

6.4.1 Rotational Symmetry Versus Lines of Symmetry

Images in the string art model in Part II of this book exhibit vertical symmetry as noted in Section 6.3.1. This means that one could imagine cutting an image in half along the vertical line through the top and the center, and then placing this half against a mirror at a right angle to the mirror. The half image plus its reflective half together create the original image (once you adjust your viewing angle to 45°).

We also know from Section 5.1 that the first cycle tells us the essential character of the image: The completed image is simply rotated versions of this cycle. As noted there, there are $C = S/GCD(S,P)$ lines per cycle and $M = Lines/C$ cycles in the final image (*Lines*, *C* and *M* are noted in cells M3, M9, and M11 in the Excel file). The number of rotations is the same as the number of vertices used in the final image (which is also the same as the number of cycles in the image, *M*).

The number of cycles determines the number of lines of symmetry. We know that the initial image has vertical symmetry. But when the number of cycles in the image *M* > 1, then there is a line of symmetry through each used vertex and the center. The reason we can say this is because we know that by rotating the image by 360°/*M* we have the same image, and if we rotate another 360°/*M* we have the same image, and so on. The number of vertices *between* used vertices is *n*/*M* (at right, 12/4 = 3, every third vertex is used). It is worth considering even versus odd *M* values separately.

Odd M. To take a very simple example, set *S* = *P* = 1, and consider a 10,4-star versus a 5,2-star. Both are created in five one-line cycles so *M* = 5, and the same image occurs each time the image is rotated 360°/5 = 72°. There are five lines of symmetry because one can draw distinct lines through each used vertex and the center, whether or not it touches a vertex on the other side of the circle. For example, the five lines of symmetry in the 5,2-star go through the vertices 0–4 and the midpoint between the two opposing vertices: 0–2.5, 1–3.5, 2–4.5, 3–0.5, and 4–1.5. Of course, the 10,4-star has even used vertices with lines of symmetry just double each of the lines noted in the prior sentence: 0–5, 2–7, 4–9, 6–1, and 8–3 since VCF = 2. Either way, it is clear that there are *M* distinct lines of symmetry when *M* is odd.

Even M. When *M* is even, you have to be a bit more careful. First, if *M* is even, then *n* must be even as well because *M* is a proper divisor of *n*. If *n* is even, and *M* is even, then *n*/2, halfway around the circle opposite *n*&0 is also a used vertex. But its line of symmetry is THE SAME AS the vertical line of symmetry. And if *M* = 4, then the line of symmetry through *n*/4 and 3*n*/4 also coincide. The image to the right shows lines of symmetry from **0** to **6** and **3** to **9**.

More generally, let *M* = 2*k*. Then 0 and *k*, 1 and *k*+1, ..., *k*-1, and 2*k*-1 are all pairs of lines sharing the same line of symmetry. *k* such lines exist (from 0 to *k*-1), so you might think that there are half as many lines of symmetry. But this ignores the other half of the lines of symmetry when *M* is even. The lines from ½ to *k*+½, 3/2 to *k*+3/2, ..., *k*-½ to 2*k*-½ are also lines of symmetry. There are *k* such lines **at the halves**. To use the image on the right, the lines from **1.5** to **7.5** and **4.5** to **10.5** are lines of symmetry. In total, there are *M* lines of symmetry whether *M* is even or odd.

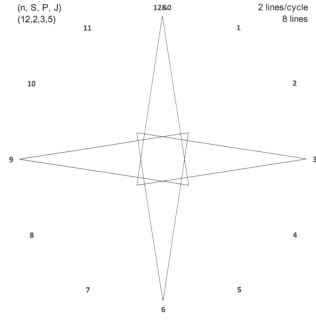

(n, S, P, J)
(12,2,3,5)

12&0

2 lines/cycle
8 lines

When are lines perpendicular to lines of symmetry symmetric? This is true when **M** is even, but not when **M** is odd.

A hint of things to come: Multiple jump sets. The image to the left does NOT have vertical symmetry, nor is there symmetry through any other line. But it does have rotational symmetry. If you flip the image over, you get the same image. Single jump pattern string art images exhibit both rotational and line symmetry, but multiple jump-set models may well exhibit rotational symmetry without linear symmetry. We do not want to focus too much on multiple jump-set models here, but a simple example will show the difference. The four-color image from Chapter 17 was created from **n** = 12, so we can do some clock arithmetic (so we use **12** here rather than **12&0** or **0**). Consider the following three-jump-set pattern: 7, 5, 6. The six-line VF of the final image is **12-7-12-6-1-6-12**. Four of the 12-gon's vertices are used in creating this image, but note that vertices **7** and **1** are only used once but vertex **6** is used twice. The resulting image has 180° rotational symmetry but there is NO line of symmetry.

6.4.2 Lines of Symmetry, Take 2

Both images were created by superimposing a **black regular polygon** on a **red irregular polygon** (black polygonal vertices are suppressed to avoid confusion). Regular polygons have equal sides and angles (the black hexagon angles are 120° and the black triangle angles are 60°). Both red polygons are irregular because the angles at each vertex are not all the same. Visual observation confirms that the red's angle at **a** in both images is smaller than their regular counterparts. Red's angle at **d** in the hexagon is identical to **a** (each is constructed 2/3 of the way along the second line from the vertex point). By contrast, red's hexagonal angles at the other four vertices (**b**, **c**, **e**, and **f**) are the same as one another and are larger than 120°, and red's triangular angles at **b** and **c** are the same as one another and are larger than 60°.

Claim: *A line of symmetry (**LOS**) maps lines to lines and angles to angles.* This leads to the following conclusions.

Black. **6 LOS**; **3** are vertex to vertex, **3** are midpoint to midpoint.

3 LOS; One each from vertex to the opposing midpoint.

Red. **2 LOS**; one vertical, **a** to **d**; one horizontal, **2.5** to **7.5**.

One **LOS** from **a** to the midpoint of segment **bc** (point **3.5**).

(In the **Red** hexagonal image, **be** is not a **LOS** because **a** ≠ **c** and midpoint **ab** to midpoint **de** is not a **LOS** because **a** ≠ **b**.)

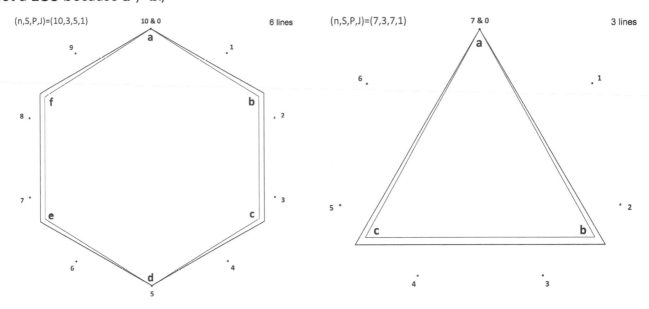

The red points used above (**2.5**, **3.5**, **7.5**) are midpoints between vertices. These midpoints allow us to create lines of symmetry without resorting to doubling **J** and **n**. Lines of symmetry <u>may</u> exist between the following pairs of points:

(a) vertex **k** and **n/2** + **k** and (b) **k** + 1/2 to (**n**+1)/2 + **k** for 0 ≤ **k** < **n/2**.

> If **n** is odd, the second point in (a) is a midpoint between vertices, but the first point in (b) is a midpoint.
> If **n** is even, both points in (a) are vertices, and both points in (b) are midpoints between vertices.

These lines may not be lines of symmetry, but all lines of symmetry must satisfy one of these two conditions.

The image on the right has four lines of symmetry: **0** to **2**; **0.5** to **2.5**; **1** to **3**; and **1.5** to **3.5**. The first and third are (a), and the second and fourth are (b).

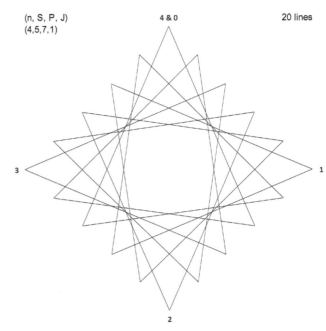

Chapter 7

Levels of Subdivision Points

7.1 Subdivisions Create **Concentric Circles** of Possible Points

One of the things that happens when subdivisions are created between vertices is that these subdivisions create concentric circles of <u>interior</u> points. If $S > 1$, then S is either even or odd and therefore can be written as either $S = 2k$ or $S = 2k+1$. This formal way of talking about even and odd is done to highlight k, the number of concentric circles and levels from Level 1 to Level k. Consider $k = 1$ (and $S = 2$ or 3). There is a single internal circle in this instance. But $S = 4$ or 5 produces $k = 2$ levels of concentric circles. The concentric circles come from the symmetry about the midpoint of any vertex frame line. Points that have the same number of subdivisions from an end are equidistant from the circle's center.

Take $S = 4$. The first (subdivision) point and the third point $(3 = 4 - 1)$ are at the same distance from the center of the circle on Level 1, and the second point (which is also the midpoint) is closer to the center than points 1 and 3.

Take $S = 5$. The first (subdivision) point and the fourth point $(4 = 5 - 1)$ are at the same distance from the center of the circle on Level 1, and the second and third points $(3 = 5 - 2)$ are at the same distance from the center of the circle but are closer to the center than points 1 and 4 on Level 2.

These concentric circles are easiest to see if there are a large number of vertices (large n) and if the number of jumps between vertices is larger than one or two. That way you see more interior points, and those points are more separated from one another rather than being packed tightly together near the outer edge of the image (since the midpoints become closer to the center). In order to distinguish between points on different interior circles, one should not choose J too close to the center. The two images show this point. Each image highlights the first line of the vertex frame.

Both images have the <u>**same** vertex frame (in light blue)</u> with the first line of VF shown in **red** since $n = 19$ and $J = 8$ for both images. And both have four concentric interior circles ($k = 4$ when $S = 2k = 8$ or $S = 2k+1 = 9$). However, it is worth noting that those circles are not the same for two reasons:

1) **Even S**: When S is even, $S = 2k$, and all but the smallest interior circle has $2n$ points (38 here). The smallest interior circle, Level 4, has only n points (19 here). In this instance, k is the (single) midpoint on the smallest circle (4 here).
 Odd S: When S is odd, $S = 2k+1$, and <u>all</u> interior circles have $2n$ points (38 here). In this instance, the smallest interior circle, Level 4, has subdivision points k and $k+1$ equidistant from the center.

DOI: 10.1201/9781003402633-9

2) The interior circles are a bit larger when **S** = 9 than when **S** = 8. Note that the even version's innermost level is as close as possible given the vertex frame (given the single closest subdivision is at a VF line midpoint).

S = 8 (as an example of even *n*) **Both images have 4 concentric circles of dots.** *S* = 9 (as an example of odd *n*)

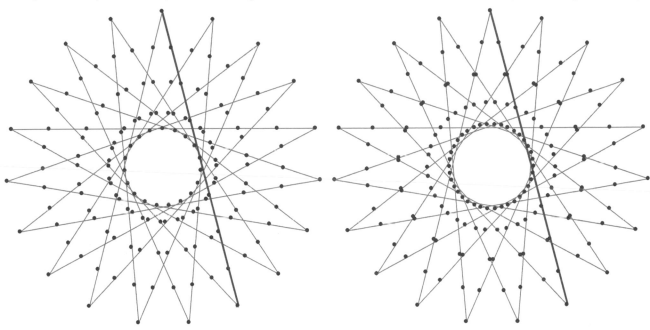

7.2 *One Level Change* Images

As you play around with the file you will inevitably come across images that are smaller than you would expect—they do not seem to use the bottom half of the vertex frame. For example, in the top image to the right, (**n,S,P,J**) = (19,6,19,6), and in the bottom image to the right, (**n,S,P,J**) = (19,7,19,7); both take up only about the top quarter of a normal image. The first segment endpoint is noted in each image.

Both images were created by setting **S** = **J** and **P** = **n** with the additional restriction that **S** < **n**/2. The resulting images have **S** segments. Once **S** > **n**/2, the images include the center of the circle. The first is a *One Level Change* image but the second is not.

Such images are very useful for showing off concentric interior circles of points. Given **S** = 6 and **S** = 7, three levels of points are expected, and three can be seen, even without subdivisions showing on each image. In the top image: Points 1 and 5 are at Level 1; points 2 and 4 are at Level 2; and Point 3 is at Level 3. In the bottom image: Points 1 and 6 are at Level 2; points 2 and 5 are at Level 3; and points 3 and 4 are at Level 1.

One Level Change images. These examples are useful for pointing out a specific kind of image, one that steps up or down by a single level each time a new point is added to the image. There are many forms that these images take, but they

have one thing in common: They move in and out one level at a time. Images that move in and out one level at a time must have the following relation between P and S:

 The *One Level Change* criterion: $P = a \cdot S \pm 1$ where a is a whole number.

In other words, P must be one larger or one smaller than a multiple of S. The upper image satisfies this criterion ($19 = 3 \cdot 6 + 1$), but the bottom image does not ($19 = 2 \cdot 7 + 5$, and 5 is 2 subdivisions from a vertex end given $S = 7$, so Point 1 is Level 2).
 Consider the location on the vertex frame of the first couple of points given $P = a \cdot S \pm 1$:

Point 1 is within a single subdivision of a vertex frame endpoint (since all vertices are multiples of S). This is a point at Level 1 as discussed in Section 7.1.
Point 2 is at subdivision $2P = 2(a \cdot S \pm 1) = 2a \cdot S \pm 2$, two points away from a vertex frame endpoint. This is at Level 2.

Subsequent points work in the same way. They move one level at a time, first in, then out. An annotated version of the upper right image from the previous page is included on the next page showing the placement of points 1, 2, and 3 on the vertex frame.
 The only time when the level does not change is when the innermost level is achieved and S is odd. The image to the left changes $P = n$ to 20 given $S = J = 7$. The criterion is once again satisfied, ($20 = 3 \cdot 7 - 1$). The image is now drawn in a clockwise direction around the seven segments (but if you change $P = n$ to 22 the reverse will occur). Notice that the third and fourth image points are both at Level 3 in this instance.
 One Level Change images need not be small images like those used above to introduce this idea (read more about *Small Images* in Section 12.4). Here are some other examples:

Even Porcupine polygons	(8,21,83,1)	See Section 11.3 (and note this is not true for *odd PPs*)
Quivering polygons	(119,120,119,40)	See Section 11.6
Stacked circles	(41,12,119,20)	See Section 11.10
Chrysanthemums	(41,12,23,20)	See Section 11.11

The first two examples show that *One Level Change* images are harder to see when lines cross back and forth (from top to bottom or side to side), but they can be seen in the way that the image fills in. Consider how the bottom right and top left points are filled in in the (8,21,83,1) Even Porcupine image (from vertices 4 to 3 and 8&0 to 7). From vertices 4 to 3, the level pattern is Level 1, 3, 5, 7, 9, 10, 8, 6, 4, 2, 0. (If you wonder why the middle is at Level 10 rather than 11 it is that $10 = S - 11 = 21 - 11$.) As this is happening, the level pattern from 8&0 to 7 is Level 2, 4, 6, 8, 10, 9, 7, 5, 3, 1. Every other level is filled in in both places. The rest are filled in in the second pass-through. *One Level Change* images are easier to see when points are close to one another (as with the last two examples). It is worth noting that the last two examples only differ by P.
 The image on the next page shows the location of the first three points on their respective parts of the vertex frame. Each part has six subdivisions. Additional portions of the vertex frame are excluded to draw attention to how the image was formed.

Point 1 is the **first** subdivision on the fourth line of the vertex frame, $19 = 3 \cdot 6 + 1$. The first three jumps on the vertex frame are from **0** to **6** to **12** to **18**. **The fourth line of the vertex frame is 18 to 5, in blue.**

Point 2 is the **second** subdivision on the seventh line in the vertex frame, 2·19 = 38 = 2·(3·6 + 1) = 6·6 + 2. The fifth and sixth jumps on the vertex frame are from **5** to **11** to **17**. **The seventh line on the vertex frame is from 17 to 4, in red.**

Point 3 is the third subdivision on the tenth line in the vertex frame, 3·19 = 57 = 3·(3·6 + 1) = 9·6 + 3. The eighth and ninth jumps on the vertex frame are from **4** to **10** to **16**. The tenth line on the vertex frame is from **16** to **3**, in green.

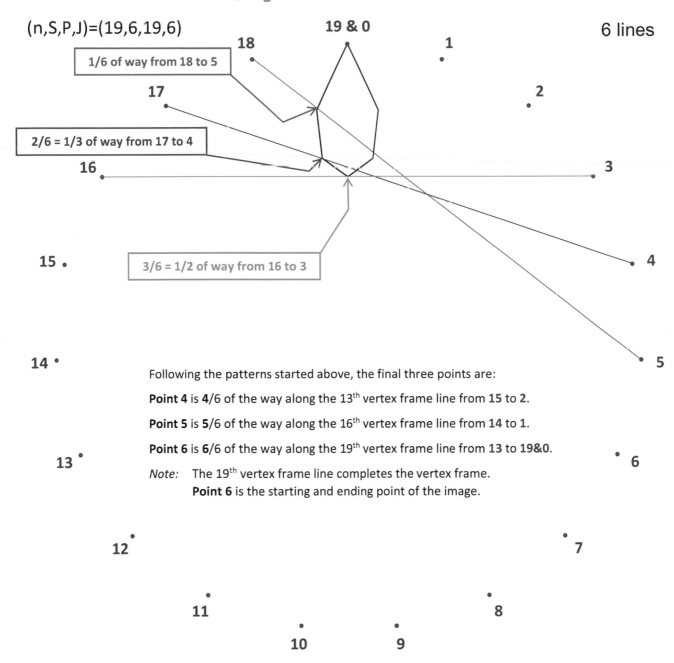

(n,S,P,J)=(19,6,19,6) 19 & 0 6 lines

1/6 of way from 18 to 5

2/6 = 1/3 of way from 17 to 4

3/6 = 1/2 of way from 16 to 3

Following the patterns started above, the final three points are:

Point 4 is **4/6** of the way along the 13th vertex frame line from **15** to **2**.

Point 5 is **5/6** of the way along the 16th vertex frame line from **14** to **1**.

Point 6 is **6/6** of the way along the 19th vertex frame line from **13** to **19&0**.

Note: The 19th vertex frame line completes the vertex frame.
Point 6 is the starting and ending point of the image.

7.3 Level Patterns Across a Cycle

One Level Change images move in and out, one level at a time, but need not look smooth as Section 7.2 discusses. For example, this 30 rotating hearts (30,21,293,13) image appears quite smooth but changes **n** from 30 to 28, and the image is a jagged starburst. In both instances, **F** = 1 where **F** is the level of the image's first endpoint. [**MA.** $F=\text{MIN}(\text{MOD}(P,S), S-\text{MOD}(P,S))$.]

When **F** > 1, the movements from point to point in terms of level are, in general, larger. The pattern of movement between levels depends on levels available and the initial remainder, **r**. The level of the first subdivision endpoint is based on the remainder when **P** is divided by **S**. This remainder is described using the MOD function so that this would be described as **r** = MOD(**P, S**). The level of the first endpoint, **F**, is given by the minimum of **r** and **S - r**. The level of the k^{th} subdivision endpoint is based on the remainder once **k·P** is divided by **S** in the same fashion.

An example. The image (**n,S,P,J**) = (10,5,8,3) is shown to the right with the first cycle noted with the numbers 1–5. Note that half of the subdivisions are not part of the final image, SCF = 2. Since **S** = 5, there are two levels of concentric circles of subdivision points in addition to polygonal vertices.

1. The first point is at Level 2 since the first point is the third subdivision endpoint on the second line of the vertex frame, **3** = MOD(8, 5) because 8 = 1·5 + **3**.

2. The second point is at Level 1 since **1** = MOD(2·8, 5), the first endpoint on the fourth line, 16 = 3·5 + **1**.

3. The third point is also at Level 1 since **4** = MOD(3·8, 5), the fourth endpoint on the fifth line, 24 = 4·5 + **4**.

4. The fourth point is at Level 2 since **2** = MOD(4·8, 5), the second endpoint on the seventh line, 32 = 6·5 + **2**.

5. The fifth point is at Level 0 since 0 = MOD(5·8, 5), the endpoint of the eighth line at polygon vertex 4.

It is worth noting that this same level pattern (2, 1, 1, 2, 0) would occur for any **P**

MOD (P,S)=	0	1	2	3	4	5	6	7	8	9	10	11	12	13	14	15	16	17	18	19	20	0
1 F	0	1	2	3	4	5	6	7	8	9	10	10	9	8	7	6	5	4	3	2	1	0
2	0	2	4	6	8	10	9	7	5	3	1	1	3	5	7	9	10	8	6	4	2	0
3	0	3	6	9	9	6	3	0	3	6	9	9	6	3	0	3	6	9	9	6	3	0
4	0	4	8	9	5	1	3	7	10	6	2	2	6	10	7	3	1	5	9	8	4	0
5	0	5	10	6	1	4	9	7	2	3	8	8	3	2	7	9	4	1	6	10	5	0
6	0	6	9	3	3	9	6	0	6	9	3	3	9	6	0	6	9	3	3	9	6	0
7	0	7	7	0	7	7	0	7	7	0	7	7	0	7	7	0	7	7	0	7	7	0
8	0	8	5	3	10	2	6	7	1	9	4	4	9	1	7	6	2	10	3	5	8	0
9	0	9	3	6	6	3	9	0	9	3	6	6	3	9	0	9	3	6	6	3	9	0
10	0	10	1	9	2	8	3	7	4	6	5	5	6	4	7	3	8	2	9	1	10	0
11	0	10	1	9	2	8	3	7	4	6	5	5	6	4	7	3	8	2	9	1	10	0
12	0	9	3	6	6	3	9	0	9	3	6	6	3	9	0	9	3	6	6	3	9	0
13	0	8	5	3	10	2	6	7	1	9	4	4	9	1	7	6	2	10	3	5	8	0
14	0	7	7	0	7	7	0	7	7	0	7	7	0	7	7	0	7	7	0	7	7	0
15	0	6	9	3	3	9	6	0	6	9	3	3	9	6	0	6	9	3	3	9	6	0
16	0	5	10	6	1	4	9	7	2	3	8	8	3	2	7	9	4	1	6	10	5	0
17	0	4	8	9	5	1	3	7	10	6	2	2	6	10	7	3	1	5	9	8	4	0
18	0	3	6	9	9	6	3	0	3	6	9	9	6	3	0	3	6	9	9	6	3	0
19	0	2	4	6	8	10	9	7	5	3	1	1	3	5	7	9	10	8	6	4	2	0
20	0	1	2	3	4	5	6	7	8	9	10	10	9	8	7	6	5	4	3	2	1	0
21	0	0	0	0	0	0	0	0	0	0	0	0	0	0	0	0	0	0	0	0	0	0

which has a remainder of 2 or 3 when divided by 5. This is the reason why the level pattern in an image only depends on the first level, **F**. The level pattern can be found for any **S** and **P** (and hence **F** = MOD(**P**, **S**)). This table shows the level patterns given are **S** = 21. The top row shows **r**, and subsequent rows show level by line number. Note the following:

- There is symmetry of **F** between remainders above and below **S**/2.
- Only MOD(**S**,**P**) = 1 or **S**-1 changes by 1 per line.
- Maximum level changes start with **F** = 10.
- Some initial remainders have **C** < 21. In particular, remainders divisible by 3 have **C** = 7, and remainders divisible by 7 have **C** = 3. This is true whenever **S** is a composite number.

The *Excel* file 7.0 allows you to examine level patterns for any **S** < 22.
This (12,13,46,5) image has **F** = 6 and is a maximum level change (as noted in M28 and M29 in the equations column of *Excel* file 3.0.2). This image is like the *ultra-needles* discussed in Section 11.9.

7.4 Symmetry Across a Cycle

One of the points made in Section 7.3 was that the level changes are symmetric about **S**/2. A closer look suggests that level changes are symmetric about **C**/2 where **C** is the number of lines in a cycle (recall from Section 5.1, **C** = **S**/GCD(**S**,**P**)). The vertical symmetry discussed in Section 6.3.1 is based on noting that the end of the last cycle looks like the start of the first cycle, and so forth, for the second line and the second to last line. Putting these ideas together we see that a cycle is symmetric about its midpoint. This symmetry extends beyond the symmetry of levels; it can be described in terms of a line of symmetry that must always exist in the cycle. That line of symmetry is from the point **E**/2 to (**n**+**E**)/2 where **E** is the end of the first cycle (Section 5.2). This **line of symmetry** is overlaid on the **first cycle** in each image below.

All images share a common **P** = 137 and **J** = 13; **n** varies by row and **S** varies by column. Since **P** is prime, **C** = **S**.

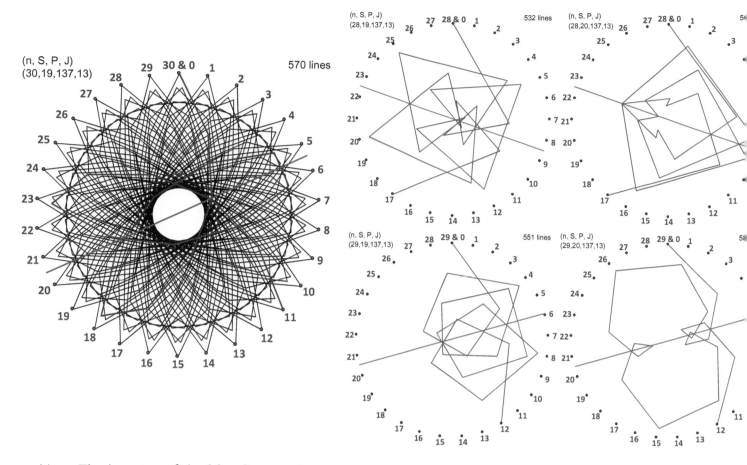

Note: The location of the **blue line** on the previous page varies by row but not column because *E* depends on *n* but not *S* when *C = S*.

Even versus odd cycles. The middle column on the previous page shows what happens when there is an even number of lines in the cycle. Notice that the **blue line** intersects at least one subdivision endpoint that is used to create the cycle. This is the end of line *C*/2 (as noted above, *C = S* since *P* is prime). By contrast, one can clearly see that the **blue line** is perpendicular to the middle line of the cycle when *C* is odd. This follows from the symmetry of levels across a cycle. When *C* is even, there is a single time that level is used, but when *C* is odd, that level is seen twice in a row. *These middle lines can be used to create internal circles.*

The image to the left, with *n* = 30 but sharing *S*, *P*, and *J* with the left column from the previous page, is provided to drive home this point. The image is shown with the **first cycle in red**. Note the dark circle created by the midpoint lines. These lines are at Level 2, just as they were when *n* = 28 and 29. By contrast, the midpoint level for the right two images on the previous page is 5.

Chapter 8

Shape-Shifting Polygons

8.1 *Shape-Shifting* Polygons

When **n** was just under or just over a multiple of **J**, we saw *Rotating Polygons* in Section 2.5. These "polygons" maintained their shape as they rotated about the vertices of the parent polygon.

After incorporating subdivisions and points, we obtain similar results when the number of lines **L** = **S·n** (assuming VCF and SCF are both 1), is just under or just over a multiple of **P**. We can visualize the problem in the opposite direction: For fixed **S** and **n**, find **P** that is close to a common fraction of **S·n**. By working with a prime polygon such as **n** = 19, we can eliminate VCF > 1 issues. Using **S** = 21 provides a nice solution because **S·n** = 399. (As an aside, note that this is the difference between two squares, 20 and 1, 21·19 = (20+1)·(20-1) = 20^2 - 1^2 = 400 - 1 = 399.) In this instance, we will need to adjust **P** so that **P** is not divisible by 3 or 7. (As a second aside, had we used 29·31 we would have had no such issues since both are prime. The difficulty here is that the images have more than twice as many lines (899) and are a bit too dense to copy and paste.) **Note:** **J** was not present in the above calculations, so this same attribute holds as **J** changes.

Consider **P** = 100, which leads to **S·n** being just under 4**P**. Quadrangles should result. And indeed, they do. The square in the **J** = 1 version can be seen once you use *Drawing Mode* setting *Drawn Lines* to the size of the polygon (as will be the case for the rest of these images). This (19,21,100,1) image looks almost the same as its rotating polygon cousin from Section 2.5. The only difference is that there is a bit of "wiggle" in the square (that is not visible) because only 19 of the star's 399 vertices are polygonal vertices, and the rest are on the line segments between polygonal vertices. This produces a faint almost-19,5-star versus this Section 2.5 **n** = 399, **J** = 100, an image in which the square rotates smoothly 100 times.

The "square" in the **J** = 3 version bounces around a bit more noticeably, but still maintains the appearance of having equal sides and right angles as witnessed by this (19,21,100,3) example.

However, the quadrilateral in the **J** = 5 version begins to show the *shape-shifting* attribute induced by **S** and **P**. To see this, increase **J** from 3 to 5 in the above link. Some sides are clearly longer than others, and the angles are obviously not right angles anymore. This same thing happens for **J** = 7, which, from a stylistic drawing perspective, is similar to **J** = 5 (just as **J** = 1 and **J** = 3 are similar).

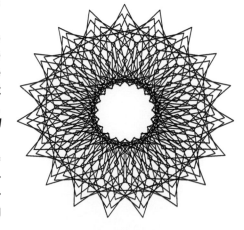

The most interesting quadrangle versions may well be **J** = 8 and 9. The **J** = 8 version, shown to the right, maintains the convex quadrangle images like **J** = 5 and 7, but now the quadrangles are smaller, and they rotate around the perimeter excluding

DOI: 10.1201/9781003402633-10

the center. Each 21-line cycle includes 5.25 quadrangles (21 = 5·4+1). Each cycle spans two polygonal vertices so this is drawn as a *twice-around image*. The nine cycles in the "first-time-around" end in even vertices, and the ten cycles in the "second-time-around" end in odd vertices. Click *Drawing Mode, Fixed Count Line Drawing* to see this cyclical behavior.

The quadrangles in the **J** = 9 **version** are no longer convex; they now resemble arrowheads. The outward pointing peak is reasonably fixed in size, but the base vertex (which creates the nonconvexity) undulates from side to side. Use *Drawing Mode* to see this happen.

We have thus far ignored the **J** = 2, 4, and 6 images. Each has a 21-segment cycle, just like other **S** = 21 images. **J** = 2 and **J** = 6 both involve successive line segment movements across the center of the image which makes following the individual jump structure hard to see (**J** = 2 appears similar to a Porcupine Polygon but it is not). By contrast, the five quadrangles in each **J** = 4 cycle are very easy to see, they are like the lights on a string of Christmas lights.

The shape-shifting images above are based on just changing **J** for fixed **n**, **S**, and **P**. This link (30,29,217,13) is a very nice shape-shifting image based on different **n**, **S**, and **P**. Without looking at the image, do you know what type of polygon is likely to be shape-shifted here? Put in terms of the discussion at the start of the section, what is **L**? Set *Drawn Lines* = **L**.

Challenge Question: Construct shape-shifting triangles for **n** = 17 and **S** = 19. What is **P** and what happens as **J** changes?

8.2 Role of *J* in *Shape-Shifting Polygons*

Compare the First cycle from *J* = 1 with *J* = 2 for *n* = *S* = 5, *P* = (*n·S*-1)/3 = (25-1)/3 = 8.

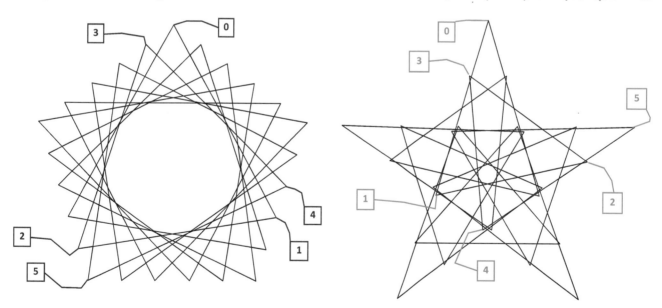

The above images show the first **S** = 5 length cycle (from polygonal vertex to polygonal vertex) for two images, both of which are created with 25 lines (**n·S** = 25). Both images have five cycles. All points in each first cycle are noted. Both images are *shape-shifting* triangles. The first cycle ends at vertex 3 on the left so subsequent cycles end at pentagon vertices 1, 4, and 2, with the final cycle ending at 5&0. The right is a *clockwise-one-time-around image* (the first cycle ends at vertex 1).

Both cycles have about "two triangles" since $S = 5 = 2 \cdot 3 - 1$. As J increases (from left image to right image), the *shape-shifting* attribute becomes more acute. The best way to see this is to watch as lines are added to create each image. To see the image emerge, use *Drawing Mode* after connecting to the link above:

The left image subdivision endpoints in the first cycle are successive points on three lines of the vertex frame. The points denoted **0** and **3** are on the fifth vertex frame line from vertex 4 to 5&0. Points denoted **1** and **4** are on the second vertex frame line from vertex 1 to 2. Points denoted **2** and **5** are on the fourth vertex frame line from vertex 3 to 4. The triangles appear to rotate counter-clockwise since the triangles are *large* and **3** is to the left of **0**.

The right image subdivision endpoints in the first cycle are successive points on three lines of the vertex frame. The points denoted **0** and **3** are on the fifth vertex frame line from vertex 3 to 5&0. Points denoted **1** and **4** are on the second vertex frame line from vertex 2 to 4. Points denoted **2** and **5** are on the fourth vertex frame line from vertex 1 to 3. Individual triangles are smaller and rotate counter-clockwise, but the image is filled in as a *clockwise-one-time-around image* since the first cycle ends at 1 as noted above, see Section 5.2.

8.3.1 Switching *S* and *n*, Take 1

Comparing the First Cycle from *n* = 7, *S* = 11 with *n* = 11, *S* = 7 for *P* = (*n*·*S*+1)/3 = 26; *J* = (*n*-1)/2.

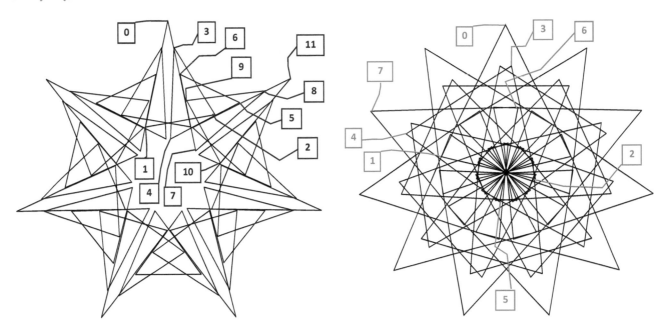

The above images show the first **S**-length cycle (from polygonal vertex to polygonal vertex) for two images, both of which are created with 77 lines (**n·S** = 77). The left image has 7 cycles of **11** and the right image has 11 cycles of **7**. All points in each first cycle are noted. Both images are shape-shifting triangles. The left is a *clockwise-one-time-around image* (the first cycle ends at vertex 1). The right is a *counter-clockwise-two-times-around image* (the first cycle ends at vertex 9 = *n*-2).

Each cycle has different numbers of "triangles" since $S = 4 \cdot 3 - 1 = 11$ on left and $S = 2 \cdot 3 + 1 = 7$ on the right. The left image has about four triangles and the right has about two. To watch the shape-shifting triangles create each image, use *Drawing Mode* after connecting to each link below:

The left image (7,11,26,3) subdivision endpoints in the first cycle are successive points on three lines of the vertex frame. The points denoted **0**, **3**, **6**, **9** are on the first vertex frame line from vertex 0 to 3. Points denoted **1**, **4**, **7**, **10** are on the third vertex frame line from vertex 6 to 2. Points denoted **2**, **5**, **8**, **11** are on the fifth vertex frame line from vertex 5 to 1.

The right image (11,7,26,5) subdivision endpoints in the first cycle are successive points on three lines of the vertex frame. The points denoted **0**, **3**, **6** are on the first vertex frame line from vertex 0 to 5. Points denoted **1**, **4**, **7** are on the fourth vertex frame line from vertex 4 to 9. Points denoted **2**, **5** are on the eighth vertex frame line from vertex 2 to 7.

8.3.2 Switching *S* and *n*, Take 2

Comparing the First Cycle from $n = 11$, $S = 13$ with $n = 13$, $S = 11$ for $P = (n \cdot S + 1)/3 = 48$; $J = (n-1)/2$.

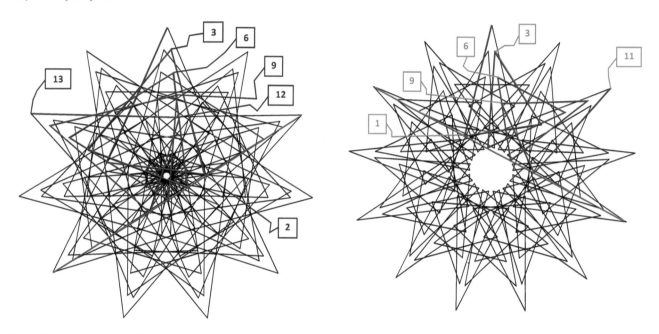

The above images show the first **S**-length cycle in red (from polygonal vertex to polygonal vertex) for two 143-line images ($n \cdot S$ = 143). The left image has 11 cycles of **13** and the right image has 13 cycles of **11**. Every third point is noted as the cycle end. Both images are shape-shifting triangles. The left is a *counter-clockwise-two-times-around image* (the first cycle ends at vertex 9 = **n**-2). The right is a *clockwise-two-times-around image* (the first cycle ends at vertex 2).

Both images have "about" **four** "triangles" per cycle since **S** = **4**·3 ± 1. An easy way to see the "four-ness" of the triangles in each cycle is to note that there are four triangle bottoms, which are successive points on a single vertex frame line (**shown in blue**) in each image. To watch these triangles create each image, use *Drawing Mode* after connecting to each link below:

The left (11,13,48,5) image bottoms are on the eighth line of the vertex frame from **vertex 2 to vertex 7** (note: **J** = 5 and **S** = **13** here) with point **2**, 5/13 of the way from vertex 2 to vertex 7 (note: **2**·48 = 96 = 7·**13** + 5).

The right (13,11,48,6) image bottoms are on the fifth line of the vertex frame from **vertex 11 to vertex 4** (note: **J** = 6 and **S** = **11** here) with point **1**, 4/11 of the way from vertex 11 to vertex 4 (note: **1**·48 = 4·**11** + 4).

8.4 *Three Shape-Shifting Triangles*

This (***n, S, P, J***) = (30, 19, 163, 13) image shows three *shape-shifting* triangles. Use multiple *Drawing Modes* and watch the image get constructed. Start with *Fixed Count Line Drawing*. Once you use *FCLD*, set *Drawn Lines* = 7 and it is immediately clear that there are three triangular images involved and each changes shape over the course of building the image.

The image below shows the **vertex frame** with **subdivision points** shown together with the first 19-segment cycle. The cycle is shown in three parts: the first part is seven green segments followed by **seven red segments** followed by **five blue segments** ending at vertex **19**.

The triangles that are created vary over the course of the cycle but notice that all are scalene triangles EXCEPT the **red isosceles triangle** in the middle of the cycle. The base of that triangle is the ninth and tenth point of the cycle, the ninth point is the end of the fourth subdivision on the **11** to **24** vertex frame line, and the tenth point is the end of the 15th subdivision **25** to **8** vertex frame line. Both points are at Level 4 as described in Section 7.1. This process continues in the second cycle. That cycle ends at vertex **8** = MOD(2·19, 30), and the Level 4 isosceles triangle base is the fourth point on the vertex frame line from **30&0** to **13** and the 15th point on the vertex frame line from **14** and **27**. (Check also *Single Line Drawing* mode with *DL* = 7.)

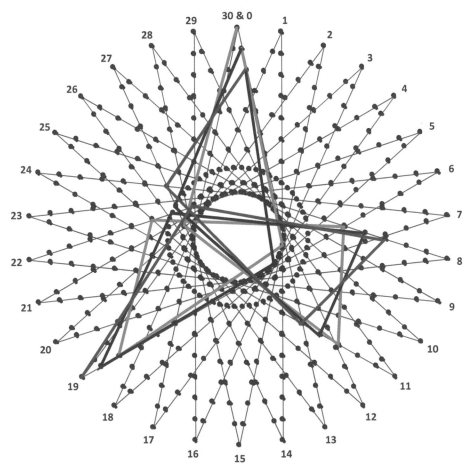

8.5.1 *Single-Step* Images

If VCF = SCF = 1, then all **nS** subdivisions are used in the final image. Most of the time, the drawn images will get filled in in a seemingly haphazard fashion (although there is a mathematical explanation for how the image gets filled in). However, there are certain situations where adjacent subdivisions are used for sub-images of **L** lines long. In this instance, the image is drawn in a fashion that is quite similar to the discussion in Section 2.5.1, *Stars as Rotating Polygons*. The difference here is that now the rotating polygons morph a bit, as they are based on subdivisions rather than the regular vertices of larger polygons. This was noted in Section 8.1, but we expand on that here.

The simplest versions to see are when **L** = 3 or 4 and the VF is a polygon rather than a star so **J** = 1 (or **n**-1). Two versions of each are provided because 120 = 3**P** = 3·40 on the left and 120 = 4**P** = 4·30 on the right. The top two images are "closed" because **nS** = 119 while the bottom two are "open" because **nS** = 121. Here are web links to these four images:

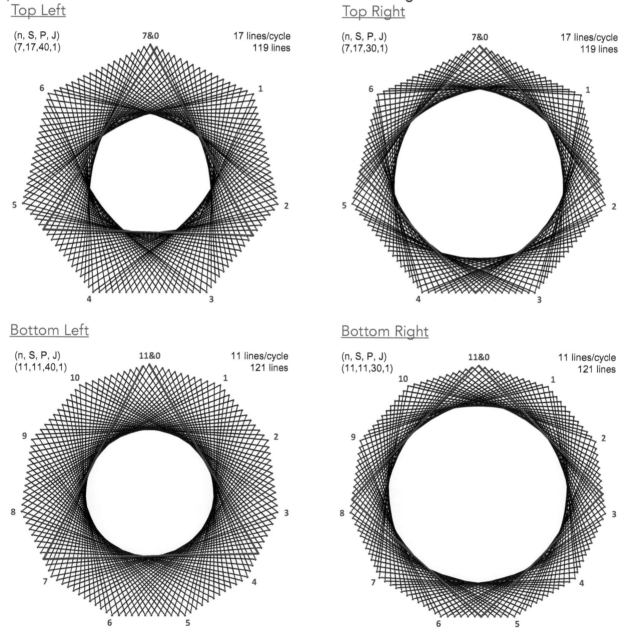

Top Left

(n, S, P, J) 7&0 17 lines/cycle
(7,17,40,1) 119 lines

Top Right

(n, S, P, J) 7&0 17 lines/cycle
(7,17,30,1) 119 lines

Bottom Left

(n, S, P, J) 11&0 11 lines/cycle
(11,11,40,1) 121 lines

Bottom Right

(n, S, P, J) 11&0 11 lines/cycle
(11,11,30,1) 121 lines

↻ or ↺? Consider for a moment the direction of rotation of the "almost" equilateral triangles and squares implied by the endpoint of the first triangle or square. (To see an exact equilateral triangle or square, set n = 12 and S = 10 while leaving P = 40 or 30 and J = 1.) The polygon's endpoints are at subdivision 1 for the upper images and at nS-1 for the lower images. The next set of ends will be at 2 upper and nS-2 lower, and so on. **The top images will rotate clockwise, and the bottom images will rotate counter-clockwise.** This is readily confirmed using the web version *Drawing Modes*.

Varying J. Additional images with the same property are available for J = 2 to 6 for the top two and J = 2 to 10 for the bottom two images. Half of the images appear to rotate in a clockwise direction and the other half appear to rotate in a counter-clockwise direction. The reason is simple: Due to the vertical symmetry inherent to File 2 images, J and n-J produce the same static image; the only difference in images is the direction the first line is drawn (see Sections 4.3 and 6.2). It is worth noting that some of the images do not "appear" to look like triangles or rectangles, but each version maintains the *single-step* forward or backward along the VF attribute.

Varying L and P (for fixed n and S). Additional L and P produce similar results so long as $L \cdot P$ = 120. Note that L = 2, P = 60 produces porcupine polygons and stars. Additionally, in order to have the polygon have L distinct sides, one must restrict L so that $P > S/2$ (otherwise, at least two of the sides will be collinear). For the S = 17 top row, this means that P = 10 (and L = 12) is the smallest possible value of P but in the bottom row, P = 6 and L = 20 since 6 > 11/2.

[MA. A general rule. A *single-step* image requires that there exists an L where $\pm 1 = LP$ MOD nS. Put another way, L and P are MMI or nMMI MOD nS. Modular multiplicative inverses and negative modular multiplicative inverses are at the center of Chapter 13 and are further discussed in Chapter 24.]

More complex single-step examples. *Three Shape-Shifting Triangles*, Section 8.4, are based on the n = 30, S = 19, P = 163, and J = 13. This image has L = 7 because LP = 7·163 = 1141, nS = 30·19 = 570, so 1 = LP MOD nS.

When $P < S$ each angle of the VF has a traditional string art curve using that angle (see Section 11.2). These curves are easiest to see when they do not overlap too much, such as n = 10, S = 40, J = 3 (from the next page) with P = 13 shown to the right. When P is a bit larger than S (such as 43, 47, 49, or 51), there is a traditional string art curve at each angular vertex *plus* reverse curves as shown on the next page. The (10,40,47,3) image with P = 47 has L = 17. The first 17 lines form a large open 9-point star and a smaller 8-point star shown at left and the completed images is on the right (since 41·47 = 799, -1 = 17·47 MOD 10·40). The image is ↺ drawn in a bit fewer than 24 of these 17-line iterations (24·17 = 408). A similar-looking image, (10,40,49,3), obtained by increasing P to 49 has L = 49 since 49·49 = 2401, and is ↻ drawn in a bit more than eight of these 49-line iterations (8·49 = 392). (Set *Drawn Lines* = L in the *Drawing Mode* in both instances.)

P = 43 image requires L = 93 (a bit more than 4 iterations) and P = 51 image requires L = 149 (a bit less than 3 iterations) to be viewed as *single-step*. Finally, the P = 13 version shown at right above can be viewed as *single-step* if L = 123 (in a bit more than 3 iterations).

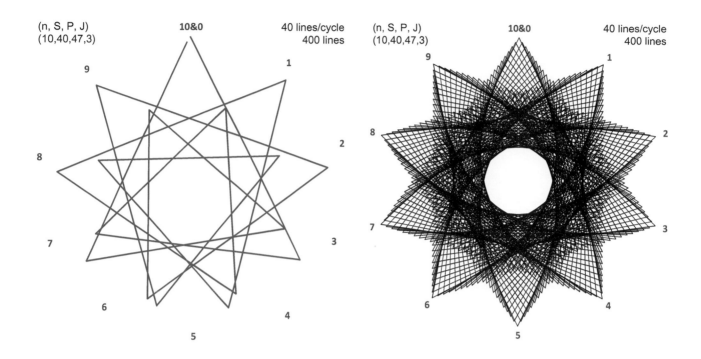

(n, S, P, J)
(10,40,47,3) 10&0 40 lines/cycle 400 lines

(n, S, P, J)
(10,40,47,3) 10&0 40 lines/cycle 400 lines

8.5.2 Composite Squares Produce Multiple *Single-Step* Polygons and Polygrams

One obtains *single-step* images of rotating **L**-sided polygons if **L·P** is one more or less than **n·S** with **J** = 1 (8.5.1). If **J** > 1, such images can either be polygons or polygrams. This explainer shows a trick that can be used to find multiple polygons if **n** and **S** differ by 2 and if the number in between (which we call **C** for center) is composite. The trick works because of the *difference between the squares* formula: $(C\text{-}k)\cdot(C\text{+}k) = C^2\text{-}k^2$ (e.g., 19·21 = 399 or 18·22 = 396, see Section 21.3).

(n, S, P, J)
(7,5,3,1) 7&0 5 lines/cycle 35 lines

(n, S, P, J)
(5,7,3,1) 5&0 7 lines/cycle 35 lines

When **b** = 1, this formula produces a number that is 1 less than a perfect square: $(C\text{-}1)\cdot(C\text{+}1) = C^2\text{-}1$. Let **n** and **S** be the numbers on either side of **C** (it does not matter which is which but if you want to create as large a *single-step* **L**-gon as possible, let **S** = **C**-1). Each factor of C^2 (2, 3, 4, 6, 9, 12, and 18 for **C** = 6) can act as either the size of the **L**-gon or the value of **P** necessary to produce that **L**-gon as long as **P** > **S**/2 so that successive lines have ends on different lines of the VF. Thus **J** = 1, **P** = 3, produces the 12-gon at left if **S** = 5 and **n** = 7 but only the 9-gon at right if **S** = 7 and **n** = 5 (since the first, third, and fourth VF lines have two segments each of the first 12 shown).

More generally, if **L** is a factor of C^2, **S**, and **n** are the numbers on either side of **C**, **J** = 1, and **P** = C^2/**L** satisfies **P** > **S**/2, then the resulting image is based on a clockwise rotating **L**-gon image because **P·L** = C^2 = **n·S**+1.

Varying J. These images show the **first five lines** (**L** = 5) and **VF** for **J** = 1 to 6 given **n** = 16, **S** = 14, so **P** = 45 = (16·14+1)/5. Similar images would have occurred had **n** = 14 and **S** = 16 been used. (Additional **L** are 3, 9, 15, and 25 given **C** = 15.)

89

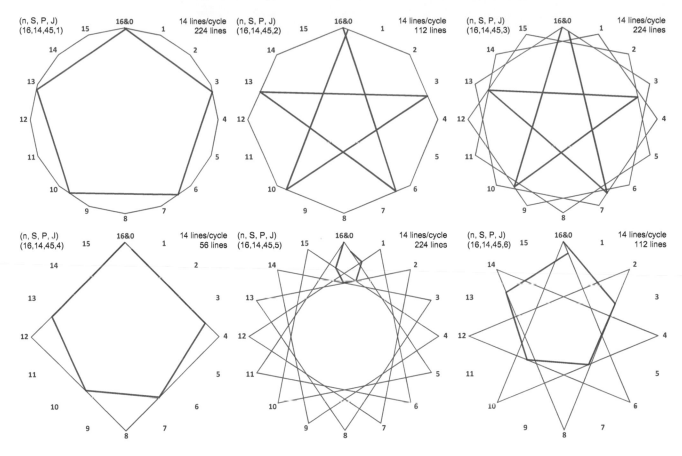

Composite L. When **L** is composite, interesting results happen when GCD(**L,J**) > 1. For example, if **L** = **C** = 30, the first 30 lines are: 1 30-gon if **J** = 1; 2 15-gons if **J** = 2; 3 10-gons if **J** = 3; 2 15-grams if J = 4; 5 6-gons if **J** = 5; 6 5-gons if **J** = 6; 10 3-gons if **J** = 10; and 15 2-gons if J = 15. Switching **n** and **S** produces similar images. But, a **L** = 60-gon (set **P** = 15) is possible only if **S** = 29, **n** = 31 and **J** =1. In this case, **J** = 10 is almost a 6,2 star.

C = 30 = 2·3·5	**L**-gon/gram	2	3	4	5	6	9	10	12	15	18	20	25	30
C² = 900	**P = C² /L**	450	300	225	180	150	100	90	75	60	50	45	36	30

8.6 Kicking the Tires of *Three Shape-Shifting Triangles*

The *Three Shape-Shifting Triangles* image analyzed in Section 8.4, (**n,S,P,J**) = (30,19,163,13), is one of a handful of images that have acted as a springboard to a deeper understanding of the intricacies of ESA images. *The seminal attribute of this image is that it is single-step of length 7 as defined in Section 8.5.1. (Other attributes are highlighted in yellow in the table.)

This follows because **n·S** = 570 and 7·**P** = 7·163 = 1141 = 2·570 + 1. [**MA.** Using Chapter 24, 7 and **P** are MMI MOD **n·S**.]

The interesting thing to note about the above calculation is that it does NOT depend on **J**. Each (**n,S,P,J**) = (30,19,163,**J**) image for 1 ≤ **J** < **n**/2 will be *single-step* of length 7. The image will not remain 570 lines long, as **J** varies because VCF > 1 for many of these values of **J**. The number of lines in the image is **n·S**/VCF because SCF = 1 (since 163 is prime). The table provides a summary of the 14 images that emerge as **J** varies from 1 to 14. The next three images focus on **J** = 9.

How is the image filled in? The 7-line sub-image will ALWAYS appear to rotate clockwise because the seventh endpoint is just to the right and below the top (since **J < n/2**). At left is the image, **k = 7** shows the **first step**, and **k = 19** shows the **first cycle**.

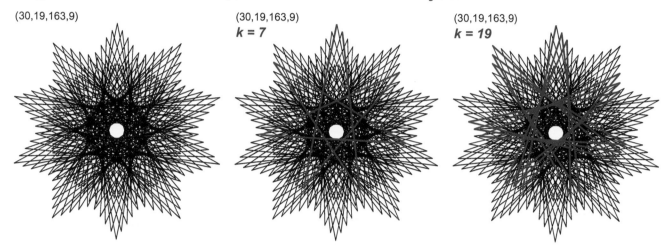

(30,19,163,9)

(30,19,163,9)
k = 7

(30,19,163,9)
k = 19

The blue highlighted row of the table shows the attributes of the above image. One can see the **open 7,3-star sub-image** in the middle panel above. This **7,3-star rotates** ↻ , but note that the image is filled in in a one-time around ↺ fashion (see Section 5.2) because the first used vertex (at the end of the **k = 19 first cycle** in the right panel) is 27 (and VCF = 3 so this is the first ↺ vertex used). Note also the 10,3-star vertex frame is visible in each panel but most especially in the left image.

Create a video of these 14 images. By setting *Drawn Lines* = 7 in the web version FCLD mode and clicking on **J** so you can change **J** using the up or down arrows, you can show each of these 14 images sequentially. Change **J** by 1 each time the image gets completed, and if you extend **J** from 16 to 29 you will see the same images drawn in reverse. Below is **J = 7**.

A 5SST with DL = 11. On a related note, check out (29,13,137,13).

J	VCF	Vertices used, V_u	Single-step sub-image	VF of final image	Number of Lines $L = 19V_u$	Number of steps^	First cycle ends at	Times around for image
1	1	30	7,2-star	30-gon	570	81	13	↻ 13
2	2	15	7,3-star	15-gon	285	41	26	↺ 2
3	3	10	7-gon	10-gon	190	27	9	↺ 3
4	2	15	7-gon	15,2-star	285	41	22	↺ 4
5	5	6	7,3-star	6-gon	114	16	5	↻ 1
6	6	5	7,2-star	5-gon	95	14	18	↺ 2
7	1	30	7,3-star	30,7-star	570	81	1	↻ 1
8	2	15	7,2-star	15,4-star	285	41	14	↻ 7
9	3	10	7,3-star	10,3-star	190	27	27	↺ 1
10	10	3	7-gon*	3-gon	57	8	10	↻ 1
11	1	30	NC 7-gon~	30,11-star	570	81	23	↺ 7
12	6	5	7,3-star	5,2-star	95	14	6	↻ 1
13	1	30	3SST	30,13-star	570	81	19	↺ 11
14	2	15	7,3-star	15,7-star	285	41	2	↺ 1

*appears as a 5-gon or a 6-gon due to 1 to 2 collinear sides across a cycle.
~non-convex 7-gon. ^Calculated as ROUND(**L**/7,0)

Chapter 9

An Overarching Question

9.1 Searching for Similarity: Exploring the *Star-in-a-Star* Pattern

Once you find an image you like, a question naturally arises:

Are there similar images?

We model this process below.

As you begin to play with subdivisions, **S**, and points between subdivisions, **P**, you will undoubtedly encounter "a star within a star" images like the one on the left, **n** = 5, **S** = 2, **P** =3, and **J** = 2 created with ten lines. Compare

that to the 5,2-star on the right.

Note that the outer star is more pointed and the inner star is less pointed than the 5,2-star to the right. Additionally, the vertices of the inner star are located at the exact midpoint between every other outer polygonal vertex. Also, the inner star is completely inside the outer.

Can we find similar images? What happens as **n** increases holding all else fixed? Interestingly, not all values of **n** produce similar images. The next five values of **n** producing similar images are **n** = 7, 11, 13, 17, and 19.

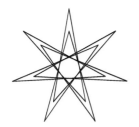

A couple of things are immediately apparent. 1) Each **n** is odd; 2) not all odd values of **n** are represented; and 3) the images have larger and larger centers. Even values of **n** reduce the vertices used because **J** = 2. Likewise, **n** = 9 and **n** = 15 are excluded because they are divisible by **P** = 3. Each is excluded because VCF > 1 (even **n**) or SCF > 1 (**n** divisible by 3) as discussed in Section 4.1.

The **n** = 7 image has a smaller star that is noticeably closer in size to the first than the others because **P** = 3 is close to half the size of **n**. The next row shows four odd **n** images (9, 11, 13, and 15) that occur when **P** increases to maintain this "closest to half" relationship. Note that **n** = 9 and **n** = 15 are no longer excluded (because **P** is no longer divisible by 3).

DOI: 10.1201/9781003402633-11

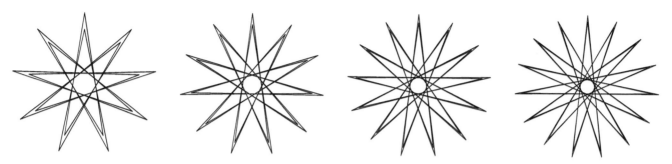

The final four images below show even values of **n**. Inner star points no longer coincide with outer star point vertices. Instead, they are between outer vertices. This will always be true when **n** is even and **S** = 2. The first three have inner spikes that are outside the footprint provided by the larger star (unlike all images above) and thus are not formally a "*star-in-a-star*," but the last one shows that internal even *star-in-a-star* images are, indeed, possible (but note that small star points are between vertices).

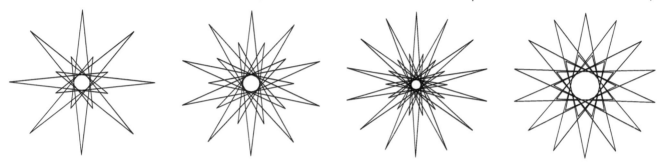

One should note that in all these images, there are additional regular stars using the closest-to-center intersections of lines used to create the image. For large **n**, these are harder to see due to the size of the images on this page.

9.2.1 Reverse-Engineering an Image

If you are presented with an image such as the one to the right, but not the values of **n**, **S**, **P**, and **J** that created that image, there are some things to notice and questions you can ask that will help you to recreate the image yourself.

Things to notice.

1. If there is a kink in the image, then that point must be a subdivision point.
 a. There are two *levels* of internal vertices (**circled**, Section 7.1).
2. All subdivision points are on the vertex frame.
 a. The first line of the vertex frame is shown in **red**.
 b. The subdivision points on this line are circled in **red**.
 c. Since these subdivisions appear to be equal distances on the line, **S = 5**.

3. Line segments in the image may or may not be part of the vertex frame.
4. The only vertex point that **MUST** be used is the starting and ending point at the top of the circle. Think of this as vertex **n** & 0.
5. Points on the polygon are easier to spot than internal points. But make sure that they are on the polygon and not simply near the polygonal frame. To clarify this idea, consider the two examples on this and the previous page.
 a. The image on the previous page has eight vertices, **n** = 8, and the red line shows **J** = 3. Additional inspection (see second vertex frame line in **blue**) suggests that **P** = **7**. You should verify that **n** = 8, **S** = 5, **P** = 7, and **J** = 3 produces this image.
 b. The image below contains two images superimposed on one another. The attributes of the **Red image** are noted, the **Black image** is a standard **n** = 5, **J** = 2 pentagram.

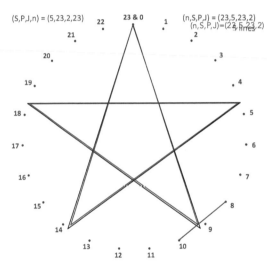

(S,P,J,n) = (5,23,2,23)

(n,S,P,J) = (23,5,23,2)
(n,S,P,J)=(23,5,23,2) lines

One additional line is shown in this compound image, a **red line** from Red's vertices 8 to 10.
This is the fifth line of Red's vertex frame.
The first four lines are 0 to 2 to 4 to 6 to 8.
The subdivision jump **P** = 23 will be on the fifth line, given **S** = 5 (4 < 23/5 < 5).
The first line in the Red image is 3/5 of the way from vertex 8 to 10.

CLAIM: The Red image is not a regular pentagram. Consider the angle at 23 & 0:

1. Black's regular pentagram's angle is 36°.
2. Red's bottom vertices are inside Black's.
3. Red's 23 & 0 angle is enclosed in Black's.
4. Red's angles cannot all equal 36° since the top red angle is smaller than 36°.

5. Therefore, Red is not a regular pentagram.
 Further, Red's pentagram includes a single polygonal vertex (at 23 & 0).
 Had you seen Red alone without vertices shown or without attributes, you may well have thought that this was a regular pentagram, **n** = 5 and **J** = 2.
6. The first (and the last) part of the image starts (and ends) at the top, so focus on the first jump to find **P** (see 5a).
7. If there are internal subdivisions that are close to the center, they MUST come from **J** values that are close to **n**/2.
8. If internal subdivision points are all close to the outside, then they are from smaller **J** values.
9. If some of the subdivision points appear to be halfway between endpoints, then **S** must be even.
 a. If only one such point is on each line in the frame, then **S** = 2.
10. If you know that **n** is larger than the number of vertex points used, then at least half of the subdivision points are not used in the final image. Do not worry about unused vertices or subdivisions.

Questions to ask:

A. What is the minimum number of **n** required to create this image? For example, can **II** be created with **n** = 5?
B. How many jumps support subdivision points that are used in the image?
 a. Put another way, what does the vertex frame look like?
C. How far along are the internal subdivision points on the segment of the vertex frame?

Challenge Questions. Use the strategies outlined above to find *n*, *S*, *P*, and *J* for each image. See Chapter 27 for the answers.

I

II

III

IV

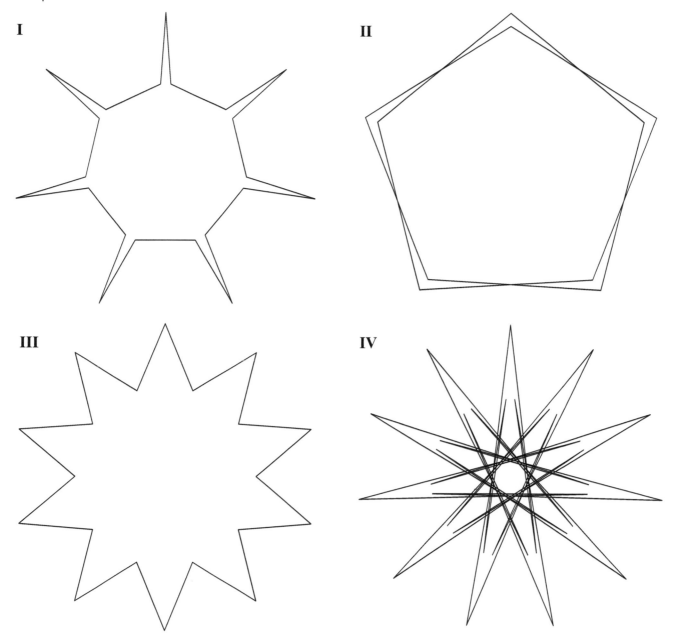

HINT: It may help to print out this page (pdf on the website) so that you can use a ruler to find subdivision points on a line.

9.2.2 Additional Image Detective Strategies

Here are additional **Things to notice** (beyond 9.2.1, #1-10).

11. If you can see a structure that repeats itself, you may benefit by restricting the analysis to a portion of the image (see Section 5.3). **n** is a multiple of the number of times that portion of the image repeats itself.

12. If there are **k** levels of interior subdivision points shown, then **S** is likely 2**k** or 2**k**+1. The reason is that the end of the first subdivision and the start of the last subdivision on a segment of the vertex frame are at the same level. The same goes for second, and second to last, and so on. Therefore,

 S = 2 and **S** = 3 produce a single level,
 S = 4 and 5 produce two levels,
 S = 6 and 7 produce three levels, and so on.

13. If you can count the number of segments in a structure that repeats itself, that provides an indication of **S**. Consider the images to the right called *Top*, *Middle*, and *Bottom*.

 a. *Top* repeats itself five times. *Middle* repeats itself ten times, and *Bottom* repeats itself 11 times.

 b. (**Green** circles) The *Top* image has subdivision points at three levels. This means **S** is likely 6 or 7 for *Top*. Counting the number of segments in 1/5 of the whole is 7 so **S** = 7. *Middle* has four subdivision levels as does *Bottom* so both are **S** = 8 or 9. Counting from peak to peak confirms that **S** = 8 in *Middle*, but *Bottom* is harder to count that way.

 c. (**Red** circles) Checking the lines drawn for *Top* if **n** = 5 and **J** = 1 or 2 suggests that **n** > 5 must be true (as none of the internal vertices are on those lines). But **n** = 10, **J** = 3 coincides with all three levels of subdivisions. Note that these three points are **not** equal spaces on the line. This confirms that **S** = 7 for *Top* with odd subdivision dots not used noted in **blue** on this first line of the vertex frame.

 By contrast, *Middle* and *Bottom* have a **J** that coincides with each level of the image so that **n** = 10, **J** = 3 for *Middle*, and **n** = 11, **J** = 4 for *Bottom*. Equal spacing of subdivisions along the first line of the vertex frame confirms that both images are **S** = 8. Continue the vertex frame in each case to find **P** (labeled **1**). The third subdivision on the fourth line of the vertex frame is the first point in the *Top* (**P** = 24 = 3·7+3). The third subdivision on the fourth

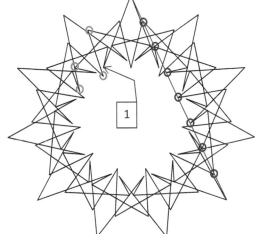

line of the vertex frame is the first point in the *Middle* (**P** = 27 = 3·8+3) Finally, the third subdivision on the sixth line of the vertex frame is the first point in the *Bottom* image (**P** = 43 = 5·8+3).

Click *Top*, *Middle*, and *Bottom*, then use the *Drawing Mode* to see each get drawn.

9.3 Curves from Lines and Points

The curves in string art images are typically created from portions of the line segments that make up the image. Using the *Image Archetypes* in Section 11.1, the curved parts of curved-tip stars, porcupine polygons and stars, and spinning needle stars are all created from small parts of line segments. (If you want to read about these small parts from a mathematical point of view, the curve is the *envelope* of a family of lines.) A second way to "see" a curve is to smooth out the small line segments that are arrayed in a curved pattern such as this (41,12,23,20) chrysanthemum (Section 11.11). A final way to view curves is to watch the pattern of kinked subdivision endpoints used to create a figure such as the *odd and even dancing partners* in spinning needle stars from Section 11.8.2.

This two-footballs (248, 164, 248, 83) image (see Section 12.6) has eight curves from lines and two footballs from subdivision endpoints.

About the footballs. If you view this image on *Pause* using *Single Lines Overlaid Drawing* SLOD mode and *Drawn Lines*, DL = 2 you will see that when the *Drawing Progress* number is **even**, the two even endpoints (the start and stop of the highlighted two lines) are on the vertical football and the odd one in the middle is on the horizontal football. However, when *Drawing Progress* is **odd**, the reverse is true. This means the vertical football contains only even endpoints, and the horizontal football contains only odd ones.

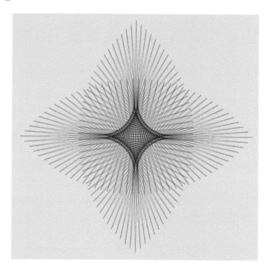

Second, notice that you can clearly see the footballs even though they really are not part of a *connected* set of lines. Put another way, here are *sets of points that create curved images*.

About the curves from lines. The image has eight distinct curves in two sets of four curves connected when they become horizontal or vertical. This 4-point star is sometimes called an *astroid* (not an asteroid). Using SLOD with DL = 1 you can quickly uncover how these curves were created. (See Section 25.4 regarding *Drawing Modes*.)

The second image shows a line at *Drawing Progress* = 21, meaning that the line in question goes from 21 (on the horizontal football) to 22 (on the vertical football). The tangency shows that this is one of the lines that help create the *Inner* curve on the *Top Left*, labeled **TLI** in the table.

If you *Step Forward* 1 so *Drawing Progress* = 22, you will note that the point on the vertical football has not changed but the point on the horizontal football has moved one point over (up and to the left). The resulting line (from 22 to 23) is helping to create the *Outer* curve on the top left, **TLO**.

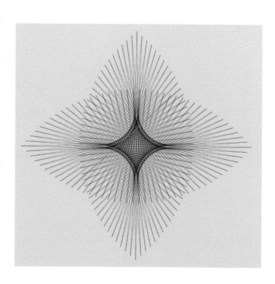

The table summarizes how each of the curves is formed. In this instance, the two 4-point stars are formed in four cycles in a counterclockwise fashion. One star is made using even starting point lines the other uses odd starting point lines.

Click *Play* in SLOD mode and watch the DL = 1 line bounce back and forth between the inner and outer curves to create both curves. Note also that inner and outer curves alternate in each star and that all 164 lines were used to create the two stars (21 for outer curves 20 for inner).

	Curve using even starting point lines.				Curve using odd starting point lines.			
Cycle	Curve	First	Last	# lines	Curve	First	Last	# lines
First	**TLO**	0	40	21	**TLI**	1	39	20
Second	**BLI**	42	80	20	**BLO**	41	81	21
Third	**BRO**	82	122	21	**BRI**	83	121	20
Fourth	**TRI**	124	162	20	**TRO**	123	163	21

Curve labels: **T/B** for *Top/Bottom*, **L/R** for *Left/Right*, **I/O** *Inner/Outer*.

Note. *Toggle Subdivisions* on and off. **Anything** inside the "donut hole" (discussed in Sections 7.1 and 10.2.1) must be line-drawn.

9.4 *Smallest-Step* Images

*(a **Quivering Triangles** Example (Section 11.6.1) with J = 7 so S = 21)*

All possible subdivisions are used in *single-step* images because VCF = 1 and SCF = 1 as noted in Section 8.5.1. It is always possible to simplify values of **n** and **J** so that VCF = 1, but the same is not true for SCF. SCF > 1 is an essential part of some images, among them Chapter 12, **n = P** Images. When SCF > 1, we can distinguish a similar notion of "closest" to the *single-step* idea found when all subdivision endpoints were employed in the final image. The notion of closest must be adjusted in this instance because used subdivisions that are closest to the top will not be on the start or end of the VF as with *single-step* images. Instead, they will be on other parts of the VF such as the six peaks (other than top) shown in the four images on the next page.

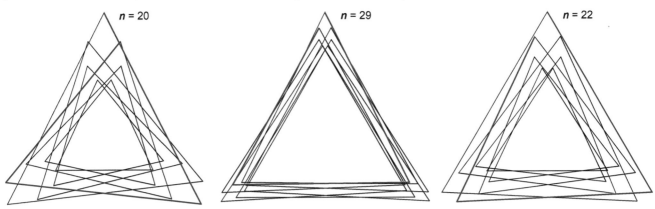

The six peaks can be thought of as 1 to 6, numbered clockwise, ↻. Thus, the top left (TL) image has a first peak at 1, while TM and TR both have a first peak at 6. *All three are smallest-step images.* Subsequent peaks change by 1 each time (1–6 ↻ for TL, and 6–1 ↺ for TM and TR). Note: 6 = **J**-1 here.

The middle image's first peak ends at 2 or 5 = **J**-2 at the top of the next page, and the bottom images end at 3 or 4 = **J**-3. This means that the middle row peaks will appear to circle around twice; the bottom row peaks will circle around three times before finishing at the top. Peak order will be:

ML, 2-4-6-1-3-5
BL, 3-6-2-5-1-4

MR, 5-3-1-6-4-2
BR, 4-1-5-2-6-3

The order in which subsequent peaks are drawn is based on counting by first peak location, MOD *J*. (See Section 23.1.)

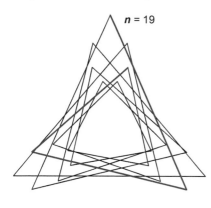

n = 19

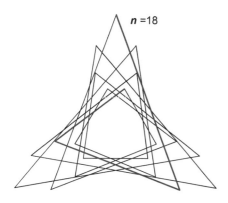

n =18

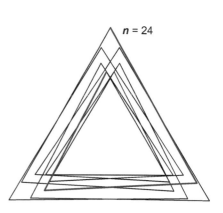

n = 23

n = 24

It is worth focusing attention on the TM image, *n* = 29. The band that the triangles quiver within is smaller than the TR *n* = 22 image, but both rotate counterclockwise one peak at a time since both have remainder 1 upon division by *J* = 7.

Drawing help. For complex images, find the sub-image length by placing *Single Lines Overlaid Drawing* mode on *Pause*, and adjusting *Drawn Lines* until the last endpoint is close to the top (DL = 3 here). Then switch to *Fixed Count Line Drawing* and *Play*.

Challenge questions. Compare two *J* = 20, *S* = 60 quivering triangles. One is (83,60,83,20), and the other is (79,60,79,20). Predict the pattern of peak fill-in in each instance. How many times around are needed, and in what direction are the peaks filled in, clockwise or counterclockwise?

9.5 Comparing *Single-Step* with *Smallest-Step* Using *Three Shape-Shifting Triangles*

On the next page, both top-row images show subdivision dots and the first seven lines, and both look quite similar, as both are versions of *Three Shape-Shifting Triangles* (3SST). The bottom row shows final images. The left, from Section 8.4, has 570 = 30·19 dots while the right has 380 = 20·19. All of the dots are used on the left, but only 1/10 of the dots are used on the right because SCF = 10.

Steps. The left 3SST image is **single-step** of length 7 (Section 8.5.1), meaning that the seventh endpoint lands on subdivision 1 (since 7·163 = 1141 = 2·570 + 1). The right 3SST image is **smallest-step** of length 7 (Section 9.4) because the seventh endpoint, at subdivision **210** = 7·30 is the closest endpoint to the top (**380&0**) that is also a multiple of 10 (since SCF = 10). The snapshot to the right (from *Excel* file 10.0.1) shows the subdivision endpoints "near" the top. The two possible candidates for the *smallest-step* are **170** and **210**, and the seventh endpoint is **170** if one of two parameters change: *P* = 350 = 380-30 or *J* = 9 = 20-11 (see Section 6.2).

	20&0	
19	380&0	1
171		209
	1379	
172 170		210 208

Cycles. As noted in Section 8.6, the left is a 30-cycle, ↻ 11-times-around image, with 81 steps. At right is a ↺ two-cycle, one-time-around image of about five steps (5 is closest to 38 lines/7). Lines 10 and 29 are the isosceles triangles vertical bases.

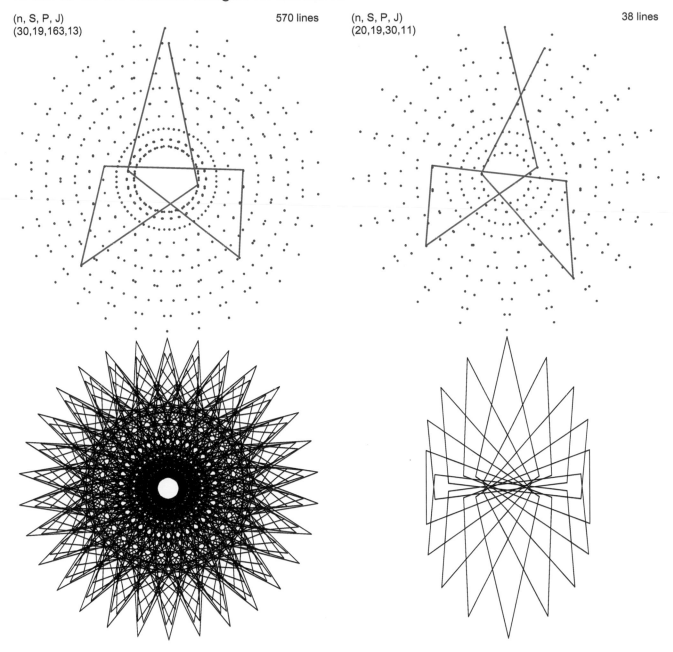

(n, S, P, J)
(30,19,163,13)

570 lines

(n, S, P, J)
(20,19,30,11)

38 lines

9.6 Pushing the Bounds of an Image Type

Oftentimes images appear to have lower bounds. If those bounds are pushed, the image tends to distort and become somewhat unrecognizable, just like a spring that is stretched too far. And sometimes new, unexpected things happen as well. We will use *spinning needle stars* from Section 11.8.1 to explore this issue. The smallest needle star known when that section was written was 5-points.

(20,19,85,9)

More than a year passed before this (20,19,85,9) 4-point image suggested that one could have needle stars with fewer than five points (perhaps the mental block to searching for these was the fact that the smallest traditional continuously-drawn star is the pentagram). This image has the classic hallmarks of spinning needle stars. It is a one-time-around image with *smallest-step* of length 2. Opposite each point is a pineapple top center with double-line curves, in this case somewhat akin to a four-leaf clover. One obtains such stars by having SCF = **n**/4 which in this instance means SCF = 5.

(30,11,50,17)

This led to a search for 3-point and 2-point needle stars. Such images require **n**/SCF to be 3 or 2. Two of each are shown here. The pineapple tops are not as visible in the three on the right, but each has a curved clover leaf between these tops. Using Sections 9.4 and 7.1, the three to the right share a *smallest-step* of length 2, whose first step ends at Level 1 [**MA.** ±1 = 2·**P** MOD **S**.]. The first 3-point star (30,11,50,17) has five levels; the second (42,15,112,17) has seven levels; and the 2-point star at right on the next page (40,19,180,17) has nine levels. The last two on the right appear (on this page and next) to have much sharper points, somewhat akin to the ultra-needles in Section 11.9. Not shown is this 2-point star: (20,29,130,9).

At left on next page. The most interesting among the images is (16,37,168,9). A casual inspection of that image suggests that it is a 6-point spinning star but in fact there are only two cycles because SCF = 8. The first *smallest-step* ends at Level 3, the 11th line ends at Level 2, and the 13th (at about 2 o'clock, near vertex 3) ends at Level 1. The point at the end of the 24th line (at about 4 o'clock, near vertex 5) is also at Level 1. [**MA.** 3 = 2·168 MOD 37, 35 = 11·168 MOD 37, 1 = 13·168 MOD 37, and 36 = 24·168 MOD 17.] This level change pattern is what allows the image to appear to have points. The illusion is enhanced because there are 18 levels, so levels are closer to one another.

(42,15,112,17)

Ties to Section 8.6. Increase **P** by 1 from left to middle to obtain the (16,37,169,9) image: a 592-line, *single-step* of length 7, ↻ 1-time around, shape-shifting 7,3-star (**the first star is shown in red**).

(16,37,168,9) (16,37,169,9) (40,19,180,17)

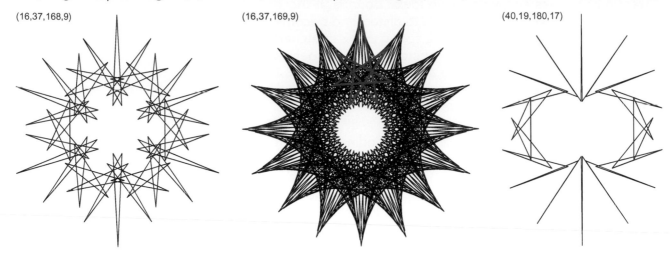

9.7 Using *Shape-Shifting* Stars to Explore Curves from Lines

k 5

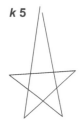

k 9

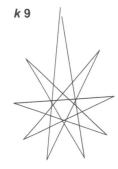

k 7

k 7

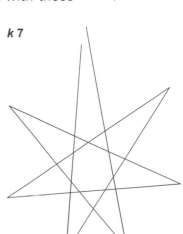

Many images have line-created curves (see Section 9.3) that seem to connect vertices of different lengths from one another. When the image is created in a multiple-times-around fashion, it is difficult to see exactly what contributed to the curve in the end. This is less of an issue if the image is created in a one-time-around fashion such as the four images shown here. The first three (13,52,135,8), (16,37,169,9), and (20,38,169,9) are from Sections 10.5, 9.6, and 5.3, and the last is (12,19,163,7). Each is *single-step* (Section 8.5.1), and the stars associated with those first *single-steps* are shown to the left and right with full images shown on the next page.

Two curves. Each image has two distinct curves emanating from each side of each vertex. *The easiest way to see this is using FCLD with DL set at single-step length.* Counting in our normal clockwise fashion, each spinning star's upper right vertex 1 will end at polygon vertex **1**, 2 will end at vertex **2**, and so on.

Consider where the curves starting at 0 end. Upper left ends at **2** and **3**. Upper right ends at **3** and **4**. Lower left ends at **4** and **5**. Lower right ends at **3** and **4**, but this one is harder to visualize because the 7,3-star sub-image surrounds the center (which is why it is so large to the right), but if you stare at it being drawn in FCLD with DL = 7 for a while, it will become clear to you.

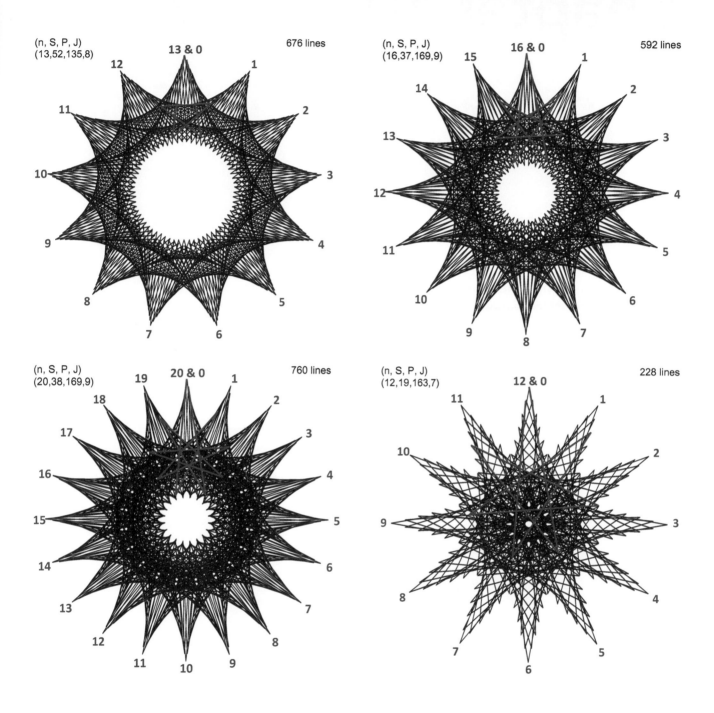

(n, S, P, J)
(13,52,135,8) 13 & 0 676 lines

(n, S, P, J)
(16,37,169,9) 16 & 0 592 lines

(n, S, P, J)
(20,38,169,9) 20 & 0 760 lines

(n, S, P, J)
(12,19,163,7) 12 & 0 228 lines

Chapter 10

Functionally Modified String Art Files

10.1 Functionally Enabling *n*, *S*, *P*, and *J*

As you get more comfortable with the basic model, you may start to search for similar images using functional relationships rather than educated guesses. More accurately, your educated guesses will turn into functional models.

A simple example. Suppose you want to find images based on a vertex frame (Section 4.2.1) that is a sharpest star (Section 2.3.1). You need to have an *n* that produces a star, *n* = 5 or *n* > 6, but once you have *n*, you need to adjust *J* to be just less than half the size of *n*. It would be nice to be able to automatically change *J* as you change *n*. An equation that works is:

J = INT((*n*−1)/2).

(**Note.** *Excel* file 10.0.5 uses exactly this equation for *J* in cell K1.) Consider how this function for *J* works:

If *n* is odd, *n* = 2*k*+1 and *n*-1 = 2*k*, so (*n*−1)/2 = *k*, the largest whole number less than *n*/2 = *k*+1/2.
If *n* is even, *n* = 2*k* and *n*−1 = 2*k*−1 is odd, and therefore INT((*n*−1)/2) = INT((2*k*−1)/2) = INT(*k*−1/2) = *k*-1.

One could use this equation to change both *n* **and** *J* by simply changing *n* if you were able to control *J* via an equation instead of being forced to adjust *J* using the ⬍ arrows (or typing in numbers).

Note: This does not ensure that an *n*,*k*-1-star as your VF because VCF > 1 may occur (as *n* = 10 = 2*k*, *k* = 5 so *J* = 4 shows us, the resulting VF is a pentagram since VCF = GCD(10, 4) = 2 here). [**MA.** This will hold if 2 = *n* MOD 4, see 23.1.]

Including functional relations is only available in the *Excel* version of the string art model. The string art *Excel* files presented in Chapter 3 force users to click the large ⬍ arrow keys to control bounds on each parameter. Additionally, the cells showing numbers for *n*, *S*, *P*, and *J* are protected against typing numbers into each cell. Five modified string art *Excel* files presented in this chapter and available via QR code from the ESA website allow users to create functional relationships between the four parameters and are provided along with suggested uses of those files. These files provide powerful tools for exploration because they streamline the exploration process especially when parameters (especially *P*) are sometimes reasonably large.

As noted in Section 25.2, the web model allows users to adjust each parameter in four ways: 1) By highlighting the number and typing in a new number, 2) by clicking the ⬍ arrow to the right of the number, 3) by using the scroll slider to the left of the number, and 4) by clicking on the box with a number in it (to make it active) and then using the ↑ or ↓ arrows on your keyboard. *These four methods provide great flexibility, but that flexibility does not extend to providing functional relations between the parameters.*

DOI: 10.1201/9781003402633-12

The modified files allow multiple methods of entering parameter values. By unlocking the cell controlling a parameter, the user is able to type in a value manually or use the large ⬍ arrow keys as before. But the user is also able to enter an equation in the cell that relates to one or more of the other parameters (just like **J** referenced **n** in the above example).

It is worth noting that the ⬍ arrow key overrides an equation controlling that cell so that care must be taken to avoid using the ⬍ arrow key of a parameter unless you want to revert to manual operation. Absent that, you must reenter the equation you are testing for further analysis. (The **S** and **P** as *linear functions* file removes the **S** and **P** ⬍ arrow keys.)

A simple example of this multiple-entry option is the treatment of the **First k lines** feature in *Excel* file 3.0.3 *String Art for teachers* that superimposes the first **k** lines in **red** on the image. The **First k lines** toggle is in cell B10, and **k** is shown in cell C11. **k** is controlled by the ⬍ arrow key in C10:C12 or by typing a number <u>or</u> an equation in C11. When the file is initially opened, C11 looks like it contains the number 2, but it contains the equation =C1 (because **S** (in C1) is the number of lines in the first *cycle*, unless GCD(**S**,**P**) > 1 in which case **C** = **S**/GCD(**S**,**P**), as noted in Section 5.1).

If using division, make sure the equation creates a whole number in the end. Each of the four parameters in the string art model is a positive whole number. If your equation uses division, you may end up with a fraction rather than a whole number. Two options are available in *Excel* to deal with this.

The integer function, INT(#), produces the integer portion of a number so that 11 = INT(11) = INT(11.3) = INT(11.5).

The round function, ROUND(#,##), produces the closest number and has two arguments: The number (#), and how many decimal places to round that number to (##, use 0 for whole numbers). Therefore,

11 = ROUND(11,0) = ROUND(11.3,0) but ROUND(11.5,0) = 12 since, by convention, 0.5 rounds up.

10.2.1 Analyzing Waves of Images and the Subdivision Donut Hole

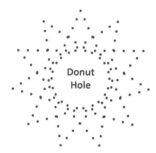

Donut Hole

As one scrolls **S** or **P** for fixed **n** and **J**, one inevitably notices that the size of the white space in the center varies in size. Some of the time, there is no noticeable white space but at other times, the amount of white space remains reasonably fixed. Recall that subdivision points form concentric circles as noted in Section 7.1. This "donut" of concentric circle subdivision **dots (numbered on the next page)** has a donut hole in the center.

The white space does not vary in size when lines from the image are "constrained" within the band created by the outer polygon and the innermost circle of subdivision points. For example, the image to the right has six concentric internal circles of subdivision points (**S** = 2·6+1), each has 22 points, and the outer circle of polygon vertices is the final 11 points (which is why there are 143 = 22·6+11 subdivision points and lines). The inner white space here is an 11-gon created by the vertex frame, VF, with pointed bottom (not top like the outer polygon since **J** is even). **P** = 6 was chosen for this image because it is the largest **P** < 30 for which image lines do not intrude on the white space shown in the center (except **P** = 13 when the image is the VF and **P** = 26 when the image is an 11,3-star). The intrusion occurs once again for 37 < **P** < 68 (except for multiples of 13 when SCF > 1) and for symmetric **P** > **nS**/2. The **lines** in the image on the next page **cross out these P values.**

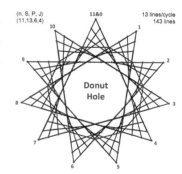

(n, S, P, J)
(11,13,6,4) 11&0 13 lines/cycle
 143 lines

Donut Hole

105

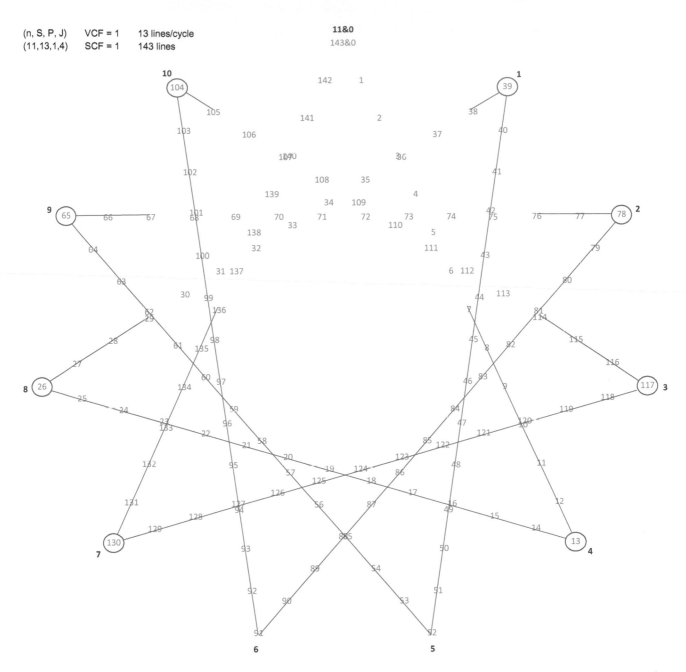

(n, S, P, J)	VCF = 1	13 lines/cycle	**11&0**
(11,13,1,4)	SCF = 1	143 lines	143&0

P values where the image encroaches on the donut hole. Roughly speaking, **P** values in the bottom half of the image above will have lines that encroach on the donut hole. The easiest to see are **P** values that are **inside** the angle created by polygon vertices **4-11&0-7** and are the bottom half of those concentric circles because first line (from **11&0** to **P**) encroaches on the donut hole.

Outside this angle of subdivision points, the first line does not encroach on the donut hole, but the subsequent line(s) do. For example, consider **P** = 43. The blow-up to the right at the top of the next page shows the second line from **43** to **86**. Points **7, 45, 46, 84,** and **85** on the border of the donut hole all lie below this line. Similar images could be created for each of the "**blue crossed-out**" subdivision numbers for at least one of the first 13 lines in the image (i.e., the first cycle).

One may wonder why the claim was made that **P** = 7 encroaches on the donut hole since it is hard to see that encroachment. The blow-up at top left on the next page shows the issue. The second line

segment, from **7** to **14**, encroaches just a bit on the **blue 11-gon**, cutting off the corner at the intersection of **7-8** and **44-45**.

Waves of images. Notice that encroaching images come in waves as **P** varies for fixed **n**, **S**, and **J**. Given VCF = 1, there are **nS** possible subdivision endpoints and images tend to change marginally for 1-unit changes in **P** unless SCF > 1. As noted in Sections 4.3, 6.1, and 6.2, images are symmetric about **P** = **nS**/2, and the same static images occur for **J** and **n-J** (but vertex numbering reverses direction) so we generally restrict our discussion to **J** < **n**/2 and **P** < **nS**/2.

Images encroach into the donut hole and recede from the donut hole systematically in each wave. There are four waves of images, one wave each that includes vertices **1**, **2**, **3**, and **4** (subdivision points **39**, **78**, **117** and **13**, respectively). More generally, there will be **J** waves, one each that includes part of the VF with vertices 1 to **J** (or **n-J** if **J** > **n**/2) if VCF = 1.

P values where the image does not encroach on the donut hole. Setting **P** equal to any of the numbers that are not crossed out in the large image on the previous page produces an image that does not extend beyond the donut of subdivisions or, to put it another way, does not encroach on the donut hole.

These **P** values are stylistically of two types: Those that produce images that include the VF and those that do not. In this example, the first six points on the first line of the VF (**P** < 7) and the last six points on the last line of the VF (**P** > 136) include the vertex frame and are simply curved-tip stars (see Section 11.2). The rest exclude the VF.

Note that these points are generally not too far from the top of the polygon. As a result, it is instructive to look at the version that is farthest away, **P** = 30. The first cycle for this image is shown graphically and in tabular fashion below.

Since the first cycle ends at **n**-1, this is a counterclockwise-drawn one-time-around image (see using the *Drawing Mode*).

As is always the case for odd **S** (and SCF = 1), the cycle includes two points on each of the internal concentric circles. Note that the fifth endpoint (at **7**) and the eighth endpoint (at **97**) are on the border of the donut hole. None of the cycle's lines cross into the donut hole.

When **S** is even (and SCF = 1), the cycle will only have one point on the innermost concentric circle. The sixth line of this 12-point spinning star (60,12,149,29) ends on the innermost circle (set *Drawn Lines* = 6). (This type of image is discussed in Section 13.1.)

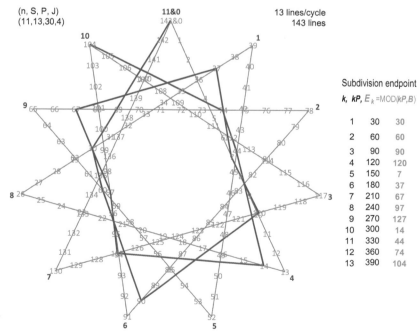

(n, S, P, J)		
(11,13,30,4)	11&0 142&0	13 lines/cycle 143 lines

		Subdivision endpoint
k	**kP**	E_k =MOD(kP,B)
1	30	30
2	60	60
3	90	90
4	120	120
5	150	7
6	180	37
7	210	67
8	240	97
9	270	127
10	300	14
11	330	44
12	360	74
13	390	104

10.2.2 MA. Automating *P* to Produce Images That Avoid the Donut Hole

One can always avoid the donut hole by setting **P** = 1 or **P** = **S** because the resulting image is simply the VF. But beyond this trivial solution, is it always possible to avoid the donut hole?

The answer is no if **J** = 1 (and **J** = **n**-1) because all non-trivial images extend into the interior of the polygon created by connecting polygonal vertices. But once we consider 1 < **J** < **n**-1 one can typically, but not always, find such images (if VCF = 1). As noted in *Waves of Images,* Section 10.2.1, **P** values satisfying this condition are either on the first or last line of the VF or on a portion of other lines of the VF that are in the top half of the image. There are **J**-1 such lines of the VF if **J** < **n**/2 (having endings at polygon vertices **1** to **J**-1) or **n**-**J**-1 having endings at polygon vertices **n**-1 to **n**-**J**+1 if **J** > **n**/2). The order in which these lines are added to the VF is the subject of *Patterns in Continuously Drawn Stars,* Section 4.2.3.

The easiest way to view this is to ask what parts of the VF intersect with the vertical radius from the center of the circle to vertex **n**&0 (radius in black to the right for **n** = 19 and **J** = 6 or 13).

If **J** < **n**/2, the first piece of the VF crossing this radius is the INTEGER(**n**/**J**)+1ˢᵗ line. For example, if **J** = 6 (shown), the first crossing occurs on the fourth line (from **18** to **5**) but if **J** = 4 (not shown), it occurs on the fifth line (from **16** to **1**). In the first instance, the crossing occurs close to the start of this segment but in the second it is close to the end and in both instances, the fractional part of **n**/**J** (1/6ᵗʰ or 3/4ᵗʰ) provides a rough balance between the two endpoints. The closest number to **S·n/J** will be reasonably close to this vertical line, and this is the **Suggested P**. To find subdivision points close to the vertical radius for the other **J**-2 VF lines (if **J** > 2), simply multiply **S·n/J** times 2, 3, ..., **J**-1 (this is the times factor **T** in the equation noted in the text-box next to *Excel* file 10.0.1's dashboard that controls **P**).

These **n** = 19, **S** = 18, and **J** = 6 images provide the rationale for including the addition factor **a** in the **Suggested P** equation. The first three images result from **a** = 0 for **T** = 1 (and 5), **T** = 2 (and 4), and **T** = 3 which have: Six lines, SCF = 57; three

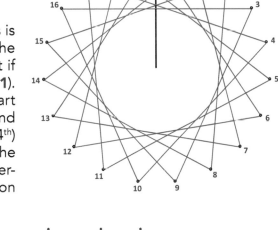

T=1 T=2 T=3 T=3
P=57 P=114 P=171 P=172

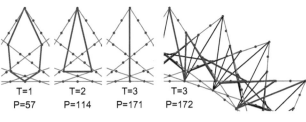

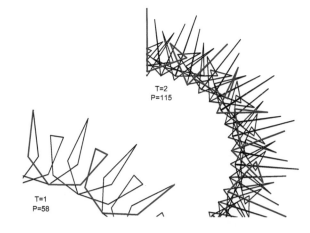

T=2
P=115

T=1
P=58

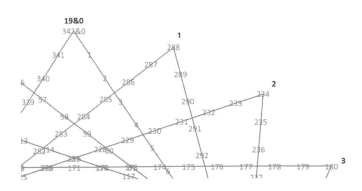

lines, SCF = 114; and two lines, SCF = 171. The third is simply a vertical line that goes from the top to the middle of the horizontal VF line from vertex **16** to **3** above and back to the top. (More generally, vertical line images result from a = 0 if $J < n/2$ and S are both even, n is odd, and $T = J/2$.)

Nudging **P** from 171 to 172 (by setting a = 1 in the dashboard) produces the fourth image on the previous page with the first **nine-line cycle** shown in **red**. The image has 171 lines and SCF = 2. Note the location of the first cycle subdivision endpoints at **172, 2, 174, 4, 176, 6, 178, 8,** and **180** (2 = 2·172 MOD 342, 342 = 19·18) using the bottom left numbered image on the previous page. These are the last five even endpoints on the tenth VF line (**16** to **3**) and the first four even endpoints on the first VF line (**0** to **6**). Only even endpoints are used because **nS** is even and SCF = 2. The bottom images on the previous page increase **P** by 1 from those shown above. **T** = 1 has 171 lines, the first cycle ends at **3,** and SCF = 2. The *extreme needles* **T** = 2 has 342 lines, the first cycle ends at **6,** and SCF = 1.

When $J > n/2$, we must replace J with n-J in order to intersect the vertical radius. To see why, note that when **J** = 13 (13 = 19-6), the second line of the VF (2 = INTEGER(19/13)+1) is from **13** to **7** (7 = 13+13 MOD 19), and the VF line between **13** and **7** lies below the center of the circle, but the fourth (4 = INTEGER(19/(19-13)+1) line from **1** to **14** intersects the vertical radius roughly 1/6th of the way past **1** (when viewed counterclockwise). The closest number to $S \cdot n/(n$-$J)$ will be reasonably close to this vertical radius, and the closest numbers to $T \cdot S \cdot n/(n$-$J)$ for $2 \leq T \leq n$-J-1 produce other subdivision points that are near the cross-over point on each of the other n-J-2 VF lines that intersect the vertical radius (when n-J > 2).

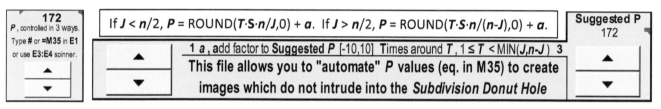

The dashboard from *Excel* file 10.0.1 shows the modifications necessary to automate **P**. The left box notes that **P** can be controlled by numerical entry in E1, by entering an equation in E1, or by using the arrows in E3:E4. **P** is automated to **Suggested P** by typing =E35 in E1 in which case **P** is controlled by the arrows controlling a and **T**.

As we see in this example, the **Suggested P** can produce an image that is quite thin. Note that **P** is just a bit more than halfway around (ROUND(29·31/2,0) = ROUND(449.5,0) = 450 because 0.5 rounds up), and the **31-line first cycle** is a "static" wave ending at vertex **1**. Had a = −1, the first cycle would have been the mirror image wave ending at **28**. As a quick glance at the first four **Subdivision endpoints** makes clear, this is a *single-step* image of length 2 (Section 8.5.1).

(n, S, P, J)	VCF = 1	31 lines/cycle
(29,31,450,2)	SCF = 1	899 lines

	Subdivision endpoint	
k,	kP,	E_k =MOD(kP,B)
1	450	450
2	900	1
3	1350	451
4	1800	2

The 11 partial images on the next page show the **first cycle** for **T** = 1 to **T** = 11 for **J** = 12 (and a = 0) with **n** = 29 and **S** = 31 as above. The images are organized as follows: The first row is **T** = 1 to 6 from left to right, and the second row is **T** = 11, 10, 9, 8, and 7 from left to right. Many are like those in *Polygons and Stars in a Cycle* (10.5) and **T** = 6 is a *Porcupine Star* (Section 11.4).

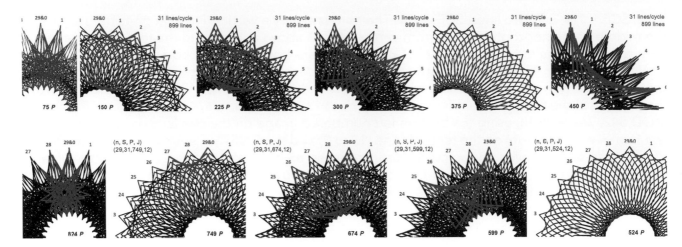

Notice the following: There are really only six static images. Each of the first five in the top row has a counterpart in the bottom row where the only difference is the ending vertex of the first cycle. The rule on this is clear: For $T > J/2$, replace T with $J-T$ and the same static image appears. Also, note that P values from these paired static images are related to one another in a simple way: They sum to 899 = $n \cdot S$, just as expected from Section 6.2. Finally, the end of the first cycle increases from **1** to **6** then increases from **-5 (24)** to **-1 (28)** as T ranges from 1 to 11 = J-1 (in the above example). This vertex-by-vertex progression of the end of the first cycle of vertices does not always hold. For example, change n to 37 keeping S = 31 and J = 12, and the first cycle ends at vertex **5** (for T = 1 at right). T = 2-11 cycle endings are **-2, 3, -4, 1, 6, -1, 4, -3, 2,** and **-5.**

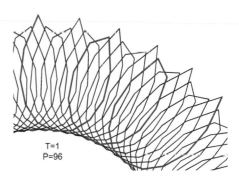

10.2.3 Create Your Own Connections: Exploring Modified Brunes Stars

This explainer is not meant as an end unto itself but simply to provide an example to spark your interest in doing your own exploration of an image you find interesting.

The 8-point Brunes star, reproduced here, was used in Section 3.3 to introduce the distinction between subdivisions, S, and points, P. That image is based on n = 4, S = 2, P = 3, and J = 1. One might wonder what happens if we alter one or more of the parameters S, P, or J. (To focus on square stars, we keep n = 4.)

Altering J is uninteresting in this situation (as long as n = 4) because J = 2 produces a vertical line and J = 3 produces the same image, drawn the other way because 3 = 4 − 1. And if you increase S holding n, P, and J fixed, you quickly have a square with cross-hatched corners since $S > P$ produces such images.

But suppose you alter *P* as you alter *S* maintaining *P* > *S* as you go. This will produce modified Brunes stars. We can quickly automate this process and obtain regular square stars with more than eight points using the automated *P Excel* file, 10.0.1.

Instead of typing =M35 in E1 (which avoids the *donut hole*), type =C1+E36 in E1 as an equation for *P*. The resulting value for *P* > *S* as long as the addition factor *a* > 0 (in E36).

Suppose you set *a* = 1 using the ⬍ arrows in E36:E39. As you increase *S* from 2 to 3, you will initially be disappointed because you end up with the triangle to the right. This occurs because SCF = 4 and the image uses only 1/4th of the subdivision points.

The process produces stars that have 4*S* points if SCF = 1. For example, increase *a* by 1 to get the bottom left 12-point square star. If you increase *S* to 9 and *a* to 8, you get the bottom right 36-point square star.

As you scroll through *S* and *a* values, you will find that certain patterns will emerge. For example, if *S* is even, then *a* must be odd, and if *a* = *S*, then the image collapses to a vertical line.

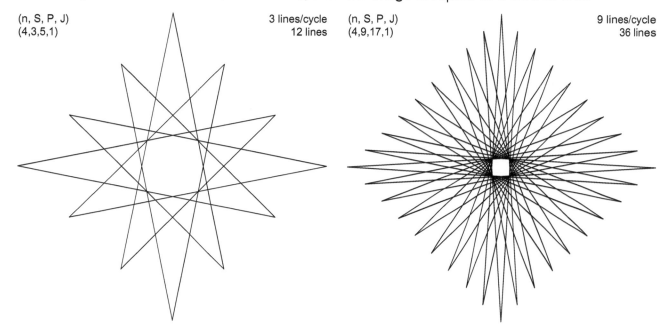

10.3 Partial-Way-Around Images: Systematically Encroaching on the Donut Hole

A simple adjustment to the *"no-donut-hole P function"* (from *Excel* file 10.0.1) produces images based on a starting point that is part of the way around the circle rather than near the top of the circle as conceptualized in the *no-donut* model. The adjustment replaces an integer number of times around the circle, *T*, by a fractional number of times around the circle.

This is accomplished in *Excel* file 10.0.2 by introducing a new parameter *u* ≥ 1 in K39 in the darker blue cells J37:L39, controlled by ⬍ arrows in J37:J39. This parameter is used in conjunction with *E* ≥ 0 in L36, controlled by ⬍ arrows in M37:M39.

Define T and P as: $T = E + 1/u$. If $J < n/2$, $P = \text{ROUND}(T \cdot S \cdot n/J, 0) + a$. If $J > n/2$, $P = \text{ROUND}(T \cdot S \cdot n/(n-J), 0) + a$.

When $u > 1$ and $E = 0$, this finds P values that are approximately $1/u$ of the way around the circle. Below are six examples chosen to emphasize the attribute of this version by setting $J = 1$. Note that with $J = 1$, **every** image other than the n-gon itself encroaches on the donut hole. This generalizes the *no-donut hole* model because T is an integer if $u = 1$.

These are *single-step* images (5.5.1) created by a single automated equation. This will not always be the case, but it is true for the images below because $13^2-1 = 12 \cdot 14 = 2^3 \cdot 3 \cdot 7$ and $13^2+1 = 170 = 2 \cdot 5 \cdot 17$. This means that 19 *single-step* u-gons are possible for $u = 2, 3, 4, 5, 6, 7, 8, 10, 12, 14, 17, 21, 24, 28, 34, 42, 56, 84,$ and 85. This is an example of *difference between squares* (see Sections 8.5.2, 21.3). Note that $u = 3, 4, 6,$ and 7 are just-under ↻ u-gons; and 2 and 5 are just-over ↺ u-gons.

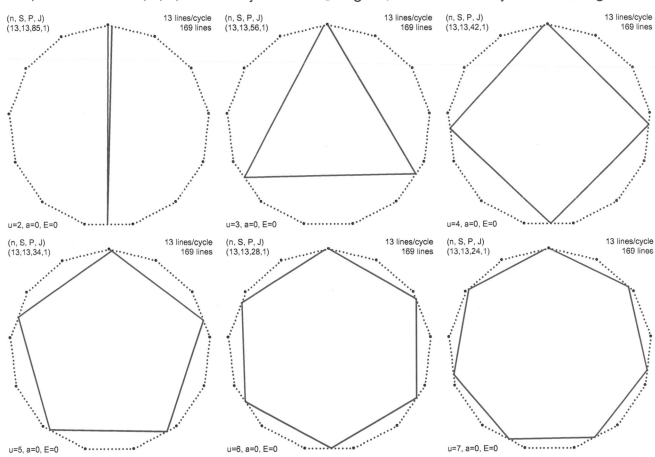

| (n, S, P, J) | 13 lines/cycle |
| (13,13,85,1) | 169 lines |

u=2, a=0, E=0

| (n, S, P, J) | 13 lines/cycle |
| (13,13,56,1) | 169 lines |

u=3, a=0, E=0

| (n, S, P, J) | 13 lines/cycle |
| (13,13,42,1) | 169 lines |

u=4, a=0, E=0

| (n, S, P, J) | 13 lines/cycle |
| (13,13,34,1) | 169 lines |

u=5, a=0, E=0

| (n, S, P, J) | 13 lines/cycle |
| (13,13,28,1) | 169 lines |

u=6, a=0, E=0

| (n, S, P, J) | 13 lines/cycle |
| (13,13,24,1) | 169 lines |

u=7, a=0, E=0

When $J > 1$ the fractional nature of the first endpoint is not quite as obvious, but some of the same rules apply as with the *no-donut* model. Note in particular that $E = 0$ and $E = J$ produce the same image. [**MA.** If we think of P as a function of E, $P(E)$, we see that $P(0) = P(J)$ MOD $n \cdot S$.] Thus, we restrict E to $0 \le E < J$. However, unlike its 10.2.2 whole number counterpart (where T and J-T produce the same static image), these images **may be** distinct due to rounding issues.

Hint. It helps to tie r to u in **Show first r lines** (type =K39 in C11) so that the number of lines shown changes as u changes.

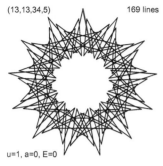

(13,13,34,5) 169 lines

u=1, a=0, E=0

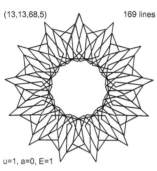

(13,13,68,5) 169 lines

u=1, a=0, E=1

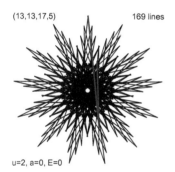

(13,13,17,5) 169 lines

u=2, a=0, E=0

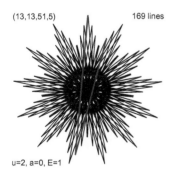

(13,13,51,5) 169 lines

u=2, a=0, E=1

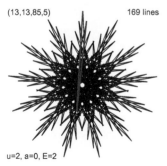

(13,13,85,5) 169 lines

u=2, a=0, E=2

These images are based on $n = S = 13$, $J = 5$, and $a = 0$ for three values of u.

The top two images on the left are *no donut-hole* versions given $u = 1$ and $E = 0$ and 1. The next two values of E produce the same static images as 1 and 0 but are drawn the other way (because of Section 6.2), and $E = 4$ produces a single point since $P = 169$.

The bottom three images on the left $E = 0$, 1, and 2 are all the static images produced given $u = 2$. The next two values of E produce the same static images as 1 and 0 but are drawn the other way.

The right images, based on $u = 3$, produce five distinct static images given $E = 0$, 1, 2, 3, and 4. If we had space to show $u = 4$, the same thing happens: Five distinct images emerge via the partial-way-around automated P function.

The above is summarized in the table below. Note the highlighted cells that compare P with $n \cdot S - P$ since both produce the same static image but are simply drawn in the reverse direction.

	Given $u = 1$		Given $u = 2$		Given $u = 3$		Given $u = 4$	
E	**P**	169-**P**	**P**	169-**P**	**P**	169-**P**	**P**	169-**P**
0	34	135	17	152	11	158	8	161
1	68	101	51	118	45	124	42	127
2	101	68	85	84	79	90	76	93
3	135	34	118	51	113	56	110	59
4	169	0	152	17	146	23	144	25

It is worth noting that several of these images are *single-step* and are quite enjoyable to watch get drawn using *Fixed Count Line Drawing* mode with varying *Drawn Lines*, DL, as noted with each image.

The top left is a swirling pentagram (set DL = 5).

The "snowflake" image at the bottom left is completed in 13 cycles that look like a lopsided chopstick rolling around a circle. Set DL = 2 for best viewing.

The second image at the bottom right appears to be a one-time around counter-clockwise-drawn image that is similar to *Three Shape-Shifting Triangles* from Section 8.4.

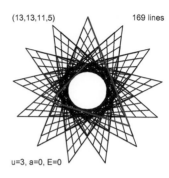

(13,13,11,5) 169 lines

u=3, a=0, E=0

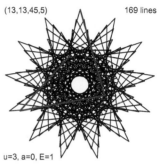

(13,13,45,5) 169 lines

u=3, a=0, E=1

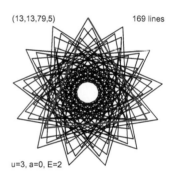

(13,13,79,5) 169 lines

u=3, a=0, E=2

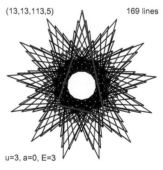

(13,13,113,5) 169 lines

u=3, a=0, E=3

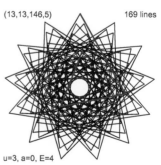

(13,13,146,5) 169 lines

u=3, a=0, E=4

Actually, the first cycle ends at vertex 6 (set DL = 13 to see), but the second cycle ends at vertex 12 (set DL = 26 to see), and thus the optical illusion is created. Set DL = 3 for best viewing.

Finally, among the **u** = 4 images noted in the table, there is a *single-step* rotating quadrangle at **P** = 42. Set DL = 4 for best viewing.

10.4 Pulsing Images

(8,61,123,3) 488 lines

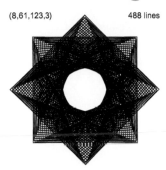

(11,81,163,5) 891 lines

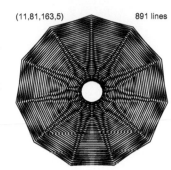

The two images at the top are completed versions of the first cycles shown at left and right at the top of the next page. If you view either image in *Drawing Mode* using the links below, you will see that the polygons pulse in and out as they complete each cycle.

These images used *Excel* file 10.0.3, a string art *Excel* file that allows one to automate **S** as a function of **n**, **a**, and **T**, much like the automating **P** file 10.0.1 controls **P**.

Set **P** = 2**S**±1 to ensure *one level change* images if GCD(**S,P**) = 1 (see Section 7.2). The term **a** in the **S** function is included to control where the first cycle ends to create *one-time-around* images (see Section 5.2). [**MA. P·J** is MMI MOD **n** (see Section 24.1).]

As you can tell from the first three images below, the parameter **T** controls the number of "replications" of the image seen. Each image is symmetric on the line from vertex **7** to midway between **0** and **1**. Think of the cross-overs as the ends of fingers that are just touching and are hugging a central figure. One can see **T**-1 sets of arms, alternating finger-touch sides with each hugging all prior sets of arms like (slightly off-center) nesting dolls (or 2 crabs fighting).

These pulsing images need not be **n**-gons matching the **n** in the underlying image as witnessed by the lower left image. The subdivision points have been included in this image. Notice that every fourth point on the first, third, fifth, and seventh line of the VF is used in this instance, but no points on the even VF lines are used in the first cycle. The second cycle reverses this pattern. This pattern is quite different from the other images, which use points on all the VF lines in the first cycle.

The first cycle given is **n** = 13, **J** = 6, **S** = a+(**T**-1)·**n**, **P** = 2**S**-1 for **T** = 2, 5, & 10. Imagine **T**-1 hugging arms nesting dolls per cycle.

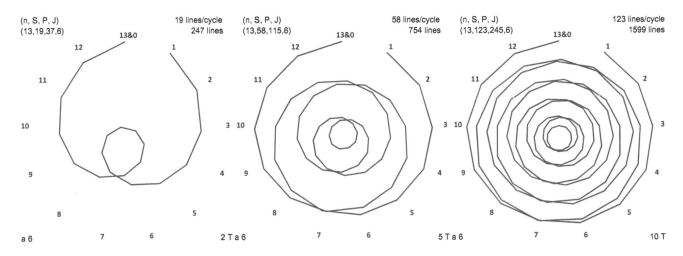

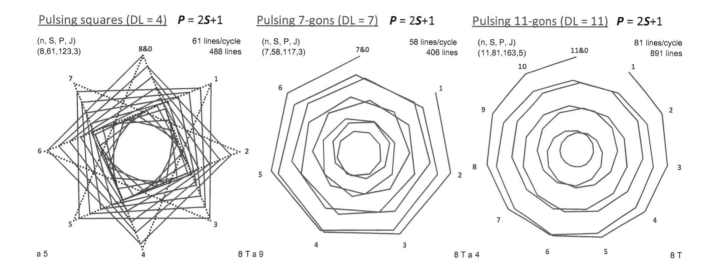

Pulsing squares (DL = 4) **P = 2S+1**

(n, S, P, J) 61 lines/cycle
(8,61,123,3) 488 lines

Pulsing 7-gons (DL = 7) **P = 2S+1**

(n, S, P, J) 58 lines/cycle
(7,58,117,3) 406 lines

Pulsing 11-gons (DL = 11) **P = 2S+1**

(n, S, P, J) 81 lines/cycle
(11,81,163,5) 891 lines

10.5 MA. Polygons and Stars in a Cycle

These one-time-around images are created when lines in each cycle connect near one another. When viewed dynamically, these images seem to swirl around the circle like many of the *60-second images* in Chapter 13.

Clockwise-drawn ↻ images can be turned into counterclockwise ↺ ones by setting **J** to **n-J** (see Section 6.1) so (**n, S, P, J**) = (13, 7, 18, 5) is the same as the top right image but is ↺ drawn.

If you find an image with a sub-image you like, you can expand the number of replications of the sub-image by changing **S** and **P** for fixed **J** and **n**. **The rule is simple and elegant:**

- Add the smaller of **J** and **n-J** to **S** for the next higher **S** (so 7 turns into 11 at top left on the next page or 7 to 12 at bottom left on the next page).
- Add **n** to **P** for the next higher **P**.

This process produces images that are similar but have one more polygon or star per cycle. Because of the overlapping and stretched nature of the

(n, S, P, J) 91 lines
(13,7,23,4)

polygons and stars, this can be confusing to count unless you think in terms of a *"distin-guished attribute"* of these looped images. In the polygon version, it might be the outer edge that goes from 1 in the left to 2, 3, and 4 in the top row on the next page from left to right (and notice that the middle edge in the odd versions has endpoints at the same level as one another). In the star version at right, tops are hard to see, but note that the bottom points go from 2 at right to 3, 4, and 5 in the bottom row

(n, S, P, J) 91 lines
(13,7,18,8)

from left to right on the next page. **Note.** The images in this section use *Excel* file 10.0.4.

$S = 4k+3 = Jk+3$ and $P = 13k+10 = nk+10$ given $J = 4$, $n = 13$ ($k = 1$ previous page left, $k = 2$-4 below) link to top right image

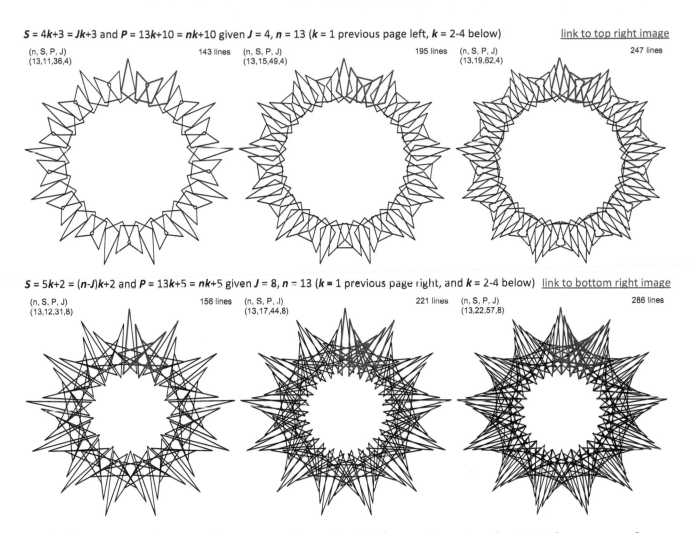

(n, S, P, J) 143 lines (n, S, P, J) 195 lines (n, S, P, J) 247 lines
(13,11,36,4) (13,15,49,4) (13,19,62,4)

$S = 5k+2 = (n\text{-}J)k+2$ and $P = 13k+5 = nk+5$ given $J = 8$, $n = 13$ ($k = 1$ previous page right, and $k = 2$-4 below) link to bottom right image

(n, S, P, J) 156 lines (n, S, P, J) 221 lines (n, S, P, J) 286 lines
(13,12,31,8) (13,17,44,8) (13,22,57,8)

The images on the next four pages show k = 1-3 for various J and n. Initial rows are shown with explicit discussion of S and P functions, but later versions leave that to the reader.

$S = 4k{+}1 = Jk{+}1$ and $P = 15k{+}4 = nk{+}4$ given $J = 4$, $n = 15$

(n, S, P, J)
(15,5,19,4) 75 lines

(n, S, P, J)
(15,9,34,4) 135 lines

(n, S, P, J)
(15,13,49,4) 195 lines

$S = 4k{+}1 = (n{-}J)k{+}1$ and $P = 17k{+}4 = nk{+}4$ given $J = 13$, $n = 17$

(n, S, P, J)
(17,5,21,13) 85 lines

(n, S, P, J)
(17,9,38,13) 153 lines

(n, S, P, J)
(17,13,55,13) 221 lines

$S = 5k{+}4 = (n{-}J)k{+}4$ and $P = 14k{+}11 = nk{+}11$ given $J = 9$, $n = 14$

(n, S, P, J)
(14,9,25,9) 126 lines

(n, S, P, J)
(14,14,39,9) 196 lines

(n, S, P, J)
(14,19,53,9) 266 lines

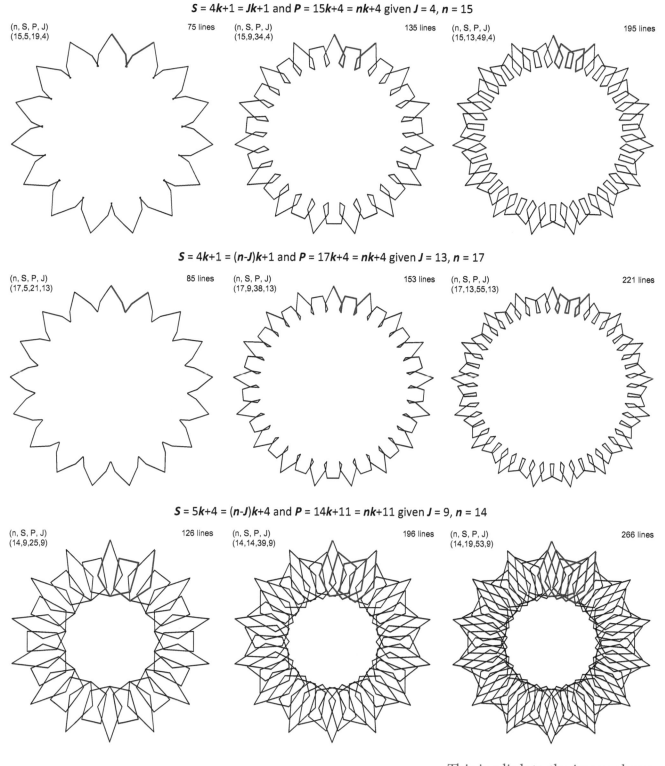

This is a link to the image above.

117

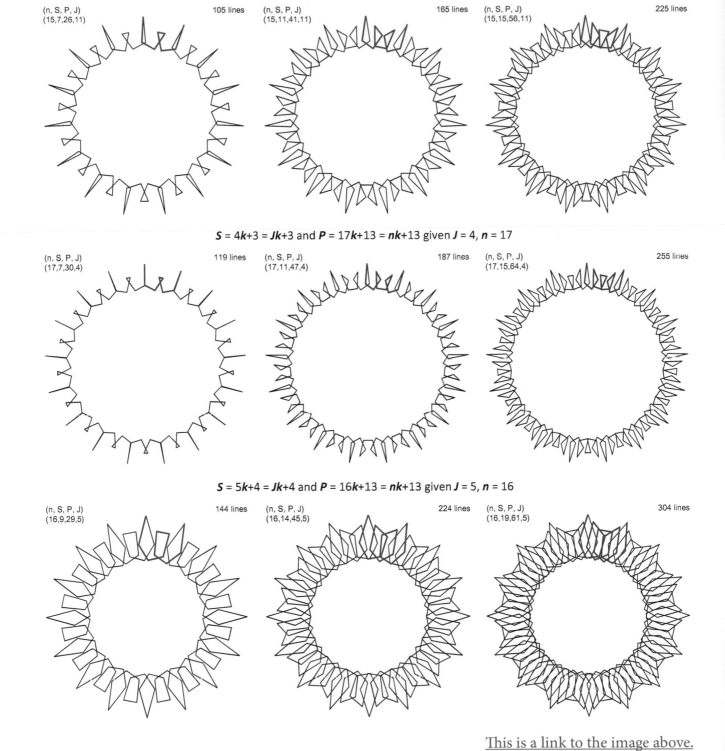

$S = 4k+3 = (n-J)k+3$ and $P = 15k+11 = nk+11$ given $J = 11$, $n = 15$

(n, S, P, J)
(15,7,26,11)
105 lines

(n, S, P, J)
(15,11,41,11)
165 lines

(n, S, P, J)
(15,15,56,11)
225 lines

$S = 4k+3 = Jk+3$ and $P = 17k+13 = nk+13$ given $J = 4$, $n = 17$

(n, S, P, J)
(17,7,30,4)
119 lines

(n, S, P, J)
(17,11,47,4)
187 lines

(n, S, P, J)
(17,15,64,4)
255 lines

$S = 5k+4 = Jk+4$ and $P = 16k+13 = nk+13$ given $J = 5$, $n = 16$

(n, S, P, J)
(16,9,29,5)
144 lines

(n, S, P, J)
(16,14,45,5)
224 lines

(n, S, P, J)
(16,19,61,5)
304 lines

This is a link to the image above.

S = 7**k**+1 and **P** = 48**k**+7 given **J** = 7, **n** = 24 (note that 2**n** are added to **P** rather than **n** in this instance)

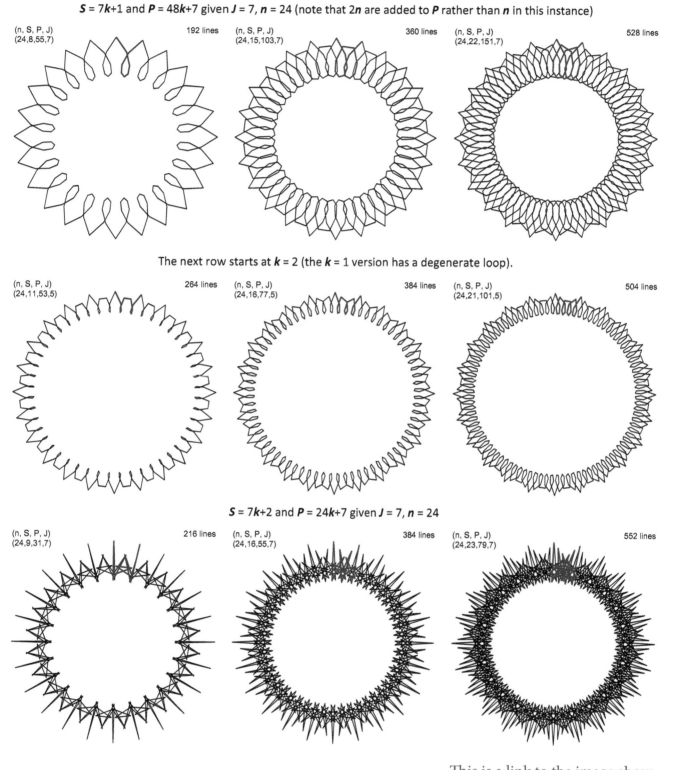

(n, S, P, J)
(24,8,55,7) 192 lines

(n, S, P, J)
(24,15,103,7) 360 lines

(n, S, P, J)
(24,22,151,7) 528 lines

The next row starts at **k** = 2 (the **k** = 1 version has a degenerate loop).

(n, S, P, J)
(24,11,53,5) 264 lines

(n, S, P, J)
(24,16,77,5) 384 lines

(n, S, P, J)
(24,21,101,5) 504 lines

S = 7**k**+2 and **P** = 24**k**+7 given **J** = 7, **n** = 24

(n, S, P, J)
(24,9,31,7) 216 lines

(n, S, P, J)
(24,16,55,7) 384 lines

(n, S, P, J)
(24,23,79,7) 552 lines

This is a link to the image above.

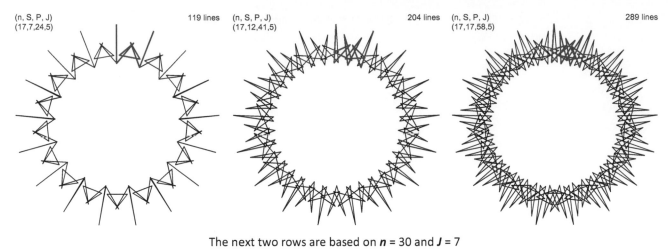

(n, S, P, J)
(17,7,24,5) 119 lines

(n, S, P, J)
(17,12,41,5) 204 lines

(n, S, P, J)
(17,17,58,5) 289 lines

The next two rows are based on *n* = 30 and *J* = 7

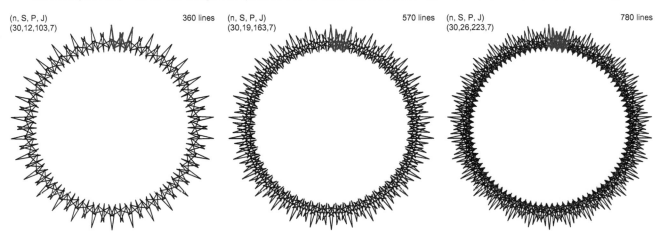

(n, S, P, J)
(30,10,43,7) 300 lines

(n, S, P, J)
(30,17,73,7) 510 lines

(n, S, P, J)
(30,24,103,7) 720 lines

Note the difference for the images in the row below. Following the strategy of adding *J* to *S* and *n* to *P* produces *P* = 133. But GCD(19, 133) = 19 so the image collapses to the vertex frame. But adding 2*n* to *P* produces subsequent images.

(n, S, P, J)
(30,12,103,7) 360 lines

(n, S, P, J)
(30,19,163,7) 570 lines

(n, S, P, J)
(30,26,223,7) 780 lines

<u>This is a link to the image above.</u>

Chapter 11

A Sampling of Image Archetypes

11.1 Some Examples of String Art Image Archetypes

Sections are noted for each image and titles are web linked. To see an image get drawn, click the title, then click *Drawing Mode* and choose either *Fixed Count Line Drawing* or *Single Line Drawing*. Adjust *Drawn Lines* and *Drawing Speed* to your taste.

(For more information on the various drawing modes, see Section 25.4.)

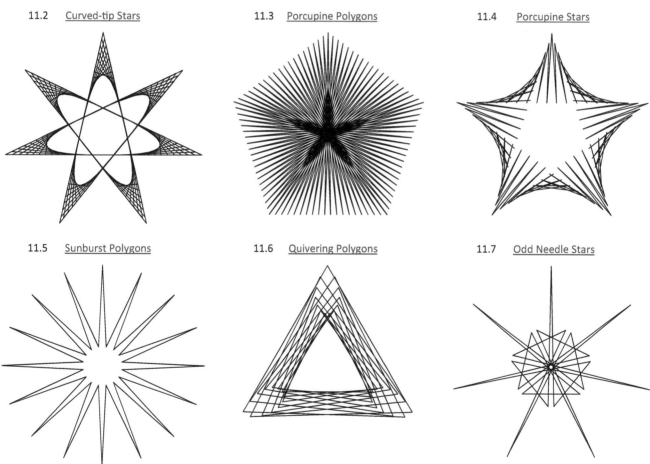

11.2 Curved-tip Stars	11.3 Porcupine Polygons	11.4 Porcupine Stars

11.5 Sunburst Polygons	11.6 Quivering Polygons	11.7 Odd Needle Stars

DOI: 10.1201/9781003402633-13

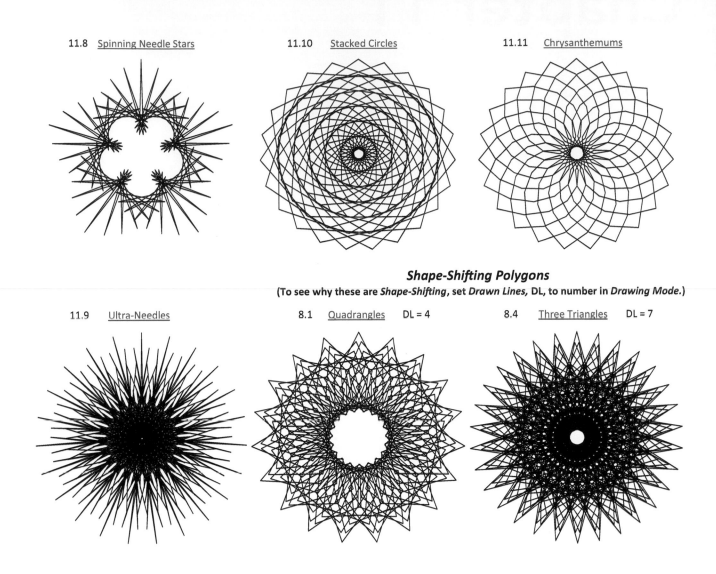

| 11.8 | Spinning Needle Stars | | 11.10 | Stacked Circles | | 11.11 | Chrysanthemums |

Shape-Shifting Polygons
(To see why these are *Shape-Shifting*, set *Drawn Lines,* DL, to number in *Drawing Mode.*)

| 11.9 | Ultra-Needles | | 8.1 | Quadrangles | DL = 4 | 8.4 | Three Triangles | DL = 7 |

11.2 Curved-Tip Stars

Curved-tip stars are images that use the vertex frame to create curved angles at each point of the star. This is very much like having a classic V-shaped image at each point of the star. Such images are easy to create. All you need is $P < S$. The smaller is P relative to S (P/S is smaller), the smaller will be the curves at each vertex. Each of the first six images has $n = 11$, $S = 23$, and $J = 5$. The top row from left to right has $P = 8, 12, 14$ and the bottom row has $P = 16, 17, 18$.

As **P** gets closer to **S**, each curve becomes harder to see, especially once **P/S** > 0.7 as there is no longer "white space" like in the final image above.

The bottom three images have the same **n**, **S**, and **P** as the upper left image, but now we vary the size of **J**. As **J** changes from 4 to 3 to 2, so does the value of **P** required to keep the internal intersections cleanly visible (you could check that the largest **P** where the first intersections occur as lines not curves is **P** = 6 for **J** = 4 and 3 but **P** = 7 for **J** =2).

Curved-tip polygons are created if **J** = 1. In this instance, the inside image is most "circle-like" when **P** is close to half of **S**.

11.3 Porcupine Polygons

(Porcupine images are created when **P** is the largest number less than **n·S**/2)

A porcupine polygon is one you would not want to step on. The internal body is surrounded by needle-like armor. Images such as these occur whenever **P** is as close as possible to **S·n**/2 without equaling that number. If **P** = **S·n**/2, the result is a vertical line. The two examples below show **S** = 29. When **n** is odd, the internal structure appears star-like (for **n** ≥ 5), and when **n** is even, the internal structure is more polygonal in nature.

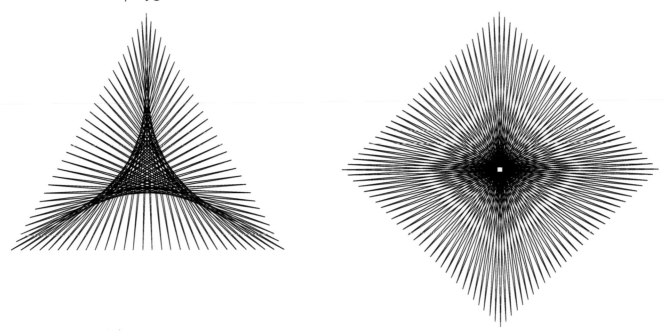

Images such as these are fun to watch being drawn. These links take you to the left image and the right image. Click *Drawing Mode* and choose FCLD to watch this happen. To reverse the direction in which the image is drawn, simply move to the other side of **n·S**/2. So, if you increase **P** from 43 to 44 for the triangle, or from 57 to 59 for the square, the image will be filled in clockwise, rather than counterclockwise. One additional thing that happens with the square is that every other vertex is filled in rather than every vertex is filled in for the triangle.

11.4 Porcupine Stars Versus Polygons

(Porcupine images are created when **P** is the largest number less than, or smallest number larger than, **n·S**/2)

The left pentagonal *porcupine polygon* (11.3) on the next page has the same **n**, **S**, and **P** as the image on the right, but the image on the right is based on a pentagram (**J** = 2) or a 5,2-star. Notice that now many of the needles are pointing inward, leading to an upside-down pentagon of "empty" space. These two examples show **S** = 29.

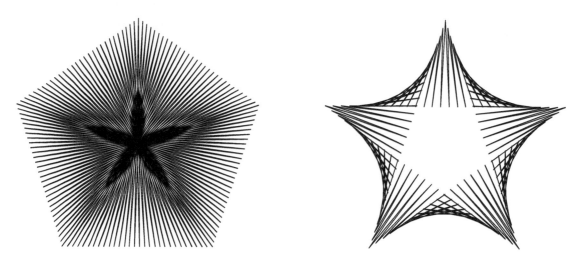

J > 1 caveats. Multiple jump models do not always lead to images using all of the vertices. The image uses fewer vertices if *n* and *J* have factors in common. (See the discussion of VCF, the *vertex common factor*, in Section 4.1 for further detail.) This is the reason that one cannot create a continuously-drawn 6-point star. But one can create two <u>distinct</u> 7-point stars (*J* = 2 and 3), one 8-point star (*J* = 3), and two 9-point stars (*J* = 2 and 4). (The word <u>distinct</u> was used because each of those solutions can be seen using two values of *J* < *n* since the same image results for *J* and *n-J* jumps as noted in Section 2.2.1.)

Versions of each of these models are shown below. The number of subdivisions between connected vertices has been reduced to *S* = 19 because the images are smaller in size in order to fit six images on one page. The images are widely varied, but they all contain sharp points at subdivision endpoints.

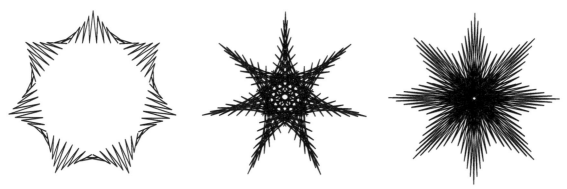

The first two are *n* = 7, the third is *n* = 8, and the bottom three all are based on *n* = 9. You should be able to explain what happened to the other six vertices in the middle image given *J* = 3. One can see the commonality between the two left images and the right image at the top of the page: Each has *J* = 2 and *n* is odd.

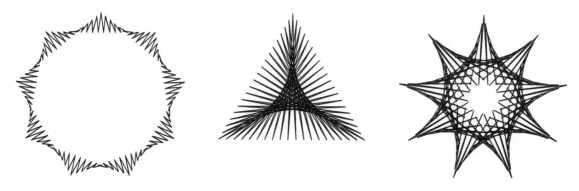

125

This is a link to the companion website for the last of these images. If you watch this get drawn (*Drawing Mode, Fixed Count Line Drawing*) you will find that it is completed in two counterclockwise rotations around the circle. Want to see it get drawn clockwise? Change **P** = 85 to **P** = 86 and use *Drawing Mode*.

11.5.1 Sunbursts

These images look like stars except that they do not have crossing lines. Since the lines do not cross, they are formally non-convex polygons with **2n** sides. Sunbursts can have an even or odd number of spikes, and the spikes can be either small or large as the images below confirm. The two left images have **n** = 16 while the right images have **n** = 17.

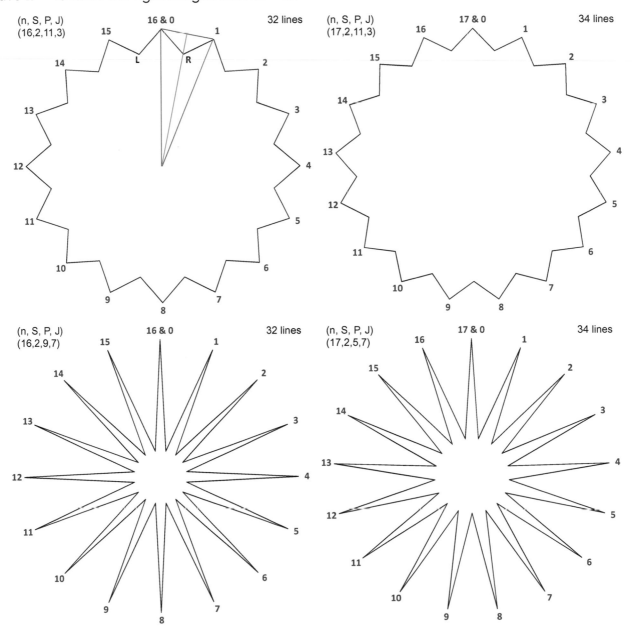

Making sunbursts. Sunbursts are easy to create. Imagine the polygon as being made of n equal-sized pieces cut in straight lines to the center. Each slice is an isosceles triangle (the upper left image shows one such slice in **blue**). The **green line** from the peak (center) to the midpoint of the base (from **0** to **1**) is the height of the triangle. The inner point of the sunburst (like **R**) must be on this **green line**. Additionally, the first such inner point must be on one of two centerlines, the one annotated above from **0** to **1** (at **R**, for example) or the one from n-1 to n (at **L**, just to the left of the centerline) since we do not want image segments to cross one another. These requirements create three conditions.

1. We guarantee midpoints if S = 2.
2. J is odd, $J = 2k+1$ for whole number k. (If J is even, midpoints are on rays through vertices not between vertices.)
3. P is set so that the endpoint of the first segment is the midpoint of either the line from n-k-1 to k or n-k to k+1.

As J increases for a given n, the spikes increase in size. The four examples on the next page are based on n = 19, the smallest n that will produce four distinct sunbursts. Note also that GCD(n, J) = 1; n = 15, J = 3 will not produce a sunburst with 15 spikes.

An example. Take the upper right image on the next page, (19,2,15,5). The midpoint of the part of the vertex frame from n-k-1 to k is the midpoint of 19-2-1 = **16** to **2** which is the point between **18** and **19**. The midpoint of n-k to k+1 is the midpoint of 19-2 = **17** to **3** which is the point between **0** and **1**. We choose to use the smallest P that works (in Section 4.3 we learned that P and $n \cdot S$-P produce the same image). Each jump of the vertex frame is five vertices, so the progression goes **0** to **5** to **10** to **15** to **1** to **6** to **11** to **16**. Therefore, **16** is the first (of **16** and **17** that straddles **19&0** with two vertices on one side and three on the other), and this occurs after seven, so $P = 2\cdot7+1 = 15$. This sunburst is therefore drawn counterclockwise.

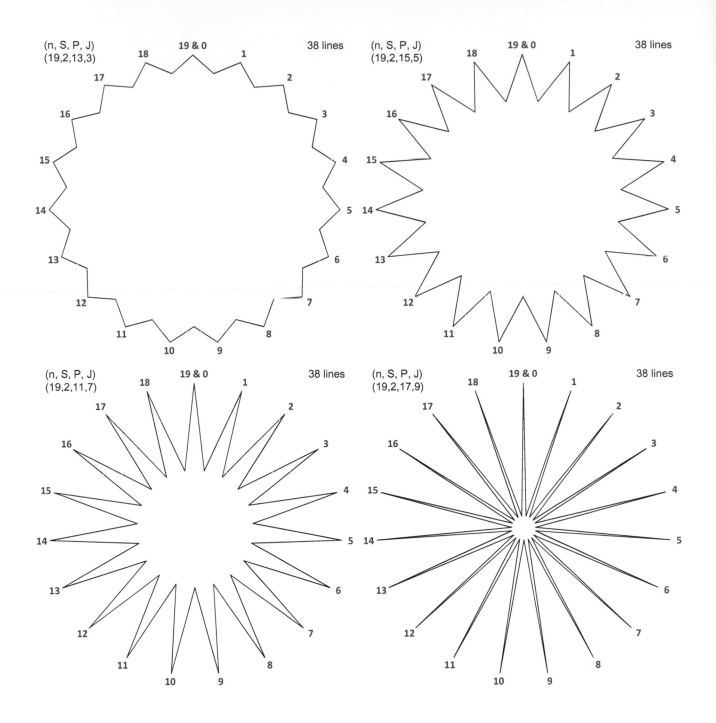

11.5.2 Variations on Sunbursts: Increasing *S* Beyond 2 While Maintaining Polygonal Status

All the sunbursts in Section 11.5.1 were polygons with **S** = 2. We can still obtain interesting alternative polygons when we increase **S** beyond 2. The strategy for finding **P** in **S** = 2 sunbursts applies here: You want the "nearest" subdivision to be the first and last point used to create the image. A relation that often works is to set **P** and **J** relative to the total lines used to create the image, **n·S**. Choose **J** and **P** such that **n·S** ± 1 = **P·J**. [**MA.** This is the notion of MMI from Chapter 25.]

Not all values of **J** and **P** satisfying this equation produce polygons. If **J** is "too large" the lines cross and the image is no longer a polygon. These three **n** = 17, **S** = 3 examples show that **J** = 2 and 4 work but 5 does not, despite having **J·P** = 50.

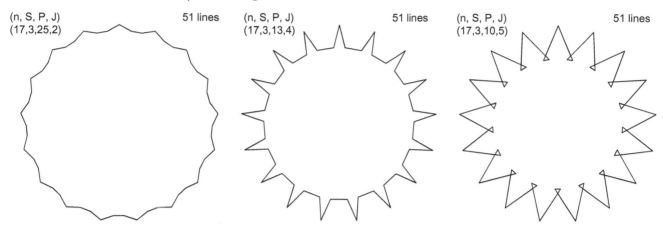

(n, S, P, J) 51 lines
(17,3,25,2)

(n, S, P, J) 51 lines
(17,3,13,4)

(n, S, P, J) 51 lines
(17,3,10,5)

Note that when **S** = 3, flats occur between spikes. Sometimes the spikes can be substantial as this (13,3,10,4) version shows.

For larger **S**, note that if **S** is even, then **J** must be odd to not have a subdivision point right beneath a vertex. Below are two examples, one for **S** = 4, and the other for **S** = 5.

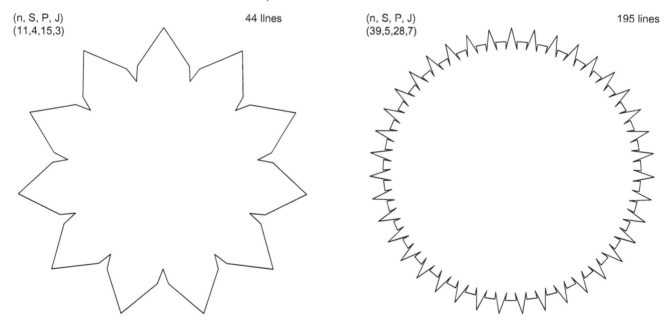

(n, S, P, J) 44 lines
(11,4,15,3)

(n, S, P, J) 195 lines
(39,5,28,7)

The link takes you to an **n** = 23, **S** = 7 example where **J** = 5. As it turns out, for this **n, S** combination, the largest **J** for which the image is still a polygon is **J** = 5. Note that when **J** = 6 and **P** = 27, crossovers occur, and the resulting image resembles a sunflower with 23 inward-pointing paddles.

Exercise. Find **J** and **P** combinations whose product is either 160 or 162 for **J** = 2, 3, 4.

11.6.1 Quivering Polygons

The image to the right is an example of a quivering square. The image is close to, but not quite, a square. Images such as this are easy to create and fun to watch get drawn.

Let **L** be the number of sides in the quivering polygon.

For example, if you want a quivering square, then set **L** = 4.

Choose the number of times you want that polygon to quiver. This will be determined by **J**. In the example to the right, **J** = 10.

Set **S** = **L·J**. Here, **S** = 4·10 = 40.

Set **n** = **P** = **S**-1 or **S**+1. Here, **n** = **P** = 39.

To see why the resulting image occurred, it is helpful to consider the first four segments, highlighted in **red**, using the **vertex labels** in the graph at the right.

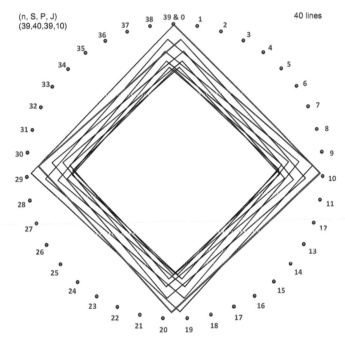

(n, S, P, J)
(39,40,39,10) 40 lines

In this instance, **P** is 1 less than **S**.

The first point is 39/40 of the way from **0** to **10** in the graph.

The second point is 38/40 of the way along the line from **10** to **20**.

The third point is 37/40 of the way along the line from **20** to **30**.

The fourth point is 36/40 = 9/10 of the way along the line from **30** to **1**, just inside the first quadrant. This is the highest peak on the right (between, but a bit below, vertices **39&0** and **1** and the **end of the fourth red line**).

The other peaks follow around in a *clockwise* oval in this instance. To verify this, click on this link (39,40,39,10) and then click *Drawing Mode, Fixed Count Line Drawing,* and set *Drawn Lines* = 4.

If you want to have the peaks drawn in the reverse fashion, just change from **n** = **P** = 39 to **n** = **P** = 41.

If you want to see a pentagon instead of a square, simply change **J** to 8 (since 8·5 = 40) and you will have an image with eight quivering pentagons.

Here is a question to test your comprehension: Suppose you want 13 triangles in your quivering triangle, and you want the peaks to be drawn in a counterclockwise oval. What values of **n**, **S**, **P**, and **J** produce such an image? Check your answer using the *Excel* file or companion website.

A glimpse of things to come. This is the first of four sections dealing with quivering polygons. Interestingly, quivering polygons also form the basis for Chapter 12. The decision was made to leave these four sections in Chapter 11 rather than moving these sections to Chapter 12 because the Chapter 12 material was uncovered much later in the process of creating this book. You can drill down into Chapter 12 immediately, of course, but there is more to see in Chapter 11.

11.6.2 The Role of *J* in Quivering Polygonal Images

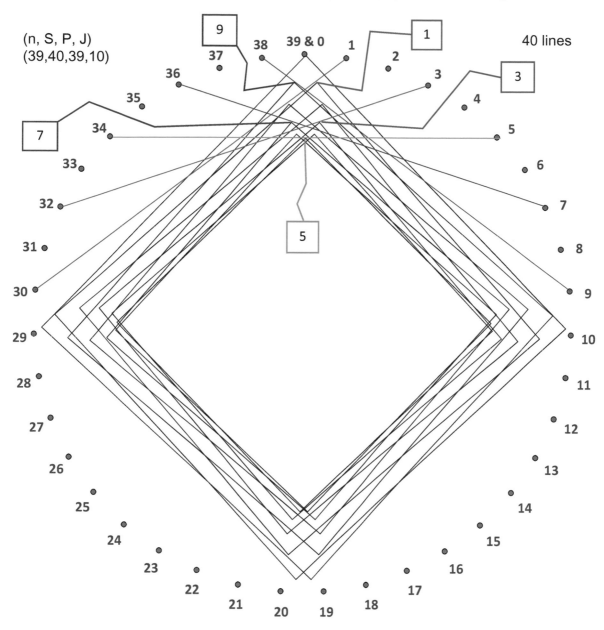

The image above, from Section 11.6.1, has been annotated to help explain why there are *J* quivering polygons in each image. Here, *J* = 10. This image is based on *n* = *P* = *S*-1 so that the apparent square peaks quiver in a clockwise direction. To reduce clutter, only the odd peaks have been annotated here (with labels 1, 3, 5, 7, and 9), located on line segments connecting to vertices **1**, **3**, **5**, **7**, and **9** of the 39-gon. Each of these line segments is part of the vertex frame.

On the number of peaks: As noted in *Quivering Polygons* Section 11.6.1, the first peak (labeled 1) is 9/10 of the way from **30** to **1** (on the blue line) or, to look at it from the other side of the coin, it

is 1/10 of the way from vertex **1** on this line. Similarly, the second peak is 2/10 on the way from the (not shown) line from **2** to **31**). And the third (labeled 3) is 3/10 away from **3** on the blue line from **3** to **32**. The same is true for all other peaks as well.

Half of the peaks have been labeled above, and we have discussed why the locations are where they are. The other half (here five) are in pairs (2 and 8, 4 and 6) at the same height as one another, plus the peak of the parent polygon (at **39&0**). Note that the only parent vertex that is part of quivering images is this peak (at **39&0** or **41&0**).

Note that if J is even, there is a SINGLE lowest peak that occurs on the line connecting $J/2$ with n-$J/2$. This line is horizontal. Further, the peak is as the MIDPOINT of that line (($J/2)/J = ½$ of the way from $J/2$ to n-$J/2$). When $n = 39$ and $J = 10$ that occurs on the green line from **5** to **34**. If J is odd, the two lowest peaks occur on lines $(J$-1)/2 to n-$(J$+1)/2 and $(J$+1)/2 to n-$(J$-1)/2. The first of these will be upward-sloping, and the second will be downward-sloping. More generally,

> When the line is connected to a vertex, v, $0 < v < J/2$ that line will be positively sloped (because the other end, at vertex n-J+v, is below v). Two such lines are provided in the annotated image, both are **blue**.
>
> When the line emanates from any vertex, v, $J/2 < v < J$ that line will be negatively sloped (because the other end, at vertex n-J+v, is above v). Two such lines are provided in the annotated image, both are **red**.

On the direction of rotation: Consider the direction of peak rotation of the quivering polygons. With $n = P = S$-1, the peaks quiver in a clockwise direction. The initial peaks (aside from the starting point) are in Quadrant I (1, 2, 3, and 4 here). When J is even, the $J/2^{nd}$ peak is on the border between Quadrants I and II. And the rest of the peaks (6, 7, 8, and 9 here) are in Quadrant II. One can see this dynamic ↻ rotation at (39,40,39,10) using *Drawing Mode, Fixed Count Line Drawing* with *Drawn Lines* = 4.

Compare this with $n = P = 41 = S$+1 shown on the next page. The first peak (labeled) is 4/40 = 1/10 of the way from vertex **40** to vertex **9** (since four segments mean 84 subdivisions given $P = 41$). This point is on the negatively sloped fifth line of the vertex frame (since $S = 40$) and is in Quadrant II. The same will be true for peaks 2, 3, and 4. The fifth peak is once again halfway between vertices **36** and **5**, and the last half are on positively sloped vertex frame lines with endpoints **35** and **4**, **34** and **3**, **33** and **2**, **32** and **1**, and **31** and **0**. Each of these peaks is in Quadrant I. In this instance, the peaks in this image are sequentially created in a counterclockwise fashion. To see this ↺ rotation, use (41,40,41,10).

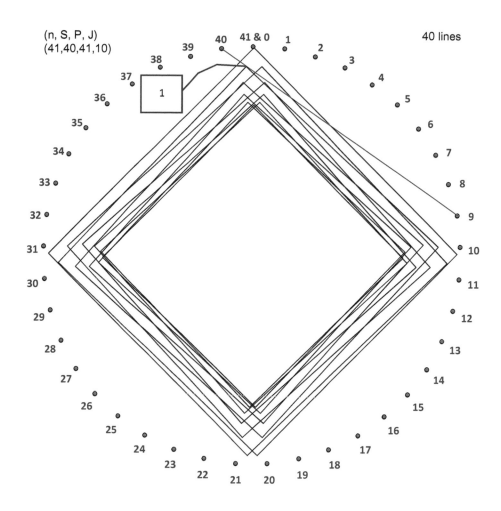

11.6.3 The Relative Size of *S* and *P* in Quivering Polygons

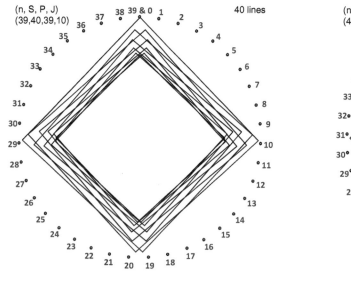

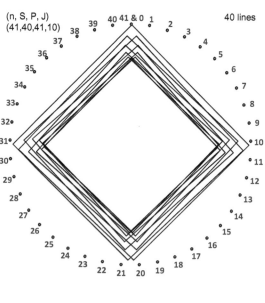

Quivering polygons are created by having *P* = *n* just above or just below *S* which is a multiple of *J*. The two 40-line images from Section 11.6.1 and 11.6.2 are shown side by side on the previous page. The one on the left has *P* = 39 < 40 = *S* and on the right *P* = 41 > 40 = *S*.

 All images are based on the subdivision points on the vertex frame. When *P* < *S* at least some part of the vertex frame will be in the final image because two endpoints are on the same part of the vertex frame (see Section 4.2.1). By contrast, if *P* > *S* then each subsequent point MUST be on a different part of the vertex frame.

 Both scenarios are seen by comparing these images with their vertex frames below (obtained by setting *S* = *P* = 40). The difference is apparent in the lines emanating from **39&0** and **41&0** in each image. The 1st and 40th line segments in the left final image **are on** the 1st and 39th part of the vertex frame (from **0** to **10** and **29** to **39**). Those same segments in the right final image are below the first and last part of the vertex frame from **0** to **10** and **31** to **41**. (They are on segments from **10** to **20** and **21** to **31** since *P* = *S*+1).

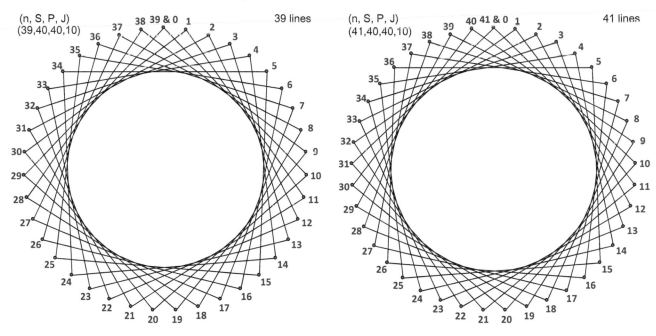

11.6.4 MA. Why Quivering Polygon Peaks Rotate the Way They Do (a **Triangular Example**)

This explainer brings together images from *Excel* files 10.0.1 (*subdivision numbers*) and 5.0 (*tracking lines*) to examine why these peaks rotate clockwise. We have ↻ rotation since *n* = *P* = 29 < 30, but change 29 to 31 and ↺ rotation occurs.

29&0

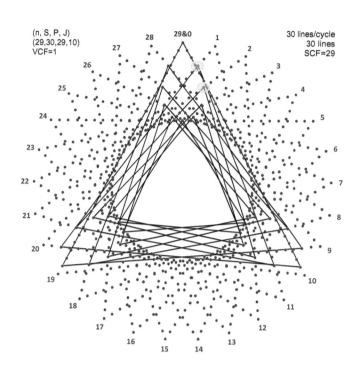

Subdivision endpoint k, kP, E_k=MOD(kP,B)		
1	29	29
2	58	58
3	87	87
4	116	116
5	145	145
6	174	174
7	203	203
8	232	232
9	261	261
10	290	290
11	319	319
12	348	348
13	377	377
14	406	406
15	435	435
16	464	464
17	493	493
18	522	522
19	551	551
20	580	580
21	609	609
22	638	638
23	667	667
24	696	696
25	725	725
26	754	754
27	783	783
28	812	812
29	841	841
30	870	0

(n, S, P, J)
(29,30,29,10)
VCF=1

30 lines/cycle
30 lines
SCF=29

In this instance, it is useful to think of the early Sub Ends (which notes the number of subdivisions from the start of the VF frame segment) as the distance from the end of the VF segment. In this conceptualization (mathematically Sub End – S), the first line ends at -1 (1/30 of the way from vertex **10** to **0**, the second ends at -2 (2/30th of the way from vertex **20** to **10**), and the third at -3. This means that the *first* peak at subdivision point **87** = 3·29, (k = 3 to left and below and highlighted in yellow above) is at Level 3 (see Section 7.1), **to the right of the centerline** of the image 3/30 = 1/10th of the way from vertex **1** to **20**. The *second* peak, also highlighted above at subdivision point **174** = 6·29, k = 6 is at Level 6. The *third* is at Level 9, the *fourth* at Level 12. The *fifth* is (the innermost) Level 15, **on the centerline**, halfway along the horizontal VF line from **24** and **5**). The *sixth* peak, at k = 18, is at Level 12, and the *seventh to the ninth*, k = 21, 24, and 27 are at Levels 9, 6, and 3, respectively. Note that **783** = 27·29 is 3/30 = 1/10th of the way from vertex **28** to **9**, **to the left of the centerline**. The final line (k = 30) completes the *tenth* peak at the top of the image. The peaks were completed in a clockwise rotation.

Line k	1	2	3	4	5	6	7	8	9	10	11	12	13	14	15	16	17	18	19	20	21	22	23	24	25	26	27	28	29	30
Sub End	29	28	27	26	25	24	23	22	21	20	19	18	17	16	15	14	13	12	11	10	9	8	7	6	5	4	3	2	1	0
Segment	0.97	1.933	2.9	3.867	4.833	5.8	6.767	7.733	8.7	9.667	10.63	11.6	12.57	13.53	14.5	15.5	16.4	17.4	18.4	19.3	20.3	21.3	22.2	23.2	24.2	25.1	26.1	27.1	28.0	29.0
VF Start	0	10	20	1	11	21	2	12	22	3	13	23	4	14	24	5	15	25	6	16	26	7	17	27	8	18	28	9	19	0
VF Stop	10	20	1	11	21	2	12	22	3	13	23	4	14	24	5	15	25	6	16	26	7	17	27	8	18	28	9	19	0	10

The Vertex Frame (VF) start and stop are the RED numbered vertices of the polygon.

Level	1	2	3	4	5	6	7	8	9	10	11	12	13	14	15	14	13	12	11	10	9	8	7	6	5	4	3	2	1	0
Δ Level	1	1	1	1	1	1	1	1	1	1	1	1	1	1	1	1	1	1	1	1	1	1	1	1	1	1	1	1	1	1

11.7 Odd Needle Stars

Needle stars are stars that are created with very sharp points. These points are sharper than you can get by setting **S** = **P**. Three rows are shown here (5-, 7- and 11-**point** stars) with three versions in each row. Each column has the same **n**, **S**, **P**, and **J** attributes as noted at the top of each column.

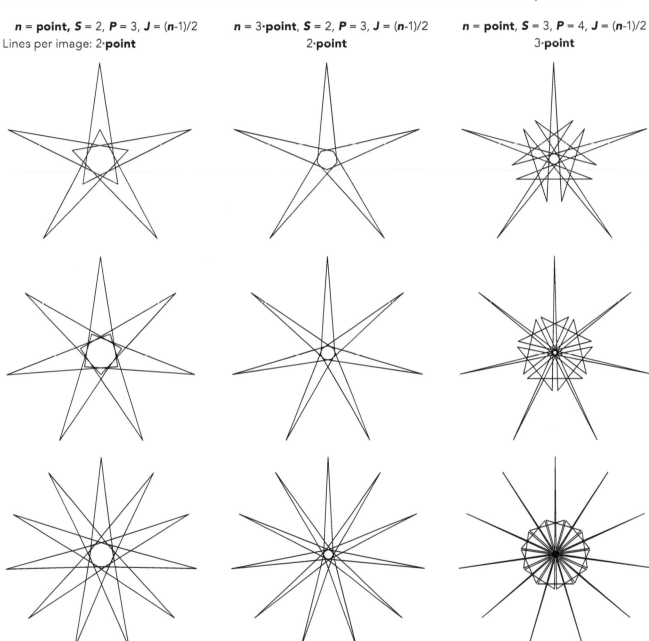

n = **point**, **S** = 2, **P** = 3, **J** = (n-1)/2
Lines per image: 2·**point**

n = 3·**point**, **S** = 2, **P** = 3, **J** = (n-1)/2
2·**point**

n = **point**, **S** = 3, **P** = 4, **J** = (n-1)/2
3·**point**

The needles get sharper going from left to right in a row, and as the number of points increases, so does the sharpness of individual points in a given column. It appears that the bottom left 11-star is no sharper than the version drawn with 11 rather than 22 lines. But a quick check confirms that the angles are sharper here than if you scroll **S** up one so that **S** = **P** = 3. Notice that the structure of each

star's first two columns is within each "leg" of the star (like the *Star in a Star* images from Section 9.1), but in the third column, there is a framework that extends beyond these legs.

A couple of questions to ponder: Can you find examples of even point-needle stars? If so, can you determine rules such as those above that produce even point stars?

11.8.1 Spinning Needle Stars

Needles are created when *large level differences* exist between points or when points are "far" away from one another (like porcupine polygons). For a review of *Levels*, see Section 7.1. Spinning needle stars all have two attributes: 1) They are *one-time around* images, and 2) each cycle does not include the center of the circle. The second attribute suggests that the points cannot be too far from one another; thus we rely on images that have substantial change in level between at least some of the points (such as the first and last points of a cycle).

The first two images are examples of "open" versions, both have **n** = 30 so only 1/6th of the vertices are included in the left image (5), and 1/5th of the vertices are included in the right image (6). Both are based on **J** = 13 and both are drawn in a counterclockwise direction. That is readily changed by changing to **J** = 17. These are best seen using *Drawing Mode*:

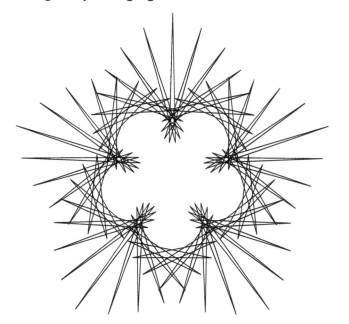

(30,25,288,13) 12 Level, 125 line, 5-point. (30,23,265,13) 11 Level, 138 line, 6-point.

It is a bit harder to see the structure of spinning stars once the number of points on the star increases. By viewing the image using *Drawing Mode, Fixed Count Line Drawing*, and watching multiple times while focusing attention on the initial part of the image, you should be able to discern the structure of the star. The links below take you to some examples:

(28,21,136,13) Level 10, 147 line, 7-point. (30,19,219,13) 9 Level, 190 line, 10-point.

(30,17,196,13) Level 8, 255 line, 15-point. (19,11,116,9) 5 Level, 209 line, 19-point.

(23,7,18,9) Level 3, 161 line, 23-point. (30,11,127,13) 5 Level, 330 line, 30-point.

(30,24,277,13) Level 12, 720 line, 30-point. (30,28,323,13) 14 Level, 840 line, 30-point.

Because the stars are created as a *one-time-around* image (Section 5.2), spikes intermingle with one another, especially in the middle-level range. These stars have a more open structure when SCF > 1 and the number of points is *n*/SCF. Compare the openness of the *n* = 30 examples above with 5, 6, 10, or 15 points versus the three 30-point versions. When SCF = 1, these images are also *single-step* (Section 8.5.1) due to the *one-time-around* nature of the image. When SCF > 1, these images tend to be *smallest-step* of length 2 (Section 9.4). Section 9.6 discusses 4-, 3-, and 2-point stars.

This crossover is most readily seen in the annotated image on the next page. This is a different 6-point star from the one shown above. **The first cycle is shown in red**. Note that the tenth line of the first cycle (from **9** to **10**) is a line whose endpoints are both at Level 5 (see last row of the table at the bottom of the page which is from *Excel* file 5.0, which tracks points on the first cycle). The even points before **10** create the left side spikes of the top star (centered at **24 & 0**), and the odd points after **9** create the right side of the star whose central spike is at **20**.

Click (24,19,124,11), use *Drawing Mode, Fixed Count Line Drawing*, and adjust *Drawn Lines* and *Drawing Speed*.

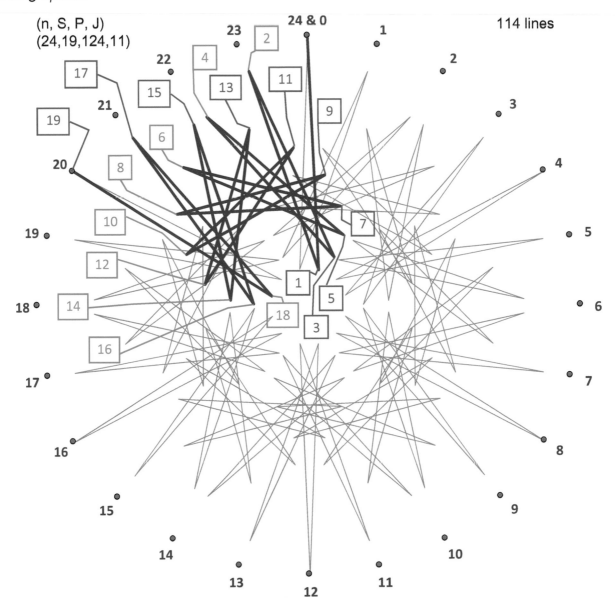

| | 24 *n* | | | | | | | | | Sub End = MOD(*k***P*, *S*) | | | | | | | | | |
| 19 *S* | | | | | | | | | | Segment = *k***P*/*S* | | | | | | | | | |

Tracking segments for first cycle of a *Spinning Star*

| 124 *P* | | | | | | | | | | VF Start = MOD(INTEGER(Segment)**J*, *n*) | | | | | | | | | |
| 11 *J* | | | | | | | | | | VF Stop = MOD(VF Start +*J*, *n*) | | | | | | | | | |

Polygon vertices are in RED

Endpoints of first cycle segments are labelled by color:

Odd endpoints in BLUE Even endpoints in GREEN

Level = MIN(Sub End, *S*-Sub End).

Line *k*	1	2	3	4	5	6	7	8	9	10	11	12	13	14	15	16	17	18	19
Sub End	10	1	11	2	12	3	13	4	14	5	15	6	16	7	17	8	18	9	0
Segment	6.53	13.05	19.58	26.11	32.63	39.16	45.68	52.21	58.74	65.26	71.79	78.32	84.84	91.37	97.89	104.4	110.9	117.5	124.0
VF Start	18	23	17	22	16	21	15	20	14	19	13	18	12	17	11	16	10	15	20
VF Stop	5	10	4	9	3	8	2	7	1	6	0	5	23	4	22	3	21	2	7

The Vertex Frame (VF) start and stop values are the **RED** numbered vertices of the polygon.

Level	9	1	8	2	7	3	6	4	5	5	4	6	3	7	2	8	1	9	0

11.8.2 Spinning Needle Stars, Take 2: Even and **Odd** Dancing Partners

This section continues the analysis of (24,19,124,11) from Section 11.8.1 that is drawn using *Drawing Mode*.

(n,S,P,J)=(24,19,124,11) 114 lines

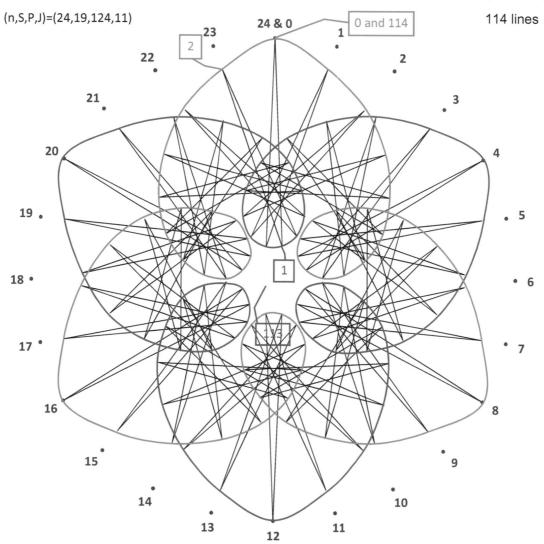

Every line segment has an **even** and an **odd** endpoint. As a result, one can consider what happens to every other endpoint to see if a pattern emerges. Because a spinning needle fan is a *one-time-around* maximal level change image, the pattern is particularly easy to see. The image above shows two hand-drawn curves, **blue** and **green**. **Blue maps all odd endpoints** and **green maps all even**. Note that both images are identical, but simply rotated 60°. Each has three inner loops and three outer leaf petals, both drawn counterclockwise. **Even** and **odd** are dancing partners, each following one another.

Blue odd values. The first **blue** vertex point (**20**) is at the 19th line (curling around from point **1** to **20** and is the **tenth odd point**). The second **blue** vertex point (**12**) is at line 57 = 3*19, and the third **blue** vertex point (**4**) is at line 95 = 5*19.

Green even values. The first **green** vertex point (**16**) is at the 38th line (looping around from point **2** to **16** and is the **19th even point**). The second **green** vertex point (**8**) is at line 76 = 4*19, and the third **green** vertex point (**24&0**) is at line 114 = 6*19.

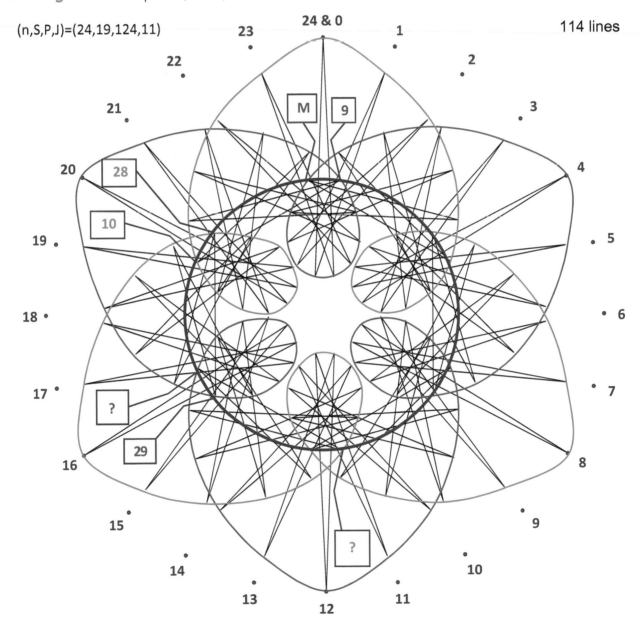

(n,S,P,J)=(24,19,124,11) 114 lines

Here is one more take on the same image. On page 2 of the first explainer on spinning needle stars, there is an *Excel* sheet that lines 9 and 10 both end at Level 5. A **red circle** has been superimposed on the image so that you can see this level. This can be thought of as the crossover between the leaf and loop part of the image. Each leaf has nine points at Level < 5, and each loop has eight points at Level > 5. By looking inside and outside the circle you can count these points.

Since there are six cycles, there are 12 points at Level 5, the first three pairs of which are noted in the image above. Two pairs have endpoint values attached, and the third set simply shows question marks, one **odd** and the other **even**.

Without manually counting along the green and blue curves, can you determine the value of **?** and **?** above?

The last six Level 5 endpoints are mirror images of the first six using the vertical diameter as the axis of reflection. One such point is labeled **M**. This endpoint is numbered according to the following rule: Reflected end = 114 − original number so that **M** = 114 − **9** = **105**. Note that each reflection maintains its property of being either **even** or **odd**.

11.9 Ultra-Needles and the Benefit of Single Line Drawing Mode

Ultra-needles require first and last lines that create very sharp angles (and hence come from very close to the vertical line without being on the vertical line). Two images are shown: The first has 23 11-line cycles; the second has 13 13-line cycles. Both are shown with the **first TWO cycles highlighted in red** to emphasize the *conelike* nature of how the image is created.

These images are like the *porcupine images* from Section 11.3 in that any two lines create a very sharp angle, but porcupine images require **P** to be the closest number to **nS**/2 without being that value. Both values of **P** are much smaller than **nS**/2.

(23,11,16,8)

First image. There are 23 bundles of lines meeting about 2/3 of the way to the center. The first line and lines 11 and 12, which create the needle at vertex 13 (two past the bottom), are centerlines to these bundles. A close-up of the **bundle** centered on vertex 0 to the left shows that 14 lines (two lines for each of seven needles) create these bundles. These bundles create striking open spaces in this ultra-needles image.

Second image. In this image, the 13 largest bundles are between the 13 vertex spikes. The close-up to the left shows the **bundle** between vertices 0 and 4 and a **bundle** with fewer lines closer to the outside as well as a **bundle** centered on vertex 0 nearer the center.

Drawing modes. (See Section 25.4.) If viewed as *Fixed Count Line Drawing* with DL = 11 for first or DL = 13 for second, the images are not as satisfying to watch get drawn as if DL = 2. Perhaps the best is to use *Single Line Drawing*, *SLD*, with DL = 11 for first or DL = 13 for second. When viewed this way, this is like this (22,13,111,9) image seen in *SLD* with DL = 13.

[These bundles are similar to those that occur in multi-jump models such as the *needle fans* discussed in Section 16.7.]

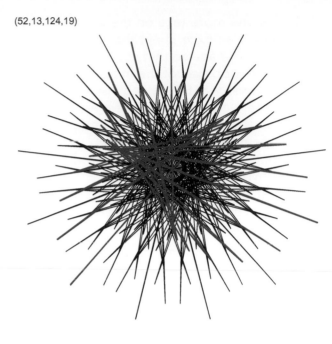

(52,13,124,19)

11.10.1 Stacked Circles

The four images below are examples of stacked circles (although the circles are really polygons with lots of sides). Each image looks like it is built out of similar layers stacked on one another.

Start with an odd n (here 23) then let $J = (n-1)/2$ (here 11) so that the vertex frame is a *Sharpest Star* (see Section 2.3.1).

If you want k circles, set $S = 2k$ (S = 6, 8, 10, and 12 here). This means that there are subdivision points at k different distances from the center with the k^{th} being closest to the center, or k Levels of subdivision points using Section 7.1.

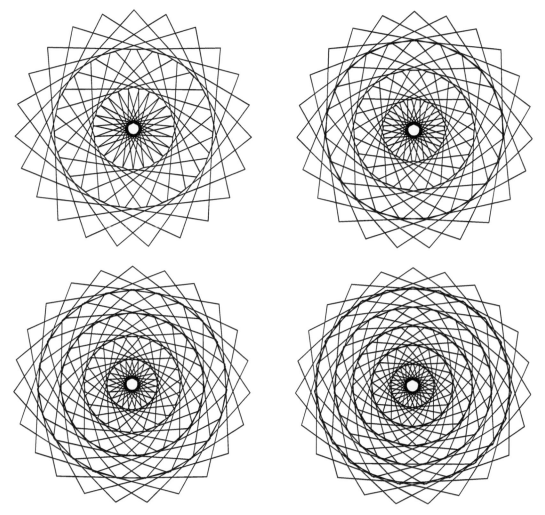

In each instance, set $P = 6S - 1$ (P = 35, 47, 59 and 71 here).

There is an annotated version of the 3-layer upper left image on the next page.

Upper left, 3-Layer Version (23,6,35,11) Upper right, 4-Layer Version (23,8,47,11)
Lower left, 5-Layer Version (23,10,59,11) Lower right, 6-Layer Version (23,12,71,11)

The annotated image shows the first *cycle* of six segments when $S = 6$. Note that the sixth endpoint is once again one of the polygonal vertices (which ends the first cycle). The layering mentioned above is clear here: The **red subdivision endpoints** create three concentric internal circles.

Subdivisions 1 and 5 on each segment of the vertex frame help create the outer circle, 2 and 4 help create the middle circle, and 3 creates the inside.

Notice how the lines from 0 to 1 (the first segment) and 5 to 6 (the last segment in the first cycle) almost seem to be on the same line from 0 to 6. In reality, they are not, but the difference is so slight that 1 to 5 appears to simply be part of the circle. This flat approach to this pair of subdivision points is why the resulting image has an apparent circle at that level. The same is true of the segments from 1 to 2 and 5 to 4 regarding how they relate to the middle set of subdivision points. Finally, the segments from 2 to 3 and 4 to 3 surround the inner circle. This loop around the center is one of the defining features of this image type. Using the above links, click *Drawing Mode* then use *Fixed Count Line Drawing* to see how each image was created using a cycle that loops around the center.

When **n** is larger, the relation **P** = 6**S** – 1 no longer provides as nice an image. For example, with **n** = 41, 8**S** – 1 and 10**S** – 1 appear to do a better job at creating the circles. This link shows a 6-layer image given **P** = 119 (compare with 71 and 95).

Six-layer version with **n** = 41: (41,12,119,20).

These images share similarities with *Mystic Roses* discussed in Section 18.2. These images create concentric circles via larger jump sets, much like stacked circles do here. The difference is that the concentric circles visible in Mystic Roses are created without subdivisions.

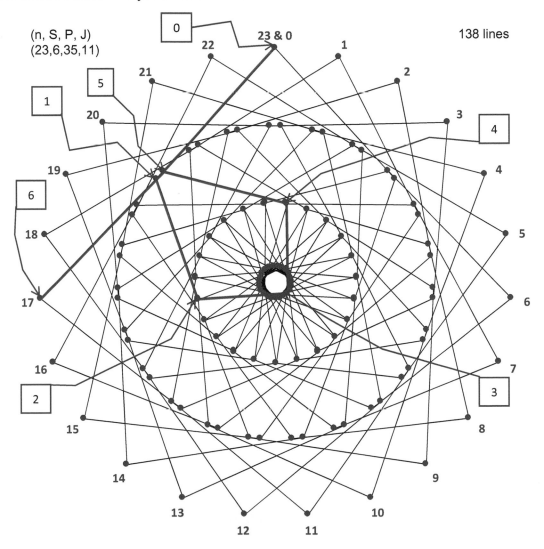

11.10.2 Stacked Circles With a Focus on Levels

Stacked circles have two additional attributes that are worth mentioning. We will continue to use the three concentric circles version discussed in Section 11.10.1, $(n,S,P,J) = (23,6,35,11)$, reproduced at left. Concentric circles are created by having an **S**-segment looping circuit move in or out one level at a time.

1) Stacked circles involve adjacent points that are no more than one level removed from one another. (See Section 7.1 for a discussion of levels of concentric circles.)

Consider *Level 0* to be the vertices of the outer polygon. *Level 1* is one subdivision in from either end of lines on the vertex frame, *Level 2* is two subdivisions in from either end, and *Level 3* is the midpoint of the vertex frame lines. In terms of levels, the first six lines annotated on stacked circles went from Level 0 to 1 to 2 to 3 to 2 to 1 to 0. Adjacent image segment endpoints move by one level in and out.

Change **P** to **P** = 63 to create the ultra-sunburst shown at top right. This image jumps from Level 0 to Level 3 to Level 0 ... completely bypassing Levels 1 and 2 since SCF = 3.

2) Stacked circle layers have a simple *cross-hatched* design like Chapter 2 stars.

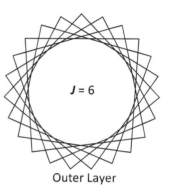

Outer Layer

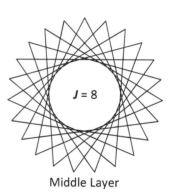

Middle Layer

Inner Layer

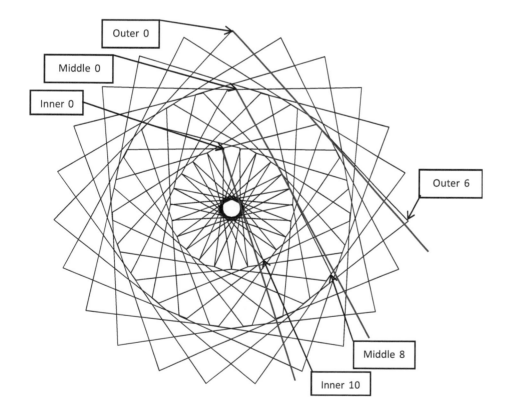

The three images to the right with J noted are 23-point stars with J determined by the closest value to the one implied by the **red lines** shown on the stacked star image. These lines are laid over image segments beginning at the **Outer 0**, **Middle 0**, and **Inner 0** points, and extended across to the outer polygonal vertices on the other side (recall how each part is created with a kink, so lines do not extend through exact J values). The first layer is a bit more than $J = 6$. The middle layer is a bit less than $J = 8$, and the inner layer is between $J = 10$ and $J = 11$ (with $J = 10$ shown). Note the similarity of cross-hatching in each part of the image to its corresponding 23,J-star to the right.

Note that sometimes the tips of the star image are cut off as with the middle layer.

11.10.3 Stacked Circles, Take 3: Variations on the Theme

Stacked circles, as conceptualized in Section 11.10.1, required four things:

1) odd n, **2)** $J = (n-1)/2$, **3)** even S, and **4)** P is just under an even multiple of S, $P = 2kS - 1$.

The resulting images have cycles that loop around the center of the circle. This creates an image with a tight-closed circle for the innermost layer and cross-hatching that does not extend into neighboring layers.

a) What happens when we relax each of these conditions without changing the other conditions?

b) Can we find alternative conditions that produce versions of stacked circles?

Question a) We start from the three-layer image annotated in 11.10.1 and 11.10.2, $(n,S,P,J) = (23,6,35,11)$, shown to the left on the next page, and change each condition.

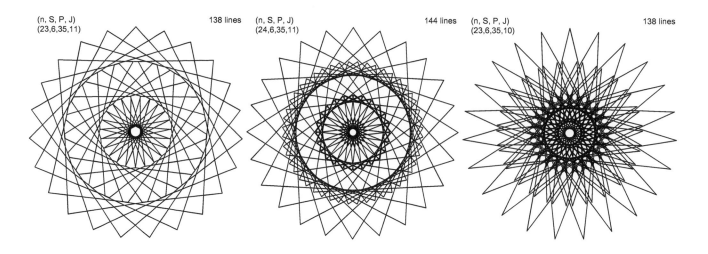

(n, S, P, J)
(23,6,35,11) 138 lines

(n, S, P, J)
(24,6,35,11) 144 lines

(n, S, P, J)
(23,6,35,10) 138 lines

1a) Changing to even **n** produces significant overlap between layers even though the images remain *One Level Change* images (see Section 7.2). For example, changing **n** = 23 to 24 (middle image above) produces two levels of cross-hatching as well as a circle that is noticeably inside the subdivision vertices creating each layer (click this link and click *Toggle Subdivisions* to see subdivision locations, or simply remember that they are at kinks in the image).

2a) Changing **J** to a value further away from the center (from 11 to 10 given **n** = 23, the right image above) produces even greater amounts of apparent movement across levels. Note that the image in this instance is more star-like.

3a) Changing **S** to the next larger or smaller number (7 or 5) reduces the image to a simple star because 35 is a multiple of both. But, to be fair, **P** was defined as a function of **S.** If we maintain the relationship, **P** = 6**S**-1, then the nearest odd choices are **S** = 5, **P** = 29, left below, or **S** = 7, **P** = 41, in the middle below are images that could be mistaken as stacked circles were it not for the **first cycle shown in red**. In both instances, the loops no longer include the center.

4a) Changing **P** to the just-over even multiple of **S**, **P** = 2**kS** + 1, right below, is also quite similar to stacked circles. But note that, as with 3a), the loops no longer contain the center.

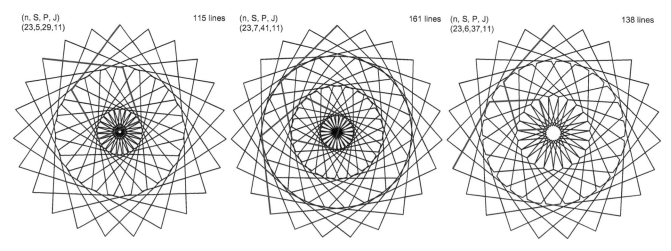

(n, S, P, J)
(23,5,29,11) 115 lines

(n, S, P, J)
(23,7,41,11) 161 lines

(n, S, P, J)
(23,6,37,11) 138 lines

Question b) We see that odd **S** and just-over **P** both produce alternative versions of stacked circles. It remains to be seen if we can find a version of stacked circles for even **n** and for **J** < (**n**-1)/2.

1b) If we combine an even **n** with a just-over odd multiple of **S** (here is **P** = 6·9+1 shown at left below), we obtain a credible version of stacked circles. The loop includes the center even though **P** is a just-over value. Just-under does not work quite as well here (try **P** = 53 and note that the center is no longer included).

2b) Changing to **J** = 10 requires a larger **P** to create the loop required to make the stacked circle image. The best version here is **P** = 53 shown on the right below, which is just-under 9**S**. The six-segment loop in this instance is a *one-time-around* image from Section 5.2 (click *Drawing Mode* to see this progression).

Notice that the loops once again include the center (unlike in **1b**) with **P** just-below.

Conclusion. We see that the class of images that might be considered stacked circles is wider than initially conceptualized. All images are *One Level Change* images, but the four restrictions initially imposed need not apply.

(n, S, P, J) 144 lines (n, S, P, J) 138 lines
(24,6,55,11) (23,6,53,10)

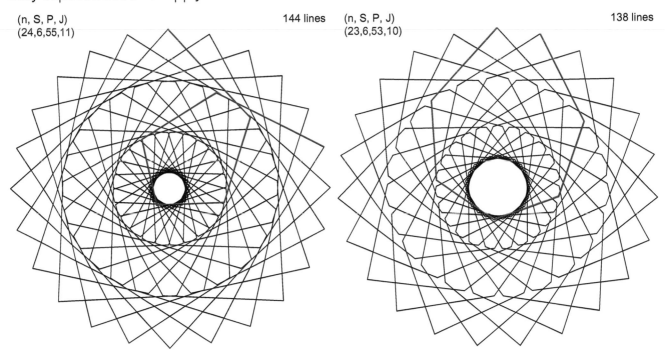

11.11 Chrysanthemums

Chrysanthemums are flowers that have a lot of small petals seemingly layered on top of one another. There are several candidate images you may come across, but an especially nice version is found by making a simple adjustment to Section 11.10, *Stacked Circles*. *Stacked Circles* are *One Level Change* images (Section 7.2) obtained by an **S**-segment cycle that loops around the center to make the levels look like circles. To make this happen, the change in direction from segment to segment is reasonably large. You can see those directional changes in the size of the kinks in the **12 red lines in the first cycle** in the left image. In that example, the cycle ends at vertex **2** so the vertex points need two clockwise rotations to complete the image (see Section 5.2). Click *Drawing Mode, Fixed Count Line Drawing* with *Drawn Lines* = DL = 12 to watch this happen.

Consider the directional changes of the lines that got us to the end of the first cycle. The lines have made almost two full counterclockwise rotations to end at vertex **2** (actual turn is 80/41). The

sixth endpoint, at Level 6, is almost one full turn (in fact it is 1/41st shy of a full turn). Put another way, note that the first and seventh red lines are almost parallel to one another (they are not but they appear to the naked eye like they could be). The second half of the first cycle is symmetric on the diameter starting at vertex **1** (see Section 6.4 for additional discussion of rotational symmetry).

For chrysanthemums, the change in direction from segment to segment within an **S**-segment cycle is smaller because the segments approximate an arc (rather than a loop). In the example on the right, the **12-segment cycle** still includes the center but arcs back to vertex **9** using a counterclockwise arc of a bit more than ¾ of a turn (actual turn is 32/41). Use the *Drawing Mode* to watch this happen. As the image is drawn, you see an approximate five-petal flower rotate around to complete the image in about nine rotations of vertex points (the five "petals" come from 41/9 being closer to 5 than 4).

stacked circles: **P** = 10**S** -1 = 119

Chrysanthemum: **P** = 2**S** -1 = 23

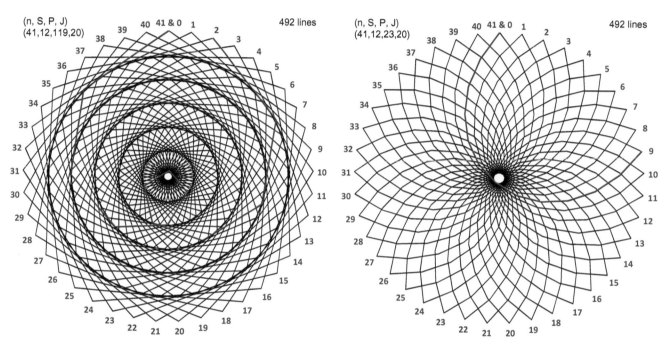

These two images differ only in **P**.

You can see variations on both images by simply increasing **P** by 2 to 121 and 25 (both are now "one over values"). Now the stacked circle loop and the chrysanthemum arc exclude the center, but the images otherwise appear very similar.

It is worth noting that the rotation pattern is very easy to see with **P** = 25. In this instance, arc vertices are eight away from one another, and **n** (41) is one off a multiple of 8 (5·8 = 40) so that the five-petal flower rotates counterclockwise one vertex for every rotation from vertex 8 back to 0. Put another way, (41,12,25,20) is ↺ *one-time-around* (Section 5.2) at 60 lines or five cycles since 12·5 = 60. Interestingly, it is also *single-step* of length 59 (Section 8.5.1) since subdivision endpoint 59 is the last subdivision point on the vertex frame before the top (59·25 = 491 MOD 492). (Use *Drawing Mode* with **P** = 25 with *Drawing Length* = 60 and 59 and reread this paragraph.)

11.12 Clothespins as Spinning Needle Stars Turned Inside-Out

As noted at various points in ESA, changing a parameter by 1 sometimes produces entirely different images. Such is the case with **some** spinning needle stars, SNS (examined in Sections 11.8.1, 11.8.2, and 9.6). Some SNS turn into traditional clothespins, CP, by changing **P** by 1. (For those who are on the younger side, a clothespin has two sides that form a sharp A-frame with a spring holding the sides together (Google it).) Only two of the 11 SNS noted in Section 11.8.1 do so. These are (30,19,219,13) 10-point SNS, add 1 for 9 CP with 57 lines; and (30,28,323,13) 30-point SNS, add 1 for 10 CP with 70 lines.

The two examples below decrease **P** by 1 from left to right. Top row (30,21,115,11) 6-point SNS to 15 CP. Bottom row (42,23,57,17) 14-point SNS to 9 CP (only three of the nine CP points are at polygonal vertices). Lines varies from left to right in each row because SCF varies as **P** varies. In each instance, the direction in which the CP is drawn is the opposite direction from which the SNS is drawn. Curves between points for CP appear to be on the outside, the reverse of SNS. Here are two more CP examples: (50,19,125,23) 6 CP, and (42,3,56,17) 3 CP.

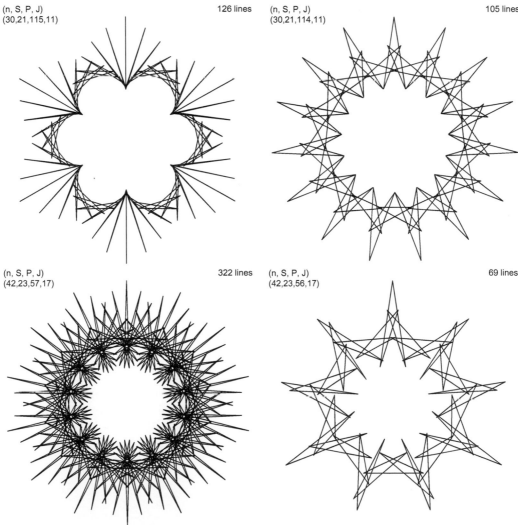

(n, S, P, J)
(30,21,115,11) 126 lines

(n, S, P, J)
(30,21,114,11) 105 lines

(n, S, P, J)
(42,23,57,17) 322 lines

(n, S, P, J)
(42,23,56,17) 69 lines

Chapter 12

n = *P* Images

12.1 An Introduction to *n* = *P* Images

Overview and rationale. The class of images where **n** = **P** deserves special attention. These images tend to have a lot fewer lines than those that "surround" these images. Increase or decrease **n** or **P** by 1 and the number of lines expands dramatically. For example, the image to the right (which provided the rationale for creating this section in the first place) has 44 lines but changes **P** by 1 to 45 and the image explodes to 2024 lines. Click (46,44,45,15) and watch the 44 lines per cycle 46-cycle **twisted**-quivering-triangle image emerge (set *Drawn Lines* = 3, *Drawing Speed* to 3 initially then to 25 or more once you see the pattern using the *Fixed Count Line Drawing*).

 n = **P** images also tend to have a lot fewer cycles. For example, the 2024-line **P** = 45 image discussed (but not shown) above had 46 cycles, and the **P** = 46 version (46,44,46,15) shown on the right has two 22-line cycles.

 Although we will explore some of the attributes of these images with *Excel*, they are most appropriately examined using the web version of the file. These images employ much larger **n** values than the *Excel* file is set up to handle.

(n, S, P, J)
(46,44,46,15)
VCF=1

22 lines/cycle
44 lines
SCF=46

DOI: 10.1201/9781003402633-14

Lines in the image. The number of lines in an image is nS/VCF/SCF as noted in Section 4.1. If $n = P$ and VCF = 1, this simplifies to S lines in the image because SCF = GCD(nS/VCF,P) = GCD(nS,n) = n. When VCF > 1, the number of points used will be S or a factor of S because $SP = Sn$ if $n = P$ so that the S^{th} subdivision endpoint MUST be a point at the top of the polygon, even if it is not the first time that the circuit has been completed. (For example, $n = P = 20$, $J = 8$ has VCF = 4. Consider three scenarios, $S = 14$, 15, and 16 shown. The image has seven lines if $S = 14$, 15 lines if $S = 15$, and four lines if $S = 16$. The first image has half as many lines as S, the second has S lines, and the third has one-fourth as many lines as S.)

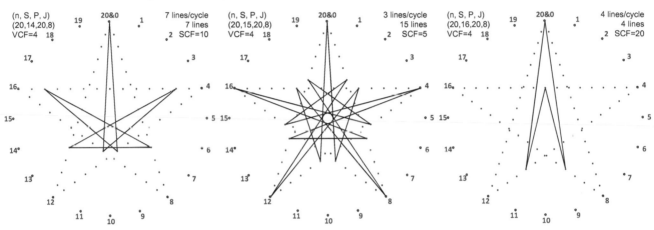

Cycles in the image. As always, the lines that comprise the image are made up of cycles. As noted in Section 5.1, the number of lines in a cycle is S/GCD(S,P). The $S = 14$ image has one cycle since there are seven lines per cycle, the $S = 15$ image has five cycles since there are three lines per cycle, and the $S = 16$ image has 1 one cycle since there are four lines per cycle.

Changing direction. As noted in Section 6.2, you always get the same image drawn in the reverse direction by changing J to n-J.

When scrolling through S or J for fixed n = P, don't simplify values. This stands in opposition to the suggestion that the smallest values of n, S, P, and J be considered when analyzing an individual image proposed in Section 6.1. The image analyzed in that explainer is the $S = 16$ version to the right, but it would not be seen in the context of varying S values had the image been simplified. Such situations inevitably arise due to common divisors between the parameters of the model.

Avoid divisibility issues by using primes for n. Note that lines in the VF depend on the GCD of n and J and lines in the image, and the number of cycles depends on the GCD of S and $P = n$. Both GCDs equal 1 if n is prime so that the number of lines in the image is always S. Rusty on your prime numbers? Section 21.1 provides a quick refresher.

12.2 *n* = *P* Image Archetypes

with Links to Similar Images with Larger *n*, DL is *Drawn Lines* in Red on Image Shown

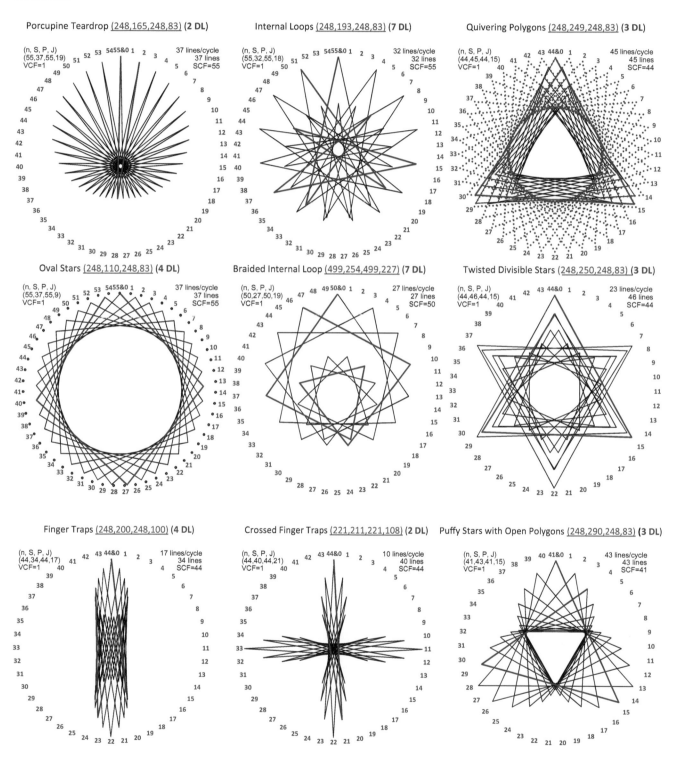

Porcupine Teardrop (248,165,248,83) (2 DL)

Internal Loops (248,193,248,83) (7 DL)

Quivering Polygons (248,249,248,83) (3 DL)

Oval Stars (248,110,248,83) (4 DL)

Braided Internal Loop (499,254,499,227) (7 DL)

Twisted Divisible Stars (248,250,248,83) (3 DL)

Finger Traps (248,200,248,100) (4 DL)

Crossed Finger Traps (221,211,221,108) (2 DL)

Puffy Stars with Open Polygons (248,290,248,83) (3 DL)

The images below are a small sampling of the wide variety one can find with larger _n_ = _P_ models using the web version.

Endpoints for the first image below stay on "their own" football so that the horizontal ball has odd endpoints, and the vertical has even. By contrast, the middle image uses endpoints across footballs. Using the _Single Line Overlaid Drawing_ mode, you can see that the 100th line starts the fill-in of the remaining half of the endpoints (100 to 198) that were not filled in the "first time around" (such as between the top starting point and endpoint 4 just past the top to the right in the image). The third image is surprising as it shows thin curves with lots of "open" space in an otherwise intricate triangular looping flower pattern. The space is "open" because only one in 499 subdivision points are used, SCF = 499. If you click _Toggle Subdivisions_ you will see that the image is no longer visible beneath the solid donut of 126,746 = 254·499 subdivision endpoints.

<u>Two footballs</u> **with 2-internal 4-point ✚ (164 lines,** 2 DL**)** <u>Three intertwined footballs</u> **(198 lines,** 4 DL**)** <u>3-strand, 7-loops of coiled rope</u> **(254 lines,** 13 DL**)**

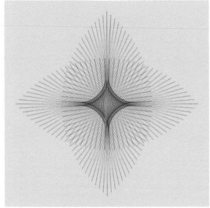 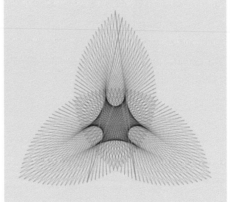

12.3 Divisibility and the Elusive 6,2-Star

As noted in Section 2.2.1, the only **_n_ > 4** for which a continuously-drawn star **cannot** be drawn is **_n_ = 6**. The problem in this situation is straightforward: The only number between 1 and **_n_/2 = 3** is 2 and **_J_ = 2** has a common factor with 6. The star can, of course, be drawn but not without lifting your pencil. There are two circuits in this instance, one **even (vertices 6&0, 2, 4)** and the other **odd (vertices 1, 3, 5)** in the image to the right. Similar issues occur whenever the _Vertex Common Factor_, VCF = GCD(**_n_**, **_J_**) > 1 so that the only way to draw a 9,3-star is with three circuits, one divisible by 3 (vertices 9&0, 3, 6), one with remainder 1 upon division by 3 (vertices 1, 4, 7), and one with remainder 2 upon division by 3 (vertices 2, 5, 8).

Electronic string art cannot draw such stars due to the _continuously-drawn_ nature of ESA images. But if we start with a quivering triangle and adjust **_S_** up or down by 1, we can get an _approximation_ of this image. Here are four examples.

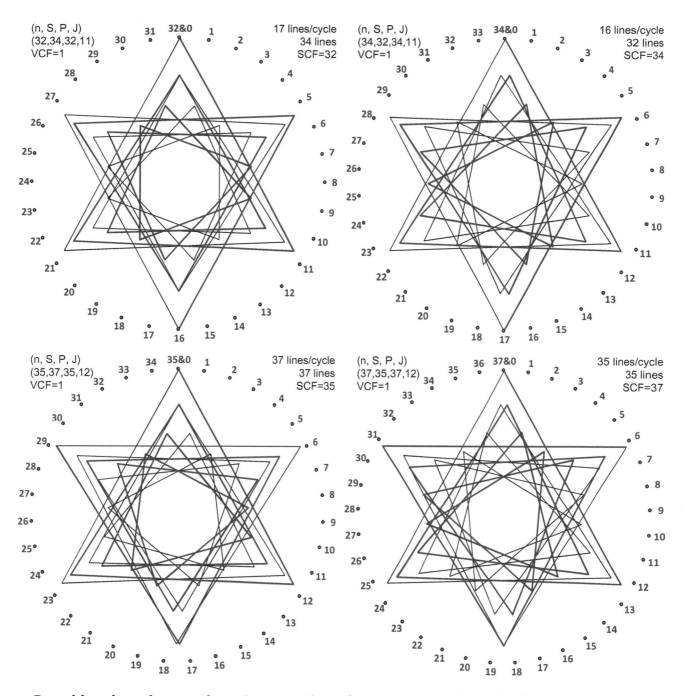

Broad brushstrokes on these images. These four examples exhibit the four possible types of 6,2-stars based on a 2×2 array. Each adjusts **S** in the opposite direction from the **n = P** adjustment. Consider columns and rows.

Columns: The images in the left column are based on triangles that rotate in a counterclockwise direction, ↺. This occurs when **S** = **n**+2 = **P**+2 and **n** = **P** = 3**J**−1. The images in the right column are based on triangles that rotate in a clockwise direction, ↻. This occurs when **S** = **n**−2 = **P**−2 and **n** = **P** = 3**J**+1.

Rows: The top row shows what happens when **J** is odd. In this instance, there are two cycles since **n** and **S** are even (the first of which is shown in **red** in the upper row). The bottom row shows what

happens when **J** is even, so **n** and **S** are odd. In this instance, there is only one cycle, but the first **18 lines (six triangles)** are highlighted in **red**.

MA. Detail. This leans heavily on the *Quivering Polygons Peak Rotation* analysis, Section 11.6.4, which showed why the peak triangle rotates ↻ when **n** = 3**J**–1 (like the left column above) and the *Tracking Lines Excel* file 5.0, shown below for all four images. When **S** = 3**J**, the peak returns to the top vertex after **J** triangles. In the current situation, the first peak (line 3) is at Level 6 instead of Level 3 for the quivering triangle counterpart. Levels change twice as rapidly here so that we are at a low level (large triangle) at the **J**/2nd triangle and once again at **J**th triangle. In the context of the upper images, **J**/2 is the fifth or sixth triangle (line 15 or 18). The upper left **J**/2 peaks are near vertices **26** and **27** at Levels 4 and 2 respectively according to the first table below, an approximate 1/6 rotation ↻. The upper right **J**/2nd peaks are near vertices **6** and **5** at Levels 2 and 4 according to the second table below, an approximate 1/6 rotation ↻. In each instance, the second half of the triangles continue rotating in the same direction ending at approximately 1/3 of a rotation. The bottom image rotations are easy to see because the sixth peak (line 18) is the end of the red line. Both are at Level 1, the left is near vertex **29** ↻, and the right is near **6** ↻.

Line k	1	2	3	4	5	6	7	8	9	10	11	12	13	14	15	16	17	18	19	20	21	22	23	24	25	26	27	28	29	30	31	32	33	34
Sub End	32	30	28	26	24	22	20	18	16	14	12	10	8	6	4	2	0	32	30	28	26	24	22	20	18	16	14	12	10	8	6	4	2	0
Segment	0.94	1.882	2.824	3.765	4.706	5.647	6.588	7.529	8.471	9.412	10.35	11.29	12.24	13.18	14.12	15.1	16.0	16.9	17.9	18.8	19.8	20.7	21.6	22.6	23.5	24.5	25.4	26.4	27.3	28.2	29.2	30.1	31.1	32.0
VF Start	0	11	22	1	12	23	2	13	24	3	14	25	4	15	26	5	16	27	6	17	28	7	18	29	8	19	30	9	20	31	10	21		0
VF Stop	11	22	1	12	23	2	13	24	3	14	25	4	15	26	5	16	27	6	17	28	7	18	29	8	19	30	9	20	31	10	21	0	11	
Level	2	4	6	8	10	12	14	16	16	14	12	10	8	6	4	2	0	2	4	6	8	10	12	14	16	16	14	12	10	8	6	4	2	0
Δ Level	2	2	2	2	2	2	2	2	0	2	2	2	2	2	2	2	2	2	2	2	2	2	2	2	2	0	2	2	2	2	2	2	2	2

The Vertex Frame (VF) start and stop values are the RED numbered vertices of the polygon.

Line k	1	2	3	4	5	6	7	8	9	10	11	12	13	14	15	16	17	18	19	20	21	22	23	24	25	26	27	28	29	30	31	32
Sub End	2	4	6	8	10	12	14	16	18	20	22	24	26	28	30	0	2	4	6	8	10	12	14	16	18	20	22	24	26	28	30	0
Segment	1.06	2.125	3.188	4.25	5.313	6.375	7.438	8.5	9.563	10.63	11.69	12.75	13.81	14.88	15.94	17.0	18.1	19.1	20.2	21.3	22.3	23.4	24.4	25.5	26.6	27.6	28.7	29.8	30.8	31.9	32.9	34.0
VF Start	11	22	33	10	21	32	9	20	31	8	19	30	7	18	29	17	28	5	16	27	4	15	26	3	14	25	2	13	24	1	12	0
VF Stop	22	33	10	21	32	9	20	31	8	19	30	7	18	29	6	28	5	16	27	4	15	26	3	14	25	2	13	24	1	12	23	11
Level	2	4	6	8	10	12	14	16	14	12	10	8	6	4	2	0	2	4	6	8	10	12	14	16	14	12	10	8	6	4	2	0
Δ Level	2	2	2	2	2	2	2	2	2	2	2	2	2	2	2	2	2	2	2	2	2	2	2	2	2	2	2	2	2	2	2	2

The Vertex Frame (VF) start and stop values are the RED numbered vertices of the polygon.

Line k	1	2	3	4	5	6	7	8	9	10	11	12	13	14	15	16	17	18	19	20	21	22	23	24	25	26	27	28	29	30	31	32	33	34	35	36	37
Sub End	35	33	31	29	27	25	23	21	19	17	15	13	11	9	7	5	3	1	36	34	32	30	28	26	24	22	20	18	16	14	12	10	8	6	4	2	0
Segment	0.95	1.892	2.838	3.784	4.73	5.676	6.622	7.568	8.514	9.459	10.41	11.35	12.3	13.24	14.19	15.1	16.1	17.0	18.0	18.9	19.9	20.8	21.8	22.7	23.6	24.6	25.5	26.5	27.4	28.4	29.3	30.3	31.2	32.2	33.1	34.1	35.0
VF Start	0	12	24	1	13	25	2	14	26	3	15	27	4	16	28	5	17	29	29	6	18	30	7	19	31	8	20	32	9	21	33	10	22	34	11	23	0
VF Stop	12	24	1	13	25	2	14	26	3	15	27	4	16	28	5	17	29	6	6	18	30	7	19	31	8	20	32	9	21	33	10	22	34	11	23	0	12
Level	2	4	6	8	10	12	14	16	18	17	15	13	11	9	7	5	3	1	1	3	5	7	9	11	13	15	17	18	16	14	12	10	8	6	4	2	0
Δ Level	2	2	2	2	2	2	2	2	2	1	2	2	2	2	2	2	2	2	0	2	2	2	2	2	2	2	2	1	2	2	2	2	2	2	2	2	2

The Vertex Frame (VF) start and stop values are the RED numbered vertices of the polygon.

Line k	1	2	3	4	5	6	7	8	9	10	11	12	13	14	15	16	17	18	19	20	21	22	23	24	25	26	27	28	29	30	31	32	33	34	35	
Sub End	2	4	6	8	10	12	14	16	18	20	22	24	26	28	30	32	34	1	3	5	7	9	11	13	15	17	19	21	23	25	27	29	31	33	0	
Segment	1.06	2.114	3.171	4.229	5.286	6.343	7.4	8.457	9.514	10.57	11.63	12.69	13.74	14.8	15.86	16.9	18.0	19.0	20.1	21.1	22.2	23.3	24.3	25.4	26.4	27.5	28.5	29.6	30.7	31.7	32.8	33.8	34.9	35.9	37.0	
VF Start	12	24	36	11	23	35	10	22	34	9	21	33	8	20	32	7	19	6	18	30	5	17	29	4	16	28	3	15	27	2	14	26	1	13	0	
VF Stop	24	36	11	23	35	10	22	34	9	21	33	8	20	32	7	19	31	6	18	30	5	17	29	4	16	28	3	15	27	2	14	26	1	13	25	12
Level	2	4	6	8	10	12	14	16	17	15	13	11	9	7	5	3	1	1	3	5	7	9	11	13	15	17	16	14	12	10	8	6	4	2	0	
Δ Level	2	2	2	2	2	2	2	2	1	2	2	2	2	2	2	2	2	0	2	2	2	2	2	2	2	2	1	2	2	2	2	2	2	2	2	

Creating divisible stars. The starting point for creating "*close to*" divisible images such as a 6,2-star, is to start with a smaller-size quivering polygon. Use a triangle for the 6,2-star, a pentagon for a 10,2-star, a quadrangle for an 8,2-star, or a triangle for a 9,3-star. Consider 12-point stars. All but 12,5 are divisible and are not possible to create as exact images. *Close to* images are possible: Use a triangle for a 12,4-star, a quadrangle for a 12,3-star, and a hexagon for a 12,2-star.

Once you decide on the type of polygon (with **G** sides), you must decide how many of those polygons are used to create the final image. The number of polygons is **J**. From here we set **n** = **P** = **G·J** ± 1. Set **S** = **G·J** ∓ 1. Notice that the directions of adjustment switch between **n** = **P** and **S**. The resulting image will be a 2**G**-star. If you want a 3**G**- or 4**G**-star, the difference |**n** – **S**| must be **S** = **G·J** ∓ 2 or 3.

Challenge Questions. By adjusting **S** or **J** turn this (299,301,299,100) 6,2-star into a 9,3-star. Would you change **J** or **S** and to what? Turn the 9,3-star into a 12,4-star. Start again with the 6,2-star. Turn it into an 8,2-star, a 10,2-star, and a 12,2-star.

12.4 Small Images

(n, S, P, J)
(19,3,19,3)
k 1 VCF = 1 SCF = 19

(n, S, P, J)
(19,4,19,4)
k 1 VCF = 1 SCF = 19

Some $n = P$ images take up only a small portion of the total n-gon interior, and they typically show up as teardrop-shaped stars or polygons. There is an easy way to generate these images. All you need to do is set $S = J < n/2$. If the inequality reverses, $S = J > n/2$, the teardrop images are larger and include the center of the n-gon.

Each image is a *single cycle image* as discussed in Section 5.5. Additional images using these same endpoints exist for $P = k \cdot n$ where $1 \le k < S/2$. 16 images are possible if $n = 19$.

(n, S, P, J) (19,5,19,5) k 1 VCF = 1 SCF = 19 (n, S, P, J) (19,5,38,5) k 2 VCF = 1 SCF = 19 (n, S, P, J) (19,6,19,6) k 1 VCF = 1 SCF = 19 (n, S, P, J) (19,6,38,6) k 2 VCF = 1 SCF = 38

(n, S, P, J) (19,7,19,7) k 1 VCF = 1 SCF = 19 (n, S, P, J) (19,7,38,7) k 2 VCF = 1 SCF = 19 (n, S, P, J) (19,7,57,7) k 3 VCF = 1 SCF = 19

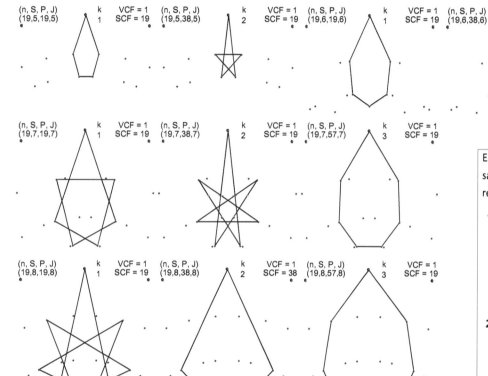

Each image was cropped to be the same width so size comparisons are readily possible. Note the following:

1. As *J* increases, the subdivision points get closer to the center (since the VF 19,*J*-star becomes sharper). Therefore, the images increase in size as *J* increases.

2. All but the third row contain a single $S = J$ value. In that row, the two $J = 5$ images are smaller than the $J = 6$ images due to Point **1**.

(n, S, P, J) (19,8,19,8) k 1 VCF = 1 SCF = 19 (n, S, P, J) (19,8,38,8) k 2 VCF = 1 SCF = 38 (n, S, P, J) (19,8,57,8) k 3 VCF = 1 SCF = 19

(n, S, P, J) (19,9,19,9) k 1 VCF = 1 SCF = 19 (n, S, P, J) (19,9,38,9) k 2 VCF = 1 SCF = 19 (n, S, P, J) (19,9,57,9) k 3 VCF = 1 SCF = 57 (n, S, P, J) (19,9,76,9) k 4 VCF = 1 SCF = 19

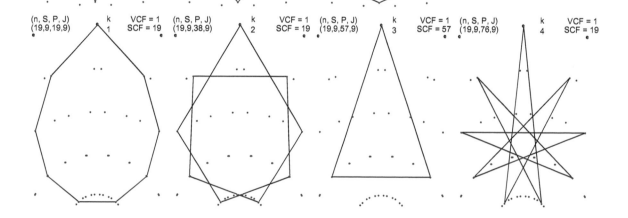

12.5 Counting Strands and Loops in Coiled Rope Images

When you encounter a thin **n** = **P** image that is comprised of multiple strands that are intertwined with one another, they look like a coil of rope with the ends spliced together to form a loop. Such a coil will have one or more loops and one or more strands in the rope. When the image is complex, the loops are sometimes difficult to count and the strands in the rope are also difficult to see. (**n** = **P**, **S**, **J**) for each image is noted: *Upper left* (251,81,251,75) has two strands and three loops; *upper right* (251,83,251,75) has two strands and four loops; *lower left* (499,254,499,227) has nine strands and three loops; and the *lower right* (499,254,499,233) has three strands and seven loops (and interestingly starting from lower right and changing **J** we see that **J** = 230 has eight loops and **J** = 236 has two loops).

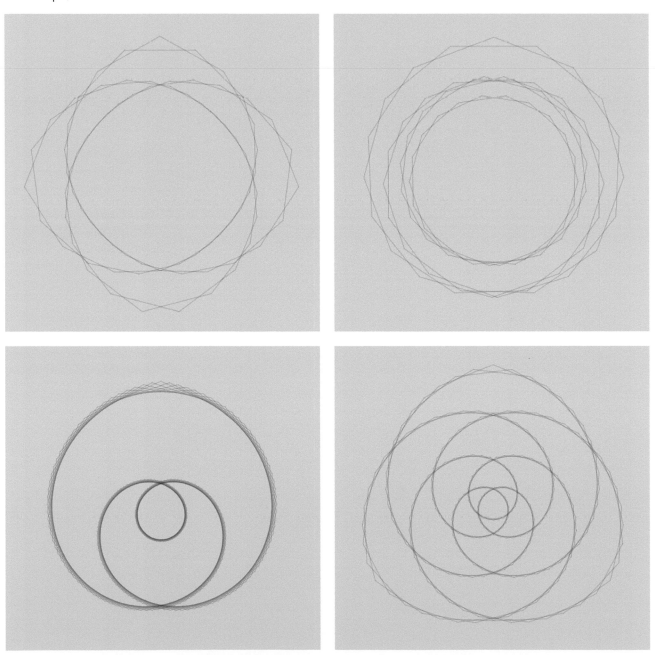

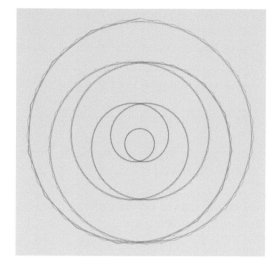

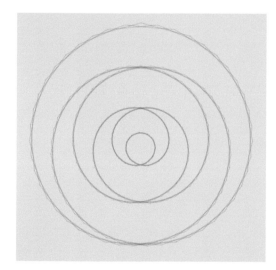

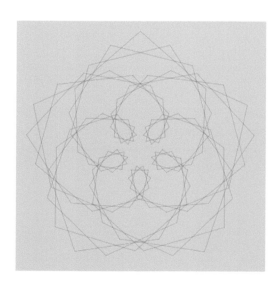

Loops. To count loops, start in the center and count outward avoiding intersections (so the *upper right* on the previous page, four loops are easily seen at the right or left side instead of the top or bottom). Do not count points (so there are three loops in the previous page *upper left*, not four).

Strands. When the number of strands is difficult to see, one can use the *Single Line Drawing, SLD,* mode (on *Pause*) to good effect. For example, the previous page *lower left* image has endpoint 28 just to the right of the top. Note that $254 = 9\cdot28+2$.

Watching spirals. Rope images with multiple loops are fun to watch get drawn, or more accurately, to watch the spiral increase and decrease in size and location as the image gets created.

The top left (499,251,499,233) image is 3 smaller *S* than the *lower right* on the previous page. It has three strands and six loops. The *top image* shows the first 15 lines in *Single Line Overlaid Drawing, SLOD,* mode. The 15th line almost completes a 360° loop. Smaller loops require fewer lines as can be seen in the *middle image*, which starts at 34. Here, the 15-line segment is about 4/3 of a loop and is about at the center of the first strand of the image—the ending of the last line before starting the second strand of the rope is at 83 (note that $83 = (34 + 15/2)\cdot2$). Also note the number of lines in the final image, $251 = 3\cdot83 + 2$. The image looks like the first cycle *nesting dolls* encountered with *Pulsing Images* in Section 10.4.

SLD mode. The best way to view this is to use SLD mode (rather than SLOD). When viewing it this way, you will note that the image curls around the smallest loop three times, once at about 34, a second time at about $117 = 34 + 83$, and the third time at about $200 = 117 + 83$.

More complex images. The *bottom image* (499,121,499,233) could be described as a puffy pentagram. The rope is more loosely wound here so it is easy to see that it has three strands. More interesting is how many loops there are in the image. *The five internal loops shout out to be counted, but is that all there is to the image?* The SLOD mode is useful in exploring this question.

Analyze using manual steps. If you put drawing on *Pause* and show the first five lines, you will see that the end of the last line is the peak of the small lower left loop. Call this loop *1*.

2. *Step Forward* five clicks (so that *Drawing Progress* shows 5) and the last line is at the top of the small upper right loop.

3. *Step Forward* five clicks (so that *Drawing Progress* shows 10) and the last line is at the top of a **large** upper left loop.

4. *Step Forward* five clicks (so that *Drawing Progress* shows 15) and the last line is at the top of the small bottom center loop.

5. *Step Forward* five clicks (so that *Drawing Progress* shows 20) and the last line is at the top of the large upper right loop.

6. *Step Forward* five clicks (so that *Drawing Progress* shows 25) and the last line is at the top of the small upper left loop.

7. *Step Forward* five clicks (so that *Drawing Progress* shows 30) and the last line is near the top of the small lower right loop.

8. *Step Forward* five clicks (so that *Drawing Progress* shows 35) and the last line is near the top of the large top center loop. The end of this line is at 40 = 35+5, the end of the first strand.

We now know that this image has eight loops (five small and three large), as we have stepped our way through all eight (ending at 40 = 8·5). Note also that the total of lines in the image is 121 = 3·40 + 1.

Challenge Question. Increase **S** by 1 to **S** = 122 (with **n** = **P** = 499, **J** = 233). The two-loop image has lots of strands. How many? Hint: SLOD.

12.6 Two Footballs

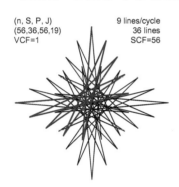

(n, S, P, J)
(56,36,56,19)
VCF=1

9 lines/cycle
36 lines
SCF=56

These images almost demand the use of the web version of the string art file. The largest possible version available using the *Excel* file is to the left which highlights the first cycle in **red**. By squinting, one can see the two footballs as well as the *inner and outer curves* discussed in Section 9.3, but they are not as readily visible as when **n**, **S**, **P**, and **J** are larger. Examples of larger **n**, **S**, **P**, and **J** images are discussed below.

How many cycles are there in a *two-football* image? Recall that a cycle requires returning to one of the vertices of the underlying regular polygon. As noted in Section 5.1, there MUST BE at least one cycle because the top is always included in the image. There are four pointed ends, two on each football, so perhaps all four points are vertices of the underlying regular polygon. If that were the case, there would be four cycles (like the top left image). Given that the two footballs are at right angles to one another, and given that both appear to be centered, an image with four cycles could only happen if **n** is divisible by 4.

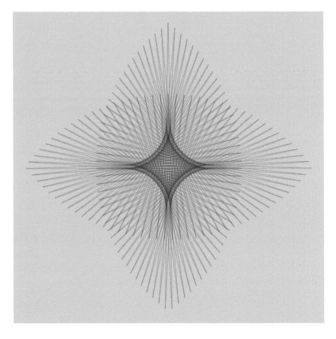

If **n** is divisible by 2 but not 4, then the vertical football may have both ends pointed (i.e., be the end of a cycle), but the horizontal football's ends are not at vertices so there are two cycles. If **n** is odd, then there is only one cycle.

The three versions shown to the right on this and the previous page each have roughly the same number of lines but vary in the number of cycles.

The first image has **S** = 166 lines, with **n** = **P** = 247 and **J** = 82. Because **S** is even, one might expect there are two cycles of 83 per cycle. But **n** is odd so that there is no vertex at the bottom and hence no possibility that the bottom of the vertical football is a vertex of the underlying polygon. Instead, there are two subdivision endpoints that seem to equally create the bottom of that football. This image has a single cycle (GCD(**S**,**P**) = 1).

The second image has **S** = 168 lines, with **n** = **P** = 250 and **J** = 83. Here GCD(**S**,**P**) = 2 so there are two cycles.

The third image has **S** = 164 lines, with **n** = **P** = 248 and **J** = 83. This is the same image used to discuss curves in Section 9.3. Here GCD(**S**,**P**) = 4 so there are four cycles.

A general rule. Base *two-football* images off of **J**. These images occur when **n** = **P** = 3**J** ± 1 and **S** = 2**J** ± 2 but are most visible when **J** is not too small.

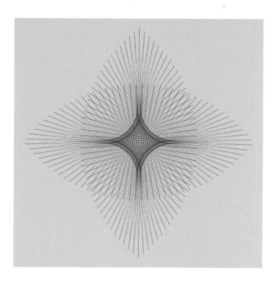

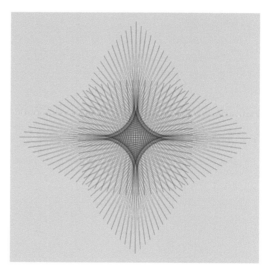

12.7 MA. Modular Analysis of *Two-Football* Cycles

In Section 12.6, *Two Footballs*, the following rule was proposed for creating *two-football* images:
Base *two-football* images on **J**. These images occur when **n** = **P** = 3**J** ± 1 and **S** = 2**J** ± 2.

This section examines the modular conditions that produce a one-, two-, or four-cycle *two-football* image.

Single cycle images. The claim was made in Section 12.6 that if **n** is odd there must be a single cycle. When will **n** be odd? Since **n** = **P** = 3**J** ± 1, **n** will be odd if 3**J** is even. Since 3 is odd, 3**J** is even only if **J** is even. This means that:

Two-football images will be single cycle whenever J is even.

Multiple cycle images. Multiple cycle *two-football* images can only occur if **J** is odd.

For each **J** there are two **S** and **n** = **P** values that produce *two-football* images; one version uses plus signs the other uses minus signs in the equations for **n** = **P** and **S**.

CLAIM: For each odd **J**, one version produces a two-cycle image and the other produces a four-cycle image.

First, consider **S**. Recall, **S** = 2**J** ± 2. If **J** is odd, then 2 = 2**J** MOD 4 or 2**J** is divisible by 2 but not 4.
Consider the adding 2 version of **S**: **S** = 2**J** + 2 so that **S** = 2**J** + 2 = 2 + 2 = 4 = 0 MOD 4.
The subtracting 2 version of **S** is even faster: **S** = 2**J** − 2 so that **S** = 2**J** − 2 = 2 − 2 = 0 MOD 4.
 In both instances, if J is odd, S is divisible by 4.

The difference between two-cycle and four-cycle versions depends on **n** = **P** when **J** is odd.
Consider **n** = **P** for odd **J**. Recall **n** = **P** = 3**J** ± 1. If **J** is odd, it must be of the form **J** = 4**k**+1 (**J** = 1 MOD 4) or **J** = 4**k**+3 (**J** = 3 MOD 4). We consider these in turn.

J = 1 MOD 4: 1) Consider **n** = **P** = 3**J** + 1. 3**J** = 3·1 = 3 MOD 4 so that **n** = **P** = 3**J** + 1 = 3 + 1 = 4 = 0 MOD 4.
 The "+1" version has four cycles, given J = 1 MOD 4.

2) Consider **n** = **P** = 3**J** − 1. 3**J** = 3·1 = 3 MOD 4 so that **n** = **P** = 3**J** − 1 = 3 − 1 = 2 MOD 4.
 The "−1" version has two cycles, given J = 1 MOD 4.

J = 3 MOD 4: 3) Consider **n** = **P** = 3**J** + 1. 3**J** = 3·3 = 9 = 1 MOD 4 so that **n** = **P** = 3**J** + 1 = 1 + 1 = 2 MOD 4.
 The "+1" version has two cycles, given J = 3 MOD 4.

4) Consider **n** = **P** = 3**J** − 1. 3**J** = 3·3 = 9 = 1 MOD 4 so that **n** = **P** = 3**J** − 1 = 1 − 1 = 0 MOD 4.
 The "−1" version has four cycles, given J = 3 MOD 4.

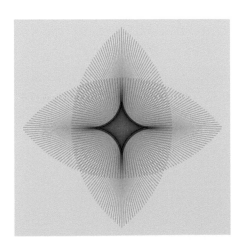

We now see how these rules apply to the images used in *Two Footballs*, Section 12.6.

The first image has **S** = 166 lines, **n** = **P** = 247 and **J** = 82. It has one cycle since **J** is even.

The second image has **S** = 168 lines, **n** = **P** = 250 and **J** = 83. **J** = 3 MOD 4 and **n** = **P** = 3**J** + 1 so this is a two-cycle image (Option 3 above).

The third image has **S** = 164 lines, **n** = **P** = 248 and **J** = 83. **J** = 3 MOD 4 and **n** = **P** = 3**J** − 1 so this is a four-cycle image (Option 4 above).

Challenge Question. The (490,328,490,163) image to the left is dense enough that it may be difficult to visually discern how many cycles it has. Using the above rules, how many cycles does it have and why?

12.8 A Quivering Triangle That Is Actually *Shape-Shifting*

Quivering triangles, *QTs*, have used subdivision endpoints that rotate in three ovals, one at the top, the other two about one-third of the way around the circle in each direction. These ovals are curves created by points, not lines (see Section 9.3). The lines that comprise *QTs* stay in one of three tubes. One tube contains lines with endpoints at the top and bottom right. A second contains lines from endpoints at the bottom left and bottom right. The third contains lines with endpoints at the top and bottom left. Other dimension quivering polygons can be described as having this same attribute.

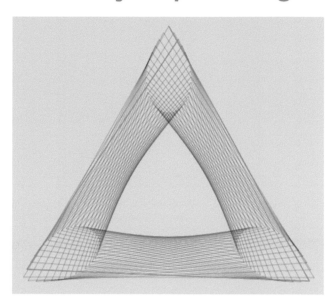

The key to *QTs* is *n* = *P* and *S* = 3*J*. The *QTs* discussed in *Quivering Polygons* Section 11.6 are based on *n* = *P* = *S* ± 1, in which case the image is drawn in a single trip around the three-point ovals.

Multiple trips around the ovals. If you increase the distance between *n* = *P* and *S*, the number of times around the ovals to complete the image changes. If *n* = *P* = *S* ± *a* then it takes *a* times around as the *a* = 2 upper (115,117,115,39) image shows. You can see the end of the third line is the second point down on the top oval: It takes two times around the oval to complete the image.

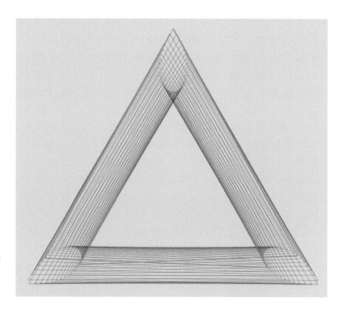

If you choose *a* near *J*/2 having the first triangle peak near the bottom of the oval like this (137,117,137,39) image (*a* = 20), things look different. The image shows *Drawn Lines* = 6. The first triangle's peak is at the bottom of the oval, and the second is just to the left of the top. Even if you use *Drawn Lines* = 3 you will quickly perceive that **there are two triangles quivering here**; each is completing half the oval. One loops counterclockwise down from the top, and the other loops counterclockwise up from the bottom.

A QT that is also a 3SST. More interesting is an image obtained while exploring *n* = *P* models searching for general patterns. That image was (500,111,500,185). Two DL = 6 versions are shown on the next page, *Drawing Progress* = 0 at left, and at halfway around the 111-line image at *Drawing Progress* = 53 at right (the midpoint of 53 and 59 = 56 right at *S*/2).

Although *n* = *P, S* is quite clearly not 3*J*, so one might imagine that this provides a new set of equations governing *QTs*. The first thing to note is that VCF = 5 so that one can simplify values to (100,111,500,37) (see Section 6.1). Now *S* = 3*J* but *n* is no longer equal to *P*. However, *P* is a multiple of *n* and the image is a single cycle. Therefore, it is one of a family of *QTs* with (*n, S, P, J*) = (100, 111, 100*k*, 37) for 1 ≤ *k* < *S*/2 and GCD(*S, k*) = 1 as discussed in the *single-cycle* Section 5.5.

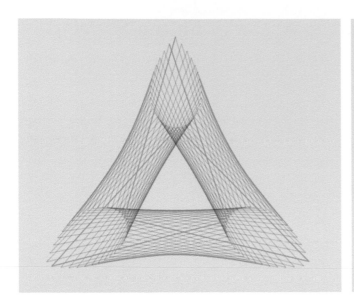
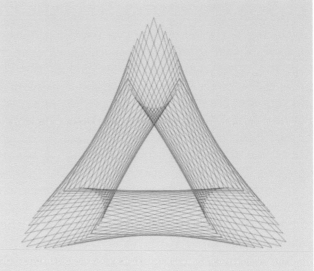

The similarity of this *QT* image with Section 8.4, *3SST*. If you set *Drawn Lines*, DL = 6 and use *Single Line Drawing* (SLD) mode with *Drawing Speed* = 20 or so, you will see the triangles shift shape from a set of sharply pointed triangles when *Drawing Progress* is small (like at left), to triangles that resemble equilateral triangles when *Drawing Progress* is in the middle (like at right) and back to sharp triangles as *Drawing Progress* approaches **S**.

Differences with 3SST. The *Three Shape-Shifting Δs* (30,19,163,13) image from Section 8.4 is clearly more complex than this *QT*. If you follow the above drawing instructions but set DL = 7, the triangles that result do change sharpness but there are three substantial differences. **1)** The triangles never look equilateral—there is always a noticeably sharpest angle. **2)** If you follow the peak from a given triangle, it does not stay in one area of the image (like the oval at the top, lower right, or lower left). Consider, for example, the triangle that starts at vertex **0**. The peak of that triangle next touches a vertex as the 133rd line drawn (133 = 7·19). This vertex is **13** NOT vertex **0**. By contrast, the peaks that start at vertex **0** stay within the oval at the top of the image with *QTs*. **3)** *3SST* is *single-step* of length 7 (Section 8.5.1), and this *QT* is *smallest-step* of length 6 (Section 9.4).

Comparing this *QT* to other *QTs*. Quite clearly the triangles change their shape much more radically in the image than if you go through this same process with the bottom image on the previous page. As noted earlier, this image seems to be drawn by two sets of triangles, one that rotates counterclockwise from the top and the other from the bottom, but both maintain their approximately equilateral status. If you use *SLD* with DL = 6 on the upper image on the previous page and watch the triangles quiver, you see two approximately equilateral triangles rotating and changing size but dancing quite close to one another – the peaks rotate clockwise around the top oval twice in this instance. Finally, if you examine DL = 6 in *SLD* with a *one time around QT* such as taking the upper image and increase **n** = **P** by 1 to (116,117,116,39), the only difference is that now the dancing partners are even closer and the image goes around the oval only once (and so gets small only once).

Variations on the theme. As you adjust **k** (i.e., adjust the 100s digit in **P**), interesting patterns emerge. The oval points do not change as **k** changes, the order that those points are used changes as discussed in the *single cycle* Section 5.5.

About the point ovals. Each is more pointed on one end than the other, so they are not true ovals. Every third line starts in the same oval as three lines before so the point ovals can be

labeled 0 MOD 3, 1 MOD 3, and 2 MOD 3 based on the location of the start of each line in the image (when **k** = 1). The top oval is 0 MOD 3. The lines that start at 1, 4, 7, ... start in the 1 MOD 3 oval (the lower right oval), and those that start at 2, 5, 8, ... start in the 2 MOD 3 oval (the lower left oval).

When **k** is divisible by 3 (**k** = 0 MOD 3), all used subdivision points stay within the 0 MOD 3 oval and *small images* (Section 12.4) emerge. Other **k** values produce *QTs* (except **k** = 37 which produces an actual triangle). When **k** = 1 MOD 3, the first line ends in the 1 MOD 3 oval, and if **k** = 2 MOD 3 the first line ends in the 2 MOD 3 oval. (So, for example, the first line of the **k** = 5 bottom left image ends in the 2 MOD 3 oval since 5 = 2 MOD 3. Indeed, it is about halfway around from its peak.)

One time around the oval. *One time around does not necessarily mean equilateral.* Both the (100,111,4700,37) *"sharp Δs"* and (100,111,1000,37) *"equilateral Δs"* images are *one time around* because the third line ends a *smallest-step* from the top. Both are *smallest-step* images of length 3. Focus on where the other two line segments end. The first segment for the equilateral version ends near the point of the 1 MOD 3 oval, the second is near the point of the 2 MOD 3 oval, and the third is a *smallest-step* from the top. These three lines map out a large "almost equilateral" triangle. By contrast, the *sharp Δs* first line ends about 1/3 around ↻ from the point of the 1 MOD 3 oval, the second ends about 2/3 around ↻ from the point of the 2 MOD 3 oval, and the third is a *smallest-step* from the top. These three lines map out a "sharply-peaked almost isosceles" triangle. This is about the sharpest triangle you could create since the first and third lines appear to be almost tangent to the inside of their ovals. This version has a squeezed-in tube in the middle.

Bow-tie QTs. If tube middles are squeezed as much as possible, the lines will appear to converge in the center. If you compare the end of the first line drawn in **P** = 800 and **P** = 3800 you will see that they are one point different from one another, 70% ↻ from the point of the 2 MOD 3 oval (**k** = 8 and 38 are both 2 MOD 3), When *Drawing Progress* = 78 for **P** = 800 and *Drawing Progress* =78 for **P** = 3800 in SLOD mode with *Drawn Lines* = 1, you will see the positively sloped line with steepest slope. Both appear tangent to the left side of the 0 MOD 3 oval and the right side of the 2 MOD 3 oval.

Fractionally filling in the ovals. If the third line ends about 1/2, 1/3, or 1/4 of the way around the 0 MOD 3 oval, then the image will appear as multiple triangles much like the bottom image on page 1 of this section. These images will emerge in *Fixed Count Line Drawing* mode regardless of the value you choose for *Drawn Lines*, but the images are best seen using the setting of *Drawn Lines* noted (based on what fraction of the way around the 0 MOD 3 oval the third line ends): ½, *Drawn Lines* = 6; ⅓, *Drawn Lines* = 9, Sharp; ⅓, *Drawn Lines* = 9, Equilateral; ¼, *Drawn Lines* = 12.

12.9 Finger Traps

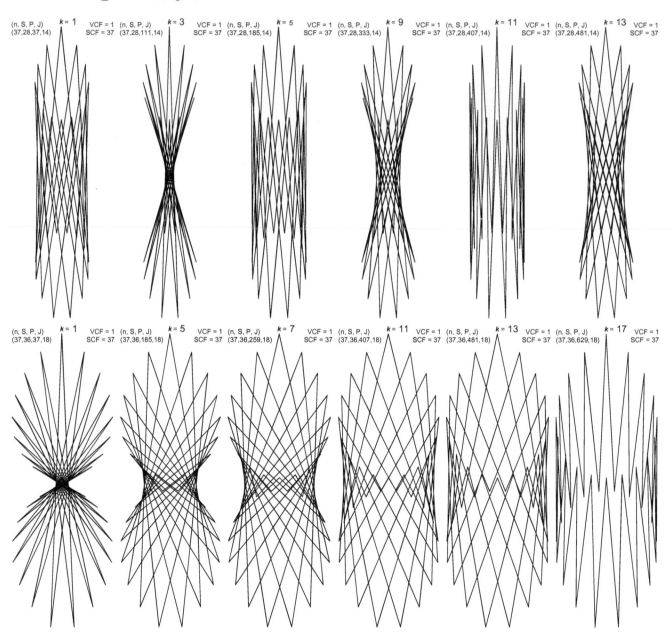

Finger traps are *quivering polygons,* Section 11.6, with two sides (rather than three or more). As discussed in the *variations on QT* Section 12.8 and *single-cycle* Section 5.5, **one obtains a family of similar images if P is a multiple of n and S is a multiple of J.** Here **S** = 2**J** and **P** = **kn**, 1 ≤ **k** < **S**/2 with **J** coprime to **n** (VCF = 1) and **J** < **n**/2. We also want GCD(**n,S**) = 1. The images will have **S** lines if GCD(**S,k**) = 1. There are two-point ovals, 0 MOD 2 (even starting points, top oval) and 1 MOD 2 (odd, bottom oval), like what was seen in Section 12.8. Even values of **k** produce *small images* from Section 12.4 since the used vertices are in the even oval and **J** < **n**/2. The images above show two sets of **n** = 37 finger traps, **J** = 14 and **J** = 18.

The top row **J** = 14 images have 28 lines; the bottom row **J** = 18 images have 36 lines. **J** = 18 is the largest **J** given **n** = 37 (19 > **n**/2 in which case the even oval includes the center of the underlying

polygon). For fixed **n**, the ovals get larger as **J** increases. Just like discussed in Section 12.8, some **k** produce images resembling bow ties (like **k** = 3 for **J** = 14 or **k** = 1 for **J** = 18).

The finger trap's woven cross-hatching is most visible in the upper right (**k** = 13, **J** = 14) image. By contrast, the lower right (**k** = 17, **J** = 18) image is like a shark's teeth with a closed mouth, but change to **n** = 35 and the shark is open-mouthed!

12.10 On the Distance Between Paired Suspension Curves

Often in **n = P** images, one finds two curves seemingly parallel to one another anchored at each end by the same point. Two analogies are power or (old school) telephone lines between poles or the cables that suspend suspension bridges. (Interestingly, a quick Google search shows that the curves created in these situations (catenary versus parabolic) differ from one another.) The analogy we will work with here is a pair of chains between fixed endpoints.

The goal is to describe the distance between the curves using the tools we have at hand. Consider a series of 5-point webbed stars created via the equations: **S** = 2**J**-**a** and **n** = **P** = 3**J**+**a**. To avoid divisibility issues, set **J** = 101 since 101 is prime. We initially vary **a** from 1 to 6. The first five highlight the first 1/5 of the image using SLOD mode (40 or 39 lines) and the sixth shows first and last lines drawn.

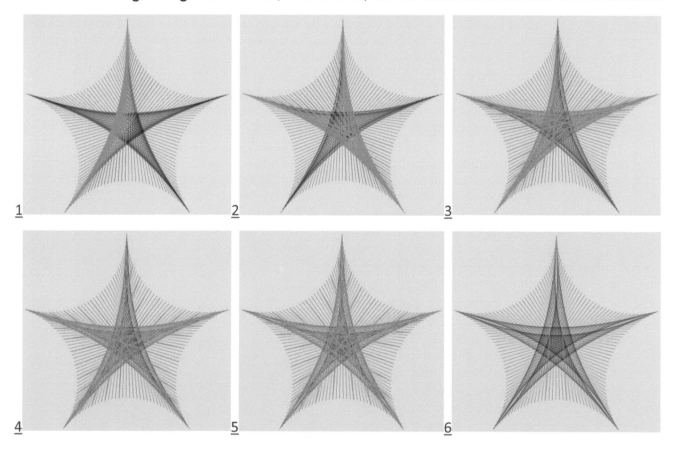

Each image has two sets of *line curves* (Section 9.3) spanning two of the five points and *point curves* between successive points of the 5-point star. Our focus is on the line curves (hereafter curves).

Density of curve creation. As **a** increases, so does the distance between adjacent used points on the *point curves*.

The **a** = 1 image is *smallest-step* (Section 9.4) and is created in a single pass. Both 0-3 curves are fully created in the first fifth of lines from lines ending in the first half of the 0-1 *point curve* and the last half of the 2-3 *point curve*.

The **a** = 2 image is the second *smallest-step* and is created in two passes around the star. The 0-2 and 2-4 curves are created at 50% density in the first 1/5 of lines because every other used line endpoint is used the first time around.

The **a** = 3 image is third *smallest-step* and is created in three passes around the star. The 0-3, 3-1, and 1-4 paired curves are created at 33% density in the first 1/5 of lines because every third-used line endpoint is used the first time around.

The **a** = 4 image is fourth *smallest-step* and is created in four passes around the star. The 0-3, 3-1, 1-4, and 4-2 curves are created at 25% density in the first 1/5 of lines because every fourth-used line endpoint is used the first time around.

The **a** = 5 image is the fifth *smallest-step* and is created in five passes around the star. All five pairs of curves are created at 20% density in the first 1/5 of lines because every fifth-used line endpoint is used the first time around.

The **a** = 6 image shows the first and last lines drawn by setting *Lines Drawn* = 2 and *Step Back* once from 0 to *Drawing Progress* = 195. Ends differ by six points on the 2-3 *point curve*. These lines are the last line of the **outer** 0-2 curve (line 196) and **outer** 0-3 (line 1) curves. If you step forward from here, note that line 2 is part of the **inner** 0-3 curve.

The distance between curves. The curves get farther apart from one another as **a** increases. When **a** = 1, the two curves appear virtually identical but if you view a larger version of this image, they are not. The curves meet at the star's vertices and towards the middle they sag according to how much slack is in each curve.

A chain analogy: Suppose you want to hang a chain across an opening between hooks on posts that are ten feet apart. You have a chain that is a bit more than twice that size, but it is connected to itself in a loop and there are an odd number of links in the looped chain, **T** = 2**k**+1. If you hook a link of the chain to one post and stretch it across the opening, you will be able to find a link to hook to the other side where there are **k** links in one "half" and **k**+1 links in the other. The curves created by both halves will be virtually identical, but if you look carefully, the one with **k** links will be a bit higher (have less curvature) than the one with **k**+1 links. If you go to a post and reduce the number of links on the small side by 1, the two curves will have length **k**-1 and **k**+2. The curves change a bit. The shorter will be a bit less curvy, and the larger will be a bit more curvy, and the distance between them will increase.

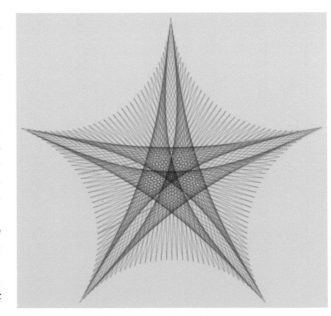

The **a** = 12 image at right with *Drawing Progress* = 37 shows lines 38 and 39. This starting point was shown because both lines share the "1" vertex of the 5-point star. As such it provides a chance to see the first (and last) line of a couple of

curves. If you change to *Drawn Lines* = 1, you will get less confused by which line is which.

Line 38 (lower line) is the last line in the outer 3-1 curve and the first line in the inner 1-4 curve (*Step Back* to 35 and note that line 36 is part of the outer 3-1 curve; *Step Forward* to 39 and note that line 40 is part of the inner 1-4 curve).

Line 39 (upper line) is the first line of the outer 1-4 curve and the last line of the inner 3-1 curve. If you set *Drawing Progress* = 40, you will note line 41 is also part of the outer 1-4 curve, but if you set it to *Drawing Progress* = 36 you will note that line 37 is part of the inner 3-1 curve.

This image has only a couple of lines on each of the curves because the density is 1/12 each time around for the reasons discussed above.

A final point to note is that the lines alternate between the inner curve and the outer curve with every other drawn line unless the curve under

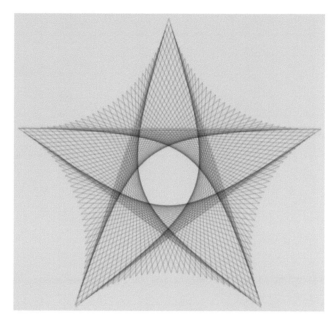

consideration changes endpoints, just like with the *point and line curves analysis* using *two footballs* in Section 9.3.

A limit on the outer curves. There is a limit to reducing the number of links on the short side of a chain loop. The limiting case is a straight line. The same goes for these images.

This 169-line *a* = 33 image is shown with *Drawn Lines* = 1 and *Drawing Progress* = 84. The 85th line is at the drawing midpoint (169/2 = 164.5), and this line IS the limiting case of the outer 4-1 curve. This image appears to have five (not ten) curves. To visualize this in context, change to *Fixed Count Line Drawing* mode. If you want to see a bit of curvature in the outer curves, try a smaller value of *a*. This link takes you to a 179-line *a* = 23 image where the outer curves take about ten lines to create.

Generalizations. Start with this *a* = 4 two-football image, and change *S* by 2 to get this *a* = 2 puffy pentagram.

12.11 Generalized Stars: Exploring One-off Images Using 7-point Stars (and More)

The rule proposed in the *divisible stars* Section 12.3 was that if you start with a quivering *G*-gon and move *S* = *G·J* in the opposite direction of *n* = *P* = *G·J* ± 1 to *S* = *G·J* ∓ 1, you end up with a divisible 2*G* star (such as a 6,2 star when *G* = 3). Such stars are even, so if you find odd quivering stars a different rule must apply. One adjustment is to increase the difference between *n* and *S* so that a 9,3 star is possible by adjusting *S* (or *n* = *P*) so that the difference is 3. Such stars are, by their very nature, divisible in the sense that the point and jump values have a common divisor. Can this be generalized to non-divisible stars such as when the number of points in the star is prime?

The following images provide a generalization of this idea by focusing on 7-point stars. Four images have *J* = 100 and are of the following form: *S* = 100·*k*-1, *n* = *P* = 100·(7-*k*)+1 for *k* = 2, 3, 4, and 5. Virtually identical images result if we reverse the − and + signs (*S* = 100·*k*+1, *n* = *P* = 100·(7-*k*)-1). At right are 7,2 and 7,3 quivering stars for reference.

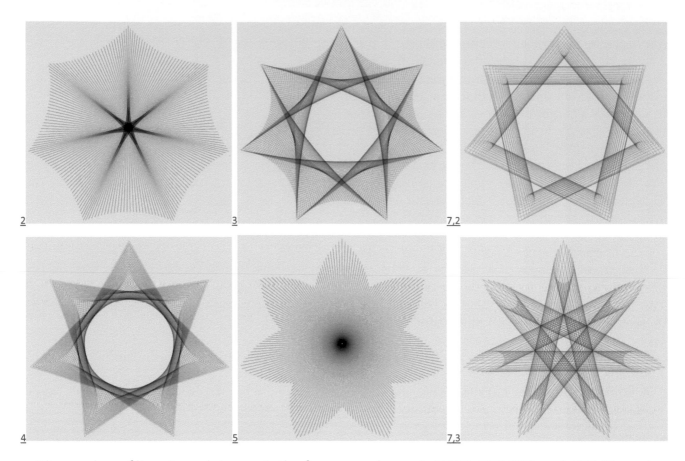

The number of lines in each image in the first two columns is **S** (199, 299, 399, and 499). Two other values are possible but were omitted because they are less interesting: 1 shows a 99-line outline of a smoothly pulled-in 7-gon, and 6 shows a 599-line outline that is virtually indistinguishable from a circle. Both right-column quivering stars have 210 lines.

There are *point curves* (Section 9.3) in each image: These curves are especially easy to see if you use *Fixed Count Lines Drawing* mode. Each image is the *smallest-step* at *Drawn Lines* = DL = **k** (Section 9.4). **k** = 2 looks very much like a porcupine image. **k** = 3 is a *shape-shifting* triangle and **k** = 4 is a *shape-shifting* quadrangle. Interestingly, **k** = 5 looks like a porcupine image (and is discussed in Section 12.12). Both quivering stars are *smallest-step* at DL = 7. The line curves are especially visible in the 299-line middle top image. (One way to know for sure that what you are looking at is a line curve is to click *Toggle Subdivisions* on. Any curve visible inside the 60K to 120K **n·S** donut hole of dots (Section 10.2) MUST BE line created.)

A generalization. Suppose you want a star with **G** points. Set **J** to a nice round number (like 100 above). If **n** + **S** = **G·J** and **n** = **P**, then the resulting star will have **G** points (however, in all likelihood, it will not be a *smallest-step* image).

An exercise. Set **J** = 100. Choose 200 < **C** < 500 with the last digit 1, 3, 7, or 9, and set **n** = **P** = **C**. Compare three **S**: **S** = 700-**C**; **S** = 800-**C**; **S** = 1000-**C**. Watch how each is drawn in *Fixed Count Lines Drawing* mode. Propose **S** if you want a 12-gram.

12.12 *n = P* Porcupines

Porcupine polygons have a spiky look, which these two images (from *Generalized Stars* Section 12.11) quite clearly qualify. The left (501,199,501,100) has 199 spikes; the right and below (201,499,201,100) has 201.

Traditional porcupine images are almost halfway around (Section 11.3), **P** is the closest number to **nS**/2 so the image is *single step* (Section 8.5.1) after two lines. Porcupines require SCF = 1 so that all subdivisions are used. By contrast, **n = P** images use very few of all possible subdivision points and at most **S** segments. The upper left is *smallest-step* (Section 9.4) after two lines, and the upper right (blown up **with one minor addition**) is *smallest-step* after five lines.

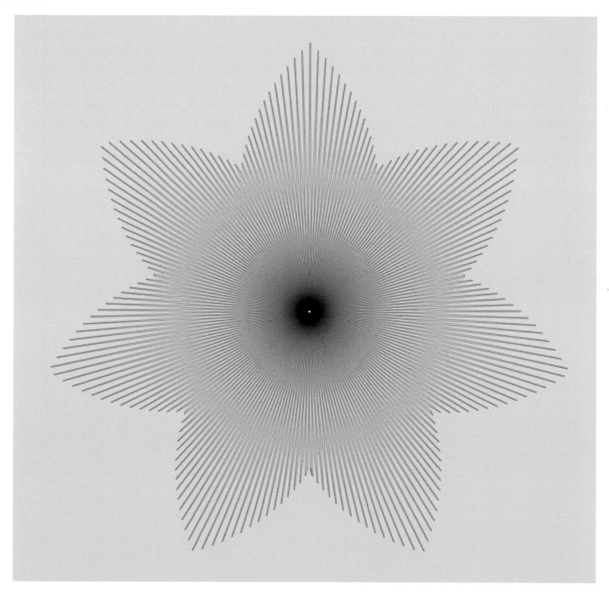

Overview of the large image. This image has $n = P = 201$, $J = 100$, and $S = 499$. Lines that look like they are going from one end to the other just missing the center are NOT single-segment lines (like the upper left image). Because $S/3 < P < S/2$, each "line" contains two to three segments, and there is at least one segment on each part of the VF (although often there are two). *Even though there are 499 lines used to create this image, it looks like 201 lines.* Roughly speaking, each *smallest-step* occurs every five segments, and each of these *smallest-step* moves creates two "lines." It is worth initially focusing on the VF.

This image "appears" to be a *scalloped* version of the VF. The VF is a *single-step* ↺ drawn 201-point star. The first two segments tell the story: The first line of the VF is from 0 to 100 just to the right of the center and the second is from 100 to 200 just to the left of the center. Note: 200 is 1 less than n. Subsequent odd segments decline from 100 by 1 and even segments decline from 200 by 1 so the VF is created in ½ ↺ rotation (201,1,1,100) using *Fixed Count Line Drawing* mode.

Most of the time, it takes five segments to draw two lines. Each segment spans $P = 201$ subdivisions of the VF so that the first two segments end at 402. Since there are 499 segments in a line of the VF, these two segments are on the first line of the VF (or put another way, they are colinear). This looks like a line spanning the image from the top to just right of the valley of the 3-4 scallop. This valley segment is at Level 97 = 499 − 402. **The next segment of the image starts at Level 97 on the first line of the VF but ends at Level 104 = 201 − 97 of the second VF line from vertex 100 to 200. THIS IS THE SEGMENT highlighted at the bottom of the large image (which is why the image is large).** Two more segments, one ending at 305 on the second VF line and the other ending at 7 on the third VF line. These three segments are NOT colinear but are close enough that they appear so. The five segments create two "lines." These five segments also create a *smallest-step*.

The point curves are created by level changes (of 7) per *smallest-step*. Subsequent five-segment additions increase level by 7 each time. The first 14 of these cycles (70 = 14·5) create the curve from the peak at the top vertex 0 to the valley between 6 and 0 (the 6 here is the last peak of the 7-point star, not the sixth of 201 vertices of the underlying polygon). The 70th line is at Level 98 (98 = 14·7). Similarly, the first two segments of each five-segment set start at Level 97 (as noted above), then decrease by 7 every five segments from here (so note line 7 ends at Level 90 and 12 ends at Level 83, ..., and line 67 ends at Level 6). Peak 3 occurs with line 72 ending at Level 1 (since a decrease of seven levels from Level 6 is Level 1).

Excel file 12.0 is a modified version of the *Tracking Lines* 5.0 file (used to analyze spinning needle stars in Section 11.8.1) and shows all 499 line segments. The first 80 are shown at the end of this section, highlighted to note changes in direction (which are the smallest levels). The table to the right summarizes this information. Note that the level information in the previous two paragraphs is summarized in the point of star 0 and 3 columns. It is worth noting that, as expected, this summary is symmetric about the vertical line.

Summary of *Tracking Lines* Locations **Excel** file	Point of star	3	6	2	5	1	4	0
	Peak line	72	144	216	283	355	427	499
	Level	1	2	3	3	2	1	0
Level just before peak (peak-5):		6	5	4	10	9	8	7
Level just after peak (peak+5)		8	9	10	4	5	6	7
Opposite valley line before peak		70	142	214	281	353	425	497
Level there		98	99	100	94	95	96	97
Opposite valley line after peak		74	146	218	285	357	429	2
Level there		96	95	94	100	99	98	97

NOTE: If using *SLOD* mode with *Drawn Lines* = 1, set *Drawing Progress* at 1 less than line number to see the line (*Drawing Progress* is start of the line).

Lines to next peak (sum to 499)	72	72	72	67	72	72	72

Near peaks, it only takes four segments to draw two lines. The clearest way to show this is to set *Drawn Lines* = 4 and *Step Back* two steps so that the last two and first two segments are shown using *Single Lines Overlaid Drawing* mode (with *Drawing Progress* = 497). This shows the first and last lines of the image since the last two are symmetric to the first two and are thus both collinear. One finds an additional two lines in four segments by setting *Drawing Progress* = Peak line-2 using the table on the last page. (In the *Excel* file 12.0, these boxed points are where the highlighting changes to the new pattern that holds until the next peak occurs. For example, multiples of 5 are highlighted green to 70, but 74 starts a new pattern in yellow.)

Small segments. Near the peak, the side with three segments has small level changes. The smallest change near each peak is shown to the right. Note that these level changes also are symmetric. If you think the 7 change in the level line is small, check out the size of the line starting at *Drawing Progress* = 213 or 285.

Smallest level change segments in the valley of each petal opposite star point listed

Star point	0		3		6		2		5		1		4	
Line k	2	3	69	70	141	142	213	214	285	286	357	358	429	430
Sub End	402	104	396	98	397	99	398	100	399	101	400	102	401	103
Segment	0.806	1.208	27.8	28.2	56.8	57.2	85.8	86.2	114.8	115.2	143.8	144.2	172.8	173.2
VF Start	0	100	87	187	173	72	58	158	144	43	29	129	115	14
VF Stop	100	200	187	86	72	172	158	57	43	143	129	28	14	114
Level	97	104	103	98	102	99	101	100	100	101	99	102	98	103
ΔLevel	104	7	92	5	94	3	96	1	98	1	100	3	102	5

A bit more on levels. Recall that Level 0 points are vertices of the underlying polygon with larger level numbers being closer to the center of the circle. Levels are created from the concentric circles of subdivision points, and these circles are not equally spaced as can readily be seen in *Levels* Section 7.1. This is the reason *point curves* based on points that are seven level changes from one another (7 = 5·*P*-2·*S* = 1005-998) appear as curves rather than straight lines.

Peaks and valleys. Looking carefully, you will note that the seven peaks differ regarding how pointy they are. This has to do with the image being *single cycle* (Section 5.5). The top (0) is clearly the sharpest. Opposite peak 0, the valley is the shallowest (Level 97). Peaks 3 and 4 are at Level 1, and the largest valley number is at Level 98. Peaks 1 and 6 are at Level 2 with the largest valley number at Level 99. Finally, Peaks 2 and 5 have peaks at Level 3 (and an adjacent ending point at Level 4), which is why these two peaks appear most rounded. By contrast, the valleys opposite these peaks are deepest at Level 100 (Level 100 and 101 are paired at lines 213, 214, and again at 285 and 286). These findings are also summarized in the three tables.

MA. Tracking lines. This analysis has leaned heavily on *Excel* file 5.0, used to track lines in the first cycle. This file was developed to analyze *spinning needle stars* from Section 11.8. The new version, *Tracking Line Locations*, has been modified to include a much larger cycle (of 560 lines) in *Excel* file 12.0. The first 80 lines are shown on the next page so that one can see what happens near the first drawn peak (3) at line 72, boxed below.

201	n
499	S
201	P
100	J

The Vertex Frame (VF) start and stop values are the **RED** numbered vertices of the polygon.

Polygon vertices are in RED
Endpoints of first cycle segments are labelled by color:
Non 5th in Blue 5th endpoints in GREEN

Sub End = MOD($k*P$, S)
Segment = $k*P/S$
VF Start = MOD(INTEGER(Segment)*J, n)
VF Stop = MOD(VF Start +J, n)
Level = MIN(Sub End, S-Sub End).

Line k	1	2	3	4	5	6	7	8	9	10	11	12	13	14	15	16	17	18	19	20
Sub End	201	402	104	305	7	208	409	111	312	14	215	416	118	319	21	222	423	125	326	28
Segment	0.40	0.806	1.208	1.611	2.014	2.417	2.82	3.222	3.625	4.028	4.431	4.834	5.236	5.639	6.042	6.4	6.8	7.3	7.7	8.1
VF Start	0	0	100	100	200	200	200	99	99	199	199	199	98	98	198	198	198	97	97	197
VF Stop	100	100	200	200	99	99	99	199	199	98	98	98	198	198	97	97	97	197	197	96
Level	201	97	104	194	7	208	90	111	187	14	215	83	118	180	21	222	76	125	173	28
ΔLevel	201	104	7	90	187	201	118	21	76	173	201	132	35	62	159	201	146	49	48	145
			small																	

Line k	21	22	23	24	25	26	27	28	29	30	31	32	33	34	35	36	37	38	39	40
Sub End	229	430	132	333	35	236	437	139	340	42	243	444	146	347	49	250	451	153	354	56
Segment	8.5	8.9	9.3	9.7	10.1	10.5	10.9	11.3	11.7	12.1	12.5	12.9	13.3	13.7	14.1	14.5	14.9	15.3	15.7	16.1
VF Start	197	197	96	96	196	196	196	95	95	195	195	195	94	94	194	194	194	93	93	193
VF Stop	96	96	196	196	95	95	95	195	195	94	94	94	194	194	93	93	93	193	193	92
Level	229	69	132	166	35	236	62	139	159	42	243	55	146	152	49	249	48	153	145	56
ΔLevel	201	160	63	34	131	201	174	77	20	117	201	188	91	6	103	200	201	105	8	89
														small change but straddles middle						

Line k	41	42	43	44	45	46	47	48	49	50	51	52	53	54	55	56	57	58	59	60
Sub End	257	458	160	361	63	264	465	167	368	70	271	472	174	375	77	278	479	181	382	84
Segment	16.5	16.9	17.3	17.7	18.1	18.5	18.9	19.3	19.7	20.1	20.5	20.9	21.3	21.8	22.2	22.6	23.0	23.4	23.8	24.2
VF Start	193	193	92	92	192	192	192	91	91	191	191	191	90	90	190	190	190	89	89	189
VF Stop	92	92	192	192	91	91	91	191	191	90	90	90	190	190	89	89	89	189	189	88
Level	242	41	160	138	63	235	34	167	131	70	228	27	174	124	77	221	20	181	117	84
ΔLevel	186	201	119	22	75	172	201	133	36	61	158	201	147	50	47	144	201	161	64	33

Line k	61	62	63	64	65	66	67	68	69	70	71	72	73	74	75	76	77	78	79	80
Sub End	285	486	188	389	91	292	493	195	396	98	299	1	202	403	105	306	8	209	410	112
Segment	24.6	25.0	25.4	25.8	26.2	26.6	27.0	27.4	27.8	28.2	28.6	29.0	29.4	29.8	30.2	30.6	31.0	31.4	31.8	32.2
VF Start	189	189	88	88	188	188	188	87	87	187	187	86	86	86	186	186	85	85	85	185
VF Stop	88	88	188	188	87	87	87	187	187	86	86	186	186	186	85	85	185	185	185	84
Level	214	13	188	110	91	207	6	195	103	98	200	1	202	96	105	193	8	209	89	112
ΔLevel	130	201	175	78	19	116	201	189	92	5	102	199	201	106	9	88	185	201	120	23
										small	PEAK 3			small						

Chapter 13

60-Second Images

13.1 *60-Second Images*

Introduction and motivation. At one time or another, all of us have found ourselves looking at a clock, entranced by the simple movement of the second hand as it clicks off second-by-second movements around the clock face. This idle introspection led to the analysis of a class of string art images one might call *"60-second images"* because one can see the image emerge from 60 cycles in which each cycle ends one vertex farther along the polygon than where the cycle started, just like with the second hand of a clock. Figure 1 shows three 240-line *60-second images* with **first cycle shown in red** (click the link then use *Drawing Mode, Fixed Count Line Drawing (FCLD)* to watch the image get drawn).

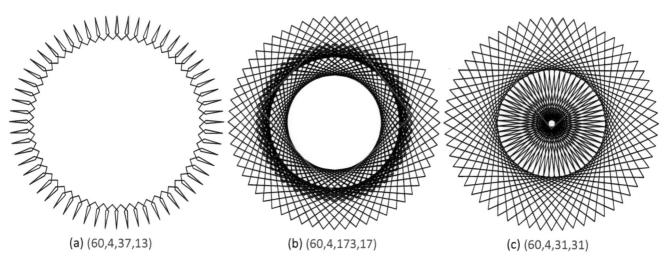

| (a) (60,4,37,13) | (b) (60,4,173,17) | (c) (60,4,31,31) |

FIGURE 1 Examples of *60-second images.*

 60-Second Images and Modular Multiplicative Inverses. We require 60 vertices to be used so we restrict our analysis to **n** = 60 and **J** coprime to **n**, VCF = GCD(**n**, **J**) = 1. Additionally, we want **S** to be coprime with **P** so that cycles have **S** lines per cycle for a total of 60**S** lines. Figure 2 provides three candidate images with **S** = 8 and **J** = 31 with links to the web version. If the first cycles were not shown in **red**, you would be hard-pressed to see a difference between these images.

DOI: 10.1201/9781003402633-15

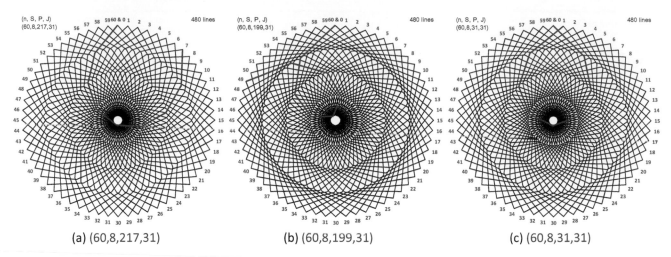

(a) (60,8,217,31) (b) (60,8,199,31) (c) (60,8,31,31)

FIGURE 2 Comparing three **n** = 60, **S** = 8, **J** = 31, 480-line images.

Consider how Figure 2(a) is drawn. The first cycle ends at **7** so subsequent cycles end at **14**, **21**, **28**, **35**, **42**, **49**, **56**, **3**, **10**, ... (3 = 63 MOD 60 and 10 = 70 MOD 60, see *Modular Arithmetic* Chapter 23). These cycles move around the circle *clockwise*, and each time "around" uses one more of the vertices from **1** to **6** that were skipped because the end of the first cycle was **7**, the first of which is **3** at the end of the ninth cycle. By contrast, the first cycle in Figure 2(b) ends at **49** so subsequent cycles end at **38**, **27**, **16**, **5**, **54**, ... (38 = 49+49 MOD 60 and 27 = 38+49 MOD 60, etc.). In this instance, each time "around" *counterclockwise* uses one more of the vertices from **59** to **50** that were skipped because the end of the first cycle was **49**, the first of which is **54** at the end of the sixth cycle. Figure 2(a) appears to be an approximately eight-petal clockwise-created flower (8·7 = 56), while Figure 2(b) appears to be an approximately five-petal counterclockwise-created flower (5·11 = 55). You can see each image emerge by clicking the link, then clicking *Drawing Mode, FCLD* with *Drawn Lines* (DL) = **S**. Figure 2(a) is clockwise seven times around, and 2(b) is counterclockwise 11 times around when viewed by how the vertices are filled in. By contrast, 2(c) is completed as a one-time-around process because each cycle ends one vertex after the prior cycle. The image is complete after 60 one-vertex forward cycles when viewed dynamically via the web link.

You may have noticed that 2(c) is the second *60-second image* shown with **J** = 31 and **P** = 31 (the first, 1(c), had **S** = 4). Additional versions occur as long as GCD(**S**, **P**) = 1 because one cycle is **S** lines or **P·S** subdivisions, but every **S** subdivisions is a vertex that is **J** away from the prior vertex so that **P** jumps of **J** is the ending vertex relative to the starting vertex (so **S** is no longer involved). The ending vertex is one larger than the starting vertex if **P·J** is one larger than a multiple of 60. Put another way, **P and J are multiplicative inverses modulo 60**. (See Chapter 24 for more on MMI.)

Definition. **a** and **b** are modular multiplicative inverses to **c** if 1 = **a·b** MOD **c** where MOD is the remainder function.

Modular multiplicative inverses have been used to create art, and the excellent (and inspiring) book *In Code: A Mathematical Journey*, by Flannery and Flannery (2002), discusses its importance in cryptography. The table shows the 16 values of **J** that are coprime with 60 and the paired values of **P** producing *60-second images*. These pairs are not as hard to find as you might imagine because **P·J** must have a last digit of 1 because multiples of 60 end in 0. This requires the last digits of **J** and **P** are both 1, both 9, or that one has the last digit 3 and the other 7. You can also find modular multiplicative inverses by "*backtracking Euclid*" as discussed in Section 24.3.

J		1	7	11	13	17	19	23	29	31	37	41	43	47	49	53	59
smallest P		1	43	11	37	53	19	47	29	31	13	41	7	2	49	17	59

Additional **P** possibilities exist for a given **J**. Distinct *60-second images* occur for **P**+60·**k** for 0 ≤ **k** < **S**. Figures 1(a), 1(c), 2(c), 3(a), and 3(b) are **k** = 0 versions for various values of **J**. You should verify that if you start with 1(a) and increase **k** to **k** = 1, 2, and 3 (i.e., **P** = 97, 157, and 217), this produces three additional images, but **P** = 277 is an identical image to **P** = 37. The reason for this identity is straight-forward: There are **n·S** = 240 possible subdivisions so counting 277 is the same as counting all of them once then the first 37 a second time.

Image types. As you play with the file you will find a wide array of *60-second images*. Some are like those found elsewhere in this book although those images are generally based on smaller **n** than 60. Instead of showing versions of those images, Figure 3 provides some images that are not among the image archetypes in Chapter 11. One might imagine the 900-line 3(a) is a version of a spinning star, but the star appears torn apart in this instance. The two legs in each cycle of the 420-line 3(b) support each needle. In the cycle shown, the second and third lines support the left-hand side of a needle (as viewed from the center, ending at vertex 22), and the fifth and sixth lines support the right-hand side of a needle (ending at vertex 39). The 1200-line spinning water bug in 3(c) has six legs, two each at Levels 1, 2, and 3 as described in Section 7.1.

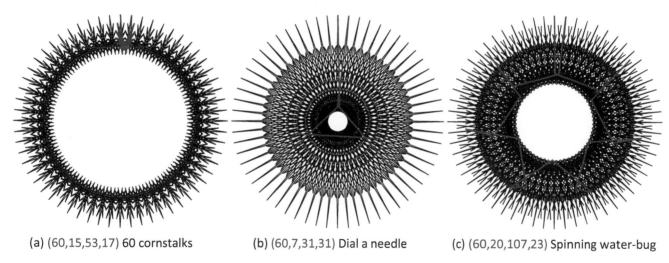

(a) (60,15,53,17) 60 cornstalks	(b) (60,7,31,31) Dial a needle	(c) (60,20,107,23) Spinning water-bug

FIGURE 3 Additional examples *60-second images* with **first cycle in red**. View each in *FCLD* or *SLD* with DL = **S**.

13.2 60 Polygon or Polygram Images (an Alternative to 60-Second Images)

Each value of **n** is a factor of 60, and the number of rotating polygons in the first cycle is 60/**n** so each image has 60-gons or -grams.

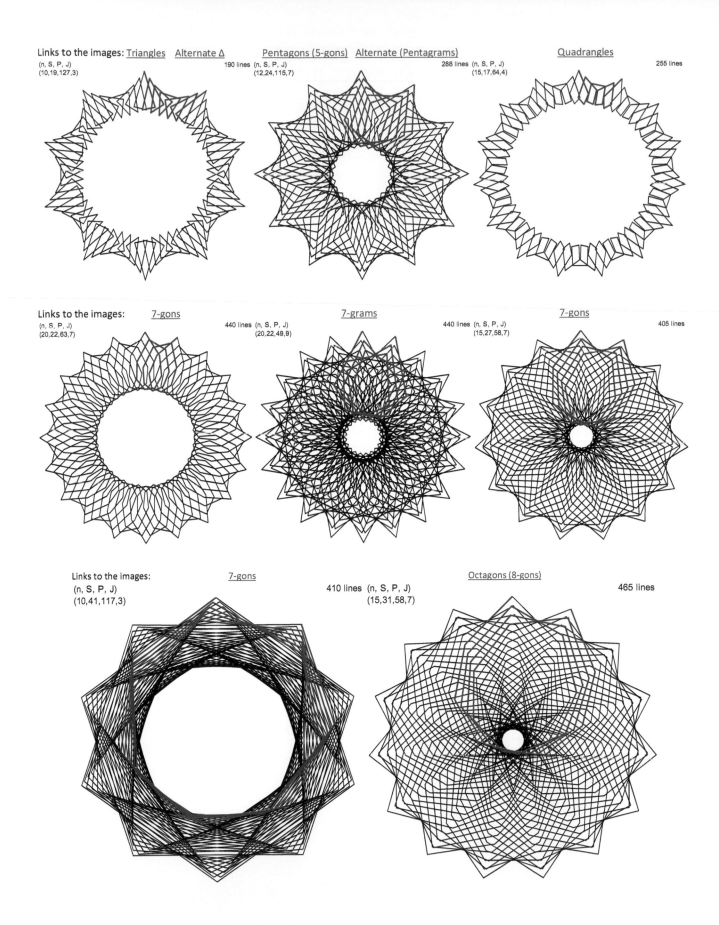

Links to the images: Triangles Alternate Δ Pentagons (5-gons) Alternate (Pentagrams) Quadrangles
(n, S, P, J) 190 lines (n, S, P, J) 288 lines (n, S, P, J) 255 lines
(10,19,127,3) (12,24,115,7) (15,17,64,4)

Links to the images: 7-gons 7-grams 7-gons
(n, S, P, J) 440 lines (n, S, P, J) 440 lines (n, S, P, J) 405 lines
(20,22,63,7) (20,22,49,9) (15,27,58,7)

Links to the images: 7-gons Octagons (8-gons)
(n, S, P, J) 410 lines (n, S, P, J) 465 lines
(10,41,117,3) (15,31,58,7)

The images on both pages are based on rules discussed in *Polygons and Stars in a Cycle*, Section 10.5, but are inspired by the *60-second images* analyzed in Section 13.1. In each case, **P** and **J** are MMI MOD **n**, 1 = **P·J** MOD **n**, so that each image is created in a "one-time-around" fashion, as discussed in Section 5.2. The only difference is these clocks use factors of 60 rather than 60 to accomplish the task. Alternative versions of the first two images were obtained by adding or subtracting 60 to **P** and changing **S** by 1. This changes the triangles from "closed" to "open" and 5-gons to 5-grams.

The images below might be called *half-second-images*, as the completed one-time-around image involves 120 rather than 60 gons or grams! This allows **n** = 24 to create images as well (there are five small pentagons in A below, 24·5 = 120). As with the rest of these images, they are most enjoyably viewed by clicking on the web link and then using *Drawing Mode*.

Link to A (5-gons) Alternative to A (7-gons) Link to B (5-gons) Alternative to B (**S** = 51 5-gons)
(n, S, P, J) 624 lines (n, S, P, J) 588 lines
(24,26,125,5) (12,49,235,7)

Link to C (5-grams) Alternative to C (7-grams) Link to D (5-grams) Alternative to D (7-gram)
(n, S, P, J) 552 lines (n, S, P, J) 564 lines
(24,23,79,7) (12,47,113,5)

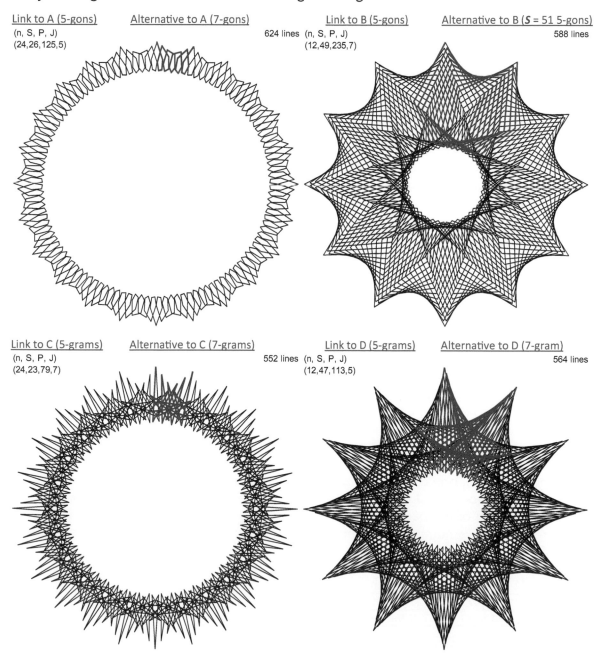

13.3 Alternative Universes

What if we had a ten-hour clock? Given our fingers, it seems a bit odd to have time that is based on 12 instead of 10. Imagine you came upon an island where the daily cycle had 20 *lhours* with 50 *lminutes* in each hour and 50 *lseconds* in each minute (the *l*'s remind us that this is *Island Time*). (For those who want to think of this in terms of traditional hours, minutes, and seconds, an hour = 1.2·*lhour*, a minute = 1.2²·*lminute*, and a second = 1.2³·*lsecond* because one day has 24·60·60 = 86,400 seconds but only 20·50·50 = 50,000 *lseconds*.)

160 lines

Our purpose here is to consider what a 50-*lsecond* image might look like. Following Section 13.1, we could examine *J* and *P* values that are MMI MOD 50. There are 20 *J, P* pairs that are MMI MOD 50 shown in the table below (*note how easy it is to see that 1 = J·P MOD 50*). As with the table in 13.1 for *n* = 60 (and as will always be the case), 1, 1 and *n*-1, *n*-1 are paired. However, other pairs are distinct, meaning *J* ≠ *P*, unlike *n* = 60 where six of the remaining 14 pairs were *J* = *P*. Here are three *J* = 19 images: (50,16,179,19) is a Section 10.4 pulsing square; (50,18,329,19) is a hooded warrior; and (50,20,629,19) is a spinning open-jawed finger trap, as seen in Section 12.9. (50,23,203,17) is a donut with four spinning 6-gons/cycle and *single-step* of length 17.

Since 50 is composite, we could also follow the strategy proposed in Section 13.2 to obtain 50 polygons and stars using factors of 50. The (10,16,107,3) 50-triangle image shown here is an example. Each cycle has five triangles (one less triangle/cycle than the (10,19,127,3) image shown in Section 13.2), with the first cycle shown in **red**.

n = 50: J	1	3	7	9	11	13	17	19	21	23	27	29	31	33	37	39	41	43	47	49
Smallest P	1	17	43	39	41	27	3	29	31	37	13	19	21	47	23	9	11	7	33	49
J·P	1	51	301	351	451	351	51	551	651	851	351	551	651	1551	851	351	451	301	1551	2401

Time on another planet. Sixty is a nice number to work with because its many factors mean that we can consider a variety of fractions of an hour that have whole number solutions (1/2, 1/3, 1/4, 1/5, 1/6, 1/10, 1/12, 1/15, 1/20, 1/30 of an hour are all recognizable units of time). The downside for our purposes is that it reduces the number of *J, P* pairs we can consider that create *60-second images* to 16 in Section 13.1 (or 20 *50-lsecond images* above) because we require that *J* and *n* (of 60 or 50) be coprime.

Imagine we lived in an alternative universe that had a day lasting a bit longer. Suppose there are 24 hours in a day but 61 minutes in an hour and 60 seconds per minute. One way to reconfigure our units of time in this instance is to say that each hour has 60 minutes, but each minute has 61 seconds.

In this happy universe, one could make *61-second images* from 60 *J, P* pairs because 61 is prime, so there is a *J, P* pair for each *J* from 1 to 60. The table below shows these pairs. As with the table above for *n* = 50, each of the pairs is distinct (except 1 and *n*-1) given *n* = 61. The closest we get to equal are the consecutive number highlighted swaps. Such images can be explored with this book's *Excel* file 13.0, *String Art MMI*, which allows up to *n* = 61 and with the web model.

J	1	2	3	4	5	6	7	8	9	10	11	12	13	14	15	16	17	18	19	20	21	22	23	24	25	26	27	28	29	30
Smallest P	1	31	41	46	49	51	35	23	34	55	50	56	47	48	57	42	18	17	45	58	32	25	8	28	22	54	52	24	40	59
MMI MOD 61 **J**,**P** for **J** = 1 to 30 in top half. Bottom half are 61-J. If **J** and **P** are MMI MOD 61 then (61-J) and (61-P) are MMI MOD 61.																														
J	60	59	58	57	56	55	54	53	52	51	50	49	48	47	46	45	44	43	42	41	40	39	38	37	36	35	34	33	32	31
Smallest P	60	30	20	15	12	10	26	38	27	6	11	5	14	13	4	19	43	44	16	3	29	36	53	33	39	7	9	37	21	2

A couple of additional points are worth noting. *First*, you may have noted in each table that if $J = a$ and $P = b$, then $J = b$ and $P = a$ are both J, P MMI pairs. J and P are MMI MOD 60, 50, or 61 so that it does not matter which is J and which is P. *Second*, additional P values occur, but care must be taken to add 50 or 61 each time (not 60) to find the next P that produces a *50-I-second image* or a *61-second image*. *Third*, there is nothing special about 50 or 61: Other values of n can also produce one-time-around images. *Fourth*, watch these one-time-around images emerge using *Fixed Count Line Drawing* with *Drawn Lines* = S. *Fifth*, if n is prime, one cannot follow a Section 13.2-style strategy since n has no proper divisors.

Turning back time. Suppose you find an image you like based on $(n, S, P, J) = (n_0, S_0, P_0, J_0)$, which is a clockwise one-time-around image. The image $(n, S, P, J) = (n_0, S_0, P_0, n_0-J_0)$ is the same static image. But if you use the *Drawing Mode* you will find that the image is now a counterclockwise one-time-around image. Put another way, if you start with a *60-second image* (or 50, or 61, or …) and change J to 60-J (or 50-J, or 61-J, or …), then you can turn back time! From a mathematical perspective, this is the notion of negative MMI discussed in Section 24.2.

Chapter 14

Challenge Questions for Part II

14.1 Introductory Challenge Questions

Q1. Find values of **n**, **S**, **P**, and **J** that produce each of these six images.

DOI: 10.1201/9781003402633-16

Q2. The top three images can be created by changing just one parameter. Which parameter changes and what are **n**, **S**, **P**, and **J** in each image?

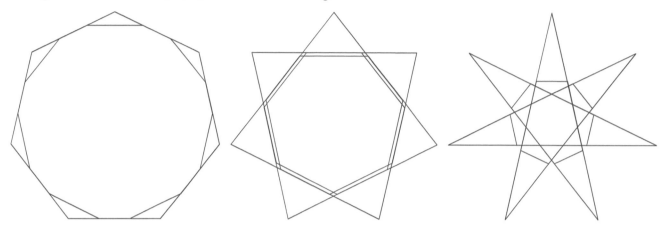

Q3. The bottom three images are similar to the bottom three images from Q1. Explain how they are similar. Provide **n**, **S**, **P**, and **J** for each image.

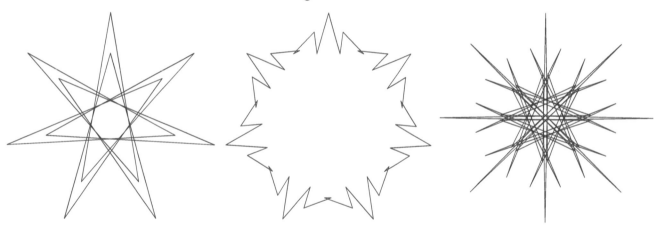

Q4. Read *Odd Needle Stars*, Section 11.7. The end of that piece poses a couple of questions. Can you find examples of even pointed needle stars? If so, can you determine rules such as those in *Odd Needle Stars* that produce even pointed stars?

14.2 Octagonal Challenge Questions

CLAIM: The **Red** and **Blue** images were created without **n** being a multiple of 8. The **Black** image is a regular octagon which has eight lines of symmetry, and all eight angles are equal to 135°. If you look at the **8&0** vertex angles you will note that **Blue∡8&0 < Red∡8&0 < 135°**. Consider **Red** versus **Blue**.

1. Which color has vertical and horizontal symmetry, and which has only vertical symmetry?
2. Given Red **n** = 9, what values of **S**, **P**, and **J** produced the **Red** image? Many answers are possible, but only one simplified set of values occurs (see Section 6.1 on simplifying values).
3. Given Blue **S** = 2, what values of **n**, **P**, and **J** produced the **Blue** image? Many answers are possible, but only one simplified set of values occurs (see Section 6.1 on simplifying values).

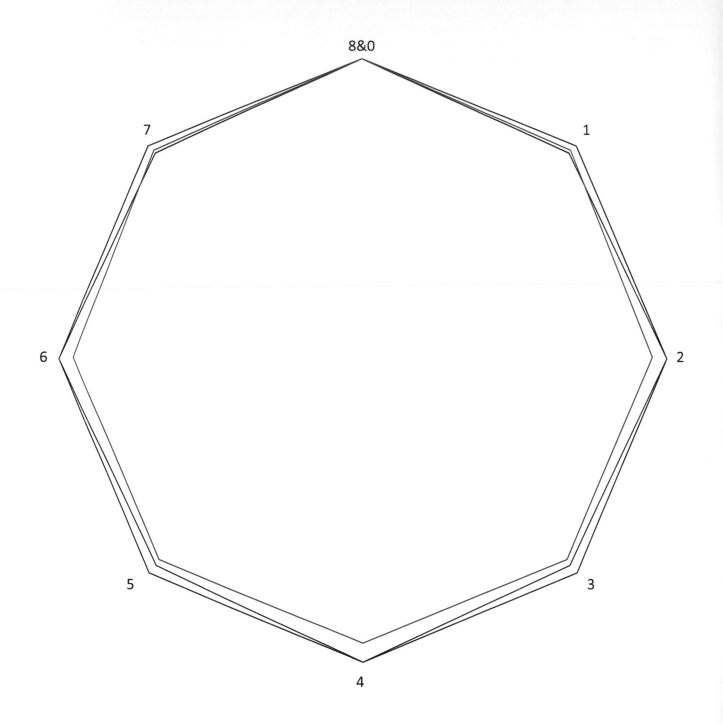

14.3 Areas of *n* = 4 Images

Each of these questions is based on *n* = 4 and *J* = 1. The vertex frame that results is a square embedded in a circle of radius 1.

1. Set *S* = *P* = 1. What is the area of that square? How did you derive your answer?
 FACT: There are at least four ways to do this.

A) Suppose you **do not** know about square roots. You **do not** know about the formula for the area of a triangle. You do know about the area of a rectangle, and you know that if you cut apart an image and reorganize the pieces then the total area remains the same, as long as the pieces do not overlap. How might you proceed?

B) Suppose you **do not** know about square roots. You **do not** know about the area of a triangle. You **do not** know how to rearrange pieces as in A. You do know about the area of a rectangle, and you know how to reflect a portion of the image so that it overlaps with the rest of the image. How might you proceed?

C) Suppose you **do not** know about square roots, but you do know the formula for the area of a triangle. How might you proceed?

D) Suppose you know about square roots. How might you proceed?

2. Set $S = 3$ and $P = 4$. What is the area of the resulting triangle?
3. Set $S = 3$ and $P = 2$. What is the area of the resulting hexagon?
4. What can you say about the relative size of the images in 2 and 3?
5. Set $S = 5$ and $P = 4$. What is the area of the resulting pentagon?
6. Set $S = 7$ and $P = 4$. What is the area of the resulting 7-gon?

More challenging challenge questions:

CLAIM: If $n = 4$, $J = 1$, and $P = 2$, a hexagon results whenever S is an odd number larger than 1. Let that area be denoted H(S).

7. Derive a formula for H(S). Make sure your answer is consistent with 3 above.

CLAIM: If $n = 4$, $J = 1$ and $P = 4$, a 7-gon results whenever S is an odd number larger than 5. Let that area be denoted A_{7gon}(S).

8. Derive a formula for A_{7gon}(S). Make sure your answer is consistent with 5 and 6 above.

14.4 Brunes Star Questions
(Created from $n = 4$, $S = 2$, $P = 3$, and $J = 1$)

This 8-point star (using the vertices of a square and midpoints between vertices) that was used in Section 3.3 to explain S and P provides a wealth of opportunities to explore mathematical issues. Indeed, entire articles are written about this image. See, for example, Kozlov 2015. Consider the image on the next page which is annotated in the following way.

Vertices are numbered starting at 1 and going to 18 to be able to talk about various parts of the star. (Don't worry, not all vertices are labeled, but enough are so that we can ask questions.) Lines are denoted by starting point and ending point so that (1,7) refers to the first line drawn in Section 3.3. Areas are labeled with lowercase letters.

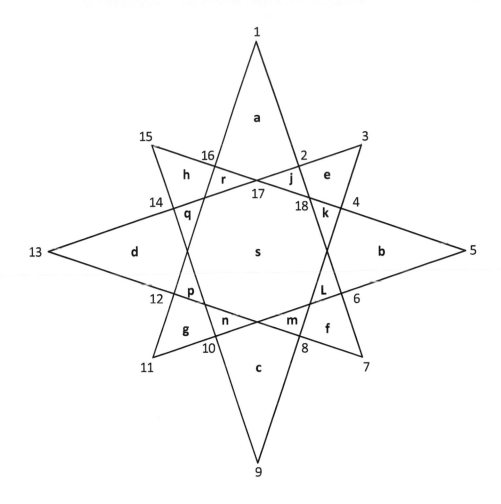

1. Some of the angles appear to be right angles. Explain why this must be the case.

FACT: Each of the triangles in the image is a 3-4-5 right triangles.

2. Choose one of these triangles (such as the triangle with vertices 1, 7, 12), and show that this is such a triangle. Vertex 1 is at (0, 1) and 7 is at (1/2, -1/2).

HINT: To do this you will have to determine the coordinates of vertex 12 (at the intersection of lines (1,11) and (13,7)). Next, use the Pythagorean theorem to show that the sides are in the ratio 3-4-5.

3. Suppose the smallest triangle, for example, triangle **j**, has length 3, 4, 5 (i.e., (2,18) is 3, (2,17) is 4, and (17,18) is 5). What is the area of the Brunes star? (Unlike in Question 2, this Brunes star does not have an initial vertex at (0,1).)

HINT: Add up areas and make sure to not double count. Also, try to do it more than one way as a check on your answer.

14.5 Image Detective A (Using Sections 4.1 and 9.2.1)

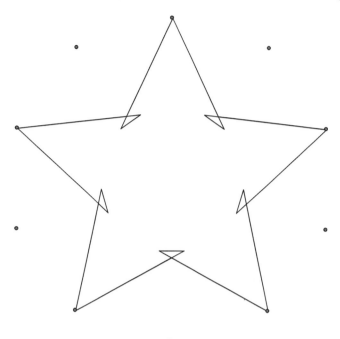

It may help to find a partner and work on this together. That way you can bounce your ideas off one another.

FACT: These are both versions of a pentagram, and they only differ by a single number from one of the parameters.

Use a ruler to find **n**, **S**, **P**, and **J** for both.
Top answer:_____
Bottom answer:_____
What are VCF and SCF for each?
Top: VCF_____ __SCF_____
Bottom: VCF_____ __SCF_____
How would you have attacked this problem if you didn't have the vertices shown?

14.6 Use a Ruler to Analyze These Image Detective Questions (Based on Section 9.2.1)

For all four images, VCF = 1 and SCF = 1. Given that, what are *n*, *S*, *P*, and *J* for each?

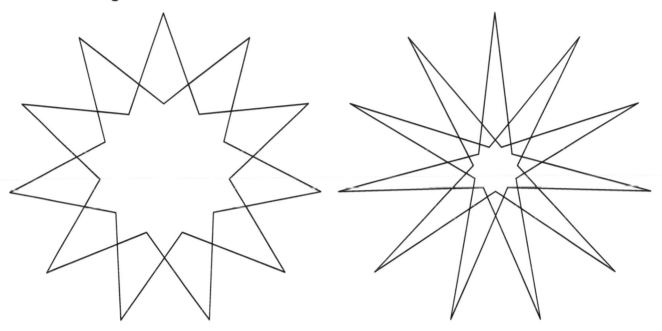

CLAIM: You can go from one to the other of the two upper images by changing one parameter value.
1. Which one changed, **n**, **S**, **P**, or **J**?
The same statement can be made for the bottom two images.
2. Which parameter changed here?

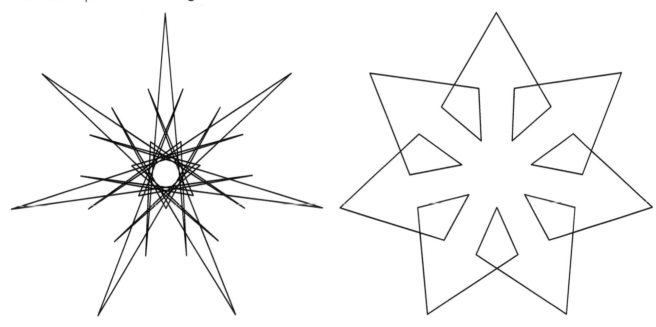

14.7 *Two Footballs* Challenge Questions

Two Footballs in Section 12.6 proposed a general rule for creating *two-football* images. That rule was:

A general rule. Base *two-football* images off of **J**. These images occur when $n = P = 3J \pm 1$ and $S = 2J \pm 2$ but are most visible when **J** is not too small.

This rule keys off of **J**. Four images were shown, but three images were of roughly the same size in terms of the number of lines (determined by **S**) and the number of vertices used from the underlying polygon, **n**. These challenge questions ask you to focus your attention on **n** rather than **J**.

The images shown there were created to highlight the different number of cycles that are possible by following the *two footballs* rule.

The values of **n** shown there were: **n** = 247 (first right); **n** = 248 (third right); and **n** = 250 (second right) from smallest to largest **n**.

Noticeably absent is **n** = 249. Of course, this may just be a byproduct of choosing images that show the various cycle outcomes shown in Section 12.6. Or is there something more going on?

Q1) Is it possible to find values of **S** and **J** satisfying the *two footballs* rule that has **n** = 249?
Q2) Provide a general condition on **n** that guarantees that no **S** and **J** can be found that satisfy the *two footballs* rule and is consistent with that value of **n**.

14.8 Searching for Squares Inside a Modified Brunes Star

The Brunes star, a copy of which is shown at the right, was used to introduce the difference between **S** and **P** in Section 3.3. The image has a fascinating history behind it as noted in the Brunes star challenge question, Section 14.4.

You will note that $(n,S,P,J) = (4,2,3,1)$ produced this image. It has (among other things) two internal squares that are plainly visible.

Consider a modified Brunes star discussed in Section 10.2.3 given by $n = 4$, $J = 1$, $S > 2$, and $S < P < 2S$ with SCF = 1. The images on the next page show are nine of ten possible given $3 \leq S \leq 7$ ((4,6,9,1) was omitted to save space).

CLAIM: Each such image creates **S** internal squares. *Can you explain why this is true?* Hint: How are lines **k** and **S+k** related?

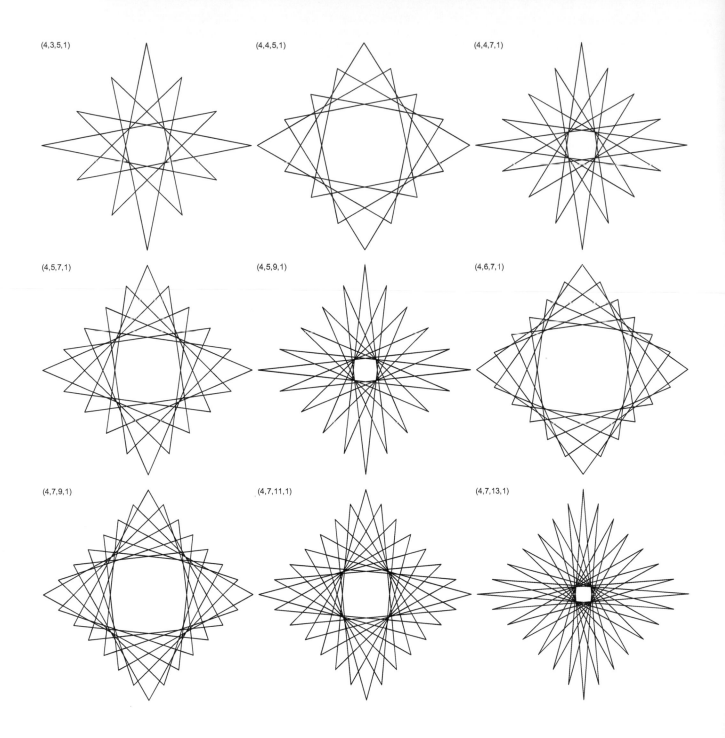

(4,3,5,1) (4,4,5,1) (4,4,7,1)

(4,5,7,1) (4,5,9,1) (4,6,7,1)

(4,7,9,1) (4,7,11,1) (4,7,13,1)

14.9 Calculating Areas of Squares in Modified Brunes Stars

(MBS is discussed in Sections 10.2.3 and 14.8.)

Modified Brunes stars occur if $n = 4$, $J = 1$ and $2 < S < P < 2S$ with SCF = 1. The left image is an example.

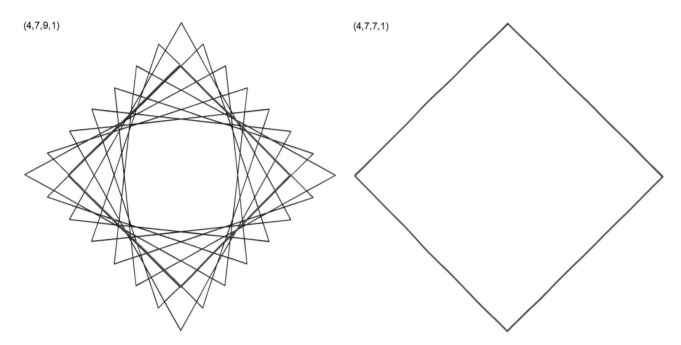

(4,7,9,1) (4,7,7,1)

The four corners of each image at vertices 0, 1, 2, and 3 are (0, 1), (1, 0), (0, -1) and (-1, 0).

1. Compare the areas of the two squares highlighted above.
 a. Is the square on the left more or less than half the size of the one on the right?
 b. Provide exact area calculations of each square in square units based on the coordinates above.

(Hint: This can be done without resorting to square roots.)

2. Consider the first line in the figure at left above, from vertex 0 to the second subdivision on the second segment of the vertex frame (since **P** = 9 = 7+2 = **S**+2). There are two lines perpendicular to this line, one of which starts at the third vertex and ends at subdivision 2 on the first line of the vertex frame. This intersection appears below and to the right of the top red right angle in the left image.
 a. Find equations for the two lines [it may help to use point-slope form of the line $y-y_0 = m(x-x_0)$].
 b. Find the intersection point in (x, y) form using these equations.
 c. Find the distance from this point to the center of the image using the *Pythagorean Theorem* [which is easy to do in this case since one of the points is (0, 0): $d = (x^2 + y^2)^{0.5}$].
 d. Is the square you just found one vertex of larger or smaller than the one in red?
3. The largest internal square from modified Brunes stars where **S** is odd occurs when **P** = **S**+2 and the vertices of the internal square are on the axes (the image at left is an example given **S** = 7).
 a. What is the smallest value of **S** that produces an internal square that is at least ¾ of the size of the square on the right above?
 b. What is the smallest value of **S** that produces an internal square that is at least 90% of the size of the square on the right above?

HINT: This is easiest to do by modeling your answer in *Excel*. Think through the steps on paper, but then let *Excel* do the work for you.

14.10 Can you find Similar Images?

Here are a few images that might have become sections in Chapter 11. Some similar images were found but not enough to create their own explainer for this image type. Thus, these are open challenge questions; no answers are provided.

 Note: SS-# is *single-step* and SmS-# is *smallest-step* of length #. The first three have internal parallel lines, ‖.

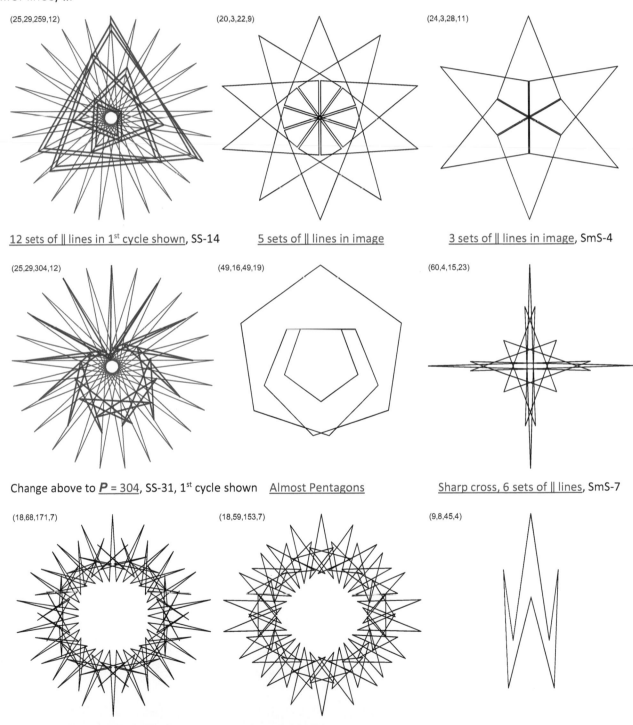

(25,29,259,12)

12 sets of ‖ lines in 1st cycle shown, SS-14

(20,3,22,9)

5 sets of ‖ lines in image

(24,3,28,11)

3 sets of ‖ lines in image, SmS-4

(25,29,304,12)

Change above to **P** = 304, SS-31, 1st cycle shown

(49,16,49,19)

Almost Pentagons

(60,4,15,23)

Sharp cross, 6 sets of ‖ lines, SmS-7

(18,68,171,7)

2 cycle, SmS-43 (1 **P** less is Sunburst)

(18,59,153,7)

2 cycle, SmS-7 (1 **P** less is Spinning Star)

(9,8,45,4)

Fangs, SmS-2 (see Finger Traps)

These 3 share inward-pointing spikes.

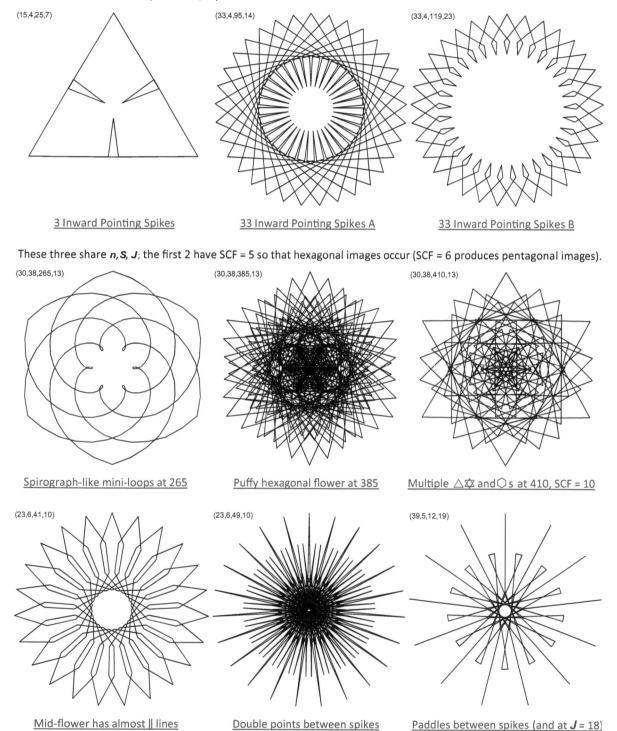

(15,4,25,7)

3 Inward Pointing Spikes

(33,4,95,14)

33 Inward Pointing Spikes A

(33,4,119,23)

33 Inward Pointing Spikes B

These three share *n, S, J*; the first 2 have SCF = 5 so that hexagonal images occur (SCF = 6 produces pentagonal images).

(30,38,265,13)

Spirograph-like mini-loops at 265

(30,38,385,13)

Puffy hexagonal flower at 385

(30,38,410,13)

Multiple △✿ and ⬡ s at 410, SCF = 10

(23,6,41,10)

Mid-flower has almost ‖ lines

(23,6,49,10)

Double points between spikes

(39,5,12,19)

Paddles between spikes (and at *J* = 18)

Here are three additional three-cycle images: *Rolling out dough*, (24,19,104,11), SmS-2; *Three Internal curves*, (24,19,64,11), SmS-11; and *Three overlapping curves*, (42,59,154,17), SmS-18. Note that the first two only differ by **P**.

193

Each image on this page has 58 lines and two cycles since SCF = 25. Each is based on n = 50 and S = 29 (so P must end in 25 or 75, and J is coprime to 50). These were uncovered while working on Sections 9.5 and 9.6.

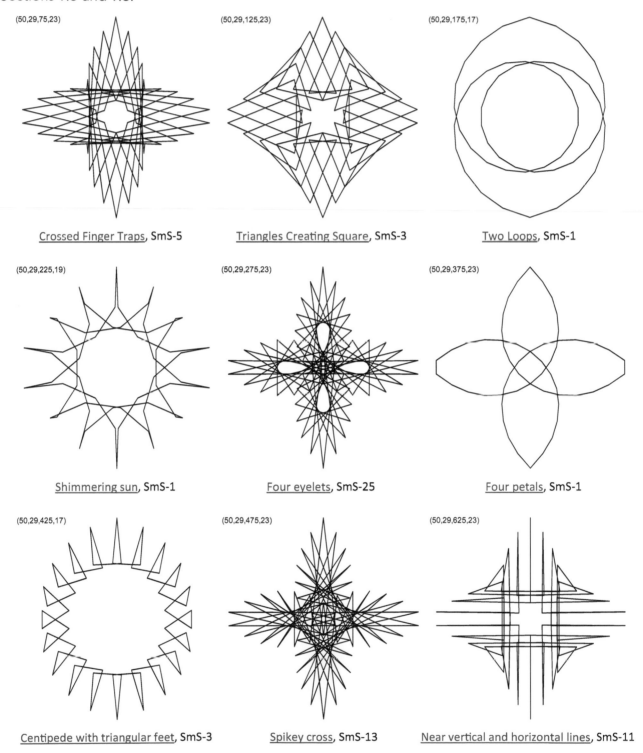

(50,29,75,23)

(50,29,125,23)

(50,29,175,17)

Crossed Finger Traps, SmS-5

Triangles Creating Square, SmS-3

Two Loops, SmS-1

(50,29,225,19)

(50,29,275,23)

(50,29,375,23)

Shimmering sun, SmS-1

Four eyelets, SmS-25

Four petals, SmS-1

(50,29,425,17)

(50,29,475,23)

(50,29,625,23)

Centipede with triangular feet, SmS-3

Spikey cross, SmS-13

Near vertical and horizontal lines, SmS-11

Additional distinct 58-line images are readily obtained by trying other odd J or by trying other odd multiples of 25 for P.

INTRODUCTION TO PART III

Variations on the String Art Model

The string art model laid out in Part II is based on four parameters, **n**, **S**, **P**, and **J**. The chapters to come create variations on those parameters in two main ways. One examines alternative formulations of jump structures (in Chapters 15–18), and the other provides an alternative to remaining on a polygon in Chapter 19.

The model examined thus far is based on a *single jump structure*—how many vertices of the polygon are jumped over before the next line of the vertex frame, VF, is created. It is a single jump structure because the jump pattern is the same each time. The jump need not be 1, rather it is a **constant**. Thus, in an image with **n** = 5 and **J** = 1, the VF is 0–1–2–3–4–0, a pentagon, but if **J** = 2, the VF is 0–2–4–1–3–0, a pentagram.

We can alter the single jump structure in a couple of ways.

The simplest is to set **J** = 1, but go into the center and out after each jump. The result is *Centered-Point Flowers* in Chapter 15. Instead of a pentagon for **n** = 5, the VF is a pentagon with radiuses as seen to the top left. When **P** < **S** one ends up with an **n**-petal flower like the **n** = 5, **S** = 17, and **P** = 16 image to the top right.

The other way to alter the VF is to have *Jump Sets*. The simplest way to explain this is using *double jumps* in Chapter 16. Consider two possible double-jump versions on a 12-gon. The bottom left is what happens when J_1 = 1 and J_2 = 2. The VF in this instance *alternates* 1 and 2 jumps: 0-1-3-4-6-7-9-10-0. The circuit is complete because the 2 jump is at the end of the jump set. The bottom right shows the VF if J_1 = 1, J_2 = 6: 0-1-7-8-2-3-9-10-4-5-11-**0**-6-7-1-2-8-9-3-4-10-11-5-6-0. Notice that the circuit was not complete the first time **0** was an endpoint (in red above from 11 to **0**) because it was not at the end of the 2-jump set.

DOI: 10.1201/9781003402633-17

Four-Color Clock Arithmetic, Chapter 17, examines 3-jump sets given n = 12. Both images have J_1 = 7, J_2 = 6. The left has J_3 = 2 (0-7-1-3-10-4-6-1-7-9-4-10-0 is the 12-line VF). Eight vertices were used, but four were used twice in four 3-jump cycles. The right shows what happens when the third jump increases to J_3 = 3 (the 9-line VF is 0-7-1-4-11-5-8-3-9-0). Nine vertices are used once each in three 3-jump cycles. But J_3 = 4 (not shown) has 36 VF lines with each vertex used three times. Larger jump set extensions examined in Chapter 18 produce more elaborate vertex frames given more jumps in a set.

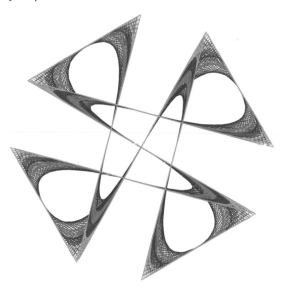
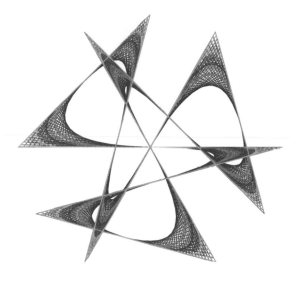

User-determined vertices. The other alteration is to scrap n and J entirely and let users create their own vertices for their string art VF. This requires more work since the user is now in charge of where the vertices are located. But this also allows great flexibility to create your own image.

These non-polygonal images are from Erfle and Erfle, **Bridges** 2020. This paper is a springboard for Chapter 19.

Chapter 15

Centered-Point Flowers

15.1 Understanding the Vertex Jump Pattern for Centered-Point Flowers, CPF

Unlike other files in **Part III**, each jump from vertex to vertex is immediately followed by a jump to the center and a jump back out to the newly acquired vertex. To create CPF images, use *Excel* file 15.0, available from the ESA website using the QR code at the front of this book.

To be explicit, consider $n = 3$. The vertices are labeled as usual, clockwise around the circle starting at 0 (& 3) at the top. Call the center **C**. The order of vertices required to complete a circuit is thus:

$$0 \text{ to } 1 \text{ to } \textbf{C} \text{ to } 1 \text{ to } 2 \text{ to } \textbf{C} \text{ to } 2 \text{ to } 3 \text{ to } \textbf{C} \text{ to } 3$$

There are three things to note about this situation:

1) The circuit is completed after $3n$ jumps rather than n jumps. There are n jumps to go around the circle, n jumps to the center, and n jumps from the center back to the vertex on the circle.
2) The circuit is **NOT** complete as soon as n & 0 is attained (the first three in the sequence above). The circuit is complete once we jump to the center and back to n & 0.
3) Jumps between polygonal vertices are fixed at $J = 1$ in this file.

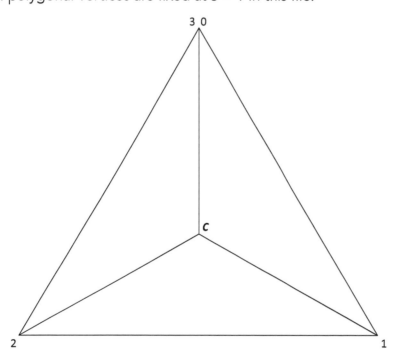

DOI: 10.1201/9781003402633-18

15.2 Finding the Total Number of Connected Line Segments in Centered-Point Flowers, CPF

When there are multiple jumps involved, it is no longer true that the maximum number of possible segments is simply $n \cdot S$, often written as nS. Now it is a multiple of that number.

In CPF, there are $3n$ vertices in the vertex frame because moving to the next vertex requires three movements: 1) the move to the next vertex, then 2) the move **in** to the center, and then 3) the move from the center back **out** to that vertex. This file forces $J = 1$ so polygons result, but the vertex frame no longer looks like a polygon but rather a polygonal pie plate with n equal-sized triangular pieces. Since $J = 1$, all polygonal vertices are used, and VCF = 1.

The number of lines calculation replaces n with $3n$ in the SCF calculation discussed in Section 4.1.

On the subdivision common factor, SCF: On each of the $3n$ line segments, we create S subdivisions. The total number of possible subdivision endpoints is thus $3nS$. Not all of these endpoints are used if P has factors in common with $3nS$.

Mathematically, the subdivision common factor, SCF, is: SCF = GCD(P, $3nS$).

The number of lines in the image, L, is then given by: $L = 3nS/$SCF.

15.3.1 Subdivision Patterns and What This Implies About S and P for Centered-Point Flowers

The simplest extension of jump patterns is to simply **Jump** one vertex ($J = 1$) then **In** to the center, C, and back **Out** to the same vertex. Each move like this carries with it S subdivisions so the image shown is unlike other files in that the center is explicitly included in each jump set. Each vertex of the n-gon gets used twice. Given the $n = 3$ vertex frame discussed in Section 15.1, this creates the following subdivision endpoints (noted beneath the vertex and center jumps):

0 to 1 to C to 1 to 2 to C to 2 to 3 to C to 3
S $2S$ $3S$ $4S$ $5S$ $6S$ $7S$ $8S$ $9S$

Because of the "**Jump, In, Out**" pattern, each new vertex involves three moves. Notice in particular that the following is true about the multiple, m, in front of S in each case:

Jump If this is the first time vertex v is used, then $m = 3v - 2$ ($m = 1$ if $v = 1$, $m = 4$ if $v = 2$, and $m = 7$ if $v = 3$).

In The move **in to the center** is always of the form: $m = 3v - 1$ ($m = 2$ if $v = 1$, $m = 5$ if $v = 2$, and $m = 8$ if $v = 3$).

Out The move back **out from the center** to v is of the form: $m = 3v$ ($m = 3$ if $v = 1$, $m = 6$ if $v = 2$, and $m = 9$ if $v = 3$).

This same pattern works for values n beyond $n = 3$, for each vertex v of the n-gon, $1 \leq v \leq n$, as we see for $n = 5$ on the next page. Note that images in Chapter 15 are denoted (S,P,n). The numbers next to vertices are the multiples m discussed above. Additionally, P/S is noted in fractional form.

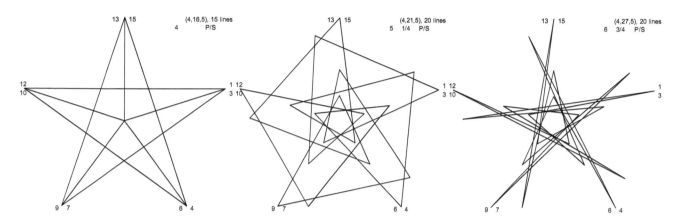

These five "pentagrams with attitude" based on **n** = 5 and **S** = 4 are each annotated with multiple values **m** noted above (together with **P/S** which tells us where the first line lands relative to these multiples of **S** vertices). Each is more pentagram-like than pentagon-like because $4 \leq$ **P/S** $< 7.5 = 3n/2$ (halfway around). You should be able to see where the first line ends in each image. Remember that **m** = 5 and 8 are at the center so the top middle 5 ¼ is 1/4 of the way out from the center 5 to **m** = 6 at vertex 2 (and the top left first four lines in terms of **m** are 4–8–12–1 since 16–15 = 1). The top three have fewer lines because SCF > 1. The bottom right is a *porcupine* (**P** = 31 is the same image and **P** = 30 is a single line).

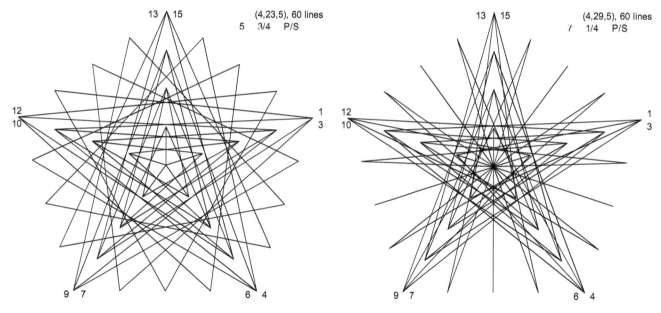

15.3.2 *P/S* Helps You Find Similar Images

Due to the *subdivision counting structure* for CPF images noted in Section 15.3.1, the ratio of **P** to **S** provides critical information to help you find similar images. Sometimes this comes from changing **S** and maintaining **P/S** at approximately the same ratio (by adjusting **P** to maintain the same SCF). At other times this comes from maintaining a location for where you want the first line to land as **n** changes. We provide examples of both types of exploration here.

Adjusting *P* as *n* changes. The center image in the top row was one of the "pentagrams with attitude" that was highlighted in the *subdivision counting structure* Section 15.3.1. This image was sufficiently interesting that it seemed to demand further exploration. What would similar images look like for different *n*? Two alternatives are shown *n* = 3 at left and *n* = 7 at right. In each image, a **1** denotes *P*, the end of Line 1.

Note that *P/S* does not remain the same as *n* changes. On the other hand, it is easy to see the change in *P/S* that happens every time *n* increases by 2. Given this, can you predict what *P* should be if you want *n* = 15? It is easy to check your prediction by going to the CPF *Excel* file 15.0 and adjusting *n* and *P* to test your answer.

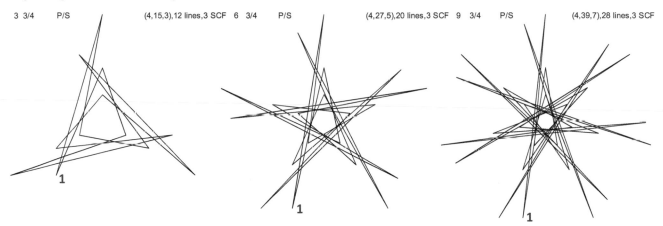

3 3/4 P/S (4,15,3),12 lines,3 SCF 6 3/4 P/S (4,27,5),20 lines,3 SCF 9 3/4 P/S (4,39,7),28 lines,3 SCF

[**MA.** To automate this note that this only works for an odd *n*. The vertex just before the bottom is (*n*-1)/2 (2 if *n* = 5) so you want *P/S* to be ¾ of the way to the next vertex (given *S* = 4), or *P/S* = 3/4+3·(*n*-1)/2 so replace the number for *P* in C1 by =4*(0.75+1.5*(L1-1)) and the image will change as *n* changes. With this, you see that *P* = 87 answers the *n* = 15 question above. An interesting question is whether you can also find *distinct* but similar images when *S* ≠ 4.]

Interestingly, if you use the equation just proposed for *n* = 4, then you obtain the bottom left image based on *P* = 21. If you follow through the first line placement there, you will see that it is on the vertical line. In this instance, it is convenient to draw it the "other way" using *P* = 3*nS*-21 = 48-21 = 27. This image shows a pair of internal squares in addition to horizontal and vertical diameters and, as above, **1** shows the location of the end of Line 1.

Adjusting *P* as *S* changes. If you want to change *S* to see if you can find similar images, you would want to follow the strategy of having the endpoint of the first line to be on the line from vertex 2 to vertex 3. Put another way: **You want to have 6 < *P/S* < 7 and you want to maintain SCF = 3.** Each of the images below satisfy these two conditions. Note that if you set *S* = 6, *P* = 39 (so *P/S* = 6.5 and SCF = 3), you obtain the Brunes star (Sections 3.3 and 14.4), this time with horizontal and vertical diameters added. Additionally, *S* = 10 has two *P* values that satisfy these conditions, *P* = 63 and *P* = 69.

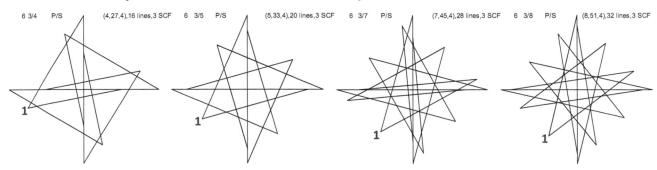

6 3/4 P/S (4,27,4),16 lines,3 SCF 6 3/5 P/S (5,33,4),20 lines,3 SCF 6 3/7 P/S (7,45,4),28 lines,3 SCF 6 3/8 P/S (8,51,4),32 lines,3 SCF

15.4 Why Do Some Subdivision Endpoints Have More Lines Than Others?

The CPF model allows multiple lines in and out of certain points but not others. Both images share **S**, **n**, and have SCF = 1. They differ by **P** to examine why some points have more lines coming out of them than others. Each image has a **1** at the end of the **P**th endpoint (Line **1**); colored circles distinguish between the three types of VF subdivision endpoints.

○ **Perimeter subdivisions but not vertex, 2.**
○ **Ray subdivisions but not center, 4.**
○ Center, 2*n*.
○ **These are not subdivision endpoints.**

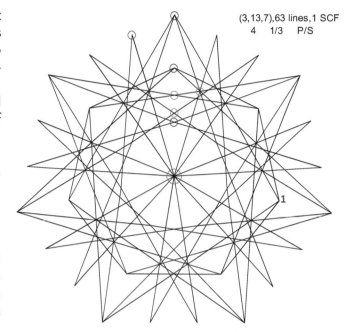

(3,13,7),63 lines,1 SCF
4 1/3 P/S

One of the differences with the traditional string art model is that those images have one line into and one line out of any used subdivision. Both images use all subdivision endpoints because SCF = 1.

A given perimeter subdivision point (except endpoints of each VF segment) has only one line in and out because the jump to a new vertex (the 1st part of Section 15.1 *3-part jumpset of Jump, In, Out*) occurs only once.

A given ray subdivision point (except center) is counted twice, once on the move **In** to the center and the second time on the move back **Out** to the vertex. Therefore, each is associated with four segments. Note that the polygon's vertex is like interior ray segments from the center to each vertex.

The center is counted each time a vertex is counted since it is the end of the *In* and start of the *Out* move in each jump set. This means that a total of 2*n* lines are tied to the center of the image.

The last of the three red subdivision points ○ on the vertical ray (2/3 of the way to the center) in the upper image is difficult to discern as it looks like it could be an intersection of two segments (like the two ○ line intersections above this point). Note that the red circles are equidistant to one another on each ray (1/**S** = 1/3 in length).

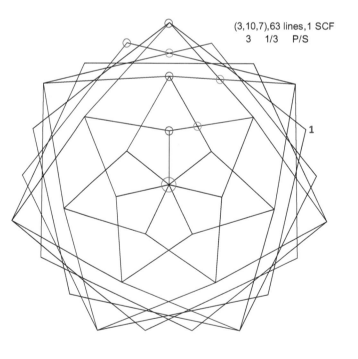

(3,10,7),63 lines,1 SCF
3 1/3 P/S

The upper image shows 14 lines associated with the center and the lower image shows half that number, 7. There are 14 lines touching the center in the lower image: Half are going into the center and half are going out and they are on top of one another. This also explains why there are 4 lines not 3 at the inner red endpoint 1/3 from the center.

15.5.1 Centered-Point Flower Images When *P* Is a Multiple of *S*

In the traditional string art model, the image is a VF polygon or star if **P** is a multiple of **S**, **P** = **m·S**. This is not always true with Centered-Point Flowers. We focus on **n** = 11 and 12 to see what differences emerge when **n** is prime versus composite. Instead of being exhaustive with images, this explainer examines some of the general patterns that are laid out in the table showing what happens given **m** ≤ 3**n**/2. (Note: **P** = **m·S** implies SCF = **S** so there are 3n possible lines regardless of **S**. These images use **S** = 1, so **P** = **m**.)

Images are symmetric across 3**n**/2. To put it in another way, **m** and 3**n-m** produce the same static image, with the only difference being the way in which the image is drawn.

When **n** is prime, all polygons and stars with and without rays are represented. The only unusual image occurs at **m** = 11, SCF = 11. This produces the obtuse triangle at left below that goes from 11-gon vertices 11&0-Center-8-11&0 (the three lines end at **P** = 11, 22, 33).

When **n** is composite, some **n,J**-stars that were not possible (Section 1.2) are possible with rays (such as those associated with **m** = 7, 10, 11, and 14). Note that one cannot draw a 6,2 or 12,3 star *without* using the center. Instead, one obtains a triangle (**m** = 12) or square (**m** = 9) since 12·3 = 9·4 = 36 = 3**n**. The mirror-image three equilateral triangles, **m** = 4 and **m** = 8, are shown below.

Each ribbed star is drawn twice in the table (and twice more for **m** > 3**n**/2). The two images on the next page are sharpest ribbed stars, 11,5 and 12,5, both of which can be drawn with **m** = 13.

m	n = 11 Image*	n = 11 3*n-m*	n = 12 Image	n = 12 3*n-m*
1	VF = 11 RP	32	VF = 12 RP	35
2	11 R	31	6 R	34
3	11 P	30	12 P	33
4	11,2 RS	29	**3 T v.1**	32
5	VF = 11 RP	28	VF = 12 RP	31
6	11,2 S	27	Hexagon	30
7	11,3 RS	26	12,3 RS	29
8	11,2 RS	25	**3 T v.2**	28
9	11,3 S	24	Square	27
10	11,4 RS	23	6,2 RS	26
11	**Obtuse Δ**	22	12,3 RS	25
12	11,4 S	21	Triangle	24
13	**11,5 RS**	20	**12,5 RS**	23
14	11,4 RS	19	6,2 RS	22
15	11,5 S	18	12,5 S	21
16	11,5 RS	17	6 R	20
17			12,5 RS	19
18			Vertical	18

*Acronyms: #,## **n ,J** -star; P-polygon; R-rays; RS-star with rays; S-star; T-equilateral triangle; VF-Vertex Frame.

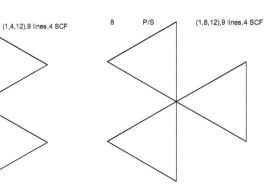

4 P/S (1,4,12),9 lines,4 SCF 8 P/S (1,8,12),9 lines,4 SCF

11 P/S (1,11,11),3 lines,11 SCF

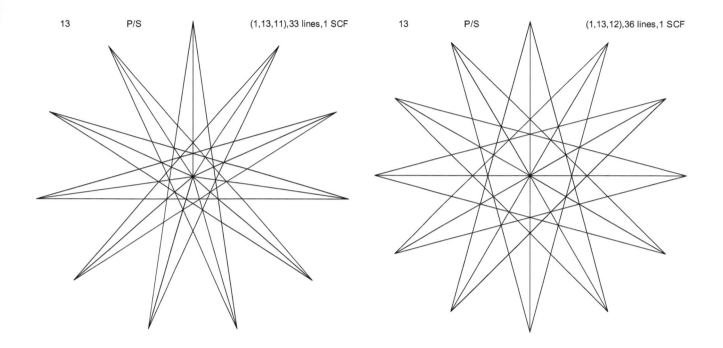

15.5.2 *P* = 2*S* Images: Even and Odd Spikes

An interesting pattern emerged in Section 15.5.1, **P** = **m·S**, where it was found that spiked images occur when **P** = 2**S**. When **n** is odd (like **n** = 11 at left), there are **n**-spikes and when **n** is even (like **n** = 12 at right), there are **n**/2 spikes.

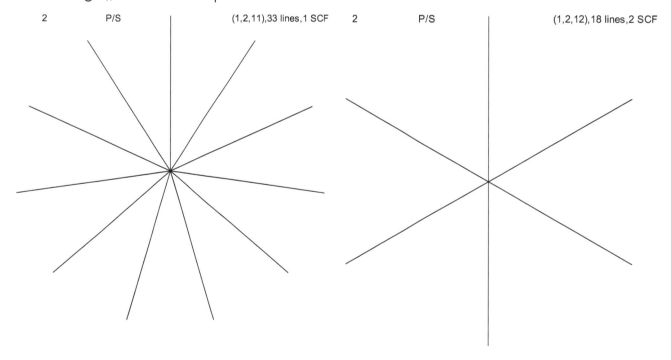

The question, of course, is: Why?

We examine this by considering the general even and odd values of **n**. Before turning to this question, consider the specific versions shown above. The first thing to recognize is that there are many more lines used than counted spikes in both models. It would not be surprising if the number of lines was twice the number of spikes since one needs to go into the center and back out to some other vertex, but in fact, it is three times this number (33 = 11·3 and 18 = 6·3). Second, although there appear to be three lines in the **n** = 12 image (3-*diameters*, from 12-6, 2-8, and 4-10 on the clockface), these three lines are actually 6-*radiuses*, one each to and from the center to hours 2, 4, 6, 8, 10, and 12.

| | | Vertex **number** of *n*-gon or Center, **C** | |
Line, **L**	**P** = 2L *	Start	End
1	2	*0*	*C*
2	4	*C*	*2*
3	6	*2*	*2*
4	8	*2*	*C*
5	10	*C*	*4*
6	12	*4*	*4*

* Since **P** = 2**S** produces the same image regardless of **S**, set **S** = 1.

Why are there 3× as many lines? The table shows the first six lines based on the **P** = 2**S** jump pattern. Since our images are continuously drawn, the ending point of a line is the starting point of the next line. Six lines were shown to focus attention on the three-line pattern that is shown twice: Lines 1 and 4 move to the center from a vertex; Lines 2 and 5 move out to *two* vertices higher than the previous line's start (0 to 2 for Line 2 and 2 to 4 for Line 5); Lines 3 and 6 stay at the same vertex because *two jumps after the first time a vertex is used, it is reused*. This *cycle* repeats every three lines (even though the third is just a point).
[**MA.** The values in the End column were obtained using this equation in *Excel*: =IF(2=MOD(P,3),"C", IF(1=MOD(P,3),(P+2)/3,P/3)), which simply operationalizes the jump pattern in Section 15.1. The other equation used was to set Start in Line 2 =End in Line 1.]

A revised notion of a cycle. The first cycle occurs once a polygonal vertex is achieved (see Section 5.1). The CPF model shows that a vertex can be achieved in two ways, 1) as the endpoint of a line from the previous vertex and 2) as an endpoint of a line from the center. The first way is at the start of a 3-jump set, the second is at the end of a set. The first cycle ends once a vertex is achieved as the end of a jump set so the cycle above is three lines long, not 2.

Even versus odd n. Another important attribute of this jump pattern is that it jumps vertices by two vertices each 3-jump set, whether **n** is even or odd. This is the attribute that creates half as many spikes when **n** is even.

n is even. If **n** is even, **n** = 2**k**. The **k**th cycle ends at vertex 2**k** = 0 and the circuit is complete with rays at all even vertices.

n is odd. If **n** is odd, **n** = 2**k**+1. The first **k** cycles create rays at even vertices ending at vertex 2**k** = **n**-1. The next cycle ends at vertex 1 = **n**-1 + 2 - **n**. The last **k** cycles create rays at odd vertices ending at 2**k**+1 = **n** completing the circuit.

NOTE: *The rest of this explainer has more mathematical detail, but you can simply ignore the equations if you do not want to wade through the detail and you can still obtain the gist of the argument.*
Background. Deeper into the table from Section 15.5.1, **P** = **mS**, (reproduced at the top of the next page), note that when **m** = 16 and **n** = 12, we once again have the six-spike pattern examined above. A simple adjustment to the table on the previous page shows how the **m** = 16 image is created, and interestingly, it is quite different from how the **m** = 2 image was created.

The **m** = 16 image shown at bottom right on the next page is the SAME static image as **m** = 2. Since **n** = 12, we can think of vertices as hours on the clockface.

Adjusting the table above. Given the automation of Start and End points in the **MA** note above, all that needs to be done is to change **P** = 2**L** to **P** = 16**L** in the second column. This is done by typing 16 in B1 and then referencing it to create the equation in cell B3 (the equation is =B1*A3). Drag

this equation to obtain multiples of 16 for **P**. The results are shown in the first four columns of the table below.

The first two lines. Rather than focus on the entire table below (which has more rows AND columns), initially focus on the first two lines because they show a very different pattern from the **m** = 2 pattern on the prior page. The first line is the vertical diameter, going from 0 (or 12 o'clock) to 6 and the second is the vertical radius from 6 to the center. The second line backtracks half of the first line.

The first line does end in a vertex, but it is the end of the *Jump* from vertex 5 (5 o'clock) to vertex 6 using the jump-set pattern of *Jump, In, Out* discussed in Section 15.3.1. As such, it is not the end of the first cycle (as discussed above) since it is not on a move out from the center back **Out** to a vertex.

The rest of the table. The third line ends at vertex 16, but of course, that is the same as vertex 4 (since **n** = 12) so it is a jump out from the center to vertex 4. This is the end of the first cycle. Rather than look at larger and larger values for Start and End vertex numbers, the vertices are transformed in columns 5 and 6 using the equations noted at the bottom of the table via the MOD function (the *Excel* COUNT function produces a 1 if a number is present). The three-line cycle is diameter, radius, radius as noted in the final column. Each cycle creates 1/3 of the image (unlike **m** = 2 which is 1/6). The table was extended to show all nine lines in the image, and <u>an underscore was included to note the end of each cycle.</u>

Nine lines versus 18 lines. The same image is created in both cases, but it takes half as many lines with **m** = 16 as **m** = 2. But remember that six of the lines for *m* = 2 were **actually** points rather than lines. If you think of it holistically, each of the three lines in the **m** = 16 version includes three lines, a diameter, and both radiuses, they just are mapped in different cycles (e.g., lines 3, 4, and 5 map the 4-10 line).

m	*Image**	*3n-m*	*Image*	*3n-m*
	n = 11		n = 12	
1	VF = 11 RP	32	VF = 12 RP	35
2	11 R	31	6 R	34
3	11 P	30	12 P	33
4	11,2 RS	29	**3 T v.1**	32
5	VF = 11 RP	28	VF = 12 RP	31
6	11,2 S	27	Hexagon	30
7	11,3 RS	26	12,3 RS	29
8	11,2 RS	25	**3 T v.2**	28
9	11,3 S	24	Square	27
10	11,4 RS	23	6,2 RS	26
11	**Obtuse △**	22	12,3 RS	25
12	11,4 S	21	Triangle	24
13	**11,5 RS**	20	**12,5 RS**	23
14	11,4 RS	19	6,2 RS	22
15	11,5 S	18	12,5 S	21
16	11,5 RS	17	6 R	20
17			12,5 RS	19
18			Vertical	18

*Acronyms: #,## **n** ,**J** -star; P-polygon; R-rays; RS-star with rays; S-star; T-equilateral triangle; VF-Vertex Frame.

m =	16	Vertex **number** of *n*-gon or Center, **C**		Vertices (MOD 12)		Diameter
Line, L	P = mL *	Start	End	Start	End	or radius
1	16	*0*	*6*	0	6	D
2	32	*6*	*C*	6	C	R
3	48	*C*	*16*	C	4	R
4	64	*16*	*22*	4	10	D
5	80	*22*	*C*	10	C	R
6	96	*C*	*32*	C	8	R
7	112	*32*	*38*	8	2	D
8	128	*38*	*C*	2	C	R
9	144	*C*	*48*	C	0	R
End		IF(2=MOD(P,3),"C",IF(1=MOD(P,3),(P+2)/3, P/3))				
MOD 12 Start		IF(COUNT(Start)=1,MOD(Start,12),"C")				
MOD 12 End		IF(COUNT(End)=1,MOD(End,12),"C")				

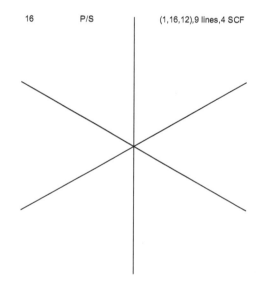

16 P/S (1,16,12),9 lines,4 SCF

15.5.3 A Deeper Dive into Spiked Images

If you poke around CPF a bit more, you will find that you CAN get **n**-spikes for even **n** *half the time*. More specifically, if **n** is divisible by 2 but not 4, then **m** = 3/2**n**-2 produces **n**-spikes, but if **n** is divisible by 4, **n**/2 spikes are produced. The table for **n** = 12 and **m** = 16 found in Section 15.5.2, **P** = 2**S**, will be useful as a contrast to the discussion below).

Automating the CPF file. If you type =1.5*L1-2 in C1 for **P** and set **S** = 1, then you can see spiked images for every even **n** created by **m** > 2 simply using the ⬍ for **n**. A | line occurs for **n** = 4, **n** = 6 has the same * image as **n** = 12, and **n** = 8 is a +. We focus here on the largest **n** divisible by 2 but not 4 available in *Excel* file 15.0, **n** = 14. The resulting 42-line image is below. The table shows how this image was created (note the 43rd and first lines share Start and End vertices).

Modifying the table in 15.5.2. For general **n**, create a cell for **n** (add a new row and put it in B1), replace **m** with =1.5*B1-2 in B2, and replace 12 by **n** in MOD **n** vertices equations).

The pattern is a double jump backwards. The first line ends at **n**/2, and the third line ends two less than **n**/2, just like with **n** = 12 (where the first line ended at 6 and the third line ended at 4). In this instance, the first line ends at 7, and the third ends at 5. The second cycle moves halfway around but does the same reduction by two vertices in moving from the fourth to sixth lines (from 10 to 8 given **n** = 12 or 12 to 10 for **n** = 14). After this, the

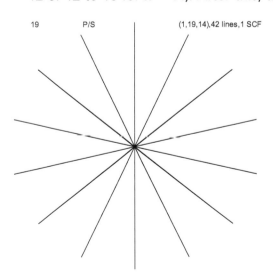

19 P/S (1,19,14),42 lines,1 SCF

n = 14		Vertex **number** of				
m = 19		n -gon or Center, **C**		Vertices (MOD n)		Diameter
Line, **L**	P = mL *	Start	End	Start	End	or radius
1	19	0	7	0	7	D
2	38	7	C	7	C	R
3	57	C	19	C	5	R
4	76	19	26	5	12	D
5	95	26	C	12	C	R
6	114	C	38	C	10	R
7	133	38	45	10	3	D
8	152	45	C	3	C	R
9	171	C	57	C	1	R
10	190	57	64	1	8	D
11	209	64	C	8	C	R
12	228	C	76	C	6	R
13	247	76	83	6	13	D
14	266	83	C	13	C	R
15	285	C	95	C	11	R
16	304	95	102	11	4	D
17	323	102	C	4	C	R
18	342	C	114	C	2	R
19	361	114	121	2	9	D
20	380	121	C	9	C	R
21	399	C	133	C	7	R
22	418	133	140	7	0	D
23	437	140	C	0	C	R
24	456	C	152	C	12	R
25	475	152	159	12	5	D
26	494	159	C	5	C	R
27	513	C	171	C	3	R
28	532	171	178	3	10	D
29	551	178	C	10	C	R
30	570	C	190	C	8	R
31	589	190	197	8	1	D
32	608	197	C	1	C	R
33	627	C	209	C	13	R
34	646	209	216	13	6	D
35	665	216	C	6	C	R
36	684	C	228	C	4	R
37	703	228	235	4	11	D
38	722	235	C	11	C	R
39	741	C	247	C	9	R
40	760	247	254	9	2	D
41	779	254	C	2	C	R
42	798	C	266	C	0	R
43	817	266	273	0	7	D
End		IF(2=MOD(P,3),"C",IF(1=MOD(P,3),(P+2)/3,P/3))				
MOD n Start		IF(COUNT(Start)=1,MOD(Start,n),"C")				
MOD n End		IF(COUNT(End)=1,MOD(End,n),"C")				

third cycle's first ending (at Line 7) is two less than where the first cycle ended (at 2 for **n** = 12 or 3 for **n** = 14).

In both instances, successive jumps backward of 2 are the norm. The difference is when **n** = 4**k**, the values that are backing up to 0 are all even so it stops at 0. If **n** = 4**k**+2, these same vertices are odd (**n**/2 = 2**k**+1), and backing up 2 from 1 yields 13 in the move from Line 9 to 13. At this same time, even vertices begin to be filled in on the right half of the circle (Line 10 ends at 8 > **n**/2 but Line 12 ends at 6 < **n**/2). This is why all vertices are used when **n** = 4**k**+2, but only half are used when **n** = 4**k**.

15.6 Creating Functionally Related Images: A *P(S)* Example

Each of the three parameters in the *Centered-Point Flowers Excel* file 15.0 is unlocked so that you can create functional relationships to test whatever idea you have about how images relate to one another. Think of this as a version of the material discussed in Chapter 10.

Suppose you want test images where **P** is a linear function of **S**: **P** = **mS**+**a**. You could type this into C1 directly and change **m** and **a** by changing this cell. *A more efficient solution is to automate your testing by using the unlocked cells in green beneath the image.* Here is a suggested way to accomplish this automation.

Type labels m in F39 and a in F40 then numbers in E39 and E40. Type =E39*B1+E40 in cell C1. This allows you to change C1 by typing different numbers in E39 or E40. For example, 3 and 0 always produce just the **n**-gon, and 1 and 0 produce the VF, an **n**-gon pie cut into **n** equal pieces. Cells F30:G31 are also unlocked so that you can transfer the numbers to the image area if you want to do so by typing =E39 in F30, =E40 in F31, m in G30, and a in G31. The images in this section were created simply by changing **m** and **a** and then using the **S** and **n** ⬍ arrows.

Irregular internal n-stars. If **P** is a bit smaller than 2**S** (so set **m** = 2 and **a** = -1) the first line will end close to the center of the ray from vertex 1. The top row (shown on this page with middle and bottom on the next) provides four examples with different **S** and **n**. Such images require **nS** lines since SCF = 3.

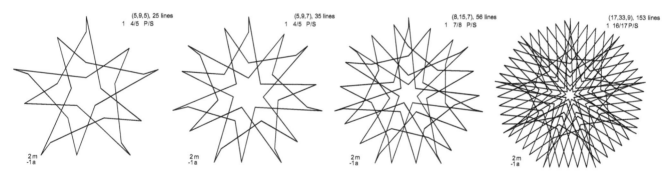

Overhead pyramid, (*m*,*a*) = (2,2) middle, *vs.* **four-leaf clover**, (*m*,*a*) = (1,1) bottom, *n* = 4 images have common *S* by column.

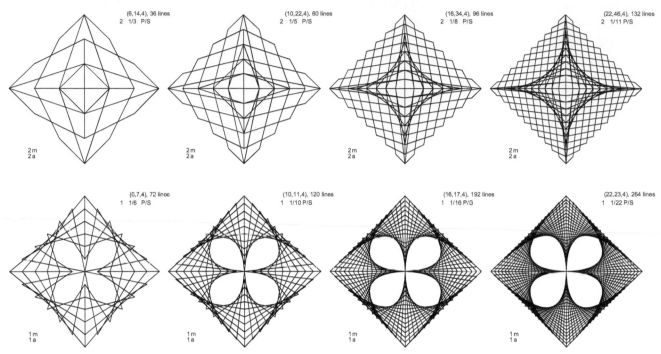

The middle row has half as many lines because SCF = 2 versus SCF = 1 in the bottom row. One can see that half the subdivision endpoints are used in the top row by looking around the outer edge (with 3, 5, 8, and 11 used subdivisions) or by looking at Levels along the four rays from the center to the four vertices. The bottom row outer edges are ragged because *P* = *S*+1 > *S*. To make the outer edge smooth, type 1 in E39, -1 in E40 (or other *a* < 0) and adjust *S* so SCF = 1.

15.7.1 SCF = 1 Images

*(*n* = 10 and *S* = 10, With *P/S* Noted for Each Image. Since *S* = 10, *P* = 10*P/S*)*

Since SCF = 1, each image has 300 = 3*nS* lines. When *P* = 150 a vertical line occurs and *P* = 151 is the same static image as *P* = 149 at the bottom right. Maximum *P/S* = 1.5*n* before the other half starts so for *n* = 16, check up to *P/S* = 24 for additional examples. *P/S* noted rather than *P* because, as noted in Section 15.3.2, this is how to find similar CPF images.

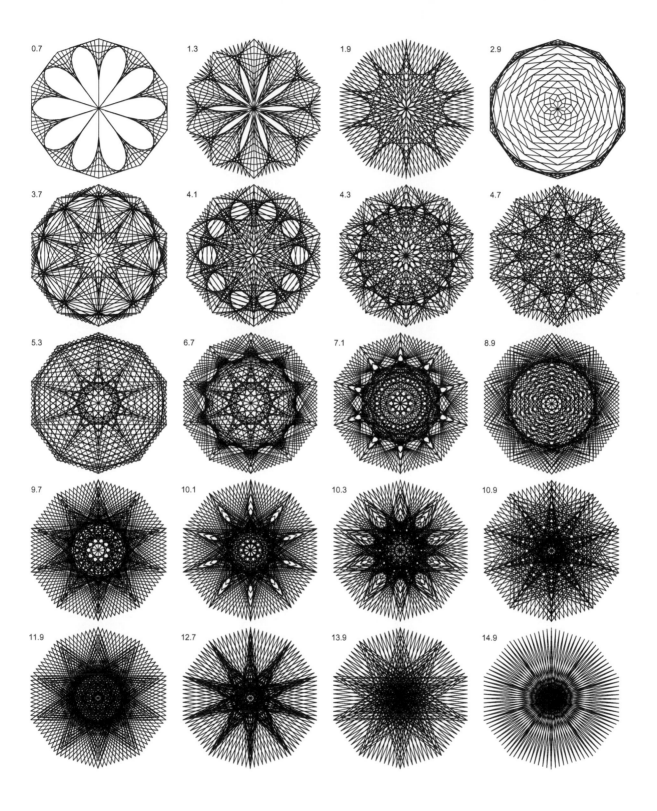

15.7.2 SCF > 1 Images

(n = 16 and S = 35, With Lines Noted for Each Image (not P). P = 1680/Lines)

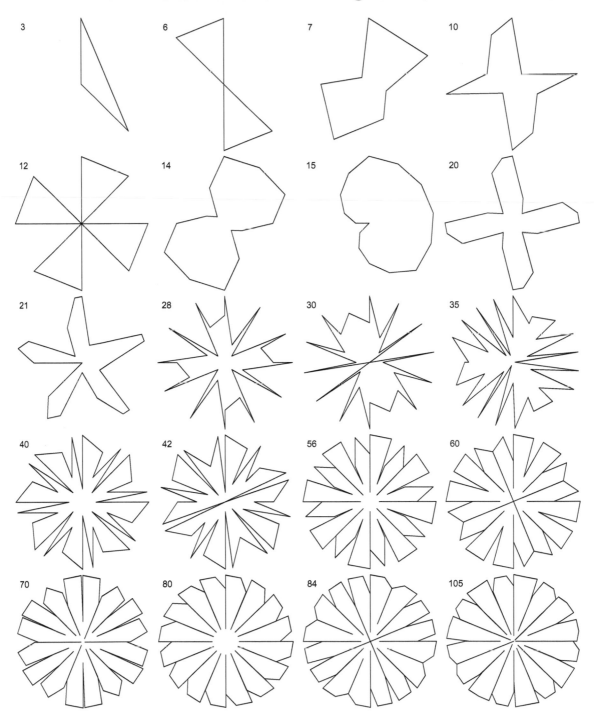

A quick scan of these images confirms that the degree of rotational symmetry is given by GCD(Lines,16). Among the last six images: 56 has 8, 60 has 4, 70 has 2, 80 has 16, 84 has 4, and 105 has 1. All factors of 3*nS* = 1680 > 2 and less than 112 are shown except 4, 8, and 16 (regular *n*-gons), 5 (two segments appear collinear), 24 (eight spikes), and 35 (Vertex Frame).

Chapter 16

Double Jump Models

16.1 Calculating Lines Used Given Jump Sets

Stars are created by having a vertex jump larger than 1. The most common is the pentagram obtained from $n = 5$ and $J = 2$. The jump of 2 occurs repeatedly until the initial vertex is obtained. Jump sets work in the same fashion except two or more different jumps occur before the pattern is repeated. The image is completed once the initial vertex is achieved AT THE END OF A JUMP SET. **A *jump set* is a pattern of jumps that is repeated.**

Images A–C involve $S = P = 1$ (so each image is the vertex frame, VF) and $n = 12$ (so that it is easy to talk about jumps in "hour" terms, meaning that if you are at 11 o'clock and add three hours you get to 2 o'clock, not 14). In Panel A, $J_1 = 3$, $J_2 = 8$, leads to jumps of:

The vertex jump pattern is thus: 3 8 3 8 3 8 **3** 8 ... 3 8
In hours, the image is drawn as 12&0 to 3 to 11 to 2 to 10 to 1 to 9 to **12&0** to 8 … to 4 to 12&0

Notice, in particular, that the pattern does NOT stop at the bolded **12&0** above after seven jumps because the jump of **3** from 9 is not the end of the jump sequence. The end of the sequence takes $2n = 24$ jumps. Note that each vertex is used TWICE (there are two lines in and out of each vertex rather than one). More generally, if there are k jumps in the sequence, the pattern of vertex usage will end after $k \cdot n$ jumps if there is no commonality between n and the sum of the k jumps. (Chapter 17 focuses on a four-color *Excel* file that allows up to three jumps for $n = 12$, and Chapter 18 allows a larger number of jumps in the set.) In Panel A, 3+8 = 11 has no divisor in common with 12, but in Panels B and C, 2+8 = 10 and 3+7 = 10, both have two in common with 12, therefore half as many jumps occur before completing the VF. Both are shown because they achieve this in different ways: B uses half the vertices, six, twice each, and C uses all vertices, 12, once each.

About labels. Since jump sets are open-ended, they are denoted by J(#, ...,#) at the end of the label (for example, J(3,8)).

DOI: 10.1201/9781003402633-19

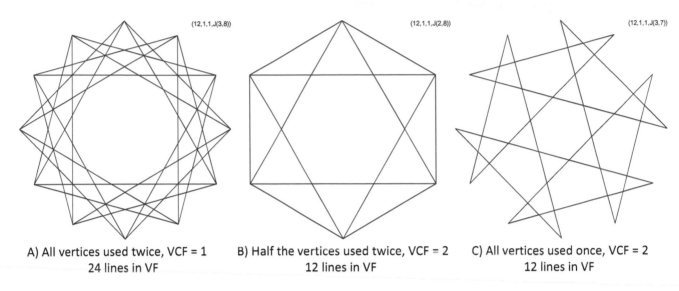

(12,1,1,J(3,8)) (12,1,1,J(2,8)) (12,1,1,J(3,7))

A) All vertices used twice, VCF = 1 B) Half the vertices used twice, VCF = 2 C) All vertices used once, VCF = 2
24 lines in VF 12 lines in VF 12 lines in VF

Calculating VCF. The equation for VCF must be altered from the one proposed in Section 4.1 given jump sets. The modified VCF is:

Given k jumps per set, the *Vertex Common Factor*, VCF, is: VCF = GCD(m, n), where $m = J_1 + \ldots + J_k$ and GCD is the greatest common divisor function.

The number of vertices used, v_{used}, (*perhaps multiple times*) and lines in VF is $v_{used} = k \cdot n/\text{VCF}$.

SCF. The number of VF line segments connecting used vertices, v_{used}, changes with jump sets, but we still create S subdivisions on each VF line leading to $S \cdot v_{used}$ possible subdivision endpoints. Nothing changes to SCF because of jump sets, it is still SCF = GCD(P, $S \cdot v_{used}$), and therefore nothing changes to lines used, $L = S \cdot v_{used}/\text{SCF}$ (except that now v_{used} may exceed n).

Subdivision size differences. In contrast to the string art model in Part II, subdivision size is not constant across jumps. The largest difference in VF segment size is between $J = 1$ and $J = \text{INT}(n/2)$, but both have S subdivisions per segment.

NOTE: The number of lines in the vertex frame may appear less than v_{used} because some lines are used multiple times.

16.2 An *Excel* Primer on Double Jump Models (While Achieving the Elusive 6,2-Star)

Background. As noted in Section 2.2.1, the only $n > 4$ for which a continuously-drawn star cannot be drawn is $n = 6$. The problem is that a single-jump pattern connecting every other vertex either attains the even vertices (**0-2-4-0**) or odd vertices (**1-3-5-1**) but not both.

We use n,J-stars to create the vertex frame for string art models. The VF forms the structure on which S and P depend to create the final image. To understand what happens when we move from a single-jump pattern model to a multiple-jump-pattern model, it is worthwhile to initially focus on the VF in this new environment. Thus, the image to the right has $S = P = 1$. As this image attests, if we allow a double jump set pattern, we can produce the 6,2-star, albeit with diameter lines included in the image. Those diameter lines allow even numbers to intersperse with odd numbers in the overall pattern.

Definition. A *jump set* is a pattern of jumps that is repeated. The traditional string art model was a single-jump pattern (although it was not discussed that way to avoid confusion because we do not mean that $J = 1$). We consider a double jump model where a pattern of two different jumps is repeated, $J_1 = 2$ and $J_2 = 3$ with $n = 6$. The initial four jumps (two sets) are **0-2-5-1-4**. Note that this creates a setting in which even and odd vertices are interspersed. The final image is completed in 12 jumps.

Even if you do not write out all the jumps, you should try to visualize the pattern that created the image above. In this instance, it is quite simple: Each jump of 2 is followed by a move to the opposite side of the *n*-gon since, in this instance, $3 = 6/2$ so that a jump of 3 is simply a move from one end of a diameter to the other. (Recall, a 6,3-star is a vertical line.)

If you had been asked to follow this jump pattern with another value of *n*, it would not be quite as easy to follow, as it is easy to forget which part of the jump set you are in. You can avoid this issue by creating an *Excel* file to do the work for you. And, if you want to change the underlying values of *n*, J_1 or J_2, just type in different numbers for these parameters.

Using *Excel* to find the VF. The table on the left below, from Excel file 16.0.4, shows how this is done (in two parts). To do your own, create the four left columns following the instructions in the right half. This involves ten cells: Four numbers (highlighted in green), three equations (in crème), and four equations that will be dragged (in yellow). (The sideways sum in C5 is a useful trick.) Column D shows the VF jump pattern. *Importantly*, note that Line 5 is the first time 0 is an endpoint vertex, but the circuit is not complete because it was attained by a J_1 jump not a J_2 jump like Line 12.

The table to the right and the image below show that, **by changing three numbers**, we see how this jump pattern creates super-imposed 11,3- and 11,5-stars.

(n,S,P,J(1,2))
(6,1,1,J(2,3))

	2 Jump 1		6
	3 Jump 2	Size of *n*-gon	
Line	Pattern	Sum	Vertex
1	2	2	2
2	3	5	5
3	2	7	1
4	3	10	4
5	2	12	0
6	3	15	3
7	2	17	5
8	3	20	2
9	2	22	4
10	3	25	1
11	2	27	3
12	3	30	0
13	2	32	2
14	3	35	5

	A	B	C	D
1		2 Jump 1		6
2		3 Jump 2	(Sideways)	Size of *n*-gon
3	Line	Pattern	Sum	Vertex
4	1	=A1	=B4	=MOD(C4,D$1)
5	=A4+1	=A2	=C4+B5	drag **D4** down
6	drag	=A4	drag **C5**	
7	**A5**	drag	down	
8	**down**	**B6**	*Highlighted cell color scheme*	
9		**down**	**Enter numbers**	
10			**Single use equations.**	
11	Equations to drag down as far as necessary to			
12	see the pattern repeat (as we see at Line 13).			
13	*Explanation of equation in cell D4 above*			
14	MOD is the remainder function when one			
15	number (**C4**, here 2) is divided by another			
16	(**D$1**, here 6). The $1 in this *Excel* equation			
17	means *fix this in Row 1 upon dragging down*.			

	3 Jump 1		11
	5 Jump 2	Size of *n*-gon	
Line	Pattern	Sum	Vertex
1	3	3	3
2	5	8	8
3	3	11	0
4	5	16	5
5	3	19	8
6	5	24	2
7	3	27	5
8	5	32	10
9	3	35	2
10	5	40	7
11	3	43	10
12	5	48	4
13	3	51	7
14	5	56	1
15	3	59	4
16	5	64	9
17	3	67	1
18	5	72	6
19	3	75	9
20	5	80	3
21	3	83	6
22	5	88	0

16.3 A Visual Interpretation of VCF, SCF, and Image Density

Background. The 12 images on the next page share a common double jump set pattern of $J_1 = 1$, $J_2 = 9$. Values for other parameters were chosen to highlight differences that arise as VCF and SCF vary.

The images are set up in three rows and four columns. Each row has a different value for n. The first column shows the vertex frame in each instance. The last three columns share a common $S = 17$, and each column has a different P, the first two of which have SCF = 1 and the final column has SCF > 1.

Vertex Frame. *Excel* file 16.0.4, discussed in Section 16.2, can examine more than one n at a time simply by dragging the fourth column to the right (after making the adjustment described in the **MA** note below) and changing n as necessary.

[**MA.** The equation in cell D4 needs to be slightly adjusted to be dragged sideways, and =MOD(C4,D$1) needs have a $ sign added to C4 so that it does NOT turn into D4 when dragged sideways. This is accomplished by fixing the column using a $ sign in front of the C. The modified equation in D4 is =MOD($C4,D$1). When dragged sideways, C remains fixed, and D turns into E. This is formally called *Mixed Referencing* in *Excel*, and it is a very powerful tool to learn how to use.]

The three values of n examined here are 12, 13, and 15 as can be seen in the table in cells D1, E1, and F1. In each column, highlighted cells are repeats from above since the circuit has been completed (at Lines 12, 26, and 6 by column).

VCF. If VCF = 1, then the VF has $2n$ lines, but more generally, the VF has $2n$/VCF lines since $k = 2$ for the double jump model as discussed in Section 16.1, *Calculating Lines*. Both examples in Section 16.2 had VCF = 1, but here we show images with VCF > 1, similar to those shown in *Calculating Lines*. As can be seen from the first column of images, VCF = 2 for $n = 12$, VCF = 1 for $n = 13$, and VCF = 5 for $n = 15$, consistent with the circuit lengths shown in the table to the right.

The sum of jumps, $J_1 + J_2 = 10$, so any even n will have VCF ≥ 2. If you check other even n such as $n = 14$ you will find VCF = 2 so 14 vertices are used. Note also that VCF = 10 when $n = 20$, and four vertices are used (the VF is rectangle 0-1-10-11-0).

SCF. Prime values were chosen for P in the middle two columns (11 and 53) to avoid SCF > 1 drop out of lines. Line usage (*image density* discussed in Section 5.4.1) drops off by a factor of SCF (4, 26, and 2) when P decreases by 1 to $P = 52$ in the final column.

Locating the first line in the third and fourth columns. Since 51 = 17·3, we know that the subdivision endpoint of the first line is just past the end of the third line on the fourth line of the VF (two subdivisions in, in the third column, and one subdivision in, in the second). Look at the VF in the first column and count the first three lines out to see where that point is likely to be.

1	J1		12	13	15
9	J2		Size of n-gon		
Line	Pattern	Sum	vertices in n-gons		
1	1	1	1	1	1
2	9	10	10	10	10
3	1	11	11	11	11
4	9	20	8	7	5
5	1	21	9	8	6
6	9	30	6	4	0
7	1	31	7	5	1
8	9	40	4	1	10
9	1	41	5	2	11
10	9	50	2	11	5
11	1	51	3	12	6
12	9	60	0	8	0
13	1	61	1	9	1
14	9	70	10	5	10
15	1	71	11	6	11
16	9	80	8	2	5
17	1	81	9	3	6
18	9	90	6	12	0
19	1	91	7	0	1
20	9	100	4	9	10
21	1	101	5	10	11
22	9	110	2	6	5
23	1	111	3	7	6
24	9	120	0	3	0
25	1	121	1	4	1
26	9	130	10	0	10
27	1	131	11	1	11

Drawing Mode. To check your work here, or to watch the images get drawn, it is useful to use the web version of each image. Rather than provide 12 different links, note that once you have one, the others are easy to get to by adjusting **n** and **P** since **S**, **J**$_1$, and **J**$_2$ are fixed for all 12 images. Perhaps most interesting is the <u>third column middle row</u>, which, if you set *Drawn Lines* = DL = 25 using the *Fixed Count Drawing* Mode, you will see this is an interesting example of a *Single-Step Image* from Section 8.5.1. The 25th line ends on a section of the VF that is a 9-jump (from 4 to 0 = 4+9 = 13 MOD 13), and subdivisions on such segments are much larger than those on 1-jump segments (use *Pause/Play* to verify location).

Similar images for different n. When **P** = 11, **n** = 14 and 16 versions look like **n** = 12 for an internal heptagon (7) or octagon (8) in place of the hexagon. The **P** = 53 version for those two **n** appears similar to the **n** = 15 versions except now there are seven or eight locations for the "Palm fans" rather than 3 with **n** = 15. These three images have quite a different drawing experience. Check by setting DL = 2 with *Drawing Speed* at 10 or so. Also, <u>**n** = 30</u> is a Section 16.7 *needle fan*.

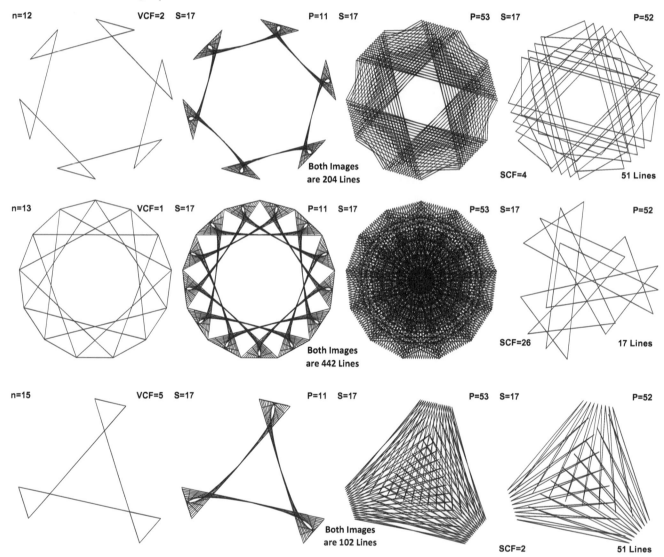

16.4 Revisiting *Single-Step* Images (from Section 8.5.1)

One of the images highlighted in Section 16.3 *Visualizing VCF, SCF, and Image Density* is shown to the <u>right</u>, (13,17,53,J(1,9)). **A.** What is it about the image that makes it *single-step*? **B.** What can be changed while maintaining its *single-step* status? These are the questions we examine here.

Answering Question A. Consider the *first single-step*. As noted there, the 25th line ends near vertex 0 on the line from vertex 4 to vertex 0. This is a point just below the top of the image, as can be seen using *Single Line Drawing*, SLD, mode on *Pause* with *Drawn Lines*, DL = 25, and *Drawing Progress* = 0. Note the following four points:

1. Subdivisions counted at that point: 25·53 = 1325.
2. INTEGER(1325/17) = 77, remainder MOD(1325,17) = 16 meaning that this endpoint is one subdivision from the 78th VF line. Put another way, 78·17 = 1326, one more than 1325.
3. Every two VF lines is a jump of 10, so 39 (39 = 78/2) jumps of ten vertices, or 390 total vertices jumped.
4. 390 vertex jumps end at vertex 0 = MOD(390,13) given n = 13.

This is why the first *single-step* ends where it does, within one subdivision of the top of the image.

[**MA.** 25 is the negative MMI of P MOD S in addition to $(J_1+J_2)\cdot$(INTEGER(25·P/S)+1) = 0 MOD n since 25 is a negative MMI. Had it been a positive MMI, the second equation would have subtracted 1 since the subdivision endpoint would in that event be "just over" rather than "just under" the VF vertex in question. See Chapter 24 on MMI.]

Next, consider static image creation and how to make the first *single-step* as small as possible before turning to **B**.

There are four ways to create this static image. By switching J_1 and J_2 one obtains the same static image. Additionally, by replacing both J_1 by n-J_1 and J_2 by n-J_2, the same static image results. So, for the above image, **J(1,9)** looks the same as **J(9,1)**, **J(12,4)**, and **J(4,12)**. Four versions exist because four lines are attached to the top vertex, not two as in Section 6.2.

About the size of single-step. Each line on the VF has S equally-sized subdivisions. But in jump set models, the lines are different sizes. The smaller the length of the VF line, the smaller the size of subdivisions on that line. As a result, we can obtain the same static image but have it drawn so that the first step is the smallest **size** possible by having the second jump be the smaller jump given the above values of n, S, and P. When viewed in terms of how the outer edges are filled in, <u>J(9,1)</u> turns ↺ while <u>J(4,12) turns</u> ↻ . (Note that because n = 13, a jump of 12 has the same size VF line as a jump of 1.)

Answering Question B. What parameters can we relax while maintaining *single-step* status? We see that each of the parameters (n, S, P, J_1, and J_2) gets involved in creating this as a *single-step* image. But that is an illusion and there is greater flexibility here than one might imagine while keeping images *single-step*. One can quickly confirm with *SLD* mode using DL = 25 as discussed above, that altering n, S, and P voids *single-step* status.

One might expect that, due to points 2 and 3 above, as long as J_1+J_2 = 10, the image remains *single-step*. Indeed, this is true. But this works even when the sum is not 10 (or 16 = 2n – 10). Indeed, *you obtain a single-step image regardless of the values you choose for both jumps.* The reason why is based on how 39 (which is 78/2 recalling that the 25th endpoint is one subdivision less than a

multiple of 17 which denotes the ends of VF lines) relates to **n** = 13. Thirty-nine is a multiple of 13, so a multiple of 39 is also a multiple of 13. Below are links to sample images. The bottom row is best viewed in SLD. Once you use the hyperlinks from *Links* available by QR code from the ESA website.

13,5-Star with spikes, 11 Rotating Polygons, Rotating Pentagrams, Interior 26-point Sunburst, Ragged Flower Petals

Rotating Triangular Porcupine SLD, Rotating Bug I. *SLD*, Rotating Bug II. *SLD*, Swirling Moth *SLD*

Extensions. One can alter **n** and maintain *single-step* status by having **n** be divisible by 13 so here are *Rotating Triangular Porcupines* at **n = 26** and **n = 39** given DL = 25. Additionally, it does not matter which of the two negative MMI values is associated with **P** and which with DL. You can switch and have *single-step* images like this **P = 25 and DL = 53** *SLD* Crab.

16.5 Functionally Related Double Jump Models

There are multiple versions of the Double Jump *Excel* file but 16.0.1 is the general version. To understand why there are three versions, it is worth considering the vertex frame (so set **S** = **P** = 1) if **n** is even, one jump is 1, and the other is **n**/2. In this instance, the frame that looks like fractions of a pie like on the left for **n** = 12, but for **n** = 14 on the right, every other piece of the pie is already eaten.

(12,1,1,J(1,6))

(14,1,1,J(1,7))

In this instance, if you set **P** close to half of **S**, flower images result. All petals are visible when **n** is divisible by 4, but half are missing if **n** is divisible by 2 but not 4 because VCF = 2 in this instance.

The smallest **n** version with missing petals is **n** = 6 which results in three petals. Since **n** = 6, you can think of a clock face with only even numbers showing. In this instance, the frame goes from 12 o'clock to 2 to 8 to 10 to 4 to 6 and back to 12 o'clock where the circuit is completed. Such values of **n** may be written as **n** = 4**k**+2 where **k** is a whole number. The other two versions allow you to examine functional relationships between parameters in a fashion similar to that proposed in Section 10.1, *Functionally Related* **n**, **S**, **P**, and **J**.

Version 2. *Excel* file 16.0.2 focuses strictly on even-petaled flowers from 4 to 24. It is initially set with **Jump 1** = 1 and with **Jump 2 = n/2**, but you can adjust **Jump 1** via scroll arrows and **Jump 2** by entering a number or an equation in place of its initial equation. There is a click box that allows you to fill in the other petals when **n** = 4**k**+2 by counting the last half of jumps counterclockwise rather than clockwise via a click box. **This click box produces images that cannot be replicated by the web version since that version does not count backwards.** (It is worth noting that when this box is checked and VCF = 2 (or a multiple of 2), the resulting image will appear as VCF = 1 (or half as large).) Many images beyond flowers are possible by varying the parameters via scroll arrows. All images

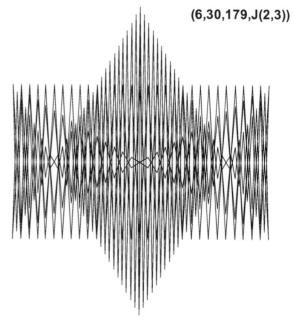

(6,30,179,J(2,3))

created using Version 2 can be obtained using Version 1 except when $n = 4k+2$ and the counter-clockwise click box is checked. Both images are porcupines. The one on the previous page has the counterclockwise box checked, the one on this page does not.

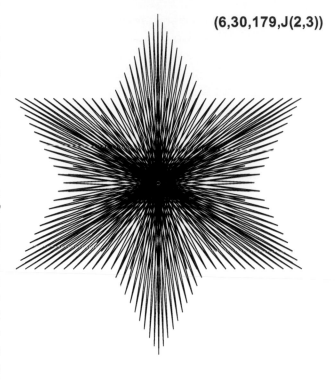

(6,30,179,J(2,3))

Version 3. *Excel* file 16.0.3 returns to clockwise counting of jumps by adjusting the first jump to 2 when $n = 4k+2$, otherwise the first jump is 1. The second jump is set to be the closest whole number to $n/2$. The automations provide the ability to have 3 to 25 petal flowers just by changing n if P is near but not half of S. This version also allows you to override the scroll arrows controlling S and P by putting equations in place of those numbers. For example, by putting the equation =B1*L1-1 in place of P in cell C1, you obtain maximally sharp starbursts if n is even (especially when $n = 4k$) but more complex images when n is odd. The reason these are maximally sharp is that there are $2nS$ subdivision points in this instance (there are nS subdivision points, but each point is counted twice, once as part of the first jump and the second time as part of the second jump). If $P = nS$ is put in cell C1, a single line results, but if $P = nS-1$ a $2nS$ image emerges (the same image as when $P = nS+1$ but drawn the other way around), both of which are examples of porcupine images.

16.6 What to Do When You Find a Nice Image

(24,3,11,J(15,2)) Is a Nice 144-Line Image: Check *P* < 72

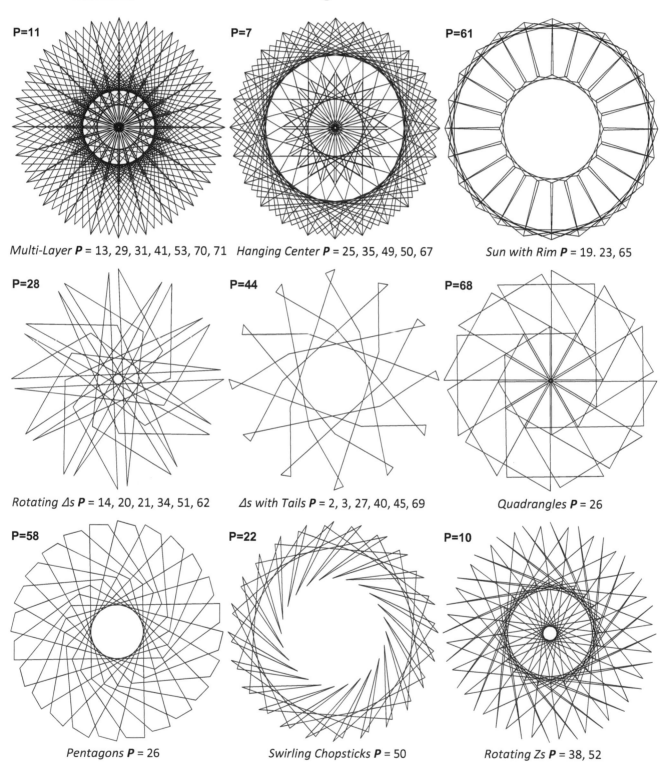

P=11

Multi-Layer **P** = 13, 29, 31, 41, 53, 70, 71

P=7

Hanging Center **P** = 25, 35, 49, 50, 67

P=61

Sun with Rim **P** = 19. 23, 65

P=28

Rotating Δs **P** = 14, 20, 21, 34, 51, 62

P=44

Δs with Tails **P** = 2, 3, 27, 40, 45, 69

P=68

Quadrangles **P** = 26

P=58

Pentagons **P** = 26

P=22

Swirling Chopsticks **P** = 50

P=10

Rotating Zs **P** = 38, 52

The top left image formed the basis for this exploration and it is one of the images on the front cover of this book. **What happens if P changes?** Other interesting **P** values exist as well, but this shows that if you find an image you really like, altering a parameter may lead to other interesting images.

These images are best viewed being drawn using either *Drawn Lines*, DL = 3 (**S**) or 6 (2**S**), and best viewing can typically be determined by starting with *Single Line Drawing* mode on *Pause* to set DL, before using *Fixed Count Line Drawing*.

16.7 Needle Fans and Blade Fans

There are a variety of versions of porcupine images (where if **P** increases by 1 the image is a single line) given multiple jumps, but one of the most interesting to watch being formed is something that might be called needle fans, in reference to the folding fans. The smallest **n** for such a fan is 9, and the jumps that are used to create this are 1,2 (or 2,1). The smaller side is where the "gathering point" is for the fan blades (in this instance needles) to come together at almost a point. The image on the left has a much larger small side than the one on the right because the difference in jumps between small and large jumps is smaller on the right (1 vs. 2) than on the left (1 vs. 6). Both images have 120 needle points, 20 on each side. Similar images can be made by increasing the larger jump by 1 and **n** by 3 (notice J_2 increased by 4 in going from left to right and **n** increased by 12). Watch these images get drawn using *Drawing Mode* FCLD with DL = 2.

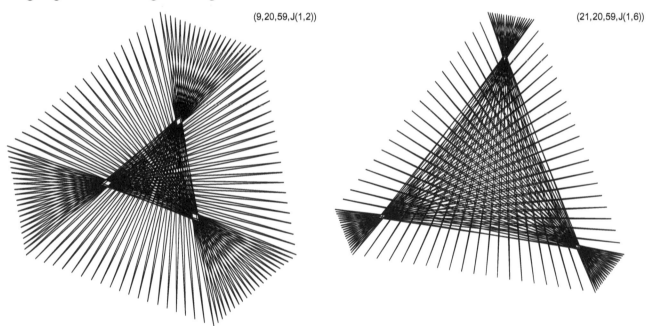

(9,20,59,J(1,2)) (21,20,59,J(1,6))

One can increase the size of the diamonds in the above images by decreasing **S** by 1 to 19.

Variations on this theme. The above images use VCF > 1 to create different density areas *within* the image. In the above images, VCF = 3 on the left and 7 on the right (the above images have 120° rotational symmetry), 3VCF = **n**.

Changing overall density: Images can be made more or less dense by adjusting **S** and **P**.

Changing the type of polygon: Other odd polygons can be created by following similar tactics, but even polygons lead to Blade Fans, such as that on the right, rather than folding needle fans. Here are a couple of examples.

Porcupine images with even **n** include the Four-Blade Fan to the right, or its cousin this Six-Blade Fan. It is worthwhile watching these images get drawn. Note that they backtrack the darker parts due to how the VF is drawn.

Here are additional examples. Pentagram needle fan, Pentagon needle fan, 7-gram needle fan, 7-gon needle fan. Finally, check out this **VCF = 1** needle fan using a 23,5-star.

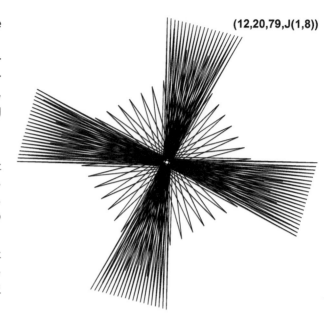

(12,20,79,J(1,8))

16.8 A Sampling of Images from the Double Jump Model

Given the scope of images available in the traditional string art model based on a single repeated jump pattern, it is not surprising that we are only able to scratch the surface of possible images once repeated sets of multiple jumps are allowed to create the vertex frame. As a result, do not consider these 12 images to provide anywhere near an exhaustive list. They should be viewed as more suggestive in nature. Nonetheless, there were reasons why these images made the cut. Those reasons are noted below.

In the notes below, *FCLD* is *Fixed Count Line Drawing* mode, *SLD* is *Single Line Drawing* mode, and DL is *Drawn Lines*.

Why These Images Were Included

Row 1 *The images in Rows 1–3 can be created with Version 1 Excel file 16.0.1 as well as with the web model.*

 Left This is 1 larger **S** but uses the same **n** and jumps as was used in Section 16.6. Note that the inward-pointing lines are not part of the vertex frame but are between vertices

 Center Interesting that seemingly three lines end at internal points rather than four or two.

 Right Although this is a porcupine (**P** = 92 is a single line), the sharp inward-pointing needles are interesting.

Row 2 Left The swirling chopsticks are even tighter than the version shown in Section 16.6.

 Center This very Escher-like running in circles is interesting to watch get drawn using DL = 11 in *FCLD* mode because a single cycle does not reveal the pattern. Compare with DL = 9 or this one with DL = 13.

 Right This sun-like image with a border looks like dealing cards if you set DL = 6 in *FCLD* mode. *How would you get the image to deal counterclockwise?*

Row 3 Left This image is either trying to turn into a pentagon or trying to break up a pentagon, you decide.

 Center One might imagine this as 14 fountain pens or perhaps sharply manicured fingernails?

 Right This image appears to have sparks coming off of the star. Of greater import is that it is the unchecked version of the image just beneath it (note that the labels are the same). To learn more, see Row 4 notes.

Row 4 *The images in Row 4 are from the Double Jump Excel file 16.0.2 with click box checked on so that the last half of the lines are counted counterclockwise. **These images are only available in Excel.***

Left This porcupine image occurs by changing J_1 from 2 to 1 from the image at mid-page of the *explainer* just noted. Note that both images appear to create "static."

Center This surprising image occurred because J_2 was manually changed from =n/2 (of 9) to another value, 12. Unfortunately, different numbers do not provide additional letters of the alphabet!

Right The image has the same counting structure as the image just above it except the last half of the lines were counted backwards.

Here Are Links via QR code to a Few More Images That Did Not Make the Cut

Change **P** in Row 1 Left to 25 yields 24 inward-pointing carrots. This is another example of Section 16.6. If you start with an interesting image and change something, you find other interesting images (like the next one).

Set DL = 11 and use *FCLD* mode, you find four shape-shifting quadrangles similar to three shape-shifting triangles from Section 8.4. If you have trouble seeing the similarity, *Pause* the *SLD* at *Drawing Progress* = 43 that spans the first jump from vertex 2 to vertex 17 with *Toggle Vertices* turned on. The 11-line string starts at vertex 2 and ends ¼ of the way toward vertex 17.

A 22-unit housing complex at Flower Circle (to understand the title, use *FCLD* mode). Here are 18 units somewhere else.

Note the small inward-pointing lines at each vertex. The only difference now is that **P** = 37.

This is like a triangular version of the Row 3 Left pentagon. The same question still applies.

This six-point star seems to be a bit out of kilter.

This sunburst remains internal rather than all the way to the vertices.

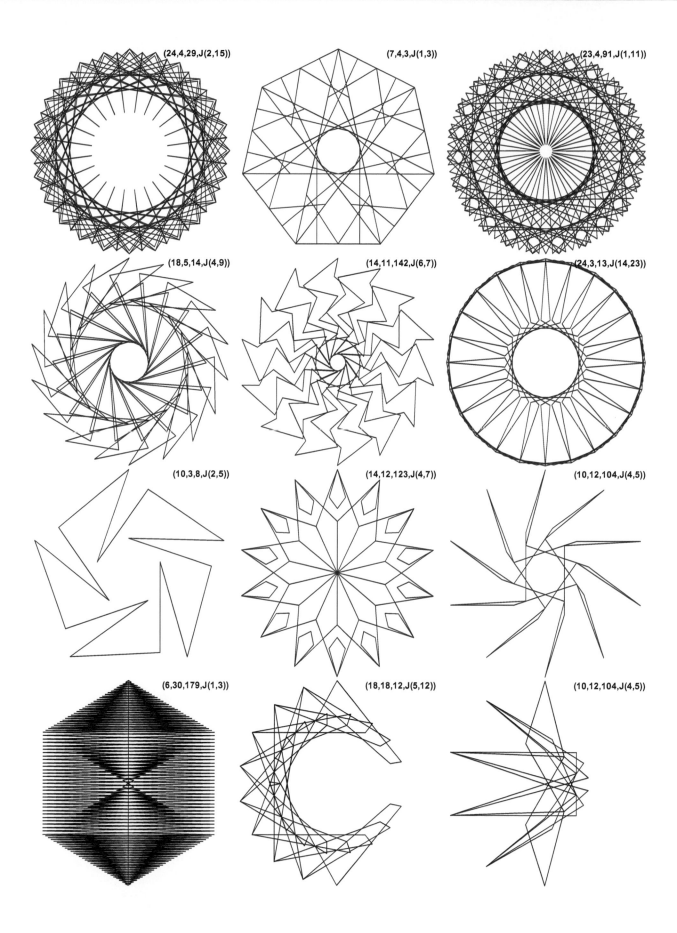

(24,4,29,J(2,15)) (7,4,3,J(1,3)) (23,4,91,J(1,11))

(18,5,14,J(4,9)) (14,11,142,J(6,7)) (24,3,13,J(14,23))

(10,3,8,J(2,5)) (14,12,123,J(4,7)) (10,12,104,J(4,5))

(6,30,179,J(1,3)) (18,18,12,J(5,12)) (10,12,104,J(4,5))

16.9 Pentagonal People

These images use **n** that is a multiple of 5 and have 72° rotational symmetry. Each uses five verti-ces—two arms, two legs, and a head. Each image has **n** = 20, **S** = 3, and **P** = 8 and only differ by **J**₁ and **J**₂. These whimsical images have an "open" design due to SCF > 1. Each has 15 lines, but the first appears to be only ten because the first two lines of each three-line cycle are collinear. Note that VCF and SCF vary, but SCF > 1 is maintained across images.

If you play with **J**₁ and **J**₂ you will find that other children that may be part of this family, here are two: (20,3,8,J(6,10)) and (20,3,8,J(10,7)).

Pentagonal Parents running after their Kids

Two Couples compete in *Dancing with the Stars*

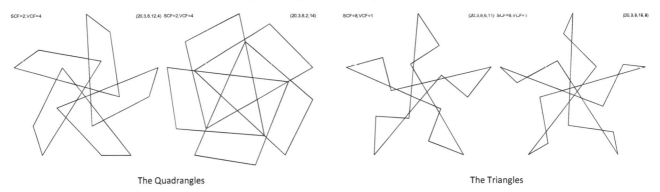

The Quadrangles The Triangles

Chapter 17

Four-Color Clock Arithmetic

17.1 An Introduction to Triple Jump Models, VCF = 1

As the number of jumps increases, so does the difficulty in keeping track of what is happening in vertex frame creation. The line, VCF, and SCF rules are the same as laid out in Section 16.1, except that now k = 3.

In order to articulate most clearly some of the things that can be created with three or more jumps per set, and to provide a bit of an artistic capstone to multiple jump set models, the Chapter 17 *Excel* files restrict n to n = 12 in order to make discussions as intuitive as possible but provides the ability to stack up to four colors in the image. Click boxes allow you to add or remove a color and S and P values must be entered by typing numbers into cells while jumps are controlled by ↕ arrows. One- and two-jump four-color files are also provided. There is no web counterpart to the four-color model, but the web version can readily create triple jump sets and more as we will discuss later.

Start with the VF. It helps to set S = P to see the vertex frame. The top image shows the VF of the image beneath it. The (2, 5, 4) jump set means that the first three vertices used are 2, 7, and 11, and the next three are 1, 6, and 10, and so on. This image is from *Excel* file 17.0.3.

When VCF = GCD(J_1+J_2+J_3, n) = 1, all vertices are used three times. In this instance, six VF lines are visible at each vertex, just like one sees in the top image. However, if one of the jumps is n/2 (or 6), the number of lines will appear as five not six as you can see by the VF at the top left on the next page.

When VCF = 1, the VF is stars stacked on top of one another. The upper right has three such stars: A 12,2-star (two hexagons), a 12,4-star (four equilateral triangles), and a 12,5-star. The top left on the next page shows a 12,2-star, a 12,5-star, and a 12,6-star (six diameter lines). Even without seeing the VF of the middle and right images on the next page, you should be able to visualize the 12,3-star (three squares), 12,4-star, and 12,6-star that comprise the VF of both images.

Even if VCF = 1, the order of jumps matters. The two blue images have the same VF, but if you look closely, you will notice that the images differ from one another. Consider the curved angles (of 75°, 30°, and 45°) at vertex 0. The middle has curves created from 9–0–4, 8–0–6, and 6–0–3 but none from 8–0–3, 6–0–4, and 9–0–6. *The right image has the reverse curves.*

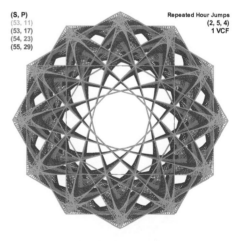

(S, P)

(1, 1)

Repeated Hour Jumps
(2, 5, 4)
1 VCF

(S, P)
(53, 11)
(53, 17)
(54, 23)
(55, 29)

Repeated Hour Jumps
(2, 5, 4)
1 VCF

DOI: 10.1201/9781003402633-20

To see why, consider the angle created by the first two jumps. Both start at 0 and end at 7 so both are 75° angles, but the middle has a vertex at 3 (the 0-3-7) while the right has a vertex at 4 (0-4-7). Or view this in a slightly different way by considering the outer 90° angle created by 0-3-6 in both images. This is composed of the 75° 0-3-7 curve plus the 15° uncurved 7-3-6 angle in the middle image, but the 15° uncurved 0-3-11 angle plus the 75° 11-3-6 curve on the right.

Note: Visualizing these differences is easier using Section 11.2, *Curved-Tip Stars, adjusted to **P/S** < 0.5 with a single color.*

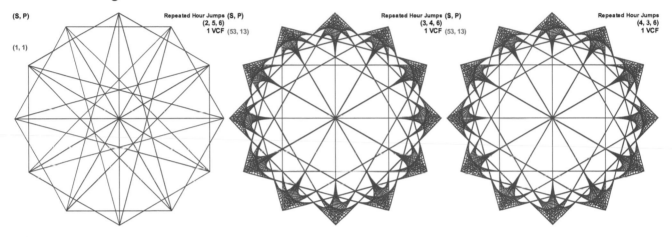

17.2 Triple Jumps with VCF > 1

When VCF > 1 the VF uses $3n$/VCF = 36/VCF vertices so that some vertices may not be used, and others may be used less than three times. The smallest decline in vertices occurs when VCF = 2, in which case 18 vertices are used. One can see this as 12 vertices with half used twice at left (where even vertices are used twice and odd are used once) or as six vertices used three times each as seen on the right. The right image requires additional explanation, as it appears that each vertex is only used twice. Were that true, it would be a double jump image, but by following the jump cycle you see that each is used three times. The first three jump sets are **2**-10-**2** – 4-0-4 – 6-**2**-6 …. Notice that vertex **2** has been used three times, not twice.

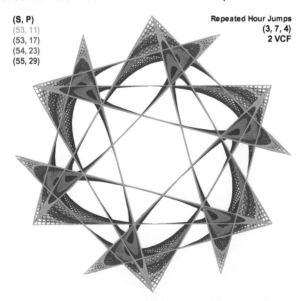

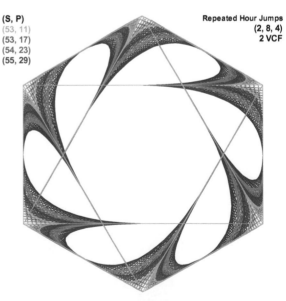

The other VCF possibilities are 3, 4, 6, and 12 so the vertices used are 12, 9, 6, and 3 shown by column below. And just like above, this can be accomplished by using some vertices more than once (top) or one time each (bottom), except for the triangles in the fourth column. Note the top row **N** image uses six vertices, not four, as vertices 0 and 6 are used twice.

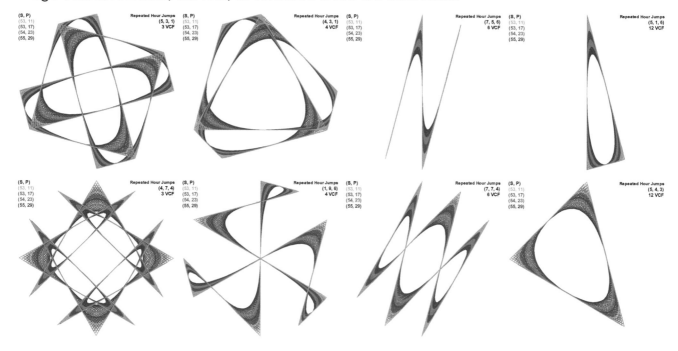

17.3 Spikes and Tails

Two of the images in Section 17.2, *VCF > 1*, used the idea of following a jump of **J** by **n-J**. When this is done in a two-jump model, a single line results but when **k** > 2, this creates a spike. Spikes can create riveting images, especially when the ends of the spikes are not used elsewhere within the image. This is what distinguished the (7,5,6) **N** on the left from the (2,8,4) hexagon on the right. The six gold spikes (from 0-4, 2-6, 4-8, 6-10, 8-0, and 10-2) seem partially hidden due to the curves that are happening at the leading part of each of those lines.

You can start the spike in any one of the three parts of the jump set. The only requirement is that the next jump must be **n-J** so that if you are starting the spike as the third jump, it should be the case that $J_3 = n - J_1$.

Spike ends at multi-use vertices. The VF of the **N** image is 7-0-6-1-6-0. The 1 and 7 vertices are single-use, and the 0 and 6 vertices are used twice. Each of the six vertices in the hexagon is used three times as noted in the VCF > 1 explainer. The same is true of the (1,5,7) dodecagon to the right.

Swirl direction. If we call the above hexagon swirl *counterclockwise*, ↺, then the dodecagon swirl is *clockwise*, ↻, as are the next three images below. The difference is whether the larger or smaller jump is first. You can also switch spike and tail directions by swapping **J** and **n-J**.

Cross-over spikes. Increase J_1 from 1 to 2, 3, and 4 from the dodecagon and we obtain examples of cross-over spikes.

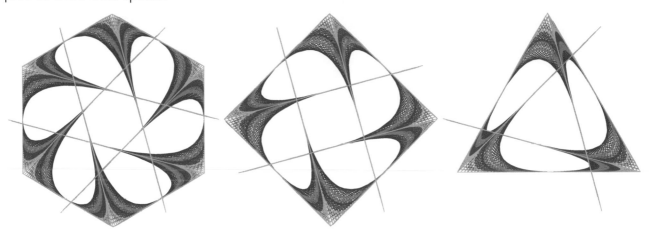

Tails. These images have 1-long tails. Try to create 2- and 3-long tails for △s, and 2-long for ◇s. **N** has two 5-long tails.

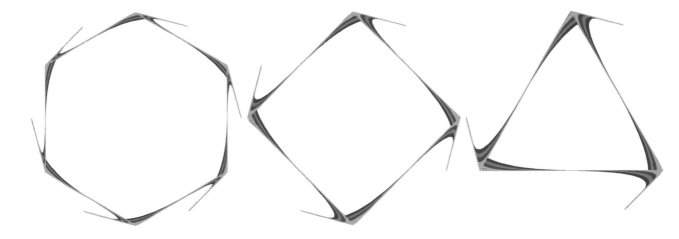

17.4.1 Comparing 1, 2, and 3 Jump Set 12,5-Stars

These images at right use four-color *Excel* files 17.0.1, 17.0.2, and 17.0.3, and each one stays within a 12,5-star. This allows us to introduce one additional jump notion to our toolbox.

Background. Each point of a 12,5-star spans 30° (Section 2.4.1), but the bottom two (on the next page) split that in half because the jump of 5 is followed by a jump of 6 (or across the diameter to the opposite side). For example, the first angle created in this image is 0-5-10, but the first angle created in the next two images is 0-5-11, so this Section 11.2 *curved-tip* angle is 15° = 180/12.

Image density. The second image shows much less cross-hatching than the first image. Each color uses between 636 and

(S, P)
(53, 11)
(53, 17)
(54, 23)
(55, 29)

Hours Jumped
5

660 lines in the upper image (12S per color although many lines overlap). Since the second image uses two 15° curves to create each 30° angle, there are twice as many lines in that image (24S per color). Twice as many lines are packed into essentially the same corner, thereby increasing the color density of the image.

Of course, the third image looks like it has half as many lines as the second image because one side of the 30° angle appears empty. *This is due to a trick that introduces asymmetry.*

What $J = 0$ does. A jump of zero puts another vertex of the VF on top of the vertex that it is already at. This creates S subdivisions all at this vertex as well. What has happened is that, **since $P < S$, the ENTIRE curve is swallowed up at the vertex.**

Consider the image at the bottom left with $P = 7 > 5 = S$. The hexagon has six vertices but 9 = 36/4 used vertices since 0, 4, and 8 are used twice. Notice the three lines that are one subdivision away from each of those vertices. It looks like $P = 2$ for these three lines, but that is an illusion because there are five subdivisions AT THOSE VERTICES, so $P = 7 = 1+5+1$ at vertices 0, 4, and 8. This is also why six lines are connected to these vertices not two like at 2, 6, and 10.

(S, P)

(53, 11)
(53, 17)
(54, 23)
(55, 29)

Repeated Hour Jumps
(5, 6)

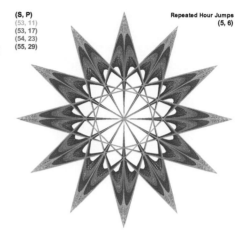

(S, P)

(53, 11)
(53, 17)
(54, 23)
(55, 29)

Repeated Hour Jumps
(5, 6, 0)

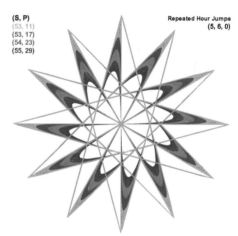

(S, P)

(5, 7)

Repeated Hour Jumps
(2, 2, 0)
4 VCF

17.4.2 A Line Analysis of a *J* = 0 Image

These images examine **S** = 5, **P** = 7 for two-jump patterns, to focus additional attention on the **J** = 0 jump introduced in Section 17.4.1. It used the blue image to provide a heuristic basis for what happens if a jump in a jump set is 0. The table to the left provides the subdivision endpoints for the **30 lines in the red model** and the **45 lines in the blue one**. The first two images note **subdivision endpoint** (or **range of endpoints**) at vertices.

Single jump of J = 2. The image is created in seven rotations around the circle (the **fifth line** starts the second rotation because the number jumps from larger to smaller). Since **P > S**, the hexagonal VF is not included in the image.

Triple jump of (2,2,0). The VF is once again a hexagon at even vertices of the 12-gon. But note that 2, 6, and 10 have a single number attached, while *4, 8, and 0 have a range of numbers attached. This occurs because each pair of 2 vertex jumps is followed by a 0 vertex jump.*

With the table, it is easy to see that the lines that were one subdivision on either side of vertices 4, 8, and 0 are the **28th**, **43rd**, and **13th lines**, respectively, **highlighted in yellow**.

In contrast to **red**, the **blue** image includes the VF. It appears that there are three lines **leaving** vertex 0 (ending at subdivision endpoints 5, 6, and 7) rather than one in the single jump model (ending at **7**). In fact, there are **six** all **highlighted in green**. The attribute of each is that it ends at a subdivision between **2** and **7** and therefore starts 7 subdivisions earlier, between **40** and **45 = 0**. Note that all but two of these **blue lines** (**1** and **33**) lie on top of one another on the first VF line from vertex 0 to 2.

The final image superimposes **blue** on **red**. Each shares four lines at the 2, 6, and 10 curves. For example, **red Line 1** and **blue Line 1** coincide, as do **14** and **14**, **27** and **27**, and **10** and **40** at curve 2.

Line	End	Vertices used Sub 6 Single	Vertices used 9 Triple
1	7	7	7
2	14	14	14
3	21	21	21
4	28	28	28
5	35	5	35
6	42	12	42
7	49	19	4
8	56	26	11
9	63	3	18
10	70	10	25
11	77	17	32
12	84	24	39
13	91	1	1
14	98	8	8
15	105	15	15
16	112	22	22
17	119	29	29
18	126	6	36
19	133	13	43
20	140	20	5
21	147	27	12
22	154	4	19
23	161	11	26
24	168	18	33
25	175	25	40
26	182	2	2
27	189	9	9
28	196	16	16
29	203	23	23
30	210	0	30
31	217		37
32	224		44
33	231		6
34	238		13
35	245		20
36	252		27
37	259		34
38	266		41
39	273		3
40	280		10
41	287		17
42	294		24
43	301		31
44	308		38
45	315		0

=MOD(SubEnd,30)
=MOD(SubEnd,45)

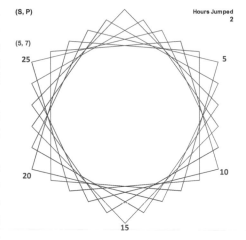

(S, P)

(5, 7)

Hours Jumped
2

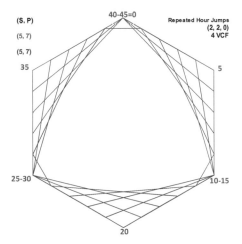

(S, P)

(5, 7)

(5, 7)

40-45=0

Repeated Hour Jumps
(2, 2, 0)
4 VCF

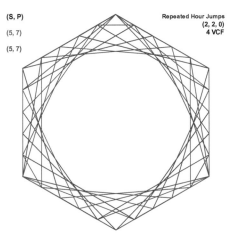

(S, P)

(5, 7)

(5, 7)

Repeated Hour Jumps
(2, 2, 0)
4 VCF

17.5 Venturing Beyond *Curved-Tip* Stars

With one exception, all images thus far have had **P** < **S** because the resulting *curved-tip* images most readily show the underlying VF. *When working with* **P** > **S**, *it is useful to work on one color at a time and put the largest* **P/S** *on the bottom.* When you find similarities between images (like **P** = 40 and 44 below), try stacking images on top of one another with different colors. The stacking order is as listed in the *Excel* file, Gold is on top followed by **Blue**, **Green**, and **Red**.

These are (0,0,7) jump images with **S** = 3 for various **P**. **P** and SCF are noted. A single color shows the resulting image.

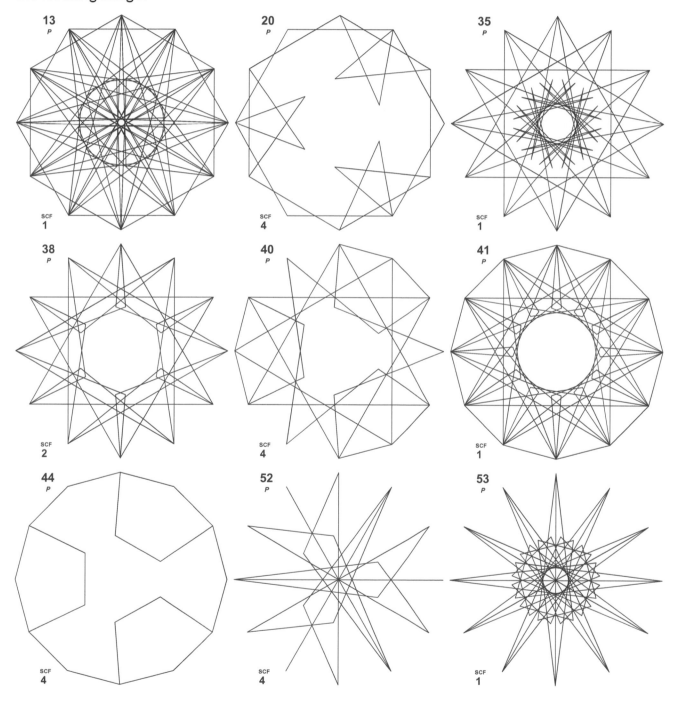

The last image (**P** = 53) is a porcupine that has center spines relative to its single jump counter-part. Many more variations on the theme seen on the previous page are possible by simply scrolling up through **P** up to 54 = 3**nS**/2 = 3·12·3/2. *Try other jump set values as well as other values for **S**. The ratio **P/S** provides useful information for attaining similar images as **P** and **S** change.*

The next two images, done with *Excel* file 17.0.2, are based on a three-color dense (1,6) flower with gold fillagree on top.

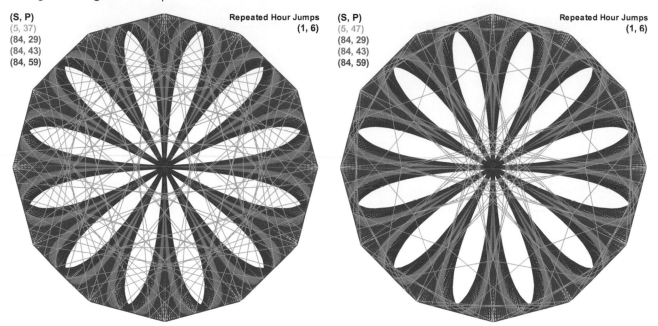

The final six images share VCF = 4 as well as the same **S** and **P**. The first 3 move **J₁** down and **J₂** up while keeping **J₁+J₂** = 13 or vertex 1. Notice that the **green curved triangular interior** gets smaller, however the **red equilateral Δ** stays fixed (like the middle image on the next page).

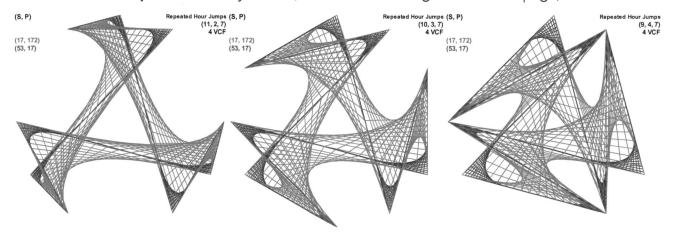

The first two images below maintain **curved triangular interiors**, and the last two have (5,7) and (6,6) Section 17.3 *spikes*.

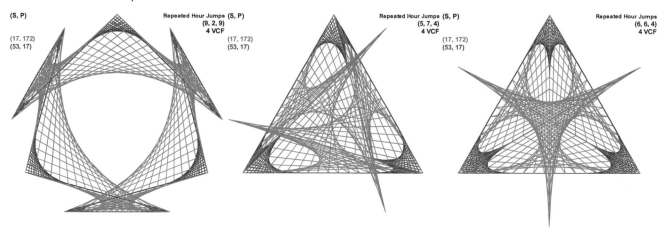

(S, P)

(17, 172)
(53, 17)

Repeated Hour Jumps (S, P)
(9, 2, 9)
4 VCF

(17, 172)
(53, 17)

Repeated Hour Jumps (S, P)
(5, 7, 4)
4 VCF

(17, 172)
(53, 17)

Repeated Hour Jumps
(6, 6, 4)
4 VCF

Chapter 18

Larger Jump Set Models

18.1 An Introduction to Larger Jump Set Models

As with smaller jump set models, it helps to start with the VF and with n = 12 so we can talk in terms of hours for vertices. All jump sets with more than three jumps and S > 1 must use the web model.

(n,k,d,c)=(12,4,1,0)
8 lines

Jump Sets by Equations Excel file 18.0.1. This file allows exploration of up to nine jumps in the jump set via equations using these additional parameters, k is the number of jumps in the set, d is the decline per jump, and c is the initial offset from vertical. These parameters lead to the following jumps:

$$J_1 = \text{INTEGER}(n/2)\text{-}c \text{ and } J_i = J_1 - (i\text{-}1){\cdot}d, \text{ for } i = 2, ..., k.$$

These equations allow the orderly examination of jump sets without having to manually change values.

Organization of these images. These images have d = 1 and c = 0. The first three images have n = 12 and the second three have n = 13. For both sets, k increases from k = 4, 5, and 6 at the first, second, and third image in the set. Note that INTEGER(12/2) = INTEGER (13/2) = 12 so jumps are the same on both sets (but of course they are easier to conceptualize for the first set since vertices are hours of a clockface). Given d = 1, jumps decline 1 starting at 6 = $n/2$ (c = 0).

(n,k,d,c)=(12,5,1,0)
15 lines

The 4-jump model is (6,5,4,3) which sums to 18.
The 5-jump model is (6,5,4,3,2) which sums to 20.
The 6-jump model is (6,5,4,3,2,1) which sums to 21.

The VCF and *vertices used* rules laid out in Section 16.1 still apply:

$$\text{VCF} = \text{GCD}(J_1+J_2+...+J_k, n).$$

Vertices used (and lines in VF) = $k{\cdot}n$/VCF.

Applying this information to the three VF images in this first set, we confirm how the images were created in this set.

DOI: 10.1201/9781003402633-21

First image. VCF = GCD(18,12) = 6 so vertices used = 48/6 = 8. The order of lines in image creation is:

$$0\text{-}6\text{-}11\text{-}3\text{-}6 - 0\text{-}5\text{-}9\text{-}0,$$

where there is a longer dash between jump sets.
This 8-line image was created in two 4-line jump sets.

Second image. VCF = GCD(20,12) = 4, vertices used = 60/4 = 15. The order of lines in image creation is:

$$0\text{-}6\text{-}11\text{-}3\text{-}6\text{-}8 - 2\text{-}7\text{-}11\text{-}2\text{-}4 - 10\text{-}3\text{-}7\text{-}10\text{-}0.$$

This 15-line image was created in three 5-line jump sets.

Third image. VCF = GCD(21,12) = 3, vertices used = 72/3 = 24. The order of lines in image creation is:

$$0\text{-}6\text{-}11\text{-}3\text{-}6\text{-}8\text{-}9 - 3\text{-}8\text{-}0\text{-}3\text{-}5\text{-}6 - 0\text{-}5\text{-}9\text{-}0\text{-}2\text{-}3 - 9\text{-}2\text{-}6\text{-}9\text{-}11\text{-}0.$$

This 24-line image was created in four 6-line jump sets.

Each of the images in the first set has less than $k \cdot n$ lines because VCF > 1. Such issues are less likely the case if n is prime.

Prime n. The only difference in the second set is that these are n = 13 images. Each image has VCF = 1 as will be the case when n is prime (unless the sum of jumps in a set is a multiple of n). Therefore, each image has $k \cdot n$ lines.

An *Excel* assist. When $n \neq 12$ we cannot use hours, but we can easily determine the drawing order using *Excel* in four equations (see table notes). This table was created for the first image in the second set (at the bottom of this page), but one could readily do sets of five or six by adjusting the jump set pattern before repeating that pattern (as was done in cell B6 for k = 4).

Stacked Stars. When VCF = 1, there will be $2k$ lines at each vertex of the VF. For example, with k = 4, the eight lines associated with vertex 0 are on either side of the four green highlighted cells in the *Excel* sheet. Note that these eight lines connect to vertices 3 – 10.

The lines at each vertex are paired with one another and create stacked stars. For example, there are four stars in the first image, one associated with each of the four jump levels 6, 5, 4, and 3. You can add or remove these stars using the ⬍ k arrows in the *Excel* file. *Note that the second adds a 13,2-star to the first and the third adds a 13,1-star (i.e., a 13-gon) to the second.*

Mystic Rose. The third image in the second set is sometimes called a *Mystic Rose*. Such images have the property that *every vertex is connected to every other vertex* in the image. Given n = 13, there are 12 lines emanating from each vertex or 78 = 13·12/2 lines (13 vertices, 12 lines per vertex, but each line has two ends, so you must divide by 2 to avoid double counting) noted on the image.

(n,k,d,c)=(12,6,1,0)
24 lines

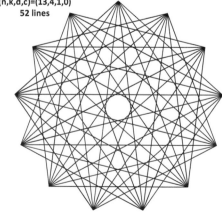

(n,k,d,c)=(13,4,1,0)
52 lines

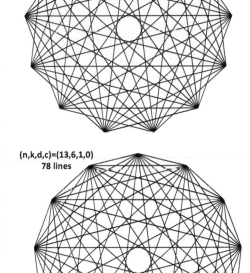

(n,k,d,c)=(13,5,1,0)
65 lines

Line	Jump	Sum	Vertex	Line	Jump	Sum	Vertex	Line	Jump	Sum	Vertex
1	6	6	6	19	4	87	9	37	6	168	12
2	5	11	11	20	3	90	12	38	5	173	4
3	4	15	2	21	6	96	5	39	4	177	8
4	3	18	5	22	5	101	10	40	3	180	11
5	6	24	11	23	4	105	1	41	6	186	4
6	5	29	3	24	3	108	4	42	5	191	9
7	4	33	7	25	6	114	10	43	4	195	0
8	3	36	10	26	5	119	2	44	3	198	3
9	6	42	3	27	4	123	6	45	6	204	9
10	5	47	8	28	3	126	9	46	5	209	1
11	4	51	12	29	6	132	2	47	4	213	5
12	3	54	2	30	5	137	7	48	3	216	8
13	6	60	8	31	4	141	11	49	6	222	1
14	5	65	0	32	3	144	1	50	5	227	6
15	4	69	4	33	6	150	7	51	4	231	10
16	3	72	7	34	5	155	12	52	3	234	0
17	6	78	0	35	4	159	3				
18	5	83	5	36	3	162	6				

Note. The table is cut into thirds to conserve on space.
Enter jump pattern in cells B2 to B5, given a four jump set.
Equations in cell: C2 = B2

 D2 = MOD(C2,13) Drag down.

 C3 = C2 + B3 Drag down.

 B6 = B2 Drag down.

18.2 Mystic Roses

A mystic rose is an image in which each vertex is connected to every other vertex. The top image is a mystic rose with **n** = 19. There are 18 lines emanating out of each vertex or a total of 171 = 19·18/2 lines. This is the largest mystic rose possible using the *Jump Sets by Equations Excel* file 18.0.1 since **k** = 9 is the largest **k** allowed in this file. The web version can create much larger mystic roses.

(n,k,d,c)=(13,6,1,0)
78 lines

(n,k,d,c)=(19,9,1,0)
171 lines

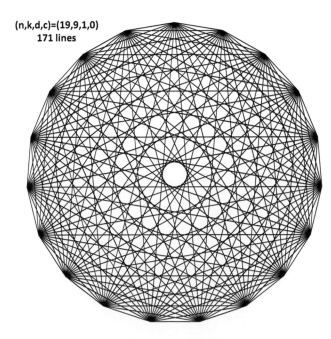

To create a mystic rose, you need to know how many jumps to set for a given **n**. The ending image must have VCF = 1 so that all vertices have a full complement of lines connecting that vertex to all other vertices.

Commonality issues. Setting k = INTEGER($n/2$) jumps in the jump set with c = 0 and d = 1 produces a jump set of (k, k-1, …, 2, 1). Unfortunately, this does not guarantee that each vertex connects to all other vertices because there may be

commonality between the sum of jumps and **n**. For example, decreasing **n** by 1 to 18 produces an image with only 18 lines because the sum of jumps is 45 = 9·10/2 and GCD(45,18) = 9.

Consider an attempt to create a bit smaller mystic rose, one based on **n** = 16. Clearly, **k** = 8 should work, but the 32-line image to the right results. The sum of indices is 36 = 8·9/2 and GCD(36,16) = 4 (which confirms that lines = **k·n**/ VCF = 8·16/4).

What is needed is to have a jump sum that has no common divisor with **n**. We can do that by increasing the jump set size.

Increasing jumps to complete the image. Two alterations turned this image into the bottom one. Increase **k** to 9 and decrease **c** to -1. The jump set (9,8,7,6,5,4,3,2,1) results. The sum of jumps is 45 and GCD(45,16) = 1. Note however that the *number of lines used to create this image*, 144, is larger than the *number of lines in the image* = 16·15/2 = 120. The remaining 24 lines were used multiple times in order to complete the *continuously-drawn* mystic rose. Finally, note that a mystic rose has spokes in the center when **n** is even.

A hint for adding jumps in the web model. You may be used to thinking in declining terms when using the web version because the *Jump Sets by Equations Excel* file 18.0.1 decreases jumps in the jump set due to the equations discussed in Section 18.1. A better solution is to use the jump labels to tell you what to set the jump value as, Jump 1 is 1, Jump 2 is 2, etc. That way, as you add jumps, you do not need to go back and adjust all earlier jumps. A mystic rose is a vertex frame, so set **S = P.**

When VCF = 1, the VF does not depend on jump order (but does change the image if **S ≠ P** (see Section 17.1)). If VCF > 1, the order matters (for example, a jump set of (1,2,3,4,5,6,7,8) produces a mirror image to the (8,7,6,5,4,3,2,1) top image on this page).

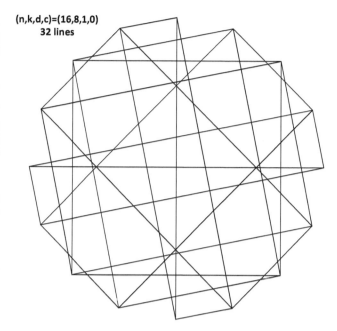

(n,k,d,c)=(16,8,1,0)
32 lines

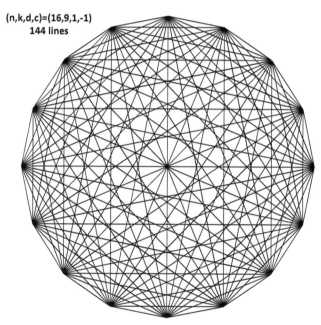

(n,k,d,c)=(16,9,1,-1)
144 lines

18.3 Counting Backwards

If you play around with the *Jump Sets by Equations Excel* file 18.0.1 you may well end up with negative values for a vertex jump. A negative vertex jump simply means to move counterclockwise or count backwards.

First image. The jump pattern created from $(n,k,d,c) = (14,7,1,3)$ is the seven-jump sequence: (4,3,2,1,0,-1,-2).

Applying these jumps leads to an image created by connecting the following sequence of vertices on the 14-gon:

0-4-7-9-**10**-**10**-9-7 – 11-0-2-**3**-**3**-2-0.

The image is created in two 7-line jump sets, although two of those lines have starting vertex and ending vertex that coincide (**10** and **3**) since they involve zero jumps.

Note the sum of jumps is 7 so VCF = 7 and Lines = 7·14/7 = 14.

If you like kinked tails, $(n,k,d,c) = (16,8,1,4)$ has four 3-kink-tails.

Second image. This is the same VF as above done in the web version with $S = 13$ and $P = 75$. If you open this image there you will note that the last three jumps are 14, 13, 12 not 0, -1, -2.

The web version does not support non-positive jumps, but realize that a jump of J and $J+n$ creates the same VF. The only difference is how many times you go around the circle before landing on the next VF vertex endpoint. Therefore, n (of 14) was added to all non-positive values to create the VF.

The jumps of 0 = n = 14 are quite clearly visible at the ends of the tails at **3** and **10**. That is the only way to get a spray of S lines, all emanating from the same point (since that point is two vertices of the VF piled on top of one another).

If you play with P in the above model, you will find other fun images. In particular, note the *very slanted S* in this $P = 27$ image.

In the same vein, Section 17.4.2, *Line Analysis of a $J = 0$ Image*, could have been accomplished in the web version by replacing the $J_3 = 0$ jump with $J_3 = 12$.

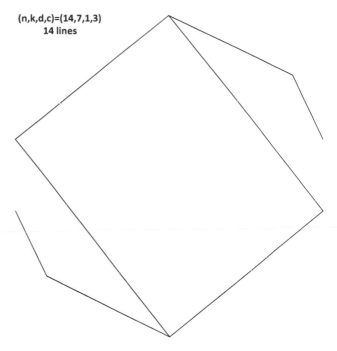

(n,k,d,c)=(14,7,1,3)
14 lines

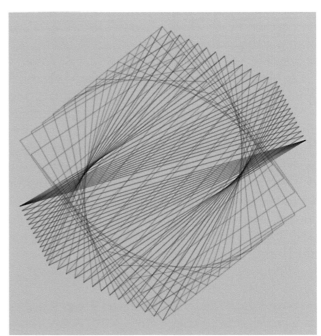

Third image. This image involves two changes from the first image. Increase **n** by 1 to 15 and set **c** = 0 so that the jumps are (7,6,5,4,3,2,1). The result is a Section 18.2 *Mystic Rose*.

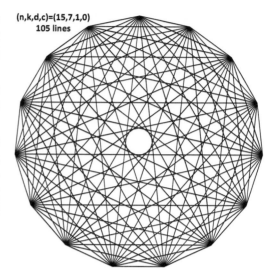

(n,k,d,c)=(15,7,1,0)
105 lines

This is an example of a composite **n** that produces an image with VCF = 1. This is true because the sum of jumps is 28 which has no factors in common with 15.

Additionally, 7, the largest jump in the set, is also the largest jump less than or equal to **n**/2, and the jump set ends at 1. Therefore, given the size of **n**, and given the jump pattern, each vertex is connected to all other vertices, just as required by a mystic rose. This rose has 105 = 15·14/2 lines.

18.4.1 From VF to String Art with Larger Jump Sets

Having a larger number of jumps in a jump set requires having a larger **n**, which increases the number of lines in the VF if VCF = 1. As we consider final images using **S** subdivisions, the number of lines in the image often gets to the point where it is impractical to try to follow exactly how the image was created. The question becomes: *How can one use VCF > 1 and or SCF > 1 to find images among neighboring images that are much more densely packed?*

There are several ways to proceed. We will only examine a couple of options here, more to offer suggestive hints than to lay out a complete superstructure of what you will find as you explore larger jump set images.

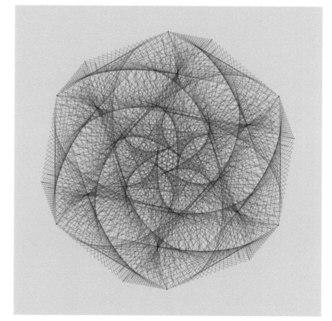

Take, this 684 line **P** = 35 *Hexagons with off-center 6,2 needle fan* (18,19,35,J(1,2,3,4,5,6)). It is reminiscent of Section 16.7 regarding needle fans when **k** = 2. The image remains manageable because VCF = 3. (Change to **n** = 17 or 19 and get 1938 or 2166 lines, respectively.) Or change J_6 = 6 to 8 above and a 2052 lines image occurs because VCF = 1. In this instance, discernable patterns are still visible but are more difficult to see due to overall line density issues.

Some nearby images have large SCF. The **P** = 19 VF is 36 lines, **P** = 36 is 19 lines, **P** = 38 is 18 lines, and **P** = 57 is 12 lines. These are shown at the top of the next page.

239

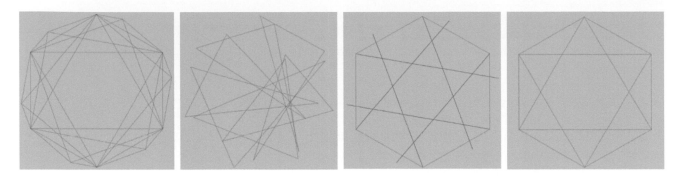

Use the scroll key on **P** to check out other options. Each of the following images maintains SCF = 1 so there are 684 lines. <u>**P** = 37</u> is a rotating ↻ 6 petal internal flower. [**MA.** This image is *single-step* with DL = 37. 1 = DL·**P** = 37·37 MOD 36·19 and V_{used} = **k·n**/VCF = 36 (as noted in the **P** = 19 VF image above).] **P** = 41 is a rotating ↻ 6 petal internal flower. **P** = 49 is something akin to six rotating feet. The last two **P** = 53, a 6,2 internal star with eyelet ends and curves, and **P** = 59, a 6,2 internal star with curved ends, are shown here at left and right. Change to <u>**n** = 15 for **P** = 59</u> and note five large and five small off-center gathering points in the resulting 570-line image.

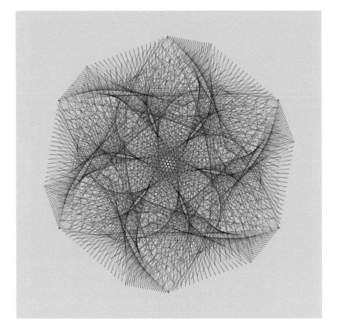

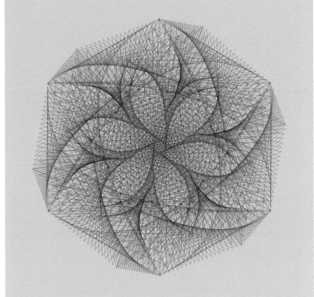

18.4.2 *Just Tails*, Asymmetric Suspension Curves, and Spirals

How VF Tails are Made							Notes: *n*-1 jumps per set.							
7 *n*	**When *n* is odd**						Increase 1 per jump							
Pattern	1	2	3	4	5	6	Results:							
Sum	1	3	6	10	15	21	Odd *n*:	1 jump set to 0						
MOD *n*	1	3	6	3	1	0		*Middle* at (*n*-1)/2						
MOD *n* is the vertex endpoint							Even *n*:	2 jump sets to 0						
of points on the VF line.								*Middle* at *n*-1						
8 *n*	**When *n* is even**						**BOTH: Mirror about *Middle***							
Pattern	1	2	3	4	5	6	7	1	2	3	4	5	6	7
Sum	1	3	6	10	15	21	28	29	31	34	38	43	49	56
MOD *n*	1	3	6	2	7	5	4	5	7	2	6	3	1	0

The table provides jump set notes for both images. The left image is **n** = 7, the right is **n** = 8 and both are VFs. Both were created by following this rule.

Just Tails Jump Rule: Set $J_i = i$ for $1 \leq i < n$. The table shows the jump pattern for both images using this rule.

Claim: This rule creates an **n**-1 line VF with (**n**-3)/2 kinks if **n** is odd, and a 2(**n**-1) line VF with **n**-2 kinks if **n** is even.

Explanation: The table shows the jump pattern for both images and provides the rationale for why each VF is simply a kinked series of lines. Note the mirroring that occurs about the *Middle* of each VF. The reason for this is straightforward. The general jump pattern is 1, 2, 3,, **n**-3, **n**-2, **n**-1. The first and last sum to **n**, the second and second to last sum to **n**, and so forth. *Each jump in the second half reverses the order of the jumps that were done in the first half.*

These images have **S** = 19 and VCF = 1. From left to right, the **n** = 7 **P** = 35 and **P** = 55 images have 114 lines while the **n** = 8 **P** = 17 and **P** = 83 images have 266. As is readily apparent, odd **n** images are not rotationally symmetric but the even ones are. Turn them over, they look the same.

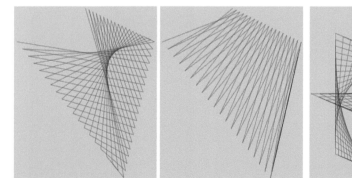

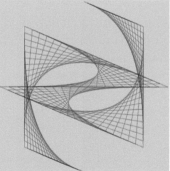

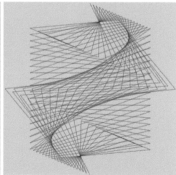

Near porcupines. The second image is a near porcupine (2 less than halfway, 1 less has VCF > 1). Even near porcupines are typically just very spiky images, but odd ones appear more interesting, for example, **n** = 9, **n** = 13, or this **n** = 19, **P** = 169 image.

Asymmetric suspension curves, ASC. In contrast to Section 12.10 on suspension curves found in single jump models, these two suspension curves are asymmetric because VF lines are of different lengths as noted in Section 16.1. The 342-line image at the bottom of the next page is a near porcupine. If you increase **P** by 1 to 170, the curves become closer together, but the image has half the line density because VCF = 2. On the other hand, decreasing **P** creates greater distance between curves as witnessed by the VCF = 1 **P** values of 167 and 163.

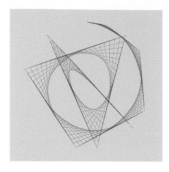

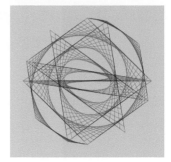

ASC works for other odd **n**. The 418 line **n** = 23, **P** = 207 version is nice because as you decrease **P** by 2 from there, VCF = 1, and the curves diverge. This 798 line **n** = 43 version has five such curves.

ASC also occurs without *just tails*, check out this pentagonal one.

Spirals. Once **n** becomes sufficiently large, you can see that the *Just Tails Jump Rule* creates clockwise spirals if **S** > **P**. These two are **S** = 19 > 13 = **P**. **n** = 19 is at left and **n** = 20 is at right.

One vertex larger (20 versus 19) looks like a lot more rotations in the spiral, but that is because an odd **n** creates single spirals (odd *just tails* images are not rotationally symmetric) while an even **n** results in double spirals (because they are rotationally symmetric).

How many rotations are in the spiral? This depends on whether **n** is even or odd. For both even and odd, the image is created in two halves with the second half backing out of the first half. Therefore, we need only consider the first half.

Odd n. The first half of the jumps is (**n**-1)/2 jumps. The sum of jumps is (((**n**-1)/2+1)·(**n**-1)/2)/2 = (**n**-1)(**n**+1)/8 = (**n**² − 1)/8 = **n**²/8 − 1/8, which, when divided by **n** is just below **n**/8.

Examples: When **n** = 7, (**n**² − 1)/8 = (49-1)/8 = 6, just like the top half Jump 3 Sum in the table. This is 6/7 of a turn around the spiral. At the top left, **n** = 19 is about 19/8 or 2.3 turns, and at the next page left, **n** = 43 is 43/8 or 5.3 turns.

Even n. There are **n**-1 first half jumps. But the **n**-1st jump ends at **n**/2 and includes both the curve emanating from vertex 0 and from vertex **n**/2 as well as the transition diameter at jump **n**/2-1 to **n**/2 (jump 3 to jump 4 in the second half of the table for **n** = 8). The spirals are symmetric, so we need only consider from 0 to **n**/2-1 and double the resulting answer to account for the spiral starting at the bottom. The sum of these first **n**/2-1 jumps is ((**n**/2-1)+1)·(**n**/2-1)/2 = **n**(**n**/2-1)/4, which, when divided by **n** and multiplied but 2 is (**n**/2-1)/2 or **n**/4-1/2.

Examples: When **n** = 8, **n**(**n**/2-1)/4 = 8·3/4 = 6, just like the bottom half Jump 3 Sum in the table. This is 1.5 turns and resembles a Yin and Yang symbol. Top right **n** = 20 is 4.5 turns, and next page right **n** = 44 is 10.5 turns.

Note: It is a bit difficult to count turns due to the sharpness of curves at the center of each image where the curves create scallops on each side of the halfway line rather than curves that rotate all of the way around. Also, for even **n**, the transitional diameter (transitioning from the spiral starting at 0 to the one starting at **n**/2) discussed earlier provides additional complexity. If **n** is divisible by 4, that diameter is horizontal, if **n** is divisible by 2 but not by 4, it is vertical.

On the next page are 798 line **n** = 43 and 1634 line **n** = 44 spirals. Here is another **n** = 44 image: Yin and Yang with two pentagrams.

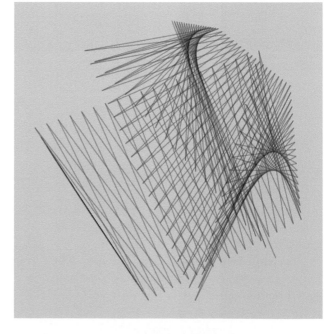

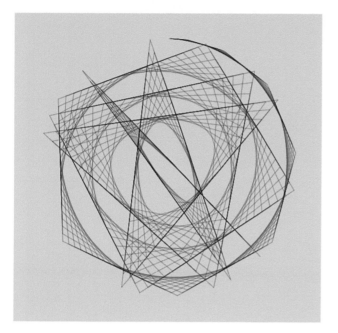 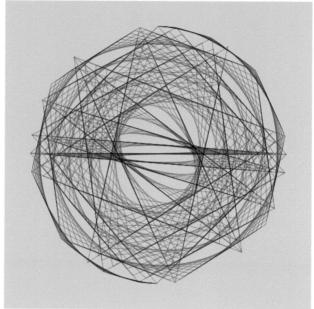

18.4.3 Fibonacci

Introduction. If you have not run into Fibonacci numbers before, it is worth a quick Google search. The ubiquity of this sequence suggested that it would be worthwhile to see if creating a jump set of Fibonacci numbers would yield interesting images. Indeed, they do.

The Fibonacci Sequence is simple: The k^{th} Fibonacci number is the sum of the previous two Fibonacci numbers. The first ten numbers in the sequence thus go: 1, 1, 2, 3, 5, 8, 13, 21, 34, 55, For simplicity, call the k^{th} value F_k.

One of the interesting properties of Fibonacci numbers is that the sum of the first k Fibonacci numbers is 1 less than F_{k+2}. It is easier to get the sum by looking later in the sequence than by repeated addition of individual Fibonacci numbers.

Curved-tip stars given F_5. The first five Fibonacci numbers sum to 12 so VCF = GCD(Sum of J,n) = GCD(12,n). More interesting images are possible given a larger P but if P is close to half of S (here 13 and 23) the curves do not overlap much in the middle and it is easy to follow the pattern of curves through a jump set. Twelve images are shown in three rows from L to R: n = 4, 6, 7, and 8; 9, 10, 11, and 12; 15, 16, 18, and 24. The only ones with VCF = 1 are 7 and 11.

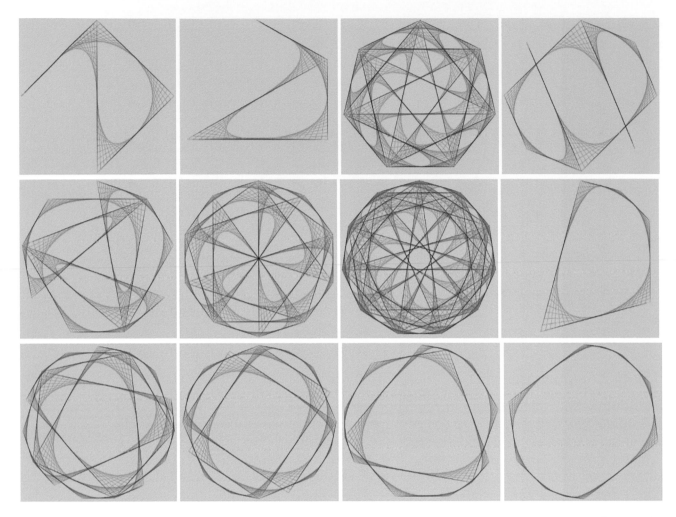

It is worthwhile to spend a few minutes looking at the images to make sure you can follow the first jump set: 1, 1, 2, 3, 5. In particular, you should be able to see why the first two images and n = 12 end after one jump set, the n = 8 and 24 images end after two sets, the n = 9 and 18 images end after three jump sets, and why three images have *spikes* (Section 17.3).

Many of these images have inherent spirals, which is not surprising given that the jump sequences are Fibonacci. A well-known result is that you can approximate a golden spiral using Fibonacci numbers (see Section 20.13 for a guided tour).

When working with larger Fibonacci sequences, you can end up with interesting images when VCF > 1. This infinity symbol image is based on n = 9 and F_8. The sum of jumps is 54 and the image is completed in a single 8-jump set.

Top left image on the next page, shown with first 5 lines drawn, is F_7 swirling *single-step* pentagram, DL = 5. The image has 90° rotational symmetry because n = 132 or four times the sum of the first seven Fibonacci numbers. This porcupine pentagram needle fan, DL = 2 has n = 165 = 5·33 is a close cousin as a result.

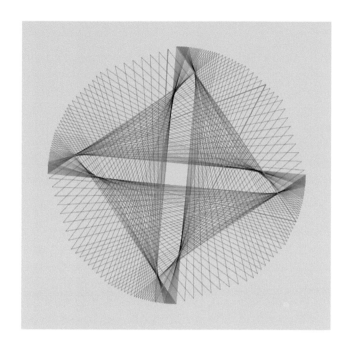

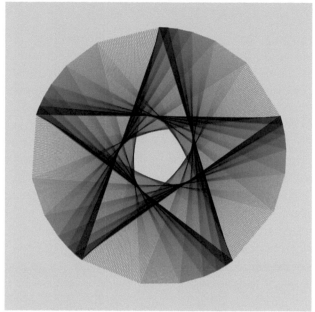

The top right <u>pentagram with creases</u> is another $n = 165$, F_7 image. The creases are created by having the first seven Fibonacci numbers create different densities of lines as vertices in the 165-gon are traversed five times. Note: The five least dense sets of lines are 13/165 = 7.8% of the circle or a bit less than 1/12 = 8.3% (at about hours 2, 4, 7, 9, and 11).

Double Fibonacci. The <u>bottom left image</u> is F_7 up then back down (or 14 jumps in a set with a sum of jumps = 66) and has 1036 lines with VCF = 22. This image has $n = 44$. Here are additional images with the only difference being alternative P values: <u>53</u> <u>61</u> <u>75</u> <u>223</u> <u>359</u> <u>423</u> <u>Letter O</u> <u>Diamond</u> <u>503</u> and <u>Porcupine 517</u>. If you return to the bottom left image but change n, you get a scowling face for <u>$n = 6$</u>. Also consider checking n = 18, 22, 24, 30, 33, 55, 66, 88, 99, 132, and 198.

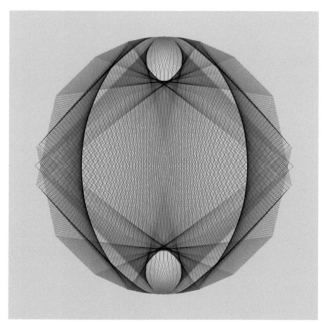

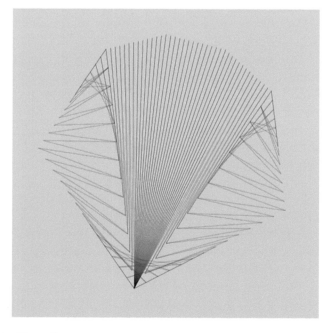

The <u>$n = 13$ bird beak</u> has a jump set of 13, not 14. This allows VCF = 13, not 1. The beak is because $J_7 = J_8 = n$ (see Section 18.3).

18.5 Creating Videos

You have long understood how to watch an individual image get drawn using the various *Drawing Modes* in the web model but here we focus on a different way to create a series of images that could be viewed as a video rather than as a single static image. The method we model here is based on the often-used idea of allowing P to vary while holding n, S, and jumps fixed. This, for example, is what led to the discussion of *waves of images* in Section 10.2.1.

What happens to images as P varies? As noted in Section 16.1, VCF = GCD($J_1+J_2+...+J_k,n$) and $v_{used} = k{\cdot}n$/VCF, some of which may be used multiple times, in the jump set context. Since n and jumps are fixed, so is v_{used}, and more concretely, *so is the vertex frame*. What varies as P varies is SCF = GCD($P,S{\cdot}v_{used}$), and hence lines in the image = $S{\cdot}v_{used}$/SCF.

Avoiding unwanted distractions. If you start from a random image in the web model and decide to scroll across P for "nearby" images, you are likely to run into images where the number of lines varies often and dramatically due to variations in SCF. To take an example that has been used often in multiple jump settings, if v_{used} is a multiple of 12 then as you scroll across images you will run into SCF that varies widely. Take, for example, the 144 line (24,3,11,J(15,2)) image on the front cover of this book and discussed in Section 16.6. With P = 11, SCF = 1, but the next 15 values of SCF are: 12, 1, 2, 3, 16, 1, 18, 1, 4, 3, 2, 1, 24, 1, and 2. This means that the number of lines in the image varies from 144 to 6 and more importantly, the overall *image density* (see Section 5.4.1) is constantly changing due to the great deal of commonality between numbers in this instance. This makes scrolling over P seem like a very disjointed experience.

Scrolling made easy. If you have a keyboard with directional arrow keys, click on the number in the *Points* area (so it turns blue) and use the ^ or ˅ key to increase or decrease P. You can hold this key down rather than tap it one P per tap.

Minimizing density changes. The commonality problems come from various sources. Note that n, k, S, and the sum of J_i all contribute to determining $S{\cdot}v_{used}$. *One thing to do is to think strategically about these values.* By making n, S, and k all powers of a *single prime number* the resulting image will have SCF > 1 only if P is a multiple of that number.

Examples. Take, for example, 5. The resulting image will only have SCF > 1 if P is a multiple of 5. Put another way, four out of five images will have the same image density, and every fifth will be 1/5, 1/25, or 1/125 as dense.

The left image is 625 line (5,25,299,J(1,2,5,3,1)). The next P has SCF = 25, but the next four after that are SCF = 1. The 250 full-density images are different but closely related to nearby images (250 = (625-125)/2 since there are 125 multiples of 5 between 1 and 625 and since the images are symmetric about the porcupine midpoint, P = 312).

The middle image is 3125 line (5,125,151,J(1,1,2,3,5)) has five times the density of the prior image, but the same rule applies. Every fifth P has a lower density, but the rest (1250 in all) are full density. The porcupine is at P = 1562.

The right is based on 7. The (7,49,33,J(1,1,2,3,5,1,6)) image has 2401 lines (2401 = 7^4). There are 1029 full-density images with a reduced density every seventh P from 1 to porcupine at P = 1200. Note multiple 7,2- and 7,3-stars here.

Additional points. The above examples should provide you with an idea of how to proceed. Here are additional links and ideas. The first image is based on 11s. The second image is based on 13s. If you violate the *single prime rule* by adding a second prime, it simply means that density changes at multiples of both of these numbers, so you lose density at multiples of 5 and 101 for S = 101. Finally, if P is prime and you scroll on S, lines change but stay at full density until S = P.

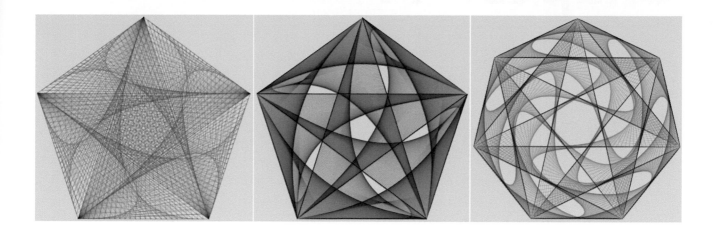

Chapter 19

Busting Out of Our Polygonal Constraint

19.1 What Changes Once We Leave Our Regular Polygonal World? The Role of V

We have relied on regular polygons to eliminate the need to think about where vertices are located. They are equally spaced around the circle, and that is that. In our new world, we eliminate the parameters **n** and **J** and replace them with a single parameter, **V**, together with (**x**, **y**) coordinates that are user-provided (in the four-color version of the model). The differences are set forth in this table. (**Note:** This is based on the Erfle and Erfle __Bridges 2020__ paper, which does not italicize letters.)

What changes What does not	Polygons String Art model	Beyond Polygons model (*Excel* file name: 4ColorAestheometry.xlsx)
How vertices are determined	Click **n**	User types in their own (**x** , **y**) coordinates of each vertex (up to 40 per color)
How the **VF** is determined	Click **n** and **J**	User types in how many coordinates to use, **V**
Calculation of VCF	VCF = GCD(**n** , **J**)	There is no VCF as the only move is a "jump" of 1
Number of **V**ertex **F**rame (VF) lines	V_{used} = **n** /VCF	**V** (As we see below, **V** can be less than vertices provided.)
Subdivisions, **S**	No change (**S** and **P** values are entered by typing (like *Four Colors* files) rather than by arrow keys.)	
Number of Subdivisions per line, **P**		
Calculation of SCF	SCF = GCD(**P** ,**S·**V_{used})	SCF = GCD(**P** ,**S·V**)
Lines in image	**n** /SCF**·S** /SCF = V_{used} **·S** /SCF	**V·S** /SCF

Since **S** and **P** work the same in both models, we only need to worry about **V** (we put aside setting coordinates for a moment) to focus attention on **V**, *the number of vertices used*. *The VF connects vertex to vertex until the last **used** vertex; the next vertex is the initial vertex.* The Excel file 19.0 *Handout* sheet explains **V**, **S**, and **P** with a *Brunes star*, as in Section 3.3.

About V. The screenshot from *Excel* file 19.0 sheet **4a** at the top of the next page shows the completed image together with 20 (**x**,**y**) coordinates based on (**V**,**S**,**P**) = (20,47,23). The rest of the images vary **V** from left to right in two rows, **V** = 3, 4 and 5 on top with 8, 12 and 16 below. The first coordinate here is (10,0), so *the VF always closes back to this point*. With **V** = 3, this creates a triangle, the **V** = 5 comma starts the (top or side?), and 6 shows it is the top which is finished at **V** = 8. **V** = 12 finishes the side, but vertex 16 is in the back-upper-left corner. *Excel* file sheet **4c** varies **V** so you can see how a **V** = 5 heart gets pierced by an arrow at **V** = 20.

DOI: 10.1201/9781003402633-22

20	47	23	primes
V, # of vertices used. V < 21	**S**, # of subdivisions per side	**P**, # of subdivisions between Points	
You can change the yellow cells			2
Note : Keep V*S<1000 (or pattern will not repeat)			3
Vertices	X	Y	5
1	10	0	7
2	0	0	11
3	0	10	13
4	10	10	17
5	14	14	19
6	4	14	23
7	0	10	29
8	10	10	31
9	10	0	37
10	14	4	41
11	14	14	43
12	10	10	47
13	0	10	53
14	0	0	59
15	4	4	61
16	4	14	67
17	4	4	71
18	14	4	73
19	14	14	79
20	10	10	83
999			89
999 above means "vertex not used"			97

You can write notes in the green cells

Try V = 4, 8, 12, and 20 ... then do the same on sheet 4b

To see how this is built out, vary V from 3 to 20

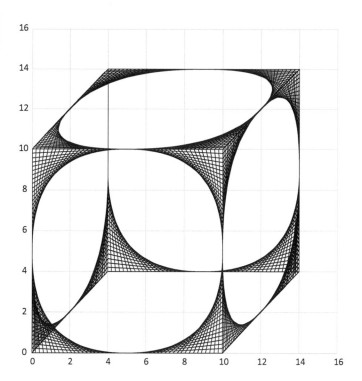

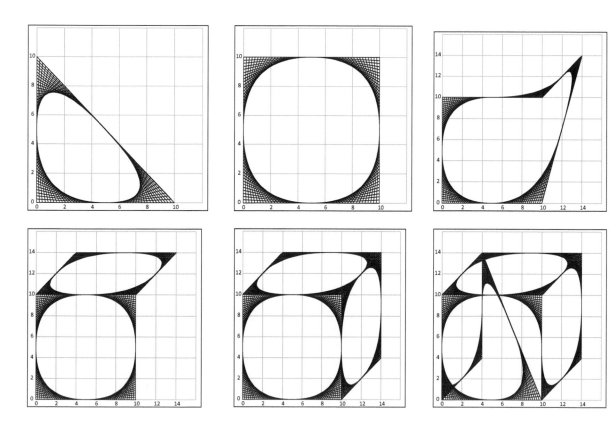

249

19.2 Linked Vertices

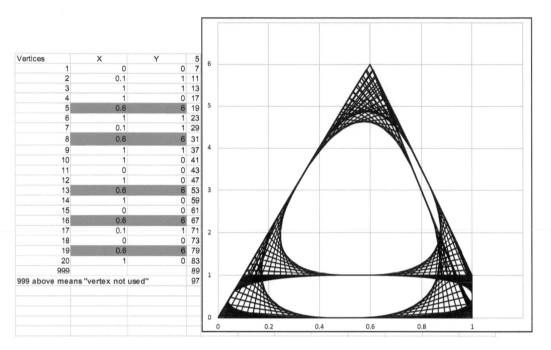

Vertices	X	Y	
			5
1	0	0	7
2	0.1	1	11
3	1	1	13
4	1	0	17
5	0.6	6	19
6	1	1	23
7	0.1	1	29
8	0.6	6	31
9	1	1	37
10	1	0	41
11	0	0	43
12	1	0	47
13	0.6	6	53
14	1	0	59
15	0	0	61
16	0.6	6	67
17	0.1	1	71
18	0	0	73
19	0.6	6	79
20	1	0	83
999			89
999 above means "vertex not used"			97

Above is a partial screenshot of *Excel* file 19.0 sheet **5a** that explores linked vertices (described below). By appropriate choice of 20 (X, Y) vertices, the base and all sides have curves at connecting corners (Note: the left side is not visible in the image above).

The other important cells in that worksheet (not shown here) are the highlighted X and Y values in cells V7:W7 (of 0.6 and 6) that control the location of the top vertex via links (=V7 and =W7) in the purple highlighted cells of the Vertices Table. If X or Y in V7 or W7 is changed, all five (purple) linked cells change. The other 15 vertices describe the base. (You could vary **V** to see how the VF was created but that is not the point here.) Sheet **5b** lets you control all four vertices of a pyramid with a triangular base.

Changing X. The bottom left image occurs if −0.2 is typed in V7. Now the peak is not over the footprint of the base.

Changing Y. The bottom right image occurs if 3 is typed in W7 (and V7 is 0.6). Now you can see the left side.

Questions to consider. How would you model flying in an airplane over this pyramid and looking down? Suppose you set Y = -3. Now which triangular face appears to be in front? Set (X, Y) = (-10, 3). Does the base still look like a base or is it now more of a side wall? Next try (10, 3) and ask the same questions. Finally, at (10, -3), which triangular face looks like it is in front?

19.3 Listing Vertices Twice in a Row (Recreating a Zero Jump)

Sheet **7a** recreates an idea introduced in Section 17.4.1. Something is going on at the upper right vertex, (1,1), that creates an asymmetry at that vertex. *The way that asymmetry is created is simple: It is listed twice in a row.* This is equivalent to having the same vertex listed twice in a row in the polygonal context, **J** = 0, **n**, or multiples of **n**.

These four images were created from a square with **V** = 5, the extra vertex comes from having (1, 1) listed twice in a row. Each image has **S** = 19 and varies by **P**. It is worth briefly discussing each image (although if you already feel comfortable with Section 17.4.1 or the additional **J** = 0 analysis in 17.4.2, you will be able to skim over this very quickly).

P = 18, left. This image has curves at all but the (1,1) corner. Since **P** < **S**, this image includes the VF. The (1,1) corner is not a single subdivision point on the VF, but instead is 20 such points (one more than **S**). After all, **S** = 19 means there are 19 subdivisions between the first time vertex (1,1) is used, and the second time (1,1) is used. The curve at that corner is in fact various lengths of horizontal or vertical lines, all of which either start or end at (1,1).

P = 21, right. The bottom and left sides of the VF are not part of the image, but the top and right sides are included. The line from (18/19, 1) to (1, 18/19) is because 21 = 1+19+1, just like we saw in Section 17.4.2 when **S** = 5 and **P** = 7.

P = 37, next page left. The curve at (1,1) is the same as the three **P** = 18 curves on previous page left image since 37 = 18+19.

P = 47, next page right. This is the porcupine image. The only parts of the VF included in the image are individual points.

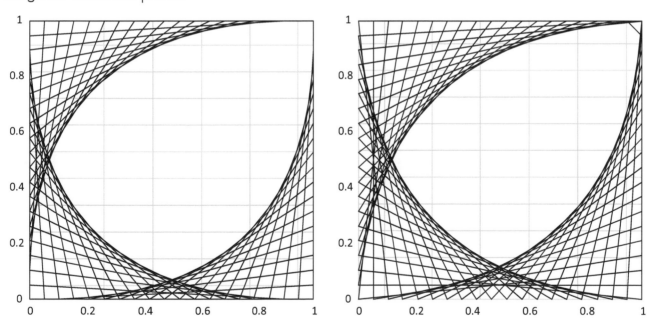

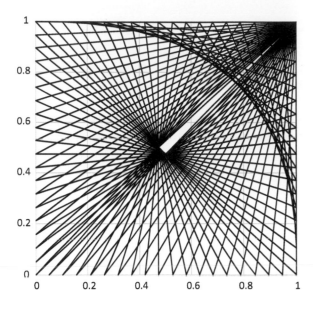
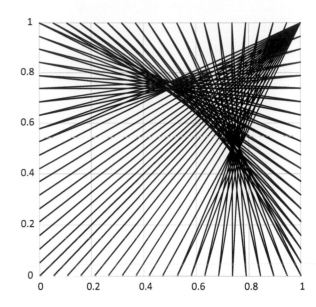

19.4 The Four-Color Model, Exploring Inside the Box

About Sheet 6. The previous three sections, together with your existing knowledge of how **S** and **P** work, provide you with a solid grounding for all but *Section 4* of the **_Bridges 2020_** paper, *4. Using the Four-Color Open Vertices Model. Section 4* deals with using the *6.FourColors* sheet in *Excel* file 19.0 (as well as at the *Bridges* webpage). This sheet allows users to add up to 40 (**x**, **y**) coordinates for each color. These vertices may be entered independently of one another, or they may use one another to create images such as the *Bridges 2020* image on the *Title* sheet of the *Excel* file in which the word **Bridges** is in **red**, with a reflection of that word in gold while **2020** is in **blue** and a reflection of 2020 is in green. Additionally, one can explore variations on any one of the parameters holding the other two fixed (as was shown on a separate sheet in the file called *Bridges Handout*) using this sheet.

Users can create tessellations of a single image and that is how the *6.FourColors* sheet is set up upon opening the sheet. The use of this sheet for that purpose is discussed on pages 551–553 of the **_Bridges 2020_** paper (which includes four four-color tessellations, horizontal, vertical, and rotational reflections), and it is best to simply refer readers to those pages.

Here, we choose to provide a couple of *explainers* that move in directions not discussed in the *Bridges* paper. This one and the next explore variations on the *zero-jump* model from Section 19.3, and the last explores how to layer colors much like we did with polygons in Chapter 17, to create initials (such as ESA, for example) or other layered images.

Saving your work to a library. You can always get back to a fresh copy of the file by opening a new copy from the website. But what should you do when you have something you want to save? You have a couple of options. First, you could simply click *File, Save As,* and then add a name to the end of the file so you will know what you have. Another option is to either add a new worksheet to the file or use the *Some4ColorShapes* sheet. You will note that the first image on that sheet saved A1:L58 but later images did not save the gray work area below the vertices. Just save what you need. You might also explore some of the images in the *8.SomeShapes* sheet which is from an earlier iteration of the file, referenced in the bibliography of the **_Bridges 2020_** paper and is single color.

Square porcupines with varying zero jumps. The porcupine polygon image at the next page left and the (**V,S,P**) = (4,17,33) at the middle differ by 45° and color. This simple image is the starting

point for the explorations on the next page which are based on simply moving along the main diagonal inside the box once you get back to (0,0). *The "data" for the upper right image on the next page is the table at right.* Focus on the last 5 (X,Y) points in the **Red Vertices *parent image*** table. Instead of stopping at (1,0) **like the red porcupine below**, (0,0) is the fifth point. The sixth vertex moves inside along the main diagonal. As you can tell, there are eight 0.5s for vertices 6–9 (although 999s show for red after 6 meaning this vertex is not used). The *"parent coordinate"* is ***x*** for vertex 6, and all other 0.5s are linked to this value. If that changes, so do the other seven.

(n, S, P, J)
(4, 17, 33, 1)

These are both Porcupine Squares.

n	S	P
6	17	49
7	17	59
8	17	67
9	17	76

V	S	P

B50:B51 has red x,y

Red Vertices

	X	Y
1	0	0
2	0	1
3	1	1
4	1	0
5	0	0
6	0.5	0.5
999	0.5	0.5
999	0.5	0.5
999	0.5	0.5

This means that we get different images depending on how far along the diagonal we go into the box. We also get different images depending on how many times we use that vertex in a row (this is a zero jump). To tile the sub-images (colors) here, set E6 = 1. **Red has no zero jumps; Green has 1 zero jump; Blue has 2 zero jumps; and Gold has 3 zero jumps.** Each ***P*** is adjusted so that the resulting image is an SCF = 1 porcupine (***P*** is closest to INTEGER(***VS***/2) with SCF = 1, e.g., red ***P*** = 50 has SCF = 2).

Each panel's vertex 6 ***x*** value (and hence ***x*** for 7-9 and ***y*** for 6-9) on the next page is: Top Left, **0.3**; Top Right, **0.5**; Bottom Left, **0.8**; Bottom Right, **1**.

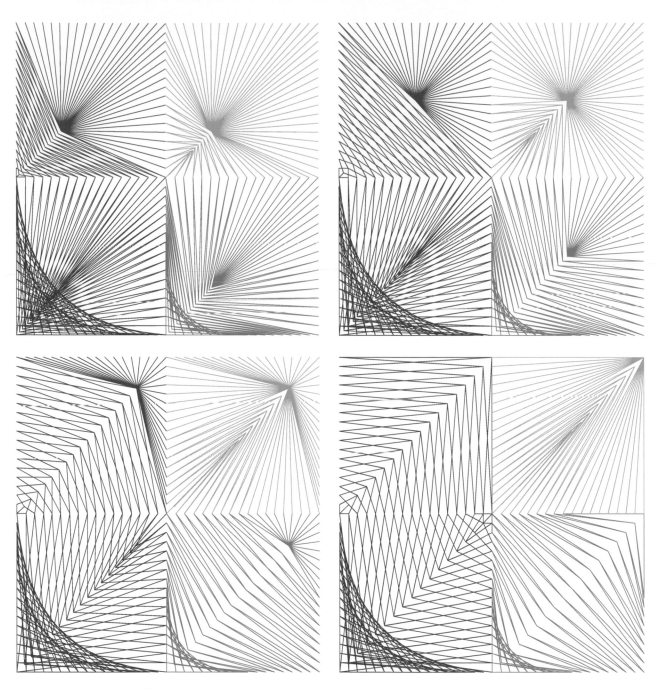

The images are different and instructive. The best starting point is the top right halfway image. **Red** has no zero jumps. **Green has 1 zero jump so 1/4 of the lines (on VF from (1.5,1) – (2,1) – (2,0.5)) are all single lines connecting to (0.5,0.5).** **Half the lines are like this for blue (on VF from (0,2) – (1,2) – (1,1)) since blue has two zero jumps.** Three-fourths of the lines are like this for gold (on VF from (1,1.5) – (1,2) – (2,2) – (2,1) – (2,1.5)) since gold has three zero jumps. These same statements hold true for other interior vertex point values; the only difference is where that interior point lies.

19.5 Moving Beyond *Inside the Box* (Section 19.4) and Letting the Image Swirl

These images start the square (vertex 1) at the outer corners so that there is rotational symmetry if **V**, **S**, and **P** are equal across colors. These four images switch internal **x** and **y** coordinates for green and **blue** sub-images and subtract from 2 for all but the **red** sub-image coordinates as appropriate for vertices 6–9. This table shows the first six vertices for the upper right image following these rules.

If green, blue, and gold vertex 6 coordinates are created from **red** via equations using these rules, one can create images by simply changing **red ver-tex 6**. Try, for example, **(-0.5,-0.5)**.

Each image has (**V,S,P**) = (9,17,76) and vertex 6 values for the upper left is (1,1), lower left is (0,0), and lower right is (2,0)

	X	Y		X	Y		X	Y		X	Y
1	0	0	1	2	0	1	0	2	1	2	2
2	0	1	2	1	0	2	1	2	2	2	1
3	1	1	3	1	1	3	1	1	3	1	1
4	1	0	4	2	1	4	0	1	4	1	2
5	0	0	5	2	0	5	0	2	5	2	2
6	0.4	0.8	6	1.2	0.4	6	0.8	1.6	6	1.6	1.2

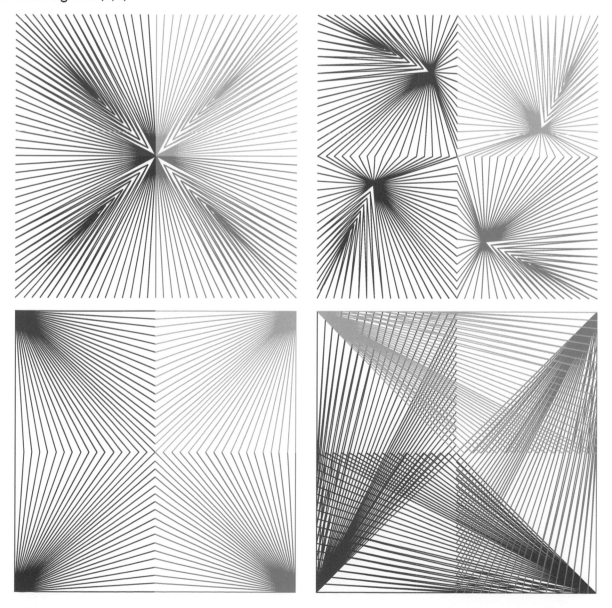

The six images on the this page move outside the box. **Challenge Question.** Using the last page as a guide, what is the **red vertex 6** in each image?

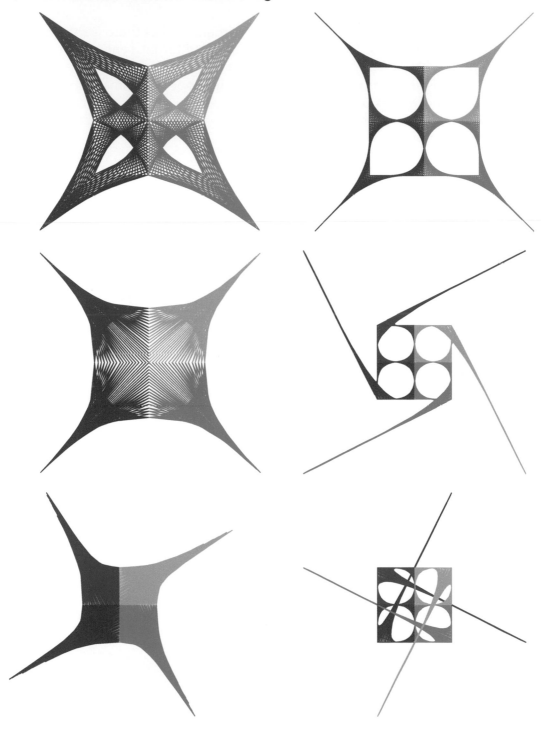

19.6 Creating Your Initials in Four Colors

Suppose you want to create your initials using electronic string art, ESA. ESA works by connecting the last vertex to the first vertex to form the vertex frame (whether we are talking about polygons or non-polygonal images), so it is important to be able to connect letters to one another. The only other option is to do each letter separately using different colors. In that event, if you have two initials, each one can still have two colors.

Here are a few suggestions as to how to proceed.

Graph paper helps. It helps to start by drawing out what you want. Use graph paper if you have it or use 19.0.1, *number-edged blank graph paper*. This helps because you can use a ruler and see how the image gets roughed out. *Use a pencil and erase often.*

When drawing, think about the slope of the longer lines if you plan to use intermediate points (like the horizontal bar in the **A** to the right). This is easily accomplished with graph paper.

When using a point multiple times, you may want to link to its first usage. If you do that you can easily adjust that vertex, and it adjusts elsewhere within the vertex list. This can help you fine-tune your image. For example, (30,5) is vertex 14, 20, 22, 33, and 34; and (50,0) is vertex 19, 23, and 32.

Sometimes you must back up. Suppose you start at the top of the **E**. In the end, you will have to backtrack to the top of the **E**.

Before entering vertices, think about where you want to start. It often helps to start in the middle and move out in both directions. The vertices to the right show that the image started at the bottom of the **E**. Vertex 7 got to the end and by 14 we were back at the bottom of the **E**.

Sometimes mixing *cursive* **and print fonts helps in connecting letters.** Do not think you need to stick to one font or another, what you are trying to achieve is something that people will recognize even though it is a blend of styles. The cursive **S** provided a natural connection between **E** and **A**.

Remember to use zero jumps if you do not want a curve. If you want to create as small a connection as possible, you can use zero jumps. Suppose you did not want a curve connecting the bottom of **S** to the **A**. Increase the size of **V** by 2 to 36, move vertices 24 – 32 to 25 – 33, 33 and 34 to 35 and 36, and add (50,0) at vertices 24 and 34 (i.e., repeat vertices 23 and 33). The new image would not have a curve connecting **S** to **A**. This was not done in the image above but note vertices 33 and 34 are the same. This was done to remove a curve that would exist at (30,5) in the absence of this duplication. To see this, type 33 in A1 (A2:A4 are linked to A1) and note that a curve results.

Use primes for *S* **and** *P* **and make sure they do not have factors in common with** *V***.** In the example just discussed, if you set **V** = 33, the gold curve is reduced from 1551 lines to 141 since SCF = 11. Note that the first four rows in the table are **V, S, P** for red, green, blue, gold.

34	47	31
34	47	25
34	47	19
34	47	11
V	**S**	**P**

B50:B51 has red x,y		
Red Vertices		
	X	Y
1	14	0
2	0	10
3	21	20
4	20	16
5	2	27
6	22	35
7	28	30
8	22	35
9	2	27
10	20	16
11	21	20
12	0	10
13	14	0
14	30	5
15	58	30
16	50	35
17	42	29
18	60	5
19	50	0
20	30	5
21	25	11
22	30	5
23	50	0
24	62	0
25	76	35
26	90	0
27	100	0
28	90	0
29	84	15
30	68	15
31	62	0
32	50	0
33	30	5
34	30	5

It is probably best to stick to $P < S$. You need not use the same number for each **S** but that makes it easier to work with, thus you see links for the other **S** values in B2:B4. Try **S** = 7 to see why $P < S$.

To stack colors, set E6 = 0. The **X** and **Y** shifters in Row 6 are all linked to this cell so one change will affect all colors. If you want them side by side, you need to figure out maximum values in both directions and shift accordingly.

Chapter 20

Challenge Questions for Part III

20.1 CPF Image Analysis

The image below is based on **n** = 3, **S** = 4, and **P** = 5 using Centered Point Flowers *Excel* file 15.0. As noted in Section 15.1, the vertex frame jumps to the next vertex then goes to the center of the circle, (0, 0), and back to that vertex before jumping to the next vertex.

1) Place numbers 1–5 next to the endpoint of the first five segments.

FACT: This image has many triangles but only ONE is equilateral.

2) Was the equilateral triangle laid out using three consecutive segments?
3) When is the first third of the equilateral triangle laid out (i.e., what section numbers)?
4) What is the area of the equilateral triangle?
5) How many right triangles are there? Place an R next to each right angle.
6) Find and label the right triangles at their sharpest apex angle. Label those with the sharpest angle, S, next sharpest, M, and least sharp, L.

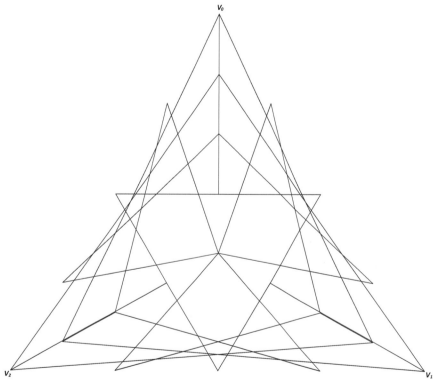

FACT: The vertex frame in this instance are V_0 = (0, 1), V_1 = ($\frac{\sqrt{3}}{2}$, -0.5) and V_2 = ($-\frac{\sqrt{3}}{2}$, -0.5).

DOI: 10.1201/9781003402633-23

20.2 CPF Area Analysis

Assuming the Circles That Contain These Polygonal Vertices Have Radius 1, What Are the Areas of These Images?

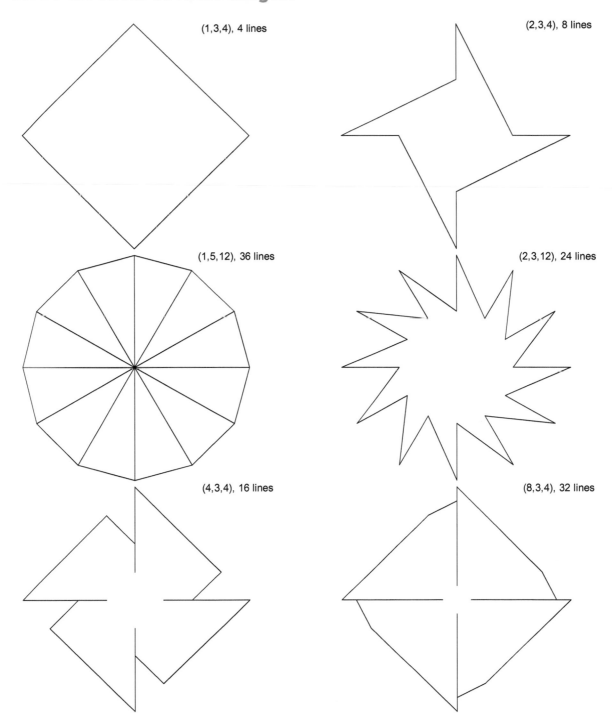

(1,3,4), 4 lines

(2,3,4), 8 lines

(1,5,12), 36 lines

(2,3,12), 24 lines

(4,3,4), 16 lines

(8,3,4), 32 lines

Hint: In each instance, the area of the left image can help you calculate the area of the right image.

20.3 CPF Point Location Challenge Questions

Note that both images on the right state that nine lines were used to create the image. Visual inspection suggests that each has only eight lines.

Image 1 (3,4,4), 9 lines

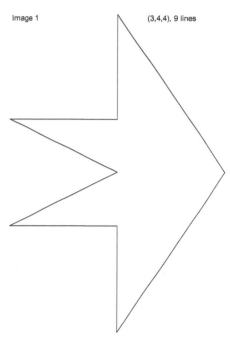

1. Verify that it takes nine moves to create the image in each instance by placing numbers from 1 to 9 next to the location of each endpoint.

HINT: It may help to sketch in the square vertex frame in a different color.
ASSUME: The enclosed triangular area in Image 2 is not part of the image.

2. With this triangular area excluded from Image 2, what is the area of each image? Which image has a greater area?
3. How much larger is the larger image? Provide this answer in square units, as well as in proportional terms.

FACTS:

 a. A polygonal area can be cut into a number of non-overlapping triangles and the area of the whole is the sum of its parts.

Image 2 (3,8,4), 9 lines

 b. The area of a triangle is:
½ base times height
 c. If two triangles have the same base and the same height, they have the same area.

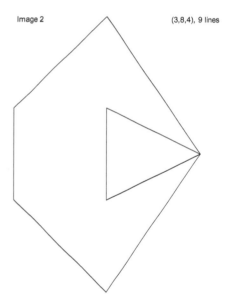

4. Using these facts, show the left-over area of the larger area image as part of that image. (Put another way, imagine you had a pair of scissors and removed equal-area triangles from each image. What would be left over once all pieces of the smaller image are removed?)

HINT: There are multiple answers here, but one is particularly elegant.
NOTE: A separate pdf file on the ESA website (available by scanning the QR code on the *Features* page at the front of this book). provides full-page versions of each of these images so you can print them out and manipulate the images as you wish.

20.4 Comparing Images Across Chapters

Both Images Have _n_ = 8 and _S_ = 30. One is Part II, the Other is from Chapter 16

Q1: How do these images differ from one another and why? What are the jump patterns in each?

Fact: Both values of _P_ are such that the image is a single line when _P_ is one larger than this value.

Q2: What are the values of _P_ in each instance?

Q3: What would each image look like if P_{new} = _P_ + 2 instead of _P_?

All three images below have _S_ = 20, _P_ = 23, and J_1 = 1

Q1: What are the values of J_2 and _n_ for each image?

Q2: What is the degree of rotational symmetry in each panel?

Q3: Which Chapter 16 _Excel_ file must have been used to create one or more of these models?
Which one(s) and why?

Both images have *n* = 8, *S* = 20, and *P* = 11. One uses Chapter 15, the other uses Chapter 16.

Q1: Which image used Chapter 15, and which used Chapter 16? How do you know which is which?

Q2: What would you do to **P** in the left image to make it more like the right image?

Both images have *n* = 10, one has 390 lines, the other 400. One uses Chapter 15, and the other Chapter 16.

Q1: Which image used Chapter 15, and which used Chapter 16? How do you know which is which?

Q2: What are J_1 and J_2 in the Chapter 16 version of this ten-point flower?

Q3: Suppose VCF = 1 and SCF = 1. What is **S** in each image? (Hint: You do not need to manually count segments along the vertex frame to answer this question.)

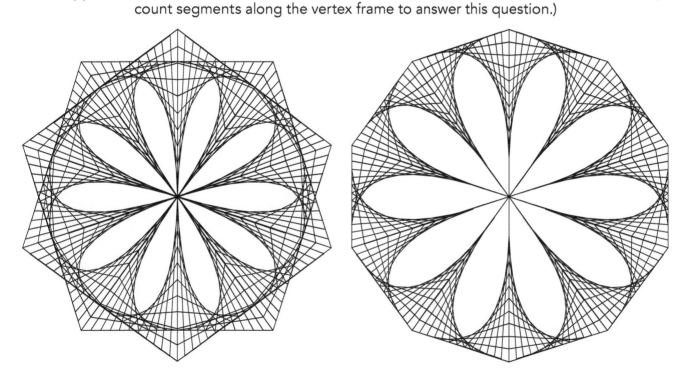

20.5 Area of Vertex Frame in the Double Jump Model

The three double jump (**n, S, P, J₁, J₂**) images to the right appear to be rectangles.

(6,1,1,1,2)

1. Provide a rationale for why they are, in fact, rectangles.

FACT: Assuming these are drawn on a unit circle (so that top and bottom vertices are (0,1) and (0,-1)), we can calculate the areas of these images without resorting to trigonometry.

For reference, the unit circle that contains each of these four points has an area π = 3.14. Refer to the images by the size of **n** = 6, 8, or 12.

You need not provide numerical answers to Questions 2, 3, and 4, educated guesses are sufficient here. Question 5 asks you to calculate exact areas (some of which involve square roots). Once you have these values you can check on your educated guesses from 2, 3, and 4.

(8,1,1,1,3)

2. Which image is closest to half as large as the circumscribed circle? Is the image more or less than half the size of the circle?
3. Which image is closest to one-third as large as the circumscribed circle? Is the image more or less than one-third the size of the circle?

Fact: One of these images is only 3.1% larger than the other (to the nearest 0.1%).

4. Which is 3.1% larger than the other?
5. What are the areas of each of the three rectangles (to the nearest 0.01)?

(12,1,1,1,5)

20.6 Double Jump "Hours" Challenge Questions

These questions deal with the 2-jump set image below, with **S** and **P** noted in the table to the right. This image was created using a Four-Color Clock Arithmetic *Excel* file, but without the colors, it is quite squarely a question asking you to analyze Double Jump Sets.

53	11
53	17
54	23
56	29
S	**P**

Each question asks you to fill in one part of the table below. The four questions relate to the four first jumps noted below. **Hint.** If confused, see Section 16.3.

For each question, answer the following: **A)** What is the second jump? **B)** What are the 24 "hour jump moves" in this instance? C) How many times around the polygon did you go to create the VF?

1. Assuming the first jump is 3.
2. Assuming the first jump is 4.
3. Assuming the first jump is 8.
4. Assuming the first jump is 9.

A) and **C)** ask you to fill in the yellow cells. **B)** asks you to fill in the rest of the table. This is easiest to do by simply creating a table that looks like this in *Excel*.

Jump #	Question 1 Jump	Sum	"Hour"	Question 2 Jump	Sum	"Hour"	Question 3 Jump	Sum	"Hour"	Question 4 Jump	Sum	"Hour"
1	3			4			8			9		
2												
3												
4												
5												
6												
7												
8												
9												
10												
11												
12												
13												
14												
15												
16												
17												
18												
19												
20												
21												
22												
23												
24												
Times around the polygon to complete image												

20.7 Four-Color Challenge Questions, Part I, Vertex Frame Analysis

Both images below use the **S** and **P** values used in the right image. The curves provide the ability to do clock arithmetic on J_1, J_2, and J_3. Answer by providing numbers (#, ##, ###) for these jump triples. Questions 1–4 are based on the left image, and Questions 5 and 6 are based on the right image.

1. There are two alternative versions where the first number is 6. What are these two triples?
2. There are two alternative versions where the first number is 0. What are these two triples?
3. There is only one version where the first number is 3. What is that triple?
4. There is only one version where the first number is 9. What is that triple?
5. The right image appears to have 12 arrows pointing counterclockwise around the circle. Propose a jump triple that will get the arrows pointing in a clockwise direction instead.
6. Provide an alternative specification of jumps producing clockwise pointing arrows that do NOT start with 0. There are four correct answers, can you get all four?

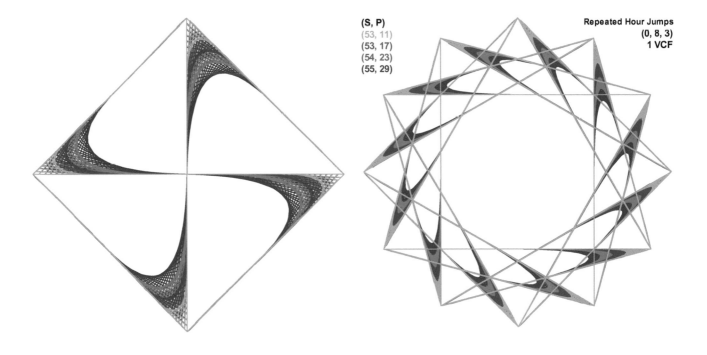

(S, P)
(53, 11)
(53, 17)
(54, 23)
(55, 29)

Repeated Hour Jumps
(0, 8, 3)
1 VCF

20.8 Four-Color Challenge Questions, Part II, Comparing Jump Sets

Facts. Suppose you like equilateral triangles and squares. Questions 1–3 examine the top two images on the next page. One is based on a 2-jump set and the other is based on a 3-jump set. Questions 4 and 5 examine the bottom two 3-jump set images. All four images start with J_1 = 3 and **S** and **P** are as noted in the table at right.

53	11
53	17
54	23
56	29
S	P

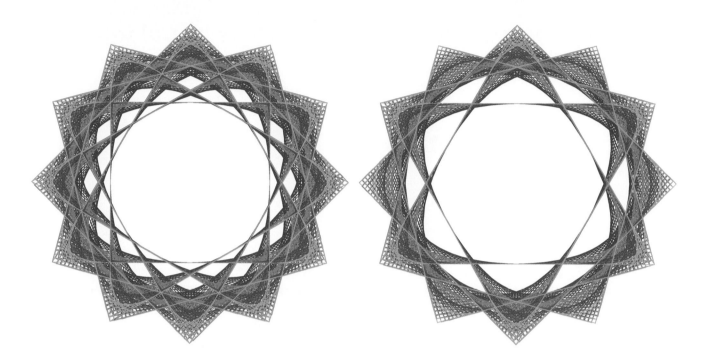

1. Which is the 2-jump model, and which is the 3-jump model?
2. What is the second jump in the 2-jump model? How many lines are in the VF?
3. What are the second and third jumps in the 3-jump model? How many lines are in the VF?

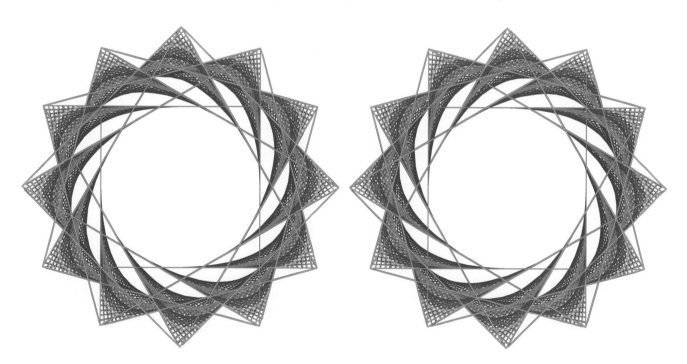

4. What are the second and third jumps for the left image? How can you tell?
5. What are the second and third jumps for the right image? How can you tell?

20.9 Four-Color Challenge Questions, Part III, Color Density Questions

(S, P)

(5, 87)

(53, 17)

(54, 23)

(56, 29)

Repeated Hour Jumps

(2, 5, 0)

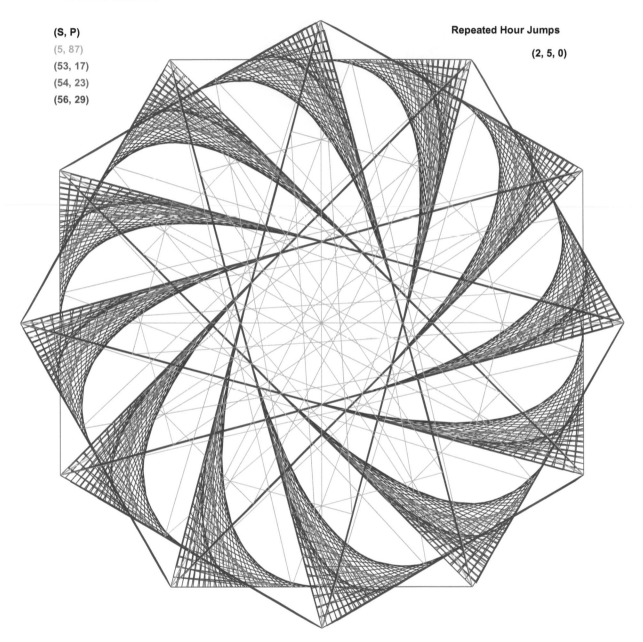

One might conceptualize this as a spinning fan with a protective gold-colored wire cover. Regardless of how you would describe this, it is apparent that there are a lot fewer lines for gold than for the other three colors.

1. Is this purely because **S** for gold is about ten times smaller than **S** for the other three colors? Briefly explain your reasoning.
2. Does the gold part of the image have 100% image density as described in Section 5.4.1? Try to provide a geometric rationale for your answer rather than simply an algebraic one.
3. How many gold lines are in the image? Compare that to the number of blue, green, and red lines.

20.10 Four-Color Challenge Questions, Part IV, Image Analysis

The image below uses the **S** and **P** values used in the *explainers* for this chapter. The curves provide the ability to do clock arithmetic on J_1, J_2, and J_3.

1. There are two possible jump triples. One set is: J_1 = __, J_2 = __, and J_3 = __ and the other is: J_1 = __, J_2 = __, and J_3 = __.
2. How do these two sets of values relate to one another?
3. The image has a number of long, thin, similar triangles. What are the angles for these triangles and how do you know that these are the angles?
4. How many such triangles are in the image?
5. How many squares are in the image?
6. How many rectangles that are not squares are in the image?

Hint: If you are having trouble answering Questions 4–6, it may help to turn off all but one of the colors and set **S** = **P** so you see just the vertex frame.

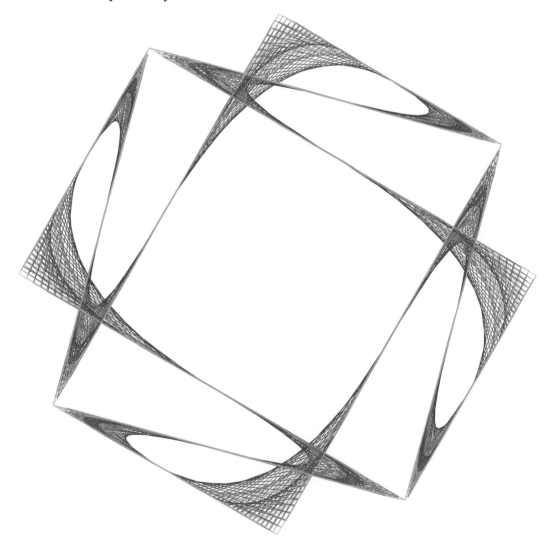

20.11 Really Sharp Triangles, Part I

This image was created with **n** = 120 to create two similar triangles with the following attributes:

1. The sharp angle is as sharp as possible.
2. The medium angle is 45°.
3. The image was created from the manual entry *Excel* file 18.0.2.
4. The image was created in four jumps.
5. The bottom triangle is as close to the same size as the top as possible, but it is just a bit larger.

Given this information, answer the following.

1. What is the sharp angle in degrees?
2. What is the obtuse angle in each triangle?
3. What is the sum of the first two jumps?
4. What is the sum of the last two jumps?
5. What are all four jumps? (Hint: There are two correct answers to this question.)
6. Which of the four lines drew the longest side of the bigger triangle?

20.12 Really Sharp Triangles, Part II

Attack this only if you have worked through Section 20.11, *Really Sharp Triangles, Part I*.

Now you are not given an image, but your job is to create an image with n = 120 to create two similar triangles with the following attributes:

1. The sharp angle is as sharp as possible.
2. The medium angle is 45° and it opens to the "northwest" just like the image in Part I did.
3. The image was created from the manual entry *Excel* file 18.0.2.
4. The image was created in four jumps.
5. One triangle is as large as possible given the above conditions. One image has a horizontal longest side to the largest triangle, the other has a vertical longest side to the largest triangle.

Given this information, answer the following.

1. What is the sharp angle in degrees?
2. What is the obtuse angle in each triangle?
3. What is the sum of the first two jumps?
4. What is the sum of the last two jumps?
5. What are all four jumps if the longest side of the largest triangle is horizontal? (Hint: There are two correct answers to this question.)
6. Which of the four lines drew the longest side of the largest triangle?
7. What are all four jumps if the longest side of the largest triangle is vertical? (Hint: There are two correct answers to this question.)
8. Which of the four lines drew the longest side of the largest triangle?

20.13 Fibonacci Golden Spiral Approximation in *Excel* (A *Guided* Challenge Question)

The approximation to the Golden Spiral using the first ten Fibonacci numbers shown on the next page did not take very long to create in **Excel**. It may be a worthwhile exercise to do it yourself. You could also do this with graph paper (that is provided on page 3) and a compass. All you need to do is follow the instructions provided.

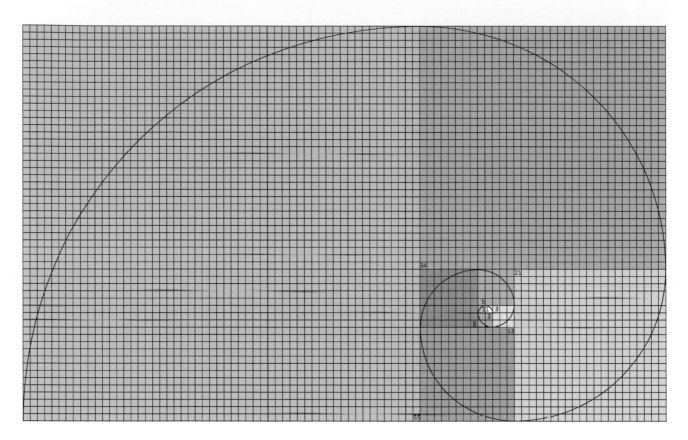

Although this has nothing to do with string art, the Fibonacci sequence was used as a point of reference in the discussion of larger jump sequences in Section 18.4.3. It is surprisingly easy to create the image above from a blank *Excel* spreadsheet. Here is how.

Creating graph paper. When *Excel* opens, it typically has a row height of 20 pixels. You can check that by going to any of the numbers on the left-hand side of the sheet that designate a row and moving your mouse down until you see a horizontal line with arrows up and down. It should say Height 20 pixels. Put your mouse on the column label A press your mouse down and scroll right until you are at least 120 columns over (I stopped at column DP which is the 120th column). All columns up to DP should be highlighted. Then put your pointer between any column edge (and see a vertical line with arrows right and left). Reduce the size of columns from 64 to 20. This will give a gridwork. Finally, in the font area, click the area just above the Row 1 label and the left of the Column A label. This highlights the entire worksheet. Choose *All Borders* from the dropdown menu and it gives gridwork that will show up even with colored squares.

Creating the colored squares. I started in BN45 (the white square). I added a gray square to the left. Then the gold square below, and so on. The squares are easy because as you highlight a set of cells it tells you how many rows and columns you have highlighted. Note that each added square after the first two has a side whose length is the sum of the previous two squares. This is exactly how the Fibonacci numbers are created. Any value is the sum of the prior two.

Creating a quarter circle. Once you have the squares colored, it is time to add the quarter circles. They are easy to create in *Excel*. Click *Insert, Illustrations, Shapes*. Among the *Basic Shapes* is an option called *Arc*. If you open it up and play with it you will see that its default is to give you a curved image in the upper right fourth of the image. If the side lengths are the same, it is a quarter circle. Given this, I suggest the first quarter circle you create is either the one associated with 5 or 34. To get the size correct, simply place the upper right corner of the tool in the upper right corner

of the square, and move the left side and the bottom side down until you get the left and bottom points of the quarter circle to the left upper or bottom right corner of the square. Note that to do this you have to have the size of the drawing tool TWICE as large as the radius you want. Color the line whatever color you want using *Shape Format* (I used black but light blue is the starting point and I also increased the *Weight* to 1 pt).

Turning and resizing the quarter circle. Once you have a one-quarter circle created, use it rather than start over with another Arc. Do this by Clicking on the image and click *Copy*, *Paste*. Click on the new image and then click *Shape Format*, **Rotate,** and rotate in either direction then redo what you just did in terms of resizing. If you do this nine times total (together with the first) you will have created the Golden Spiral.

Modifying the image (if you want). There are two things you might consider doing. First, you could remove the square gridwork so that the spiral will become more well-defined. Second, you might consider changing the whole sheet to White, then the spiral will simply be on a white background, and no one will be able to figure out how you created it. You can do both tasks by using the area just above the Row 1 label and the left of the Column A label just as you did before to add the gridlines.

If doing this as a *Paper and Compass* exercise, you need at least a 60x100 piece of graph paper. The final image is 55x89. Start in the yellow highlighted cell.

1. Add squares following the first ten Fibonacci numbers $F_1 - F_{10}$ (1, 1, 2, 3, 5, 8, 13, 21, 34, 55) as side lengths, to the side whose length is that number. The second 1-sized square is just to the left of the yellow square, the third is below, and so on. 2. As each square is added, draw a quarter circle with radius F_k connecting with the previous quarter circle. The center of a quarter circle is the corner of each added square (the final image has numbers in those corners).

273

20.14 Bird Beak Challenge Questions

1. The Bird Beak image discussed in the *Fibonacci* Section 18.4.3 is based on extensive use of 13s. Can you alter **n**, **S**, **P**, and jumps to create a Bird Beak image based on 14s?

HINT. The final image has 196 lines and is a porcupine.

2. How was the image shown below, a bird beak using 15s, created? There are 210 lines total, and this is a close porcupine with SCF = 1. What are the values for **n**, **S**, **P**, and jumps?

HINTS. This started with Fibonacci but then jumps were altered symmetrically to obtain this image. An important part of figuring out how this was done is deciding how many zero jumps are in the middle of the jump set that creates the spray of lines that define the beak.

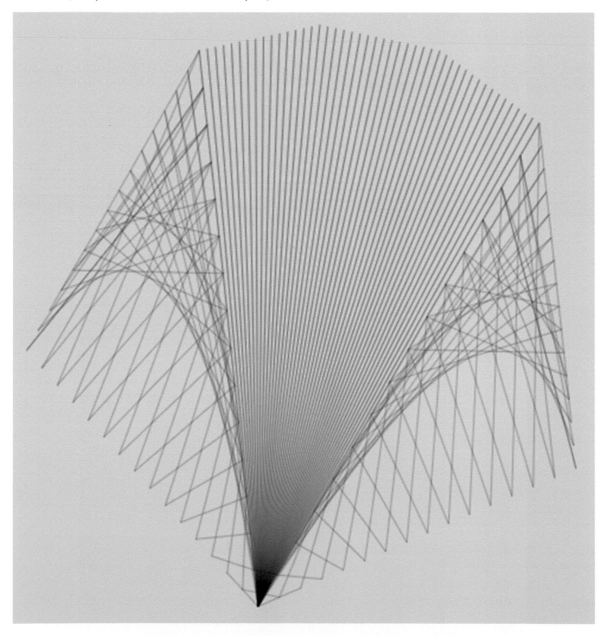

20.15 Variations on Being *Inside the Box*

These images are variations on images created in the *Inside the Box* Section 19.4. Each has **S** = 17 as in that *explainer*, and each image has **P** as close to INTEGER(17**V**/2) as possible given SCF = 1.

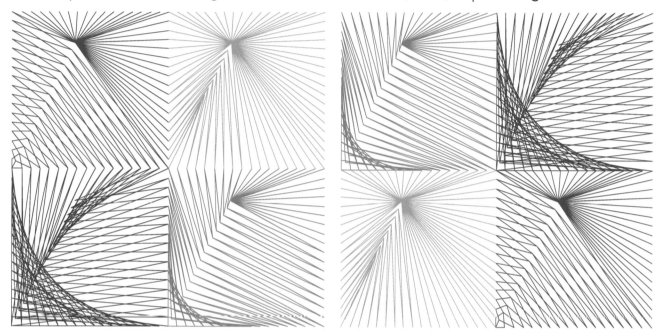

1. Explain what was done to create the image on the left above. What can you say about the vertex that is inside the box in this situation?
2. The image on the right above was created by changing a single number in the *Excel* file once the left image was created. Can you figure out what was done?

FACTS. The image at the bottom right involved a bit more work to create, but it was created to satisfy two properties.

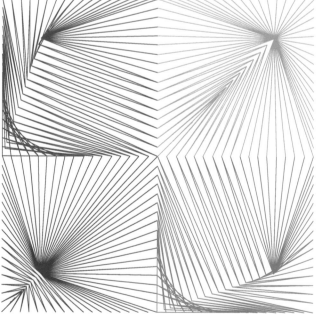

I. It is symmetric about the main diagonal from (0,0) to (2,2).
II. If you were to connect the interior points you would end up with a square whose area is 2.25, a bit more than half of 4, the total area covered by the four tiles.

3. Given the facts discussed above, recreate this image. What are the values of **V** and **P**, and what are the vertices for each color in the image? In particular: What are the four inside points? You may want to check your work by recreating this image.

20.16 Four-Point Stars

The four images below have 90° rotational symmetry (ignoring color differences), and each is based on **S** = 17. The square created by linking the four internal vertices has a total area of 1/16 the area of the total image in each case for the left column and 1/100 of the area of the total image for the right column.

Using the ideas set forth in the *Beyond Inside the Box* Section 19.5, can you determine the values of **V, P,** and the vertex 6 coordinates for each image?

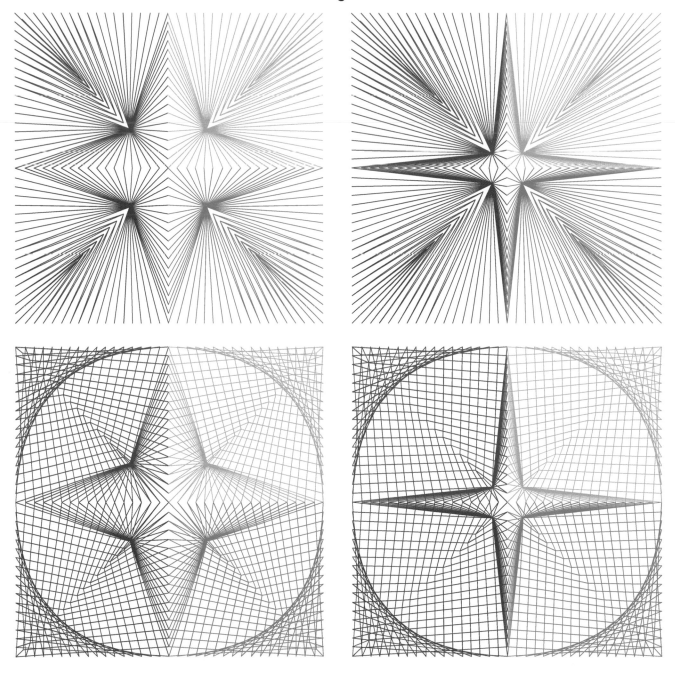

AN INTRODUCTION TO PART IV

Issues, Mathematical and Otherwise

Part IV acts as a resource for Parts I–III. As such it may be viewed as a series of appendices, but these appendices (chapters) have been written in the same *explainer* (small, self-contained sections) style used in earlier portions of the book. Most of the topics are mathematical, but that is not always the case. Two of the mathematical topics are traditional parts of the K-12 curriculum, a third is not, and the fourth keys off the third. These chapters are not meant to be comprehensive discussions of each topic area but are instead meant to focus attention on specific concepts or ideas that may have not been used in a while but which are of central importance to ESA.

Chapter 21 examines some basic properties of numbers. Particular focus is paid to prime, composite, and coprime numbers. The first two sections are anchored by the work of two Greek mathematicians, Eratosthenes and Euclid. The final section shows a pattern in times tables that can be used to encourage young people to both learn their times table and enjoy the beauty of mathematics.

Chapter 22 focuses attention on various theorems dealing with angles created from lines intersecting a circle. These intersections come in three forms, inscribed angles (in which the intersection occurs on the perimeter of the circle), interior angles (inside the circle), and exterior angles (outside the circle).

Chapters 23 and 24 deal with modular arithmetic. To deeply understand how images are created in ESA, one needs to learn a bit about modular arithmetic. Numbers wrap around in a modular setting, and all that matters is what is left over. The simplest example of modular arithmetic is clock arithmetic. If it is 11 pm and you say, we should meet up again in three hours, no one thinks, ok we'll meet at 14 pm … we all know that we are going to meet at 2 am. The 12 is simply ignored, all that matters is the remainder. If you are partial to a 24 hour clock the same statement applies. If you are at 23 hundred hours (11:00 pm) and want to meet in three hours you meet at 2 hundred hours (2:00 am) not 26 hundred hours. The 24 is ignored, all that matters is the remainder.

Chapter 23 deals with modular basics. Chapter 24 deals with the concept of modular multiplicative inverses. Two numbers a and b are modular multiplicative inverses modulo a third number c if the product of a and b is one more than a multiple of c (for an MMI to exist, b and c must be coprime). To stick with the clock example, 5 and 5 are MMI MOD 12 since $5 \cdot 5 = 2 \cdot 12 + 1$. Other MMI pairs MOD 12 are (1,1), (7,7), and (11,11). These examples make it look like a and b are the same. But 2 and 5 are MMI MOD 9 ($2 \cdot 5 = 9 + 1$), as are 4 and 7 ($4 \cdot 7 = 3 \cdot 9 + 1$). Interestingly, one can find a given coprime b and c by backtracking Euclid's Algorithm for finding the greatest common divisor of two numbers (from Chapter 21).

DOI: 10.1201/9781003402633-24

Chapter 25 provides a guide to the web model. Included in this chapter is a three-part section that introduces the basics of ESA for younger users. This is provided using a "guided inquiry" approach in which the reader is asked to adjust each parameter and see what happens. This is a purely visual introduction to ESA that works even for those who have not yet learned about multiplication, division, or ideas like the greatest common divisor of two numbers.

Chapter 26 provides information for teachers. Included in this chapter is a teaching companion to the web model guided inquiry for younger users from Chapter 25 as well as quick-start guides to *Polygons and Stars for Teachers*, *Excel* file 2.0.2, and *String Art for Teachers*, *Excel* file 3.0.3.

Chapters 27–29 provide answers to challenge questions, a glossary and index, and a bibliography.

Chapter 21

Basic Properties of Numbers

21.1.1 About Prime and Composite Numbers

Most of the time we restrict our discussion to the *natural numbers*, 1, 2, 3, … and 0, but there are times when it is useful to consider negative numbers as well. Some authors include 0 among the natural numbers but that is not universally agreed upon, and the number 0 has its own very interesting history (as you can see by Googling *who invented zero*).

Natural numbers larger than 1 can be categorized into two types of numbers, those that have proper divisors and those that do not. The term "proper" is included because any natural number, n, can be written as $n = 1 \cdot n$, but 1 and n are too trivial to count as proper divisors of n.

Definitions: ***Proper divisors***. A natural number has proper divisors if it can be expressed as the product of two natural numbers smaller than that number. Divisors are also called *factors*.
 For example, 2 and 3 are proper divisors of 6, but 1 and 6 are not.
 Composite number. A number is called a *composite* number if it has proper divisors.
 The first ten composite numbers are 4, 6, 8, 9, 10, 12, 14, 15, 16, and 18.
 Prime number. If a natural number larger than 1 has no proper divisors, it is called a *prime* number.
 The first ten prime numbers are 2, 3, 5, 7, 11, 13, 17, 19, 23, and 29.

One could have defined these terms using multiplication rather than division. A composite number is a number that is a multiple greater than one of another number greater than one. A prime number is a number that is not a multiple greater than one of a number smaller than that number.

Testing for primes. How can you tell if a number is composite or prime? There are some easy rules for looking for factors, but these rules only cover certain factors. Here are three simple rules:

1. If a number ends in 0, 2, 4, 6, or 8, it is divisible by 2 and is therefore composite. Any even number larger than 2 is composite.
2. If the sum of the digits is divisible by 3, then the number is divisible by 3.
3. If the number ends in 0 or 5 it is divisible by 5.

Interestingly, using just these three rules, you can find whether any number less than 49 is a prime. Consider four examples: $n = 45$. Composite due to rules 2 and 3. Factors are 1, 3, 5, 9, 15, and 45.
 $n = 46$. Composite due to rule 1. Factors are 1, 2, 23, and 46.
 $n = 47$. Prime. Factors are 1 and 47.
 $n = 48$. Composite due to rules 1 and 2. Factors are 1, 2, 3, 4, 6, 8, 12, 16, 24, and 48.

DOI: 10.1201/9781003402633-25

The reason these rules work for numbers up to 49 is that $49 = 7^2$ and 7 is the fourth prime.

If you follow the above three rules and additionally check whether n is divisible by 7, you can tell whether n is prime as long as $n < 121$. The reason is simple, $121 = 11^2$, and 11 is the fifth prime.

More generally, to test whether n is prime, you need only test whether the number is divisible by the prime factors less than the square root of n. [There are two ways to obtain the square root of n in *Excel*, type =SQRT(n) or =n^0.5.] This idea of checking primes less than the square root of the number you are interested in is central to a method of finding primes that is more than 2,000 years old. This method is discussed in the *Sieve of Eratosthenes* Section 21.1.2, and it works by using the patterns created by multiples of primes to remove composites from an array of numbers.

More on factors. It is worth noting that if divisors are listed from smallest to largest then they are connected to one another in a very specific fashion. The first and last multiply to n; the second and second-to-last multiply to n, and so on. (So, given the factors of $n = 48$ listed above: $1 \cdot 48 = 48$; $2 \cdot 24 = 48$; $3 \cdot 16 = 48$; $4 \cdot 12 = 48$; and $6 \cdot 8 = 48$.)

This pairing up of smaller factors with larger ones means that, in general, a number will have an even number of factors. This is true unless n is a perfect square. In this case, the middle factor squared is the number. For example, the perfect square 16 has five factors listed from smallest to largest: 1, 2, 4, 8, 16. The middle factor is 4 and $4^2 = 16$.

21.1.2 Identifying Prime Numbers Using the Ancient *Sieve of Eratosthenes* (From the 3rd Century BC)

The Greek mathematician Eratosthenes proposed a simple mechanism for finding prime numbers. *Primes are numbers that cannot be obtained as the product of two smaller numbers. If a number can be expressed that way, it is a composite number.* The eight panels above show the first eight iterations

·	2	3		5		7			
11		13				17		19	
		23						29	
31						37			
41		43				47			
		53						59	
61						67			
71		73						79	
		83						89	
						97			
101		103				107		109	
		113							
						127			
131						137		139	
								149	
151						157			
		163				167			
		173						179	
181									
191		193				197		199	
211									
		223				227		229	
		233						239	
241									
251						257			
		263						269	
271						277			
281		283							
		293							
						307			
311		313				317			
331						337			
						347		349	
		353						359	
						367			

of the sieve, and the images on this page show the results: There are 73 primes less than 370. (370 was chosen so that the numbers are not too small, the panels find all primes less than 529, see *Excel* file 21.0.1.)

The *Sieve* works by systematically eliminating composite numbers using the composite patterns highlighted in each panel.

The first panel highlights all numbers which are multiples of 2. These numbers are removed (except for 2) in Panel 2 which highlights all multiples of the next number, 3. These are removed in Panel 3 and all multiples of the next remaining number, 5, are highlighted. *Each time we remove highlighted numbers (except for the first) we then highlight multiples of the next remaining number. This number is the next prime.* The tables to the left and right show the results based on the first eight primes.

The general pattern in each panel is shown in yellow. The first number to be removed is highlighted in gold. This number is the square of the prime associated with that panel (since all highlighted composites less than this are multiples of this prime and an (already removed) smaller number).

How can this be extended? Suppose you want to know whether 797 is composite or prime. The square root of 797 is 28.23... . Since this is less than 29, you need only examine the first nine primes (2, 3, 5, 7, 11, 13, 17, 19, 23). It turns out that it is, indeed, prime (but 799 is composite since 799 = 17·47).

Composites by Panel based on Prime to Delete			Remaining in *Sieve*	
			37 rows of 10	370
Panel	Prime	Delete	less number 1	369
1	2	184	even	185
2	3	61	divisible by 3	124
3	5	24	divisible by 5	100
4	7	13	divisible by 7	87
5	11	7	divisible by 11	80
6	13	4	divisible by 13	76
7	17	2	divisible by 17	74
8	19	1	divisible by 19	**73**

The Panel 1-8 patterns could be extended to find all primes to $529 = 23^2$ since 23 is the 9th prime.

21.2.1 Commonality Between Numbers

Prime numbers are the building blocks for both integers and rational numbers. The images created in electronic string art (ESA) are based on composite numbers as well as prime numbers. For some of the models, when composite numbers are used, the images will "collapse" or look less complete for certain values of other parameters. This happens when there is a commonality between the numbers.

Examples of commonality. If the number of vertices in the polygon, n, is even, then when the number of jumps between vertices $J = n/2$, the image reduces to a vertical line. Similarly, one can draw a single distinct *continuously-drawn* 12-point star, $n = 12$, $J = 5$ shown to the right (noting

that **J** = 7 produces the same image seemingly drawn in a counterclockwise fashion). By contrast, there are four distinct continuously-drawn stars when **n** = 11 (**J** = 2, 3, 4, and 5) shown below. The difference is that 2, 3, and 4 are all factors of 12 so that 1/2, 1/3, or 1/4 of the vertices is used, and a hexagon (6 = 1/2·12), square (4 = 1/3·12), or triangle (3 = 1/4·12) results if **J** = 2, 3, or 4, respectively.

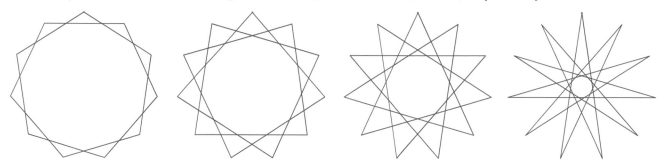

Commonality between numbers occurs if the numbers have factors in common. Two numbers may have several factors in common with one another. Consider the two numbers **a** = 24 and **b** = 40.

Factors of **a**: 1, 2, 3, 4, 6, 8, 12, 24 Factors of **b**: 1, 2, 4, 5, 8, 10, 20, 40
Factors in common between **a** and **b**: 1, 2, 4, and 8.

The largest of these common factors is called the *greatest common divisor* of **a** and **b**, GCD(**a**, **b**), so GCD(24, 40) = 8.

Finding the GCD of two numbers. If **g** = GCD(**a**, **b**), then it is the largest number that properly divides both **a** and **b**. By properly divides, we simply mean leaves a remainder of zero upon division by **g**. This number is simple to find in *Excel*, by using the GCD function. If you type =GCD(24,40) in a cell and hit Enter, the number 8 is shown in the cell.

It is also easy to find the GCD if you have *complete factorization* of both **a** and **b** (like the example above). This process is made easier by systematically organizing your factors from smallest to largest (as done above) and comparing lists until you find the largest value common to both lists.

You can also find the GCD by comparing *prime factorizations* of both numbers. Using the above, **a** = $2^3 \cdot 3$ and **b** = $2^3 \cdot 5$ so that GCD(**a**, **b**) = 2^3. (Prime factorization also allows us to easily identify the *least common multiple* of two numbers which in this case is simply 120 = $2^3 \cdot 3 \cdot 5$.)

Interestingly, factoring large numbers is not something that is easy to do. This fact, discussed in the wonderful book *On Code* by Sarah Flannery, is at the core of *public key cryptography*. Of course, the numbers involved in creating public key systems are very large compared to what we work with in ESA (imagine trying to factor a 100-digit number).

Despite the difficulty of factoring numbers in general, there is a method to find the GCD of two numbers that does not require knowing the factors of either number. This method, known since ancient times, is called the *Euclidian algorithm* or *Euclid's algorithm*. Although we do not employ Euclid's algorithm directly in ESA, it is a very elegant algorithm. It can also be used to help find *modular multiplicative inverses*, a concept used to explain some of the most interesting images in ESA and discussed in Chapter 24. (You need not wade through Chapter 24 to enjoy ESA. ESA images and the way they were drawn are visually appealing in any event.) As such, Euclid's algorithm is examined in Section 21.2.3.

21.2.2 About *Relatively Prime* (or *Coprime*) Numbers

ESA images are based on a *continuously-drawn* series of lines. An image is *continuously-drawn* if you start at a vertex (the top in ESA) and add a line by following a rule for finding the next endpoint then draw the line and repeat this process until the endpoint of the last line drawn is the starting point of the first line drawn. A simple example is the pentagram shown to the right.

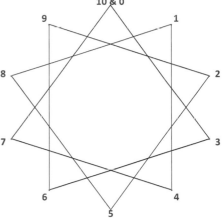

There are two ways to *continuously-draw* a 5-point star starting at the top: Either draw a line every second vertex (from **0–2–4–1–3–0**); or draw a line every third (from **0–3–1–4–2–0**). Both rules produce the same star, the only difference is whether that star appears drawn in a clockwise or counterclockwise fashion.

Similarly, we can continuously-draw a 10-point star such as the one to the right by connecting every third or seventh vertex because 3 and 7 are *relatively prime* to 10.

Definition: Two numbers **a** and **b** are **relatively prime** if their greatest common divisor is 1, GCD(**a**, **b**) = 1. We also say that the numbers are **coprime**.

But if we count every fourth line given **n** = 10, we end up with a pentagram like the above (except the vertices are **0-4-8-2-6-0**, as this is the pentagram noted in black in the third image). Notice that only even vertices have been used in this instance. This is because **n** = 10 and **J** = 4 are not relatively prime; they contain a common factor of 2. We call this the *Vertex Common Factor*, VCF; see Sections 2.2.2 or 4.1.

In this situation, it is not possible to draw a 10-point star with four vertex jumps. Of course, such stars exist but they are based on two circuits, one even and the other odd. Both circuits are provided in the third image to the right: **The black star shows even**; **the red star shows odd**. It is simply impossible to create this star using the *"Add 4 and draw a line"* rule because that rule will never move between odds and evens.

This is the same reason the **n** = 6, and **J** = 2 image to the left is a triangle rather than a 6-pointed star. The *"Add 2 and draw a line"* rule that drew the pentagram at the top (when **n** = 5) produces a triangle here because this rule only includes even used vertices. This is because **n** = 6 and **J** = 2 are not relatively prime; they contain a common factor of 2. To produce the "other" triangle in the

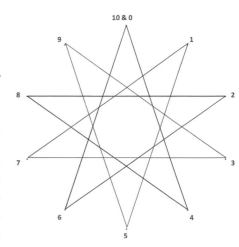

hexagram, one would need to start at an odd-numbered vertex, just like the **red star** in the *n* = 10 and *J* = 4 image to the right.

This is not to say that *J* = 2 uses only even vertices. It is easy to see that odd vertices are used in the second pass around the circle if *n* is an odd number. Consider the *n* = 9 and *J* = 2 image. The used vertex order is 0-2-4-6-8-1-3-5-7-0. Note that the first half is even, and the second half is odd (the final vertex can be viewed as both even and odd if one notes that it is both *n* = 9 and 0). The same pattern is seen in the *n* = 5, *J* = 2 pentagram we started with above.

A general rule. To create an *n*-point star, one need only find a number *J* with 1 < *J* < *n*-1 such that *n* and *J* have no factors in common. Such *J* are relatively prime to *n* (or coprime) and have GCD(*J*, *n*) = 1. *CLAIM*: This is possible for every *n* > 4 with the exception of *n* = 6. One can always create an *n*-sided polygon because *J* = 1 and *J* = *n*-1 are both coprime to *n*.

Finding the GCD of two numbers. When numbers are "small," it is relatively easy to find the greatest common divisor of two numbers because all that needs to be done is to compare the prime factorizations of both numbers. But when the numbers are larger and such factorization becomes tedious, we can be happy that more than 2,000 years ago, Euclid provided us with a very nice algorithm for finding the GCD of two numbers, discussed in Section 21.2.3.

21.2.3 MA. Euclid's Algorithm

How can you find the greatest common divisor of two numbers without knowing the factors? These days it is easy because you can always use the GCD function in *Excel* but prior to computers, you had to rely on other means. Interestingly, the great Greek mathematician Euclid provided a solution to this problem more than 2,000 years ago. This solution has come to be known as the *Euclidean algorithm*, or simply *Euclid's algorithm*. Here is how it works.

Consider any two numbers *b* and *c* greater than zero. In this instance, there exist unique numbers *m* and *r* with $0 \leq r < c$ such that *b* = *m·c* + *r*. If *b* is a multiple of *c* then *r* = 0 and *m* is the multiple. If *b* is not a multiple of *c* then the remainder *r* is positive, and *m* is the largest number of times that *c* could be subtracted from *b* and still leave a positive remainder (of *r*). Note that when *b* < *c*, *m* = 0 and *r* = *b*.

Put another way, if we consider *b/c* in decimal form the number can be thought of as having two parts, the stuff to the right of the decimal point and the stuff to the left. The stuff to the left is the integer part of this fraction, *m*, and the stuff to the right (typically called the fractional (or decimal) part) once multiplied by *c* is *r*. When *b* < *c* we typically call the fraction *b/c* a *proper* fraction and if *b* > *c* the fraction *b/c* is said to be an *improper* fraction.

Since one of the two must be larger, let that be *b*. Euclid noted that the GCD between *b* and *c* must also be the GCD between *c* and *r*. The same goes for further iterations of this same idea. Each time, the numbers become smaller and easier to compare. Finally, we will end up with a zero remainder of these comparisons. **The last positive remainder before this happens is the GCD(*b*, *c*).** Here are two examples.

The left and right columns show the iterative process; the middle shows the underlying structure.

First example: b = 1155 and c = 308. Second example: b = 1155 and c = 307.

Large = Multiple·*Small* plus *Remainder*

1155 = 3·308 + 231	Iteration 1	$b = m_1 \cdot c + r_1$
308 = 1·231 + **77**	Iteration 2	$c = m_2 \cdot r_1 + r_2$
231 = 3·77 + 0	Iteration 3	$r_1 = m_3 \cdot r_2 + r_3$
	Iteration 4	$r_2 = m_4 \cdot r_3 + r_4$
	Iteration 5	$r_3 = m_5 \cdot r_4 + r_5$
	Iteration 6	$r_4 = m_6 \cdot r_5 + r_6$
	Iteration 7	$r_5 = m_7 \cdot r_6 + r_7$

1155 = 3·307 + 234
307 = 1·234 + 73
234 = 3·73 + 15
73 = 4·15 + 13
15 = 1·13 + 2
13 = 6·2 + **1**
2 = 2·1 + 0

Each iteration reduces the size of the numbers being compared. The *Small* number from one iteration becomes the *Large* number for the next and the *Remainder* from one iteration becomes the *Small* number for the next. This process continues until a remainder of zero has been achieved.

In the first instance, GCD(1155, 308) = 77 in three iterations. In the second instance, GCD(1155, 307) = 1 in seven iterations. When GCD = 1, we say the numbers are relatively prime or coprime.

In both instances, these conclusions were obtained without factoring b or c. All that is necessary is a simple division with remainders noted.

Even when the numbers are reasonably large, this process converges reasonably quickly. Consider for example the somewhat larger numbers b = 1,453,568 and c = 280,137. You can check that these numbers are coprime in seven iterations, just like the second example above. See also, *Excel* file 21.0.2, available via QR code on the *Features* page at the front of this book.

21.3 What is the Product of Two Numbers that Differ by an Even Amount? (This looks at times table patterns along diagonals.)

The next page shows a different way to look at a *times table*. It is provided to highlight a pattern in numbers that differ by an even amount. It is based on a formula used in a couple of places in ESA called the **Difference between Squares** formula. That formula is $(x+y) \cdot (x-y) = x^2 - y^2$. This works for any x and y, not just whole numbers.

Let $a - b = 2k$ where a, b, and k are whole numbers. This means that the difference between a and b is an even number.

The number $c = b+k$ is halfway between a and b but so is $c = a-k$. Regrouping both side we have $a = c+k$ and $b = c-k$.

The product of a and b is thus:
$$a \cdot b = (c+k) \cdot (c-k)$$

Distributing the right hand side we obtain:
$$a \cdot b = (c+k) \cdot c - (c+k) \cdot k$$

Distributing once again we obtain:
$$a \cdot b = c^2 + k \cdot c - c \cdot k - k^2$$

Cancelling common terms:
$$a \cdot b = c^2 - k^2$$

How does this relate to the highlighted cells? Look at the numbers inside each red oval.

c **Yellow** cells are perfect squares. These are the values of c, the center number.

$k=1$ **Green** cells are 1 less in one direction, 1 more in the other. So, subtract 1.

$k=2$ **Blue** cells are 2 less in one direction, 2 more in the other. So, subtract $4 = 2^2$.

$k=3$ **Tan** cells are 3 less in one direction, 3 more in the other. So, subtract $9 = 3^2$.

This same pattern works regardless of where the center c is located!

Look to the adjoining cells at left above or at right below.

This pattern can be extended beyond $k = 3$. In the end, half of all multiplication values can be calculated this way.

This can be used to excite young learners about playing with numbers once they know about multiplication. Here is how.

1 Teach perfect squares of "round" numbers.
10, 15, 20, 30, ..., depending on age level.

2 Ask them multiplication questions that "surround" those numbers.

3 For example, most would work at $17 \cdot 23$
But they have no problem subtracting 23-17
The result, 6, divided by 2 is 3, $3^2 = 9$.
The midpoint is 20.
The square of 20 is easy ...4 with 2 zeros.
So **$17 \cdot 23 = 400 - 3^2 = 400 - 9 = \mathbf{391}$.**

Diagram labels: $k=1$, $k=2$, $k=3$; -9, -4, -1; -1^2, -2^2, -3^2; c^2

Oval (center 2500): 2491 2496 2499 **2500** 2499 2496 2491

Oval (center 400): 391 396 399 **400** 399 396 391

x	1	2	3	4	5	6	7	8	9	10	11	12	13	14	15	16	17	18	19	20	21	22	23	...	50	...
50																									2500	...
...																										
23																	391									
22																		396								
21																			399							
20	20	40	60	80	100	120	140	160	180	200	220	240	260	280	300	320	340	360	380	**400**						
19	19	38	57	76	95	114	133	152	171	190	209	228	247	266	285	304	323	342	361	380	399					
18	18	36	54	72	90	108	126	144	162	180	198	216	234	252	270	288	306	324	342	360		396				
17	17	34	51	68	85	102	119	136	153	170	187	204	221	238	255	272	289	306	323	340			391			
16	16	32	48	64	80	96	112	128	144	160	176	192	208	224	240	256	272	288	304	320						
15	15	30	45	60	75	90	105	120	135	150	165	180	195	210	225	240	255	270	285	300						
14	14	28	42	56	70	84	98	112	126	140	154	168	182	196	210	224	238	252	266	280						
13	13	26	39	52	65	78	91	104	117	130	143	156	169	182	195	208	221	234	247	260						
12	12	24	36	48	60	72	84	96	108	120	132	144	156	168	180	192	204	216	228	240						
11	11	22	33	44	55	66	77	88	99	110	121	132	143	154	165	176	187	198	209	220						
10	10	20	30	40	50	60	70	80	90	100	110	120	130	140	150	160	170	180	190	200						
9	9	18	27	36	45	54	63	72	81	90	99	108	117	126	135	144	153	162	171	180						
8	8	16	24	32	40	48	56	64	72	80	88	96	104	112	120	128	136	144	152	160						
7	7	14	21	28	35	42	49	56	63	70	77	84	91	98	105	112	119	126	133	140						
6	6	12	18	24	30	36	42	48	54	60	66	72	78	84	90	96	102	108	114	120						
5	5	10	15	20	25	30	35	40	45	50	55	60	65	70	75	80	85	90	95	100						
4	4	8	12	16	20	24	28	32	36	40	44	48	52	56	60	64	68	72	76	80						
3	3	6	9	12	15	18	21	24	27	30	33	36	39	42	45	48	51	54	57	60						
2	2	4	6	8	10	12	14	16	18	20	22	24	26	28	30	32	34	36	38	40						
1	1	2	3	4	5	6	7	8	9	10	11	12	13	14	15	16	17	18	19	20						
y	1	2	3	4	5	6	7	8	9	10	11	12	13	14	15	16	17	18	19	20	21	22	23	...	50	...

287

Chapter 22

Angles in Polygons and Stars

22.1.1 Inscribed Angles and Central Angles

Arcs of a circle and central angles. Connecting any three vertices of a regular n-gon produces a triangular image like the one at top left on next page. One can easily describe the size of the angles of this triangle by counting the number of vertices between points, a, b, and c. By construction, $a + b + c = n$ in that image.

One can think of a, b, and c as *arcs of a circle* that cumulatively create the circle. One can also conceptualize these as *central angles of a circle* created by connecting the endpoints of each arc to the center of the circle (via three radiuses as shown to the right).

Each arc has a central angle of: $360a/n°$, $360b/n°$, and $360c/n°$.
 The sum of these central angles is 360°.

The triangle angles are: $180a/n°$, $180b/n°$, and $180c/n°$.
 Note that each of these angles is half the size of its associated central angle and that, as expected, the sum of angles is 180°. Each of these angles is an example of an *inscribed angle*.

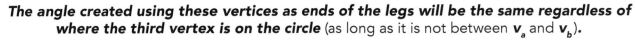

Two *intersecting* line segments (chords of a circle) create angles in one of two ways: *Inscribed Angles* and *Interior Angles*. Inscribed angles occur if the intersection is on the circle while interior angles occur if the intersection is on the interior of the segments. Interior angles are discussed in Section 22.2.

Inscribed angles. If an angle is formed from three points on a circle, the angle formed is called an *inscribed angle*. If the three points are vertices of a regular n-gon, then the angle created is determined by the number of vertices between the points relative to n. In the bottom right image, let $a = |v_a - v_b|$ where v_a and v_b are vertices of the regular n-gon.

The angle created using these vertices as ends of the legs will be the same regardless of where the third vertex is on the circle (as long as it is not between v_a and v_b).

The top right image on the next page shows three such examples at points t, u, and w on the perimeter of the circle. The angle in each case is half the size of the central angle a according to the *Inscribed Angle Theorem*. The central angle is $360a/n°$. The inscribed angle is $180a/n°$.

Counting vertices. When creating angles from polygonal vertices, the number of polygonal vertices between the used vertices determines the angle in question. After that, multiply by $360/n$ or $180/n$ to get the central or inscribed angle measured in degrees. Therefore, **it is often easiest to focus on counting the vertices between *used* vertices instead of thinking of angles in terms of number of degrees**.

DOI: 10.1201/9781003402633-26

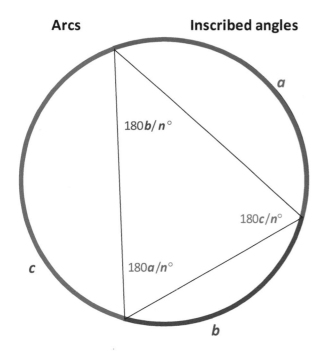

Arcs Inscribed angles Inscribed angles

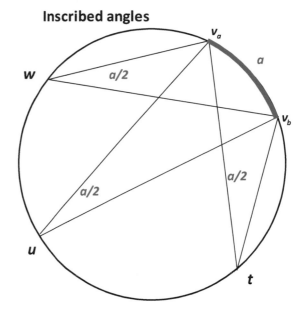

22.1.2 Why the *Inscribed Angle* Theorem Works

There are really two surprising points about the *Inscribed Angle Theorem*.

A. The inscribed angle is exactly half the size of the central angle.
B. It doesn't depend on which point you choose for the common vertex of the angle as long as it is on the circle.

You can see the rationale for both points by considering the possible locations for the common vertex. There are three possibilities. **I.** One line is the diameter of the circle. **II.** The two lines "surround" the center of the circle. **III.** The angle created by the two lines excludes the center of the circle. The three possibilities are shown in the images to the right.
 We start with three facts from geometry.

a. An *isosceles* triangle has two equal sides, traditionally called *legs*. The third side is called the *base*. The angle formed by the two legs is called the *vertex angle* and the other two are *base angles*. The base angles are equal.
b. The sum of angles in a triangle is 180°.
c. The sum of adjacent angles constructed when two lines intersect is 180°. These angle pairs are often called *supplementary angles*.

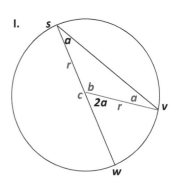

A point about notation. In all three images, the angle under consideration is ∠ **vsw**. The lines that create the angle, **sv** and **sw**, are in black, and all other identifying letters and lines are in blue. The letter **r** stands for radius.

I. In Figure I, angle **a** has one line (**sw**) which is the diameter of the circle. The midpoint of this line is **c**, the center of the circle. Two sides of △ **scv** are **r** so the triangle is isosceles with apex angle **b** and base angles of **a**. The sum of triangle angles is **b** + 2**a** = 180°.

Line **vc** creates two supplementary angles, **b** and ∠ **vcw** = 180° - **b** which is a central angle. We know that **b** + 2**a** = 180° so ∠ vcw = 2**a**. The inscribed angle spanning **vw** is half the size of the central angle spanning these same points.

II. By moving **s** in Figure **I.** counterclockwise by a bit, one could obtain an angle in which the two lines surround the center, but the angles would be smaller, and labeling would be harder. As a result, ∠ **vsw** is larger in Figure **II** than in **I**. The diameter through **s** intersects the circle at **y**. This creates two angles, **a** and **d** that sum to ∠ **vsw**.

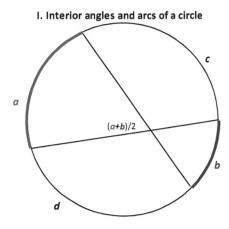

Applying the argument made in **I.** twice we obtain the central angle spanning **vw** is 2**a** + 2**d** = 2·(**a** + **d**) or twice the inscribed angle of **a** + **d**.

III. The point **s** was chosen so that ∠ **vsw** excludes the center in Figure **III**. Construct a diameter through **s** that intersects the circle at **y**. Construct a radius at **v**. The newly constructed isosceles triangle **scv** has a base angle of **b** = **csv** and a central angle of ∠ **ycv** = 2**b** using the argument presented in **I.** above.

Construct a radius at **w**. The newly constructed isosceles triangle **scw** has base angle **a** + **b** = ∠ **csw** and central angle 2·(**a** + **b**) = ∠ **ycw** using similar reasoning.

Since the central angle 2·(**a** + **b**) = 2**a** + 2**b** = ∠ ycw = ∠ ycv + ∠ vcw and because ∠ ycv = 2**b**, we see that central angle ∠ vcw = 2**a** by subtraction.

Wherever the vertex is placed, the inscribed angle is half the central angle.

22.2 About Interior Angles and Parallel Lines

Two intersecting line segments (chords of a circle) create angles in one of two ways: *Inscribed Angles* and *Interior Angles*. Inscribed angles occur if the intersection is on the circle while interior angles occur if the intersection is on the interior of the segments.

Interior angles. *Interior angles* are created when two segments intersect on the interior of the circle. Four angles are created but only two of them are distinct. If **a** and **b** represent the two opposing arcs of a circle, then the angle created is (**a**+**b**)/2 as shown in **I.** to the right. However, if **a** and **b** represent the number of vertices between regular **n**-gon vertices then **a**+**b**+**c**+**d** = **n**, and the angular measure of the interior angle is (**a**+**b**)·180/**n**°.

I. Interior angles and arcs of a circle

Note that had we examined the other two arcs created by these two lines, **c** and **d**, then the measure of the angle created from arcs **c** and **d** is (**c**+**d**)/2 which is supplementary to (**a**+**b**)/2. *Supplementary angles* sum to 180°. Since **a**+**b**+**c**+**d** = 360°, (**a**+**b**)/2 + (**c**+**d**)/2 = 180°, if **a**, **b**, **c**, and

d are considered arcs of a circle. If *a*, *b*, *c*, and *d* are the number of vertices between endpoints, the interior angles are $180 \cdot (a+b)/n°$ and $180 \cdot (c+d)/n°$.

Interior angles can be thought of as a generalization of inscribed angles. If one of the arcs is of zero size (i.e., just a point) then we have an inscribed angle. In this instance, the measure of the interior angle becomes the measure of the inscribed angle, half the size of the arc (or central angle).

Exploring why this formula works using parallel lines. As noted in the *Analyzing Stars Inside a Star* Section 2.6.2, parallel lines occur when lines have the same number of vertices different from one another on both sides. This is simply a discrete example of a more general notion about the arcs of a circle.

The *green labels* in Figure **II** denote the endpoints of arcs and the intersection point *t* for ease of referencing below. Start from **I** and rotate a copy of arc *b* clock-wise around the circle until it just touches arc *a* at point *y* as shown in Figure **II**.

Draw a line (shown in **red**) connecting *x* and *w*. The angle *xwu* is half the size of the arc *a+b* according to the *Inscribed Angle Theorem*, Section 22.1.1.

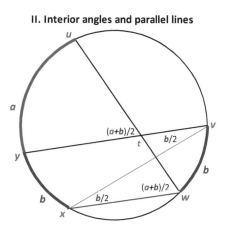

II. Interior angles and parallel lines

Consider the light blue line from *x* to *v*. This creates two angles ∠ *yvx* and ∠ *vxw* both of which measure *b*/2 according to the inscribed angle theorem. These are *alternate internal angles* of the lines *xw* and *yv* meaning that these two lines are parallel.

Since the lines are parallel, the corresponding angles are the same. Therefore, since ∠ *xwu* = (a+b)/2, we know that ∠ *ytu* = (a+b)/2. This discussion shows how the interior angle theorem and inscribed angle theorem are related.

22.3 About Implied Exterior Angles

If two lines spanning vertices a regular *n*-gon do not intersect, there are one or more vertices between the two lines on each side. Let those number of vertices be *a* and *b*. One of two things must be the case.

 A. The lines are parallel.
 B. The lines are not parallel.

If the lines are parallel, the lines are an equal number of vertices apart or *a* = *b*. Otherwise, one is larger. Let that be *a* so that *a* > *b*. This is the situation shown as Figure **I**. If the lines between vertices are extended, they will eventually inter-sect on the smaller side. The angle thus created is called an *Implied Exterior Angle* since it is exte-rior to the circle.

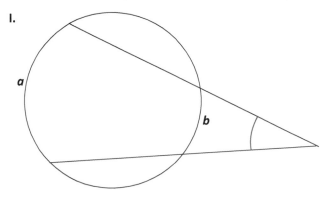

I.

The size of the implied exterior angle is equal to the difference between *a* and *b* times 180/*n*°.

Alternatively, if *a* and *b* represent arcs of the circle and central angles, then the implied exte-rior angle is half the difference between *a* and *b*.

A numerical example. Let $a = 11$, $b = 5$, and $n = 36$. The implied exterior angle is $(11-5) \cdot 180/36° = 30°$.

Alternatively, If $a = 110$, $b = 50°$ then the implied exterior angle is $(110-50°)/2 = 30°$.

These answers are the same because a 1-vertex arc of a 36-gon is 10°, so an 11-vertex arc is 110°.

Why this formula works. In Figure II, let v and w be vertices of an n-gon and a and b are numbers greater than zero where $a+b < n-1$ (so that each line spans at least one vertex) and $a > b$. Since $a > b$, we can add b to v, and the line between $v+b$ and w is parallel to the line between v and $w+b$ since each of the two lines spans b vertices and are hence parallel, just like in Section 22.2.

This newly constructed line has the same angle as the original angle, but this angle is an inscribed angle. This angle has size $(a-b) \cdot 180/n°$, the same as the implied exterior angle because *complementary angles* are the same.

If instead, a and b are arcs or central angles, then the implied exterior angle is $(a-b)/2$.

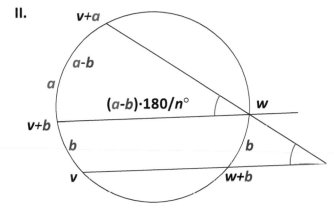

II.

292

Chapter 23

Modular Arithmetic

23.1 About MOD: When Counting Round and Round, the Remainder Is All That Matters

To create the simplest star, the **n** = 5, **J** = 2 pentagram using the ESA files, you start at the top then draw a line from **0** (the top) to the second vertex (**2** in the lower right), then to the **4**th vertex, and so on. The rule is to add 2 and draw the next line. But the third line has an end that is 2 more than 4 or 6 **...** but there are only five vertices in the **n** = 5 gon. It is natural to put the end of the third line at vertex **1** (since it is 1 after 5, the top of the 5-gon).

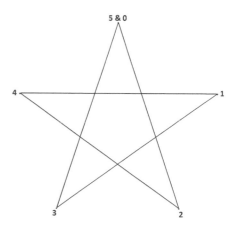

This same idea applies if it is now 11 o'clock and your friend says, *let's meet in two hours*. You know that is at 1 o'clock, not 13 o'clock. In both instances, **all that matters is what is left over** after you pass around the top of the image (or go past 12 o'clock). The location of the next point is the **remainder** upon division by 12.

To push this a bit further, suppose we create a 12-point star with five jumps between used vertices. This is easy to think of in terms of hour jumps because 12 equally spaced vertices create a clock face if we start at the top which we call **0** (or 12 & 0 instead of 12). The jumps and lines look like this:

Counting rule for creating a 12-point, 5-jump star: Add 5 starting at 0												
Line number L	1	2	3	4	5	6	7	8	9	10	11	12
*Ending number m	5	10	15	20	25	30	35	40	45	50	55	60
Ends at vertex v	5	10	3	8	1	6	11	4	9	2	7	0
Times past top t	0	0	1	1	2	2	2	3	3	4	4	5
*Equations: m = 5·L; v = MOD(m,12); t = INT(m/12). *Note:* m = 12·t + v												

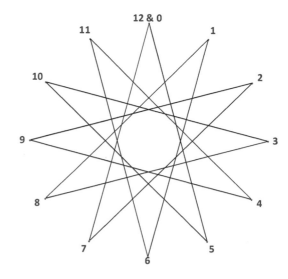

DOI: 10.1201/9781003402633-27

293

About MOD. The third and fourth rows were created using the MOD and INT functions in *Excel*. the INT function provides the integer portion of a number so INT(12.37) = 12, and MOD is the remainder once one number is divided by another. MOD(**b**,**c**) is *Excel's* function that produces a remainder **r** with $0 \leq r < c$ once a number **b** is divided by a divisor, **c** > 1. Thus, **r** = MOD(**b**,**c**) if **b** = **c**·**x** + **r** where **x** is an integer and $0 \leq r < c$. [Mathematicians write this as **b** = **r** mod **c**.]

If **b** is a multiple of **c**, **r** = 0, if not, $0 < r < c$. In the table on the previous page, the 12th ending number, 60, is a multiple of 12.

The MOD and INT functions are related (as noted in the last line of the table): **b** − **c**·INT(**b**/**c**) = MOD(**b**,**c**).

Why is MOD useful? The remainder function allows us to only worry about leftovers when doing additional calculations. One need not work with larger numbers when smaller numbers will suffice to answer the question. There are a number of properties of modular arithmetic (that you can read about on Wikipedia or in the rest of Chapters 23 and 24) but in this pass, we will focus on two: Addition and multiplication by a constant.

Addition by a constant. If **d** is an integer and **r** = MOD(**b**,**c**) then **r**+**d** = MOD(**b**+**d**,**c**).
For example, in the table above, since 2 = MOD(50,12) then 2+5 = 7 = MOD(50+5,12).
Multiplication by a constant. If **d** is an integer and **r** = MOD(**b**,**c**) then **r**·**d** = MOD(**b**·**d**,**c**).
In the table above, since 3 = MOD(15,12), 6 = MOD(15·2,12), 9 = MOD(15·3,12), and 12 = MOD(15·4,12) but note that 0 = MOD(12,12) which is why this last multiple is written as 0 = MOD(60,12).

An example from Section 3.3. The location of the **k**th endpoint is easily obtained using the remainder function (MOD). If **n** = 4, **S** = 2, **n**·**S** = 8 possible endpoints, the **k**th is at **r** = MOD(**k**·**P**, **n**·**S**) with **P** = 3. So, for example, the seventh is at 5 = MOD(7·3, 4·2). This is the midpoint between the second and third vertex because **r**/**S** = 5/2 = 2.5 in this instance, and it was attained during the third time around the circle since 2 < (**k**·**P**)/(**n**·**S**) = 21/8 < 3.

23.2 MA. MOD Take 2: Additional Properties of Modular Arithmetic

Section 23.1 noted two properties of modular arithmetic, *addition by a constant* and *multiplication by a constant*. This explainer provides some other useful properties of mod arithmetic that are encountered directly and indirectly throughout ESA. This explainer discusses this material in a bit more abstract fashion than in the introductory MOD explainer, so do not worry if some of this sounds more abstract as well. We start with *congruence*.

Congruence. If the difference between two numbers **a** and **b** is divisible by a third number **m**, 0 = **a** - **b** MOD **m**, we say the two numbers are congruent modulo **m**. This is written as $a \equiv b$ (MOD **m**).

If you are not used to reading mathematical symbols, you may not have noticed the three line \equiv congruence symbol (and read it as the two line = equality symbol), and you may wonder why the (MOD m) is shown with parentheses here. These distinctions are best explained by providing a concrete example. (One final distinction is that mathematicians use mod rather than MOD (capitals are used here as it is similar to *Excel's* MOD(a,b) function which is used throughout ESA).)

What time is it? Suppose it is now 12 o'clock. What time was it 11 hours ago? What time will it be 13 hours from now?

The answer to both questions is 1 o'clock. In mathematical terms:

$$-11 \equiv 13 \ (MOD \ 12) \quad because \quad 0 = -11 - 13 \ MOD \ 12 = -24 \ MOD \ 12.$$

The (MOD 12) applies to both $a = -11$ and $b = 13$ so that $-11 \equiv 13$ (MOD 12) means -11 MOD $12 = 13$ MOD 12. The expression on each side of the $=$ sign equals 1 ($-11 = 1-1\cdot12$ or $1 = -11$ MOD 12 and $13 = 1 + 1\cdot12$ or $1 = 13$ MOD 12).

Note that we do not know the remainder in the above congruence. All we know is that a and b will have the **SAME** remainder upon division by m. We see why the remainders must be the same by assuming this is not the case and deriving a contradiction based on that incorrect assumption.

Assume $a = r_a + x\cdot m$ with $0 \le r_a < m$ and x an integer, $b = r_b + y\cdot m$ with $0 \le r_b < m$ and y an integer and $r_a \ne r_b$. Define a as the number with larger remainder so $r_a - r_b > 0$. Given this, $a - b = r_a - r_b + (x - y)\cdot m$ with $0 < r_a - r_b < m$. But this says that $a - b$ has a non-zero remainder upon division by m, contradicting $0 = a - b$ MOD m.

We say that a and b are in the same *residue class* MOD m if they have the same remainder upon division by m.

Properties. Modular congruence has many properties in common with the more common notion of equality.

Let a, b, c, d, and k be integers. The modulus, m, is an integer greater than 1. The following are true.

Reflexivity:	$a \equiv a$ (MOD m)
Symmetry:	$a \equiv b$ (MOD m) if and only if $b \equiv a$ (MOD m)
Transitivity:	If $a \equiv b$ (MOD m) and $b \equiv c$ (MOD m), then $a \equiv c$ (MOD m)
Addition by a constant, k:	If $a \equiv b$ (MOD m), then $a + k \equiv b + k$ (MOD m)
Multiplication by a constant, k:	If $a \equiv b$ (MOD m), then $a\cdot k \equiv b\cdot k$ (MOD m)
Addition:	If $a \equiv b$ (MOD m) and $c \equiv d$ (MOD m), then $a + c \equiv b + d$ (MOD m)
Subtraction:	If $a \equiv b$ (MOD m) and $c \equiv d$ (MOD m), then $a - c \equiv b - d$ (MOD m)
Multiplication:	If $a \equiv b$ (MOD m) and $c \equiv d$ (MOD m), then $a\cdot c \equiv b\cdot d$ (MOD m)
Exponentiation:	If $a \equiv b$ (MOD m), then $ak \equiv bk$ (MOD m) for non-negative k

Challenge Questions. Assume: My 21st birthday is on Tuesday. What day of the week will my 25th birthday be on? How about my 65th?

23.3 MA. Counting Backwards (Modular Arithmetic, Take 3)

Although ESA only counts using positive numbers (for jumps, or points, for example), it is sometimes worthwhile to consider the negative counterpart of that positive counting process. *A number of the most interesting images occur when one number is just under or just over a multiple of another number* (see, for example, *Stars as Rotating Polygons* in Section 2.5.1 or *Porcupine Polygons* in Section 11.3).

This material is discussed in a bit more abstract fashion than in the *Introductory MOD* Section 23.1, so do not worry if some of this sounds more abstract as well. We also reexamine the notions of *congruence* and *residue class* introduced in Section 23.2 to add additional detail to these concepts.

In this *explainer*, we use m as the modulus (or denominator), and we restrict ourselves to $m > 0$. We use m rather than n because sometimes we will want to have denominators other than n (like S, $n\cdot S$, or something else).

Claim: There are m possible modular outcomes MOD m since the only possible remainders are $0, 1, \ldots, m\text{-}1$.

This means that we can categorize ALL numbers according to their remainder. Suppose we want to describe all numbers with remainder r upon division by m, $0 \le r < m$. This is easy to describe. Consider the set of numbers:

$$..., r - 3 \cdot m, r - 2 \cdot m, r - 1 \cdot m, r - 0 \cdot m, r + 1 \cdot m, r + 2 \cdot m, r + 3 \cdot m,$$

This can be more compactly described as the set of numbers of the form: $r + x \cdot m$ where x is the set of integers. Each of these numbers has the same remainder upon division by m. One can describe these numbers as being in the same *residue class* MOD m. If two numbers a and b are in the same residue class, their difference is divisible by m. As noted in Section 23.2, we say that a and b are *congruent modulo* m, $a \equiv b$ (mod m) if a MOD $m = b$ MOD m.

Examples: **A)** ..., -47, -30, -13, 4, 21, 38, 55, ... **B)** ..., -47, -27, -7, 13, 33, 53, 73, ... **C)** ..., -57, -38, -19, 0, 19, 38, 57, ...
Answer *i.* and *ii.* for **A**, **B**, and **C**: *i. What is the modulo for each set of numbers? ii. What is the remainder in each case?*
Answer two final questions: *iii. Describe what you would need to do to each set of numbers if you wanted to obtain the next higher remainder for that set of numbers? iv. How about the next lower remainder?*
Questions *iii.* and *iv.* were asked to make three points.

(1) Each set of numbers (residue class) is just one larger or one less than the original set of numbers. Note that we could ask question *iii. m* times. After that, we would return to the original residue class of numbers.
(2) One less than remainder 0 is remainder m-1 (as noted in the move from **C** to **C⁻**). The other side of this coin is that one more than m-1 is 0, MOD m (as noted in the move from **C⁻** to **C**).
(3) Although **PwP** only counts using positive numbers (for jumps or points, etc.), it is sometimes worthwhile to consider the negative counterpart.

Positive and negative a. If $r = a$ MOD m, then $-r = -a$ MOD m because of the *multiplication by a constant rule* (the constant here is -1). If $r = 0$, a and $-a$ are both divisible by m, and if $r > 0$, $0 < r < m$ implies $0 > -r > -m$ (because multiplying by a negative number changes the direction of the inequality). Adding m to each term does not change the direction of each inequality so $m+0 > m-r > m-m = 0$. Reorganizing yields: $0 < m-r < m$ so that if $r = a$ MOD m, then $m-r = -a$ MOD m.

Answers. *i.* and *ii.* The modulus, m, is the difference between successive numbers and the remainder is the first non-negative value in each set of numbers. This will necessarily be a number between 0 and m-1. Given this:

A) Modulo $m_A = 17$, the remainder is 4. **B)** Modulo $m_B = 20$, the remainder is 13. **C)** Modulo $m_C = 19$, the remainder is 0.

iii. Next higher: **A⁺)** ..., -46, -29, -12, **5**, 22, 39, 56, ... **B⁺)** ..., -46, -26, -6, **14**, 34, 54, 74, ... **C⁺)** ..., -56, -37, -18, **1**, 20, 39, 58, ...

iv. Next lower: **A⁻)** ..., -48, -31, -14, **3**, 20, 37, 54, ... **B⁻)** ..., -48, -28, -8, **12**, 32, 52, 72, ... **C⁻)** ..., -58, -39, -20, -1, **18**, 37, 56, ...

These examples amplify the third point and show how images can be *conceptualized* as being *counterclockwise-drawn* by simply counting backwards. We start with a quick discussion of MOD 5.

MOD 5 is even easier than MOD 12. Because we have five fingers and our number system is base 10, it is easy to see the remainder for any number, positive or negative, MOD 5.

Positive values: Consider the number 27. Because 10 is a multiple of 5, we can ignore all but the ones digit (7) of any number MOD 5. But 7 = 5 + 2 (five fingers on one hand and the last two on the other), so 2 = 27 MOD 5.

Negative values: Consider the number -27. As above we can ignore all but the ones digit, but what does -7 signify? The first thing to note is that -7 is the same as -2 MOD 5 because of the -2 = -7 + 5. Applying this a second time (3 = -2 + 5) shows that 3 = -27 MOD 5. This can also be seen by noting that -27 = 3 - 6·5, or to put it in the terms used above, -27 is part of the residue class **...**, -12, -7, -2, **3**, 8, 13, 18, **...** so that in fact, 3 = -27 MOD 5.

It is worth explicitly pointing out that this example reminds us that the mod of a negative number is NOT the same as the MOD of its absolute value counterpart. Indeed, as noted above: if **a > 0** and **r** = **a** MOD **m**, then **m-r** = **-a** MOD **m**.

How pentagons and pentagrams are drawn. The table below shows the possible outcomes from File 1 given **n** = 5. For a given value of **J**, one of five things must happen because there are five possible remainders. These outcomes are listed in the Resulting Image column. There is no image (or more accurately, there is a single point) if **J** is a multiple of **n** = 5 (which is the remainder = 0 row). Two remainders produce a pentagon, and two produce a pentagram.

Remainder	Possible Jump Values*	Vertex Jump Pattern	Resulting Image (and how it is actually drawn)	Appears as if drawn as
0	... -5 0 5 10 15 ...	0, 0, ...	A single point, the top vertex alone	-
1	... -4 1 6 11 16 ...	0, 1, 2, 3, 4, 0, ...	Pentagon drawn clockwise each vertex connected to next	clockwise, J = 1
2	... -3 2 7 12 17 ...	0, 2, 4, 1, 3, 0, ...	Pentagram drawn clockwise every 2nd vertex connected	clockwise, J = 2
3	... -2 3 8 13 18 ...	0, 3, 1, 4, 2, 0, ...	Pentagram drawn clockwise every 3rd vertex connected	counterclockwise, J = -2
4	... -1 4 9 14 19 ...	0, 4, 3, 2, 1, 0, ...	Pentagon drawn clockwise every 4th vertex connected	counterclockwise, J = -1

*Jump values are positive in ESA.

Consider first the remainder 1 pentagon. It is drawn as five segments in a one-time-around fashion if **J** = 1. But exactly the same clockwise-drawn pentagon is created in a six-times-around fashion if **J** = 6. (The first line is drawn after going around once and ending one vertex past the top, 6 = 1 + 1·5, the second goes around a second time and ends at vertex 2, 12 = 2 + 2·5, and so on until the fifth line ends at vertex 0, 30 = 0 + 6·5.) Had **J** = 11, then the image is still a clockwise-drawn pentagon created by counting 11 times around (since 11·5 = 55, which represents 11 clockwise counts around the five vertices).

Consider next the remainder 4-pentagon. It is drawn as five segments in a four-times-around fashion if **J** = 4. Exactly the same clockwise-drawn pentagon is created in a nine-times-around fashion if **J** = 9. However, notice that it could be *conceptualized* as counting backwards (**J** = -1, counterclockwise) one vertex at a time as a one-time around *counterclockwise-drawn* image.

*The **J** = 2 and **J** = 3 pentagrams follow the same patterns*. The **J** = 2 pentagram is drawn as a two-times-around clockwise-drawn image. The **J** = 3 pentagram is drawn as a three-times-around clockwise-drawn image, but you could conceptualize this image as a two-times-around *counterclockwise-drawn* image (**J** = -2).

Note: We can conceptualize a *just-under-a-multiple* as a -1 and a *just-over-a-multiple* as a +1 in modular terms.

A more general rule. If all you care about is the final image, it makes sense to count in whichever direction creates the least total counting. This is why we restrict *J* to *J* < *n*. However, note that many ESA images exhibit vertical symmetry. In this instance, the same image will result for *J* and *n-J* so one can simply ask which is smaller, *J* and *n-J*? Put another way, in this instance, we can restrict ourselves to *J* < *n*/2 and count vertices in a clockwise fashion around the polygon.

23.4 MA. A(nother) Party Trick

This has nothing to do with string art but like the difference between the squares pattern discussed in Section 21.3, or the Fibonacci-created spiral discussed in Section 20.13, the mathematics here is sufficiently fun that it is included in ESA. This trick is inspired by the party trick described by Sarah Flannery in *In Code: A Mathematical Journey* on pages 77–79, but the calculations proposed here are a bit simpler than presented there. (A third version is presented that is more restrictive but even easier.) Each is based on a result from modular arithmetic called the *Chinese remainder theorem*.

The trick involves guessing someone's age. Let *a* be the age of the person in question.

The "simple" version. This version is based on the answers to two questions and a calculation based on those answers.

> **Q1:** What is the remainder once you divide *a* by 4?
> Let that be *x*. In modular terms, *x* = *a* MOD 4.
> **Q2:** What is the remainder once you divide *a* by 25?
> Let that be *y*. In modular terms, *y* = *a* MOD 25.

Claim: The person's age is the last two digits in the calculation: 25*x* + 76*y*.
> In modular terms, 25*x* + 76*y* = *a* MOD 100.

Two examples:	Suppose your age is 65. *x* = 1, *y* = 15.	25·1 + 76·15 = 11**65**.	The last two digits are 65.
	Suppose your age is 47. *x* = 3, *y* = 22.	25·3 + 76·22 = 17**47**.	The last two digits are 47.

This works for every age (number) from 1 to 99. (Note: 100 = 4·25.)

Sarah's *In Code* Party Trick. This version is based on the answers to three questions and a modular calculation.

> **Q1:** What is the remainder once you divide *a* by 3?
> Let that be *x*. In modular terms, *x* = *a* MOD 3.
> **Q2:** What is the remainder once you divide *a* by 5?
> Let that be *y*. In modular terms, *y* = *a* MOD 5.
> **Q3:** What is the remainder once you divide *a* by 7?
> Let that be *z*. In modular terms, *z* = *a* MOD 7.

> Calculate: 70*x* + 21*y* + 15*z* = *S*

Claim: The person's age is the remainder once *S* is divided by 105.
> In modular terms, 70*x* + 21*y* + 15*z* = *a* MOD 105.

Two examples: Suppose your age is 65. $x = 2$, $y = 0$ and $z = 2$. $70 \cdot 2 + 21 \cdot 0 + 15 \cdot 2 = 170 = 105 + 65$.
Suppose your age is 47. $x = 2$, $y = 2$ and $z = 5$. $70 \cdot 2 + 21 \cdot 2 + 15 \cdot 5 = 257 = 2 \cdot 105 + 47$.

This works for every number from 1 to 104. (Note: $105 = 3 \cdot 5 \cdot 7$.)

A not-MA youth version. This only works for $a < 20$, but you can coach young people to do this without discussing MOD.

> **Q1:** What is the remainder once you divide a by 4? Let that be x. Multiply x times 5 (the result is *0, 5, 10* or *15*)
>
> **Q2:** What is the remainder once you divide a by 5? Let that be y. Multiply y times 16 (the result is *0, 16, 32, 48* or *64*)
>
> **Claim:** Add these *results*. The person's age is the remainder once $5x + 16y$ is divided by 20.

This works for $a < 20$.

The largest age example: Suppose your age is 19. $x = 3$, $y = 4$. $5 \cdot 3 + 16 \cdot 4 = 15 + 64 = 79 = 3 \cdot 20 + 19$.

The question, of course, is: *Why multiply by 25 and 76 in the first instance, 70, 21, and 15 in the second, or 5 and 16 in the third?* If you spend a while reading about the *Chinese remainder theorem* you will see why, and you will be able to create your own party trick with divisors of your own choosing. These challenge questions nudge you in that direction.

Challenge Question 1: What are the multiples m_x and m_y of $x = a$ MOD 9 and $y = a$ MOD 10 if you use x and y to predict a using the remainder of $m_x \cdot x + m_y \cdot y = a$ MOD 90, for $1 \le a < 90$?

Challenge Question 2: What are the multiples m_x and m_y of $x = a$ MOD 10 and $y = a$ MOD 11 if you use x and y to predict a using the remainder of $m_x \cdot x + m_y \cdot y = a$ MOD 110, for $1 \le a < 110$?

Challenge Question 3: What are the multiples m_x and m_y of $x = a$ MOD 9 and $y = a$ MOD 11 if you use x and y to predict a using the remainder of $m_x \cdot x + m_y \cdot y = a$ MOD 99, for $1 \le a < 99$?

Chapter 24

Modular Multiplicative Inverses, MMI

24.1 Introduction to Modular Multiplicative Inverses

On the next page, the star on the left has 57 points, and the one on the right has 58 points, but all in all they look very similar to one another. Beneath each image, the first five segments of how each star is drawn are noted in **red**. Each appears to be a pentagram cracked open a bit rather than closed so that subsequent sets of five continue making open pentagrams.

If you watch the <u>image on the left</u> get created (using *Drawing Mode* once you click on the link (available from the *Links* document on the ESA website via QR code on the *Features* page at the front of this book)), the image is one of a pentagram bouncing around a lot, but the <u>image on the right</u> shows a much simpler pattern—the pentagram rotates around one vertex at a time until the image is completed. The fifth segment ends after $175 = 5 \cdot 35$ vertices have been counted in both images. To get to this endpoint all vertices have been counted three times in both cases ($171 = 3 \cdot 57$ and $174 = 3 \cdot 58$), and the fifth endpoint is at vertex $4 = \text{MOD}(5 \cdot 35, 57)$ on the left but at vertex $1 = \text{MOD}(5 \cdot 35, 58)$ on the right. Put another way, ***35 and 5 are modular multiplicative inverses modulo 58*** (or in shorthand, **35 and 5 are MMI MOD 58**).

DOI: 10.1201/9781003402633-28

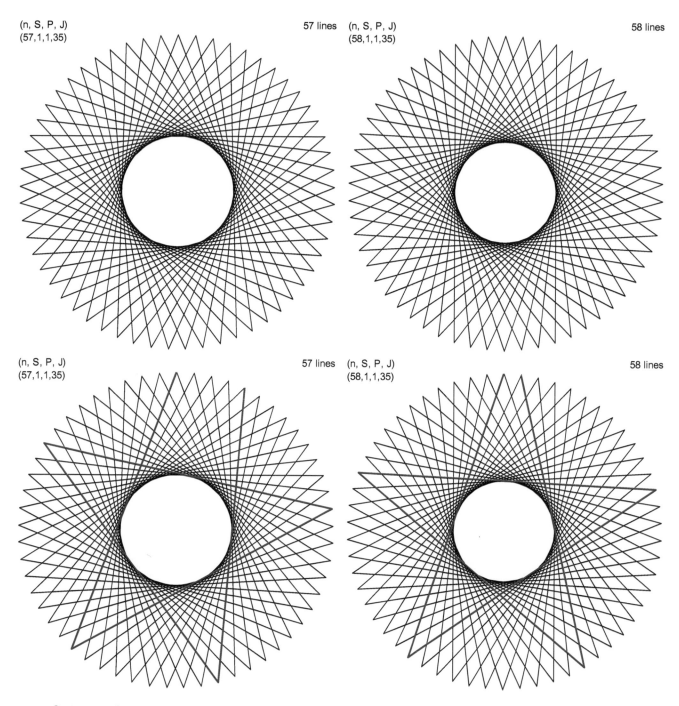

(n, S, P, J)
(57,1,1,35) 57 lines

(n, S, P, J)
(58,1,1,35) 58 lines

(n, S, P, J)
(57,1,1,35) 57 lines

(n, S, P, J)
(58,1,1,35) 58 lines

Definition. If two numbers **a** and **b** > 0 are relatively prime, then there will be a number **c** such that **a·c** = 1 MOD **b**. The numbers **a** and **c** are said to be **modular multiplicative inverses MOD b** (**a** and **c** are MMI MOD **b**).

Given this, we might expect other five-sided rotating figures to emerge when **b** is coprime to 5. Check that _**n** = 57, **J** = 23_ is also a rotating pentagram while _**n** = 56, **J** = 45_ and _**n** = 54, **J** = 11_ produce stars as rotating pentagons because, in each case, **J** is the MMI of 5 MOD **n**. Similarly, the _**n** = 55, **J** = 37_ star is a rotating triangle because 37 is the MMI of 3 MOD 55.

A string art example. The two puffy pentagrams are created by "almost-triangles" being rotated around the vertices of the vertex frame. The only difference is that **P** = 32 on the left and 33 on the

right. Each image has 95 subdivision endpoints (**n·S** = 95) and 95 segments, and **the first _cycle_ is shown in red** below. The <u>left image</u> is created in a special way: Note in **red** that each point on the vertex frame is ticked off, **one next to another**. The right image ticks off every fourth vertex point on the vertex frame. Using _Drawing Mode_ makes the <u>right image</u> look much more "haphazard." This ticking off of subdivisions along the vertex frame is a due to modular arithmetic: **3 is the MMI of 32 MOD 95** on the left (1 = MOD(3·32, 95) since 3·32 = 96), but on the right, 4 = MOD(3·33, 95) since 3·33 = 99.

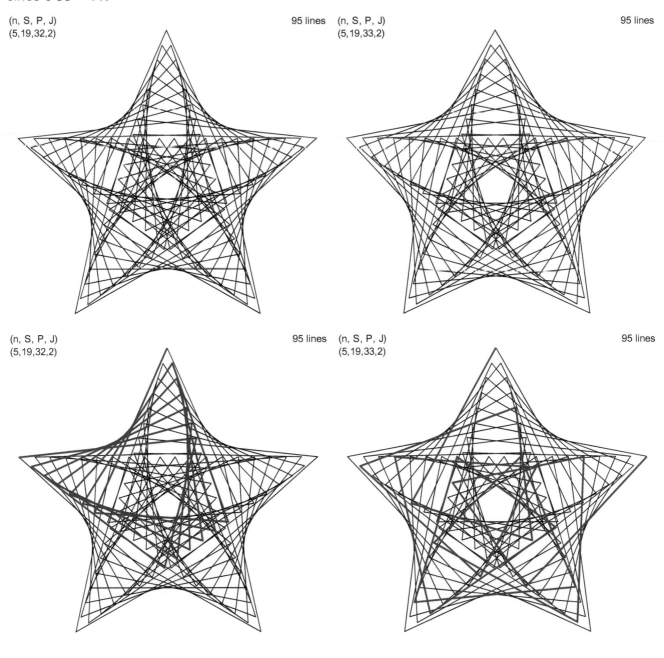

(n, S, P, J)
(5,19,32,2) 95 lines

(n, S, P, J)
(5,19,33,2) 95 lines

(n, S, P, J)
(5,19,32,2) 95 lines

(n, S, P, J)
(5,19,33,2) 95 lines

24.2 MA. MMI and Negative MMI (nMMI)

Background. In arithmetic, the multiplicative inverse of a number $x \neq 0$ is a number that, when multiplied by x, is equal to 1. The multiplicative inverse of x is $1/x$ or x^{-1}. For example, the multiplicative inverse of 3 is 1/3 because $3 \cdot (1/3) = 1$. Note in particular that if the number is an integer (other than 1 or -1) the multiplicative inverse is NOT an integer but is instead a fraction. In modular arithmetic, the product of two integers can be 1 larger than a multiple of a third. This is the essence of *modular multiplicative inverse*, MMI.

Definition. When numbers a, b, and m have the property that $a \cdot b = b \cdot a$ is 1 larger than a multiple of m we say that *a and b are modular multiplicative inverses modulo m* (a and b are MMI MOD m if $1 = a \cdot b$ MOD m).

Facts about MMI.

Existence. If b and m are coprime, then there exists a number a such that a and b are MMI MOD m.

Special values. The MMI of 1 is 1 MOD m for all m. The MMI of m-1 is m-1 MOD m for all m.

Excluded values. If b is not coprime to m, then it is not possible to find an a such that $1 = a \cdot b$ MOD m. In particular, there is no MMI for 0 MOD m.

Examples. m = 5 Since 5 is prime, b and m are coprime for b = 1, 2, 3, 4, it is possible to find the MMI for each value of b. Since order does not matter, the three (a, b) MMI pairs are: (1, 1), (2, 3), and (4, 4).

 m = 12 b = 1, 5, 7, 11 are coprime to m. Here the (a, b) MMI pairs are: (1, 1), (5, 5), (7, 7) and (11, 11).

We have only discussed MMI for a and b smaller than m. But a and b are only the smallest positive number examples of two numbers that are in an MMI MOD m. Note that *the residue class of a*, defined as the set of numbers $x_a = a + k \cdot m$ for integer values of k once multiplied by b, is also 1 more than a multiple of m. This is easy to see:

Assume $1 = a \cdot b$ MOD m. Consider $x_a \cdot b = (a + k \cdot m) \cdot b = a \cdot b + k \cdot m \cdot b$. This has the same product, MOD m, as $a \cdot b$.

The same argument can be made for the residue class b, $x_b = b + j \cdot m$ for integer values of j.

Extended values. If $1 = a \cdot b$ MOD m, then $1 = x_a \cdot x_b$ MOD m for $x_a = a + k \cdot m$ and $x_b = b + j \cdot m$ for all integers k and j.

Examples. Since 2 is MMI of 3 MOD 5, we know that $1 = 17 \cdot 48$ MOD 5 because $17 = 2 + 3 \cdot 5$ and $48 = 3 + 9 \cdot 5$.

Since 5 is MMI of 5 MOD 12, we know that $1 = 17 \cdot 65$ MOD 12 because $17 = 5 + 1 \cdot 12$ and $65 = 5 + 5 \cdot 12$.

Left Image Both are *60-second images* (click *Toggle Drawing*) because Right Image
1 = 29·29 = 89·29 = **P·J** (MOD 60).

(n, S, P, J) 120 lines
(60,2,29,29)

(n, S, P, J) 120 lines
(60,2,89,29)

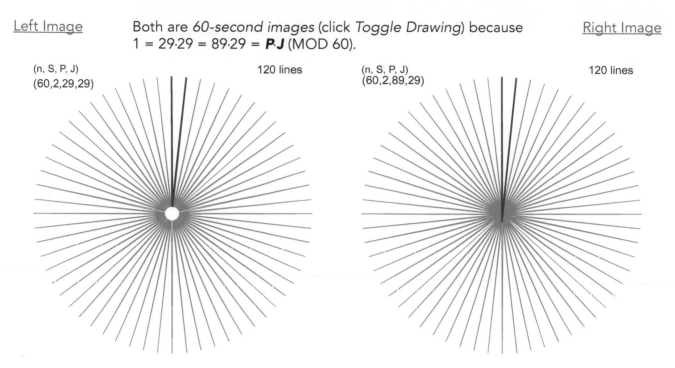

The **first cycle is shown in red** in both images and each ends one vertex past the top of the hour; subsequent cycles click off seconds one at a time, just like the second hand of a clock (in this instance a very quick clock). The difference is that the first image excludes the center and the second crosses over the center. If you change **S** to values other than 2, you maintain the same 60-second attribute as long as **P** and **J** are MMI MOD 60 (with the additional requirement that the GCD(**S**, **P**) = 1), but the images can become much more intricate.

For example the 16-point spinning star on the left or the stacked circles image on the right. The only difference is **P** = 167 on the left and 47 on the right. Like above, the **first cycle** ends at vertex 1 because 1 = 167·23 = 47·23 MOD 60. In the terms used above, 167 is in residue class 47 MOD 60, and because 47 is MMI of 23 MOD 60, so is 167 (and other values).

(n, S, P, J) 960 lines
(60,16,167,23)

(n, S, P, J) 960 lines
(60,16,47,23)

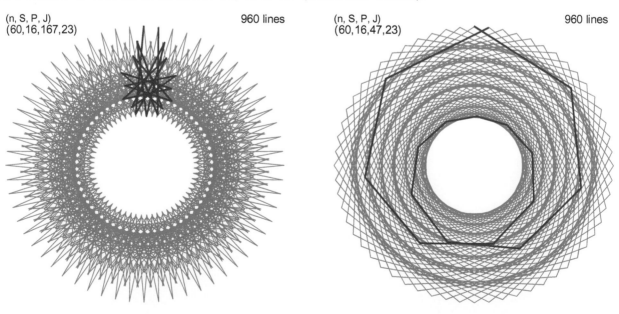

If you want to learn more about *60-second images*, Section 13.1 deals with this topic as does Section 13.2, *60 Polygons and Stars*. Section 13.3, *Alternative Universes*, considers clocks without 60 seconds per minute.

Negative MMI. One point discussed in Section 13.3 is that one can readily conceptualize an extension to the notion of MMI, by asking: Can we describe two numbers *a* and *b* whose product is 1 **less than** a multiple of *m*? If so, we call this a negative MMI. Such values would allow us to model a fanciful world in which clocks run backwards.

Definition. When numbers *a*, *b*, and *m* have the property that *a·b* is 1 smaller than a multiple of *m* we say that *a and b* are **negative** *modular multiplicative inverses modulo m* (*a* and *b* are nMMI MOD *m* if *m*-1 = *a·b* MOD *m*).

This does indeed happen, and in fact it happens just as often as MMI because if 1 = *a·b* MOD *m* then -1 = -1·*a·b* MOD *m*. Note that *m-a* = -1·*a* MOD *m* and *m-b* = -1·*b* MOD *m* since it does not matter whether you apply the -1 to *a* or *b*.

Examples. Suppose you want to replicate the images above, but you want them drawn counterclockwise. All you need to do is replace *J* by *n* - *J* above. Here are links to the backward left image, and to the backward right image.
A second way to obtain the same image drawn counterclockwise is to replace *P* by *n·S-P*.
(1, 4), (2, 2), (3, 3) are all nMMI pairs MOD 5. Additionally, (1, 11) and (5, 7) are nMMI pairs MOD 12.

A final note. Many of the images in ESA that appear to be the most interesting are ones where one or more of the parameters are a bit more or less than a multiple of another parameter (or product of parameters). We informally describe this as "just above" or "just below" images. The formal mathematical issue in this instance boils down to MMI and nMMI.

24.3 MA. Backtracking Euclid's Algorithm to Find Modular Multiplicative Inverse

Suppose we want to know the MMI of 11 MOD 60. This means we want to know the number that when multiplied by 11 gives a number that is 1 larger than a multiple of 60. The answer in this case is easy to see because we know that 11·11 = 121 = 2·60 + 1 so that 11 is the MMI of 11 MOD 60. How do we find the MMI without "seeing" the answer?

Example 1. We know that there will be an MMI because 11 and 60 are coprime. Nonetheless, following Euclid's Algorithm (see 21.2.3); we see that 11 and 60 have a GCD of 1 in three iterations as shown in the left half of the table below. The right half simply rewrites each iteration (except the last) solving for the remainder (noting Integer·Smaller is now subtracted).

Larger	=	Integer	*	Smaller	+	Remainder	Iteration, *k*	Remainder	=	Larger	−	Integer	*	Smaller
60	=	5	*	11	+	5	1	**5**	=	60	−	5	*	11
11	=	2	*	5	+	1	2	1	=	11	−	2	*	**5**
5	=	5	*	1	+	0	3							

To find the MMI, start at the bottom and work upward using the equations on the right-hand side.

Substitute the first into the second in place of **5** we have: $1 = 11 - 2\cdot(\mathbf{60 - 5\cdot11})$

Distributing: $1 = 11 - 2\cdot60 + 2\cdot5\cdot11$

Regrouping we have 1 as a multiple of 11 and 60: $1 = -2\cdot60 + (1 + 2\cdot5)\cdot11 = \mathbf{11}\cdot11 - 2\cdot60$.

This says that 11 is the MMI of 11 MOD 60.

Example 2. A more challenging question is: what is the MMI of 11 MOD 52? This is not readily apparent but is easily found by backtracking Euclid as was done above.

Larger	=	Integer	*	Smaller	+	Remainder	Iteration, *k*	Remainder	=	Larger	−	Integer	*	Smaller
52	=	4	*	11	+	8	1	8	=	52	−	4	*	11
11	=	1	*	8	+	3	2	3	=	11	−	1	*	8
8	=	2	*	3	+	2	3	2	=	8	−	2	*	3
3	=	1	*	2	+	1	4	1	=	3	−	1	*	2
2	=	2	*	1	+	0	5							

To find the MMI, start at the bottom and work upward on the right-hand side.

Substitute the third into the fourth in place of **2** and we have: $1 = 3 - 1\cdot(\mathbf{8 - 2\cdot3})$

Distributing: $1 = 3 - 1\cdot8 + 1\cdot2\cdot3$

Regrouping we have 1 as a multiple of 3 and 8: $1 = -8 + (1 + 2)\cdot3 = -8 + 3\cdot\mathbf{3}$.

Substitute the second in place of **3** and we have: $1 = -8 + 3\cdot(\mathbf{11 - 1\cdot8})$

Distributing: $1 = -8 + 3\cdot11 - 3\cdot8$

Regrouping we have 1 as a multiple of 8 and 11: $1 = 3\cdot11 - (1 + 3)\cdot8 = 3\cdot11 - 4\cdot\mathbf{8}$

Substitute the first into in place of **8** and we have: $1 = 3\cdot11 - 4\cdot(\mathbf{52 - 4\cdot11})$

Distributing: $1 = 3\cdot11 - 4\cdot52 + 4\cdot4\cdot11$

Regrouping we have 1 as a multiple of 11 and 52: $1 = -4\cdot52 + (3 + 16)\cdot11 = \mathbf{19}\cdot11 - 4\cdot52$.

This says that 19 is the MMI of 11 MOD 52.

When Euclid has remainder 0 in an odd Iteration, *k*. You may have noticed that these two examples both achieve a zero remainder in an odd iteration (*k* = 3 and *k* = 5). When this happens, the backtracking process produces a positive value as a multiple of the *Smaller number*. That multiple is the MMI of the *Smaller number* MOD *Larger number*. The only difference is the number of backward substitutions necessary to end up writing 1 as a function of the *Larger* and *Smaller numbers*. This will occur after *k*-2 substitutions.

When Euclid has remainder 0 in an even Iteration, *k*. When the Euclidean Algorithm takes an even number of iterations to achieve remainder 0, the result of the backtracking process produces negative numbers as the multiple of the *Smaller number*. In this instance, we must do one more step to find the MMI of *a* MOD *b* as we see in this example.

Example 3. What is the MMI of 11 MOD 59? This is not readily apparent but is also easily found by backtracking Euclid.

Larger	=	Integer	*	Smaller	+	Remainder	Iteration, *k*	Remainder	=	Larger	−	Integer	*	Smaller
59	=	5	*	11	+	4	1	4	=	59	−	5	*	11
11	=	2	*	4	+	3	2	3	=	11	−	2	*	4
4	=	1	*	3	+	1	3	1	=	4	−	1	*	3
3	=	3	*	1	+	0	4							

To find the MMI, start at the bottom and work upward using the equations on the right-hand side.

Substitute the second into the third in place of **3** we have:	$1 = 4 - 1 \cdot (\mathbf{11 - 2 \cdot 4})$
Distributing:	$1 = 4 - 1 \cdot 11 + 1 \cdot 2 \cdot 4$
Regrouping we have 1 as a multiple of 4 and 11:	$1 = -11 + (1 + 2) \cdot 4 = -11 + 3 \cdot \mathbf{4}.$
Substitute the first in place of **4** and we have:	$1 = -11 + 3 \cdot (\mathbf{59 - 5 \cdot 11})$
Distributing:	$1 = -11 + 3 \cdot 59 - 3 \cdot 5 \cdot 11$
Regrouping we have 1 as a multiple of 11 and 59:	$1 = 3 \cdot 59 - (1 + 15) \cdot 11 = 3 \cdot 59 - 16 \cdot 11.$

So, -16 is **an** MMI of 11 MOD 59.

But -16 is not a number between 1 and 58 so it is not **THE** MMI of 11 MOD 59.

The MMI is defined as a positive number less than the *Larger number* (the modular base) that, when multiplied by the Smaller number, produces a result that is 1 more than a multiple of the *Larger number*.

The extra step. To get the MMI, add 59 (the *Larger number*) to the result. In this instance, 43 = 59-16.

43 is the MMI of 11 MOD 59.

Here is a check: $43 \cdot 11 = 473$. But $8 \cdot 59 = 472$, so: $1 = 43 \cdot 11 - 8 \cdot 59$, just as required by MMI.

In words: 43 times 11 produces a number that is one more than a multiple of 59, just as required by the definition of MMI.

An automated version in *Excel*. This backtracking process can be set up in *Excel*, much as Euclid's Algorithm for finding the GCD was shown in the *Euclid's Algorithm in Excel* file 21.0.2. The **Backtrack equation** required for this process (cell P5 in *Finding MMI Excel* file 24.0) is shown at the bottom of the page without formal discussion of why it works, but the reason it works is that it mimics the iterations discussed above. When $GCD(n_1, n_2) > 1$, a "quasi-MMI" is calculated as long as the Smaller number is not a multiple of the Larger number (i.e., as long as $GCD(n_1, n_2) < MIN(n_1, n_2)$).

A non-ESA example: Q: What is the MMI of 1,234,567 MOD 87,654,321?
A: 75,327,931.

MMI Check
92,997,377,790,877
-92,997,377,790,876

The image below shows the Euclidean Algorithm to the left, and the backtracking to the right. The far right numbers are the MMI check with the top = $n_2 \cdot$MMI, and bottom = $n_1 \cdot$-1060956.

87654321	n_1	87654321	= n_1/GCD		-1060956	multiple on Larger		This file finds MMI of two numbers with GCD = 1 Put						
1234567	n_2	1234567	= n_2/GCD		**75327931**	MMI (P5 or A5+P5)		numbers in yellow cells, MMI is in F2.						
GCD =		1	1		GCD check: GCD = D5*F2 + A5*F1			See *Backtracking Euclid* Section 24.3 for heuristic on the P5 eq.						
Larger	=	Integer	* Smaller	+	Remainder	Iteration	Remainder	=	Larger	−Integer	*	Smaller	**Backtrack**	Eq. i
87654321	=	71	1234567	+	64	1	64	=	87654321	-71	* (1234567) **-12326390**	=IF(F5
1234567	=	19290	64	+	7	2	7	=	1234567	-19290	* (64) 173611	
64	=	9	7	+	1	3	1	=	64	-9	* (7) -9	
7	=	7	1	+	0	4								

Backtrack equation in P5: =IF(F5="","",IF(F5=0,"",IF(F6=0,K5,IF(F7=0,K6*K5+1,IF(F8=0,P6*K5+K7, IF(F8>0,K5*P6+P7))))))

Chapter 25

A Guide to the Web Model

25.1 An Introduction to the Web Version of String Art

The electronic string art files were originally created in *Excel*, and if you are just starting out and have access to *Excel*, that is the wise place to start. The web version, developed by Liam Myles, can do many of the same things as the *Excel* files, and it also has additional capabilities that are not available in the *Excel* files. The reason to start with the *Excel* files can best explained by a simple analogy. If you are just learning how to drive, you are generally better served if you start out in a Volvo or Toyota with an automatic transmission instead of a Ferrari or Corvette with a manual transmission. It is best to minimize the number of things you need to think about and not overwhelm yourself as you learn the basics. Both versions can be accessed by QR code on the *Features* page at the front of the book.

The *Excel* files are layered and allow you to see one thing at a time until you have learned the basics, but the web version provides access to everything at once. Most basically, string art is created from four parameters, *n*, *S*, *P*, and *J*, and the *Excel* files allow users to individually focus on each of those parameters rather than face all four at once.

You will be able to use the web model to recreate any string art image created using the *Excel* files shown in the book, with a few exceptions. In Part III, one version of the Double Jump Set model in Chapter 16 as well as the models in Chapters 15, 17, and 19 are ONLY available using *Excel*. You cannot examine *functional relations between parameters*, Chapter 10, as seamlessly using the web version. The *Excel* files are also more fine-tuned for those who are interested in teaching from this material. On the other hand, there are a few topics that are ONLY available on the web version (including larger jump set models in Chapter 18 or images with more than 2,000 lines). Additionally, *Excel* does not have automated *Drawing Modes*, although there are *Excel* files that allow manual drawing of the first *k* lines. In short, the two modalities complement one another nicely.

Web *explainers*. The image on the next page highlights three sets of controls which we discuss in three separate *explainers*. Each presupposes a familiarity with the "just the basics" sections noted in Section 1.2.

**25.2 *Changing Numbers*, highlighted green, focuses attention on how to enter data in the web version.
**25.3 *Web Jumps*, highlighted yellow, discusses the open-ended way that jumps are handled in the web version.
**25.4 *Drawing Modes*, highlighted blue, examines how to use the various *Drawing Modes*.

DOI: 10.1201/9781003402633-29

The final three web sections (25.5.1–3) provide **guided inquiries** into the basics for younger users (25.5.1–3 is also available in *Excel* on the ESA website via the QR code on the Features page at the front of this book). These **guided inquiries** explore the basics from the ground up without assuming a knowledge of multiplication, division, or string art basics. They provide a heuristic visual introduction to these concepts. *A Teaching Companion to the Web Guide* is provided as Section 26.4.

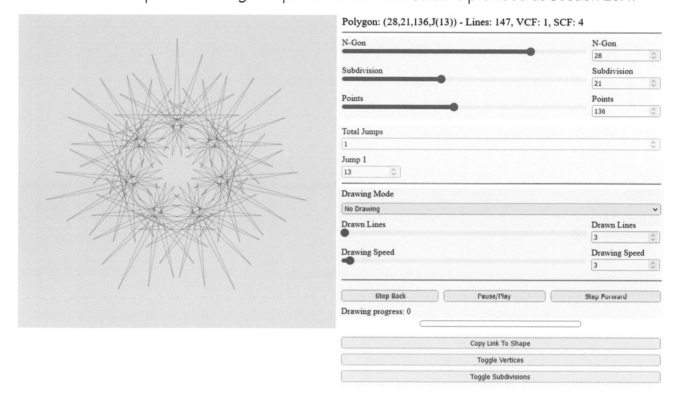

25.2 Changing Numbers in the Web Version

There are five methods to change numbers in the web version for **n**, **S**, and **P**.

1. Click on the **blue ball** to the left of the number and drag it right or left.

 a. Scrollbar bounds: $1 \leq n \leq 36$; $1 \leq S \leq 50$; $1 \leq P \leq n \cdot S/2$.

2. Click on the line to the left or right of the **blue ball's** location to lower or raise the number.
3. Use the ⬍ arrows to the right of the number to either scroll up or scroll down the number.

 a. ⬍ bounds: There are no set bounds using these scrollbars but processing large numbers takes longer.

4. Highlight the number and change it by typing in a new number.
 a. That new number need not be close to the previous number so this allows you to move very quickly to a new value.
 b. If following this method, you must highlight the old number, or it will simply add it to the end of the existing number.

 i. For example, if you want to change **n** from 4 to 50, if you click next to the 4 and type 50, the new **n** will be 450. However, if you highlight the 4, then type 50, it will change to 50.

 c. This method works well if you are trying to examine functional relations between parameters like those in Chapter 10 since discrete changes are most easily achieved with this method of data entry.

5. Click on the box of the parameter you want to change. Once the box is surrounded by a **blue line**, that number is active and can be changed using the ˄ and ˅ directional arrow keys on your keyboard.

 a. The keyboard arrow key need not be tapped one at a time. If you continue to depress the up key, for example, the parameter will increase at a steady rate.

 b. In fact, it is often easier to use these arrow keys than the small ⬍ arrows to the right of the number as it is easy to slip from one to the other due to the size of those up and down arrows.

Toggles. The two toggles are useful for pedagogical purposes. *Toggle Vertices* produces the numbers from 0 (**in a blue dot**) and 1 to **n**-1 (**in green dots**) at vertices, and *Toggle Subdivisions* produces **S purple** • subdivision endpoints on each line of the vertex frame, VF. If you have either on as you scroll through values of **n**, **S**, and **J**, you will quickly be able to see the vertex frame implied by the subdivision values and jump patterns. To see the VF, set **S** = **P** and the result is always the VF.

Saving an image. You can use the *Copy Link to Shape* button to copy a link, and by right-clicking on the image you can save it using *Save Image As*. This is how images and links were saved for this book.

Entering jump information. The open-ended nature of jumps (discussed in the *Web Jumps* Section 25.3) means that there is no scrollbar to the left of the fourth parameter in the model, **J**, therefore the first two methods discussed above do not apply. **J** can be changed using any of the last three methods listed above.

25.3 How Jumps are Incorporated into the Web Version of String Art

Vertex jumps takes on a special role within the string art model. If no jump is noted, the assumption is that one moves from vertex to vertex one at a time ending in an **n**-gon. This may also be explicitly noted by saying **J** = 1. The number of vertex Jumps, **J**, is conceptualized as a constant jump pattern; a 5,2-star means you draw a series of connected lines between every other vertex to create a pentagram in Section 1.2. The **n**,**J**-star creates the vertex frame, VF, on which string art images are created as noted in Section 4.2.1. The difference between successive used vertices is CONSTANT in Parts I and II. In Part III we relax this assumption and provide for *Jump Sets* of two or more distinct values before repeating the pattern of jumps. The web version allows each of these possibilities.

Absent explicit instructions to the contrary (via different numbers for the parameters available from the *Links* document on the ESA web page via QR code on the *Features* page at the front of this book), the opening image for the <u>web version of the model</u>, creates an 8-point Brunes Star, the same image used to explain the difference between *n*, *S*, and *P* in Section 3.3 although note that in (*n*,*S*,*P*) = (4,2,3) there. This is also the image used as the starting point for the **guided inquiries** in Section 25.5 and it is directly available via the WEB VERSION QR code on the *Features* page at the front of this book. The web version image description (*n*,*S*,*P*) is (4,12,30) and notes that *Total Jumps* is 0.

Images from the web version: Polygon: (4,12,30)

> Total Jumps
> 0

These are shown because *Total Jumps* = 0 means, there is no set jump set. It DOES NOT mean that one does not move from vertex to vertex. If you click the ⬍ arrow up 1 so that Total Jumps = 1, the IMAGE DOES NOT CHANGE but the image description changes to **(4,12,30,J(1))**, and a new parameter, *Jump 1*, is created beneath the *Total Jumps* box as seen to the right. **Jump 1 is the J that is used throughout Parts I and II of the ESA**.

> Total Jumps
> 1
> Jump 1
> 1

Why is J different? The description of the image treats *J* differently from the other three parameters. It seems odd to put the jump inside a set of parentheses. This is done because *J* can take on more than one value once jump sets are allowed (in Part III). It is also why we describe images as (*n*,*S*,*P*,*J*) in Part II even though *n* and *J* are used first (to create the VF) then *S* and *P* are used to create the image from the VF.

The box at the top of the jumps area, *Total Jumps*, refers to the number of jumps in a *Jump Set*. A *jump set* is a sequence of jumps and is denoted by *k* in Section 16.1. Take, for example, *n* = 12. Both 1 and 5 are coprime to 12 so that if *J* = 1 you have a 12-gon, and if *J* = 5 you have a 12,5-star. But if you have *Total Jumps* = 2, *Jump 1* = 1, and *Jump 2* = 5, the VF is a long rectangle connecting 0–1–6–7–0 as you can see from this <u>(I2,1,1,J(1,5))</u> image. Interesting images with larger jump sets abound (check out this <u>*k* = 13 bird beak</u>), but it is wise to learn to walk before you run. Master *k* = 1 first.

Do not increase *Total Jumps* past 1 until you understand the basics. When you want **to create stars, or create VFs that are stars**, you must have *J* > 1. That does not mean that *Total Jumps* > 1. It means that **Total Jumps = 1 and Jump 1 > 1**.

To take the simplest example, *suppose you want to create a 5,2-star or pentagram*. Using the <u>(4,12,30)</u> Brunes Star as the starting point, this can be done in three steps.

1) To remove string art complications, set *S* = *P* = 1. The resulting image is a square.
2) To get a star you need five vertices, so set *n* = 5. The resulting image is a pentagon.

To turn this pentagon into a pentagram, you need *J* = 2. Suppose you had not carefully read the above. It would seem natural to set *Total Jumps* = 2.

Bad 3) If you set *Total Jumps* = 2, you end up with a pentagon. As each new jump is added that jump is set to a jump of 1. Therefore, if *Total Jumps* = 2, you have *Jump 1* = 1 and *Jump 2* = 1 which are not distinct from one another, both are jumps of 1 and could have been modeled using *Total Jumps* = 1 (or 0).
Good 3) Set *Total Jumps* = 1 and *Jump 1* = 2. The resulting image is a pentagram.

Where is J in (*n*,*S*,*P*,*J*)? This has already been stated above but it is worth repeating. To set a constant number of vertex jumps, *J*, per line used to create the VF, **set Total Jumps = 1 and Jump 1 = J**.

25.4 Using the Web Version Drawing Mode

All string art images are *continuously-drawn*, thus the image can be drawn as a connected set of lines from start to finish without interruption. Each of the four drawing options is useful in showcasing how a given static image was created.

Basics. The *Drawing Mode* module is shown to the right. The dropdown menu shows one static and four drawing modes.

1. No Drawing (default)
2. Fixed Count Line Drawing (FCLD)
3. Fixed Count Fading Line Drawing (FCFLD)
4. Single Line Drawing (SLD)
5. Single Lines Overlaid Drawing (SLOD)

Additionally, *Drawn Lines* (DL) and *Drawing Speed* (DS) are parameters that can be adjusted just like *n*, *S*, and *P*.

Buttons allow you to *Pause* drawing (or resume *Play*), and *Step Back* or *Step Forward* the drawing one step at a time. *Drawing Progress* (DP) notes the **start** of the DL lines. Initial values are DL = 3, DS = 3, DP = 0, and *Pause/Play* is set on *Play*.

Common instructions. If you want to show the first DL lines without having them move once you request any of the four drawing modes, start by depressing *Pause/Play*. If you want to get an initial view of how the image was drawn, it is worthwhile to simply start with FCLD and adjust DS up or down based on the number of lines in the image. You need not let the image complete its drawing cycle. You can interrupt drawing by changing modes. Changing modes resets DP to 0.

About FCLD and FCFLD. Both modes add DL lines at a time starting at 0 to all lines previously drawn. The total lines drawn are thus DL, 2DL, 3DL, …, until the full image is visible. (For example, you will see this 147-line *spinning needle star* from Section 11.8 emerge as seven discrete *cycles* (Section 5.1) if you set DL = 21, but if you set DL = 2 or 1 and increase DS accordingly, you will see the image emerge as more of a spinning needle creating the spinning needle star.)

These two drawing modes **do not adjust** as parameters change; lines are **FIXED**. Additionally, the DL "footprint" does not change for the first two modes (so that if you move from DL = 3 to DL = 2 with *Pause* on, it will look like there are three lines, even though the image will only proceed two at a time. On the other hand, changing DL from 3 to 4 will add a line as the footprint has expanded. Similarly, *Step Back* is not visible but *Step Forward* does show forward movement. It is worthwhile to use these modes once you have decided on an image you want to watch get drawn and the size of DL.

FCLD. As noted above, this produces completed images and is typically your starting (and ending) point.

FCFLD. FCFLD is useful if the image has densely packed lines. Compare this <u>2133-line DL = 3 image</u> in FCLD and FCFLD. This pulsing twisted triangular ↻ *one-time around image* (see Section 5.2) is harder to see after the first third is completed in FCLD than in FCFLD. This is very much like a *Ticking-Clock* image from Section 13.1 if clocks had 79 seconds in a minute.

About SLD and SLOD. The last two drawing modes **adjust** as the parameters change and, as a result, they are particularly useful for determining the attributes of an image. They also help in analyzing images like in Sections 11.9, 12.5, and 9.4.

SLD. Both SLD and SLOD maintain DL lines. As a new line is added to the sequence of DL lines, the first line in the sequence is removed maintaining DL lines in both modes. For example, watch <u>(30,19,163,13)</u> from Section 8.4 with SLD DL = 7 to see how the three triangles change and rotate based on seven lines. See also Section 12.8.

SLOD. Use this to find images that have properties you are interested in showcasing. For example, click *Toggle Subdivisions* on; and you can see that the first line ends at a subdivision that is as close as you can get to the top in this <u>image</u>, which is surprisingly simple given that there are

1817 lines, but note how small each line is as a result. Once you see this, set DL = 23, and watch the image emerge in 79 cycles using FCLD. Change to **_P_ = 962** and note that the image is *single-step* (8.5.1) at DL = 6 and is another ↻ one-time-around image that can also be viewed using DL = 23.

 Strategies for finding a satisfying DL. Often you will find it beneficial to use multiple modes. A typical strategy is to simply adjust DS and watch the image get drawn in FCLD. One useful starting point is DL = **_S_**/GCD(**_S_**,**_P_**) so you can see a cycle (this was the strategy discussed above with the spinning needle star). Sometimes a sub-image emerges like this *single-step* rotating pentagram in this image (set DL = 5, not DL = 11 = **_S_**). For porcupines, set DL = 2 like this bird beak.

25.5.1 A Guided Inquiry to the Web Version for Younger Users: Entering Numbers

25.5.2 A Guided Inquiry to the Web Version for Younger Users: Web Jumps

25.5.3 A Guided Inquiry to the Web Version for Younger Users: Drawing Modes

Sections 25.5.1–3 walk readers through the web version of string art by asking a series of pointed questions or suggesting a series of short exercises. Each starts from the same opening file which is the "plain vanilla" version of the web model available via the WEB VERSION QR code on the *Features* page at the front of this book. Each section is one page long.

 These questions and exercises use addition but avoid discussion of multiplication and greatest common divisor. Nonetheless, students playing with the web file will obtain an intuitive feel for these concepts, and more as they discover patterns in the numbers used to create string art images.

 Section 25.5.1 focuses on three of the four parameters (**_n_**, **_S_**, and **_P_**) that form the basis for the string art file. It also provides an intuitive introduction to the notion of subdivision common factor, SCF, from a non-mathematical perspective.

 Section 25.5.2 focuses on the fourth parameter; **_J_**. Jumps is a bit more complex to work with because it is very open-ended in the web model. This section also provides an intuitive introduction to the notion of vertex common factor, VCF, from a non-mathematical perspective.

 Section 25.5.3 introduces readers to the various drawing modes available with the web version of string art.

 These sections can be used in K-5 classrooms or by students on their own. They are shown on the next three pages but are also available as *Excel* file 25.0 from the ESA website for teachers who would like to modify the presentation. Additionally, Section 26.4 provides a teacher's perspective on sections 25.1–3. Using the *Excel* file, teachers can cut and paste instructions onto handouts, for example, and they can change wording if they wish. Transferring information from *Excel* to *Word* is discussed in Section 26.5.

PART I deals with changing the numbers associated with n, S, and P, and seeing what SCF means

Even without knowing multiplication and division, you can see many of the ideas used to create String Art.
Click *Toggle Vertices* on. As you do this you will see numbered points (called vertices).
You can turn them off to view images but we will use them often in the discussion below.

What n in an N-gon means n is the number of vertices and sides of a regular polygon, called an n-gon.
Click on the 4 and as you increase or decrease n, the number of equally-spaced points changes.
Do not worry about why images look like they do, just note that numbered points go from 0 to n-1.
Return n to 4.

What S in Subdivisions means Click *Toggle Subdivisions* on. You should see **purple dots, •**.
Click on the 12. Change S and the number of equally-spaced **dots** between numbered vertices changes.
Return S to 12.

What P in Points means You use P to draw lines in the final image.
Click on the 30. Change P and see what happens as P changes. The image changes a lot as we move P.
Return P to 30 to see how P tells us where to draw lines.

Drawing lines in the final image: *Lines are drawn connecting every P^{th} dot, starting at vertex 0 (the top).*
The image is made by counting out P = 30 subdivisions starting at the top and going around the **dots**.
There are 12 between vertex 0 and 1, 12 more between 1 and 2, and 6 more halfway between 2 and 3.
If P = 31, the first line is one **dot** closer to vertex 3, if P = 29 it is one **dot** closer to vertex 2.
Notice that the center gets larger with P = 31, and smaller with P = 29, and smallest with P = 25 or 23.
Return P to 30.

Visualizing SCF

SCF stands for *Subdivision Common Factor*.
In a geometric sense, **SCF means: What portion of the subdivision dots does the final image use?**
The initial setup was n = 4, S = 12, and P = 30, and this produced a star made from 8 lines.
Click *Toggle Subdivisions* on (for the rest of **Visualizing SCF**). Note that only every 6^{th} **dot** is being used.
That is what SCF = 6 means.
Click P up to 31. Note that there are now 48 lines and ALL subdivision endpoints are being used.
That is what SCF = 1 means.
Click P up to 32. Now there is a triangle and every 16^{th} subdivision endpoint is being used.
That is what SCF = 16 means.
Click P down and watch what happens as P changes

P	Lines	SCF	Proportion of subdivisions used
29	48	1	all
28	12	4	one fourth
27	16	3	one third
26	24	2	one half
25	48	1	all
24	2	24	one twenty-fourth

This looks like one line but is two because
you always have to return to the top. Note: 24+24 = 48

Put P back at 30. We know there are 8 lines here since that is where we started.
If we increase n to 5, it looks like there is 1 line, but the image says 2.
The same thing is happening here as with P = 24 in the box above.
Notice that 30 = 12+12+6 so 30 **dots** is exactly half way around the pentagon.
Put another way, there are 60 subdivision endpoints possible, but only 2 are used in this image.
One to get to the middle bottom, the other to get back to the top. 30+30 = 60 and SCF = 30.
Next, change P to 29. Now every subdivision is attached to the image and there are 60 lines total.
You should have a very fun looking pointy image, kind of like a porcupine with needles everywhere.
This is actually called a *Porcupine Polygon* because it as close as you can get to halfway around.
Check other P between 28 and 24. You will find there are less than 60 lines since SCF > 1 in each instance.

PART II deals with using jumps to create stars and seeing what VCF means

Using Jumps The url above has n = 4, S = 12 and P = 30. Change P to 29.

If *Total Jumps* says 0, then we automatically just move around the polygon, one vertex at a time.

We can change that, and the smallest n for which we can make a star is 5.

Therefore, increase n by 1 to n = 5.

The result is a *porcupine pentagon* (because there are now 60 **dots** and 29 is close to half).

Click *Total Jumps* up to *Total Jumps* = 1.

Notice that a new box underneath appears that says *Jump 1*.

The number 1 is always the starting point so notice that this looks no different than when *Total Jumps* = 0.

Click *Jump 1* up to 2.

DO NOT click *Total Jumps* up to 2, that does something different.

Before looking at what this does, it is best to learn the basics.

The resulting image no longer has **dots** on the outside. Now they skip a vertex and create a star of **dots**.

If you find that hard to see, set P = 12 and it will be obvious.

> **VERY IMPORTANT NOTE: When we say J = 1, or 2, ... 7, or whatever, we mean *Jump 1*.**
> **We look at multiple jump sets in Part III of ESA. This is when *Total Jumps* > 1.**

With P = 29, all subdivision points are used but the image is very different if J = 2 than if J = 1.

With J = 2, you have a star with curves between each point, and a spiky center.

Also check P = 30 and note that you have a vertical line just like you did with J = 1.

The line is shorter now because halfway around is on the flat part of the star between 1 and 4.

If numbered vertices are not visible, click *Toggle Vertices* to see numbered vertices.

If you check other P between 28 and 24 you will find that there are always less than 60 lines since SCF > 1.

Setup to see what VCF means

With n = 5 and S = 12, set P = 18 and J = 1 (recall, J = *Jump 1*).

You get a 10-sided star with 10 lines.

Points of the star are at pentagon vertices and midway between pentagon vertices when J = 1.

If you set J = 2, you get a star inside a star image.

In both images, every 6th subdivision is used because SCF = 6.

Set J = 1 and change to P = 17 . Now every subdivision is used and there are 60 lines because SCF = 1.

The inside looks like a curvy upside down (point on bottom) pentagon.

Change n to 6. Now you have a curvy hexagon with 72 lines because SCF = 1.

Click *Toggle Vertices* and *Toggle Subdivisions* on (so you see vertices 0 1 2 3 4 and 5 and **purple dots**).

Visualizing VCF

VCF stands for *Vertex Common Factor*.

In a geometric sense, **VCF means: What portion of the vertices are you using?**

Change *Jump 1* to J = 2.

Even though you have a hexagon (n = 6) the image only uses vertices 0, 2, and 4.

Half of the vertices (1, 3, and 5) are not used. **This is because VCF = 2.**

The total number of subdivision points in this instance is 36 = 12+12+12.

The image is a *porcupine triangle* because 1 more P, P = 18, is a single line (VCF = 2 and SCF = 18).

Like above, it just looks like 1 line, but it is 2 because you have to get back to the top, so 18+18 = 36.

However, if you set *Jump 1* = 1 with P = 18 and n = 6, you have a 4 line diamond since 18+18+18+18 = 72.

Note that this uses all vertices (VCF = 1) but only 1/18th of the subdivisions (SCF = 18).

And if you change to n to 4, you once again have the star we started out with.

Change to n = 8 and you have a 16-point star if J = 1, and the 8-point star on a square if J = 2 (since VCF = 2).

Change J = 3 and you have an interesting 16-line, 16-point star where every other point is much shorter.

Click *Toggle Subdivisions* on and note that the **dots** almost coincide for one smaller P.

Check what this means by noting the very spiky 96-line, 8-point star at $\underline{n = 8, S = 12, P = 17, \text{and } J = 3}$.

PART III introduces *Drawing Modes,* discusses how to simplify values, and looks at *n* = 12

Drawing the first line The url above has *n* = 4, *S* = 12 and *P* = 30.

Images are continuously-drawn every *P*th **dot**. It makes sense to see the first line, **P dots** from the top.

The top vertex will always have two lines, one starting and other finishing the image.

Therefore, once you see the first line, you can follow the rest of the lines until completion.

There are multiple *Drawing Modes*, but one in particular is useful in showing the first line.

*To show 1*st	1 Click *Pause/Play*. This is done because the default is *Play* and we want to *Pause*.
line, follow	2 Change *Drawn Lines* from 3 (where it starts) to 1.
these steps	3 Click the dropdown menu and choose the last option: *Single Lines Overlaid Drawing* mode.

The image will now show up with a single line highlighted with image behind it.

Change *P* to 29 or 31 and see how much easier it is to see where the first line ends.

Watching an image get drawn Set *P* back to 29, with *n* = 4 and *S* = 12.

Instead of pausing drawing, click Pause/Play once more (if you are doing this right after above).

This will cause the drawing modes to draw rather than remain static.

Choose the first *Drawing Mode: Fixed Count Line Drawing.*

Watch the image get drawn to completion after 48 lines.

Speed up or slow down the drawing as you wish.

An important point: The static (*No Drawing*) image does not shout out: ***I'm really a rotating star.*** Watching the image get drawn does. In this case, the star rotates clockwise.	
To see this most	1 Return to *No Drawing* mode. (Doing this resets *Drawing Progress* to 0.)
clearly, follow	2 Set *Drawn Lines* = 5.
these steps.	3 Change to *Fixed Count Line Drawing.* See the star walk around the square.

This does not always happen. Change to *S* = 19 and see a similar image get drawn without a visible pattern.

Simplifying Values Set *P* = 18, with *n* = 4 and *S* = 12.

This star looks the same as when *P* = 30 but notice that *P* is much smaller.

It takes less counting to create the image when *P* = 18.

Note: 18 = 48 - 30 = Total Subdivisions - Original *P*. *Both values of P produce the same final image.*

Use the smaller number because it cuts down on counting.

Notice that both images (*P* = 30 and *P* = 18) use only one subdivision out of 6. This is because SCF = 6.

So, change *Subdivisions* to *S* = 2, and *Points* to *P* = 3.

The image looks the same, and notice that now SCF = 1.

We have an 8-point star using the vertices of the square and the midpoint between vertices.

But now we only have to count 3 to draw each line rather than 30.

Set *n* = 12 and see what happens as you vary *J*. (*Remember, there are 12 hours on a clockface.*)

Only jumps 1, 5, 7, and 11 use all vertices. Overall, we have the following.

J	VCF	Image Created by the Subdivision Dots (this is called the *Vertex Frame*, VF).
1	1	12-sided polygon (dodecagon)
2	2	6-sided polygon (hexagon)
3	3	Square
4	4	Triangle
5	1	12,5-star
6	6	vertical line
7	1	12,7-star (looks the same as the 12,5-star)
8	4	Triangle
9	3	Square
10	2	6-sided polygon (hexagon)
11	1	12-sided polygon (dodecagon)

Note the symmetry about the middle (*J* = 6). This is why we often only consider *J* less than half of *n*.

Note: *J* = 12 is a single point since you always stay at the top.

Chapter 26

Suggestions for Mathematics Teachers

26.1 Introductory Remarks for Teachers

Electronic String Art (ESA) is simply a book of recreational math and art. The files have been crafted for independent learning experiences rather than as a formal teaching tool. Think of this process as *Play to Learn*. Nonetheless, ESA certainly can be used to supplement teaching, and this chapter speaks to those who wish to teach from these files.

ESA's underlying philosophy. ESA's goal is to provide an immersive experience so that users do not notice that they are learning math. Users are simply playing with numbers, either using arrow keys or by entering them in cells and seeing what happens. The images that they create will naturally present opportunities for mathematical learning albeit in a subtle way. The images that users find interesting will have a mathematical reason for being so, but users need not know the reason to enjoy the images. For example, even very young users will appreciate learning how to create pentagons and pentagrams from polygons with more than five sides. Those in grades K-2 need not know that the answers they derive (that *n* = 10, 15, 20, 25, …) are all multiples of five. They will see the pattern even though they cannot express it in multiplicative terms. Visualization of patterns such as these primes them to understand multiplication more deeply once it is formally introduced.

This book pulls together topics at various levels of mathematical sophistication. Given the highly visual nature of the material, students can enjoy exploring a variety of topics even when they do not fully understand the underlying mathematics. Such explorations are attuned with Sherman Stein's suggestion that mathematical understanding is best accomplished by following what he called *The Triex: Explore, Extract, Explain.* Stein recommends that we encourage students to *explore* and gather data, seek to *extract* some sort of order or pattern from those explorations, and ultimately seek an *explanation* for what has been found. He points out that even if students are unable to attain that third step, they have been primed to appreciate the explanation provided by the instructor or another student for why the pattern exists. Such explorations encourage learning, and this learning can occur outside the classroom even in the absence of a complete understanding of the results.

The search for similarity is foundational to ESA and is the subject of Chapter 9. Once you find an image you like, you are naturally drawn to the question: *Are there similar images that have similar attributes but a different number of sides, jumps, or subdivisions?* As you help students explore questions such as this, you will undoubtedly lean (perhaps unknowingly) on the masterful little book *How to Solve It*, written by George Pólya in 1945. Summaries of this work abound on the internet, and *How to Solve It* even has its own entry in Wikipedia.

The visual appeal of the images created in ESA suggests that students should be introduced to the model and then be allowed to play. Different students will, of course, be drawn to different images and a useful early exercise is to let a student tell you the numbers that created an image they liked. You can then project that image on a smart-board for discussion. Such show-and-tell

DOI: 10.1201/9781003402633-30

often becomes an interactive learning experience as other students offer their own variations on the image. Such experiences engage students and encourage them to engage in mathematical thinking without even knowing it. This can help them learn to like mathematics rather than dread it.

How does ESA fit into the curriculum? String art can be used to highlight many concepts up and down the curriculum. One of the most interesting aspects of string art is that it can be viewed in a very layered fashion with different questions being asked based on the same image to different audiences. The *Teaching Companion to the Web Guide*, Section 26.4, provides examples of this layering.

Many challenge questions provide ideas for group and individual exercises, and by altering any of the parameters of the model, new images can be created that are worthy of additional analysis. Answers to almost all of the challenge questions in the book are provided in Chapter 27, and a complete answer key is available on the ESA website (available by scanning the QR code on the *Features* page at the front of the book).

Teaching from ESA works best if students have their own tablets that they can use to explore ESA. Students need not have access to *Excel* since most of the material is available in the web version, developed by Liam Myles, but faculty (and their students) will benefit from the enhanced features available in the *Excel* files that can be projected onto smart boards, even if students are only able to access the web version from their tablets.

Two sets of materials are specifically aimed at younger users. The *Polygons and Stars* in Chapter 2 is based on an *SIE* article targeted at K-2 by Erfle, Wensel, Erfle, and Polinka. This article was co-authored with early elementary educators and includes lesson plans and suggestions from teachers who have used early versions of this material in actual classrooms. The teacher edition of the Chapter 2 *Excel* file (2.0.2) provides additional functionality not available in the article mentioned above. A *Quick-Start Guide* for this file is provided in Section 26.2.

The second set of material specifically targeted at younger users is the **guided inquiry** approach to introducing users to string art using the web model. This material is presented in three one-page sections, Sections 25.5.1, 25.5.2, and 25.5.3, (but these sections are also available in *Excel* from the ESA website, and a *Teaching Companion* to the **guided inquiry** is provided in Section 26.4.

There are several *Excel* files in Part II of ESA that teachers will find especially valuable, the most important of which is the *String Art For Teachers Excel* file 3.0.3. A *Quick-Start Guide* for this file is provided in Section 26.3. *Excel* file 10.0.1 provides the option of showing subdivision numbers (up to 1,000), and this file builds off the *For Teachers* file 3.0.3. Other files in Chapter 10 maintain this functionality.

Beyond the basics. Teachers who want to examine functional relationships with students will find the functionally related string art files from Chapter 10 quite useful, both for projection purposes and for creating challenge questions of your own using those files. As noted above, several versions allow you to identify individual subdivision dots by number thereby allowing you to specify the value of **P** associated with an image whose first line ends at that point.

ESA is presented using regular polygons as the point of reference. This allows users to not have to worry about where to position vertices in the (**x**, **y**) plane, or indeed, even to know that there is something called the (**x**, **y**) plane. This is what allows ESA to be accessible to very young users.

If you want your students to think about vertex placement, there is an option available. The non-polygonal version, introduced in Chapter 19, is based on the Erfle and Erfle *Bridges* 2020 paper. It has a higher mathematical bar as users become responsible for vertex placement, which is a very useful thing to allow students to do if you want them to have practice modeling images in the (**x**, **y**) plane. That *Excel* file (19.0) has several sheets that provide a *guided inquiry* approach to learning about **S** and **P**. These sheets are not discussed within ESA, since **S** and **P** are discussed in Part II, but are available should you decide to use this option as your starting point. *Excel* file 19.0.1 provides edge-labeled

blank graph paper that is useful for those wishing to create their own images (like their *Initials*, discussed in Section 19.6).

ESA is based on modular arithmetic, and modular arithmetic is not a standard part of the K-12 curriculum. Modular arithmetic is just a fancy term for doing old-fashioned division and ignoring everything except the remainder. (If you want to divide *a* by *b* you can write this as *a/b*. For any *a* and *b* ≠ 0 the answer to *a/b* is given by two numbers *c* and *r* such that *a* = *b*·*c* + *r* with 0 ≤ *r* < *b*. *a* is the dividend, *b* is the divisor, *c* is the quotient, and *r* is the remainder.) Clock arithmetic is a form of modular arithmetic. If it is 10 pm, and I say, let's meet in three hours, you know we are meeting at 1 am not 13 pm. Once we move past 12, we only care about what is left over. Chapters 23 and 24 deal with this topic.

Sections (or parts of sections) that have a significantly higher level of mathematical content are noted as **MA** (for **M**athematical **A**pproach). **MA** material can be skimmed or ignored by those who do not want to wade through the mathematics (such as that of *modular multiplicative inverses* (the topic of Chapter 24). And note that, even if an image requires an **MA** explanation to fully understand WHY it works, the image is artistically engaging and interesting without knowing why it works. The *Teaching Companion to the Web Guide* in Section 26.4 provides examples of how you might layer your discussion of this material, even in an introductory setting.

Ancillary materials. First and foremost, numerous *Excel* files are available from the ESA website via QR code on the Features page at the front of the book. In addition to materials in ESA, there are ready-to-print handouts that could be used in classrooms posted to the ESA website. Many of these handouts have been road-tested in classroom and after-school settings. The *Guided Inquiry for Younger Users*, Section 25.5, is also available as a three-page handout on the ESA website and as *Excel* file 25.0 if you would like to change any part of that handout. This *Guided Inquiry* uses the web version of string art available via the WEB VERSION QR code on the *Features* page at the front of the book.

This material intersects with <u>Common Core State Standards for Mathematics</u> in many ways. Suggestions for how ESA can enhance learning of specific Grade Level Standards for Mathematical Content are provided in a document on the ESA website.

26.2 A Quick-Start Guide to Using the *Polygons and Stars for Teachers Excel* File 2.0.2

Excel file 2.0.2 allows you to quickly show how polygons and stars are made using just two numbers. The dashboard is shown below, but you should really have the file open as you read this.

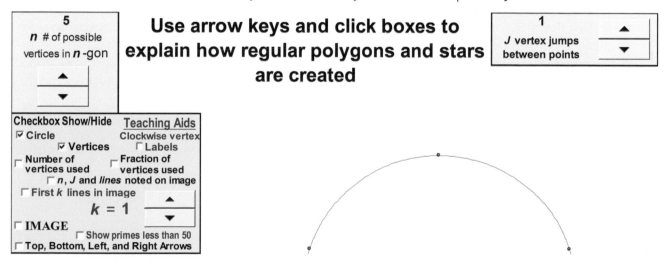

This file has a number of **Show/Hide** toggle switches in the boxed green **Teaching Aids** area and one additional set of Up/Down ⬍ arrows that allow you to show the first *k*-line segments from the image.

These modifications allow you to create your own interactive teaching materials. *The way to use the file depends on the grade level of students as well as what you are trying to teach in the specific session.* The following are six suggestive ideas, just to get you comfortable with using the file as a teaching tool.

1. **Showing the vertices of a regular polygon as points on a circle**
 Click **Circle** and **Vertices** on, and turn all other toggles off. Increase *n* and watch what happens.
 To see these vertices as vertices of a polygon, click **Circle** off, **IMAGE** on, set *J* = 1, *n* = 3 then increase *n*.
 To show that the polygon gets closer and closer to the circle as *n* increases, click **Vertices** off and scroll *n* up to 50. Once *n* is near 50, click **Circle** on and off to show the images are close to each other.

2. **To investigate patterns in vertices of regular polygons**
 The ten questions on the *Polygons* sheet can be asked here as well by clicking the **Top, Bottom, Left, and Right Arrows** on. These arrows can examine even/odd patterns as well as patterns that occur every fourth value of *n*. (Note that **Labels** should be turned off in this instance (since they are superimposed on the arrows.))

3. **Showing how *continuously-drawn* stars are created from regular polygonal vertices by varying *J***
 Click **Image, Vertices**, and **Labels** on, and turn all other toggles off.
 Set *n* = 12. There is only one distinct *continuously-drawn* 12-point star.
 (*J* = 5 and *J* = 7 produce stars that look the same but are drawn in a different order).
 Set *n* = 11. There are four distinct *continuously-drawn* 11-point stars (and *n* = 13 has five).
 These comparisons provide a direct visual entry into discussing prime and composite numbers.

4. **Showing inside/outside issues with *continuously-drawn* stars**
 Turn all but **Vertices** and **First *k* lines in image** off, set *k* = 1 and *n* > 20 and *J* > 1 but less than *n*. For younger children, *J* should initially be set at a small number such as 2 or 3 (2 works well in kindergarten).
 Click *k* from **1** to **2** then ask: *Once we have a completed image, will all vertices be included in the image, or will some be left out?*
 The answer, of course, is: *It depends*. If *n* and *J* have a common factor (greater than 1) then the answer is **NO**, otherwise, the answer is **YES**.
 Whatever the answer was, manipulate *n* so that the reverse answer occurs and use this as a springboard to composite numbers and GCD (if you want to go there).
 In the event you want to discuss this further, click **Number of vertices used** and **Fraction of vertices used** on and vary *n* and *J* and watch what happens. If doing this, I suggest turning **First *k* lines in image** off and **IMAGE** on.

5. **Examining prime versus composite numbers (see also Section 21.1.1, *Prime and Composite Numbers*)**
 The **Show primes less than 50** box provides one additional way to visually examine composites versus primes.
 Have a student choose a prime number from the list. Set *n* to that number. Start with *J* = 1 and set **IMAGE** on.
 Increase *J* from 1 to *n*-1. Every value of *J* will use all vertices.
 (NOTE: If *J* = *n* then there is no image visible as the starting point and ending point coincide.)

Next, return **J** to 1 and increase or decrease **n** by 1 from the prime number chosen (ask someone whether you should go up or down).

Increase **J** from 1 to the **new n**-1. Now AT LEAST every other **J** uses half the vertices (or less).

To emphasize what is happening, click **Number of vertices used** and **Fraction of vertices used** on when you do this exercise.

6. **Examining stars as rotating polygons (based on Section 2.5.1, *Stars as Rotating Polygons*)**
 The values below produce a 49-point star created as a *clockwise rotating pentagon*. Since **k** = **5**, the 50th endpoint is as vertex **1** (since **n** = 49). Increase **k** to **10** then **15**, and the last used vertex ends at **2** then **3**, and so on. Each additional five lines creates another pentagon that ends one vertex higher. (Change to **J** = 12, and the 49-point star is created as a *counterclockwise rotating square*. Ask students, **WHY?**
 The answer is: 4·12 = 48 which is 1 less than 49. The next 4 lines will end at 47, and so on.

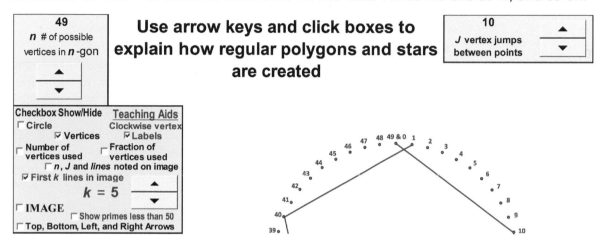

26.3 A Quick-Start Guide to Using the *String Art for Teachers Excel* File 3.0.3

Excel file 3.0.3 allows you quickly to show how the various parameters relate to one another. The dashboard is shown below, but you should really have the file open as you read this. This is like the teachers version of *Polygons and Stars Excel* file 2.0.2, but you can explain that material using this file as well (by setting **S** = **P** = 1).

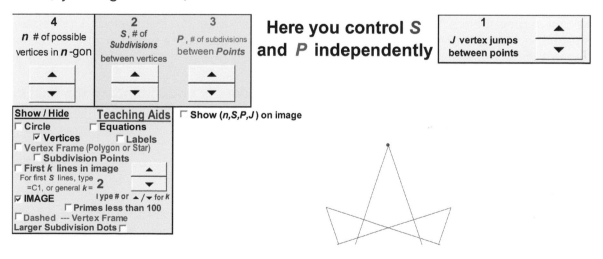

This file has a number of **Show/Hide** toggle switches in the boxed green **Teaching Aids** area and one additional set of Up/Down ⬍ arrows that allow you to show the first *k*-line segments from the image. Additionally, the **Vertices** and **Labels** toggles are separated in case you would prefer to show one but not the other.

These modifications allow you to create your own interactive teaching materials. *The way to use the file depends on the grade level of students as well as what you are trying to teach in the specific session.* The following are four suggestive ideas, just to get you comfortable with using the file as a teaching tool.

1. **Showing the vertices of a regular polygon as points on a circle**
 Click **Circle** and **Vertices** on, and turn all other toggles off. Increase *n* and watch what happens.
2. **Showing how *continuously-drawn* stars are created from regular polygonal vertices by varying J**
 Set *S* = *P* = 1. Click **Image, Vertices** and **Labels** on, and turn all other toggles off.
 Set *n* = 12. There is only one distinct continuously-drawn 12-point star.
 (*J* = 5 and *J* = 7 produce stars that look the same but are drawn in a different order).
 Set *n* = 11. There are four distinct continuously-drawn 11-point stars (and *n* = 13 has five).
3. **Showing the distinction between** subdivisions between vertices, *S*, and subdivisions between points, *P*
 Set *n* = 3, *J* = 1 so we are drawing an equilateral triangle clockwise from the top. Set *S* = 3. This means there are 3 equal-sized subdivisions on each side of the triangle.
 Click **Vertices, Labels, Vertex Frame**, and **Subdivision Points** toggles on, all other toggles off.
 Click the **Vertex Frame** toggle on and off to highlight how subdivisions are placed along the frame.
 Click **Vertices** on and off to note that each vertex is also a subdivision endpoint.
 Now set *P* = 2 and *k* = 1 with all toggles <u>except</u> **Subdivision Points** and **First *k* lines in image** turned off.
 This shows the first segment of the final image, two subdivisions away from the starting point.
 The line segment is drawn from vertex **0** at the top to 2/3 of the way to vertex **1**.
 Click *k* up to **2**. A second segment appears with the endpoint 1/3 of the way from vertex **1** to vertex **2**.
 Click *k* up to **3**. The third segment appears connecting to vertex **2**.
 Once *k* = 9, the image is complete. **Note:** This image includes the vertex frame as part of the image.
 Repeat the above, with *P* = **4**.
 The first segment ends 1/3 of the way along the vertex frame line from vertex **1** to vertex **2**.
 The second segment ends 2/3 of the way from the vertex frame line from vertex 2 to vertex **3&0**.
 Once *k* = 9, the image is complete. **Note:** The vertex frame is NOT part of the image (toggle **Vertex Frame**).
4. **To show why *Cycles* (Section 5.1) are useful to consider in understanding the final image**
 The complete image is typically made up of a number of cycles. A cycle is a set of connected line segments that starts and ends at a polygonal vertex.
 The value of *k* (**First *k* lines in image**) can be manually controlled by typing numbers in cell C11 or using the up/down arrows OR you can tie it to the length of a cycle by typing =M9 in cell C11 if **Equations** are visible or =C1 (as noted in the instructions next to cell C11).
 This shows one or more cycles based on the GCD(*S*, *P*).
 NOTE: Each equation has a comment tab, ◥, that provides the equation.
 The setup below (toggles and values) is particularly nice for showing how images are created from cycles.

The first line is three subdivisions in on the fourth line of the VF from vertex **12–3** (the first three lines are **0–4–18–12**, and 36 = 3·12+3).

The image shown is a *one-time around image* (Section 5.2) since the endpoint of the first cycle is next to **n&0** (at either vertex **1** for clockwise-drawn, or **n-1** for counterclockwise-drawn).

If you click **IMAGE** and **Labels** on, and **Circle** and **VF** off, you will see this relationship very clearly. The completed image is composed of 13 cycles created in a clockwise fashion (with the second cycle ending at **2**, etc.).

Next change to **P = 35** leaving all other values as is.

Now the image is a three-time around counterclockwise image because the end of the first cycle is vertex **10** (10 = 13 - 3). The next few cycles end at vertices **7, 4, 1, 11, 8**, ….

Next change to **P = 37** leaving all other values as is.

Now the image is a five-time-around clockwise image because the end of the first cycle is vertex **5**. The next few cycles end at vertices **10, 2, 7, 12, 4**, ….

To see the image on its own, turn off all toggles except for **IMAGE**.

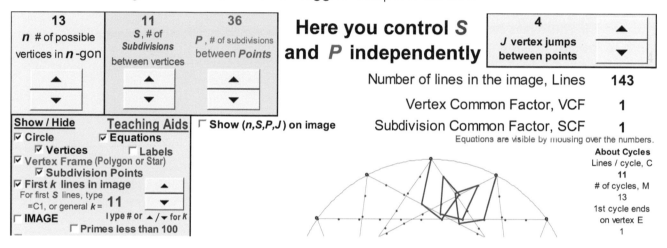

26.4 A Teaching Companion to the Web Guide for Younger Users

The web guide in Chapter 25 includes three one-page **Guided Inquiries** targeted at younger users (Sections 25.5.1–3). These guides introduce the basics of string art in a visual way by guiding users through a series of small exercises that introduce string art without referencing the mathematics involved in a direct fashion. These guides help users, who may not know the mathematics behind the idea of greatest common factor, see what happens as the greatest common factor changes. The point is visually unmistakable, the image has fewer lines as the greatest common factor (divisor) increases.

The first guide explores vertices, subdivisions between vertices, and how subdivision endpoints are used to create an image. The second introduces jumps between vertices. The third examines various drawing modes. This third guide allows users to see the dynamic nature of how a specific image is drawn. This is, of course, different from the dynamics involved in seeing different images appear as parameters change.

If introducing this in a classroom. If you are leading a class through these exercises, it may help to project your screen onto a smart-board showing the first line even though they are not introduced to how to do this until the top of the third guide, Section 25.5.3. That way you can very easily

show what happens as **P** changes. (You could always talk them through those three steps but that is not of the point as they learn the basics.)

How you might alter your presentation based on grade level. If presenting this in an early elementary classroom, it makes sense to slow down and let each lesson percolate for a bit before moving on to the next lesson.

If introducing this in later grades, you can of course move much more quickly. You can also ask students: How would you describe a concept that has been presented using mathematical concepts you know that were not used in the guides themselves? Quite clearly, the basics of string art are much easier to explain if you know about *multiplication*, *division*, *fractions*, *prime* versus *composite* numbers, and the concept of *greatest common divisor*. So, ask students: Where do these concepts apply? Chapter 21 examines these basic properties of numbers.

This material is very layered. This 8-point star is the starting image for the web guide. Ignore the discussion below if you are teaching younger students, the notes below are for those in later grades.

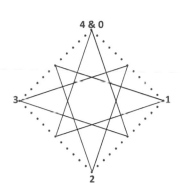

Geometric Musings. If you want to take students down a different path, and if your class has the appropriate background, you might ask them to look at those angles that look like right angles. Are they really right angles and if so, how can you prove that? (Yes. Show this by considering the equations for the lines that intersect. Note that their slopes are negative inverses of one another (±3 and ±1/3).)

You also might ask, are all the triangles in the image similar triangles? (Yes.) In fact, if you want to take the time to show it, and if they know the Pythagorean Theorem, these triangles are all 3-4-5 triangles! See Section 14.9 to learn more.

Comparing Fractions. The (**n**, **S**, **P**) images (4, 12, 29) and (4, 19, 29) look very similar and were compared in the third guide based on how the images were drawn. One might ask: Which has a smaller center? The first guide noted that the closer **P** gets to halfway around, the smaller the center of the image is. Students will have to work through finding how close each **P** is to halfway. Halfway around for the first is 24 **dots**, so 29 is 5 more or 5/12 of the way from vertex **2** to vertex **3**. Halfway around for the second is 38 **dots**, so 29 is 9 less or 9/19 of the way from vertex **2** to vertex **1**. So, the question comes down to: Which is smaller, 5/12 or 9/19? Once you find a common denominator (of 228) you see that 5/12 = 95/228 < 108/228 = 9/19. Indeed, if you look at the (4, 19, 30) image you will find that it is still larger but as close to the same size as possible since 8/19 = 96/228.

Modular analysis. You might ask: Why did the (4, 12, 29) image look like a ↻ rotating pentagram? The answer is that 5 lines is 5·29 = 145 **dots** which is 1 more than three times the number of subdivisions in the image, 48 = **n·S**, 3·48 = 144. Every 5 lines drawn moves one **dot** farther along the vertex frame. Put in modular terms: *5 and 29 are modular multiplicative inverses MOD 48.* By contrast (4, 11, 29) looks like a ↻ rotating triangle because 3·29 = 87 = 2·4·11 − 1.

To read about modular arithmetic and modular multiplicative inverses, and to find talking points for discussing this with students, see Chapters 23 and 24.

26.5 Making Your Own Handouts Using the *Excel* Files

Excel to Word. Transferring an image from *Excel* to *Word* is easy to do, and you can build old-fashioned handouts using single or multiple images. All you need to do is follow these steps.

1. Find an image you like (it may be a completed image or an incomplete one that you have set up using the teacher version of either the *Polygons and Stars* or *String Art* file).

2. Use your mouse or the arrow keys to navigate to the upper left corner of the image.
3. While holding the Shift key down, use the → arrow key to highlight the right edge of the image and then the ↓ arrow key to extend the highlighted row to the bottom of the image.
4. To copy the highlighted image, click *Copy*, or depress the *Ctrl* key and type *C*.
5. Either open a *Word* document or place your cursor in an existing document. DO NOT choose *Paste*. Instead, click the small down arrowhead beneath *Paste* and choose *Paste Special*.
6. From the *Paste Special* popup menu, choose *Picture (Enhanced Metafile)*.
7. To resize, click on the image and resize as you wish using *Word's Picture Format* ribbon which becomes visible once you click on the image.

Excel file 2.0.1, from Erfle, Wensel, Erfle, and Polinka "Connecting Geometric Patterns to Numeric Patterns using the *Polygons and Stars* Excel File," *Spreadsheets in Education, 2021, pages 1–11*, has a *Worksheet-Builder* sheet that helps automate creating worksheets, and there is an introductory video for using this sheet posted to the *SIE* website as well as to ESA. This paper also includes two other introductory videos that are included on the ESA website.

Images can be created that show numbered vertices, vertex frames (based on *n* and *J*), and sub-division points on the vertex frame (*S*) using *Excel* file 3.0.3. As a counting and drawing exercise, you could pass out the same underlying worksheet (and a ruler), and then assign each student a different counting rule *P*. Compare what each one produces to the actual (*n*, *S*, *P*, *J*) image that you project on a smart-board. This can lead to discussions of commonality in situations where SCF > 1.

Resizing your images in *Word*. For maximum flexibility, choose narrow margins (0.5" on all sides), which provide a 7.5"x10" page. Click *Layout* Ribbon, *Margins* dropdown, *Narrow*.

In this setting, it is comfortable to place four 3.7"-wide images on a page (you can place them in the four corners using the *Position* menu within *Picture Format*). Then write your instructions in the middle of the page. Or you can stack them in a 2x2 stack and place your instructions at the top of the page.

With no words, this can accommodate a maximum of 12 2.5"x2.5" images per page, but you must set Paragraph Spacing to 0 pt to accomplish this structure.

You can also use the *Header* to label your documents (*Insert* Ribbon, *Header* dropdown menu).

Chapter 27

Challenge Question Answers

Overview. An answer key for all Challenge Questions is provided on the ESA website. Some of the web answers amplify or provide geometric backup to the answers provided here. Most Challenge Questions are posed in three locations: Section 2.7 (for Polygons and Stars), Chapter 14 (for Part II), and Chapter 20 (for Part III), but a few are also posed elsewhere. In each case, the answers provided here note the appropriate section rather than page reference.

Part I

2.1 Images (a), (c), (d), and (h) are polygons. Image (b) violates 1, (e) violates 3, (f) violates 2, and (g) violates the image being closed. It is worth emphasizing that (a) and (c) are not convex but are still polygons where (a) is a hexagon and (c) is a pentagon.

2.2.1 There are seven distinct 17-point stars: 17,2 17,3 17,4 17,5 17,6 17,7 17,8. The number after the comma refers to the number of jumps between drawn lines. This can be more compactly stated as 17,J for 1 < J < 17/2.

2.7.1 **1.** 1/J. **2.** A vertical line. **3.** 3J. **4.** A triangle. **5.** Larger and larger polygons emerge. **6.** One draws the image in a clockwise fashion, the other in a counterclockwise fashion. **7.** Since J is not a multiple of n, there is a remainder > 0 to the fraction J/n. Let that remainder be r. The n,J-star and the n,r-star are the same. The only difference is the number of times you count around the circle. **8.** 2n. **9.** 2J. An n,J-star and a 2n,2J-star are the same. **10.** 2n,2J and 3n,3J are the same as n,J. **11.** 2n,2J , 3n,3J and 4n,4J are the same as n,J.

2.7.2 **1.** 31,9-star. **2.** Yes. **a.** 7,2-star. **b.** Clockwise, the seventh end is at vertex **1**. **c.** Common angle is 180·13/31 at vertices **5, 9, 14, 18, 23**, and **27**. The single angle between 0 and 1 is 180·15/31 since 15 = 1 + (23-9). **d.** Regular 7,2-star has angles 180·(7-4)/7 so the sum of seven of these angles is 540. The sum of the seven angles in the rotating 7,2-star is (180/31)·(6·13+15) = (180/31)·(78+15) = (180/31)·93 = 540. The two stars have the same sum of angles.

2.7.3 **1. a.** Instead of using the six lines 1, 11, …, 51, use the six lines 5, 15, 25, … , 55. **b.** Each line is 5 MOD 10.
2. a. Create a second set of six lines midway between each of the previous set. **b.** 12 lines are required. **c.** Use lines 1, 6, 11, …, 56. **d.** Each line is 1 MOD 5. **Note:** The final image is shown in the web answer key.
3. a. Thirty lines are required. **b.** Use lines 1, 3, 5, … ,59. These are just the odd numbers starting at 1. **c.** Each line is 1 MOD 2. **d.** Yes, because each of those lines is odd.
4. a. Fifteen lines are required. **b.** Use every fourth line starting at 1 or 1, 5, 9, 13, … , 57. **c.** Each line is 1 MOD 4. **d.** No, the blue lines are used, but not the red lines because they are 3 MOD 4. Put another way, 11, 31, and 51 (the red lines) are not part of this image.

DOI: 10.1201/9781003402633-31

5. a. No, this is created from squares, not triangles (12/3 = 4 so the underlying image is a square). **b.** 12 lines are required. **c.** Use lines 1, 6, 11, ..., 56. **d.** Each line is 1 MOD 5.
6. a. This occurs for the same reason that there are multiple internal stars if J > 2. If this is confusing, reread the stars inside of a star explainer which discusses these stars based on a 12,5-star. **b.** You can also see an internal 12,5-star and a 12-2-star in this situation.

2.7.4 1. The triangle does not have a right angle. **a.** The reason is that for a right angle to occur, one must span HALF of the vertices. This can only occur if *n* is even. But *n* = 31 here. **b.** the angles are:

The **1-10, 5-14** angle is 180/31·((5–1) + (14–10)) = 180/31·8 = 46.45.
The **5-14, 9-18** angle is 180/31·((9–5) + (18–14)) = 180/31·8 = 46.45.
The **10-1, 9-18** angle is 180/31·((10–9) + (31–18+1)) = 180/31·15 = 87.10.

Notice that 15/31 is close to but not equal to ½ (which would be required if that angle were in fact a right angle. Note also that 8+8+15 = 31. The triangle is isosceles but not right.
2.a These two lines create two angles, 180/31·8 and 180/31·23. **b.** The first cannot be used to create isosceles triangles because 31-8 = 23 is odd. As such, it cannot be equally divided as required for equal angles. The second can be used to create an isosceles triangle because 31-23 = 8 is even. The line **3-12** does the job, as the vertex angle is 23·180/31 and the base angles are both 4·180/31.

Part II

4.2.3 The fifth line lands at vertex **1** after going twice around the *n* = 57 polygon. Therefore 5*J* = 2·57+1 = 115. This means that *J* = 115/5 = 23.

4.2.4 Each image would have a line 1/3 of the way from each star point. This is the same pattern shown in Section 3.3 described as a hexagon inside a triangle with the understanding that when *n* = 3 one cannot draw a star just a triangle.

5.4.2 The top row, *n* = 14, *S* = 15, and *J* = 5, has GCD(*n*,*P*) = 7 and GCD(*S*,*P*) = 1 therefore 1/7 or two vertices are in the final image, but each type of subdivision remainder is used for both *P* = 77 and 91. For the bottom row, *n* = 15, *S* = 14, and *J* = 7, has GCD(*n*,*P*) = 1 and GCD(*S*,*P*) = 7, therefore all vertices are used but only 1/7 of subdivision types (or the middle) is used in the final image. The sunburst must be the *n* = 15 set of values because then all vertices are used.

8.1 Since 17·19 = 323, we need *P* = 108 since 3*P* = 324 in that instance. Since both *n* is prime, VCF = 1 regardless of *J* so all eight values of *J* < *n*/2 produce shape-shifting triangles.

9.2.1 Image **I** is (14, 3, 8, 5). Image **II** is (15, 2, 3, 2). Image **III** is (10, 2, 7, 3). Image **IV** is (11, 3, 4, 4). For geometric explanations, see the web answer key.

9.4 Peak order: 17-14-11-8-5-2-19-16-13-10-7-4-1-18-15-12-9-6-3 and 1-20. One is 3× ↺ the other is 1× ↻.

12.3 Increase *S* to *S* = 302 for 9,3-star. Increase *S* to *S* = 303 for 12,4-star. Start from the 6,2-star, decrease *J* to *J* = 75 to produce an 8,2-star. Start from the 6,2-star, decrease *J* to *J* = 60 to produce a 10,2-star. Start from the 6,2-star, decrease *J* to *J* = 50 to produce a 12,2-star.

12.5 The image has 11 strands. See by using SLOD with DL = 11 on pause which is *smallest-step*. Note, Lines = 122 or 11·11+1.

12.7 The (490,328,490,163) image has four cycles because *J* = 1 MOD 4 and *n* = 3*J*+1 so it is the first option discussed in 12.7. You can check that this is true by using SLOD on Pause with DL = 82. Then check DL = 164 and 246.

14.1 Q1. Top row: For all three images set *n* = 5, *J* = 2 and *P* = 2. From left to right: *S* = 3, 5, 7. Bottom row: For all three images set *n* = 5, *J* = 2. From left to right: *S* = 2, *P* = 3; *S* = 5, *P* = 12; *S* = 5, *P* = 7.

Q2. Top row: **J** is the parameter that changes. Each has **n** = 7, **S** = 3 and **P** = 2. From left to right: **J** = 1, 2, 3.

Q3. Bottom row: Left same except **n** = 7. Middle same except **n** = **S** = 7, **P** = 24. Right **n** = 8, **S** = 5, **P** = 7, **J** = 3.

Note in Bottom Right on p.1, **J** = 2 and 3 produce the same with **n** = 5 but not with **n** = 8.

Q4. Bottom right on p.2 is an example of an even needle star. Can you find others based on being shown one?

14.2 **1.** Blue has horizontal and vertical symmetry because it has points that coincide with Black's regular polygon vertices at even-numbered vertices 0, 2, 4, and 6. Red has only vertical symmetry. Red's 2 and 6 cannot be used for horizontal symmetry because the red angle at 8&0 need not equal the red angle at 4. **2.** Given **n** = 9, **P** = 9, **S** = 8, **J** = 1 works. (We have similar versions of this idea in ESA, consider, for instance, Section 6.4.2.) **3.** Given **S** = 2, if we let **P** = 3, **J** = 1, and **n** = 12 we get an image with eight lines. This is what you would get if you start with a Brunes Star (Section 3.3) and increase **n** to 12.

14.3 **1.** Area is 2. **2.** Area is 8/9. **3.** Area is 16/9. **4.** Hexagon is twice as large. **5.** Area 8/5. **6.** Area 88/49. **7.** H(S) = 2-2/S^2. **8.** $A_{7\text{-gon}}$(S) = 2-10/S^2. These answers are explained in the web answer key.

14.4 **1.** There are eight right angles, even-numbered intersections from 2 to 16. **2.** Coordinates of point 12 =(-0.4, -0.2). **3.** Area is 432. These answers are explained in the web answer key.

14.5 Top is (10,3,7,4) or (10,3,8,4), VCF = 2, SCF = 1. Bottom is (10,3,8,3), VCF = 1, SCF = 2.

14.6 Top: Left is (11,2,5,4) Right is (11,2,5,5). **J** changes.
Bottom: Left is (7,4,5,3) Right is (7,4,9,3). **P** changes.
Additional instructions for teachers are noted on the web answer key for creating further image detective problems.

14.7 **1.** There is no **S** or **J** that produces **n** = 249 and satisfies this criterion. The reason has to do with solving for **J** using the equation 249 = 3**J** + 1 or 249 = 3**J** - 1. But 249 is a multiple of 3 so it cannot have remainder 1 or 2 when divisible by 3. **2.** **n** must have remainder 1 or remainder 2 when divisible by 3. **n** cannot be a multiple of 3.

14.8 See web answer key for a detailed explanation.

14.9 **1.** More than half (actually 51%). **3a.** **S** = 4. **3b.** **S** = 10. See web answer key for a detailed explanation that includes a substantial build-out in *Excel*.

Part III

19.5 Both top row and middle left images are (-1,-1). Middle right is (-2, 4). Bottom left is (-2,-1). Bottom right is (2,4). It was not asked, but all six images have **V** = 6. The three images on the right have **P/S** close to 0.6. The top left image has **P/S** of about 1.5. Middle left and bottom left are both porcupines with **P/S** of a bit smaller than 3.

20.1 See web answer key for graphics on questions 1 and 6. **2.** No. **3.** Tenth and eleventh segments. **4.** Area = 0.75·$3^{0.5}$. **5.** 18.

20.2 Top left area = 2. Top right is half the size so area = 1. Middle left has area = 3. Middle right has area of 1.5. Bottom left is ¼ less than 2 or 1.75 Bottom right is 1/16 less than 2 or 31/16.

20.3 See web answer key for image labeling. **2.** Image 2 is larger. **3.** It is 50% larger or 4/9 square units larger. **4.** See explanation in web answer key.

20.4 Page 1. Q1. The left image is from the double jump model due to the dark streaks at vertex diagonals. Left 1,4 or 4,1, and right 1. Q2. **P** = 239 left, **P** = 119 right. Q3. Both images

would look the same. Each then is simply one more than half-way around but the images are symmetric about half-way around.

Page 2. Q1. Left, $J2 = 3$, $n = 6$. Middle, $J2 = 4$, $n = 8$. Right, $J2 = 5$, $n = 10$. Q2. 2, 8, 2. Q3. Left and Right must be done with 18.0.2 with the last half counterclockwise clicked on. Middle can be done with all three versions.

Page 3. Q1. Left uses Chapter 15, right uses 16 (1,4 or 4,1 jump pattern). Q2. Increase P to make the curve move "outward."

Page 4. Q1. Left, Chapter 16 because 15 does not allow jumps > 1. Right Chapter 15. Q2. Left 2,5 or 5,2. Q3. Left: Given a double jump set, the number of lines is $2nS$. Given VCF = SCF = 1, solve for S: $400 = 20S$ so $S = 20$. 390 cannot be the answer for the left model because 390 is not divisible by 4. Right: In CPF, Lines = $3nS$ (if VCF = SCF = 1). Therefore, $30S = 390$ implies $S = 13$.

20.5 **1.** Inscribed angle theorem. **2.** 6, larger. **3.** 8 is a bit smaller than 1/3 of the circle's area. **4.** 8 is 3.1% larger than 12. **5.** The three areas are 1.73, 1.03, and 1 for 6, 8, and 12, respectively. See web answer key for detailed answers.

20.6 Jump 2 is: 8 9 3 4 Times around is: 11 13 11 13. *Excel* file shown in web answer key.

20.7 **1.** (6,3,0) and (6,0,9). **2.** (0, 6,3) and (0,9,6). **3.** (3,0,6). **4.** (9,6,0). **5.** (0,3,8) **6.** (3,8,0), (8,0,3), (4,9,0), and (9,0,4) all work. These just rotate around the answer to 5 or reverse order with 12-J.

20.8 **1.** The left is two jumps; the right is three jumps. **2.** The second jump is 4. Since the sum is 7 and GCD(7,12)=1 VF has 24 lines. **3.** The second jump is 3, and the third jump is 4. The Second cannot be 4, as only curve at vertex 3 is to vertex 6. Since the sum 3+3+4=10 and GCD(10,12) = 2 there are 18 lines. Even vertices are used twice and odd are used once. **4.** The left image is $J(3,4,0)$ since there is a curve from 0-3-7. **5.** The right image is $J(3,0,4)$ since there is NO curve from 0-3-7. These statements are easily confirmed using the *Excel* file.

20.9 **1.** The color density for gold is not due to just the smaller S value here. Look at any of the 12,2-star VF lines here, for example from 0 to 2. **2.** No. If gold were of full density, there would be gold lines at four interior points on this line. There is only one 60% of the way from 0 to 2. **3.** SCF = GCD(36·5,87) = 3 so that Gold lines = 36·5/3 = 60. So gold density is 33%. The other three lines have 1908 blue, 1944 green, 2016 red. Each of these has SCF = 1.

20.10 **1.** (2,9,4) and (8,3,10). **2.** Replace J_1 with n-J_3 and 2 with n-J_2 and J_3 with n-J_1. **3.** Each triangle is a 15° 75° 90° triangle because of the Inscribed Angle Theorem. **4.** There are 16, 4 sets each of small, medium, large, and extra-large. **5.** 2. **6.** 10. See web answer key for additional details.

20.11 **1.** To be as sharp as possible it should only span a single vertex. Therefore, 1.5° = 180/120. **2.** Sum must be 180 so the obtuse angle is 133.5°. **3.** The sum must be ¾ of the way around the circle or 90 vertices jumped. **4.** The last two jumps need to get back to the top while going around once so they must sum to 150 = 30+120. **5.** (45,45,74,76) or (44,46,75,75). If the third and fourth swapped (in the first version), then the long side would be a bit smaller, and the top would then be a bit larger than the bottom. **6.** If you answered (45,45,74,76), it is the second line. If you answered (44,46,75,75), it is the third line.

20.12 The answers to **1–4** are the same as in Part I. This is a result of the inscribed angle theorem. **5&6.** If (30,60,59,91), then the second is a horizontal line. If (29,61,60,90), then the third is horizontal.

7&8. If (60,30,91,59), then the first is vertical. If (61,29,90,60), then the fourth is vertical.

20.13 This CQ contains its own answer key.

20.14 **1.** Change n, S, $J7$ and $J8$ to 14 and add 14th jump. See web answer key for additional details.

20.15 1. The inside point is off the main diagonal. Without further information, it is impossible to be exact with its location. The actual location is (0.4, 0.8). **2.** If you change the Shifter in cell E1 from 1 to -1 you get the right image. **3.** See web answer key for details.

20.16 This is straightforward if you have read *Beyond Inside the Box*, Section 19.5. Set up vertices as shown there; the interior point is (0.75,0.75) for the left column and (0.9,0.9) for the right. This means side lengths for the internal square are 1/4 the size of the overall box or 1/16 the area for the left, and 1/10 the length for the right column or 1/100th the size. Top row has **V** = 9 and **P** = 76 for both. Bottom row has **V** = 7 and **P** = 50 for both. These are easily verified using the Non Polygon *Excel* file 19.0.

23.2 *For 25*. Each four-year cycle has one leap year so T_{days} = 3·365+366. Since 52·7 = 364, 1 = 365 MOD 7, 2 = 366 MOD 7 so, 5 = 3·1 + 2 = 3·365+366 = T_{days} (MOD 7) or your 25th will be on a Sunday (five more than Tuesday).

 ***For 65*.** 65 = 21 + 4·11 so, 6 = 55 = 11·5 = 11·T_{days} (MOD 7) so that your 65th birthday will be on a Monday (six more than Tuesday).

23.4. 1. The multiples of **x** = **a** MOD 9 and **y** = **a** MOD 10 are m_x = 10 and m_y = 81 so 10**x** + 81**y** = **a** MOD 90 for 1 ≤ **a** < 90. **2.** The multiples of **x** = **a** MOD 10 and **y** = **a** MOD 11 are m_x = 11 and m_y = 100 so 11**x** + 100**y** = **a** MOD 110 for 1 ≤ **a** < 110. **3.** The multiples of **x** = **a** MOD 9 and **y** = **a** MOD 11 are m_x = 55 and m_y = 45 so 55**x** + 45**y** = **a** MOD 99 for 1 ≤ **a** < 99.

Chapter 28

Glossary of Commonly Used Terms and Abbreviations and Index

(Index to the section of ESA introducing or adjusting the term is provided in parentheses.)

B is the number of possible subdivisions available in the image. **B** = **nS**/VCF. (Section 4.2.4)

C is the number of segments in a cycle. **C** = **S**/GCD(**S**, **P**). **C** is in cell M9 in the equations column of the *Excel* file. (Section 5.1)

CPF stands for Centered-Point Flowers. This is the simplest variation on the string art model discussed in Part III. After each vertex jump, there is a jump to the center and a jump back out to the vertex. (Chapter 15)

Circuit: A circuit is complete once the starting point for the image (in ESA this is always the top of the circle (except in the non-polygonal Chapter 19)) is achieved as an endpoint. (Section 2.2.1)

Continuously-drawn: An image is *continuously-drawn* if line segments are connected from one to another following a rule until the initial starting point is obtained as the end point of a segment. This applies both to polygons and stars (Section 2.2.1) and images with subdivisions (Section 4.2.1).

Cycle: A partial image consisting of the line segments needed to get from Level 0 back to Level 0. Level 0 points are vertices of the **n**-gon. This is a non-mathematical usage of this term inspired by a spirograph. In mathematical terms, this would more aptly be described as a *cycle generator* and the completed image is a cycle. (Section 5.1)

Curved-tip stars: A curved-tip star is created when the vertex frame is a star and **P** < **S**. (11.2) Such images include the vertex frame and are useful when initially working with jump-sets in Part III, especially in Chapter 17.

DL stands for *Drawn Lines* in the web model. (Used throughout ESA but discussed formally in Section 25.4.)

DP stands for *Drawing Progress* in the web model. (Used throughout ESA but discussed formally in Section 25.4.)

DS stands for *Drawing Speed* in the web model. (Used throughout ESA but discussed formally in Section 25.4.)

Degree of rotational symmetry: The degree of rotational symmetry is the number of different vertices it can be rotated to, for which it matches the original. (Section 6.4.1)

Distinct images: Images based on different **n**, **S**, **P**, **J** values may look identical to one another—they may produce the same static image. There are a variety of reasons this may happen. Distinct images have different **n**, **S**, **P**, **J** values AND look different from one another. (Section 4.3) See also static image. (Section 6.2)

Donut hole: The *donut hole* is the area inside the innermost concentric circle of subdivisions. (Section 10.2.1)

Drawing Mode is the name of the drop-down menu in the web model. Four drawing choices are available: FCLD, FCFLD, SLD, and SLOD. (Section 25.4)

DOI: 10.1201/9781003402633-32

E is the number of the parent polygon vertex that occurs at the end of the first cycle. *E* is in cell M14 in the equations column of the *Excel* file. (Section 5.2)

ESA stands for Electronic String Art. (Section 1.1.1)

Explainer: Sections within this book are, in general, very short and targeted. They have been created to explain something, and hence they are sometimes called *explainers* instead of sections. Care has been taken to provide specific numerical reference to *explainers* outside the "just the basics" *explainers* noted in Section 1.2. (Section 1.2)

F is the Level of the first endpoint in the image. *F* is in cell M28 in the equations column of the *Excel* file. (Section 7.2)

FCFLD stands for *Fixed Count Fading Line Drawing* Mode in the web model. Use if you have large numbers of lines in the image. This drawing mode fills in the image DL lines at a time. (Section 25.4)

FCLD stands for *Fixed Count Line Drawing* Mode in the web model. This is typically the most heavily used line drawing mode. (Section 25.4)

GCD: The greatest common divisor of two numbers is the largest factor common to both. (First mentioned in Section 2.2.2 but discussed at length in Chapter 21)

Image: Term used for a completed graph. (Section 1.1.1)

Image density: Density relates to the portion of potential subdivisions that are used in the image. (Section 5.4)

J is the number of *J*umps between vertices. When *J* = 1, the resulting image is a polygon. If *J* > 1, stars can emerge. (Sections 1.1 and 2.2.1)

Jump Set: A *jump set* is a pattern of jumps that is repeated. (Section 16.1)

Just-over and just-under multiples: Interesting images often occur when one parameter is close to but not quite a multiple of another. This is seen in numerous places but notably in Section 2.5, stars as rotating polygons (*n* = *m·J* ± *a* where *m* is a whole number and *a* is a small whole number). In Part II, this is seen in Section 7.2, *One Level Change* images, Section 8.1 *Shape-Shifting* polygons, as well as with numerous images in Chapters 11–13. A more mathematical approach to this is in Chapter 24 on modular multiplicative inverses and negative MMIs.

k is used to define a range of values of a parameter. This example is from Section 2.3.3. Suppose you want to list the values of *n* ≥ 4 that are multiples of 4. You could do this by stating *n* = 4, 8, … or by saying *n* = 4*k* for *k* ≥ 1. By contrast, if you want *n* larger than 5 that are divisible by 2 but not 4, you would say *n* = 4*k*+2 for *k* ≥ 1. The letter *k* is also used to show the first *k* lines (using the toggle switch in cell B10 value in C11) in multiple string art *Excel* files from Part II starting with 3.0.3 (but in Chapter 10, *r* describes this attribute as noted at *r* below).

L is the number of *L*ine segments in the image. An image may appear to have fewer line segments than listed for a couple of reasons: 1) segments may overlap; and 2) segments may be part of the same line. An example of the first is the vertical line that results whenever *n* is even and *J* = *n*/2. A simple example of the second is when (*n, S, P, J*) = (3, 2, 1, 1). The resulting triangle has *L* = 6, 2 on each of the three sides. (Section 4.1)

L is also used to denote the number of lines in a sub-image, for example the lines in a *single-step*. *Single-step* images require VCF = SCF = 1. The sub-image is *single-step* when *L* satisfies ±1 = *L·P* MOD *n·S*. (Section 8.5.1, see also Section 11.6.1)

Levels: There are INTEGER(*S*/2) subdivision-point-created concentric interior circles. (INTEGER is the integer portion of a fraction so INTEGER(5/2) = INTEGER(2.5) = 2 (not 3 as would be the case were we to round up to the next nearest integer as is common mathematical practice).) Points at Level 0 are polygonal vertices, and Level INTEGER(*S*/2) is the smallest circle (this is the boundary of the *donut hole* discussed in Section 10.2.1). (Section 7.1)

M is the number of cycles in an image. *M* must be a factor of *n*. *M* is in cell M11 in the equations column of the *Excel* file. (Section 5.1)

MA stands for **M**athematical **A**pproach. It signifies that the *explainer* in question [or the bracketed part of an *explainer*] may not be accessible to primary school audiences.

MBS stands for *Modified Brunes Star*. (Sections 10.2.3, 14.8, and 14.9)

MMI stands for *Modular Multiplicative Inverse*. Two numbers are multiplicative inverses if their product is 1. If one number is a whole number **a**, the other is a fraction 1/**a**. In modular arithmetic, two numbers **a** and **c** are modular multiplicative inverses mod **b** > 0 if **a·c** is 1 more than a multiple of **b**. This is the mathematical description of "just-over multiples." (Examined in Chapter 24 but used extensively throughout the book (sometimes without attribution as such, for example in Section 8.4).)

MOD is the mathematical way of saying remainder upon division by a number. For example, 5 = 1 MOD 2 since 5 = 2·2+1 or 17 = 2 MOD 5 since 17 = 3·5+2 but so is 2, 7, 12, and so forth, MOD 5. (Chapter 23)

Mystic Rose: A mystic rose is an image in which each vertex is connected to every other vertex. The number of distinct lines in an **n**-point mystic rose is **n**·(**n**-1)/2. (Introduced in Section 18.1 but discussed more formally in Section 18.2.)

n-gon: An **n**-sided polygon. (Sections 1.1.1 and 2.1)

n-gram: An **n**-sided star. This is a generalization of a pentagram. (Section 1.1.1 and 2.2)

n,J-star: An explicit version of an **n**-gram. Note that an **n,J**-star only has **n** points if VCF = 1. (Section 2.2)

nMMI is negative MMI. In modular arithmetic, two numbers **a** and **c** are nMMI MOD **b** > 0 if **a·c** is 1 less than a multiple of **b**. This is the mathematical description of "just-under multiples." (Examined in Chapter 24 but used extensively throughout the book; see, for example, Section 2.5.1 without attribution or Section 13.1 with attribution.)

NP stands for the *Non-Polygon* model (with user-controlled vertices) presented in Chapter 19.

One-level change images move in and out one level at a time. (Section 7.2)

One-time-around images: If **T** = 1 the image is called a *one-time-around* image. (Section 5.2)

P is the number of subdivisions between **P**oints. **P** is a positive whole number that provides the counting rule for producing images. The image is created by connecting subdivision endpoints that are **P** subdivisions apart from one another with a line segment starting at the top and ending when the last endpoint completes the circuit by being at the starting point. (Sections 1.1.1 and 3.2)

Polygon: A polygon occurs if the line segments comprising the image do not cross over one another except at the common endpoint. A polygon is regular if all vertices are equally spaced around a circle. Also called an **n**-gon. (Section 2.1)

Polygram: Another name for a star, for example, a pentagram is a 5,2-star. Also called an **n**-gram.

Porcupine: An almost halfway-around image. (Sections 11.3 and 11.4 but introduced informally in Section 1.1.1)

r is the remainder when one number is divided by another. This concept is used informally throughout this book but is formally defined in Section 23.1. See also Section 7.3. In the Chapter 10 *Excel* files, **r** is used in place of **k** (the show first **r** lines toggle in cell B10 value in C11) because **k** is used to describe functional forms in that chapter.

S is the number of equally spaced **S**ubdivisions between successive vertices in the vertex frame. **S** is a positive whole number. (Sections 1.1.1 and 3.1)

SCF: The *subdivision common factor*, SCF, is given by SCF = GCD(**P**, **S*****v**$_{used}$). (Sections 4.1, 15.2, and 16.1)

SLD stands for *Single Line Drawing* Mode in the web model. This mode shows DL lines from the image regardless of DP. (explained in Section 25.4 but heavily used in Sections 8.4, 11.9, and 12.8)

SLOD stands for *Single Line Overlaid Drawing* Mode in the web model. This mode overlays DL lines on a completed image. (Explained in Section 25.4 but heavily used in Sections 9.4, 12.5, and 12.10)

Shape-Shifting Polygons involve sub-images that change shape over the course of a cycle. Chapter 8 is devoted to a general discussion of this topic, but the most interesting version may well be 3SST noted next.

3SST is short-hand for *Three Shape-Shifting Triangles*, examined in Sections 8.4 and 8.6. Variations on 3SST are seen in Section 9.5, which compares the concepts of *single-step* and *smallest-step*, and in Section 12.8, which provides a version of 3SST using quivering triangles. Section 8.6 notes a similar image that is 5SST with DL = 11.

single-step images: *Single-step* images occur when a subset of lines in the image ends at 1 more or 1 less than the top of the image. The image will then appear to fill in sequentially around that subset of lines. (Section 8.5.1)

smallest-step images: When SCF > 1, one cannot have *single-step* images, but one can obtain sub-images that are as close to the top as possible. That is what the *smallest-step* means. (Sections 9.4 and 9.5)

Spinning Needle Stars: This is an image that is the *smallest-step* of length 2 that is one-time-around. Formally discussed in Section 11.8.1, but it is also examined elsewhere, most notably in Sections 11.8.2, 9.6, and 11.12.

Star: A star occurs when the image has segments that cross over other segments at points other than their endpoints. Also called an **n**-gram. Often a star is described as a **n,J**-star where **n** and **J** are the number of vertices and the number of jumps, so a 5,2-star is a common pentagram. (Sections 1.1 and 2.2)

Static image: The notion of the same static image typically refers to the idea that if you replace *J* with **n-J** you have the same image, but it is drawn in the reverse direction. (Section 6.2) See also *Distinct image* (as a function of **P**). (Section 4.3)

Sub-image: This is a partial image used to explain a specific point or understand the overall structure of the image. The most common sub-images are cycles (Chapter 5) or the lines required for a *single-step* image (Section 8.5.1) or a *smallest-step* image (Section 9.4).

T is the number of times around vertices of the parent polygon are added to create the image. This is most easily seen using the FCLD *Drawing Mode* on the companion website. The easiest to see are *one-time-around* and *two-time-around* images. **T** is in cell M25 in the equations column of the *Excel* file. (Section 5.2)

V is the number of user-determined vertices that are used in the non-polygonal model introduced in Chapter 19. It takes the place of **n** and **J** in that chapter. (Section 19.1)

VF: The *Vertex Frame*, VF, is the set of line segments that include all possible subdivisions. The vertex frame is solely determined by **n** and **J**. Visualize the vertex frame by setting **S** = **P**. (Sections 1.1 and 4.2.2)

VCF: The *vertex common factor*, VCF, is given by VCF = GCD(**J**, **n**). (Sections 2.2.2, 4.1, and 16.1)

v$_{used}$: The *number of polygon vertices used* is given by **v**$_{used}$ = **n**/VCF. (Sections 4.1 and 16.1) Note that a vertex being used does not mean that it is part of the final image. (Section 5.4.2. But see Section 11.8.1 for very clear examples of this notion.)

(**Punctuation guide**. Individual letters are italicized and bold, acronyms are normal typeface unless necessary for emphasis. **MA** is always bold not italicized. Continuously-drawn uses a dash to emphasize the connectedness of this idea.)

Bibliography

M. E. Boole. *The Preparation of the Child for Science*. Clarendon Press, 1904.

H. S. M. Coxeter. *Regular Convex Polytopes*. Cambridge University Press, 1974.

S. E. Erfle and K. A. Erfle, "Exploring Symmetry Using Aestheometry in Classrooms and Beyond." *Bridges Conference Proceedings*, August 1–5, 2020, pp. 547–554. https://archive.bridgesmathart.org/2020/bridges2020-547.html.

S. E. Erfle, L. Wensel, V. Erfle, and B. Polinka. "Connecting Geometric Patterns to Numeric Patterns using the *Polygons and Stars* Excel File." *Spreadsheets in Education*, vol. 12, no. 3, pp. 1–11, 2021. https://sie.scholasticahq.com/issue/2701.

S. E. Erfle "The Ticking Clock: A Geometric Interpretation of Modular Multiplicative Inverses." *Bridges Conference Proceedings*, July 27-31, 2023, pp. 243-250. http://archive.bridgesmathart.org/2023/bridges2023-243.html

S. Flannery with D. Flannery, *In Code: A Mathematical Journey*. Algonquin Books, 2002.

D. Kozlov. "Eight-Pointed Star and Precise Construction of 7×7 Square Grid." *Bridges Conference Proceedings*, July 29–August 2, 2015, pp. 331–334. https://archive.bridgesmathart.org/2015/bridges2015-331.html.

L. Myles, "Playing with Polygons." https://www.playingwithpolygons.com/.

National Governors Association Center for Best Practices (NGA Center) and Council of Chief State School Officers (CCSSO). *Common Core State Standards for Mathematics*. NGA Center and CCSSO, 2020. https://www.nctm.org/ccssm/.

G. Pólya, *How to Solve It*. Princeton University Press, 1945.

D. Spector. "Images Produced via Modular Multiplicative Inverse Filters" *Bridges Conference Proceedings*, July 16-20, 2019, pp. 367–370. http://archive.bridgesmathart.org/2019/bridges2019-367.html

S. K. Stein. "The Triex: Explore, Extract, Explain." *Humanistic Mathematics Network Journal*, vol. 1, no. 14, pp. 6–8, 1996. http://scholarship.claremont.edu/hmnj/vol1/iss14/4/.